THE ILLUSTRATOR

100 BEST FROM AROUND THE WORLD

Edited by Steven Heller & Julius Wiedemann

TASCHEN

CONTENTS

LONG LIVE THE ILLUSTRATION BOOKS!

by Julius Wiedemann

It was not long ago—meaning about 20 years—that the propagation of the art and craft of illustration was mostly confined to editorial and advertising. That has now changed dramatically. When I asked Christoph Niemann, commissioned to produce the cover of this book, to say something about today's state of affairs, he wrote back to me: "One of the side effects of the digital age is that it has shown how visually literate our audience is, and no medium can celebrate this literacy quite as well as illustration." It still surprises me that we, in the fields of publishing, curating, buying, and judging illustration, hadn't realized we could appeal to a much bigger audience. And so we started to understand books about illustration in a completely different way.

Illustrators are now more than creators of images designed to sell a product or convey the main idea of an article. They are now the purveyors of much deeper and more diverse experiences. The murals and the gallery exhibitions were not the only changes in a landscape that encompassed bigger and more complex drawings, paintings, installations, toys, and so many other media. The biggest change lay in the shift in understanding what illustration means to a wider audience.

As in every technological revolution that democratizes tools and empowers users, it is not hard to understand why most people instinctively thought that anyone could illustrate (or photograph, for that matter) at any level. As a simple tool, illustration is a potent vehicle for self-expression and for transmitting ideas, and should be learned by all. But what is interesting is the learning curve we had to go through to appreciate the hard work that is done by thousands of professionals every day, and to realize that together we are creating a new collective visual culture.

For about ten years now we have teamed up with Steve Heller to follow new developments in the field. Just as illustration and illustrators changed, so did the publications about their work. The wide variety of monographs available on the market is a sign that these illustrators have a lot to show. They should also be collected. This book, a compilation of works of 100 artists, is not comprehensive of the entire field, of course. But it manages quite well to display the current state of affairs, with a reasonable—and perfection here is a very abstract concept—distribution of styles, techniques, and use of color, by illustrators of different genders from many different countries. The publication does not aim to be the only standard reference book, but is still a compelling snapshot of what is happening right now. Many of the artists included already show their work in contemporary art collections, and the others might follow soon. This book allows you to appreciate the images, the profiles of the artists, and the reach of their work. I dare you to pick your favorites, and seek more information until you become an illustration connoisseur.

EIN HOCH AUF ILLUSTRIERTE BÜCHER!

von Julius Wiedemann

Es ist noch nicht lange her – etwa 20 Jahre –, dass die Verbreitung der Kunst und des Handwerks der Illustration hauptsächlich auf Redaktion und Werbung beschränkt war. Das hat sich inzwischen grundlegend geändert. Als ich Christoph Niemann, der das Cover dieses Buches gestaltet hat, bat, mir etwas über den heutigen Stand der Dinge zu sagen, schrieb er zurück: „Einer der Nebeneffekte des digitalen Zeitalters ist, dass es gezeigt hat, wie gut sich unser Publikum mit Visuellem auskennt, und kein Medium kann diese Erkenntnis so gut darstellen wie die Illustration." Es überrascht mich noch immer, dass wir, aus den Bereichen des Publizierens, Kuratierens, Kaufens und Beurteilens von Illustrationen, nicht erkannt hatten, dass wir ein noch viel größeres Publikum ansprechen könnten. Und so begannen wir, Bücher über Illustration auf eine ganz andere Art zu verstehen.

Illustratoren sind heute mehr als nur Schöpfer von Bildern, die dazu bestimmt sind, ein Produkt zu verkaufen oder die Grundidee eines Artikels zu vermitteln. Sie sind die Lieferanten von viel tieferen und vielfältigeren Erfahrungen. Wandgemälde und Ausstellungen in Galerien sind nicht die einzigen Veränderungen in einer Landschaft, die größere und komplexere Zeichnungen, Gemälde, Installationen, Spielzeug und so viele andere Medien umfasst. Die größte Veränderung bestand darin zu verstehen, was Illustration für ein breiteres Publikum bedeutet.

Wie bei jeder technologischen Revolution, die Werkzeuge demokratisiert und die Nutzer stärkt, ist es auch dieses Mal nicht schwer zu verstehen, warum die meisten Menschen instinktiv dachten, dass jeder illustrieren könne (und übrigens auch fotografieren), und zwar auf jedem Niveau. Da die Illustration ein einfaches Werkzeug und ein starkes Mittel zur Selbstdarstellung und zur Weitergabe von Ideen ist, sollte sie von jedem erlernt werden. Interessant ist jedoch die Lernkurve, die wir durchlaufen mussten, um die harte Arbeit zu schätzen, die täglich von Tausenden von Profis geleistet wird, und um zu erkennen, dass wir gemeinsam eine neue kollektive visuelle Kultur schaffen.

Seit rund zehn Jahren arbeiten wir nun mit Steve Heller zusammen, um die neuesten Entwicklungen auf diesem Gebiet zu verfolgen. So wie sich Illustrationen und Illustratoren veränderten, veränderten sich auch die Veröffentlichungen über ihre Arbeit. Die Vielfalt der auf dem Markt verfügbaren Monografien ist ein Zeichen dafür, dass diese Illustratoren viel zu zeigen haben und gesammelt werden sollten. Dieses Buch, eine Zusammenstellung von Werken von 100 Künstlern, umfasst natürlich nicht das gesamte Feld. Aber es gelingt ihm ziemlich gut, den aktuellen Stand der Dinge aufzuzeigen, mit einer angemessenen – und Perfektion ist hier ein sehr abstraktes Konzept – Verteilung von Stilen, Techniken und dem Einsatz von Farbe, von Illustratoren verschiedener Geschlechter aus vielen unterschiedlichen Ländern. Diese Publikation hat nicht den Anspruch, das einzige Standard-Nachschlagewerk zu sein, ist aber eine überzeugende Momentaufnahme des aktuellen Geschehens. Viele der hier aufgeführten Künstler zeigen ihre Arbeiten bereits in Sammlungen zeitgenössischer Kunst, die anderen könnten bald folgen. Dieses Buch ermöglicht es Ihnen, die Bilder, die Profile der Künstler und den Umfang ihrer Arbeiten zu würdigen. Ich möchte Sie dazu auffordern, Ihre Favoriten auszuwählen und weitere Informationen zu suchen, bis Sie zu einem wahren Illustrationsconnaisseur werden.

VIVE LES LIVRES D'ILLUSTRATION!

par Julius Wiedemann

Il y a encore de cela une vingtaine d'années, la diffusion des travaux d'illustration se cantonnait principalement aux domaines éditorial et publicitaire ; la réalité est aujourd'hui tout autre. Quand j'ai demandé à Christoph Niemann, chargé de créer la couverture de ce livre, de se prononcer sur l'état actuel des choses, il m'a répondu : « L'une des conséquences de l'ère numérique est qu'elle a démontré à quel point notre public s'y connaît, et aucune technique ne fait plus honneur à ce savoir que l'illustration. » Je reste surpris de constater qu'en matière de publication, de conservation, d'acquisition et de critique d'illustrations, nous n'avions pas réalisé la véritable étendue du public potentiel. C'est alors que nous avons commencé à aborder tout autrement les livres parlant d'illustration.

Les illustrateurs sont désormais bien plus que des créateurs d'images conçues pour vendre un produit ou transmettre l'argument principal d'un article : ils font aussi partager des expériences nettement plus profondes et variées. Peintures murales et expositions en galeries n'ont pas été les seules nouveautés dans un paysage fait de dessins, peintures, installations, jouets et bien d'autres supports, plus grands et plus complexes. Le changement majeur a été de comprendre ce que l'illustration signifiait pour un public plus large.

Comme pour toute révolution technologique qui démocratise les outils et responsabilise les utilisateurs, la plupart des gens ont en toute logique pensé que l'illustration (comme la photographie, d'ailleurs) était à la portée de tous. L'illustration est certes un outil simple, mais aussi un puissant vecteur d'expression de soi et de transmission d'idées que tout le monde devrait maîtriser. Notre courbe d'apprentissage n'a en cela pas été banale pour apprécier le dur labeur au quotidien de milliers de professionnels et comprendre qu'ensemble, ils sont en train de créer une nouvelle culture visuelle collective.

Voilà 10 ans environ que nous faisons équipe avec Steve Heller pour suivre les nouveaux développements dans ce domaine. L'illustration et les illustrateurs ont changé, tout comme les publications à ce sujet. Le large éventail de monographies disponibles sur le marché démontre que ces illustrateurs ont beaucoup à enseigner et que leurs créations devraient intégrer des collections. Cet ouvrage offre la compilation d'œuvres de 100 artistes sans évidemment être exhaustif. Il parvient toutefois assez bien à montrer l'état actuel des choses, avec une bonne représentation (ici, la perfection est un concept très abstrait) de la diversité de styles, de techniques et d'usages de la couleur par des illustrateurs de genres et d'origine variés. L'objectif de cette publication n'est pas d'être l'unique livre de référence, mais d'offrir un instantané éloquent de la situation. De nombreux artistes présentés exposent déjà leurs œuvres dans des collections d'art contemporain, les autres les imiteront peut-être bientôt. Cet ouvrage vous permet d'apprécier les visuels des artistes, leurs profils et la portée de leur travail. Je vous mets au défi de choisir vos préférés et de vous informer davantage pour devenir un véritable connaisseur en illustration.

THE ILLUSTRATOR: ALIVE, WELL AND ILLUSTRIOUS

by Steven Heller

In the past two introductions written within the last five years for TASCHEN's *Illustration Now!* series, I predicted that the art of illustration was on the verge of extinction as we know it. It seemed like a logical assumption at the time. The pen (and brush), no longer mightier than the sword, have succumbed to Adobe Photoshop and Illustrator programs, which I implied in my texts made illustration now less an art than a digital technique. My apologies: I was wrong on both counts. Illustration is alive and the new digital tools have given the art renewed vigor and the illustrator greater stamina.

Nonetheless it would probably be just as foolish to bloviate that we are currently experiencing the most fertile period of illustration in its long "illustrious" history as to say it is nearing the end. Constantly, I hear complaints from illustrators and art directors that the business of editorial and advertising illustration has declined since the rise of digital media (especially owing to the availability of stock online images) and the flood of tightened budgets throughout the 2000s. However, while this may be true for some kinds of illustrators, equally important is the fact that the digital world has opened alternative platforms for illustration for the surge of newcomers and old-timers alike. So to put my the-sky-is-falling-crying-wolf pronouncement into perspective: There were extraordinary eras before contemporary mass visual media changed our perceptual habits, back in the day when illustration was the most effective—and the primary—means of illuminating *the* word on paper, to today when we get our words and images on screens as small as a watch face. And in this environment today's tableau and sequential illustrations (along with pictograms, icons, symbols) are holding their own brilliantly. The evidence of the creative explosion—the 100 illustrators' work that is presented in this book—is so utterly persuasive that when I saw the layouts for the first time I was in heaven.

So being one who is given to extremes, I shall now unequivocally proclaim that we have definitely entered a new golden—if not a platinum and titanium—age of illustration.

Please note, however, that there have been many "golden ages" over the past two centuries comprised of legendary artists whose works are treasured today. In the United States, the titan of early- to mid-20th-century magazine illustration, Norman Rockwell, insisted in his autobiography that the Brandywine School generation, founded during the late 19th century by Howard Pyle

(1853–1911), which preceded Rockwell's own prominence, was the last of a golden breed. Yet another generation predictably believed that Rockwell's own golden age, and the creative circle that he inspired, was the highest peak of illustration. Frankly, being of an even later subsequent generation, I have long held that the late 1960s, 70s and 80s, which, among other things, introduced Push Pin Studios and many expressive, satiric, representational, and conceptual illustrators to the public's eyes was the most incredible of all periods (and everything has been downhill since).

But enough of this shortsighted doomsday blather. I've been wrong about the recent past future of illustration. The cataclysm that promised to wipe illustration, like dinosaurs, off the planet never arrived. And, even if there were some professional valleys among the hills, about this joyful book I can say: It marks a stronger life for a venerable art; illustration is exciting—more free and varied than ever— and it is ubiquitous in all kinds of media from paper to screen, from small to large screen, and let's not forget books, packages, and clothing. There are more illustrators contributing to the overall popular culture now than I can recall in those past golden ages.

There has been an existential shift in illustration practice from 2000 to the present that has fostered its own distinctive identity, personality, and attitude. Illustration is going through a kind of climate change (and getting hotter all the time), an evolutionary stage that is best described in the catchphrase "the illustrator as author." There have been illustrators, including most of the veterans in this book, who are known for their formidable styles, but today their pictorial approaches—and content—are telegraphing more intimate viewpoints on a level comparable to the construct of *art for art's sake* (the ideal that absolute art serves itself and its maker before any other master). Conversely, illustration will (and should) always be defined as a response to external stimuli—the assignment; only these days, many assignments are either self-initiated or redefined to be more responsive to the artist's needs. Illustration must still solve a client's need but the old bugaboo of having to be slavishly literal to someone else's concept is on the way out. Clients want independent thinking—I think!

An impressive number of the illustrations selected to appear in this volume unapologetically satisfy the illustrators' own political beliefs, social concerns, and aesthetic. This is not exactly illustration without a client but the point of view is what draws the client to the illustrator in the first place. Work by Sue Coe, Brad Holland, Anita Kunz, Maira Kalman, Christoph Niemann, Peter Blake, Steve Brodner, Edel Rodriguez (and I can go on and on) are among the dozens of illustrations that began as personal commentaries and found outlets that reached their public. Their work and a lot more on the following pages have integrity apart from their respective contexts. Viewers need not even know the starting point for the art, although matching concept to the problem being solved is part of fun in deciphering an illustration.

What's more, illustrators are creatively prospering in ways that have exponentially increased their powers of innovation and their value as creators, inventors and conjurers of all kinds of content. It is an old canard, but illustrators have long been seen as stepchildren to artists in the art world(s). This seemingly pragmatic distinction made sense when the needs of "art" and the demands of "commercial illustration" could be easily polarized. Of course, there remain huge gaps between what is deemed illustration compared to that which is hung in a gallery or museum (and this impacts the monetary worth of art as well as its

cultural-historical standing in the world), but motivational differences between art and illustration are not widening— in fact, they are shrinking. Which has forced gallery artists to radically experiment with form and media in ways that will not be confused with illustration. Abstract Expressionism was a mid-century break with the representational art that illustrators were known for and fought for, until some of them began using abstraction in their own work. It happens like that: you're viscerally against something, then all of a sudden—"presto"—it's the greatest thing since stuffed artichokes. Today, many of the art styles of the past have pushed like a liberating army into the hearts of illustrators and fans alike. Conversely, bio- and performance art have not yet found a welcome berth in the illustration space.

One goal of today's conceptual illustration is to provide the audience, through aesthetics and intelligence, with an additional sensory experience once the puzzle is decoded. For me, there are few better examples of this than Melinda Beck's *New York Times* Old English type "T" logo atop Donald Trump's body with top of the letter form made to look like President's formidable coif (p.38). But this is just one highlight out of a fount of them. Paul Davis reveals how he's evolved from his popular portrait style into a collagist of comic juxtapositions (p.164). Matt Dorfman's eye slinking off abstract yet suggestively human shapes is hilariously eerie (p.190). Catalina Estrada's exquisitely hypnotic patterns beg the viewer to see beyond the surface of her art (p.216). John Hendrix's packed tableaux carry so much narrative they are epic (p.262). The fantasies of Jeremyville are like falling into a deep REM dream (p.308). Igor Karash's reminiscences of the Soviet regime are documents of comic horror (p.336). And I cannot even imagine what willpower and fortitude it took for Eduardo Kobra to create his mammoth, celebratory street murals (p.358). Obviously, you will soon see and be inspired for yourself.

This book, *The Illustrator*, is extraordinary for the quality, diversity, intensity, comedy, vivacity, and exceptionality of the work, but also because it is just the tip of the proverbial iceberg. These are the "100 Best From Around The World" but there are likely 100 more waiting in the wings. Multiply the amount of work for each illustrator here, add a similar amount for the talented others and, if nothing else, there is mathematical proof that illustration is very much alive, well and illustrious.

DER ILLUSTRATOR: LEBENDIG, GUT UND ILLUSTER

von Steven Heller

In den vergangenen fünf Jahren, in denen ich zwei Einführungen für TASCHENS „Illustration Now!"-Reihe schrieb, sagte ich voraus, dass die Kunst der Illustration, so, wie wir sie kennen, vom Aussterben bedroht sei. Das schien mir damals eine logische Annahme zu sein. Die sprichwörtliche Feder, in unserem Fall Stift und Pinsel, sind heutzutage nicht mehr mächtiger als das Schwert, sie unterliegen Programmen wie Adobe Photoshop und Illustrator. Also deutete ich in meinen Texten an, würde Illustration nun weniger eine *Kunst* als vielmehr eine digitale *Technik* sein. Ich entschuldige mich: Ich habe mich in beiden Punkten geirrt. Die Illustration ist lebendig, und die neuen digitalen Werkzeuge haben der Kunst neue Kraft und dem Illustrator größere Beständigkeit verliehen.

Trotzdem ist es wahrscheinlich genauso töricht zu sagen, dass wir derzeit die fruchtbarste Zeit der Illustration in ihrer langen „illusteren" Geschichte erleben, wie zu meinen, dass sie sich dem Ende nähere. Ich höre ständig Beschwerden von Illustratoren *und* Artdirectors, dass das Geschäft mit redaktionellen und gewerblichen Illustrationen seit dem Aufkommen der digitalen Medien zurückgegangen sei (insbesondere aufgrund der ständigen Verfügbarkeit von Onlinebildern), und über die immer knapperen Budgets in den 2000er-Jahren. Während dies für einige der Illustratoren zutreffen mag, ist es ebenso wichtig zu erwähnen, dass die digitale Welt alternative Plattformen für die Illustration geöffnet hat, für den Aufstieg sowohl von Neulingen als auch für die alten Hasen. Um also meine damals alarmschlagende, pessimitischere Haltung in die richtige Perspektive zu rücken: Es gab außergewöhnliche Epochen, bevor die zeitgenössischen visuellen Massenmedien unsere Wahrnehmungsgewohnheiten veränderten, damals, als die Illustration am effektivsten war – und sie ist bis heute das wichtigste Mittel, um das Wort auf dem Papier hervorzuheben, zum Beispiel wenn wir Worte und Bilder auf so winzigen Bildschirmen ansehen, die so groß wie das Zifferblatt einer Uhr sind. Und in dieser Umgebung haben sich das heutige Tableau und die sequenziellen Illustrationen (gemeinsam mit Piktogrammen, Icons, Symbolen) glänzend gehalten. Der Beweis der kreativen Explosion – die Arbeit der 100 Illustratoren, die in diesem Buch präsentiert wird – ist so überzeugend, dass ich, als ich die Layouts zum ersten Mal sah, wie im siebten Himmel war.

Da ich jemand bin, der die Extreme mag, werde ich jetzt unmissverständlich verkünden, dass wir definitiv in ein neues goldenes Zeitalter der Illustration eingetreten sind – wenn es nicht gar eine Platin- oder Titanzeit der Illustration ist.

Bitte beachten Sie jedoch, dass es in den letzten zwei Jahrhunderten viele „goldene Zeitalter" mit legendären Künstler gab, deren Werke heute geschätzt werden. In den Vereinigten Staaten bestand Norman Rockwell, der Titan der Zeitschriftenillustration vom Anfang bis Mitte des 20. Jahrhunderts, in seiner Autobiografie darauf, dass die Generation der Brandywine-Schule, die im späten 19. Jahrhundert von Howard Pyle gegründet (1853–1911) worden war und Rockwells eigener Prominenz vorausging, die letzte der goldenen Art gewesen sei. Eine andere Generation glaubte voraussehend, dass Rockwells eigenes goldenes Zeitalter und der kreative Kreis, den er inspiriert hatte, der Höhepunkt der Illustration seien. Ehrlich gesagt, da ich einer noch späteren Generation angehöre, war ich lange der Ansicht, dass Ende der 1960er-, 70er- und 80er-Jahre die Push Pin Studios und viele ausdrucksstarke, satirische, repräsentative und konzeptuelle Illustratoren, die in der Öffentlichkeit standen, die unglaublichsten aller Zeiten seien (und dass seitdem alles bergab gegangen sei).

Aber genug von diesem kurzsichtigen Weltuntergangsgeist. Ich habe mich in Bezug auf die jüngste Vergangenheit der Illustration geirrt. Die Katastrophe, die die Illustration wie Dinosaurier vom Planeten zu vertreiben drohte, ist nie eingetreten. Und selbst wenn es zwischen den Hügeln einige professionelle Täler gab, kann ich über dieses erfreuliche Buch sagen: Es markiert eine stärkere Lebendigkeit einer ehrwürdigen Kunst als je zuvor; Illustration ist heute aufregend – freier und vielseitiger denn je – und sie ist in allen Arten von Medien allgegenwärtig, vom Papier bis zum Fernsehapparat, vom kleinen bis zum großen Bildschirm, und vergessen wir nicht Bücher, Verpackungen und Kleidung. Es gibt jetzt mehr Illustratoren, die zur allgemeinen Populärkultur beitragen, als in den vergangenen goldenen Zeiten.

In der Illustrationspraxis hat es seit 2000 bis heute eine existenzielle Veränderung gegeben, die ihre eigene unverwechselbare Identität, Persönlichkeit und Haltung gefördert hat. Die Illustration macht eine Art Klimawandel durch (und es wird immer heißer), eine Evolutionsstufe, die am besten mit dem Schlagwort „der Illustrator als Autor" beschrieben wird. Es gibt Illustratoren, einschließlich der meisten Veteranen in diesem Buch, die für ihre beeindruckenden Stile bekannt sind. Heute jedoch übermitteln ihre bildnerischen Ansätze und Inhalte intimere Ansichten auf einer Ebene, die mit dem Konstrukt der „Kunst um der Kunst willen" vergleichbar ist (das Ideal, dass die absolute Kunst sich selbst und ihrem Schöpfer vor jedem anderen Meister dient). Umgekehrt wird (und sollte) Illustration immer als Reaktion auf äußere Reize definiert werden – Reize in Form eines konkreten Auftrags; heute aber werden viele Aufträge entweder selbst initiiert oder neu definiert, um den Bedürfnissen des Künstlers besser gerecht zu werden. Illustration muss noch immer die Bedürfnisse eines Kunden erfüllen, aber das alte Schreckgespenst, das Konzept eines anderen sklavisch wortwörtlich umsetzen zu müssen, hat ausgedient. Die Kunden wollen unabhängiges Denken – denke ich!

Eine beeindruckende Anzahl der ausgewählten Illustrationen, die in diesem Band erscheinen, werden wie selbstverständlich den politischen Überzeugungen, sozialen Anliegen und der Ästhetik der Illustratoren gerecht. Das heißt nicht unbedingt, dass die Illustration ohne einen Kunden entsteht, sondern der Standpunkt des Illustrators ist es, der den Kunden überhaupt anlockt. Die Arbeiten von Sue Coe, Brad Holland, Anita Kunz, Maira Kalman, Christoph Niemann, Peter Blake, Steve Brodner, Edel Rodriguez (und ich könnte so fortfahren) gehören zu den Dutzenden von Illustrationen, die als persönliche Kommentare begannen und dann Absatzmöglichkeiten fanden, die ihr Publikum erreichten. Die Arbeiten dieser Künstler und vieler mehr auf den folgenden Seiten besitzen neben ihrem jeweiligen

Kontext auch Integrität. Der Betrachter muss nicht einmal den Ausgangspunkt für die Kunst kennen, obwohl das Zuordnen des Konzeptes zu dem zu lösenden Problem Teil des Spaßes bei der Entschlüsselung einer Illustration ist.

Darüber hinaus gedeihen Illustratoren kreativ auf eine Weise, die ihre Innovationskraft und ihren Wert als Gestalter, Erfinder und Beschwörer aller Arten von Inhalten exponentiell gesteigert hat. Es ist überholt, aber Illustratoren wurden lange als die Stiefkinder in der (den) Kunstwelt(en) gesehen. Die scheinbar pragmatische Unterscheidung ergab Sinn, als Bedürfnisse der „Kunst" und die Anforderungen an „kommerzielle Illustration" sich noch auf ganz einfache Weise widersprachen. Natürlich gibt es einen großen Unterschied zwischen dem, was als Illustration betrachtet wird, und dem, was in einer Galerie oder einem Museum hängt (und dies beeinflusst sowohl den monetären Wert der Kunst als auch ihre kulturhistorische Stellung in der Welt), aber die Motive für die Schaffung von Kunst bzw. Illustration entwickeln sich nicht auseinander – im Gegenteil. Das hat die Galeriekünstler gezwungen, radikal mit Form und Medien auf eine Weise zu experimentieren, die nicht mit Illustration verwechselt werden kann. Der abstrakte Expressionismus in der Mitte des Jahrhunderts war ein Bruch mit der gegenständlichen Kunst. Die Illustratoren widersetzten sich und kämpften dagegen an, bis einige von ihnen anfingen, selbst Abstraktion in ihrer eigenen Arbeit zu verwenden. Das passiert folgendermaßen: Du bist gegen etwas, und dann plötzlich – „presto" – ist es das Größte seit der Erfindung gefüllter Artischocken. Heutzutage sind viele der Kunststile der Vergangenheit wie eine befreiende Armee in die Herzen von Illustratoren und Fans vorgestoßen. Umgekehrt haben BioArt und Performancekunst noch keinen willkommenen Platz im Illustrationsraum gefunden.

Ein Ziel der heutigen konzeptionellen Illustration ist es, dem Publikum durch Ästhetik und Intelligenz ein zusätzliches sinnliches Erlebnis zu bieten, sobald das Rätsel entschlüsselt ist. Für mich gibt es nur wenige bessere Beispiele als Melinda Becks altes englisches „T"-Logo der *New York Times* als Körper von Donald Trump, dessen oberste Buchstabenform wie eine imponierende Haartolle des Präsidenten aussieht (S. 38). Dies ist jedoch nur ein Highlight von vielen. Paul Davis enthüllt, wie er sich von seinem populären Porträtstil zu einem Collagisten mit komischen Gegenüberstellungen entwickelt hat (S. 164). Matt Dorfmans Auge, das von abstrakten, aber suggestiv menschlichen Formen abblättert, ist unheimlich und gruselig (S. 190). Catalina Estradas exquisit hypnotische Muster fordern den Betrachter auf, hinter die Oberfläche ihrer Kunst zu schauen (S. 216). John Hendrix' Arbeiten haben so viel Erzählendes, dass sie schon episch sind (S. 262). Die Fantasien von Jeremyville sind wie ein tiefer REM-Schlaf (S. 308). Die Erinnerungen von Igor Karash an das Sowjetregime sind Dokumente des komischen Horrors (S. 336). Und ich kann mir nicht einmal vorstellen, welche Willenskraft und Standhaftigkeit Eduardo Kobra brauchte, um seine riesigen, feierlichen Straßengemälde zu schaffen (S. 358). Sie können sich nun selbst ein Bild machen und sich inspirieren lassen.

The Illustrator ist außergewöhnlich in Hinblick auf die Qualität, Vielfalt, Intensität, Komik, Lebhaftigkeit und Einzigartigkeit der gezeigten Arbeiten, aber auch, weil es nur die Spitze des sprichwörtlichen Eisbergs präsentiert. Dies sind die „100 Besten aus aller Welt", aber wahrscheinlich stehen noch 100 weitere in den Startlöchern. Multiplizieren Sie die Menge der Arbeiten jedes Illustrators dieses Buchs, fügen Sie eine ähnliche Menge für die anderen Talente hinzu, und schließlich hat man mathematische Beweise, dass die Illustration sehr lebendig, gut und illuster ist.

L'ILLUSTRATEUR: FRINGANT, BIEN PORTANT ET ILLUSTRE

par Steven Heller

Dans les deux introductions que j'ai écrites au cours des cinq dernières années pour la série «Illustration Now!» de TASCHEN, j'avançais que l'art de l'illustration tel qu'on le connaissait était en voie de disparition; une hypothèse qui semblait fondée à l'époque. N'en imposant plus autant qu'avant, le crayon et le pinceau avaient succombé aux programmes Adobe Photoshop et Illustrator, et j'insinuais dans mes textes que l'illustration devenait ainsi moins un *art* qu'une *technique* numérique. Toutes mes excuses, j'avais doublement tort. Car bien vivante, l'illustration a connu un regain de vigueur grâce aux nouveaux outils numériques qui dotent l'illustrateur d'une énergie accrue.

Il serait néanmoins tout aussi ridicule d'avancer que nous vivons la période la plus fertile de la longue et prestigieuse histoire de l'illustration que d'annoncer que sa fin est proche. J'entends constamment des illustrateurs et des directeurs artistiques se plaindre que le métier de l'illustration éditoriale et publicitaire a baissé avec l'essor des supports numériques (en raison notamment de la disponibilité d'images en ligne) et la prolifération des restrictions budgétaires dans les années 2000. Même s'il s'agit d'une réalité pour certains types d'illustrateurs, le fait que le monde numérique propose d'autres plateformes d'illustration explique aussi l'avalanche de nouveaux venus comme de vétérans. Je vais donc mettre en contexte mes déclarations alarmistes: il y a eu d'extraordinaires périodes avant que les médias visuels de masse contemporains ne changent nos habitudes perceptuelles, quand l'illustration constituait le moyen le plus efficace (et principal) d'enluminer les mots sur papier, jusqu'à aujourd'hui, où les textes et les images nous arrivent sur des écrans de la taille d'un cadran de montre. Dans un tel contexte, le panorama actuel et les illustrations séquentielles (ainsi que les pictogrammes, icônes et symboles) tiennent bon. L'explosion créative, avec le travail de 100 illustrateurs présenté dans cet ouvrage, est tellement probante qu'au moment d'en découvrir la composition, j'ai été aux anges.

Comme j'ai tendance à tomber dans l'extrême, j'affirmerai qu'un nouvel âge d'or, voire de platine ou de titane, a débuté pour l'illustration.

À noter toutefois qu'il y a eu de nombreux «âges d'or» au cours des deux derniers siècles, de la main d'artistes légendaires dont les œuvres sont aujourd'hui chéries. Le géant américain de l'illustration de magazines du début et milieu du XXe siècle que fut Norman Rockwell défend dans son autobiographie comme l'ultime lignée d'excellence la génération de la Brandywine School, fondée au XIXe siècle par Howard Pyle (1853–1911), fort d'une grande notoriété avant le propre Rockwell. Pourtant, pour une autre génération,

l'âge d'or de Rockwell et de tout son cercle d'influence a symbolisé le summum de l'illustration. En toute honnêteté, appartenant à une génération encore postérieure, je considère depuis longtemps que la fin des années 1960 et les années 70 et 80, qui ont vu naître entre autres Push Pin Studios et pléthore d'illustrateurs expressifs, satiriques, figuratifs et conceptuels, est la période la plus incroyable (et que tout ce qui a suivi depuis va à vau-l'eau).

Mais assez de jacasseries catastrophes et peu perspicaces : je me suis trompé sur ce qu'allait être l'avenir de l'illustration. Le cataclysme qui promettait d'exterminer, comme les dinosaures, l'illustration ne s'est jamais produit. Et même si le métier a connu des bas, je peux affirmer que ce réjouissant livre augure une grande vitalité pour l'art vénérable de l'illustration : elle est palpitante, plus libérée et diverse que jamais, et aussi omniprésente sur tous les supports, du papier aux écrans petits et grands, sans oublier les livres, les emballages et les vêtements. Selon moi, les illustrateurs contribuant à la culture populaire générale sont aujourd'hui plus nombreux que lors des âges d'or passés.

Entre l'an 2000 et aujourd'hui, la pratique de l'illustration a connu un glissement existentiel qui a nourri l'identité, la personnalité et l'attitude la caractérisant. Elle fait l'objet d'une sorte de changement climatique (et ne cesse de se réchauffer), un stade d'évolution que la devise « l'illustrateur comme auteur » résume parfaitement. Certains illustrateurs, comme la plupart des vétérans de cet ouvrage, sont célèbres pour leur style remarquable, mais l'approche visuelle qu'ils adoptent aujourd'hui et le contenu qu'ils créent expriment des points de vue plus intimistes, à un niveau comparable à *l'art pour l'art* (l'idée que l'*art* absolu se sert à lui-même et à son créateur avant tout autre maître). À l'inverse, l'illustration sera (et doit être) toujours définie comme une réponse au stimulus externe d'une commande sauf que dernièrement, nombre de tâches sont lancées de façon autonome ou adaptées aux besoins de l'artiste. L'illustration doit continuer à satisfaire la demande d'un client, mais l'obligation de se plier servilement à l'avis d'autrui perd de la force. Je pense que le client attend une réflexion indépendante !

Une quantité impressionnante d'illustrations retenues pour ce volume répondent sans complexe aux convictions politiques, aux préoccupations sociales et aux critères esthétiques de l'illustrateur. Non pas que le client en soit totalement absent, mais il choisit d'abord l'illustrateur pour le point de vue que celui-ci transmet. Le travail de Sue Coe, Brad Holland, Anita Kunz, Maira Kalman, Christoph Niemann, Peter Blake, Steve Brodner, Edel Rodriguez (la liste est infinie) s'inscrit parmi les dizaines d'illustrations qui sont parties de commentaires personnels et qui ont fini par atteindre leur cible. Leurs œuvres et bien d'autres dans les pages qui suivent affichent une intégrité malgré la variété de contextes. Le public n'a pas besoin de connaître le point de départ d'une création artistique, même si associer un concept à la problématique abordée contribue au plaisir de déchiffrer une illustration.

Par ailleurs, les illustrateurs s'épanouissent sur le plan créatif par des moyens qui ont multiplié leur capacité d'innovation et leur valeur en tant que créateurs, inventeurs et prestidigitateurs de tous les types possibles de contenu. C'est certes un racontar, mais les illustrateurs ont longtemps été vus comme des pièces rapportées dans le(s) sphère(s) artistique(s). Cette distinction visiblement pragmatique avait un sens quand les besoins en « art » et les demandes en « illustration commerciale » pouvaient facilement être polarisés. Le fossé reste bien sûr profond entre ce qui est considéré illustration et ce qui est accroché dans une galerie ou un musée (avec un impact sur la valeur monétaire de l'art et son statut culturel et historique dans le monde). Les divergences de motivation entre l'art et l'illustration n'augmentent pourtant pas ; de fait, elles sont en train de diminuer, ce qui a obligé les artistes exposant dans des galeries à faire des choix extrêmes en matière de formes et de supports pour éviter toute confusion avec l'illustration. Au milieu du siècle dernier, l'expressionnisme abstrait a supposé une rupture, un art figuratif pour lequel les illustrateurs étaient célèbres et décriés, jusqu'à ce que certains se tournent vers l'abstraction. Les choses se passent comme ça : vous êtes viscéralement opposé à quelque chose et tout à coup, voilà qu'elle est ce qu'on a fait de mieux depuis les artichauts farcis. Tels des libérateurs, de nombreux styles artistiques du passé ont conquis le cœur des illustrateurs et de leurs fans. Pour leur part, le bio-art et les performances artistiques ne se sont pour l'instant pas encore fait une place dans l'univers de l'illustration.

Aujourd'hui, l'illustration conceptuelle vise à apporter au public, par le biais de l'esthétique et de l'intelligence, une nouvelle expérience sensorielle une fois le mystère résolu. À mon sens, peu de créations sont plus parlantes que le logo conçu par Melinda Beck pour le *New York Times* : un « T » dans la police Old English symbolise le visage de Donald Trump, le haut de la lettre rappelant la renversante coiffure de l'homme d'État (p. 38). Mais ce n'est qu'un exemple parmi tant d'autres. Paul Davis montre l'évolution qu'il a suivie, de son style de portrait populaire à ses amusantes compositions par collage (p. 164). Les yeux de Matt Dorfman, s'échappent d'une forme humaine abstraite mais très suggestive, créent une étrangeté hilarante (p. 190). Les motifs merveilleusement hypnotiques de Catalina Estrada poussent le public à regarder au-delà de ses œuvres (p. 216). Les compositions chargées de John Hendrix transmettent une telle dose d'histoire qu'elles en sont épiques (p. 262). L'imaginaire de Jeremyville est comme tomber dans un sommeil paradoxal (p. 308). Les évocations du régime soviétique par Igor Karash donnent des visuels avec une touche de comics d'horreur (p. 336). Et je ne peux pas imaginer la volonté et le courage qu'il a fallu à Eduardo Kobra pour créer ses gigantesques peintures murales (p. 358). Quand vous les découvrirez, vous serez forcément inspiré.

L'ouvrage *The Illustrator* est extraordinaire pour la qualité, la diversité, l'intensité, l'humour, la vitalité et l'exceptionnalité des œuvres qu'il présente, mais aussi parce qu'il ne s'agit que de la pointe de l'iceberg proverbial. Voici les « 100 meilleurs au monde », sachant qu'il y en a probablement 100 de plus qui attendent dans les coulisses. Multipliez la quantité de travail de chaque illustrateur dans ces pages, ajoutez une dose équivalente pour les autres talents du genre ; à tout le moins, vous obtenez la preuve mathématique que l'illustration est fringante, bien portante et illustre.

THE
PROFILES

> "To me, illustration is about discovering something new every day."

MONIKA AICHELE

WWW.MONIKAAICHELE.COM · @monikaaichele

Monika Aichele's serendipitous practice reflects a life of wanderlust. Born in 1971, in Ruit auf den Fildern, in the Southern German state of Baden-Württemberg, she attributes her inquisitive approach to experimentation and problem-solving as a direct influence of her engineer-inventor father. After graduating from the State Academy of Fine Arts Stuttgart in 1999, where she studied under Heinz Edelmann, Aichele began traveling and working in various locations, from Barcelona to New York and Berlin—drawing inspiration from her associations with a host of other prominent illustrators around the world, including Thomas Fuchs, Isabel Klett, Yuko Shimizu, and Gary Taxali. Working in various media, from ink and acrylic to vector illustrations and screenprints, Aichele creates whimsical compositions often characterized by flat colors and hatch lines, sometimes with collage. Ranging from book design, postcards, lettering, and murals to 3D objects, the scope and breadth of her portfolio is impressive. In 2015, her

In Monika Aicheles durch glückliche Zufälle entstandenen Stil spiegelt sich ein Leben mit Fernweh wider. Sie wurde 1971 in Ruit auf den Fildern (heute Ostfildern) in Baden-Württemberg geboren und beschreibt ihre neugierige Herangehensweise an das Experimentieren und Lösen von Problemen als direkten Einfluss ihres Vaters, einem Techniker und Erfinder. Nach ihrem Abschluss an der Staatlichen Akademie der Bildenden Künste Stuttgart im Jahr 1999, wo sie bei Heinz Edelmann studierte, begann Aichele zu reisen und arbeitete an verschiedenen Standorten von Barcelona bis New York und Berlin – und zog ihre Inspiration aus der Zusammenarbeit mit einer Reihe anderer prominenter Illustratoren auf der ganzen Welt, zum Beispiel Thomas Fuchs, Isabel Klett, Yuko Shimizu und Gary Taxali. In ihren Arbeiten in verschiedenen Techniken, von Tusche und Acryl über Vektorillustrationen und Siebdrucke, erschafft Aichele wunderliche Kompositionen, oft gekennzeichnet durch flächige Farben und

Le travail innovant de Monika Aichele est l'expression d'une vie de globe-trotter. Née en 1971 à Ruit auf den Fildern, dans le land de Baden-Württemberg au sud-ouest de l'Allemagne, elle explique sa curiosité pour l'expérimentation et la résolution de problèmes par l'influence directe de son père ingénieur et inventeur. Diplômée en 1999 de l'académie des arts de Stuttgart, où elle a été élève de Heinz Edelmann, Aichele a commencé à voyager et à travailler dans diverses villes, comme Barcelone, New York et Berlin, et à s'inspirer de collaborations avec une kyrielle d'autres grands noms de l'illustration du monde entier, dont Thomas Fuchs, Isabel Klett, Yuko Shimizu et Gary Taxali. Recourant à plusieurs techniques, de l'encre et de l'acrylique aux illustrations vectorielles et à la sérigraphie, Aichele crée des compositions fantaisistes à base d'aplats et de hachures, parfois de collages. L'étendue de son portfolio est impressionnante, de la conception de livres aux cartes postales, au lettrage, aux peintures murales et aux

"Angry White Monkeys" giant inflatable sculptures for Stefan Sagmeister were selected as "Best of Show" by *3x3 Magazine* at the Six Cities Design Festival in Scotland. Today, she splits her time between her studio in an old fruit market in Munich and Mainz, where she lectures in illustration at the University of Applied Sciences. In 2016, Aichele was Director of Study for the Gutenberg-Intermedia master's degree course. Aichele has exhibited around the world and received accolades from the Society of Publication Designers and the Art Directors Club Germany, among others. She is a contributor to *The New York Times* and *Frieze* magazine.

Schraffurlinien – manchmal auch als Collage. Ihr Werk umfasst Buchdesign, Postkarten, Schriftzüge und Wandgemälde bis zu 3-D-Objekten, der Umfang und die Weite ihres Portfolios sind beeindruckend. Im Jahr 2015 wurden ihre für Stefan Sagmeister geschaffenen „Angry White Monkeys", riesige aufblasbare Skulpturen, vom *3x3 Magazine* als „Best of Show" beim Six Cities Design Festival in Schottland ausgewählt. Heute pendelt sie zwischen ihrem Atelier in einem alten Obstmarkt in München und Mainz, wo sie Illustration an der Fachhochschule lehrt. Im Jahr 2016 war Aichele Studienleiterin eines Gutenberg-Intermedia-Kurses für den Masterstudiengang. Sie hat überall auf der Welt ausgestellt und wurde unter anderem von der Society of Publication Designers und dem Art Directors Club Germany ausgezeichnet. Sie ist Mitarbeiterin der *New York Times* und des *Frieze*-Magazins.

objets 3D. En 2015, ses sculptures gonflables géantes intitulées « Angry White Monkeys » pour Stefan Sagmeister ont été élues Best of Show par *3x3 Magazine* à l'occasion du Six Cities Design Festival organisé en Écosse. Aujourd'hui, elle partage son temps entre son studio, installé dans un ancien marché aux fruits à Munich, et Mayence, où elle donne des cours d'illustration à l'université de sciences appliquées. En 2016, Aichele a été directrice des études pour le diplôme de maîtrise Gutenberg-Intermedia. Elle a exposé dans le monde entier et reçu des distinctions de la Society of Publication Designers et de l'Art Directors Club Allemagne, entre autres. Elle est une collaboratrice de *The New York Times* et du magazine *Frieze*.

MONIKA AICHELE

Worker, 2016
Personal work, *20 Years
Shining-Labor*, group show;
screen printing

opposite
Dictatorship, 2018
*Frankfurter Allgemeine
Zeitung*, newspaper;
mixed media

p. 18
Unicorn, 2016
Block, magazine;
mixed media

Gallus Opportunus, 2017
Büchergilde; mixed media

opposite
Cancan-Gans/Anser Mingens,
2017, Büchergilde; mixed media

opposite top
Der Berg ruft, Homage to
Niklaus Troxler, 2012
Akademie der Bildenden
Künste, Stuttgart; mixed media

MONIKA AICHELE

Selected Exhibitions: 2018, *Buch & Lesen*, group show, Wissenschaftliche Stadtbibliothek, Mainz · 2017, *American Illustration*, group show, Angel Orensanz Foundation, New York · 2016, *American Illustration*, group show, Angel Orensanz Foundation, New York · 2015, *American Illustration*, group show, Angel Orensanz Foundation, New York

Selected Publications: 2017, *False Bird Club,* Büchergilde Gutenberg, Germany · 2017, *Paradies der falschen Vögel,* Büchergilde Gutenberg, Germany · 2017, *American Illustration 37,* Amilus, USA · 2016, *American Illustration 36,* Amilus, USA · 2015, *American Illustration 35,* Amilus, USA

> "I identify as a feminist and I consider some—but not all—of my work to be a form of low-key activism. This isn't always obvious in the outcome, though, because a major part of it is just about standing up for my beliefs when working with clients." *for i-D*

SARA ANDREASSON

WWW.SARAANDREASSON.SE · @saraandreasson

Bold and sassy, Sara Andreasson's colorful, attention-grabbing images exude a confidence that reflects female empowerment and gender equality. Voluptuous or musclebound figures inhabit vibrant block-color scenes—to dispel stereotypes she references male images to depict women, and vice-versa—accentuating an observational savvy that teases the viewer with sexual playfulness. Andreasson approaches fashion illustration on her own terms, exploring themes of alt femme, relationships, and everyday social noise with a sense of assurance. Born in Kristinehamn, Sweden, in 1989, she studied in Gothenburg, first completing a BSc in Product Design Engineering at Chalmers University of Technology in 2011, before attending the HDK Academy of Design and Crafts, where she graduated with a BFA in Design in 2015. The same year, she gained recognition for her work in the *Pick Me Up* graphic arts festival at Somerset House in London, as well as her contributions to *The Guardian* and *The New York Times*.

Kühn, bunt und frech – Sara Andreassons Aufsehen erregende Bilder strahlen ein Selbstvertrauen aus, das die Stärkung der Frauen und die Gleichstellung der Geschlechter widerspiegelt. Üppige oder muskulöse Figuren bevölkern in ihren Arbeiten lebhafte Szenen in Kontrastfarben – um Stereotype aufzubrechen, verweist sie dabei auf männliche Bilder, um Frauen darzustellen, und umgekehrt und unterstreicht so ihre clevere Beobachtungsgabe, die den Betrachter durch sexuelle Verspieltheit reizt. Andreasson nähert sich der Modeillustration nach ihren eigenen Vorstellungen und erforscht die Themen Alt Femme, Beziehungen und Alltagslärm sehr gewissenhaft. Geboren 1989 in Kristinehamn (Schweden), studierte sie in Göteborg und machte 2011 ihren Bachelor in Produktdesign an der Chalmers-Universität für Technologie, anschließend besuchte sie die HDK Akademie für Design und Kunsthandwerk, die sie 2015 mit einem Bachelor in Design verließ. Im selben Jahr fand ihre Arbeit beim „*Pick Me Up*"-Grafik-Festival

Osées, colorées et insolentes, les images accrocheuses de Sara Andreasson expriment une confiance en soi propre à l'émancipation féminine et à la parité des sexes. Des silhouettes voluptueuses ou hyper-musclées s'affichent dans des scènes aux couleurs vives : pour combattre les stéréotypes, l'artiste se sert d'images masculines pour dépeindre des femmes et inversement, et provoque ainsi le public par un jeu d'observation et d'espièglerie sexuelle. Andreasson aborde l'illustration de mode en suivant ses propres critères, explorant avec assurance des thèmes comme la culture « alt femme », les relations et le bruit environnant de notre quotidien. Née en 1989 dans le ville suédoise de Kristinehamn, elle a étudié à Göteborg, décrochant d'abord en 2011 une licence ès science en ingénierie de conception de produits à l'université de technologie de Chalmers, avant d'étudier à l'académie de design et d'artisanat HDK, où elle a obtenu une licence de design en 2015. La même année, elle s'est fait remarquer pour son

To date, Andreasson has notched an impressive tally of commissions from the likes of Converse, *Le Monde*, Spotify, and Tumblr. Together with her friend Josefine Hardstedt, she has also co-edited and art-directed the independent feminist magazine *BBY* in Gothenburg. Andreasson is currently based in London.

im Somerset House in London, ebenso Anerkennung wie ihre Beiträge im *Guardian* und in der *New York Times*. Bislang hat Andreasson eine beeindruckende Anzahl von Aufträgen für Kunden wie Converse, *Le Monde*, Spotify und Tumblr ausgeführt. Zusammen mit ihrer Freundin Josefine Hardstedt arbeitete sie auch an der unabhängigen feministischen Zeitschrift *BBY* in Göteborg mit und leitete diese künstlerisch. Andreasson lebt und arbeitet derzeit in London.

travail lors du festival d'arts graphiques Pick Me Up au Somerset House de Londres, ainsi que pour ses contributions dans *The Guardian* et *The New York Times*. Andreasson a réalisé une foule de projets pour des clients comme Converse, *Le Monde*, Spotify et Tumblr, pour n'en citer que quelques-uns. Avec son amie Josefine Hardstedt, elle a également coédité et assuré la direction artistique du magazine féministe indépendant *BBY* à Göteborg. Andreasson réside actuellement à Londres.

SARA ANDREASSON

Fiery, 2017
Süddeutsche Zeitung
Magazine; digital

opposite
Muddy, 2018
Personal work; digital

p. 24
Whatever, 2016
Personal work; digital

Vårens Böcker, 2018
Svensk Bokhandel,
book cover; digital

Årsrapport, 2017
Svenska Tecknare,
book cover; digital

right
Untitled, 2017
Personal work; digital

opposite
Fizzy Flowers, 2017
Personal work; digital

SARA ANDREASSON

Selected Exhibitions: 2017, *Clueless*, solo show, Ninasagt, Düsseldorf · 2016, *New Nordic Fashion Illustration*, group show, Estonian Museum of Applied Art and Design, Tallinn · 2015, *Pick Me Up*, group show, Somerset House, London

Selected Publications: 2015, *Illusive IV*, Gestalten, Germany · 2015, *Behind Illustrations 3*, Index Book, Spain

"My work aims to stimulate a response in the viewer so they can relate to or react to the story or character I'm portraying."

for *Minus 37*

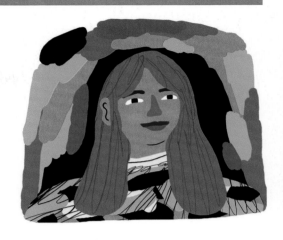

CLARA SELINA BACH

WWW.CLARASELINABACH.COM · @claraselinabach

Copenhagen native Clara Selina Bach has emerged as one of the freshest voices in Danish illustration today. Born in 1989, she attended The Royal Danish Academy of Fine Arts—Schools of Architecture, Design and Conservation (KADK), where she studied illustration, narratives, and graphic design. After graduating with a BA in 2015, she continued at KADK doing postgraduate studies in visual communication, whilst undertaking freelance graphic projects for *Newspaper Information* and Danish not-for-profit organization INDEX: Design to Improve Life. In a short space of time, her commissions have ranged from urban planning projects, editorial, book illustration, storytelling, and surface pattern design. Her clients include children's clothing brand Comme Ci Comme Ça; We Do Democracy, a Copenhagen-based independent change agency; and the municipality of Fredensborg Kommune. Bach's instinct to explore new visual textures and formats is reflected in her eclectic portfolio. Fluid in various media, from

Die 1989 in Kopenhagen geborene Clara Selina Bach hat sich zu einer der frischesten Stimmen in der dänischen Illustrationsszene entwickelt. Sie studierte Illustration, Texten und Grafikdesign an der Königlich Dänischen Akademie der Schönen Künste – Schule für Architektur, Design und Konservierung (KADK). Ihrem Bachelorabschluss im Jahr 2015 folgte ein Aufbaustudium in Visueller Kommunikation, ebenfalls an der KADK, während sie bereits freiberuflich grafische Projekte durchführte, etwa für *Newspaper Information* und die dänische gemeinnützige Organisation INDEX: Design to Improve Life. Innerhalb kurzer Zeit reichten ihre Aufträge von Stadtplanungsprojekten über redaktionelle Arbeiten, Buchillustrationen, Storytelling bis zu Surface Pattern Design. Ihre Kunden sind zum Beispiel die Kindermodemarke Comme Ci Comme Ça, We Do Democracy (eine unabhängige Beratungsagentur mit Sitz in Kopenhagen) sowie die Gemeindeverwaltung der Kommune Fredensborg. Bachs

Originaire de Copenhague, Clara Selina Bach s'est affirmée comme l'une des toutes nouvelles voix de l'illustration danoise du moment. Née en 1989, elle a étudié à l'école d'architecture, de design et de conservation de l'Académie royale des beaux-arts du Danemark (KADK), où elle a étudié l'illustration, la création narrative et le design graphique. Après avoir décroché une licence en 2015, elle a poursuivi à la KADK avec des études de troisième cycle en communication visuelle, tout en menant des projets graphiques en freelance pour *Newspaper Information* et l'ONG danoise INDEX: Design to Improve Life. En peu de temps, les commandes se sont diversifiées avec des projets d'urbanisme, éditoriaux, d'illustration de livres, de narration et de conception de motifs de surface. Parmi ses clients, elle compte la marque de vêtements pour enfants Comme Ci Comme Ça, l'agence pour le changement We Do Democracy basée à Copenhague, et la municipalité de Fredensborg. Son portfolio éclectique reflète l'instinct qui

acrylics and watercolor to pencils, ink, and digital, she approaches her subjects with intuition and honesty. People in everyday scenarios, in both urban communities and the natural world, are rendered with a playful abstraction and sense of equilibrium.

Instinkt, neue visuelle Texturen und Formate zu erkunden, spiegelt sich in ihrem vielseitigen Portfolio wider. Sie arbeitet in verschiedenen Techniken, von Acryl und Aquarell über Bleistift und Tusche bis zu digital und geht mit Intuition und Ehrlichkeit an ihre Motive heran. Menschen in Alltagsszenarien sowohl in der Stadt als auch in der Natur, werden mit einem Gespür für spielerische Abstraktion und Gleichgewicht dargestellt.

la pousse à explorer des textures et des formats visuels inédits. Maîtrisant divers techniques, de l'acrylique et l'aquarelle aux crayons, à l'encre et aux outils numériques, elle aborde ses sujets avec intuition et honnêteté. Des personnages dans des scènes du quotidien, tant au sein d'univers urbains qu'en pleine nature, sont représentés avec une amusante abstraction et un sens de l'équilibre.

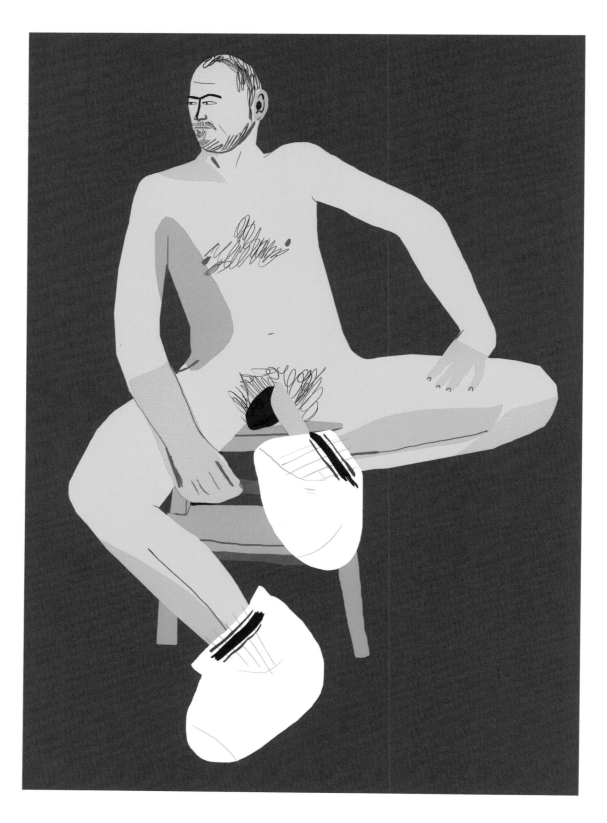

CLARA SELINA BACH

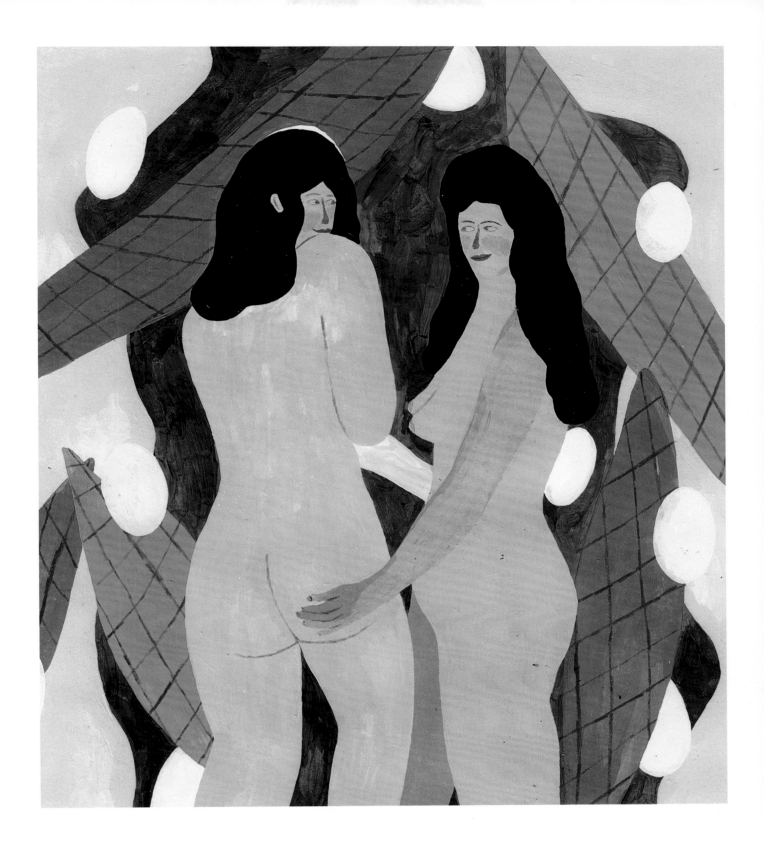

Untitled, 2018
Personal work; painting,
acrylic, color pencils

opposite
Boyfriend With White
Tennis Socks, 2018
Personal work; digital

p. 32
Spaghetti Western, 2018
private commission, poster;
digital, pencil, acrylic, ink

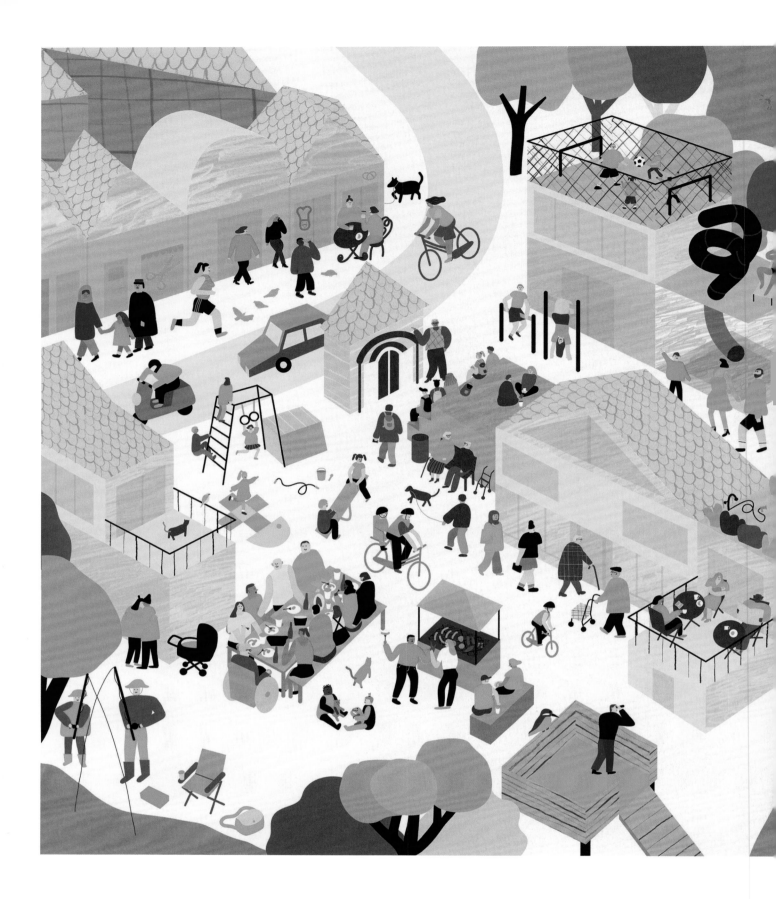

The Future of Nivå City
Center, 2018
Municipality of Fredensborg;
digital; art director:
Signe Bjerregaard (Andel)

right
Untitled, 2016
Personal work;
ink, pencil, digital

CLARA SELINA BACH

Selected Exhibition: 2014, *100th Anniversary Exhibition of H. J. Wegner*, group show, Tønder Art Museum, Denmark · 2014, solo show, Art Rebels, Copenhagen

Selected Publication: 2018, *Women, Gender & Research*, University Press of Southern Denmark

> "Don't create art you think is
> marketable; create art you love
> and find a market for it."
>
> for *AI-AP*

MELINDA BECK

WWW.MELINDABECK.COM · @melindabeckart

Born in New York in 1966 to graphic designer parents, Melinda Beck grew up playing with Letraset, rubber cement, and T-squares. In 1989, she graduated with distinction in graphic design from Rhode Island School of Design, and has since enjoyed a highly accomplished career as an illustrator, animator, and graphic designer. With a range of styles to hand—from abstract and surreal to collage and silhouette—Beck's work displays both technical mastery and conceptual adeptness. Equally at home in color or monochrome, she draws and paints, sometimes employing found objects before working digitally. A distinctive quality is her ability to deliver a clear visual message—on tone and on target—through either complex or reduced compositions, whether patterning everyday symbols for op-ed layouts or children's books. Her broad visual language has attracted clients from publications and retail, including *The New Yorker*, Random House, and Neiman Marcus. An active educator and communicator, Beck has

1966 in New York als Kind von Grafikdesignern geboren, wuchs Melinda Beck mit Letraset, Rubber Cement und Zeichenschienen auf. 1989 schloss sie ihr Grafikdesign-Studium an der Rhode Island School of Design mit Auszeichnung ab und macht seitdem sehr erfolgreich Karriere als Illustratorin, Animatorin und Grafikdesignerin. Unter Berufung auf eine Reihe von Stilen – von abstrakt und surreal bis zur Collage und Silhouette – zeigt Beck in ihren Arbeiten sowohl technische Meisterschaft als auch konzeptionelle Fähigkeiten. Gleichermaßen in Farbe oder monochrom zu Hause, zeichnet und malt sie und verwendet manchmal lieber Fundobjekte, bevor sie digital arbeitet. Herausragend ist ihre Fähigkeit, eine klare visuelle Botschaft zu vermitteln – sowohl was den Ton als auch das Ziel angeht – durch komplexe oder reduzierte Kompositionen, ob bei der Bebilderung von Alltagssymbolen für Layouts oder für Kinderbücher. Ihre umfassende Bildsprache hat Kunden aus Editorial und Handel angezogen, zum Beispiel den

Née à New York en 1966 de parents concepteurs graphiques, Melinda Beck a grandi en jouant avec Letraset, de la colle caoutchouc et des équerres en T. En 1989, elle a obtenu avec mention un diplôme en design graphique de l'école de design de Rhode Island ; elle a connu depuis lors une solide carrière comme illustratrice, animatrice et conceptrice graphique. Dominant une variété de styles, tant abstrait et surréaliste que de collage et de silhouette, Beck fait preuve dans son travail d'une maîtrise technique et d'une habileté conceptuelle. Dans ses dessins et ses peintures, elle est tout aussi à l'aise en monochrome qu'avec de la couleur, se servant parfois d'objets trouvés avant de travailler en numérique. Elle se distingue par sa capacité à transmettre des messages visuels clairs, tant pour le ton que pour le public visé, à l'aide de compositions complexes ou au contraire épurées, insérant des symboles quotidiens dans des compositions de tribune libre ou des albums pour enfants. Son langage visuel large a attiré

lectured at Parsons School of Design (New York) and Grafill (Oslo), and served as the vice president of ICON9, the Illustration Conference. Among her tally of awards are two Emmy nominations and a Gold Medal from the Society of Illustrators. In 2018, Beck won an American Illustration International Motion Award for a cheery animation she created for *Harvard Business Review*. Beck lives and works in Brooklyn.

New Yorker, Random House und Neiman Marcus. Als aktive Lehrende und Kommunikatorin unterrichtete Beck an der Parsons School of Design (New York) und an der Grafill (Oslo) und war Vizepräsidentin der ICON9 – The Illustration Conference. Zu ihren Auszeichnungen zählen zwei Emmy-Nominierungen und eine Goldmedaille der Society of Illustrators. Im Jahr 2018 gewann Beck einen American Illustration International Motion Award für eine fröhliche Animation, die sie für die *Harvard Business Review* schuf. Beck lebt und arbeitet in Brooklyn.

des clients dans le domaine éditorial et de la vente au détail, dont *The New Yorker*, Random House et Neiman Marcus. Pédagogue et communicatrice, Beck a donné des cours à la Parsons School of Design (New York) et Grafill (Oslo), et elle a exercé comme vice-présidente d'ICON9 – The Illustration Conference. Parmi les nombreux prix qui lui ont été décernés, elle compte deux nominations aux Emmy et une médaille d'or de la Society of Illustrators. En 2018, Beck a reçu un prix International Motion Award d'American Illustration pour une amusante animation créée pour *Harvard Business Review*. Beck vit et travaille à Brooklyn.

MELINDA BECK

The Enigmatic Trans-Pacific
Partnership Trade Agreement, 2016
Harvard Law Bulletin; mixed media

p. 38

opposite
Me Too a Year of Reckoning, 2018
The New York Times; mixed media

When All the News
That Fits Is Trump, 2017
Columbia Journalism Review; vector

Selected Exhibitions: 2018, *Drawn to Purpose: American Women Illustrators*, group show, The Library of Congress Gallery, Washington, D.C. · 2018, *Art as Witness*, group show, School of Visual Arts, Chelsea Gallery, New York · 2018, *Illustration: Women Making A Mark*, group show, University of Indianapolis Gallery · 2017, *The Narrative Image: Melinda Beck & Julia Rothman*, group show, Rhode Island School of Design ISB Gallery, Providence · 2014, *The Art of Melinda Beck*, solo show, The University of the Arts, Philadephia

Selected Publications: 2018, *Drawn to Purpose: American Women Illustrators,* The Library of Congress, USA

MELINDA BECK

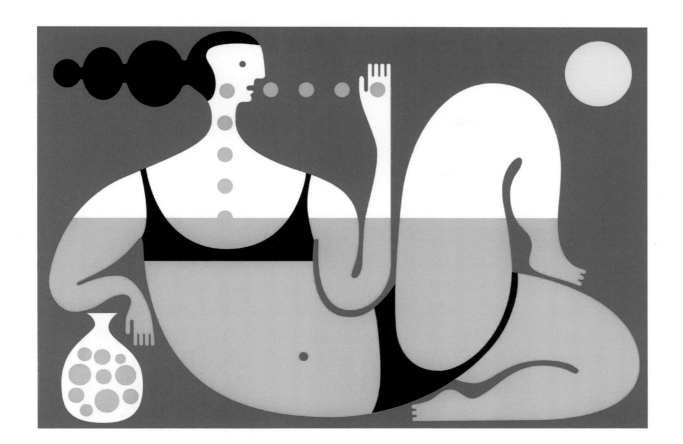

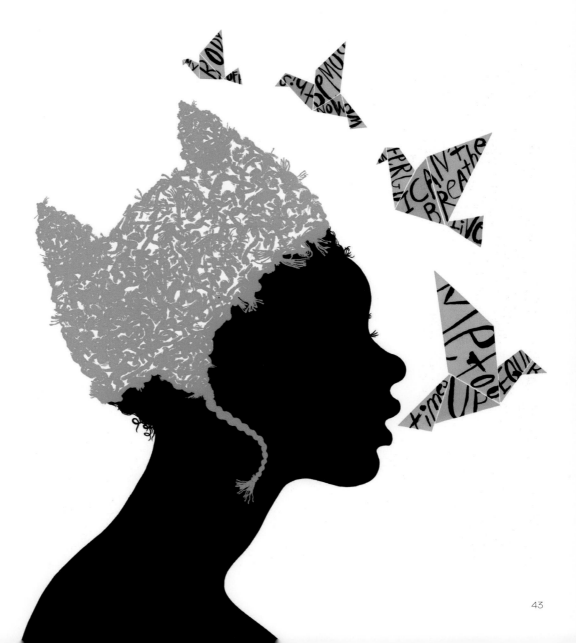

Edible Sun Screen, 2016
The New York Times; vector

right
Freedom of Speech:
A New Vision of Norman
Rockwell's America, 2017
Smithsonian magazine;
mixed media

opposite
Advocating Diplomacy
Over War, 2017
The New York Times,
newspaper; mixed media

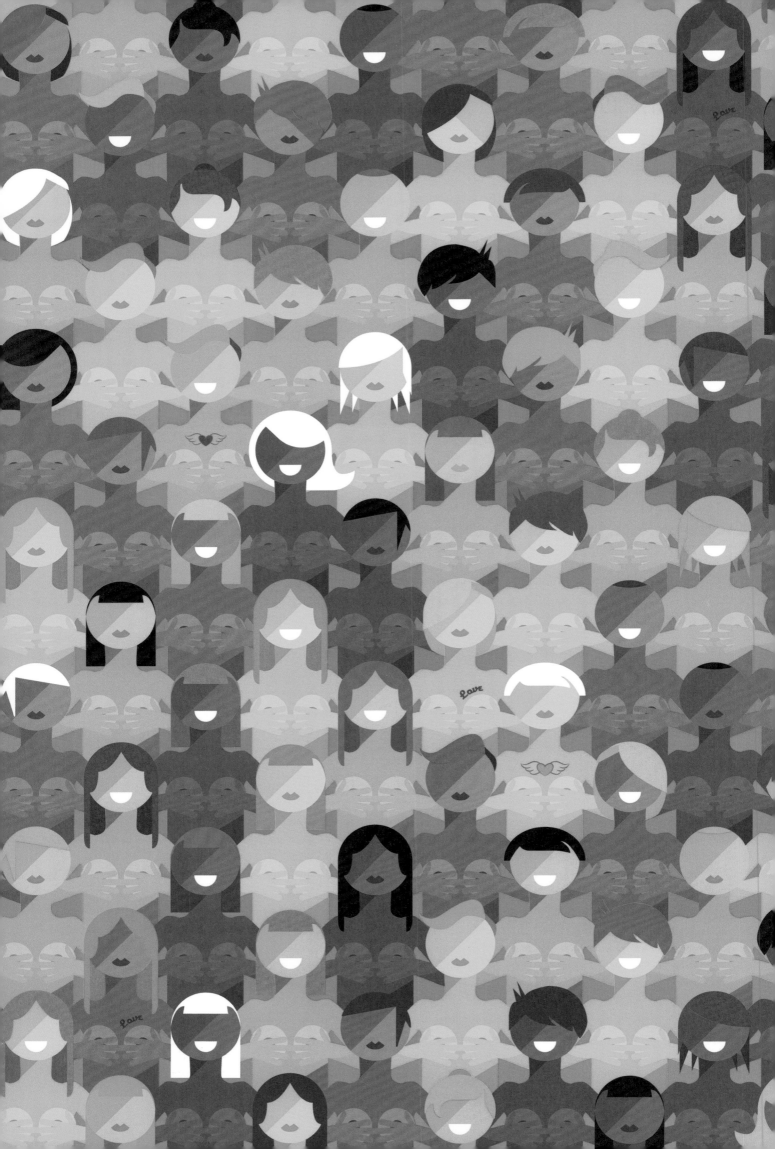

> "I've always been a huge fan of Pop Art and early 1980s graffiti (the NYC Wild Style era), so I learned from the greats about how to use color, to be brave with color, and to find a balance between different colors." *for Design Tutsplus*

BEN THE ILLUSTRATOR

WWW.BENTHEILLUSTRATOR.COM · @benillustrator

Ben O'Brien (aka Ben the Illustrator) was born in London in 1976. After a foundation course at Central St Martins School of Art in the mid-1990s, O'Brien went on to study animation at Surrey Institute of Art and Design, attaining a BA in 1999. Armed with his showreel, he gained entry into the music promo business, animating and directing for the likes of Skint Records and Sony Japan before leading a small animation design studio in London. Realizing his main passion, he jumped ship in 2005 and went freelance as "Ben the Illustrator," teaching himself Adobe Illustrator in two sleepless weeks. Commissions for the BBC and Airside soon followed. A big break arrived with an invitation to illustrate for Smart Cars. A self-confessed color addict, Ben gets excited by shapes and forms, and the way things move. His boundless enthusiasm rubs off through his rainbow-colored pictographic arrangements. What distinguishes Ben's work from countless other flat vector graphics is the interplay between his trinity of shape, color, and form—straight

Ben O'Brien (aka Ben the Illustrator) wurde 1976 in London geboren. Nach einem Grundkurs an der Central St Martins School of Art Mitte der 1990er-Jahre studierte O'Brien am Surrey Institute of Art and Design Animation und machte seinen Bachelor im Jahr 1999. Mit seinem Showreel bewaffnet, schaffte er den Einstieg in das Musik-Promo-Geschäft, animierte und führte Regie für Skint Records und Sony Japan, bevor er ein kleines Animationsdesignstudio in London leitete. Als er sich seiner Hauptleidenschaft bewusst wurde, wagte er 2005 den Schritt und wurde, nachdem er sich in zwei schlaflosen Wochen Adobe Illustrator selbst beigebracht hatte, freiberuflich tätig als „Ben the Illustrator". Es folgten bald Aufträge für die BBC und Airside. Sein großer Durchbruch kam mit einem Illustrationsauftrag für Smart Cars. Als bekennender Farbsüchtiger kann sich Ben für Formen und Gestalten und die Art und Weise, wie sich Dinge bewegen, begeistern. Sein grenzenloser Enthusiasmus zeigt sich in seinen

Ben O'Brien (alias Ben the Illustrator) est né à Londres en 1976. Après avoir suivi au milieu des années 1990 un cours d'initiation au Central Saint Martins College of Art and Design, O'Brien est parti étudier l'animation au Surrey Institute of Art and Design, y décrochant une licence en 1999. Avec une vidéo résumant ses travaux sous le bras, il a réussi à entrer dans le monde de la promotion musicale, l'animation et la réalisation, comme chez Skint Records et Sony Japon, avant de monter un petit studio d'animation à Londres. Pour matérialiser sa grande passion, il l'a abandonné en 2005 afin d'exercer en freelance sous le nom « Ben the Illustrator », apprenant Adobe Illustrator en autodidacte en deux semaines de nuits blanches. Les projets pour la BBC et Airside n'ont pas tardé à suivre, mais c'est grâce à une commande pour Smart Cars qu'il a vraiment percé. Accro de la couleur comme il l'a lui-même reconnu, Ben est inspiré par les formes et la façon dont les choses bougent. Son enthousiasme sans fin transparaît

lines and curves intersect and overlap to create a clarity and depth, accentuated by the odd brush spatter. Nothing gets lost in translation. Today, O'Brien lives and works in Frome, Somerset. His work can be found on everything from Innocent Smoothie bottles to retailers' walls. In 2017, Ben designed and conducted a survey of his own profession, asking 1,261 illustrators about their working lives.

piktografischen Arrangements in Regenbogenfarben. Was Bens Arbeit von unzähligen anderen flachen Vektorgrafiken unterscheidet, ist das Zusammenspiel der Dreieinigkeit von Form, Farbe und Gestalt – gerade Linien und Kurven überschneiden und überlappen sich, um Klarheit und Tiefe zu schaffen, akzentuiert durch gelegentliche Pinselspritzer. Er erreicht so eine sehr genaue Darstellung. Heute lebt und arbeitet O'Brien in Frome (Somerset). Seine Arbeiten sind auf Innocent Smoothie-Flaschen sowie auf Wänden von Einzelhandelsläden zu finden. 2017 entwarf und führte Ben eine Studie seines eigenen Berufs durch und befragte 1.261 Illustratoren zu ihrem Arbeitsleben.

à travers ses compositions pictographiques aux couleurs de l'arc-en-ciel. Mais comparé à d'innombrables graphiques vectoriels plats, le travail de Ben se démarque par l'interaction entre silhouettes, couleurs et formes : des lignes droites et des courbes se coupent et se chevauchent pour apporter clarté et profondeur, le tout accentué par des éclaboussures au pinceau. Le rendu est des plus fidèles. Aujourd'hui, O'Brien vit et travaille à Frome, dans le Somerset. Son travail est présent dans une foule d'endroits, des bouteilles Innocent Smoothie aux façades de magasins. En 2017, Ben a élaboré et mené une enquête sur sa profession en interrogeant 1 261 illustrateurs sur leur vie professionnelle.

BEN THE ILLUSTRATOR

Madonna, 2018
Personal work; vector

p. 44

opposite
Monty Python, 2018
Personal work; vector

Festifeel, 2016
CoppaFeel!, exhibition,
House of Vans, London; vector

Metropolis, 2016
Box Pensions, website;
design and concept:
We Launch, London

Selected Exhibitions: 2017, *Endless Summer*, group show, Atelier Meraki, Paris · 2016, *Festifeel*, group show, House of Vans, London · 2016, *Prince Exhibition*, group show, Fred Aldous, Manchester · 2016, *Secret 7's*, group show, Sonos Studio, London · 2012, *Art V Cancer*, group show, TwentyTwentyTwo, Manchester

Selected Publications: 2018, *CreativePool Annual,* CreativePool, United Kingdom · 2017, *Pattern Euphoria,* Sandu, Hong Kong · 2015, *Yellow*, Studio OL, United Kingdom · 2013, *Illustration 2*, Zeixs, Germany · 2008, *Beyond Trend*, HOW Books, USA

> "I like to work in black ink and watercolor to express the movement and transiency of fashion and to mirror the joy that looking at beauty creates in us."

MAYA BEUS

WWW.MAYABEUS.COM · @mayabeus

Whether attending fashion shows, client events, or openings, Maya Beus never leaves her studio without her sketchbook and iPad. Born in the small medieval town of Vrgorac, Croatia, in 1981, Beus studied at the School of Fashion and Design in Zagreb, graduating in 2009. After briefly working for an architecture design studio she moved to London, where she realized that illustration was her calling. Beus's evolving practice stems from a deep exploration of her chosen field. From pencil studies to digital painting over photos, or ink blots and bleeds accentuated by bold brushstrokes, her illustrations give her subjects mood, form, and texture, with a sketchiness that captures the fleeting catwalk moment or a delicate burst of fragrance. Beus has worked for the likes of CC KUO, *Harper's Bazaar* (Turkey), LVMH, Oscar de la Renta, San Pelegrino, St Regis Hotels, and Mercedes-Benz Fashion Week Australia. In 2013, she was selected Best Fashion Illustrator at the Fashion Fringe, part of London Fashion Week.

Ob zu Besuch bei Modenschauen, Kundenevents oder Openings, Maya Beus verlässt ihr Atelier nie ohne Skizzenbuch und iPad. Geboren wurde sie 1981 in der kleinen mittelalterlichen Stadt Vrgorac (Kroatien). Beus studierte an der Schule für Mode und Design in Zagreb und schloss ihr Studium 2009 ab. Nach einer kurzen Zeit in einem Architekturdesignbüro zog sie nach London, wo sie erkannte, dass die Illustration ihre Berufung ist. Beus' sich ständig entwickelnde Technik beruht auf ihrer tiefgehenden Beschäftigung mit ihrem jeweiligen Thema. Von der Bleistiftstudie zur digitalen Malerei über Fotos oder Tuscheflecken und Farbverwaschungen, in die sie kräftige Pinselstriche als Akzente zetzt – ihre Illustrationen verleihen dem Dargestellten Stimmung, Form und Textur. Dabei erreicht sie eine Skizzenhaftigkeit, die den flüchtigen Moment auf dem Laufsteg oder den zarten Duft eines Parfums einfangen kann. Beus hat für Kunden wie CC KUO, *Harper's Bazaar* (Türkei), LVMH, Oscar de la Renta, San Pelegrino,

Maya Beus ne sort jamais de son studio sans se munir de son carnet à dessin et d'un iPad quand elle part assister à des défilés de mode, des événements organisés par des clients ou des inaugurations. Née en 1981 dans la petite ville médiévale croate de Vrgorac, Beus a étudié à l'école de mode et de design de Zagreb, dont elle s'est diplômée en 2009. Après un court passage par un studio de design et d'architecture, elle s'est installée à Londres, où elle a compris que l'illustration était sa vocation. L'évolution qu'a connue sa pratique émane d'une exploration en profondeur de son domaine d'activité. D'études au crayon à la peinture numérique de photos ou aux tâches et coulures d'encre travaillées à grands coups de pinceau, ses illustrations dotent les sujets d'un état d'esprit, de silhouettes et de texture, avec un look sommaire captant un moment fugace sur un podium ou la délicate bouffée d'un parfum. Beus a travaillé pour des clients comme CC KUO, *Harper's Bazaar* (Turquie), LVMH, Oscar de la Renta, San

In 2015, Beus had her first solo exhibition at the luxury Le Méridien Lav hotel in Split. She lives and works in Zagreb.

St Regis Hotels und für die Mercedes-Benz Fashion Week Australien gearbeitet. Im Jahr 2013 wurde sie als bester Fashion Illustrator bei der Fashion Fringe ausgezeichnet, einem Teil der Londoner Fashion Week. Im Jahr 2015 hatte Beus ihre erste Soloausstellung im Luxushotel Le Méridien Lav in Split. Sie lebt und arbeitet in Zagreb.

Pelegrino, St Regis Hotels et la semaine australienne de la mode Mercedes-Benz. En 2013, elle a été élue Best Fashion Illustrator par Fashion Fringe, dans le cadre de la semaine de la mode de Londres. En 2015, Beus a exposé pour la première fois en solo à l'hôtel de luxe Le Méridien Lav de Split. Elle vit et travaille actuellement à Zagreb.

Wild Animal, 2017
Personal work;
watercolor and ink

right
Baby Owl, 2018
Bambini Furtuna,
packaging; watercolor

opposite
Perfume Table, 2016
Good Weekend magazine;
watercolor and ink

p. 50
St. Michel, 2018
Lodestars Anthology
magazine; watercolor

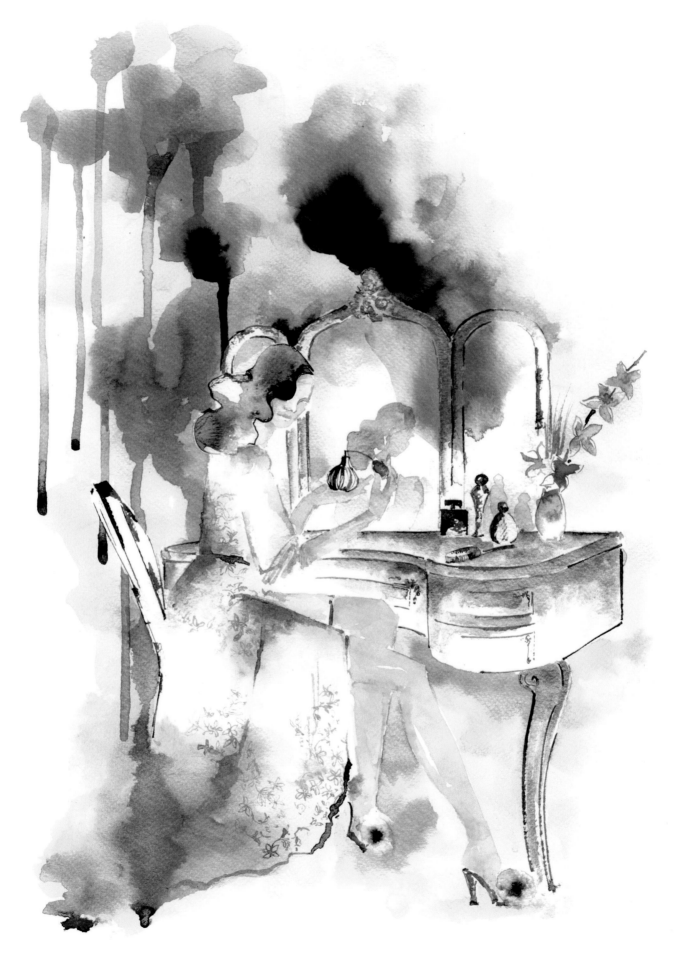

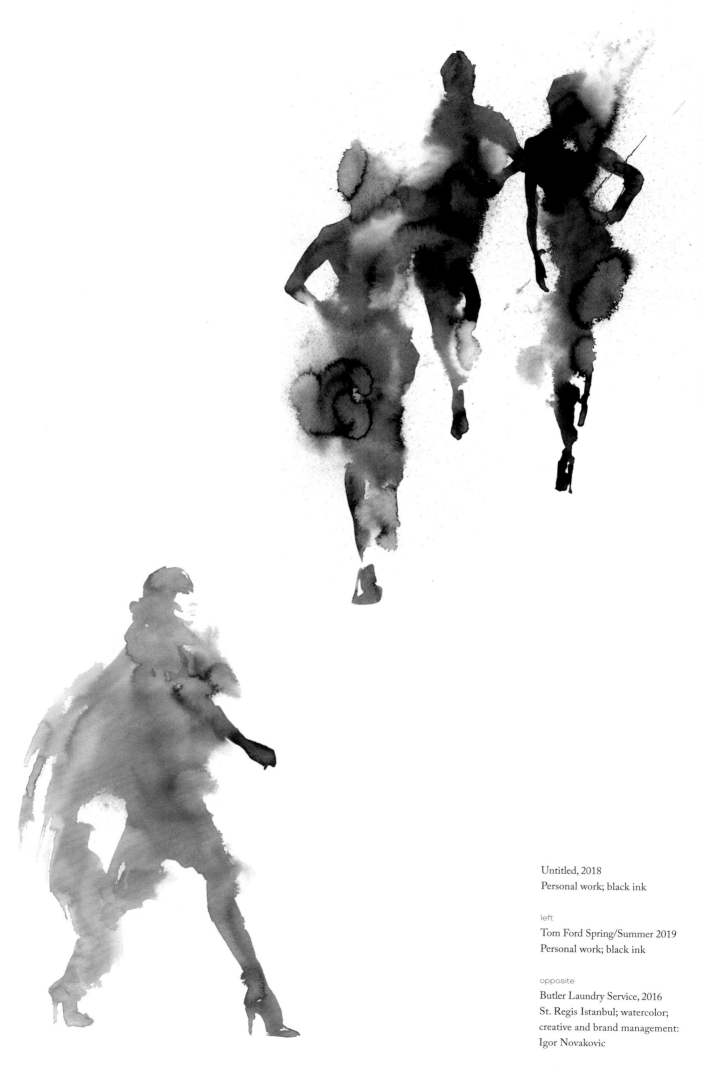

Untitled, 2018
Personal work; black ink

Tom Ford Spring/Summer 2019
Personal work; black ink

Butler Laundry Service, 2016
St. Regis Istanbul; watercolor;
creative and brand management:
Igor Novakovic

MAYA BEUS

Selected Exhibitions: 2016, *Memorable Oscar Dresses*, solo show, City Center One, Zagreb · 2015, *Cocktail Party*, solo show, Le Meridien Lav Hotel, Split

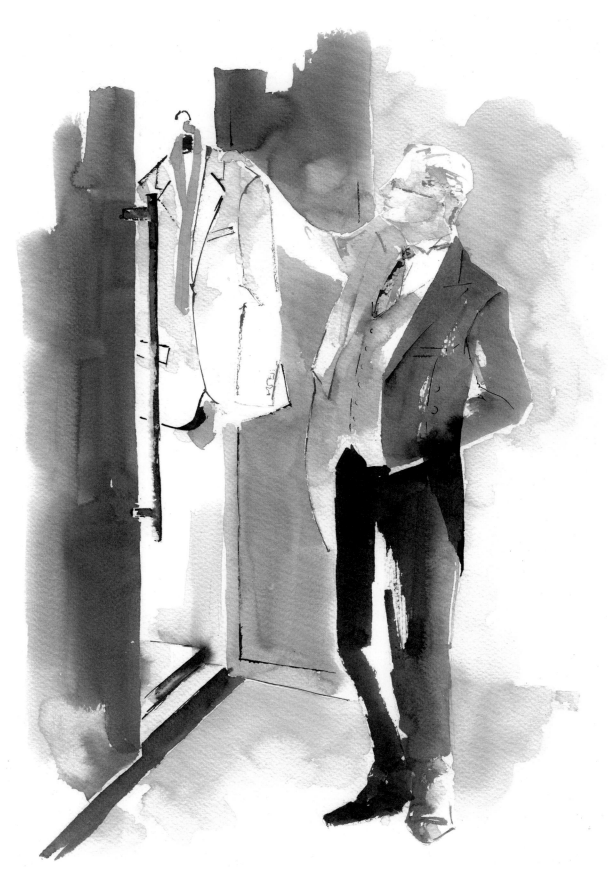

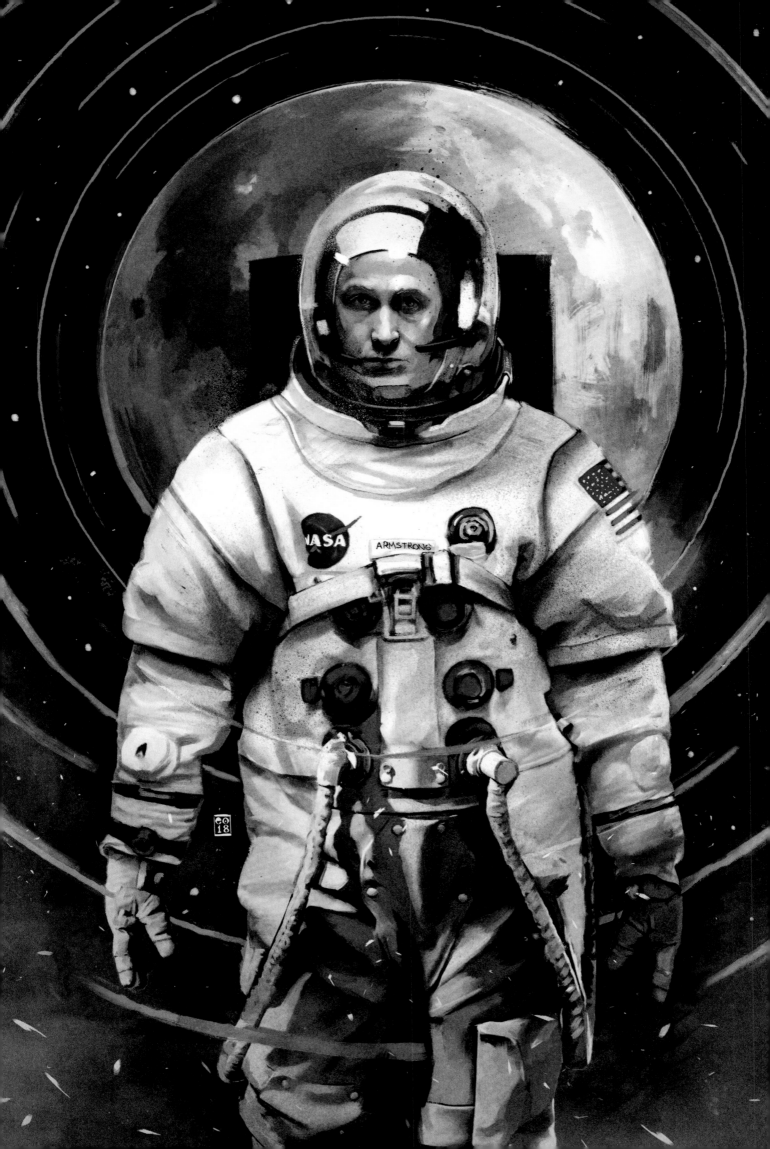

"I am a designer and a draftsman.
I love poems. I learned about fine arts
from an artist I happened to meet,
and decided to shape my future in
this field."

ETHEM ONUR BILGIÇ

WWW.ETHEMONUR.COM · @ethemonurb

Ethem Onur Bilgiç was born in 1986 in the coastal town of Inebolu on the Black Sea in Turkey. During his teens he moved to Ereğli in Anatolia, where a local painter spurred him on his creative path. In 2019, he completed his studies in graphic design at the Mimar Sinan Fine Arts University in Istanbul. While a student, he began undertaking commissions for various publications, as well as movie and theater posters. His moody, atmospheric style fuses attributes of the graphic novel with a color-graded, cinematic feel—allowing his work to cross over naturally from print to the moving image. Bilgiç works in both traditional media, such as acrylic, watercolor, ink, and marker pen, and digital tools, through which he translates a handcrafted aesthetic. In addition to his commercial work as an illustrator and motion-graphics artist, he also produces short films. Turkish literature and Japanese anime are close to his heart. Based on the poem "Salkim Söğüt" by romantic revolutionary writer Nazim Hikmet Ran, his first

Ethem Onur Bilgiç wurde 1986 in der türkischen Küstenstadt Inebolu am Schwarzen Meer geboren. Als Teenager zog er nach Ereğli in Anatolien, wo ihn ein lokaler Maler auf seinen kreativen Weg brachte. Im Jahr 2019 schloss er sein Grafikdesign-Studium an der Mimar-Sinan-Kunsthochschule in Istanbul ab. Während seines Studiums begann er, Aufträge für verschiedene Publikationen, sowie für Film- und Theaterplakate anzunehmen. Sein stimmungsvoller, atmosphärischer Stil verbindet Merkmale des Bildromans mit einer farblich abgestuften, filmischen Optik, sodass seine Arbeit ganz natürlich vom Druck zum bewegten Bild übergeht. Bilgiç arbeitet sowohl in traditionellen Techniken wie Acryl, Aquarell, Tusche und Filzstift als auch mit digitalen Werkzeugen, mit denen er eine handgemalte Ästhetik kreiert. Neben seiner kommerziellen Tätigkeit als Illustrator und Grafiker produziert er auch Kurzfilme. Außerdem liegen ihm türkische Literatur und japanischer Anime am Herzen. Sein auf dem Gedicht

Ethem Onur Bilgiç est né en 1986 dans la ville côtière turque d'Inebolu, sur la mer Noire. Au cours de son adolescence, il a déménagé en Anatolie, à Ereğli, où un peintre local l'a poussé sur le chemin de la création. En 2019, il a terminé ses études de design graphique à l'université des beaux-arts Mimar Sinan d'Istanbul. Encore étudiant, il a commencé à accepter des commandes pour diverses publications et à créer des affiches de films et de théâtre. Son style, qui dénote une atmosphère maussade, mêle des aspects de la bande dessinée et un rendu cinématographique, ce qui permet à ses créations de passer naturellement du tirage papier à l'image en mouvement. Bilgiç travaille aussi bien avec des moyens traditionnels, comme l'acrylique, l'aquarelle, l'encre et les feutres, que des outils numériques, grâce auxquels il traduit une esthétique artisanale. Outre son travail commercial comme illustrateur et concepteur d'animations, il produit des courts-métrages. La littérature turque et les animes japonais lui tiennent

animated short *Weeping Willow* (2014) was selected for numerous film festivals. Bilgiç has participated in exhibitions throughout his native country and beyond. His inaugural solo show *Sweet Nightmares* opened at Milk Gallery in Istanbul in 2013. Bilgiç's clients include the Akban Film festival, Coca-Cola, Denizbank, and Turkish Airlines.

„Salkim Sögüt" des romantisch-revolutionären Schriftstellers Nazim Hikmet Ran basierender erster animierter Kurzfilm *Weeping Willow* (Trauerweide) (2014) wurde zu zahlreichen Filmfestivals eingeladen. Bilgiç hat an Ausstellungen in seinem Heimatland und darüber hinaus teilgenommen. Seine erste Einzelausstellung *Sweet Nightmares* (Süße Albträume) eröffnete in der Milk Gallery in Istanbul im Jahr 2013. Zu Bilgiçs Kunden zählen das Akban Film Festival, Coca-Cola, die Denizbank und Turkish Airlines.

particulièrement à cœur. S'inspirant du poème « Salkim Sögüt » de l'écrivain romantique révolutionnaire Nazim Hikmet Ran, son premier court animé *Weeping Willow* (Saule pleureur) de 2014 a été sélectionné à de nombreux festivals de film. Bilgiç a participé à des expositions dans son pays natal et à l'étranger, et la première qu'il a faite en solo, intitulée « Sweet Nightmares », s'est tenue en 2013 à la Milk Gallery d'Istanbul. Parmi ses clients, Bilgiç compte le festival de cinéma Akbank, Coca-Cola, Denizbank et Turkish Airlines.

ETHEM ONUR BILGIÇ

Neset Ertas, 2018
Oz Cekim, magazine; digital

right
Waves, 2018
Personal work; digital

opposite
Miguel de Cervantes, 2018
ArkaKapak, magazine cover;
digital

p. 56
First Man, 2018
United International
Pictures Turkey, poster; digital

ETHEM ONUR BILGIÇ

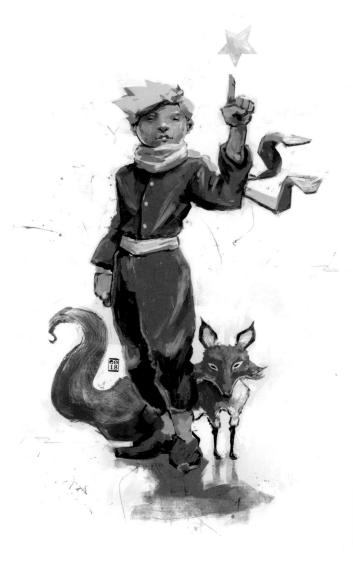

Selected Exhibitions: 2018, *Mix-Tape*, solo show, Izmir International Fair, Izmir Art Center, Turkey · 2018, *The Big Picture*, group show, Depo, Istanbul · 2018, *Illustrators*, group show, Dada Salon Art Gallery, Istanbul · 2017, *Tovbeler Tovbesi*, solo show, Bang Mag. Havuz/Bina, Istanbul · 2013, *Sweet Nightmares*, solo show, Milk Gallery & Design Store, Istanbul

Selected Publication: 2015, *Bant Mag. Artist Dossier No.2, Ethem Onur Bilgiç*, Bant Mag., Turkey

The Little Prince, 2018
Tuhaf, magazine; digital

right
Rabbit, 2017
Personal work; digital

opposite
Time, 2016
Personal work; digital

"I'm a kind of jobbing artist, a journeyman artist." for *The Spectator*

PETER BLAKE

@peterblakeartist

Born in Dartford, Kent, in 1932, Peter Blake's standing in modern visual culture is nothing less than iconic. Often regarded as the "Godfather of British Pop Art," Blake's stellar career has transcended the realms of graphic design, fine art, and illustration. He studied at Gravesend School of Art before fulfilling his National Service duties in the Royal Air Force. Upon graduation from the Royal College of Art in 1956 he received a Leverhulme Trust research award to study popular art around Europe before teaching at various London art schools and working as an artist. Combining mixed media techniques of painting, collage, and assemblage to appropriate everyday images—from ephemera to fairground art—Blake's work had a defining impact on British youth culture in the 1960s. He produced several album sleeves, including the seminal cover for *The Beatles' Sgt. Pepper's Lonely Hearts Club Band* (1967), co-created with his then wife, American-born artist Jann Haworth. Other notable works include the cover of the Band Aid single "Do They Know It's Christmas?"

Peter Blake, 1932 in Dartford, Kent, geboren, ist in der modernen visuellen Kultur inzwischen eine Ikone. Die herausragende Karriere des oft als „Pate der britischen Pop-Art" bezeichneten Blake hat die Grenzen zwischen Grafikdesign, bildender Kunst und Illustration überschritten. Er studierte an der Gravesend School of Art, bevor er seinen Wehrdienst bei der Royal Air Force leistete. Nach seinem Abschluss am Royal College of Art im Jahr 1956 erhielt er einen Forschungspreis des Leverhulme Trust, um populäre Kunst in ganz Europa zu studieren, bevor er an verschiedenen Londoner Kunstschulen unterrichtete und als Künstler tätig war. Seine Arbeiten, in denen er Mixed-Media-Techniken aus Malerei, Collage und Assemblage kombiniert, um sie Alltagsbildern anzupassen, von Ephemera bis zur Jahrmarktkunst –, hatten in den 1960er-Jahren einen entscheidenden Einfluss auf die britische Jugendkultur. Er gestaltete mehrere Plattenhüllen, darunter auch das bahnbrechende Cover für *Sgt. Pepper's Lonely*

Né en 1932 à Dartford, dans le Kent, Peter Blake occupe une place iconique dans la culture visuelle moderne. Souvent considéré le « parrain du pop art britannique », Blake a mené une brillante carrière qui a transcendé les domaines du design graphique, des arts plastiques et de l'illustration. Il a étudié à la Gravesend School of Art, avant de remplir ses obligations militaires à la Royal Air Force. Diplômé en 1956 du Royal College of Art, il a reçu une bourse de recherche du Leverhulme Trust pour étudier l'art populaire en Europe, puis a enseigné dans plusieurs écoles d'art londoniennes et exercé en tant qu'artiste. Mariant des techniques mixtes de peinture, de collage et d'assemblage pour détourner des images du quotidien, de l'art éphémère aux arts forains, l'œuvre de Blake a eu une influence déterminante sur la culture de la jeunesse britannique dans les années 1960. Il est l'auteur de plusieurs pochettes d'album, dont la couverture phare pour *Sgt. Pepper's Lonely Hearts Club Band* (1967) des Beatles,

(1984), and the Live Aid concert poster (1985). Among his numerous honors, Blake received a knighthood in 2002. Continually active into the new millennium, Blake has designed prints for Stella McCartney's couture and given the Brit Awards statuette a makeover.

Hearts Club Band (1967) der Beatles, das er gemeinsam mit seiner damaligen Frau, der in Amerika geborenen Künstlerin Jann Haworth, schuf. Weitere bemerkenswerte Werke sind das Cover der Band-Aid-Single *Do They Know It's Christmas?* (1984) und das Live-Aid-Konzert-Poster (1985). Neben seinen zahlreichen Ehrungen wurde Blake 2002 zum Ritter geschlagen. Blake ist auch im neuen Jahrtausend weiter aktiv und entwarf Druckgrafiken für Stella McCartneys Couture und überarbeitete die BRIT-Awards-Statuette.

qu'il a co-créée avec sa femme à l'époque, l'artiste américaine Jann Haworth. À noter parmi ses œuvres de référence la couverture du single de Band Aid intitulé « Do They Know It's Christmas? » (1984) et l'affiche du concert Live Aid (1985). Blake a reçu de nombreuses distinctions et a été honoré du titre de chevalier en 2002. N'ayant jamais cessé d'exercer depuis le changement de millénaire, Blake a signé des imprimés pour la collection de Stella McCartney et relooké la statuette des BRIT Awards.

PETER BLAKE

"Gettin' in Over My Head",
Brian Wilson, single, 2004

opposite
Everybody Razzle Dazzle, 2015
photo: Ant Clausen

p. 62
Her Majesty Queen
Elizabeth II, 2017
Vogue, magazine

"Do They Know It's Christmas",
Band Aid, 1984
Mercury Records, single

opposite
The Sailors' Arms
Personal work, *Under Milk Wood*,
"Llareggub", 2013

PETER BLAKE

Selected Exhibitions: 2018, *Drawing Retrospective*, solo show, Waddington Custot, London · 2007, *Retrospective*, solo show, Tate Liverpool · 1997, *Now We Are 64*, solo show, The National Gallery, London · 1983, *Retrospective*, solo show, Tate Britain

Selected Publications: 2011, *Peter Blake. A Museum for Myself*, The Holburne Museum, United Kingdom · 2007, *Peter Blake. A Retrospective*, by Christoph Grunenberg & Laurence Sillars, Tate Publishing, United Kingdom · 2003, *Peter Blake. Modern Artists Series*, by Natalie Rudd, Tate Publishing, United Kingdom · 2001, *Peter Blake. One Man Show*, by Marco Livingstone, Lund Humphries, United Kingdom

> "I like to keep it simple. I work with two key colors and, of course, black, white, and gray. People think that working with computers is very constrained and controlled, but those accidents offer the never-to-be repeated moments of creativity that every artist strives for."
>
> for *Marshwood Vale Magazine*

PAUL BLOW

WWW.PAULBLOW.COM · @paulyblow

Paul Blow was born in Falkirk, Scotland, in 1969, but grew up near the Dorset coast in England, where he lives and works today. His love of drawing is rooted in his childhood during the 1980s, when he escaped through the world of comics. He received his BA (Hons) from Maidstone College of Art in 1992 before completing an MA in Narrative Illustration at the University of Brighton. Working from his studio in an old rope-making factory, Blow is a firm believer in concept over style. Wit and nostalgia abound in his work. Often inspired by vintage photos, his characters are rendered by wispy lines that crease and fold to give expression. He mixes his own hues, creating a bold, minimal palette that lends his work an enchanting warmth. Blow has a list of prominent editorial clients to his name, from *The Washington Post* to *The Guardian*, and his passion also extends to collaborative projects for small enterprises, like an ethical bike-skate clothing firm. His work adorns everything from murals on old furniture to T-shirts.

Paul Blow wurde 1969 in Falkirk (Schottland) geboren, wuchs aber in der Nähe der Küste von Dorset in England auf, wo er noch heute lebt und arbeitet. Seine Liebe zum Zeichnen wurzelt in seiner Kindheit in den Achtzigerjahren, als er sich in die Welt der Comics flüchtete. Er machte seinen Bachelor mit Auszeichnung 1992 am Maidstone College of Art, bevor er seinen Master in Narrative Illustration an der University of Brighton erlangte. Sein Atelier hat er in einer alten Seilfabrik eingerichtet und folgt hier unbeugsam seiner Philosophie „Konzept vor Stil". In seiner Arbeit steckt viel Witz und Nostalgie. Seinen Charakteren, die oft von Vintage-Fotos inspiriert sind, verleiht er mit zarten Linien einen knittrigen und gefalteten Ausdruck. Er mischt seine Farbe selbst und kreiert so eine kühne, minimalistische Palette, die seiner Arbeit eine bezaubernde Wärme verleiht. Blow hat eine Reihe prominenter redaktioneller Kunden wie die *Washington Post* oder den *Guardian*. Seine Leidenschaft erstreckt sich aber auch auf

Né en 1969 à Falkirk, en Écosse, Paul Blow a grandi près du littoral anglais du Dorset, où il réside et travaille aujourd'hui. Son amour pour le dessin prend racine dans son enfance, dans les années 1980, quand il se réfugiait dans l'univers de la bande dessinée. En 1992, il a décroché une licence (avec les honneurs) au Maidstone College of Art avant d'obtenir une maîtrise en illustration de narration à l'université de Brighton. Travaillant dans son studio installé à l'intérieur d'une ancienne usine de cordes, Blow est fermement convaincu que le concept prime le style, et ses œuvres démontrent souvent une finesse d'esprit et de la nostalgie. Grandement inspiré par les photos vintage, il crée ses personnages à l'aide de lignes délicates qui se tordent et se plient pour leur donner corps. Il mélange ses propres teintes et obtient une palette vive et minimale qui dote ses créations d'une agréable chaleur. Blow compte une liste d'importants clients dans le monde éditorial, de *The Washington Post* à *The Guardian*, et sa passion

He has also created animations for VH1 and was an art lecturer at the Arts Institute at Bournemouth.

Kopererationsprojekte mit kleinen Unternehmen, wie zum Beispiel einer ethisch handelnden Bike-Skate-Bekleidungsfirma. Seine Arbeiten schmücken einfach alles: von Wandgemälden über alte Möbel bis zu T-Shirts. Er hat außerdem Animationen für VH1 geschaffen und war Kunstdozent am Arts Institute in Bournemouth.

s'étend à des projets collaboratifs pour de petites entreprises, comme une marque de vêtements éthiques pour faire du vélo et du skate. Ses compositions se retrouvent partout, de peintures sur de vieux meubles à des T-shirts. Il est par ailleurs l'auteur d'animations pour VH1 et a donné des conférences sur l'art à l'université des arts de Bournemouth.

PAUL BLOW

A.I., 2017
Caspian, magazine,
Real Deals; digital

opposite top
The Last Polar Bear, 2018
Greenpeace magazine; digital

opposite bottom
Go With the Flow, 2017
WeTransfer; digital

p. 68
Jackass TV, 2018
MTV; digital

War in Yemen series, 2018
International Rescue
Committee; digital

opposite
Food Lover, 2018
Personal work; digital

Hangin' Out, 2017
Handsome Frank agency,
promotional; digital

opposite
Turkey, 2018
The Economist,
magazine; digital

opposite top
Animal Farm, 2017
Soulpepper theatre
company; digital

PAUL BLOW

Selected Publications: 2017, *American Illustration*, USA · 2017, *Society of Illustrators*, USA · 2017, *Communication Arts*, USA · 2014, *IdN*, Systems Design Ltd, China · 2007, *Nobrow 1*, Nobrow, United Kingdom

> "My work is feminine, playful
> and colorful. I think cute is also
> a good word to describe it."
>
> for *Metal* magazine

BODIL JANE

WWW.BODILJANE.COM · @bodiljane

Combining delicious, flat colors with a hint of the exotic, Dutch illustrator Bodil Jane celebrates the diversity of the modern lifestyle through her wide range of subjects—from empowered women, relationships, and interiors to food, nature, plants, and animals. Born in Amsterdam in 1990, Bodil Jane moved to Haarlem, where her creative seeds were nurtured by her freelance artist parents. Whilst studying illustration at the Willem de Kooning Academy in Rotterdam, she was already proactively mapping out pathways with an Erasmus exchange program in visual communication at the School of Design, Copenhagen, followed by commissions for ad agencies and internships with design shops. Since receiving her degree in 2014, her career has snowballed—thanks largely to her entrepreneurial streak and Internet savvy. Today she shares her daily practice with hundreds of thousands of online followers. As for style and technique, all her work is rendered entirely by hand in watercolor, pencil, and ink. Her diverse output

Die holländische Illustratorin Bodil Jane kombiniert herrliche, flächige Farben mit einem Hauch Exotik und feiert in ihrer breiten Palette von Themen – von starken Frauen, Beziehungen und Innenräumen bis zu Nahrungsmitteln, Natur, Pflanzen und Tieren – die Diversität des modernen Lebens. Bodil Jane wurde 1990 in Amsterdam geboren und zog dann nach Haarlem, wo ihre kreative Veranlagung von ihren freiberuflich tätigen Künstlereltern gefördert wurde. Schon während des Studiums der Illustration an der Willem de Kooning Akademie in Rotterdam zeigte sie mit einem Erasmus-Austauschprogramm für visuelle Kommunikation an der Schule für Design in Kopenhagen eigenständig Wege auf. Es folgten Aufträge für Werbeagenturen und Praktika bei Designshops. Seit ihrem Abschluss im Jahr 2014 ging es mit ihrer Karriere steil bergauf – vor allem dank ihres Unternehmergeistes und ihres Internetverständnisses. Heute teilt sie ihre tägliche Arbeit mit Hunderttausenden von Online-Followern. Was Stil und

En ajoutant à d'élégants aplats une touche exotique, l'illustratrice hollandaise Bodil Jane évoque le mode de vie moderne à travers tout un éventail de sujets : femmes émancipées, relations, intérieurs, aliments, nature, plantes ou encore animaux. Née en 1990 à Amsterdam, Bodil Jane s'est installée à Haarlem, et ses parents, tous deux artistes freelance, ont cultivé sa graine créatrice. Encore étudiante à la Willem de Kooning Academy à Rotterdam, elle s'est inscrite à un programme d'échange Erasmus en communication visuelle à l'école de design de Copenhague ; ont suivi des commandes pour des agences de publicité et des stages dans des boutiques de design. Diplômée en 2014, sa carrière a connu un effet boule de neige, principalement grâce à son esprit entrepreneur et sa maîtrise d'Internet : elle partage aujourd'hui son activité en ligne avec des centaines de milliers de followers. En matière de style et de technique, toutes ses créations sont exclusivement faites à la main à l'aquarelle, aux crayons et à

encompasses editorials, ad campaigns, stationery, and home furnishings. In 2015, she was honored with a Silver Award at the European Design Awards. To date, her clientele includes Air Canada, Casetify, *Flow Magazine*, Jamie Oliver, Rabobank, UNICEF, and Waitrose. In 2018, she selected ten inspirational women, from civil rights activist Rosa Parks to Nobel Prize laureate Malala Yousafzai, for an illustrated French children's book *Il était une fois des femmes fabuleuses*.

Technik angeht, erstellt sie all ihre Arbeiten in Aquarell, Bleistift und Tusche vollständig von Hand. Ihre vielfältige Produktion umfasst Editorials, Werbekampagnen, Schreibwaren und Einrichtungsgegenstände. 2015 wurde sie bei den European Design Awards mit einem Silver Award ausgezeichnet. Heute zählen Air Canada, Casetify, *Flow Magazine*, Jamie Oliver, Rabobank, UNICEF und Waitrose zu ihren Kunden. 2018 wählte sie zehn inspirierende Frauen für das illustrierte französische Kinderbuch *Il était une fois des femmes fabuleuses* aus – von der Bürgerrechtsaktivistin Rosa Parks bis zur Nobelpreisträgerin Malala Yousafzai.

l'encre, et on les retrouve dans le monde éditorial, des campagnes publicitaires, des papiers à lettres et des accessoires pour la maison. En 2015, elle a reçu un Silver Award aux European Design Awards. Elle a jusqu'à présent travaillé pour Air Canada, Casetify, le magazine *Flow*, Jamie Oliver, Rabobank, UNICEF et Waitrose. En 2018, elle a choisi dix femmes considérées comme des sources d'inspiration, de l'activiste pour les droits civiques Rosa Parks à la lauréate du prix Nobel de la paix Malala Yousafzai, pour un livre illustré pour enfants intitulé *Il était une fois des femmes fabuleuses*.

BODIL JANE

Air Pollution, 2016
UNICEF, online campaign;
analogue textures, ink, digital

opposite
Bloom, 2018
Happinez magazine;
analogue textures, digital

p. 76
Frida Kahlo, 2018
Bravery, magazine cover;
analogue textures, digital

Selected Publication: 2018, *Il était une fois des femmes fabuleuses*, Larousse Jeunesse, France

Slumber Party, 2018
Personal work; analogue
textures, digital

right
Hands, 2017
Happinez magazine;
analogue textures, digital

opposite
Joséphine Baker, 2018
Il était une fois des femmes fabuleuses,
book, Larousse Jeunesse;
analogue textures, digital

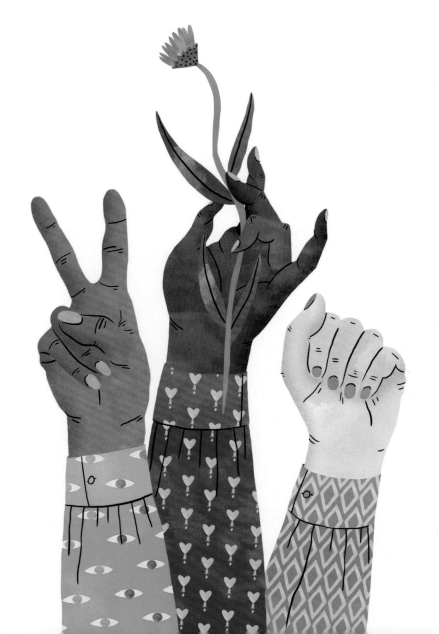

> "The quantity of images we consume daily and the speed at which everything happens don't allow us to stop for a moment and enjoy—or suffer, or simply be conscious of the here and now."

for Café Babel

PAULA BONET

WWW.PAULABONET.COM · @paulabonet

Born in 1980 in Villarreal, in the Valencian Community of Spain, Paula Bonet joined a drawing academy at the age of 14. Although her peers tried to persuade her to go into a more secure profession, she followed her passion, gaining a BFA at the Polytechnic University of Valencia in 2003 before traveling and completing her studies at the Pontifical Catholic University of Chile in Santiago and New York University, as well as taking short courses in Urbino, Italy. Returning home, she pursued a career in teaching and painting before devoting her to time to freelance work. Although she has exhibited in Spain, as well as in London, Paris, and Berlin, it is through the Internet that her talents have gained her the attention of hundreds of thousands of followers on social media. In 2009, she began applying her engraving and oil-painting techniques to a broader mixed-media practice. Bonet's work combines text and images, giving equal weight to both. Whether working in pencil, ink, watercolor, or engraving, her expressionist and

Paula Bonet wurde 1980 in Villarreal in der Valencianischen Gemeinschaft im Osten Spaniens geboren. Mit 14 Jahren trat sie einer Zeichenakademie bei. Obwohl ihr Umfeld versuchte, sie zu einer sichereren Berufswahl zu bewegen, folgte sie ihrer Leidenschaft und erhielt 2003 einen Bachelor an der Polytechnischen Universität von Valencia, bevor sie reiste und ihre Studien an der Päpstlichen Katholischen Universität von Chile in Santiago und der New York University abschloss sowie Sommerkurse in Urbino in Italien belegte. Nach ihrer Rückkehr nach Hause widmete sie sich zunächst dem Unterrichten und Malen, bevor sie all ihre Zeit in ihre freiberufliche Arbeit investierte. Sie hat zwar in Spanien, London, Paris und Berlin ausgestellt, aber erst durch das Internet erhielt ihr Talent die Aufmerksamkeit Hunderttausender Follower in den sozialen Medien. 2009 begann sie, ihre Gravur- und Ölmalereitechniken in einer breiteren Mixed-Media-Arbeitsweise anzuwenden. Bonet kombiniert in ihren Arbeiten zu gleichen Teilen

Née en 1980 à Villarreal, dans la Communauté valencienne, Paula Bonet a intégré à l'âge de 14 ans une académie de dessin. Même si ses proches ont voulu la convaincre de choisir une profession plus sûre, elle a écouté sa passion et décroché en 2003 une licence en beaux-arts à l'université polytechnique de Valence. Elle a ensuite voyagé et complété ses études à l'université pontificale catholique du Chili (Santiago) et à l'université de New York, ainsi que suivi des cours à Urbino, en Italie. De retour au pays, elle a exercé comme professeur et peintre, avant d'exercer en freelance. Elle a exposé en Espagne, ainsi qu'à Londres, Paris et Berlin, mais c'est sur Internet que son talent a retenu l'attention de centaines de milliers de followers sur les réseaux sociaux. En 2009, elle a commencé à appliquer ses techniques de gravure et de peinture à l'huile à une pratique plus large avec des matériaux mixtes. Le travail de Bonet associe textes et images de manière équilibrée. Qu'elle ait recours au crayon, à l'encre, à l'aquarelle

contemplative subjects entice the viewer through surface layers and into a deeper visual narrative. This approach has naturally resulted in several illustrated books of writings and poetry, among them *Qué hacer cuando en la pantalla aparece The End* (2014) and *813* (2015), the latter a tribute to the French film director François Truffaut. In 2016 she published *La sed*, an illustrated poem about sentimental and emotional disorientation that breaks with all previous aesthetics. *Roedores. Cuerpo de embarazada sin embrión* (2018), a book in diary format accompanied by an animated painting, gives voice to silence, breaks a taboo, and normalizes a reality as common as miscarriage. Bonet also created the paintings and engravings for Joan Didion's *The Year of Magical Thinking* (2005).

Text und Bilder und verwendet dabei Bleistift, Tusche, Aquarell oder Gravur. Ihre expressionistischen und kontemplativen Motive locken den Betrachter durch Oberflächenschichten zu einer tieferen visuellen Erzählung. Aus diesem Ansatz entstanden mehrere illustrierte Bücher mit Texten und Gedichten, unter anderem *Qué hacer cuando en la pantalla aparece The End* (2014) und *813* (2015), Letzteres ist eine Hommage an den Regisseur François Truffaut. 2016 veröffentlichte sie *La sed*, ein illustriertes Gedicht über sentimentale und emotionale Desorientierung, das mit allen bisherigen Ästhetiken bricht. *Roedores. Cuerpo de embarazada sin embrión* (2018), ein Buch im Tagebuchformat, das von einem animierten Gemälde begleitet wird, gibt der Stille eine Stimme, bricht ein Tabu und normalisiert eine Realität – die häufig vorkommende Fehlgeburt. Bonet schuf auch die Gemälde und Gravuren für Joan Didions *Das Jahr magischen Denkens* (2005).

ou à la gravure, ses sujets expressionnistes et pensifs font traverser au public différentes couches jusqu'à une narration visuelle plus profonde. Cette approche a donné jour à plusieurs livres illustrés d'écrits et de poésies, parmi lesquels *Qué hacer cuando en la pantalla aparece The End* (2014) et *813* (2015), ce dernier rendant hommage à François Truffaut. En 2016, elle a publié *La sed*, un poème illustré qui traite de désorientation sentimentale et émotionnelle, marquant une rupture avec son esthétique habituelle. Dans *Roedores. Cuerpo de embarazada sin embrión* (2018), un ouvrage au format de journal intime décoré de peintures animées, elle donne la parole au silence, brise un tabou et normalise une réalité aussi courante qu'une fausse couche. Bonet a également produit les peintures et gravures illustrant le livre de Joan Didion intitulé *L'Année de la pensée magique* (2005).

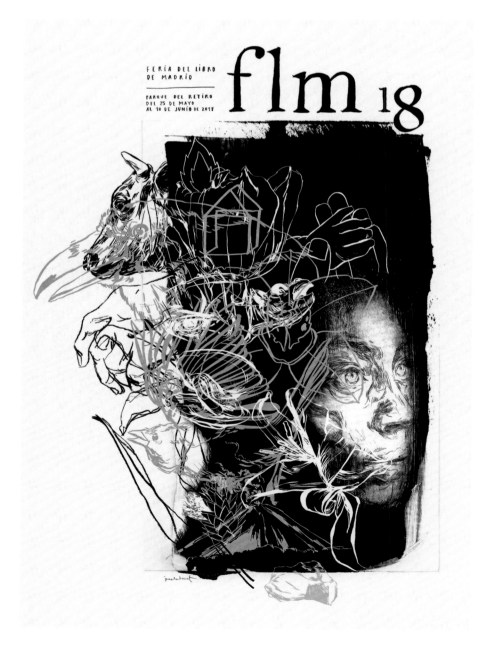

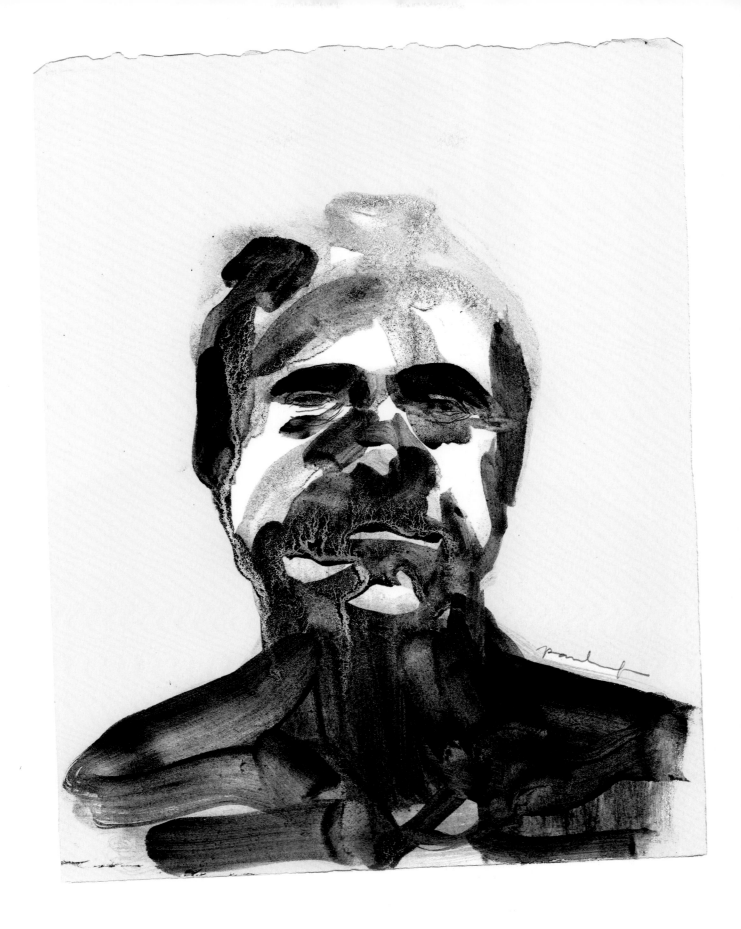

The European Cinema Festival
of the City of Segovia, MUCES,
poster, 2018

opposite
Madrid Book Fair, 2018, poster

p. 82
Untitled, 2016
La sed, Lunwerg Editores, book

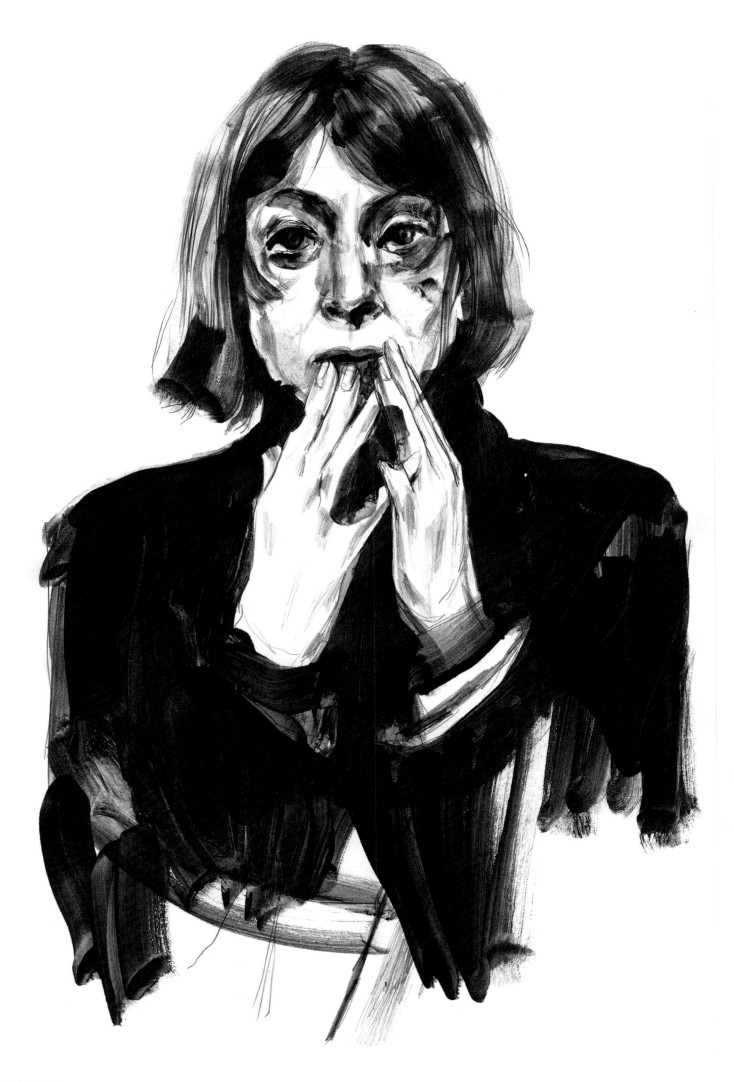

PAULA BONET

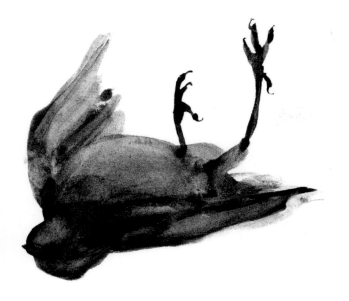

Selected Exhibitions: 2018, *Por el olvido*, solo show, Pepita Lumier, Valencia · 2017, *Una habitación oscura*, solo show, La Fábrica, Madrid · 2017, *La sed*, solo show, Miscelánea, Barcelona · 2016, *813/Truffaut*, solo show, Galería de Cristal, Centro Cibeles, Madrid · 2015, *No te acabes nunca*, solo show, Ailaic, Barcelona

Selected Publications: 2018, *Por el olvido*, Lunwerg Editores, Spain · 2018, *Roedores/Cuerpo de embarazada sin embrión*, Random House, Spain · 2017, *Quema la memoria*, Lunwerg Editores, Spain · 2016, *La sed*, Lunwerg Editores, Spain · 2015, *813/Truffaut*, La Galera, Spain · 2014, *Qué hacer cuando en la pantalla aparece The End*, Lunwerg Editores, Spain

La sed, 2016, book, Lunwerg Editores

right
Por el olvido, 2018, by Aitor Saraiba, book, Lunwerg Editores

opposite
El año del pensamiento mágico, 2019, by Joan Didion, book, Penguin Random House Grupo Editorial

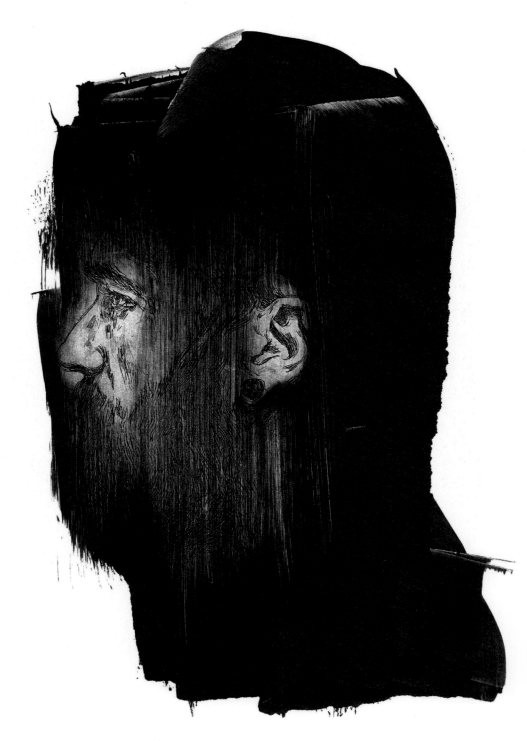

> "I don't come from a typically 'artsy' family, but I do come from a family with a lot of meticulously skilled tradespeople, like carpenters, woodworkers, and bricklayers."
>
> for *The Great Discontent*

DARREN BOOTH

WWW.DARRENBOOTH.COM · @darrenbooth

Born in 1978, in the city of Sault Ste. Marie, Ontario, Darren Booth is an award-winning Canadian illustrator and lettering artist with a unique visual vocabulary. After graduating in illustration from Sheridan Institute in 2001, Booth's distinctive, handmade style began to attract the attention of major brands. Today, his impressive tally of clients includes Google, Coca-Cola, AOL, Target, Pinterest, Penguin Books, and Disney. His colorful and uniquely shaped lettering designs, sometimes blending into abstract compositions, have adorned book covers for imprints such as Crown Publishing and Picador. His jacket design for actor Steve Martin's novel *The Object of Beauty* (2010) was selected for the *Communication Arts Design Annual* and the American Institute of Graphic Arts' 50 Books/50 Covers. His personal work includes ongoing experiments with patterns, which have appeared on home furnishings, notebooks, and skis. Booth has an instinctive approach to his creative process. He keeps journals and

Darren Booth wurde 1978 in Sault Ste. Marie (Ontario) geboren und ist ein preisgekrönter kanadischer Illustrator und Schriftsteller mit einem einzigartigen visuellen Vokabular. Nach dem Abschluss des Illustrationsstudiums am Sheridan Institute im Jahr 2001 erregte Booths unverkennbarer, handgefertigter Stil die Aufmerksamkeit großer Marken. Heute umfasst sein beeindruckender Kundenstamm Google, Coca-Cola, AOL, Target, Pinterest, Penguin Books und Disney. Seine farbenfrohen und einzigartig geformten Schriftzüge, die manchmal zu abstrakten Kompositionen verschmelzen, haben Buchcover für Verlage wie Crown Publishing und Picador geziert. Sein Umschlagdesign für den Roman des Schriftstellers Steve Martin *An Object of Beauty* (Ein Objekt der Schönheit) (2010) wurde für die Auszeichnung *Communication Arts Design Annual* und für die *50 Books/50 Covers* des American Institute of Graphic Arts nominiert. In seiner Arbeit experimentiert er laufend mit Mustern, die auf Einrichtungsgegen-

Né en 1978 dans la ville ontarienne de Sault-Sainte-Marie, le Canadien Darren Booth est un illustrateur et artiste en lettrage primé qui emploie un vocabulaire visuel unique. Après avoir obtenu en 2001 un diplôme en illustration du Sheridan College Institute, Booth a développé un style caractéristique qui n'a pas tardé à se faire remarquer par de grandes marques. Son impressionnante liste de clients inclut Google, Coca-Cola, AOL, Target, Pinterest, Penguin Books et Disney. Ses conceptions de lettrage hautes en couleur et aux formes uniques, qui créent parfois des compositions abstraites, ont décoré des couvertures de livres pour des maisons d'édition comme Crown Publishing et Picador. Son œuvre pour la jaquette du roman de l'acteur Steve Martin intitulé *An Object of Beauty* (2010) a été retenue dans le *Communication Arts Design Annual* et pour le concours 50 Books/50 Covers organisé par l'American Institute of Graphic Arts. Son travail personnel passe par des assemblages de motifs qui se

sketchbooks that are separate from his illustration work; he blogs and tweets, and favors simple briefs that give him *carte blanche* to create. He lives with his family in St. Catherines, Ontario.

ständen, Notebooks und Skiern erschienen sind. Booth hat einen instinktiven Ansatz in seinem kreativen Prozess. Er führt neben seiner Illustrationsarbeit Tage- und Skizzenbücher, er bloggt und schreibt Tweets und bevorzugt einfache Aufträge, bei denen er seiner Kreativität freien Lauf lassen kann. Er lebt mit seiner Familie in St. Catharines, Ontario.

retrouvent sur des accessoires pour la maison, des carnets ou encore des skis. Booth suit une approche instinctive pour son processus de création. Il tient des journaux et des carnets à dessin à côté de son travail d'illustration, écrit un blog, fait des tweets et privilégie les briefings simples lui donnant carte blanche pour créer. Il vit avec sa famille à St. Catharines, en Ontario.

DARREN BOOTH

Monster, 2018
Personal work; digital

opposite
U Can Read This, 2019
The Cut & Paste Bureau; digital

p. 88
Blue Grid, 2018
Superfit Hero; acrylic, collage

pp. 92–93
Share the Warmth, 2015
Second Cup Coffee; acrylic,
collage, digital

Selected Exhibitions: 2018, *Society of Illustrators 60th*, group show, New York · 2017, *Heavyweights*, group show, Redefine Gallery, Orlando · 2015, *Society of Illustrators 57th*, group show, New York · 2003, *The Art of Burlesque*, group show, Gladstone Hotel, Toronto · 2003, *Heaven & Hell*, group show, various, USA

Selected Publications: 2017, *Expressive Type,* Rockport, USA · 2017, *Society of Illustrators 60,* USA · 2017, *Creative Pep Talk,* Chronicle Books, USA · 2017, *IdN: Illustration in Pattern Making,* International Designers Network, China · 2016, *Illustration Annual, Communication Arts*, USA

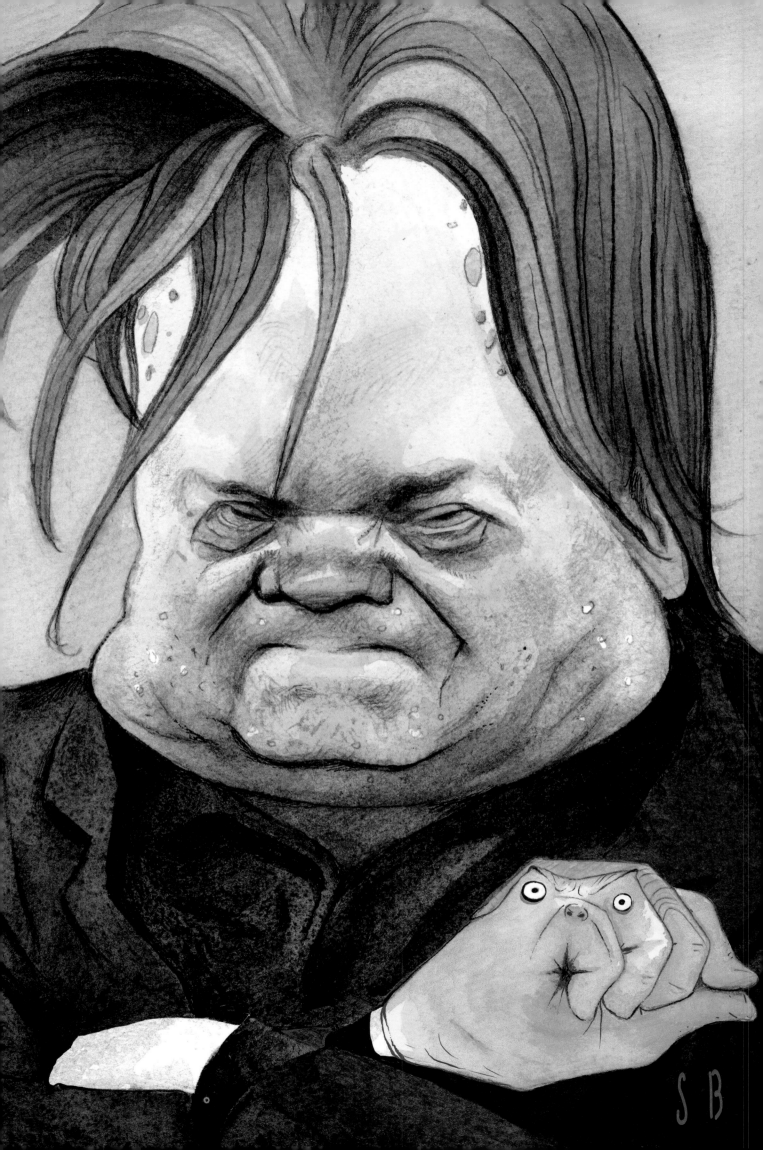

> "The drawing process is actually a way of depicting insight in visualized code. It's kind of an infographic about a face."

for John Hopkins University

STEVE BRODNER

WWW.STEVEBRODNER.COM · @sbrodner

Since the late 1970s, Steve Brodner has been keeping the US political establishment in check through his satirical visual commentary. Coming from a long-standing tradition of political caricature, Brodner possesses the deft ability to elicit a response with his informed brand of art journalism. Born in 1954 in Brooklyn, he won the 1974 Population Institute Cartoon Contest—receiving the award from his idol, Al Hirschfield. Upon graduating with a BFA from the Cooper Union in 1976, his first job was as editorial cartoonist for the *Hudson Dispatch* in Union City, New Jersey. His talents were quickly noticed, and commissions followed for *The New York Times Book Review*. In the early 1980s, he began contributing "Ars Politica," a regular monthly feature in *Harper's Magazine*. As the decade progressed, most of the nation's leading editorials were clamoring to print his cutting visual essays, from *Esquire*, *National Lampoon* and *Playboy*, to *Sports Illustrated* and *Spy*. Throughout his career, Brodner has covered numerous campaigns and national political

Schon seit den späten 1970er-Jahren hält Steve Brodner das politische Establishment der USA mit seinen satirischen visuellen Kommentaren in Schach. Brodner, der sich in eine lange amerikanische Tradition der politischen Karikatur einreiht, verfügt über die große Fähigkeit, mit seinem geistreichen Kunstjournalismus Reaktionen zu erzwingen. Er wurde 1954 in Brooklyn geboren, gewann 1974 den Cartoon Contest des Population Institute – und nahm den Preis von seinem Idol Al Hirschfeld entgegen. Nach seinem Bachelorabschluss im Jahr 1976 an der Cooper Union war sein erster Job der des redaktionellen Karikaturisten für den *Hudson Dispatch* in Union City, New Jersey. Sein Talent blieb nicht lange unbemerkt und es folgten bald Aufträge für die *New York Times Book Review*. In den frühen 1980er-Jahren begann er mit „Ars Politica", einem regelmäßig erscheinenden monatlichen Beitrag im *Harper's Magazine*. Im Laufe des Jahrzehnts wollten die meisten der führenden Redaktionen seine bissigen visuellen

Depuis la fin des années 1970, Steve Brodner applique son talent à l'establishment politique américain à travers ses illustrations satiriques. Se livrant depuis longtemps à la caricature politique, Brodner a le don de susciter des réactions grâce à sa maîtrise du journalisme créatif. Né en 1954 à Brooklyn, il a remporté en 1974 le concours de dessins humoristiques du Population Institute et reçu ce prix de la main de son idole, Al Hirschfield. Après avoir obtenu une licence à la Cooper Union en 1976, il a décroché son premier travail comme dessinateur humoristique au *Hudson Dispatch*, à Union City, dans le New Jersey. Très vite, son talent a été remarqué et des commandes sont arrivées pour *The New York Times Book Review*. Au début des années 1980, il a débuté sa collaboration pour « Ars Politica », une rubrique mensuelle qui paraissait dans *Harper's Magazine*. Au cours de cette décennie, la plupart des principaux éditorialistes d'Amérique se battaient pour publier ses essais visuels acerbes, de *Esquire*,

conventions, from the Reagan era through to posting art live on social media during the Trump–Clinton race in 2016. Constantly broadening his platform, he has lectured widely, produced movie caricatures for *Rolling Stone*, poster art for Warren Beatty, and backdrop murals for Alec Baldwin, as well as making several guest appearances on national television. His prolific output was condensed into his book *Freedom Fries* (2004). Among his many accolades, Brodner's 2008 exhibition *Raw Nerve* was the first retrospective by a living illustrator to be presented at the Norman Rockwell Museum in Stockbridge, Massachusetts.

Erzählungen drucken, von *Esquire, National Lampoon* und *Playboy* bis zu *Sports Illustrated* und *Spy*. In seiner Karriere hat Brodner mit seinen Arbeiten zahlreiche Kampagnen und US-Parteitage begleitet und kommentiert, von der Reagan-Ära bis zur Liveübertragung seiner Kunst in den sozialen Medien während des Trump-Clinton-Wahlkampfs 2016. Seine Bühne ständig erweiternd, hat er viele Vorträge gehalten, produzierte Filmkarikaturen für den *Rolling Stone*, Poster-Art für Warren Beatty, Wandgemälde als Filmkulissen für Alec Baldwin und hatte außerdem mehrere Gastauftritte im US-Fernsehen. Zeugnis seines höchst produktiven Schaffens ist auch sein 2004 erschienenes Buch *Freedom Fries*. Zu Brodners zahlreichen Auszeichnungen gehört seine Ausstellung *Raw Nerve* im Jahr 2008, denn sie war die erste Retrospektive eines lebenden Illustrators im Norman Rockwell Museum in Stockbridge (Massachusetts).

National Lampoon et *Playboy* à *Sports Illustrated* et *Spy*. Au fil de sa carrière, Brodner a participé à de nombreuses campagnes et conventions politiques à travers les États-Unis, de l'ère Reagan à la publication en direct de créations sur les réseaux sociaux pendant la course à la présidentielle de 2016 entre Trump et Clinton. Ne cessant d'étendre ses activités, il a donné d'innombrables conférences, produit des caricatures de films pour *Rolling Stone*, des affiches pour Warren Beatty et des toiles de fond pour Alec Baldwin, sans compter plusieurs apparitions comme « guest star » à la télévision américaine. L'ouvrage *Freedom Fries* (2004) résume son travail prolifique. Entre autres reconnaissances, son exposition en 2008 intitulée « Raw Nerve » a été la première rétrospective par un illustrateur en vie à être présentée au Norman Rockwell Museum à Stockbridge, dans le Massachusetts.

STEVE BRODNER

Worlds Collide, 2017
Village Voice, newspaper; hand
drawing, watercolor, digital

opposite
Buffoon Tycoon Baboon, 2018
The Nation, online magazine;
hand drawing, watercolor

p. 94
Talk to the Hand, 2017
The American Bystander, magazine;
hand drawing, watercolor

Court of Donald I, 2017
Los Angeles Times, newspaper;
hand drawing, watercolor

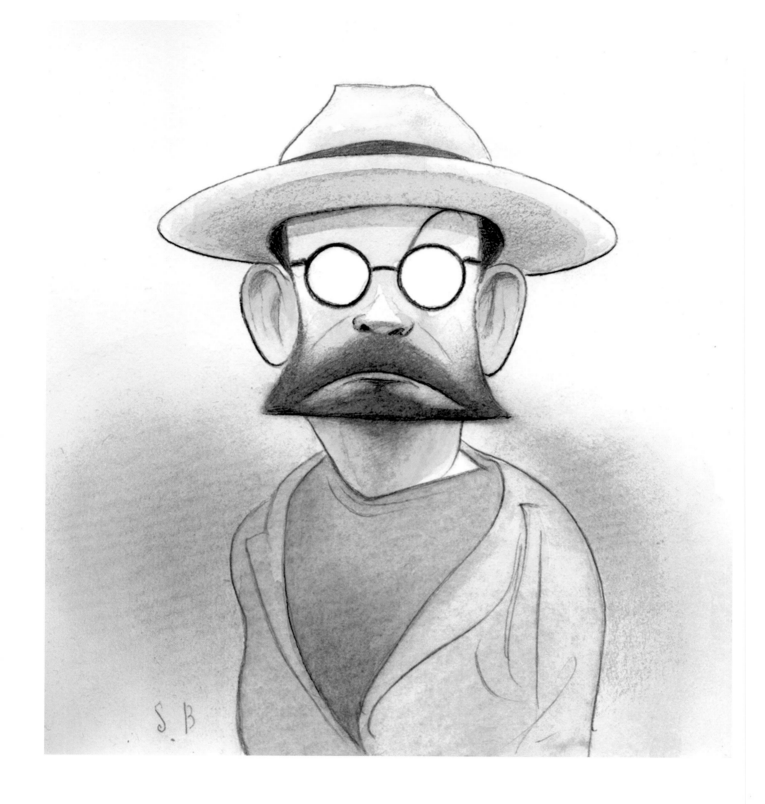

Barry, 2018
Riverhead, by Barry Blitt, book;
hand drawing, watercolor, digital

opposite top
Bridging the Divide, 2016
The Nation, 150th anniversary issue;
hand drawing, watercolor, digital

opposite bottom
Cosby, 2017
GQ magazine; hand drawing,
watercolor, digital

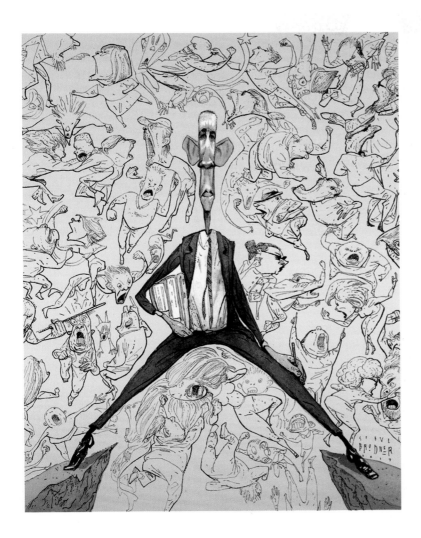

Selected Exhibitions: 2018, *Art as Witness*, group show, School of Visual Arts, New York · 2018, *American Illustration 38*, group show, New York · 2018, *Society of Illustrators*, group show, New York · 2008, *Artists Against the War*, group show, Society of Illustrators, New York · 2008, *Raw Nerve*, solo show, Norman Rockwell Museum, New York

Selected Publication: 2004, *Freedom Fries*, Fantagraphics Books, USA

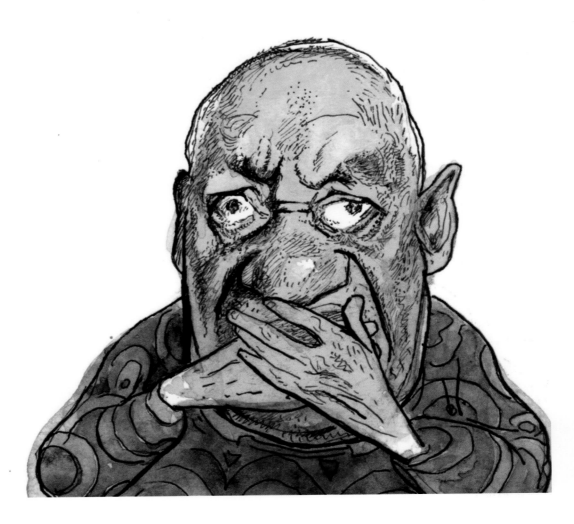

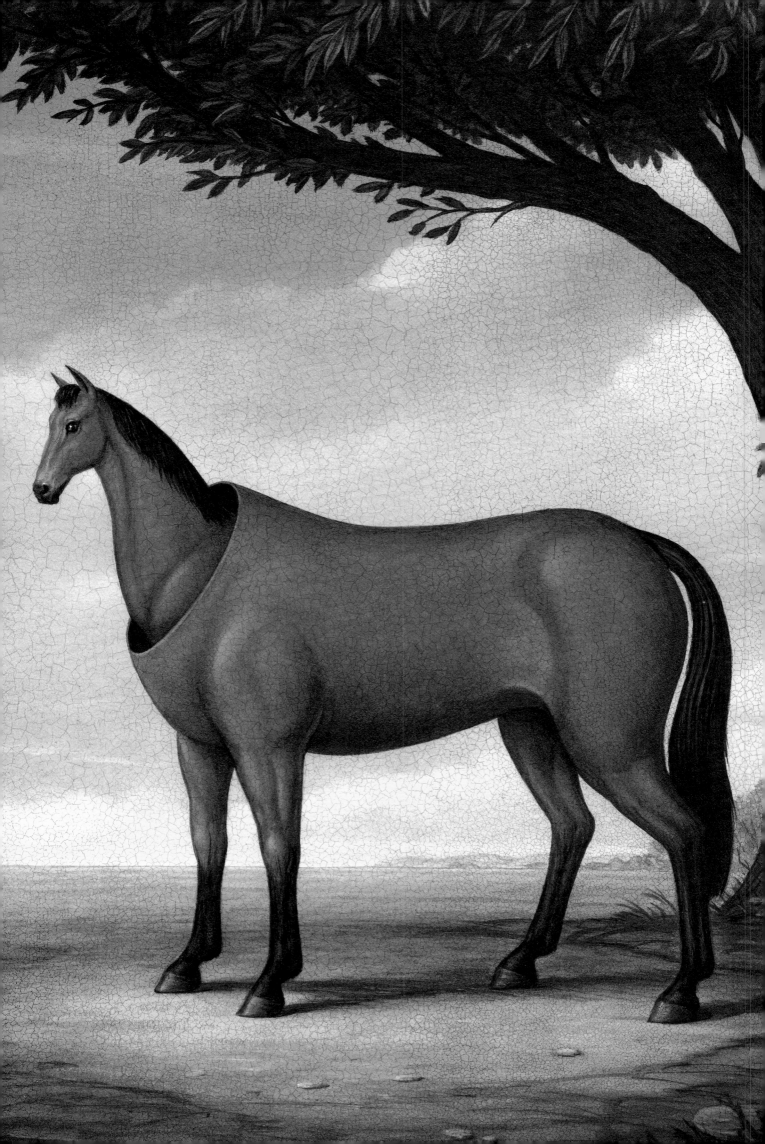

> "For me, ideas come from the most mysterious of places, so my process tends to be nonlinear." *for Wow x Wow*

MARC BURCKHARDT

WWW.MARCBURCKHARDT.COM · @marc_burckhardt

Marc Burckhardt was born in Rüsselsheim, Germany, in 1962, and raised in Waco, Texas. His father was a German academic and his mother a painter from Chicago. Childhood summer vacations in Europe would leave an indelible imprint on his later visual perspective. After studying art history and printmaking at Baylor University, he attended ArtCenter College of Design in Pasadena, graduating with a BFA in 1989. New York beckoned, where he started out as a freelancer, later also teaching at the School of Visual Arts. Imbued with symbolism from myths and fables to religious iconography, Burkhardt's take on the modern world through an art-historical lens offers viewers a fresh perspective. References to the Flemish Masters and English painters of the 18th century abound in his oeuvre, whilst elements of Americana and Mexican folklore emerge from his Texan milieu, resulting in a wonderful interplay of cultural streams. With studios in Austin, Texas and Bremen, Germany, Burckhardt travels back and forth frequently, dividing his time between

Marc Burckhardt wurde 1962 in Rüsselsheim geboren und wuchs in Waco, Texas auf. Sein Vater war ein deutscher Akademiker, seine Mutter eine Malerin aus Chicago. Die Sommerferien seiner Kindheit verbrachte er in Europa, und dies sollte seine spätere visuelle Perspektive unauslöschlich prägen. Nach dem Studium der Kunstgeschichte und der Druckgrafik an der Baylor University erhielt er 1989 am ArtCenter College of Design in Pasadena seinen Bachelor. Anschließend zog es ihn nach New York, wo er zunächst als Freiberufler arbeitete und später auch an der School of Visual Arts lehrte. Die in seinem Werk verwendete Symbolik hat ihre Wurzeln in Mythen und Fabeln sowie in der religiösen Ikonografie. Burkhardts Blick auf die moderne Welt durch eine kunsthistorische Linse eröffnet dem Betrachter eine frische Perspektive. Bezüge zu den flämischen Meistern und zu den englischen Malern des 18. Jahrhunderts sind in seinem Schaffen ebenso reichlich vorhanden wie Elemente der amerikanischen und

Marc Burckhardt est né en 1962 à Rüsselsheim, en Allemagne, mais il a grandi à Waco, au Texas. Fils d'un professeur universitaire allemand et d'une peintre originaire de Chicago, il a passé en Europe les étés de son enfance, qui ont laissé une marque indélébile sur sa perspective visuelle postérieure. Après des études d'histoire de l'art et de gravure à l'université Baylor, il s'est inscrit à l'Art Center College of Design à Pasadena, où il a obtenu une licence en 1989. Parti à New York, il s'est lancé à son compte, puis a aussi donné des cours à la School of Visual Arts. Imprégnée du symbolisme des mythes, des fables et de l'iconographie religieuse, la vision que Burkhardt transmet du monde moderne à travers un filtre artistique et historique apporte au public un point de vue original. Son œuvre est truffée de références aux maîtres flamands et à la peinture anglaise du XVIIIᵉ siècle, et s'y glissent également des éléments du folklore de la culture des États-Unis et du Mexique émanant de ses origines texanes, d'où une

fine art (his work is part of several notable collections) and commercial illustration. With a client list that scrolls from *Time* magazine and *Rolling Stone* to Sony Music and Pentagram, his arresting imagery has gained him worldwide attention and a slew of awards, including the 2011 Society of Illustrators Hamilton King Award. Burckhardt illustrated *The Legend: Johnny Cash*, which won the 2006 Grammy for Best Limited Edition Box Set Packaging. The singer also commissioned him to paint a portrait of his late wife, June Carter. Burckhardt is a former president of the Icon Illustration Conference.

mexikanischen Folklore. So entsteht ein wunderbares Zusammenspiel kultureller Strömungen. In seinen Studios in Austin und Bremen teilt er seine Zeit zwischen bildender Kunst (seine Arbeit ist Teil einiger bemerkenswerter Sammlungen) und kommerzieller Illustration auf. Zu seinen zahlreichen Kunden zählen das *Time Magazine*, *Rolling Stone*, Sony Music und Pentagram. Seine faszinierenden Bilder haben ihm weltweite Aufmerksamkeit und eine Menge Preise eingebracht, zum Beispiel 2011 die Auszeichnung der Society of Illustrators, den Hamilton King Award. Für seine Illustration für die CD-Box von *The Legend: Johnny Cash* erhielt er 2006 den Grammy für das „Best Limited Edition Box Set Packaging". Der Sänger beauftragte ihn auch mit einem Porträt seiner verstorbenen Frau June Carter. Burckhardt ist ehemaliger Präsident der Icon Illustration Conference.

formidable interaction de courants culturels. Propriétaire de studios à Austin et à Bremen, Burckhardt voyage souvent entre les deux destinations et répartit son temps entre les arts plastiques (son travail figurant dans plusieurs grandes collections) et l'illustration commerciale. Sa liste de clients va des magazines *Time* et *Rolling Stone* à Sony Music et Pentagram, et son imagerie saisissante lui a valu une reconnaissance mondiale et une foule de récompenses, dont en 2011 le prix Hamilton King de la Society of Illustrators. Burckhardt a illustré *The Legend: Johnny Cash,* qui a remporté en 2006 le Grammy Award du meilleur coffret ou édition spéciale limitée. Le chanteur lui a également demandé de peindre un portrait de sa défunte épouse, June Carter. Burckhardt a été président d'Icon – The Illustration Conference.

MARC BURCKHARDT

Archbishop Richard
Benson, 2016
Atlantic Monthly, magazine;
acrylic and oil on panel;
art direction: Paul Spella

right
Ananke, 2017
Copro Gallery, *Blab!*, group
show; acrylic and oil on panel

opposite
Literary Classics, 2016
Denison magazine, EmDash
Design; acrylic and oil on panel;
art direction: Erin Mayes

p.102
Shrinking Animals, 2018
Scientific American, magazine;
acrylic and oil on panel;
art direction: Jason Mischka

The Vision, 2016
Paul Roosen Contemporary,
Fault Lines, duo show;
acrylic and oil on paper
mounted on wood

MARC BURCKHARDT

Gucci Gorilla, 2018
Gucci, advertising;
acrylic and oil on panel;
creative direction: Alberto Russo

opposite
Three Fates, 2016
Gallery Shoal Creek,
Allegorical Narratives, solo show;
acrylic and oil on wood

MARC BURCKHARDT

Selected Exhibitions: 2017, *Ornithology*, solo show, Paul Roosen Contemporary, Hamburg · 2016, *Allegorical Narratives*, solo show, Gallery Shoall Creek, Austin · 2016, *MenschTierWir*, group show, Affenfaust Gallerie, Hamburg · 2014, *Mythmaker*, solo show, Mindy Solomon Gallery, Miami · 2012, *Cathedral*, Silas Marder Gallery, Bridgehampton, New York

Selected Publications: 2017, *Hey! Modern Pop & Culture*, 619 Publcations, France · 2017, *The Illustrated Man*, Folio Society, USA · 2016, *Dante's Inferno*, Easton Press, USA · 2016, *Virginia Quarterly Review*, National Journal of Literature, USA · 2016, *Variations on a Rectangle*, University of Texas, USA

"Earthy and folk-inspired, my work also draws on fantastical elements and wild imagination."

MARGAUX CARPENTIER

WWW.MARGAUXCARPENTIER.COM · @margauxcarpe

Margaux Carpentier's alluring images are characterized by light, color, and pattern. Drawing inspiration from urban and natural environments she creates vibrant works in various scales—from paintings and screenprints to wall-size murals. Tinged with the exotic, her style hints at the Post-Impressionism of Henri Rousseau and the cut-outs of Matisse, mixed with symbolism from world folklore. Born in 1987 in the town of Suresnes, on the outskirts of Paris, she studied in the capital for one year then transferred to the graphic communication degree course at the University of Creative Arts in Surrey, where she graduated in 2010. Together with fellow alumni Lana Hughes and Rory Elphick she formed the creative trio Animaux Circus, noted for producing a broad-ranging portfolio of corporate and educational projects. The group, who have a penchant for wildlife and fantasy scapes, have received several commissions throughout London, from designing a mural at Waterloo Station for Southbank London to conducting

Die faszinierenden Bilder von Margaux Carpentier zeichnen sich durch Licht, Farbe und Muster aus. Sie zieht Inspiration aus urbanen und natürlichen Umgebungen und schafft lebendige Werke in verschiedenen Formaten – von Gemälden und Siebdrucken bis zu großen Wandbildern. Durchzogen vom Exotischen, deutet ihr Stil auf den Postimpressionismus von Henri Rousseau und Scherenschnitte von Matisse hin, vermischt mit der Symbolik aus der Weltfolklore. Geboren wurde Carpentier 1987 in Suresnes am Stadtrand von Paris. Sie studierte ein Jahr lang in der Hauptstadt und wechselte dann zum Studium der Grafikkommunikation an die University of Creative Arts in Surrey, an der sie 2010 ihren Abschluss machte. Zusammen mit den ehemaligen Mitstudenten Lana Hughes und Rory Elphick bildete sie das Kreativtrio Animaux Circus, das für die Schaffung eines breit gefächerten Portfolios von Unternehmens- und Bildungsprojekten bekannt wurde. Die Gruppe, die eine Vorliebe für wildlebende Tiere

Les images aguichantes de Margaux Carpentier se caractérisent par la lumière, la couleur et les motifs qu'elles affichent. Elle tire son inspiration des environnements urbains et de la nature et de là, elle crée des œuvres pleines de vie et de toutes tailles : tableaux, sérigraphies, mais aussi peintures murales. Doté d'une touche exotique, son style évoque le post-impressionnisme d'Henri Rousseau et les découpages de Matisse, qu'elle assortit d'un symbolisme issu du folklore mondial. Née en 1987 à Suresnes, elle a étudié pendant un an à Paris avant de faire une licence en communication graphique à l'université des arts créatifs à Surrey, qu'elle a obtenue en 2010. Avec deux autres étudiants, Lana Hughes et Rory Elphick, elle a fondé le studio de création Animaux Circus, remarqué pour son vaste portfolio de projets corporatifs et éducatifs. Avec un penchant pour les animaux sauvages et les paysages fantastiques, le collectif a été engagé pour plusieurs événements à Londres, de l'élaboration d'une peinture murale

creative workshops at Tate Britain and the Victoria and Albert Museum. Carpentier also works as an independent freelancer from her studio in Stoke Newington, North London. Her 2016 solo show *In the Heart of a Whale* at NOW Gallery, part of the fifth East London Comics and Arts Festival, showcased her ability to create a fresh narrative by illustrating on different surfaces, such as 3D sculptures and hanging mobiles.

und Fantasy-Landschaften hegt, erhielt in London zahlreiche Aufträge, die von der Gestaltung eines Wandbildes in South Bank an der Waterloo Station bis zur Durchführung kreativer Workshops in der Tate Britain und dem Victoria and Albert Museum reichen. Carpentier arbeitet außerdem als unabhängige Freiberuflerin in ihrem Studio in Stoke Newington im Londoner Norden. In ihrer Soloshow *In the Heart of a Whale* (Im Herzen eines Wals) in der NOW Gallery, die 2016 im Rahmen des fünften East London Comics and Arts Festival gezeigt wurde, bewies sie ihre Fähigkeit, eine innovative Erzählweise zu schaffen, durch Illustrationen auf verschiedenen Oberflächen wie 3-D-Skulpturen und hängenden Mobiles.

dans la gare de Waterloo sur la rive sud de la capitale à l'organisation d'ateliers créatifs à la Tate Britain et au Victoria and Albert Museum. Carpentier travaille également à son compte dans son studio à Stoke Newington, dans le nord de Londres. En 2016, son exposition en solo intitulée « In the Heart of a Whale » à la NOW Gallery, dans le cadre du cinquième East London Comics and Arts Festival, a démontré sa capacité à créer une narration originale à l'aide d'illustrations sur diverses surfaces, comme des sculptures en 3D et des mobiles suspendus.

MARGAUX CARPENTIER

Farès, 2018
Painting for restaurant;
gouache on paper

opposite
Le voyage (Stolen Dream), 2018
Personal work; screen print

p. 110
Incantation, 2018
Personal work; screen print

Love at the Time of Cholera, 2017
Blisters, the Paperback Show,
Print Club, London; screen print

opposite top
Mandril, 2018
Djeco, Flexanimals
Kaleidocycles; digital

opposite middle and bottom
Girlfriends and Messy Hair, 2018
BBC News, "Festival Love
Stories" online article; digital

MARGAUX CARPENTIER

Selected Exhibitions: 2018, *La vie secrete des etres*, solo show, Print Van Gallery, Paris · 2017, *Blisters*, group show, MC Motors, London · 2016, *Jungle Book Club*, group show, The Book Club, London · 2016, *In the Heart of the Whale*, solo show, Now Gallery, London · 2015, *Art against Knives*, group show, Jealous Gallery, London

> "What separates children from animals or plants is as meaningful as what unites them."

HSIAO-RON CHENG

WWW.HSIAORONCHENG.COM · @hsiaoroncheng

The strange visual world of Taiwanese digital artist-illustrator Hsiao-Ron Cheng reveals a complex interplay of emotion and fantasy, where realist human subjects are juxtaposed or sometimes obscured by flora and fauna in surreal dreamscapes. She describes her work as alluding to "the deformation that physically separates children from plants and animals," with her aim being to convey "different kinds of the fragile and oppressive anima in life." A lifelong Taipei native, Cheng was born in 1986, and gained her BFA from Taiwan University of Art in 2010. After a brief stint as a concept artist for an animation studio, she launched herself as a freelancer, gaining almost immediate attention through her nomination for the 2012 Young Illustrators Award. Cheng's work has since featured in *Communication Arts*, *Hi-Fructose*, *Interview*, and *Juxtapoz* magazine. Her work has also been exhibited in Beijing, Berlin, Chania (Greece), Las Vegas, New York, and Vancouver. Working exclusively with digital tools, Cheng invites the viewer

Die merkwürdige visuelle Welt der taiwanesischen Künstler-Illustratorin Hsiao-Ron Cheng offenbart ein komplexes Zusammenspiel von Emotion und Fantasie, wobei realistische menschliche Gestalten in unwirklichen Traumlandschaften nebeneinanderstehen oder manchmal von Flora und Fauna verdunkelt werden. Sie beschreibt ihre Arbeit als Anspielung auf „die Deformation, die Kinder physisch von Pflanzen und Tieren trennt", mit dem Ziel, „verschiedene Arten fragiler und unterdrückender Seelen" zu zeigen. Cheng wurde 1986 in Taipeh geboren und erhielt 2010 ihren Bachelor von der Taiwanesischen Universität der Künste. Nach einer kurzen Zeit als Konzeptkünstlerin für ein Animationsstudio begann sie als Freiberuflerin zu arbeiten, und man wurde auf sie aufmerksam, als sie für den Young Illustrators Award 2012 nominiert wurde. Die Arbeiten von Cheng waren seitdem in *Communication Arts*, *Hi-Fructose*, *Interview* und dem *Juxtapoz Magazin* zu sehen. Ihre Werke wurden auch in Peking, Berlin, Chania (Griechenland),

L'étrange monde visuel de l'artiste numérique et illustratrice taïwanaise Hsiao-Ron Cheng révèle un jeu complexe entre émotions et fantastique, où des sujets humains réalistes sont juxtaposés ou parfois occultés par la flore et la faune dans des paysages oniriques irréels. Elle considère son travail comme une allusion à « la déformation qui sépare physiquement les enfants des plantes et des animaux », son objectif étant de représenter « différents types d'âmes fragiles et oppressives qui existent dans la vie ». Née en 1986 à Taipei, Cheng a obtenu une licence à l'université de Taïwan en 2010. Après une courte période comme artiste conceptuelle pour un studio d'animation, elle s'est installée à son compte et a été presque aussitôt remarquée grâce à sa nomination en 2012 pour le Young Illustrators Award. Le travail de Cheng est depuis lors paru dans *Communication Arts*, *Hi-Fructose*, *Interview* et *Juxtapoz*, et elle a exposé à Pékin, Berlin, La Canée, Las Vegas, New York et Vancouver.

to enter her subconscious realm of muted color. Her projects include jacket artwork commissioned by Pentagram for Penguin Books, interior murals for Sydney-based artisanal chocolatier Zokoko, and album covers for Canadian singer-songwriter Cœur de pirate, and actor-singer and YouTube star Troye Sivan. In 2016, Cheng was invited by Paramount Pictures to the New Zealand set of the movie *Ghost In The Shell*, for which she contributed to the official social media promotional campaign.

Las Vegas, New York und Vancouver ausgestellt. Cheng arbeitet ausschließlich mit digitalen Werkzeugen und lädt den Betrachter dazu ein, in ihr Unterbewusstsein aus gedeckten Farben einzutreten. Zu ihren Projekten zählen zum Beispiel Umschlaggestaltungen für Penguin Books (beauftragt durch Pentagram), Innenwandbilder für die Schokoladenmanufaktur Zokoko aus Sydney und Albumcover für den kanadischen Singer-Songwriter Cœur de Pirate sowie Schauspieler-Sänger und YouTube-Star Troye Sivan. Im Jahr 2016 wurde Cheng von Paramount Pictures nach Neuseeland eingeladen, um am Set für den Anime-Film *Ghost In The Shell* zu arbeiten, wo sie zur offiziellen Werbekampagne in den sozialen Medien beitrug.

Travaillant exclusivement avec des outils numériques, Cheng invite le public à pénétrer dans son subconscient aux couleurs pâles. Ses projets incluent l'illustration de jaquettes commandées par Pentagram pour Penguin Books, des fresques pour le chocolatier artisanal Zokoko installé à Sydney, ainsi que des pochettes d'albums pour le chanteur et compositeur canadien Cœur de pirate et l'acteur, interprète et star sur YouTube Troye Sivan. En 2016, Cheng a été invitée par Paramount Pictures au tournage en Nouvelle-Zélande du film *Ghost In The Shell*, pour lequel elle a participé à la campagne promotionnelle officielle sur les réseaux sociaux.

Ghost in the Shell, 2017
Paramount Pictures; digital

opposite
Troye, 2018
EMI; digital

p. 116
Untitled, 2016
Personal work; digital

Selected Exhibitions: 2014, *Castles in the Air*, group show, Mare Gallery, Chaniá, Crete · 2014, *Show #3*, group show, Spoke Art Gallery, San Francisco · 2013, *Illustrative*, group show, Direktorenhaus, Berlin · 2013, *Kindred*, group show, Bold Hype Gallery, New York · 2013, *Image Makers*, group show, O Gallery, Beijing

Selected Publications: 2012, *Juxtapoz New Contemporary*, book, USA · 2012, *Joia Magazine*, vol.25, Chile · 2012, *Hi-Fructose Magazine*, #24, USA ·

HSIAO-RON CHENG

Untitled, 2015
Personal work; digital

opposite
Untitled, 2016
Personal work; digital

> "Generalists have more freedom, which helps us stay enthusiastic. My lack of specialization has allowed me to explore many different ways to solve problems."
>
> for *Design Boom*

SEYMOUR CHWAST

WWW.PUSHPININC.COM · @seymourchwast

For six decades, Seymour Chwast has been reinventing the wheel of graphic illustration in an oeuvre that has left an indelible imprint on American visual culture. Born in the Bronx in 1931, he attended the Cooper Union, receiving his BFA in 1951. Together with Milton Glaser, Reynold Ruffins, and Edward Sorel, he founded the legendary Push Pin Studios in 1954. With his unique brand of absurdist wit, Chwast was instrumental in transforming the commercial art land-scape in the 1950s and 1960s. He sup-planted the nostalgic realism of Norman Rockwell, reviving period styles beyond mere pastiche—taking socio-historical and cultural referents and graphically sculpting them in a way that captured the aesthetics of the zeitgeist—all the while laying conceptual foundations for successive generations of visual commu-nicators. From expressionist woodcuts to bold flat colors, Chwast has experi-mented with the complete gamut. An ob-sessive innovator, he created typefaces, including Artone (1964) and Blimp (1970),

Seit sechs Jahrzehnten erfindet Seymour Chwast das Rad der grafischen Illustration immer wieder neu in einem Œuvre, das die amerikanische visuelle Kultur nachhaltig geprägt hat. 1931 in der Bronx geboren, besuchte er die Cooper Union und erhielt 1951 seinen Bachelor. Zusammen mit Milton Glaser, Reynold Ruffins und Edward Sorel gründete er 1954 die legendären Push Pin Studios. Mit seinem einzigartigen absurden Witz war Chwast in den 1950er- und 1960er-Jahren maßgeblich an der Transforma-tion der kommerziellen Kunstlandschaft beteiligt. Er verdrängte den nostalgi-schen Realismus von Norman Rockwell und belebte Stilformen jenseits von bloßer Pastiche – indem er sozialge-schichtliche und kulturelle Bezüge auf-nahm und sie grafisch auf eine Weise formte, die die Ästhetik des Zeitgeists widerspiegelte – und legte gleichzeitig die konzeptionellen Grundlagen für die folgenden Generationen visueller Kommunikatoren. Von expressionisti-schen Holzschnitten bis hin zu mutigen

Voilà six décennies que Seymour Chwast réinvente la roue de l'illustration gra-phique avec une œuvre dont l'empreinte sur la culture visuelle américaine est indélébile. Né dans le Bronx en 1931, il a étudié à la Cooper Union où il a obtenu une licence en 1951. Aux côtés de Milton Glaser, Reynold Ruffins et Edward Sorel, il a fondé en 1954 les légendaires Push Pin Studios. Avec l'approche absurde qui lui est propre, Chwast a grandement contribué à la transformation du pay-sage artistique commercial des années 1950 et 60. Il a supplanté le réalisme nostalgique de Norman Rockwell et remis à la mode des styles dépassant le simple pastiche : pour cela, il s'est servi de références socio-historiques et culturelles et les a modelées graphi-quement de façon à capter l'esthétique de l'air du temps, tout en posant les bases conceptuelles pour les généra-tions postérieures de communicateurs visuels. Qu'il s'agisse de gravures sur bois expressionnistes ou d'aplats vifs, Chwast a tout essayé. Innovateur

and was an early adopter of merchandizing his creations. In 1983, he was inducted to the Art Directors Hall of Fame. Two years later saw the publication of his first monograph, *The Left-Handed Designer*. Chwast's work has appeared in editorials, book covers, record sleeves, packaging, animation, and stage backdrops. His illustrations belong to several major collections. In 2015, the D.B. Dowd Modern Graphic History Library at Washington University acquired a complete collection of Chwast's posters. Among his many accolades are honorary doctorates from Parsons School of Design and Rhode Island School of Design. Chwast lives and works in New York with his wife, the renowned graphic designer Paula Scher.

flächigen Farben hat Chwast mit der gesamten Bandbreite experimentiert. Als obsessiver Erneuerer schuf er Schriften, darunter Artone (1964) und Blimp (1970), und begann früh mit der Vermarktung seiner Kreationen. Im Jahr 1983 wurde er in die Art Directors Hall of Fame aufgenommen. Zwei Jahre später erschien seine erste Monografie *The Left-Handed Designer* (Der linkshändige Designer). Chwasts Arbeiten umfassen redaktionelle Arbeiten, Buchumschläge, Plattenhüllen, Verpackungen, Animationen und Bühnenbilder. Seine Illustrationen sind in mehreren großen Sammlungen zu finden; so erwarb 2015 die D.B. Dowd Modern Graphic History Library an der Washington University eine komplette Sammlung von Chwast-Postern. Zu seinen zahlreichen Auszeichnungen zählen Ehrendoktorwürden der Parsons School of Design und der Rhode Island School of Design. Chwast lebt und arbeitet mit seiner Frau, der bekannten Grafikdesignerin Paula Scher, in New York.

obsessif, il a créé des polices de caractères, dont Artone (1964) et Blimp (1970), et il a été un pionnier dans la commercialisation de ses créations. En 1983, il a été admis à l'Art Directors Hall of Fame ; deux ans plus tard est parue sa première monographie, *The Left-Handed Designer*. Le travail de Chwast a agrémenté éditoriaux, couvertures de livres, pochettes de disques, emballages, animations et décors de scènes, et ses illustrations figurent dans plusieurs grandes collections. En 2015, la D.B. Dowd Modern Graphic History Library de l'université de Washington a acquis une collection complète d'affiches de Chwast. Parmi les nombreuses distinctions qu'il a reçues, il a obtenu un doctorat honoris causa de la Parsons School of Design et de la Rhode Island School of Design. Chwast vit et travaille à New York avec sa femme, la célèbre conceptrice graphique Paula Scher.

SEYMOUR CHWAST

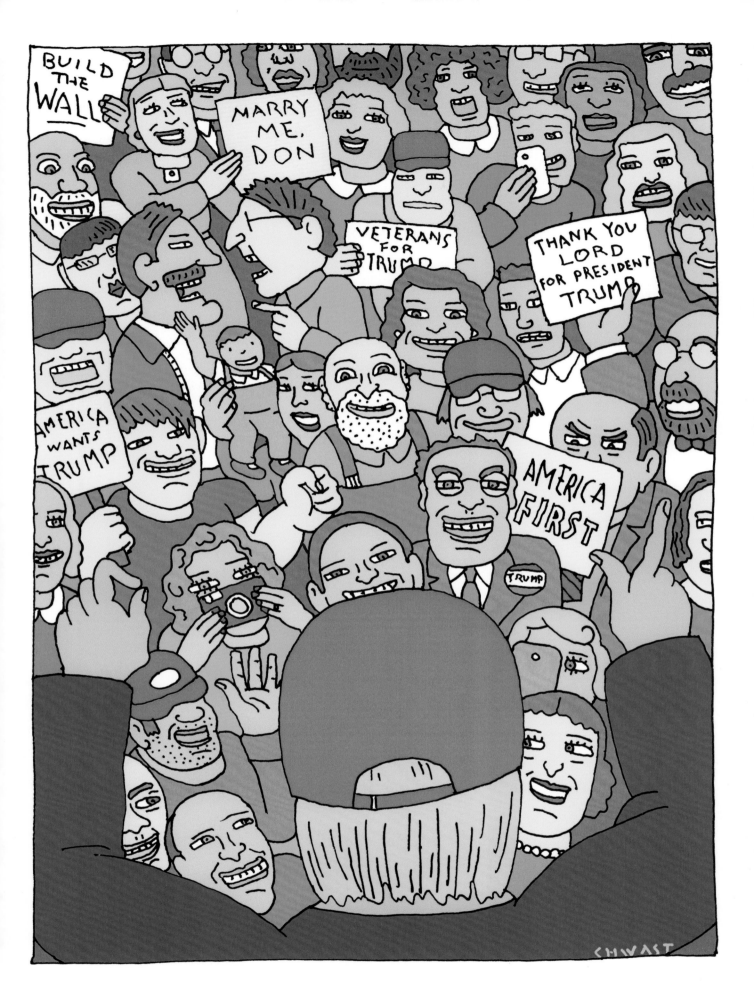

Who Are All These
Trump Supporters?, 2016
The New Yorker, magazine;
ink on paper, digital color

opposite
How Woodpeckers Will
Save Football, 2016
Nautilus, magazine;
ink on paper, digital color

p. 122
Artificial Intelligence, 2017
MIT Technology Review,
drawing and ink on paper,
digital color

Hanukkah, 2015
Tablet, magazine; ink on
paper with digital color

SEYMOUR CHWAST

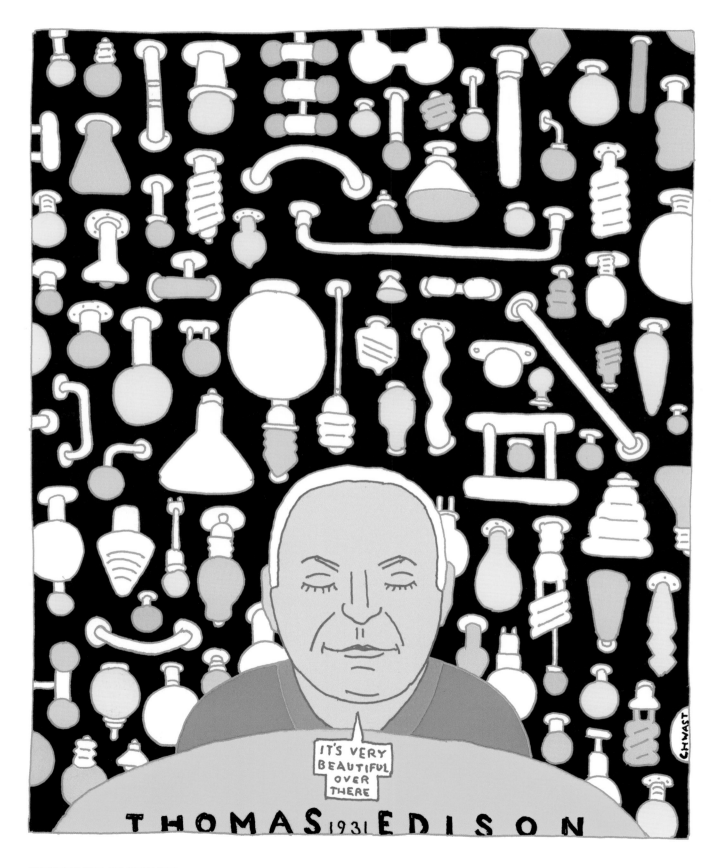

Selected Exhibitions: 2019, solo show, Binghamton University Museum of Art, New York · 2018, solo show, Bienal Internacional del Cartel en México · 2018, *Art as Witness*, group show, School of Visual Arts, New York · 2016, *Poster Power*, solo show, Payne Gallery at Moravian College, Bethlehem · 2016, *All the Wars*, solo show, Society of Illustrators, New York

Selected Publications: 2018, *The Jickle and Other Curious Pets*, Page Publishing, USA · 2017, *At War with War: 5000 Years of Conquests, Invasions, and Terrorist Attacks – An Illustrated Timeline*, Seven Stories Press, USA · 2016, *The Pancake King*, Phyllis La Farge, Princeton Architectural Press, USA · 2015, *Dr. Dolittle*, Creative Company, USA · 2009, *Seymour: The Obsessive Images of Seymour Chwast*, Chronicle Books, USA

The Light Years, 2016
Playwrights Horizons;
ink on paper, digital color

right
Captain America, 2018
Personal work; woodcut

opposite
Famous Last Words, 2017
Print magazine;
ink on paper, digital color

> "I prefer pencil then woodcut then litho. I prefer to draw as if I am painting and cut wood like a drawing. It's elegant and simple." for Parsons School of Design

SUE
COE

WWW.GRAPHICWITNESS.ORG/COE · **@coe_sue**

Sue Coe's Twitter account profile reads: "Vegan Artivist," an apt self-description for the British artist who has devoted her entire career to giving a visual voice to activism. Born in Tamworth, Staffordshire, in 1951, Coe grew up near a farm slaughterhouse, an experience that would later spur her on a personal crusade for social change. Accepted at Chelsea School of Art in London at the age of 16, she received her BA in 1970, then enrolled in the Royal College of Art. After graduating with an MA in Graphic Design, Coe moved to New York, where she lived and worked from 1972 to 2001, before relocating upstate. She draws and makes prints in woodcut and lithograph, with a graphic style that veers from neo-expressionist to realist and harks back to the nightmarish imagery of Hieronymus Bosch, the dystopian terror of Orwell, and the panoramic scale of Sebastião Salgado. Coe's books, comics, and visual essays have spotlighted such highly charged topics as factory farming, meat packing, apartheid, sweat shops, prisons, AIDS, and

Im Twitter-Profil von Sue Coe steht: „Vegan Artivist". Dies ist eine treffende Selbstbeschreibung der britischen Künstlerin, die ihre gesamte Karriere durch ihre visuelle Stimme dem Aktivismus gewidmet hat. Geboren wurde sie 1951 in Tamworth (Staffordshire) und wuchs in der Nähe eines Schlachthofs auf – eine Erfahrung, die sie später zu einem persönlichen Kreuzzug für soziale Veränderungen anspornen sollte. Mit 16 Jahren wurde sie an der Chelsea School of Art in London angenommen und schrieb sich 1970 nach Erhalt ihres Bachelors am Royal College of Art ein. Nach ihrem Masterabschluss in Grafikdesign zog Coe nach New York, wo sie von 1972 bis 2001 lebte und arbeitete, bevor sie sich im Umland niederließ. Sie zeichnet und druckt Holzschnitte und Lithografien in einem grafischen Stil, der vom Neo-Expressionistischen zum Realistischen wechselt, und greift dabei auf die albtraumhaften Bilder von Hieronymus Bosch, den dystopischen Schrecken von Orwell und das

Le profil Twitter de Sue Coe annonce «Vegan Artivist», une auto-description pertinente de cette artiste britannique qui a consacré toute sa carrière à doter l'activisme d'une voix visuelle. Née en 1951 à Tamworth, dans le Staffordshire, Coe a grandi à proximité d'un abattoir, une circonstance qui l'a plus tard portée dans une croisade personnelle pour le changement social. Admise à l'âge de 16 ans au Chelsea College of Art and Design à Londres, elle a décroché une licence en 1970, puis s'est inscrite au Royal College of Art. Une fois diplômée d'une maîtrise en design graphique, Coe s'est installée à New York, où elle a résidé et travaillé de 1972 à 2001 avant de déménager dans le nord de l'État. Elle dessine et réalise des gravures sur bois et des lithographies avec un style graphique allant du néo-expressionnisme au réalisme, pour évoquer l'imagerie cauchemardesque de Jérôme Bosch, l'horreur dystopique d'Orwell et l'échelle panoramique de Sebastião Salgado. Les livres, bandes dessinées et essais

war. Her work has been published in *The Nation*, *Newsweek*, and *Mother Jones*, among countless others. Since the late 1990s, Coe has used her exhibition platforms to raise funds for animal rights organizations. Her work is in several major collections, including Cooper Hewitt, the Museum of Modern Art (MoMA), and the Stedelijk Museum in Amsterdam. In 2013, she was a visiting artist at Parsons School of Design, where she taught about social awareness in art. A full Academician of the National Academy of Design since 1994, Coe has been recognized by several prominent institutions. In 2017, she received a Southern Graphics Council International Lifetime Achievement award in printmaking.

panoramische Ausmaß von Sebastião Salgado zurück. Coes Bücher, Comics und visuelle Essays behandeln so hochaufgeladene Themen wie Massentierhaltung, Fleischverpackung, Apartheid, Ausbeutungsbetriebe, Gefängnisse, AIDS und Krieg. Ihre Arbeit wurde unter anderem in *The Nation*, *Newsweek* und *Mother Jones* veröffentlicht sowie in unzähligen anderen Magazinen. Seit den späten 1990ern nutzt Coe ihre Ausstellungsplattformen, um Geld für Tierrechtsorganisationen zu sammeln. Ihre Arbeiten befinden sich in mehreren großen Sammlungen, darunter Cooper Hewitt, The Museum of Modern Art (MoMA) und das Stedelijk Museum in Amsterdam. Im Jahr 2013 war sie Gastkünstlerin an der Parsons School of Design, wo sie zu sozialem Bewusstsein in der Kunst lehrte. Coe ist seit 1994 Vollmitglied der National Academy of Design und wurde von mehreren renommierten Institutionen gewürdigt. Im Jahr 2017 erhielt sie den Graphics Council International Lifetime Achievement Award für Druckgrafik.

visuels de Coe ont mis en avant des thèmes de fond comme l'élevage industriel, les usines de transformation de la viande, l'apartheid, les ateliers d'exploitation, les prisons, le SIDA et la guerre. Son travail a été publié dans *The Nation*, *Newsweek* et *Mother Jones*, parmi tant d'autres. Depuis la fin des années 1990, Coe se sert de ses plateformes de diffusion pour lever des fonds en faveur d'organisations de défense des animaux. Ses œuvres sont présentes dans plusieurs grandes collections, dont le Cooper-Hewitt, le Museum of Modern Art (MoMA) et le Stedelijk Museum Amsterdam. En 2013, elle a été artiste invitée à la Parsons School of Design, où elle a donné des cours sur la conscience sociale dans l'art. Académicienne à part entière depuis 1994 de la National Academy of Design, Coe a obtenu la reconnaissance de plusieurs institutions de renom. En 2017, elle a reçu le prix Southern Graphics Council International Lifetime Achievement en gravure.

Second Millennium, 1998
courtesy Galerie St. Etienne,
New York

opposite
Faithfull Elephants, 2009
courtesy Galerie St. Etienne,
New York

p. 130
War, 1991
Private collection, courtesy
Galerie St. Etienne, New York

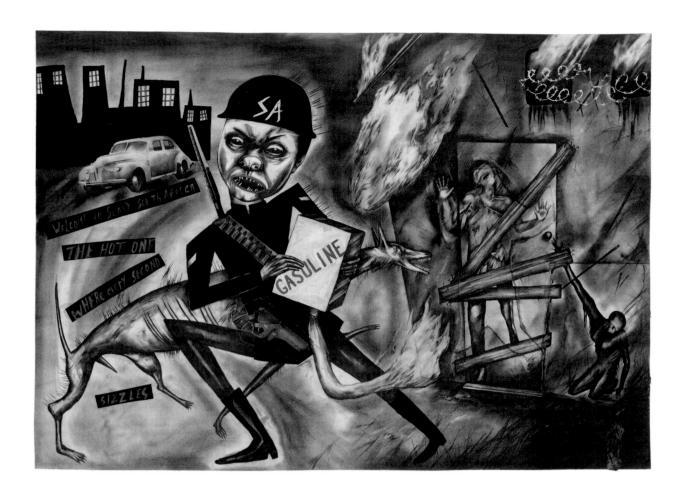

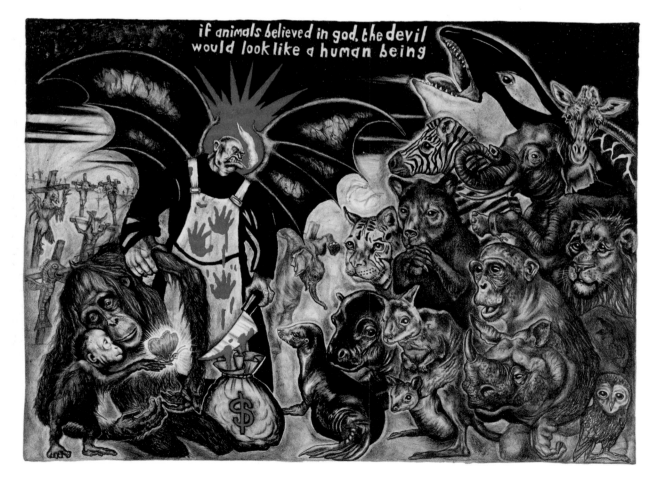

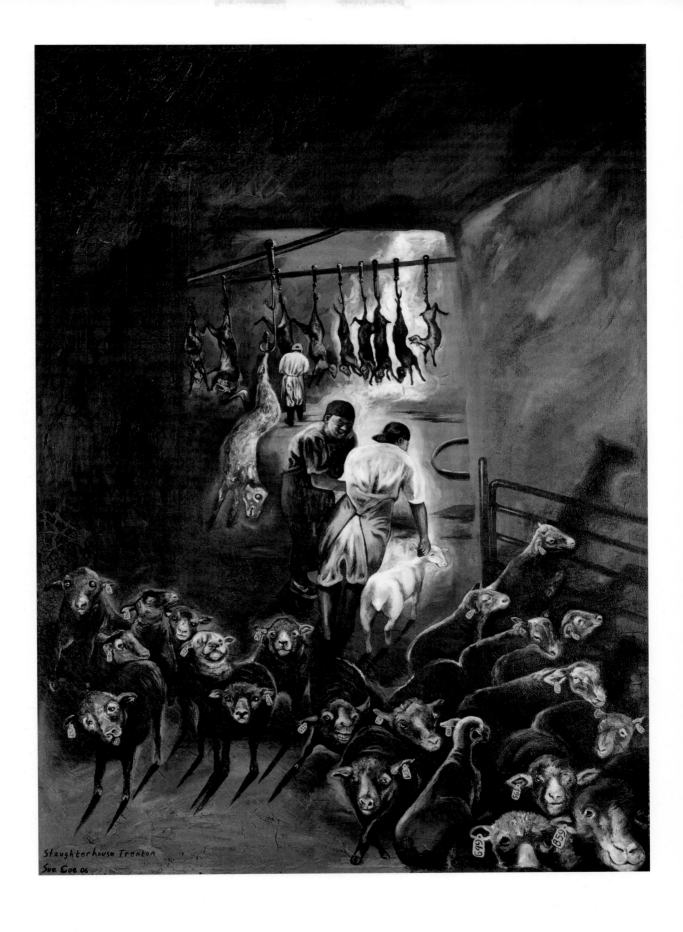

Slaughterhouse Trenton, 2006
courtesy Galerie St. Etienne,
New York

opposite top
Welcome to Sunny South Africa, 1983
courtesy Galerie St. Etienne,
New York

opposite bottom
If Animals Believed in God the Devil
Would Look Like a Human Being, 2018
courtesy Galerie St. Etienne, New York

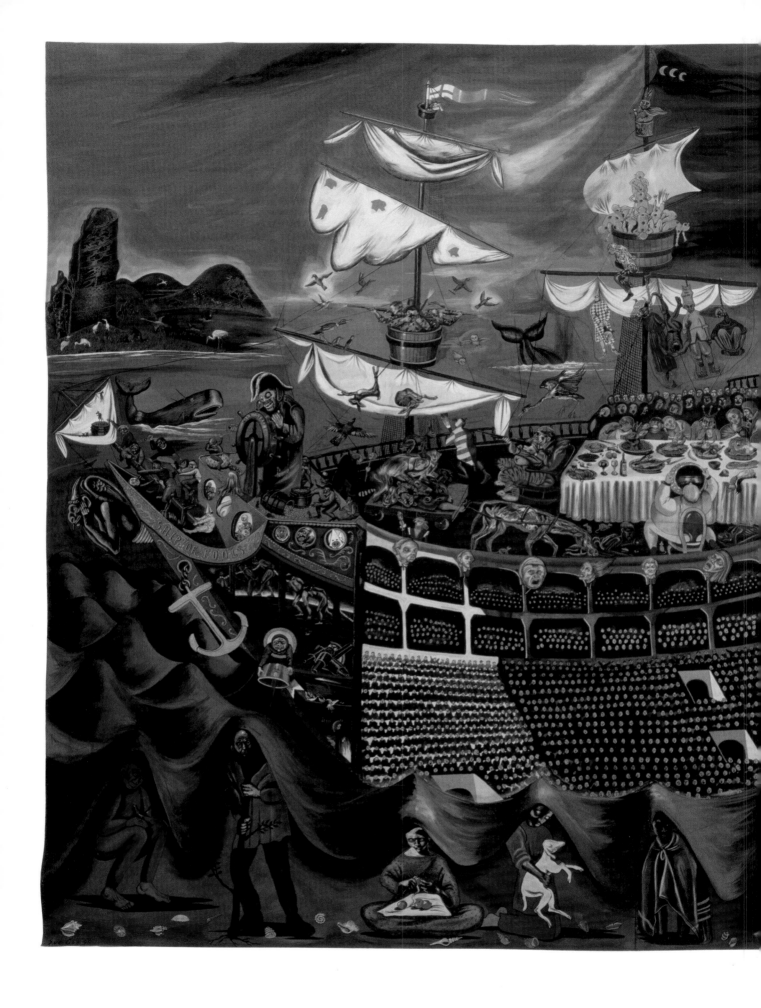

Ship of Fools, 1996
courtesy Galerie St. Etienne, New York

SUE COE

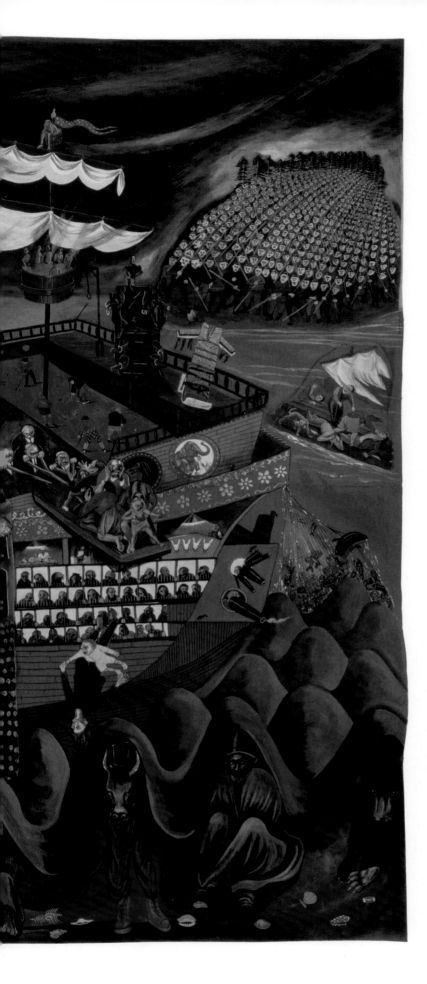

Selected Exhibitions: 2018, *All Good Art is Political: Käthe Kollwitz & Sue Coe*, group show, Galerie St. Etienne, New York · 2018, *Graphic Resistance: Sue Coe*, solo show, MoMA PS1, New York · 1994, *Sue Coe*, solo show, Hirshorn Museum and Sculpture Garden, Washington, D.C. · 1989, *Porkopolis: Animals and Industry*, solo show, Galerie St. Etienne, New York · 1987, *Police State*, solo show, traveling exhibition, USA and Europe

Selected Publications: 2018, *Zooicide*, AK Press, USA · 2017, *The Animals' Vegan Manifesto*, OR Books, United Kingdom · 2012, *Cruel*, OR Books, United Kingdom · 1996, *Dead Meat*, Four Walls Eight Windows, USA · 1992, *X. The Life and Times of Malcolm X*, The New Press, USA

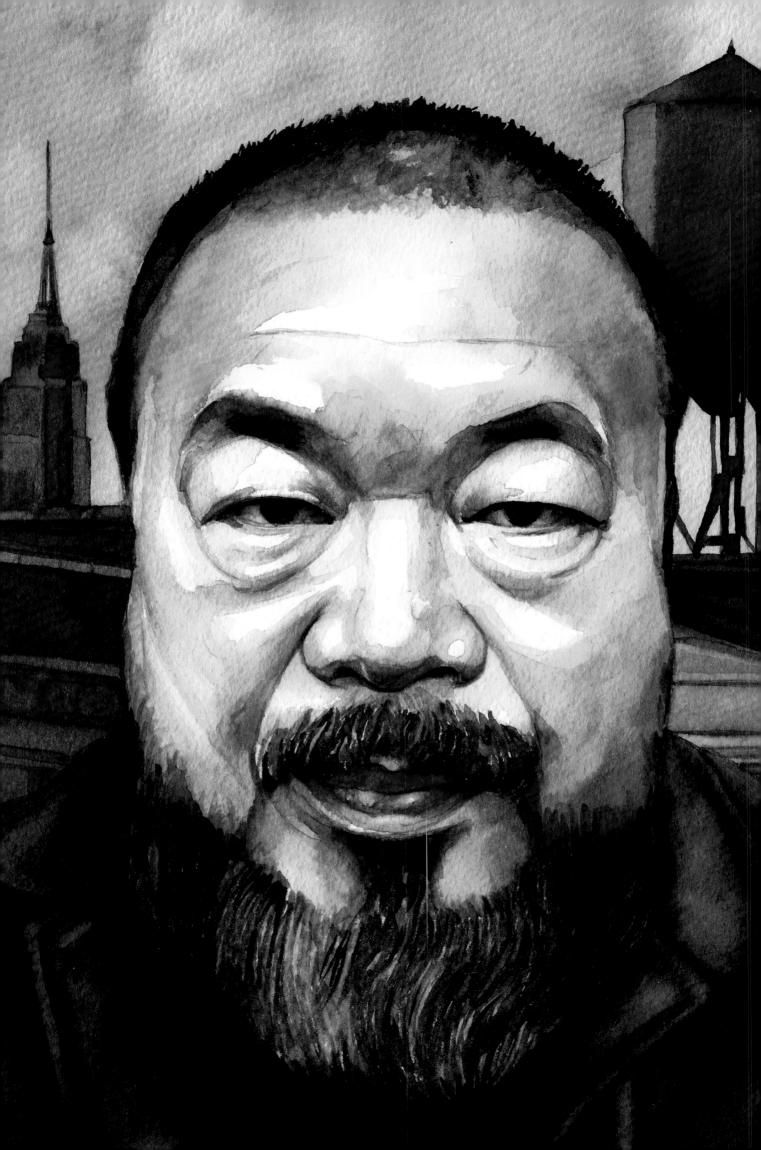

> "I believe in the magic of the painting so when I do a portrait I feel close to the model, even if I don't know him or her."

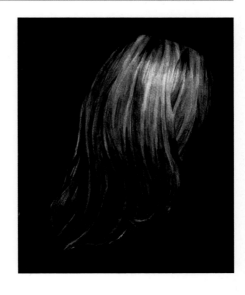

ALEXANDRA COMPAIN-TISSIER

WWW.ALEXANDRACOMPAINTISSIER.COM · @alexandracompaintissier

Alexandra Compain-Tissier is a French illustrator renowned for her work in the fashion, style, music, and publishing arenas. Her personal passion is for the intimacy of books and exhibitions that bring her work in direct contact with the viewer. Born in Versailles in 1971, she dreamt of being a painter from the age of 13. After graduating from the Paris-Cergy National School of Arts with a Higher National Diploma in Plastic Arts in 1995, she spent three years living and working in New York at the turn of the millennium. Upon her return she published her first book, a collection of pencil drawings from photographs called *Dumbo Alex* (2001). A foray into animation resulted in a music video for the band TTC on the Ninja Tune label before she joined American creative agency Art Department. Compain-Tissier approaches her subjects with a warmth and affinity, creating observational studies that range from portraits to still lifes and outdoor environments. As well as having been displayed in exhibitions around the world, her natural,

Alexandra Compain-Tissier ist eine französische Illustratorin, die für ihre Arbeiten in den Bereichen Mode, Stil, Musik und Publishing bekannt wurde. Ihre persönliche Leidenschaft gilt der Intimität von Büchern und Ausstellungen, die ihre Arbeiten in direkten Kontakt mit dem Betrachter bringen. Sie wurde 1971 in Versailles geboren und träumte schon mit 13 Jahren davon, Malerin zu werden. Nach ihrem Abschluss am École Nationale Supérieure d'Arts de Paris-Cergy im Jahr 1995 mit einem Diplom in Bildender Kunst lebte und arbeitete sie um die Jahrtausendwende drei Jahre lang in New York. Nach ihrer Rückkehr veröffentlichte sie ihr erstes Buch, eine Sammlung von Bleistiftzeichnungen von Fotografien, genannt *Dumbo Alex* (2001). Aus einem Abstecher in die Animation resultierte ein Musikvideo für die Band TTC von Ninja Tune, bevor sie sich der amerikanischen Kreativagentur Art Department anschloss. Compain-Tissier nähert sich ihren Objekten mit Herzlichkeit und Nähe und erstellt Beobachtungsstudien,

Alexandra Compain-Tissier est une illustratrice connue pour son travail en matière de mode, de tendance, de musique et d'édition. Elle est passionnée par l'intimité des livres et des expositions qui mettent ses œuvres en contact direct avec le public. Née à Versailles en 1971, elle rêvait depuis l'âge de 13 ans d'être peintre. En 1995, avec en poche un diplôme national supérieur d'expression plastique obtenu à l'École nationale supérieure d'arts de Paris-Cergy, elle est partie vivre et travailler trois ans à New York au tournant du millénaire. À son retour en France, elle a publié en 2001 son premier ouvrage intitulé *Dumbo Alex*, un recueil de dessins au crayon à partir de photographies. D'une incursion en animation est ressorti un clip pour le groupe TTC sous le label Ninja Tune, puis elle a rejoint l'agence de création américaine Art Department. Compain-Tissier aborde ses sujets avec une dose de chaleur et de tendresse et réalise à base d'observation des études incluant portraits, natures mortes et

realist style of watercolors or high-contrast pencil work have enriched the pages of *Elle*, *GQ*, *Cosmopolitan*, and *Dazed & Confused*, whilst her list of clients includes Air France, LVMH, Diesel, and American Express.

die von Porträts bis zu Stillleben und Outdoor-Umgebungen reichen. Neben Ausstellungen auf der ganzen Welt hat ihr natürlicher, realistischer Stil in dem sie Aquarelle oder kontrastreichen Bleistiftarbeiten fertigt, die Seiten von *Elle*, *GQ*, *Cosmopolitan* und *Dazed & Confused* geziert, während ihre Kundenliste genauso Air France, LVMH und Diesel wie auch American Express umfasst.

extérieurs. Outre sa participation à des expositions à travers le monde, le style naturel et réaliste de ses aquarelles et son travail très contrasté aux crayons de couleur ont rempli les pages de *Elle*, *GQ*, *Cosmopolitan* et *Dazed & Confused*. Parmi ses clients, elle compte Air France, LVMH, Diesel et American Express.

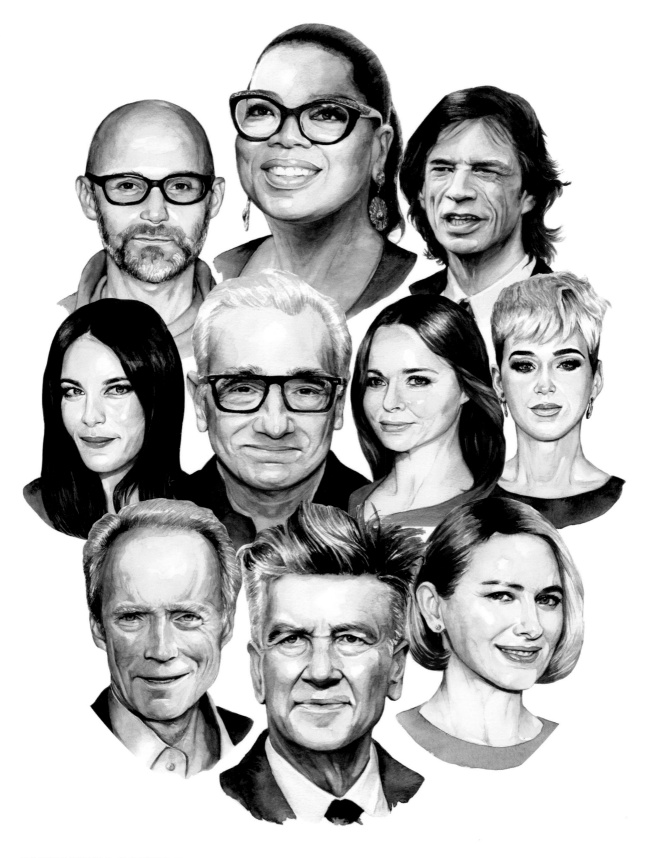

ALEXANDRA COMPAIN-TISSIER

Volume 25 / Issue 4 September / October 2016

Rise of the Buy Side
All hail the mighty bond
lords, who suddenly seem
stronger than ever *p82*

The Seven-Year Short
China's yuan has defied
hedge fund manager Mark
Hart. Will he prevail? *p90*

Alpha Insights, Revealed
Portfolio analysis uncovers
what propelled a "Dogs
of the Dow" strategy *p58*

Game Your Gray Matter
Train your brain for
trading! Neuroscience
informs a new function *p48*

Bloomberg Markets

"I will
never
declare
victory"

Tidjane Thiam
on the total makeover
of Credit Suisse
p 74

Tidjane Thiam, 2016
Bloomberg Markets magazine;
watercolor

right
Sharon Stone, 2018
V Magazine; watercolor

opposite
Stars, 2018
Grazia magazine; watercolor

p. 138
Ai Weiwei, 2017
ArtNews magazine; watercolor

Iris Cristal and Iris Opéra, 2017
Personal work, exhibition,
Ambassade excellence,
Hôtel Renaissance République;
watercolor on fine art paper

opposite
Still life, 2017
Grazia magazine; watercolor

Selected Exhibition: 2017, *Ambassade Excellence*, group show, Renaissance Palace, Paris

Selected Publications: 2013, *Anouck*, Ding ding dong éditions, France · 2001, *Dumbo Alex*, Éditions Flux, France

> "I always try to create a marriage between a good synthesis of the character and its image, and a solid idea, no matter how simple it is."

COSTHANZO

WWW.COSTHANZO.COM · @costhanzo

Augusto Costhanzo (simply known by his family name) was born in Buenos Aires in 1969. Raised within an artistic family he took to pen and paper as soon as he could walk, later enrolling in local art classes at 15. His inspirations were the titan Argentine graphic humorists of the day, such as Roberto Fontanarrosa, Caloi, and Quino. From the outset of his career in 1989, Costhanzo worked in various styles, eventually synthesizing these into his now identifiable look. Loaded with wit, Costhanzo's appealing imagery is wonderfully simple, with well-known personalities from the arts, film, music, entertainment and sport as recurring inspirations. Using an economy of bold outlines and flat colors, his signature front-facing, near-symmetrical caricatures are endearing. Costanzho's delightfully pictographic take on the world has transcended the borders of his native Argentina, where his work is part of the cultural fabric. Absolut Vodka, *AdWeek*, *Corriere della Sera*, *El País*, and *Vanity Fair* are just a few of his international clients. Costhanzo is

Augusto Costhanzo (bekannt unter seinem Familiennamen) wurde 1969 in Buenos Aires geboren. Da er in einer künstlerischen Familie aufwuchs, nahm er Stift und Papier zur Hand, sobald er laufen konnte. Mit 15 Jahren schrieb er sich in lokale Kunstkurse ein. Seine Inspiration erhielt er von den argentinischen Grafikhumoristen der damaligen Zeit wie Roberto Fontanarrosa, Caloi und Quino. Von Beginn seiner Karriere im Jahr 1989 an arbeitete Costhanzo in verschiedenen Stilen und kombinierte diese schließlich zu seinem jetzt unverwechselbaren Look. Costanzhos ansprechende Bilder sind wunderbar einfach und immer wieder angeregt durch bekannten Persönlichkeiten aus Kunst, Film, Musik, Unterhaltung und Sport. Seine markanten, fast symmetrischen, nach vorne gerichteten Karikaturen zeichnen sich durch eine Kombination aus starken Konturen und flächigen kräftigen Farben aus. Costanzhos wunderbar malerische Darstellung der Welt hat die Grenzen seiner Heimat Argentinien weit überschritten,

Augusto Costhanzo (simplement connu par son nom de famille) est né à Buenos Aires en 1969. Élevé par des parents artistes, il a fait siens papier et crayons au même âge qu'il a appris à marcher, puis a pris des cours de dessin à l'âge de 15 ans. Il s'est inspiré des grands humoristes graphiques argentins du moment, comme Roberto Fontanarrosa, Caloi et Quino. Depuis le début de sa carrière en 1989, Costhanzo a pratiqué une variété de styles et a fini par les combiner pour créer son look caractéristique. Pleine d'esprit, la séduisante imagerie de Costhanzo est d'une merveilleuse simplicité et s'inspire souvent de personnalités de l'art, du cinéma, de la musique, du spectacle et du sport. Quelques contours en gras et des aplats suffisent pour que ses caricatures de face et quasiment symétriques séduisent. La vision que Costhanzo porte sur le monde est délicieusement pictographique et a franchi les frontières de son Argentine natale, où ses œuvres font partie du tissu culturel. Parmi ses

of that ilk of illustrator to have success-
fully married a traditional practice with
digital tools. To redress the balance, he
enjoys escaping his studio and creating
murals whenever he can.

wo seine Arbeit Teil des kulturellen Gefü-
ges ist. Absolut Vodka, *AdWeek*, *Corriere
della Sera*, *El País* und *Vanity Fair* sind
nur einige seiner internationalen Kunden.
Costhanzo ist ein Illustrator, der eine
traditionelle Arbeitsweise erfolgreich
mit digitalen Werkzeugen verbunden hat.
Um sein inneres Gleichgewicht wieder-
herzustellen, genießt er es, wann immer er
kann, seinem Atelier zu entkommen und
Wandbilder zu malen.

clients internationaux figurent Absolut
Vodka, *AdWeek*, *Corriere della Sera*,
El País et *Vanity Fair*. Costhanzo est le
genre d'illustrateur ayant su marier avec
succès une pratique traditionnelle et
les outils numériques. En contrepartie,
il aime s'échapper de son studio et créer
des peintures murales chaque fois qu'il
en a l'occasion.

Stephen King, 2017
Personal work, poster; vector

opposite
Guillermo Del Toro, 2018
El País, newspaper article; vector

p. 144
Costhanzo en su laberinto, 2018
Usina del Arte, solo show, poster; vector

Selected Exhibitions: 2018, *Costhanzo en su laberinto*, solo show, Usina del Arte, Buenos Aires · 2011, *AC/DC*, solo show, Parque España, Rosario · 2010, *AC/DC*, solo show, Centro Cultural Recoleta, Buenos Aires · 2004, *Muertes vulgares para animales célebres*, solo show, Centro Cultural España, Córdoba · 2002, *Muertes vulgares para animales célebres*, solo show, Centro Cultural Recoleta, Buenos Aires

Seinfeld, 2016
Personal work; vector

right
Sherlock, 2017
Personal work; vector

opposite
New York, 2017
Personal work,
"Music & Cities"
poster series; vector

> "So much of what we love and do feeds into our work, and vice versa, so it never really feels separate from life." *for Design Boom*

CRAIG & KARL

WWW.CRAIGANDKARL.COM · @craigandkarl

Craig & Karl are an Antipodean art and design duo producing some of the most colorful and striking communication graphics on offer today. Both born in 1978, and hailing from Australia, Craig Redman (Gloucester, New South Wales) and Karl Maier (Gold Coast, Queensland) met on their first day at Queensland College of Art in Brisbane and have been joined at the creative hip ever since. Following their graduation as bachelors of design studies, the pair joined forces with a few college mates to form the acclaimed Rinzen art and design collective, before honing their skills in corporate identity at the same Sydney design studio. When Craig transplanted to Manhattan's Lower East Side in 2007 and Karl moved to London in 2012, their transatlantic collaboration blossomed—the pair officially launching as a joint brand in 2011. The duo epitomize cloud-based collaboration—ideas ping back and forth through the wonders of Skype and Dropbox. Craig & Karl's unique form of graphics contains a collision of high- and low-culture references. Bold

Craig & Karl ist ein antipodisches Kunst- und Designduo, das einige der farbenfrohsten und auffälligsten Kommunikationsgrafiken produziert, die heutzutage zu sehen sind. Beide wurden 1978 geboren und stammen aus Australien. Craig Redman (Gloucester, New South Wales) und Karl Maier (Gold Coast, Queensland) trafen sich an ihrem ersten Tag am Queensland College of Art in Brisbane und sind seitdem kreativ unzertrennlich. Nach ihrem Studienabschluss mit dem Bachelor of Design gründeten die beiden gemeinsam mit einigen Kollegen vom College das renommierte Rinzen Kunst- und Design-Kollektiv, bevor sie ihre Fähigkeiten in Corporate Identity im selben Designstudio in Sydney verfeinerten. Als Craig 2007 in Manhattan an die Lower East Side und Karl 2012 nach London zog, blühte ihre transatlantische Zusammenarbeit auf – die beiden werden seit 2011 offiziell als gemeinsame Marke geführt. Das Duo steht für cloudbasierte Zusammenarbeit – die Ideen fliegen dank der Wunder von Skype und Dropbox

Originaire d'Australie, le duo d'artistes et concepteurs Craig & Karl a signé certaines des propositions graphiques actuelles les plus colorées et saisissantes. Tous deux nés en 1978, Craig Redman (Gloucester, Nouvelle-Galles du Sud) et Karl Maier (Gold Coast, état australien du Queensland) se sont connus leur premier jour au Queensland College of Art à Brisbane et n'ont depuis cessé d'évoluer dans la sphère créative. Après l'obtention d'une licence en design, le duo s'est associé à des copains de fac pour former le célèbre collectif d'art et de design Rinzen; ils ont ensuite parfait leurs compétences en matière d'image de marque au sein du même studio de design de Sydney. Quand Craig est parti s'installer en 2007 dans le Lower East Side de Manhattan et que Karl a déménagé à Londres en 2012, leur collaboration transatlantique a prospéré à tel point qu'ils ont lancé en 2011 une marque commune. Ils incarnent parfaitement le concept de collaboration sur le cloud, leurs idées faisant des allées et venues

colors, often in thick-tubed outlines, purvey their "crazy, pop stylings," as Maier puts it. From famous portraits (such as Obama's 2012 re-election for the cover of *New York* magazine) and mural installations like the sensory-exploding *72DP* in a Sydney car park, to packaging for Wacom and Nespresso, Craig & Karl like to keep things fresh, leapfrogging from medium to medium. Transcending the realms of branding, accessories, editorial, and public art, the pair have also exhibited worldwide, including at the Museum of Advertising in the Louvre, and the Liu Haisu Art Museum in Shanghai.

hin und her. In ihrer einzigartigen Grafikform prallen Referenzen aus Hoch- und Popkultur aufeinander. Kräftige Farben, oft in dicken Konturen, sorgen für ihre „verrückten Popsdesigns", wie Maier es formuliert. Ihr Werk umfasst berühmte Porträts (etwa zu Obamas Wiederwahl 2012 für das Cover des *New York Magazines*), Wandinstallationen wie das sinnesbetäubende 72DP in einem Parkhaus in Sydney und Verpackungen für Wacom und Nespresso. Craig & Karl möchten immer aktuell und innovativ bleiben und springen von Technik zu Technik. Sie überwinden die Grenzen zwischen Branding, Accessoires, Redaktion und Kunst im öffentlichen Raum und haben weltweit ausgestellt, unter anderem im Museum für Werbung im Louvre und im Liu Haisu Art Museum in Schanghai.

grâce à la magie de Skype et de Dropbox. Le style graphique unique de Craig & Karl confronte des références issues de la culture élitiste et de la culture populaire ; couleurs vives et contours souvent épais donnent pour leur part « des looks pop et délirants », comme explique Maier. Auteurs de portraits célèbres (comme celui pour la réélection d'Obama en 2012 en couverture du magazine *New York*), d'installations murales (comme l'explosion sensorielle de *72DP* dans un parking à Sydney), ainsi que d'emballages pour Wacom et Nespresso, Craig & Karl aiment créer des œuvres originales et changer constamment de support. Le duo transcende les domaines du branding, des accessoires, de l'édition et de l'art public, et a exposé dans le monde entier, y compris au musée de la publicité (dans le palais du Louvre) et au Liu Haisu Art Museum à Shanghai.

DAS BESTE AUS DEUTSCHLANDS GROSSER TAGESZEITUNG

Süddeutsche Zeitung
LANGSTRECKE

Süddeutsche Zeitung

Die Welt nach Trump

★

17 Seiten Essays, Einsichten und Hintergründe

WER BIN ICH

Beate Zschäpe
wird vor Gericht
zerlegt. Näher
kommt man ihr
dabei nicht

ANNETTE
RAMELSBERGER

**GEFAHR
ERKANNT**

Die Behörden
wussten
von Anis Amri –
wieso stoppten
sie ihn nicht?

GEORG
MASCOLO

**„EIN BISSCHEN
BAUCH,
UND DU BIST
RAUS"**

Ein Schönheits-
chirurg erklärt,
warum sein Geschäft
so gut läuft

VARINIA BERNAU
MALTE CONRADI

**FALSCHE
KÖNIGE**

Die FIFA feiert
den Fußballer
des Jahres –
und sich selbst

HOLGER
GERTZ

**ANATOMIE
EINES AMTES**

Der Bundes-
präsident:
über eine Aufgabe,
die mit ihrem
Träger wächst

HERIBERT
PRANTL

**LEIPZIGER
VIELERLEI**

Unterwegs
auf der
berüchtigten
Eisenbahnstraße

CORNELIUS
POLLMER

**AUSGABE 01/2017
SZ.DE/LANGSTRECKE
#LANGSTRECKE
8 EURO
ÖSTERREICH 8,80 EURO
337 MINUTEN**

Trump, 2017
Süddeutsche Zeitung Magazin,
cover; vector; art direction:
Christian Toensmann

opposite top
Here After, 2017
Stanhope, installation;
acrylic; agency: Purple PR

opposite bottom
Optimystic, 2016
Personal work, installation;
colored sawdust

p. 150
Tropics, 2016
Personal work;
vector

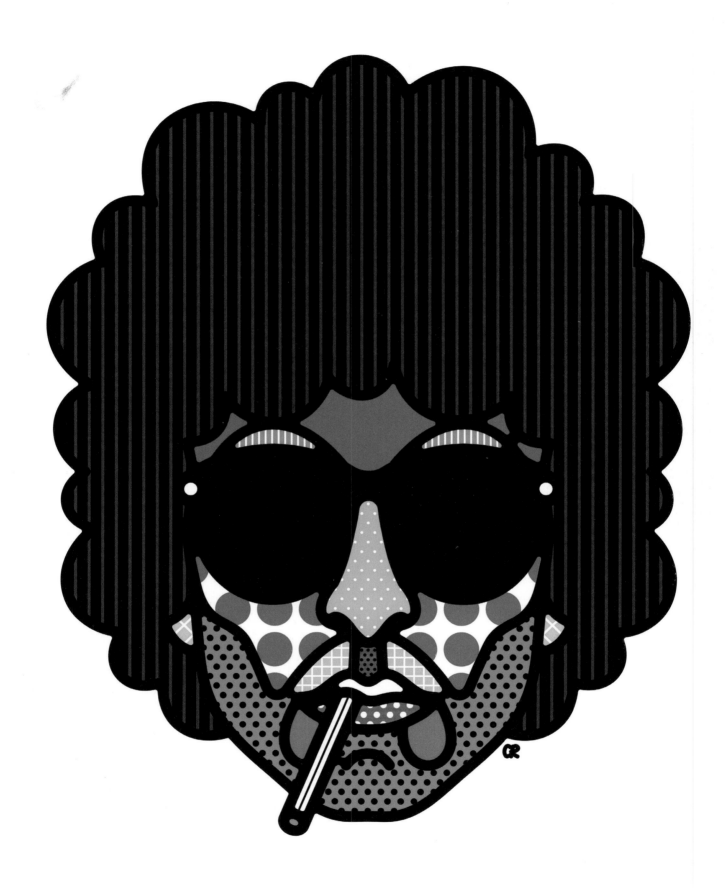

So It Grows, 2016
Wacom, packaging, digital, print;
vector; agency: Hazel Brands

right
Baskin-Robbins, 2018
packaging; vector

opposite
Bob Dylan, 2018
Personal work, poster; vector

Selected Exhibitions: 2018, *Shanghai Art & Design*, group show, Liu Haisu Art Museum, Shanghai · 2017, *Here After*, solo show, White City, London · 2016, *Optimystic*, solo show, Fox International, Guatemala City · 2016, *Wow*, group show, C-Mine Cultural Institution, Genk · 2016, *Creep*, solo show, M-One, Manchester

Selected Publications: 2018, *It's Nice That*, United Kingdom · 2018, *Computer Arts*, United Kingdom · 2018, *Playboy*, USA · 2018, *Graphic Fest*, Victionary, Hong Kong · 2017, *Design Boom*, USA

Woah, 2017
Personal work; vector

right
Mexico City, Roma Norte, 2018
Personal work; vector

opposite
Grace Jones, 2016
Another Planet Entertainment,
poster; vector

CRAIG & KARL

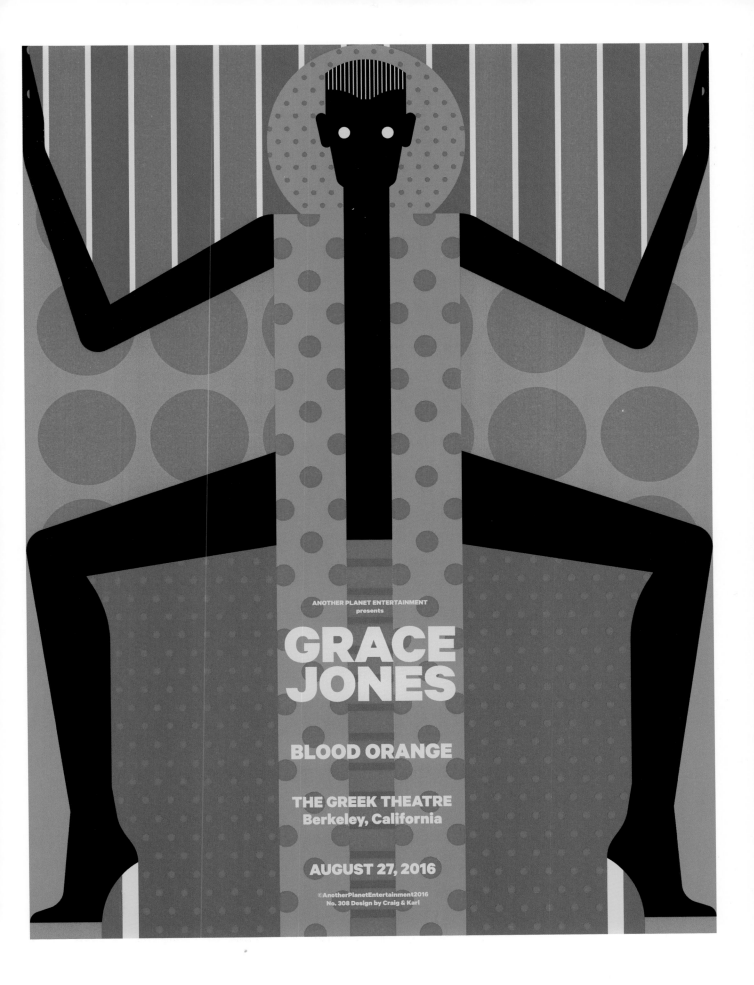

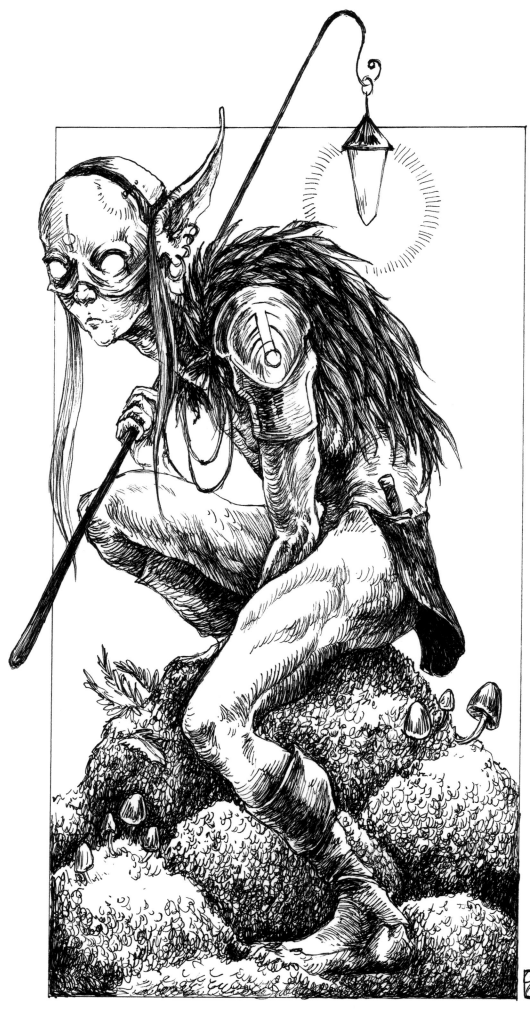

> "I am a traditional artist, through and through. I like working with my hands and feeling the art grow under my fingertips."

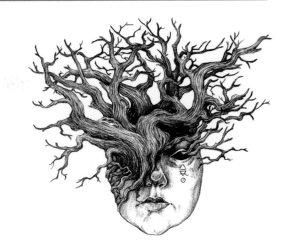

CUSTOM, BY SOPHY

WWW.CUSTOMBYSOPHY.COM · @custombysophy

"Death inspires me like a dog inspires a rabbit," muses Custom, by Sophy on her Instagram profile. The artist and illustrator behind the moniker is Sophia Fredriksson, a freelancer based in the city of Kristianstad, Sweden. Born in Enköping in 1983, she found an early creative outlet working as a tattoo artist whilst still at high school. Later, she got a job as a scientific illustrator. Both disciplines would influence her style and approach. After a period of designing shoes and accessories as a hobby, Fredriksson amalgamated her interests into a self-employed practice in 2015. Primarily drawn with inks, including ballpoint pen—though she also uses watercolor and gouache—her subjects are folkloric and darkly mythical. It's a world inhabited by nature spirits and fantastic creatures—beautiful anatomical renderings fused by flora and fauna and rune symbols. She draws inspiration from queer feminism and literature. Fredriksson graduated with a BA in Information Design from Mälardalen University in 2010. She also

„Der Tod inspiriert mich wie ein Hund ein Kaninchen", sinniert Custom, by Sophy in ihrem Instagram-Profil. Die Künstlerin und Illustratorin hinter dem Pseudonym ist Sophia Fredriksson, eine Freiberuflerin in Kristianstad (Schweden). Geboren wurde sie 1983 in Enköping und fand schon früh ihre kreative Berufung – während sie noch zur Schule ging, arbeitete sie bereits als Tätowiererin in einem Tattoo-Studio. Später bekam sie eine Anstellung als wissenschaftliche Illustratorin. Beide Disziplinen sollten ihren Stil und ihre Herangehensweise beeinflussen. Nach einer Zeit, in der sie nebenher Schuhe und Accessoires entwarf, führte Fredriksson 2015 ihre Interessen in einer freiberuflichen Tätigkeit zusammen. Sie zeichnet hauptsächlich mit Tusche oder Kugelschreiber – obwohl sie auch Aquarell- und Gouache-Farben verwendet. Ihre Motive sind folkloristisch und düster mythisch. Es ist eine Welt, die von Naturgeistern und fantastischen Kreaturen bevölkert wird – schöne anatomische Darstellungen, die mit

Sur son profil Instagram, Custom, by Sophy explique : « La mort m'inspire comme un chien inspire un lapin ». L'artiste et illustratrice derrière ce surnom est Sophia Fredriksson, une freelance installée à Kristianstad, en Suède. Née à Enköping en 1983, elle a très tôt trouvé un débouché créatif comme tatoueuse alors qu'elle était encore au lycée, puis elle a décroché un travail comme illustratrice scientifique, deux expériences qui ont influencé son style et son approche. Après une période à concevoir comme passe-temps des chaussures et des accessoires, Fredriksson a mis en commun ses centres d'intérêt et travaille à son compte depuis 2015. Principalement dessinés à l'encre, dont le stylo à bille, mais aussi à l'aquarelle et la gouache, ses sujets sont folkloriques, sombres et fabuleux. Son univers est habité par des esprits de la nature et des créatures fantastiques, autant de superbes rendus anatomiques qui sont assortis de symboles de la flore, de la faune et de runes. Elle puise son inspiration

has a BA and MA in English Language and Literature from Dalarna University, where she graduated in 2013. As well as undertaking commissions, Fredriksson has created a range of limited-edition prints, from Tarot cards to her *100 Days of Anatomical Hearts* project, for which she interpreted the human organ in a richly eclectic series of drawings.

Flora, Fauna und Runensymbolen verschmolzen werden. Fredriksson lässt sich von queerem Feminismus und ebensolcher Literatur inspirieren. 2010 absolvierte sie ihren Bachelor in Informationsdesign an der Universität Mälardalen und 2013 ihren Bachelor und Master in englischer Sprache und Literatur an der Universität in Dalarna. Neben der Ausführung von Auftragsarbeiten hat Fredriksson auch eine Reihe von Druckgrafiken in limitierter Auflage erstellt, vonvon Tarotkarten bis hin zu dem Projekt *100 Days of Anatomical Hearts*, für das sie das menschliche Organ in einer sehr vielseitigen Reihe von Zeichnungen interpretierte.

dans le féminisme queer et la littérature. Fredriksson a décroché en 2010 une licence en conception de l'information à l'université Mälardalen. Elle possède également une licence et une maîtrise en langue et littérature anglaises de l'université Dalarna depuis 2013. En plus des commandes qu'elle reçoit, Fredriksson a conçu une série de visuels en édition limitée, comme un jeu de tarot ou son projet *100 Days of Anatomical Hearts*, pour lequel elle a représenté l'organe humain dans une série de dessins des plus éclectiques.

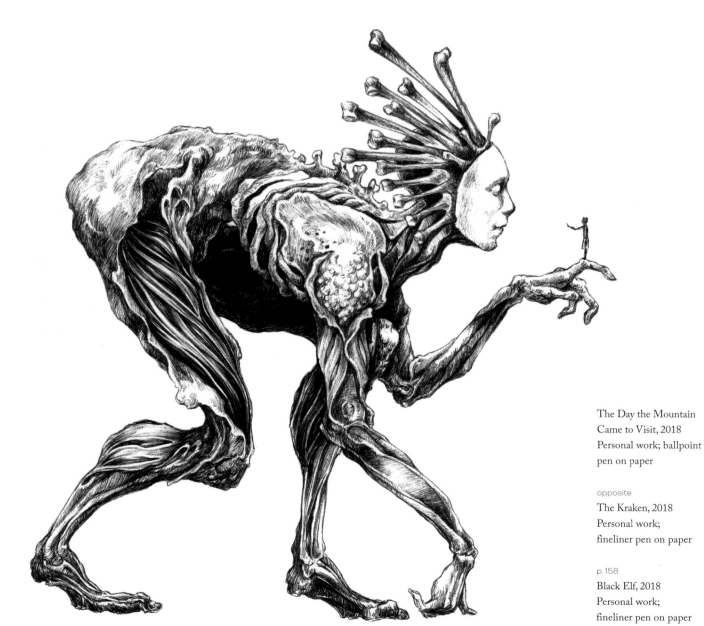

The Day the Mountain
Came to Visit, 2018
Personal work; ballpoint
pen on paper

opposite
The Kraken, 2018
Personal work;
fineliner pen on paper

p. 158
Black Elf, 2018
Personal work;
fineliner pen on paper

Water, 2018
Personal work; ballpoint
pen on paper

opposite
Alchemy: Air, 2017
Personal work;
ink, brush, digital color

CUSTOM, BY SOPHY

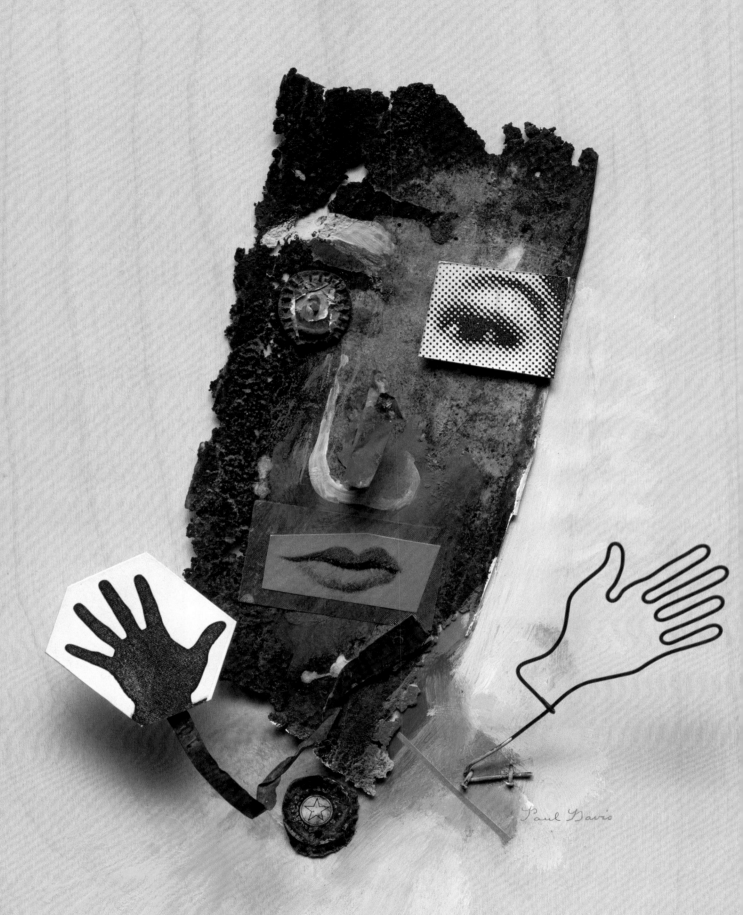

> "I am most satisfied in my work when I am able to convey some sense of the peculiar and particular emotional qualities that I perceive in daily life."

PAUL DAVIS

WWW.PAULDAVISPOSTERS.COM · @okie1938

Paul Davis belongs to that generation of illustrators swept along by the tide of revolt in late-1950s America. His ability to blend in new forms made him a driving force during the 1960s and 70s: "Style is a voice one chooses for its effect, and I want to be able to use as many voices as possible," he once remarked. Born Paul Brooks Davis in Centrahoma, Oklahoma, in 1938, he left for New York at 17, where he took classes at the Cartoonists and Illustrators School (later the School of Visual Arts). His first commission came via Art Paul, the founding art director of *Playboy*. In 1959, Davis landed a job at Push Pin Studios. Inspired by the incendiary Pop Art of Jasper Johns and Robert Rauschenberg, he began distilling the essence of American folk art with a touch of surrealism. Davis left Push Pin in 1963 and began his solo ascent. Regular assignments for the likes of *Sports Illustrated* and *Esquire* gave him artistic freedom. In 1967, his portrait of Cuban revolutionary Ernesto Che Guevara for the cover of *Evergreen*

Paul Davis gehört zu jener Generation von Illustratoren, die von der Flut der Bürgerrechtsbewegung im Amerika der späten 1950er-Jahre mitgerissen wurden. Seine Fähigkeit, neue Formen zu übernehmen, machte ihn in den 1960er- und 70er-Jahren zu einer treibenden Kraft: „Stil ist eine Stimme, die man aufgrund ihres Effekts wählt, und ich möchte so viele Stimmen wie möglich verwenden können", hat er einmal bemerkt. Geboren wurde Paul Brooks Davis 1938 in Centrahoma (Oklahoma). Mit 17 ging er nach New York, wo er Unterricht in der Cartoonists and Illustrators School nahm (später School of Visual Arts). Seine erste Auftragsarbeit vermittelte ihm Art Paul, der Gründungsdirektor des *Playboy*. Im Jahr 1959 bekam Davis einen Job bei den Push Pin Studios. Inspiriert von der brandneuen Pop-Art von Jasper Johns und Robert Rauschenberg, begann er, die Essenz der amerikanischen Volkskunst mit einem Hauch Surrealismus zu überziehen. Davis verließ Push Pin im Jahr 1963 und begann

Paul Davis appartient à cette génération d'illustrateurs entraînés par la vague de révoltes dans l'Amérique de la fin des années 1950. Sa capacité à se réinventer lui a fait jouer un rôle moteur au cours des années 1960 et 70. Comme il a une fois déclaré : « Le style est une voix que l'on choisit pour son effet, et je veux pouvoir employer autant de voix que possible ». Né Paul Brooks Davis en 1938 à Centrahoma, dans l'Oklahoma, il est parti à 17 ans vivre à New York, où il a pris des cours à la Cartoonists and Illustrators School (rebaptisée plus tard School of Visual Arts). Sa première commande lui est venue par Art Paul, le directeur artistique fondateur de *Playboy*. En 1959, Davis a décroché un emploi chez Push Pin Studios. S'inspirant du pop art incendiaire de Jasper Johns et de Robert Rauschenberg, il a commencé à distiller l'essence de l'art populaire américain avec une touche de surréalisme. Davis a quitté Push Pin en 1963 et commencé son ascension en solo ; des missions régulières pour des clients comme

Review became an era-defining poster. The 1970s heralded further departures from style and convention, notably in his typographic experiments in the theater posters for Joseph Papp's New York Shakespeare Festival. Davis would later assume art directorship of the festival itself. In 1977, a solo exhibition of his works formed part of the opening of the Centre Georges Pompidou in Paris. He was awarded the prestigious American Institute of Graphic Arts medal in 1989. Davis lives in Sag Harbor, New York.

seinen Soloaufstieg. Regelmäßige Aufträge für *Sports Illustrated* und *Esquire* verschafften ihm künstlerische Freiheit. Sein Porträt des kubanischen Revolutionärs Ernesto Che Guevara für das Cover der *Evergreen Review* aus dem Jahr 1967 prägte die Ästhetik dieser Ära. Die 1970er-Jahre läuteten eine weitere Abkehr von seinem bestehenden Stil und herrschenden Konventionen ein, wie in typografischen Experimenten auf den Theaterplakaten für Joseph Papps New Yorker Shakespeare Festival sichtbar wurde. Davis übernahm später die künstlerische Leitung des Festivals. 1977 fand eine Einzelausstellung seiner Werke im Rahmen der Eröffnung des Centre Georges Pompidou in Paris statt. Davis wurde 1989 mit der prestigeträchtigen Medaille des American Institute of Graphic Arts ausgezeichnet und lebt heute in Sag Harbor, New York.

Sports Illustrated et *Esquire* lui ont alors offert une grande liberté artistique. En 1967, son portrait du révolutionnaire cubain Ernesto Che Guevara pour la couverture de la revue *Evergreen Review* a marqué toute une époque. Les années 1970 ont annoncé d'autres changements de style et de convention, notamment avec ses expériences typographiques des affiches de théâtre pour le New York Shakespeare Festival alors dirigé par Joseph Papp, mais dont Davis a plus tard assumé la direction artistique. En 1977, une exposition individuelle de ses œuvres s'est tenue pour l'inauguration du Centre Georges Pompidou. Il s'est vu décerner en 1989 la prestigieuse médaille de l'American Institute of Graphic Arts. Davis réside à présent à Sag Harbor, dans l'État de New York.

PAUL DAVIS

Pride, 2005
Personal work; mixed media

opposite
Blue Bottle, 2001
Personal work; collage, acrylic

p. 164
Imagine, 2002
Personal work; mixed media

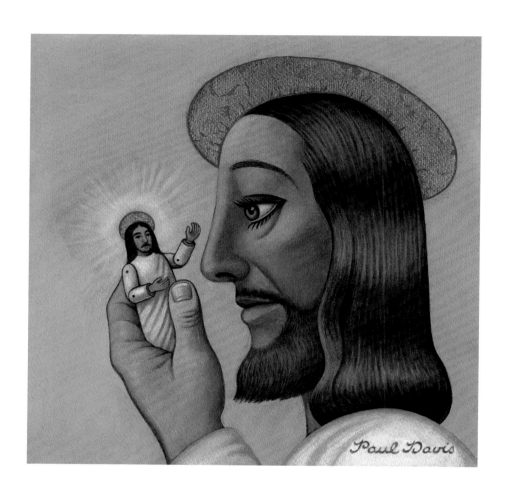

American Jesus, 2003
Boston Magazine; acrylic;
art direction: Robert Parsons

right
Duke Ellington, 2010
Jazz at Lincoln Center,
program cover; acrylic

opposite
I. L. Peretz, 2015
Pakn Treger, magazine cover;
acrylic; art direction:
Alexander Isley

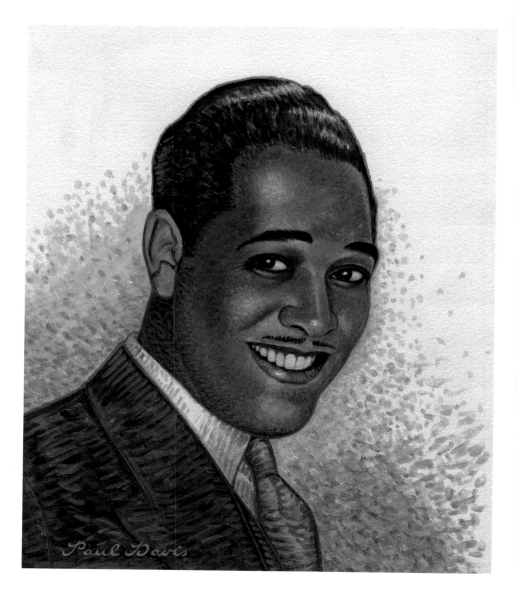

PAUL DAVIS

Selected Exhibitions: 2007, *I Manifesti di Paul Davis*, solo show, Basilica Palladiana, LAMeC, Vicenza · 2005, *Paul Davis, Show People*, solo show, Santa Maria della Scala, Siena · 1987, *Paul Davis in Japan*, solo show, various museums, Tokyo · 1977, *Paul Davis*, solo show, Centre George Pompidou, Paris · 1975, *Paul Davis*, solo show, Museum of Modern Art, Kyoto

Selected Publications: 2007, *I manifesti di Paul Davis*, Nuages, Italy · 2005, *Paul Davis, Show People,* Nuages, Italy · 1987, *Paul Davis Exhibition in Japan,* Mainichi Newspapers, Japan · 1975, *Paul Davis Exhibition*, Olivetti, Japan · 1968, *Idea's Extra Issue Paul Davis, Idea* magazine, Japan

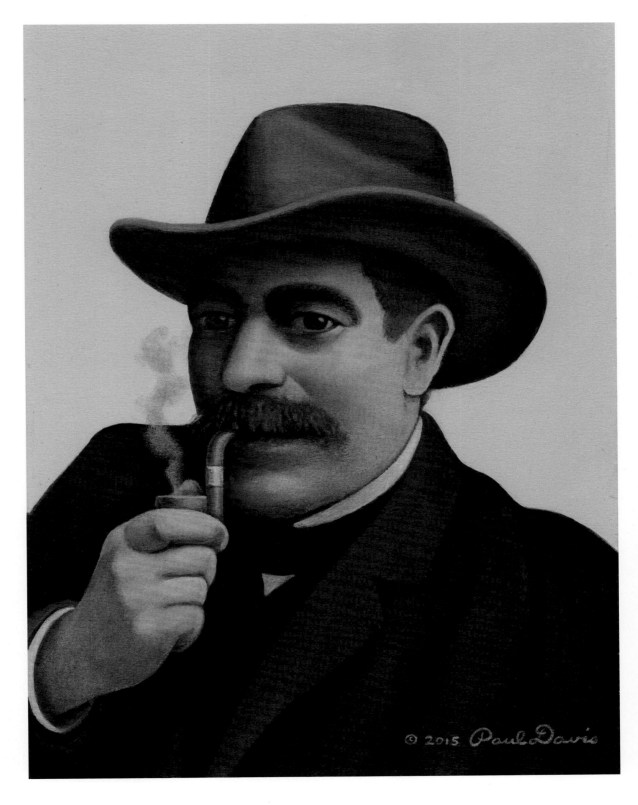

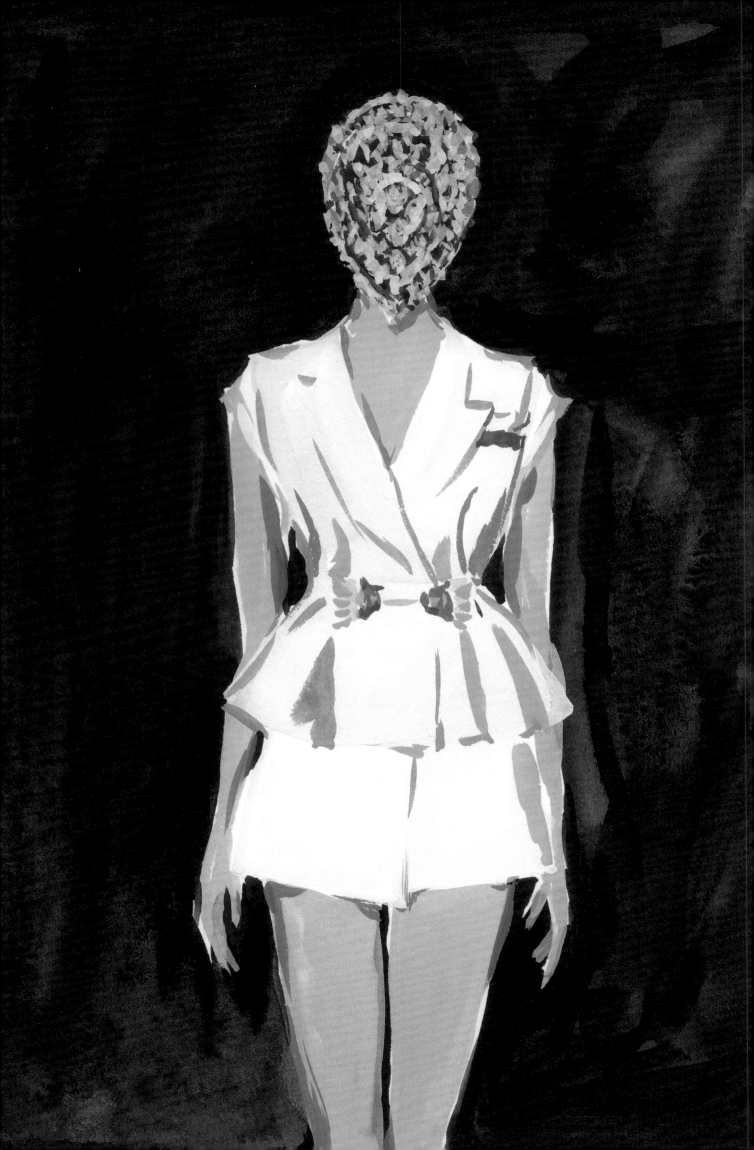

> "I aim to express someone's personality with the minimum of essential details. I always suggest the body language and physical presence, not just the face."

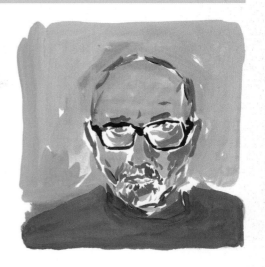

JEAN-PHILIPPE DELHOMME

WWW.JPHDELHOMME.COM · @jeanphilippedelhomme

Painter, writer, poet, and satirist, Jean-Philippe Delhomme is a cultural chronicler with a sharp eye and visual wit. Born in Nanterre, France, in 1959, Delhomme's creative bent was shaped whilst growing up in Normandy and later Paris. His surgeon father was an amateur landscape painter while his grandfather became the first Creative Director of Lancôme. He studied at the National School of Decorative Arts in Paris but felt disconnected from the abstract leanings of his contemporaries. Seeing the touring exhibition *Hockney Paints the Stage* in 1983 was a turning point for Delhomme, inspiring him to experiment with different media. He began to play with snapshot photography as a basis for his illustrational process. After transporting himself to New York, he soon began circulating in and capturing the *beau monde* milieu in what would become his customary, lampooning cartoon style. Through his quivering gouache fills or color pencil and pastel flourishes, Delhomme's quick, whimsical style has provided the perfect antidote to glossy

Jean-Philippe Delhomme, Maler, Schriftsteller, Dichter und Satiriker, ist ein Kulturchronist mit scharfem Blick und visuellem Witz. Geboren 1959 im französischen Nanterre, entwickelte sich Delhommes kreative Neigung in der Normandie und später in Paris. Sein Vater, ein Chirurg, war ein Amateurlandschaftsmaler während sein Großvater der erste Kreativdirektor von Lancôme war. Delhomme studierte an der Nationalen Kunstgewerbeschule in Paris, konnte jedoch mit der Vorliebe seiner Zeitgenossen für die Abstraktion nichts anfangen. Die Wanderausstellung *Hockney Paints the Stage* im Jahr 1983 war ein Wendepunkt und inspirierte ihn, mit verschiedenen Techniken zu experimentieren. Er begann, mit der Schnappschussfotografie als Grundlage für seinen Illustrationsprozess zu spielen. Nach seinem Umzug nach New York fing er an, sich in der besseren Gesellschaft zu bewegen, und fing diese in seinem nun typischen spöttischen Cartoonstil ein. Mit seinem zittrigen Gouache-Auftrag

Peintre, écrivain, poète et satiriste, Jean-Philippe Delhomme est un chroniqueur culturel au regard affûté et doté d'une intelligence visuelle. Né en 1959 à Nanterre, il voit son penchant créatif prendre forme pendant son enfance en Normandie, puis à Paris. Son père chirurgien peignait des paysages en amateur et son grand-père fut le premier directeur de la création chez Lancôme. Delhomme a étudié à l'école nationale supérieure des arts décoratifs de la capitale mais s'est senti déconnecté des tendances abstraites de ses contemporains. L'exposition itinérante intitulée *Hockney Paints the Stage* en 1983 représente un tournant pour Delhomme, car elle le motive à expérimenter avec différents supports. Il a ainsi commencé à jouer avec des instantanés comme base pour son processus d'illustration. Après son installation à New York, il a rapidement intégré le beau monde et l'a capturé dans ce qui est devenu son style de dessin satirique habituel. À travers ses gouaches pamphlétaires et ses fioritures aux crayons

photo ads aimed at the luxury brand customer—a notable example being his award-winning ad campaign for Barney's New York in the early 1990s. Along with a slew of self-penned and illustrated novels and columns under his by-line, and visual observations in almost every fashion publication of note, Delhomme has exhibited worldwide, produced animated ads for Saab USA and Visa France, and created postcard collections for Moncler. He lives and works in Paris.

oder seinen Farbstift-und Pastellschnörkeln, ist Delhommes schneller, skurriler Stil das perfekte Gegenstück zu den glänzenden Fotoanzeigen, die sich an Luxuskunden richten – ein bemerkenswertes Beispiel ist seine preisgekrönte Werbekampagne für Barney's New York in den frühen 1990er-Jahren. Neben einer Reihe von selbst geschriebenen und illustrierten Romanen und Kolumnen, die er als Nebenbeschäftigung kreiert sowie visuellen Beobachtungen in fast jeder wichtigen Modezeitschrift, hat Delhomme weltweit ausgestellt, animierte Anzeigen für Saab USA und Visa France produziert und Postkartensammlungen für Moncler erstellt. Er lebt und arbeitet in Paris.

de couleur et pastels, le style dynamique et fantaisiste de Delhomme s'est avéré être l'antidote parfait aux publicités sur papier glacé visant la clientèle de marques de luxe : sa campagne publicitaire primée pour Barneys New York au début des années 1990 en est un exemple probant. Outre une foule de romans et de colonnes écrits et illustrés de sa main, ainsi que des observations visuelles dans quasiment toutes les grandes publications de mode, Delhomme a exposé dans le monde entier, produit des publicités animées pour Saab USA et Visa France, et créé des collections de cartes postales pour Moncler. Il vit et travaille actuellement à Paris.

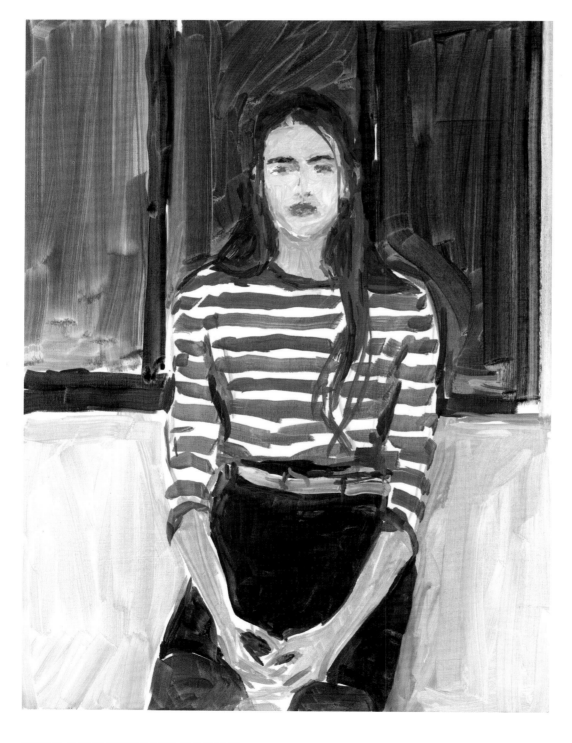

JEAN-PHILIPPE DELHOMME

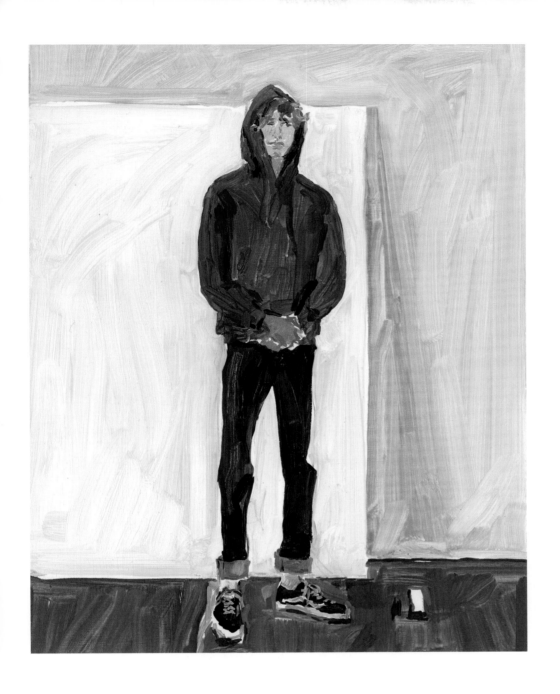

Emile with Blue Hood, 2017
Personal work; oil

right
Gramercy Park, 2017
August Journal, magazine;
color pencil

opposite
Lomane, 2018
Personal work; oil

p. 170
Margiela, 2018
Document Journal, magazine;
gouache; creative direction:
Nick Vogelson

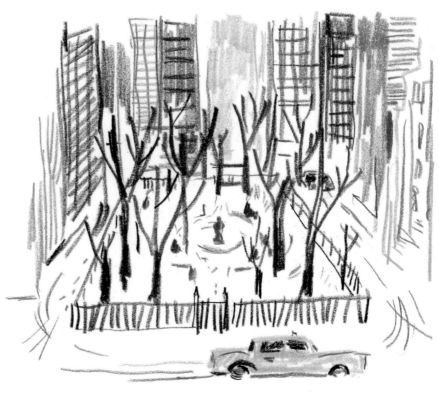

The Mark Coloring Book, 2018
The Mark Hotel, New York,
coloring book; marker;
art direction: Bill Loccisano,
Pandiscio Green

opposite
Fashion Gossips, 2018
System magazine;
gouache; creative direction:
Thomas Lenthal

LA Sunset, 2018
Personal work; oil

Selected Exhibitions: 2019, *Fina Estampa*, group show, ABC Museum, Madrid · 2017, *Studio aux dimensions variables*, solo show, Lucien Terras, New York · 2017, *Dessins de Mode*, solo show, Galerie Martine Gossieaux, Paris · 2015, *Bushwick Landscape*, solo show, Lucien Terras, New York · 2013, *New York*, solo show, Galerie Martel, Paris

Selected Publications: 2019, *Artists Instagrams,* August Editions, USA · 2018, *M Le Mag, Le Monde*, France · 2018, *Purple Magazine,* France · 2017, *Apartamento Magazine,* Spain · 2013, *The Unknown Hipster Diaries,* August Editions, USA

> "I like to capture a face at its most vulnerable, with all the interesting imperfections. No gloss, no fluff, just the raw basics with a depth of character."

VANESSA DELL

WWW.VANESSADELL.COM · @vanessadelll

British artist Vanessa Dell draws and paints everything from objects to landscapes and seascapes, but is best known for her endearing, colourful, and uncannily real portraits. She renders her subject's features with the slightest of hint of caricature, choosing oils or colored pencils as her preferred media, with Photoshop occasionally used for composition and touching up in the latter stages. Dell was born in Carshalton, Surrey, in 1983. Her interest in faces evolved from drawing cartoon characters like Bugs Bunny and Sylvester the Cat. Later influences would include Lucian Freud, Stanley Spencer, Peter Blake, Sidney Nolan, and Patrick Heron. In 1995, she attained a degree in graphic design from Kingston University and has since gone on to enjoy a successful career illustrating book covers, magazine features, posters, and ad campaigns both in the UK and abroad. As well as working with a host of commercial clients, including *Time Out*, the BBC, Macmillan Publishers, and Saatchi & Saatchi, Dell also undertakes

Die britische Künstlerin Vanessa Dell zeichnet und malt alles, von Objekten über Landschaften und Meereseindrücke, ist aber am besten für ihre liebenswerten, farbenfrohen und seltsam realistischen Porträts bekannt. Sie versieht ihre Motive mit einem Hauch von Karikatur und nutzt Öl oder Buntstifte als bevorzugte Technik sowie Photoshop, das sie gelegentlich zur Komposition und in den letzten Phasen zur Nachbearbeitung verwendet. Dell wurde 1983 in Carshalton (Surrey) geboren. Ihr Interesse an Gesichtern entwickelte sich aus dem Zeichnen von Cartoonfiguren wie Bugs Bunny und dem Kater Sylvester. Spätere Einflüsse waren zum Beispiel Lucian Freud, Stanley Spencer, Peter Blake, Sidney Nolan und Patrick Heron. 1995 schloss sie ihr Grafikdesignstudium an der Kingston University ab und macht seitdem erfolgreich Karriere als Illustratorin von Buchumschlägen, Magazinen, Postern und Werbekampagnen inner- und außerhalb der USA. Neben der Arbeit mit einer Vielzahl von gewerblichen

L'artiste britannique Vanessa Dell dessine et peint tout, d'objets à des paysages terrestres et marins, mais elle est surtout connue pour ses portraits attachants, hauts en couleur et étrangement réels. Elle dote les traits de ses sujets d'une légère touche caricaturale, travaillant de préférence à l'huile et ou avec des crayons de couleur, et parfois dans Photoshop pour composer et faire des retouches finales. Dell est née en 1983 à Carshalton, dans le comté de Surrey. Son intérêt pour les visages a bien évolué depuis qu'elle dessinait des personnages de dessins animés comme Bugs Bunny et Sylvestre ; avec le temps, ses influences sont devenues Lucian Freud, Stanley Spencer, Peter Blake, Sidney Nolan ou encore Patrick Heron. En 1995, elle a obtenu un diplôme en design graphique à l'université de Kingston ; depuis, elle mène une brillante carrière, illustrant des couvertures de livres, des articles de magazines, des affiches et des campagnes publicitaires tant au Royaume-Uni qu'à l'étranger. Outre une liste de clients

private portrait commissions and produces her own fine art. She is based in Surrey, where she lives with her family and an Irish Terrier named Twiggy.

Kunden, einschließlich *Time Out*, der BBC, Macmillan Publishers und Saatchi & Saatchi, übernimmt Dell auch private Porträtaufträge und produziert eigene Kunst. Sie lebt mit ihrer Familie und einem Irish Terrier namens Twiggy in Surrey.

commerciaux comme *Time Out*, la BBC, Macmillan Publishers et Saatchi & Saatchi, Dell accepte des commandes privées de portraits et produit des œuvres personnelles. Elle réside dans le comté de Surrey avec sa famille et un terrier irlandais nommé Twiggy.

Housing's Diversity Challenge, 2017
Inside Housing magazine; oil on
paper, digital

right
The Labor Game, 2018
Greenhouse Management magazine
cover; oil, gouache, and colored
pencils on paper

opposite
Hilary Haters, 2016
Slate Magazine, oil on paper

p. 178
Peter Capaldi, 2017
Personal work; oil and colored
pencils on paper

Teeth & Pills, 2018
Poster; oil and gouache
on paper

opposite
Ed Sheeran, 2017
Personal work; oil and
pencil on paper

Selected Publications: 2015, *Stellenwert,* Stampfli Verlag,
Switzerland · 2013, *100 Illustrators,* TASCHEN, Germany ·
2010, *Illustration Now! Portraits,* TASCHEN, Germany ·
2005, *Illustration Now! Vol.1,* TASCHEN, Germany

MATT DORFMAN

WWW.METALMOTHER.COM · @matt.dorfman

Employing a cut-and-paste style akin to the Dadaist photomontages of John Heartfield, the kitchen-sink psychedelia of Victor Moscoso, and the pioneering graphic communication of Quentin Fiore—all of whom rank highly among his influences—Matt Dorfman mashes up found images with lettering and various media to create illustrations that are both potent and witty. His wizardry lies in his peculiar ability to imbue visual meaning into text-based content that seems to defy the two-dimensional plane of the printed page. No surprise then that Dorfman is an in-demand global talent. When not conjuring up imagery for *The New York Times Book Review*, he keeps busy with a continual stream of commissions through his own freelance practice Metalmother, active since the mid-2000s. Born in Philadelphia in 1977, Dorfman majored in illustration at Syracuse University before renouncing the discipline in favor of design. A job offer as a production manager for a major record company

Mit einem Cut-and-Paste-Stil, der den dadaistischen Fotomontagen von John Heartfield, den psychedelischen Bildern von Victor Moscoso und der bahnbrechenden grafischen Kommunikation von Quentin Fiore ähnelt (allesamt Arbeiten von Künstlern, die ihn beeinflussten), mischt Matt Dorfman gefundene Bilder mit Schriftzügen und verschiedenen Medien, um Illustrationen zu schaffen, die sowohl kraftvoll als auch witzig sind. Seine Genialität beruht auf der besonderen Fähigkeit, textbasierten Inhalten, die der zweidimensionalen Ebene der gedruckten Seite zu trotzen scheinen, visuelle Bedeutung zu verleihen. Kein Wunder, dass Dorfman ein weltweit begehrtes Talent ist. Wenn er nicht gerade Bilder für die *New York Times Book Review* erschafft, bewältigt er seit Mitte der Nullerjahre mit seinem Einmannunternehmen Metalmother eine stetige Flut von Aufträgen. Dorfman wurde 1977 in Philadelphia geboren und studierte zunächst Illustration an der Syracuse University, bevor er sich dem Design widmete. Ein

Avec des découpages et des collages comparables aux photomontages dada de John Heartfield, au naturalisme psychédélique de Victor Moscoso et à la communication graphique pionnière de Quentin Fiore, autant d'artistes figurant parmi ses principales influences, Matt Dorfman mélange images trouvées, lettrage et divers supports pour réaliser des illustrations aussi puissantes que pleines d'esprit. Son génie tient à sa capacité à imprégner d'une signification visuelle un contenu textuel, qui semble alors défier le plan en deux dimensions de la page imprimée. Rien de surprenant que Dorfman soit un talent prisé dans le monde entier. Quand il ne s'invente pas une imagerie pour *The New York Times Book Review*, il se consacre aux commandes incessantes qui lui arrivent, et qu'il réalise pour son compte sous le nom de Metalmother depuis le milieu des années 2000. Né à Philadelphie en 1977, Dorfman s'est spécialisé en illustration à l'université de Syracuse avant de renoncer à cette discipline et de préférer le

prompted a move to New York at the turn of the millennium, but this was not the creative springboard he had anticipated. For over a decade, he worked within the music industry by day whilst developing his graphic portfolio at night. In 2011, his perseverance finally paid off when he was offered the coveted art director's chair at the op-ed page of *The New York Times*. Dorfman's freelance client list reads like a who's who of the publishing world—from Anchor Books, *Esquire*, and Knopf to *Time*, *Vanity Fair*, and *Wired*. Other projects have included rebranding the identity for the National Public Radio talk show *Fresh Air with Terry Gross* (2015). He has also been a juror for the American Illustration competition, and a speaker at events hosted by the Society of Publication Designers and the Type Directors Club.

Stellenangebot als Produktionsleiter einer großen Plattenfirma veranlasste ihn, zur Jahrtausendwende nach New York umzuziehen, doch dies war nicht das kreative Sprungbrett, das er erwartet hatte. Über ein Jahrzehnt lang arbeitete er tagsüber in der Musikbranche und entwickelte nachts sein grafisches Portfolio. Seine Ausdauer zahlte sich 2011 aus, als ihm der begehrte Art-Director-Posten für die op-ed page, der Kommentarseite der *New York Times* angeboten wurde. Die Liste von Dorfmans Kunden liest sich wie ein Who is Who der Verlagswelt — von Anchor Books, *Esquire* und Knopf bis zur *Time*, *Vanity Fair* und *Wired*. Ein anderes seiner Projekte war zum Beispiel die Neuentwicklung des Corporate Designs der National-Public-Radio-Talkshow *Fresh Air with Terry Gross* (2015). Dorfman war außerdem Juror beim American-Illustration-Wettbewerb und Redner bei Veranstaltungen der Society of Publication Designers und des Type Directors Club.

design. Une offre d'emploi comme responsable de production pour une importante maison de disques a motivé son départ pour New York au tournant du millénaire, mais l'expérience n'a pas été le tremplin créatif qu'il avait imaginé. Pendant plus d'une décennie, il a travaillé de jour dans l'industrie de la musique et élaboré la nuit son portfolio graphique. En 2011, sa persévérance a fini par payer quand il s'est vu offert le poste si convoité de directeur artistique pour la tribune libre de *The New York Times*. La liste de clients pour lesquels Dorfman a travaillé en freelance ressemble à un *Who's who* du monde éditorial : Anchor Books, *Esquire*, Knopf, *Time*, *Vanity Fair* et *Wired*. Par ailleurs, il s'est chargé de la refonte de l'identité pour l'émission *Fresh Air with Terry Gross* sur la National Public Radio (2015). Il a également été juré lors du concours d'American Illustration et orateur lors d'événements organisés par la Society of Publication Designers et le Type Directors Club.

THE INSECT APOCALYPSE IS HERE *What will the decline of bugs mean for the rest of life on Earth? By Brooke Jarvis*

Whiskey and Ink, 2018
The New Yorker, magazine; collage, digital;
art direction: Nico Schweizer, Nicholas Blechman

opposite
The Insect Apocalypse Is Here, 2018
The New York Times Magazine, cover;
collage, digital; art direction: Gail Bichler

p. 184
Stupid Heroes #1, 2017
Personal work; collage,
found material

Knockout, 2016
Soft Skull Press, book cover;
grease pencils; art direction:
Kelly Winton

In the Land of Armadillos, 2016
Scribner Books, book cover;
ink, brush, watercolor;
art direction: Jaya Miceli

opposite
Bach's Holy Dread, 2017
The New Yorker, magazine;
collage, digital; art direction:
Chris Curry

Downer #1, 2018
Personal work; collage,
found material

opposite
Really Good Birthday, 2018
Personal work, party favor bag
for a five-year-old's birthday
party; collage, found material

MATT DORFMAN

Selected Publications: 2018, *American Illustration 38*, Amilus, USA · 2017, *American Illustration 37*, Amilus, USA · 2016, *American Illustration 36*, Amilus, USA · 2013, *Fully Booked*, Gestalten, Germany · 2010, *Penguin 75: Designers, Authors, Commentary (the Good, the Bad…)*, Penguin, USA

"My mind has always been alert to image debris, keeping ideas and images in books, which then spill into my painting and illustration. In my image-making I try to convey the idea of 'everything at once'."

HENRIK DRESCHER

WWW.HDRESCHER.COM · @henrik.drescher

Henrik Drescher was born in Copenhagen in 1955. When he was 12, his family immigrated to the United States. He was awarded a full scholarship at the School of the Museum of Fine Arts in Boston in 1972, but decided to drop out after one semester. This signaled a period of extensive travel throughout America and Europe, during which he began keeping visual notebooks as a place to record his ideas. His renouncement of academia led to an exploration of and affinity with Outsider Art. After settling in New York in 1982, Drescher began working full-time as an illustrator. His first book, *The Strange Appearance of Howard Cranebill, Jr.*, was named *The New York Times* Best Illustrated Book of 1982. He has since produced over 50 titles, including children's books. Drescher's work has graced the pages of *Rolling Stone*, *Time* magazine, and *The Washington Post*. In 1992, he was honored with a solo show at the United States Library of Congress. His practice has extended to murals and installations. In the 2010s he began

Henrik Drescher wurde 1955 in Kopenhagen geboren, doch als er zwölf Jahre alt war, wanderte seine Familie in die USA aus. 1972 erhielt er ein Vollstipendium an der School of Museum of Fine Arts in Boston, beschloss jedoch, nach nur einem Semester auszusteigen. Es folgte eine Periode ausgedehnter Reisen durch Amerika und Europa, während derer er seine visuellen Ideen in Notizbüchern festhielt. Sein Verzicht auf eine akademische Ausbildung führte zur Entdeckung der Outsider Art, für die er eine Affinität entwickelte. Nachdem er sich 1982 in New York niedergelassen hatte, arbeitete er hauptberuflich als Illustrator. Sein erstes Buch *The Strange Appearance of Howard Cranebill, Jr.* wurde von der *New York Times* als bestes illustriertes Buch des Jahres 1982 ausgezeichnet. Seitdem hat er über 50 Titel veröffentlicht, darunter auch Kinderbücher. Außerdem zierten Dreschers Arbeiten die Titelseiten von *Rolling Stone*, *Time* und *The Washington Post*. 1992 wurde er mit einer Einzelausstellung in

Henrik Drescher est né à Copenhague en 1955 mais quand il avait 12 ans, sa famille a émigré aux États-Unis. En 1972, il a obtenu une bourse pour l'école du musée des beaux-arts de Boston, des études qu'il a abandonnées au bout d'un semestre. À cette époque, il a beaucoup voyagé à travers l'Amérique et en Europe, tenant pendant ses périples des carnets illustrés pour y consigner ses idées. Cet éloignement du monde universitaire lui a permis d'explorer et d'apprécier l'art brut. S'installant à New York en 1982, Drescher a commencé à travailler à temps complet comme illustrateur. Son premier ouvrage intitulé *The Strange Appearance of Howard Cranebill, Jr.* a été élu meilleur livre illustré en 1982 par *The New York Times*. Depuis, il a produit plus de 50 titres, dont des livres pour enfants. Le travail de Drescher a embelli les pages de *Rolling Stone*, du magazine *Time* et de *The Washington Post*. En 1992, il a été gratifié d'une exposition en solo à la bibliothèque du Congrès des États-Unis, et sa pratique artistique

to develop Nervenet, an evolving gallery construction or "thought diagram," as the artist has described it, where he mounts images from his notebooks on wires. His aim is to convey a sense of totality: "In my image making I try to register the idea of 'everything at once,' a sort of Sears & Roebuck [sic] mail-order catalog filled with an inventory of all that has ever existed in the course of organic history and human memory... scars, tattoos, cracks, memories, impressions, flashbacks, and forgotten instructions." In the 2000s, Drescher began exploring shan shui, the traditional Chinese art of landscape painting, which is documented in his 2014 book *China Days—A Visual Journal from China's Wild West*. Dreschler now lives with his wife, the artist Wu Wing Yee, and divides his time between New York and Dali, Yunnan Province, China.

der Kongressbibliothek der Vereinigten Staaten ausgezeichnet. Inzwischen erstreckt sich seine Arbeit auch auf Wandgemälde und Installationen. In den 2010er-Jahren begann er *Nervenet* zu entwickeln, eine Galeriekonstruktion oder ein „Gedankenschema", wie der Künstler es bezeichnete, bei der er Bilder aus seinen Notizbüchern auf Drähte montierte. Sein Ziel ist es, ein Gefühl der Totalität zu vermitteln: „Ich versuche bei meiner Bildgestaltung die Idee von ‚alles auf einmal' zu registrieren, eine Art Sears-&-Roebuck-[sic] Versandkatalog, angefüllt mit einer Bestandsaufnahme all dessen, was im Verlauf der organischen Geschichte und des menschlichen Gedächtnisses jemals existiert hat … Narben, Tätowierungen, Risse, Erinnerungen, Eindrücke, Rückblenden und vergessene Anweisungen." In den 2000er-Jahren begann Drescher mit *Shan Shui*, der traditionellen chinesischen Kunst der Landschaftsmalerei, die in seinem Buch *China Days—A Visual Journal from China's Wild West* (Tage in China – Ein visuelles Tagebuch aus Chinas Wildem Westen) dokumentiert ist. Heute lebt Drescher mit seiner Frau, der Künstlerin Wu Wing Yee, in New York sowie in Dali in der Provinz Yunnan (China).

s'est étendue à des peintures murales et des installations. Dans les années 2010, il s'est lancé dans l'élaboration de Nervenet, une installation évolutive ou « diagramme pensé » comme l'artiste l'a décrite, dans laquelle il a pendu à des câbles des images issues de ses carnets. L'objectif était de transmettre un sentiment de totalité : « J'essaye dans ma production d'images d'intégrer l'idée du ‹ tout à la fois ›, une sorte de catalogue de vente par correspondance de Sears & Roebuck [sic] rempli de tout ce qui a existé au long de l'histoire organique et de la mémoire humaine : cicatrices, tatouages, crevasses, souvenirs, impressions, reviviscences et instructions oubliées. » Dans les années 2000, Drescher s'est mis au shanshui, l'art pictural traditionnel chinois de peinture de paysages qu'il présente dans son livre publié en 2014 et intitulé *China Days—A Visual Journal from China's Wild West*. Dreschler vit avec sa femme, l'artiste Wu Wing Yee, et partage son temps entre New York et Dali, dans la province chinoise du Yunnan.

HENRIK DRESCHER

Forever Young, 2019
Personal work,
Psychadelicious series;
acrylic, colored ink

opposite
Ventriloquist, 2019
Personal work,
Psychadelicious series;
acrylic, colored ink

p. 192
Johnyoko, 2019
Personal work,
Psychadelicious series;
acrylic, colored ink

Roaster, 2019
Personal work; acrylic on board

opposite
Thumb Shine®'s series, 2019
Personal work; paper, ink, and
markers on paper

HENRIK DRESCHER

Selected Exhibitions: 2017, *Big Rock Candy Mountain*, solo show, Jack Fisher Gallery, San Francisco · 2009, *Comeundone*, solo show, Stir Gallery, Shanghai · 1994, *Mental Pictures*, solo show, Library of Congress, Washington, D.C.

> "When I don't have a clear idea, I usually sit with my trusty sketchbook and doodle a few thumbnails, or even write down words that I feel relate to the project."

CHRISTI DU TOIT

WWW.CHRISTIDUTOIT.CO.ZA · @christidutoit

André Christiaan "Christi" du Toit (b. 1991) is a South-African-born illustrator and designer with Franco-Dutch heritage. As a child growing up in the small coastal town of Gordon's Bay (his father was an architect and mother an artist) his creativity was unleashed through drawing. Eventually the big city beckoned, and in 2014 he graduated with a degree in graphic design and visual communication from AAA School of Advertising in Cape Town. Like many in his field, du Toit honed his creative and professional skills under the auspices of various illustration and design studios. Now an independent freelancer, his style and practice combines traditional hand-drawing with digital conjuring. As well as illustration, du Toit specializes in custom lettering, typography, and animation. An avid experimenter, he has even produced his own set of brushes for Photoshop. Du Toit's wide-ranging style is infused with a handcrafted quality that translates perfectly into print and the digital domain. With a broad commercial output, du Toit is equally at

André Christiaan „Christi" du Toit, Jahrgang 1991, ist ein in Südafrika geborener Illustrator und Designer mit französisch-niederländischen Wurzeln. Als Kind wuchs er in der kleinen Küstenstadt Gordon's Bay auf. Sein Vater war Architekt und seine Mutter Künstlerin. Seine Kreativität wurde durch das Zeichnen geweckt. Schließlich lockte ihn die Großstadt, und im Jahr 2014 studierte er Grafikdesign und visuelle Kommunikation an der AAA School of Advertising in Kapstadt. Wie viele auf seinem Gebiet, verfeinerte Du Toit seine kreativen und professionellen Fähigkeiten unter der Federführung verschiedener Illustrations- und Designstudios. Als unabhängiger Freiberufler kombiniert er heute seinen Stil und seine Praxis des traditionellen Zeichnens von Hand mit digitalem Zauber. Neben der Illustration hat sich Du Toit auf maßgeschneidertes Lettering, Typografie und Animation spezialisiert. Als begeisterter Experimentator hat er sogar einen eigenen Pinselsatz für Photoshop produziert. Du Toits vielseitiger Stil ist geprägt

Né en 1991, André Christiaan « Christi » du Toit est un illustrateur et concepteur originaire d'Afrique du Sud avec un héritage franco-hollandais. Fils d'un architecte et d'une artiste, il a grandi dans la petite ville côtière de Gordon's Bay et a donné cours à sa créativité à travers le dessin. L'appel de la grande ville s'est fait entendre et en 2014, il a obtenu un diplôme en design graphique et en communication visuelle à la AAA School of Advertising à Le Cap. Comme beaucoup d'autres dans ce domaine, du Toit a perfectionné ses compétences créatives et professionnelles sous les auspices de plusieurs studios d'illustration et de design. Travaillant désormais à son compte, son style et sa pratique associent le dessin traditionnel à la main et la magie du numérique. Outre l'illustration, du Toit est spécialisé en lettrage, typographie et animation ; friand d'expérimentation, il a même produit son propre jeu de pinceaux pour Photoshop. Son style riche est imprégné d'une qualité artisanale qui se révèle à la perfection

home visualizing briefs for British Airways and Vans as he is indulging in his love of music and pop culture, through his posters and merchandise for rock and metal bands and his own interpretations of fan art. He lives and works in Cape Town.

von einer handgefertigten Qualität, die sich perfekt in Print und digitale Bereiche übertragen lässt. Aufgrund seiner umfassenden kommerziellen Erfahrung ist Du Toit mit der Visualisierung von Aufträgen für British Airways und Vans genauso vertraut, wie mit der Gestaltung von Postern und Merchandisingartikeln für Rock- und Metalbands. In seiner eigenen Interpretation von Fankunst gibt er sich wiederum seiner Liebe zur Musik und Popkultur hin. Er lebt und arbeitet in Kapstadt.

dans les impressions papier et en numérique. Très sollicité pour des projets commerciaux, du Toit peut tout aussi bien consacrer son temps à repasser des briefings pour British Airways et Vans qu'à se livrer à son amour pour la musique et la culture pop : affiches et produits pour des groupes de rock et de métal, ainsi qu'interprétations personnelles de fan art. Il réside et exerce actuellement à Le Cap.

Gravity, 2016
Vini Vici, poster; digital

opposite
Tattoodles, 2018
Personal work, print; digital

p. 198
The Eighth Merchant, 2018
Beer label; digital

Hungry Ghosts, 2018
Ohgod, merchandising; digital

right
Zero Division, 2017
Jeandré Viljoen, album cover; digital

opposite
Intergalactic, 2017
Marie & Boone, book cover; digital

"I'm optimistic to the point of it being kind of silly."

ROBIN EISENBERG

WWW.ROBINEISENBERG.COM · @robineisenberg

Los Angeles native Robin Eisenberg is one of those inherently obsessive creatives who have managed to turn a doodling compulsion into a successful profession. Born in 1983, she grew up in Eagle Rock and Glendale, California, on a staple diet of pop culture and sci-fi TV. A talented pianist, she was awarded a jazz scholarship to study at San Diego State University, which she forfeited by skipping class to get her drawing fix. She later switched to English, receiving her bachelor's in 2007, though it wasn't until 2010 that Eisenberg would finally begin to transform her lifelong hobby into a career. Whilst touring as keyboardist for indie-pop band Crocodiles, she found herself living in Berlin on an artist visa, and designing album covers for other bands. In an interview she once described her work as "a weird neon dream about alien babes, junk food, solitude, and space." Indeed, women outnumber men by ten to one in her compositions—assertive, pizza-munching skate chicks and mermaids who inhabit a brightly colored,

Die 1983 in Los Angeles geborene Robin Eisenberg ist eine dieser von Natur aus besessenen Kreativen, die es geschafft haben, ihren Drang zu kritzeln zu einem erfolgreichen Beruf zu machen. Sie wuchs in Eagle Rock und Glendale (Kalifornien) auf. Als ihre kreativen Grundnahrungsmittel gibt sie Popkultur und Sci-Fi-TV an. Als talentierte Pianistin erhielt sie ein Jazz-Stipendium an der San Diego State University, das sie jedoch verlor, weil sie den Unterricht schwänzte, um zu zeichnen. Später wechselte sie zum Studienfach Englisch und erhielt hierfür ihren Bachelor 2007. Erst 2010 sollte sie damit beginnen, ihr lebenslanges Hobby in eine Karriere zu verwandeln. Auf einer Tournee als Keyboarderin der Indie-Pop-Band Crocodiles lebte sie mit einem Künstlervisum in Berlin und entwarf Albencover für andere Bands. In einem Interview bezeichnete sie ihre Arbeit einmal als „einen seltsamen Neon-Traum über außerirdische Babes, Junkfood, Einsamkeit und den Weltraum". In der Tat überwiegen Frauen gegenüber

Originaire de Los Angeles, Robin Eisenberg est l'une de ces créatives de nature obsessive qui a su convertir des envies compulsives de griffonnage en une réussite professionnelle. Née en 1983, elle a grandi à Eagle Rock et Glendale, en Californie, abreuvée de programmes télévisés de science-fiction et de culture pop. Pianiste de talent, elle a obtenu une bourse pour étudier le jazz à l'université de San Diego, qu'elle a fini par perdre en raison de ses absences pour se former en dessin. Elle a ensuite décroché en 2007 une licence en langue anglaise mais ce n'est qu'en 2010 qu'Eisenberg a finalement commencé la mutation de son hobby de toujours en carrière. Pendant les tournées avec le groupe indie pop Crocodiles dont elle était claviériste, elle a vécu à Berlin avec un visa d'artiste et conçu des pochettes d'albums pour d'autres groupes. Lors d'un entretien, elle a une fois décrit son travail comme « un étrange rêve en fluo de canons extraterrestres, de malbouffe, de solitude et d'espace ». Les femmes sont en effet

space-pop landscape. Eisenberg's vision has attracted some memorable collaborations, including with Vans, and *Thrasher* magazine. Other notable works include GIF animations for Canadian rapper Drake's *More Life* (2017) playlist on Apple Music through Tumblr Creatrs, and in 2018 she created the artwork for, and co-directed (with Kris Baldwin), the animated music video for British singer Chelou's single, "Out of Sight." She spends most of her time at her desk and, when not working on commissions, turns her visual musings into enamel pins, stickers, and zines.

Männern in einem Verhältnis von zehn zu eins in ihren Kompositionen, die durchsetzungsfähige, Pizza fressende Skate-Chicks und Meerjungfrauen in bunten Weltraum-Pop-Landschaften bevölkern. Eisenbergs Vision hat zu einigen denkwürdigen Kollaborationen geführt, unter anderem mit Vans und dem *Thrasher*-Magazin. Andere bemerkenswerte Arbeiten umfassen GIF-Animationen für die Playlist *More Life* (2017) des kanadischen Rappers Drake auf Apple Music und Tumblr Creatrs, und 2018 kreierte sie das Artwork und führte Co-Regie (mit Kris Baldwin) für das animierte Musikvideo für die Single „Out of Sight" des britischen Sängers Chelou. Die meiste Zeit verbringt sie an ihrem Schreibtisch, und wenn sie nicht an Aufträgen arbeitet, verwandelt sie ihre visuellen Träumereien in Emaille-Pins, Aufkleber und Zines.

dix fois plus nombreuses que les hommes dans ses compositions : des filles qui font du skate et dévorent de la pizza, ou des sirènes qui vivent dans un paysage spatial pop et bariolé. La vision d'Eisenberg a motivé des collaborations mémorables, dont celle avec Vans et le magazine *Thrasher*. Elle a signé d'autres œuvres phares comme des animations GIF à l'aide de Tumblr Creatrs pour la liste de lecture *More Life* du rapper canadien Drake (2017) sur Apple Music. Et en 2018, elle a créé et codirigé (avec Kris Baldwin) le clip animé pour le single « Out of Sight » du chanteur britannique Chelou. Elle passe la plupart de son temps à sa table de travail et quand elle ne se consacre pas à des commandes, elle transpose ses pensées dans des broches, des peintures et des fanzines.

ROBIN EISENBERG

Untitled, 2018
Personal work; digital

right
Out of Sight, 2018
Chelou, album cover; digital

opposite
Untitled, 2019
Personal work; digital

p. 204
Untitled, 2018
Vans; digital

Untitled, 2018
Personal work; digital

right
Untitled, 2018
Personal work; digital

opposite
Untitled, 2018
Personal work; digital

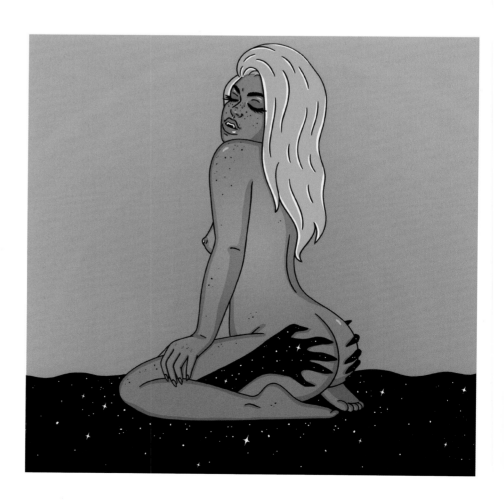

ROBIN EISENBERG

> "I believe that in creativity it's important to be able to observe the social and cultural surroundings, and to translate that information into art with honesty and simplicity."

for *Fashion Africa Now*

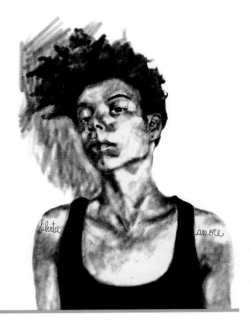

DIANA EJAITA

WWW.DIANAEJAITA.COM · @dianaejaita

Born in Cremona, Italy, in 1985, to an Italian mother and Nigerian father, today Diana Ejaita is an illustrator and textile designer based in Berlin. Her work references symbols and ideograms from the ancient Nsibidi system indigenous to southeast Nigeria—a decorative script associated with rituals and secret male societies—and the wisdom symbols of Adinkra, which originated in Ghana. Her practice is staunchly feminist and, as well as critiquing a range of themes from identity, race, and gender, also celebrates cultural diversity. Ejaita's distinctive images reveal a fascinating interplay between sharp, contrasting black-and-white spaces and soft organic forms. Elements are overlaid and patterns are repeated, creating an almost abstract illusory effect. Her process involves making stamps by engraving on wood, painting, and silkscreen printing. Ejaita grew up traveling with her family, with periods of study in both France and Germany. In 2014, she established her own ethical fashion and textile brand

Diana Ejaita wurde 1985 in Cremona (Italien) als Tochter einer italienischen Mutter und eines nigerianischen Vaters geboren. Heute lebt sie als Illustratorin und Textildesignerin in Berlin. Ihre Arbeit nimmt Bezug auf Symbole und Ideogramme des alten Nsibidi-Systems, das im Südosten Nigerias beheimatet ist — eine dekorative Schrift, die mit Ritualen und geheimen männlichen Gesellschaften verbunden ist — und die Adinkra-Symbole der Weisheit, die ihren Ursprung in Ghana haben. Ihre Praxis ist konsequent feministisch und beschäftigt sich kritisch mit verschiedenen Themen wie Identität, Rasse und Geschlecht, feiert aber auch die kulturelle Vielfalt. Ejaitas unverkennbare Bilder zeigen ein faszinierendes Spiel zwischen strengen, kontrastierenden schwarz-weißen Räumen und weichen organischen Formen. Elemente werden überlagert und Muster wiederholt, was einen fast abstrakten illusorischen Effekt erzeugt. Zu ihrer Arbeit gehören die Herstellung von Stempeln durch das Gravieren auf Holz, die

Née dans la ville de Crémone en 1985, d'une mère italienne et d'un père nigérien, Diana Ejaita est aujourd'hui une illustratrice et créatrice textile installée à Berlin. Son travail fait référence aux symboles et idéogrammes de l'ancien système nsibidi indigène du Sud-Est du Nigeria, une écriture décorative associée à des rites et des sociétés masculines secrètes, ainsi qu'aux symboles visuels Adinkra originaires du Ghana. Sa pratique est résolument féministe et outre son approche critique d'une série de thèmes comme l'identité, la race et le genre, elle rend hommage à la diversité culturelle. Les images distinctives d'Ejaita offrent un jeu intéressant entre des zones en noir et blanc et des formes organiques. Les éléments sont superposés et les motifs se répètent, ce qui crée un effet illusoire frôlant l'abstraction. Elle a recours à des tampons en bois gravé qu'elle fabrique, ainsi qu'à la peinture et à la sérigraphie. Dans son enfance, Ejaita a beaucoup voyagé avec sa famille et elle a étudié en France et en Allemagne.

WearYourMask. Ejaita's work has appeared in a variety of publications, including covers for the *World Policy Journal* and feminist culture magazine *Bitch*. In 2017, she participated in an artist-in-residence program with Waaw in Saint-Louis, Senegal, where she exchanged printmaking workshops with local artisans.

Malerei und Siebdruckverfahren. Ejaita war mit ihrer Familie viel auf Reisen und studierte in Frankreich und Deutschland. 2014 gründete sie ihre eigene ethisch handelnde Mode- und Textilmarke Wear-YourMask. Ihre Arbeiten sind in verschiedenen Publikationen erschienen, zum Beispiel auf Covern für das *World Policy Journal* und das feministische Kulturmagazin *Bitch*. 2017 nahm sie an einem Artist-in-Residence-Programm in Waaw in Saint-Louis (Senegal) teil, wo sie gemeinsam mit lokalen Kunsthandwerkern Druckgrafik-Workshops durchführte.

En 2014, elle a créé sa propre marque éthique de mode et textile nommée WearYourMask. Son travail est paru dans une variété de publications, dont des couvertures pour *World Policy Journal* et le magazine culturel féministe *Bitch*. En 2017, elle a pris part à un programme d'artistes en résidence avec Waaw à Saint-Louis, au Sénégal, où elle a échangé des ateliers d'estampe avec les artisans locaux.

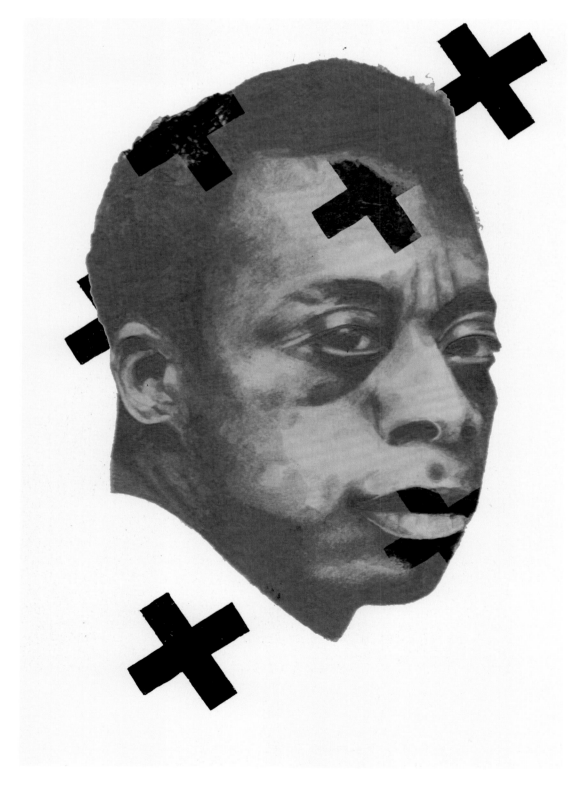

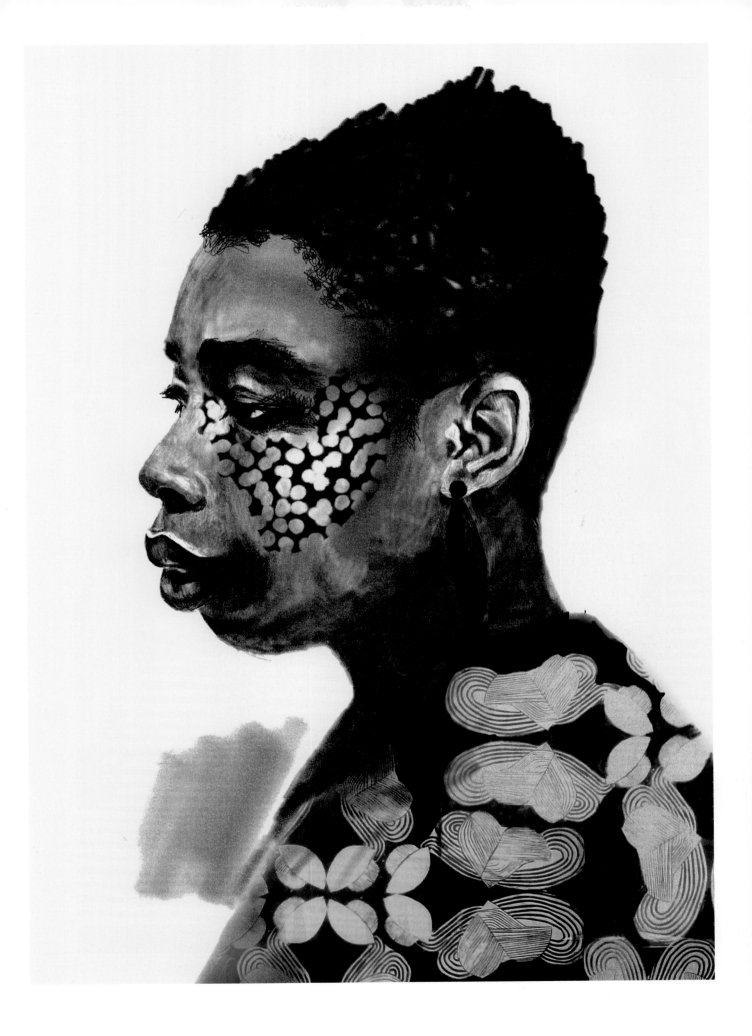

Untitled, 2016
Personal work, digital

opposite
Baldwin's Speech, 2017
Migrate magazine; pencil, silkscreen

p. 210
Barbagianni, 2018
Erri Spotti, by Anna Mori, book; pencil, digital

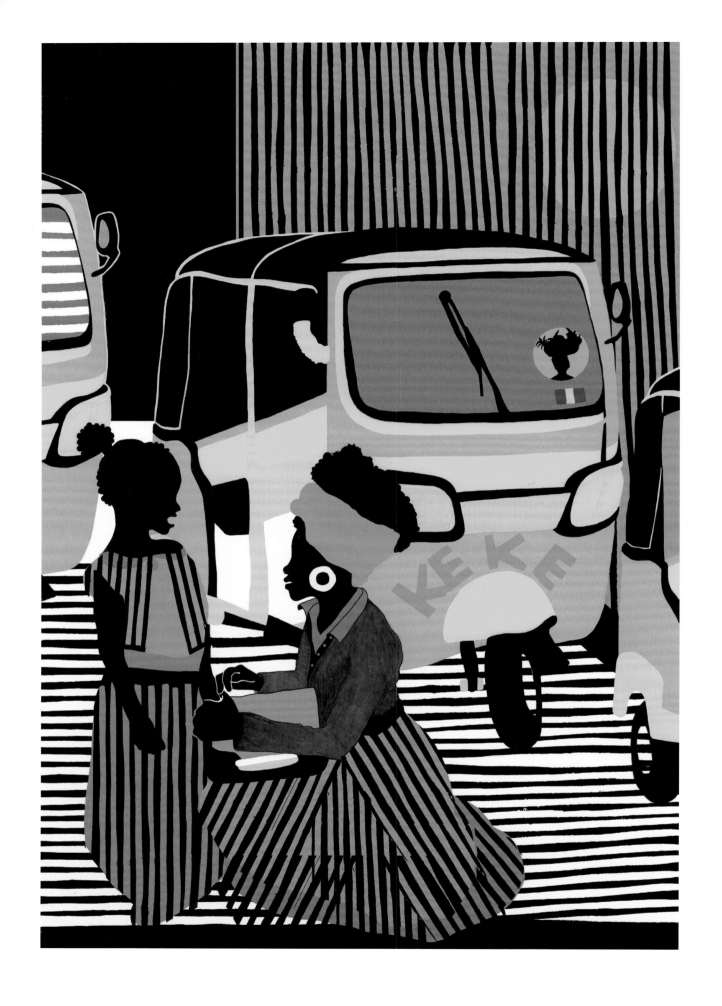

Selected Exhibitions: 2018, *Conversation with Tutola's Legacy*, solo show, Lukelule, Hamburg · 2018, *Appear*, group show, Kunstschule Krabax, Hamburg · 2017, *Fleuve en couleur*, solo show, H. la Residence, Saint Louis, Senegal · 2017, *Design Biennale*, group show, Old Botanic Garden, Zurich · 2016, *Wicaf*, group show, Art Basel, Brussels

Selected Publications: 2018, *Missy Magazine*, Germany · 2018, *Migrate Magazine*, South Africa · 2018, *Aristide*, Switzerland · 2018, *Erri Spotti*, libro.it, Italy · 2018, *Devotion*, Bitch Media, USA

Untitled, 2016
Personal work; silkscreen

right
Amos Tutuola, 2018
Personal work; linocut, digital

opposite
Iya Ni Wura (Mother Is Gold), 2019
The New Yorker, magazine cover;
linocut, digital

> "My work consists of all the colors and power of Latin-American folklore, refined with a subtle touch of European sophistication."

CATALINA ESTRADA

WWW.CATALINAESTRADA.COM · @catalinaestrada

Born in Medellín, Colombia, in 1974, artist-illustrator Catalina Estrada Uribe has been based in Barcelona since 1999. As a child, she would roam the countryside in a reverie and fill up boxes of images taken from labels, tags, and magazine cut-outs. She went on to study graphic design at the Pontifical Bolivarian University in Medellín, receiving an honors degree in 1998. After working in her qualified field for a number of years, she switched to illustration in 2005. This breakthrough year saw her visual interpretation of "Aladdin and the Wonderful Lamp" published in a 16-illustrator anthology of *1001 Nights: Illustrated Fairy Tales from One Thousand And One Nights*. In addition, she was featured as a new talent in both *Communication Arts* and *Computer Arts* magazines. "My heart needs rhythm, my mind needs harmony and my soul needs color," exclaims Estrada on her website, with a passion that courses through her visual work. Inspired by the natural world, her ability to reimagine the folkloric traditions of Latin America in a kaleidoscope

Die Künstlerin und Illustratorin Catalina Estrada Uribe wurde 1974 in Medellín, Kolumbien, geboren und lebt seit 1999 in Barcelona. Als Kind streifte sie träumend durch die Landschaft und füllte Kisten mit Bildern, die von Etiketten, Schildern und aus Zeitschriften stammten. Später studierte sie an der Päpstlichen Bolivianischen Universität in Medellín Grafikdesign und machte 1998 ihren Abschluss mit Auszeichnung. Nachdem sie einige Jahre in ihrem erlernten Bereich gearbeitet hatte, wechselte sie 2005 zur Illustration. In diesem Durchbruchjahr entstand ihre visuelle Interpretation von „Aladin und die Wunderlampe", veröffentlicht in einer Anthologie mit 16 Illustratoren in *1001 Nights: Illustrated Fairy Tales from One Thousand And One Nights* (1001 Nächte: Illustrierte Märchen aus Tausendundeiner Nacht). Darüber hinaus wurde sie als neues Talent in den Zeitschriften *Communication Arts* und *Computer Arts* vorgestellt. „Mein Herz braucht Rhythmus, mein Geist braucht Harmonie, und meine Seele

Née à Medellín en 1974, l'artiste et illustratrice Catalina Estrada Uribe vit depuis 1999 à Barcelone. Enfant, elle aimait vagabonder à la campagne, plongée dans sa rêverie, et remplissait des boîtes d'images récupérées d'emballages, d'étiquettes et de magazines. Elle a suivi des études de design graphique à l'université pontificale bolivarienne de Medellín et décroché en 1998 son diplôme avec les honneurs. Après avoir travaillé dans son domaine de qualification pendant plusieurs années, elle est passée à l'illustration en 2005. Cette même année déterminante, son interprétation visuelle de « Aladin ou la lampe merveilleuse » a été publiée dans une anthologie de 16 illustrateurs intitulée *1001 Nights: Illustrated Fairy Tales from One Thousand And One Nights*. Elle a par ailleurs été présentée comme nouveau talent dans les magazines *Communication Arts* et *Computer Arts*. « Mon cœur a besoin de rythme, mon esprit a besoin d'harmonie et mon âme a besoin de couleur », déclare-t-elle sur son site Web, avec une passion qui

of color and symmetry has resulted in mesmerizing optical creations for brands such as Brazilian fashion label Anunciação, packaging for Shakira's fragrance, and digital murals for Starbucks. Estrada works exclusively with digital media for commercial projects and uses paints for her fine art.

braucht Farbe", schreibt Estrada auf ihrer Website mit einer Leidenschaft, die sich durch ihre gesamte visuelle Arbeit zieht. Inspiriert von der Natur, hat ihre Fähigkeit, die folkloristischen Traditionen Lateinamerikas in einem Kaleidoskop aus Farbe und Symmetrie neu zu interpretieren, faszinierende optische Kreationen für Marken hervorgebracht, wie zum Beispiel die Verpackung für Shakiras Parfum für das brasilianische Modelabel Anunciação und digitale Wände für Starbucks. Estrada arbeitet ausschließlich mit digitalen Medien für ihre kommerziellen Projekte und verwendet Farbe für ihre bildende Kunst.

s'infiltre dans l'ensemble de son travail visuel. Puisant son inspiration dans la nature, elle est capable de réinventer les traditions folkloriques d'Amérique latine dans un kaléidoscope de couleurs et de symétries, ce qui l'a conduite à produire des créations optiques captivantes pour des projets comme le label de mode brésilien Anunciação, l'emballage du parfum de Shakira et des peintures murales numériques pour Starbucks. Estrada emploie exclusivement des outils numériques pour ses projets commerciaux et a recours à la peinture pour ses créations artistiques.

Tiger-jungle, 2018
Coordonné, wallpaper;
drawing, vector;
photography: Sandra Rojo;
art direction: Helena Agustí

opposite
Peking Duck, 2017
Personal work; drawing, vector

p. 216
Jungle at Night, 2015
Arrels Barcelona; drawing, vector

CATALINA ESTRADA

São Jorge, 2018
Anunciação, fashion collection;
drawing, vector

right
Guacamayas, 2015
Arrels Barcelona; drawing, vector

opposite
Jaguares, 2015
Museo de Arte Moderno de Medellín,
bags, cups, wallets; drawing, vector

CATALINA ESTRADA

Pheasants, 2015
Personal work; drawing, vector

opposite
Font Vella, 2016
Special edition label; drawing, vector

CATALINA ESTRADA

Selected Exhibitions: 2013, *Sala a cielo abierto*, solo show, Museo de Arte Moderno Medellín · 2009, *Desarmando sueños*, solo show, Iguapop Gallery, Barcelona · 2007, *Sweet Company*, solo show, La Luz de Jesus Gallery, Los Angeles · 2006, *No me quieras matar corazón*, solo show, Iguapop Gallery, Barcelona · 2005, *Once Upon a Time*, solo show, Roa La Rue Gallery, Seattle

Selected Publications: 2013, *100 Illustrators*, TASCHEN, Germany · 2013, *A Life in Illustration*, Gestalten, Germany · 2008, *12 Exceptional European Illustrators*, *Print* magazine, USA · 2007, *Illusive*, Gestalten, Germany

NIL
BY
MOUTH

> "There is definitely religious symbolism running throughout my work. I am both mocking religion and at the same time embracing certain aspects of its spiritual teachings." *for Tiny Pencil*

JOE FENTON

WWW.JOEFENTONART.COM · @jfentonart

Joe Fenton is a British artist noted for his large-scale surrealist, monochrome drawings using graphite, ink, acrylics, oils on paper, canvas, and other media. Born in Hampstead, London, in 1971, he grew up in Bath, London, and Southern Spain. He received a BA (Hons) in Sculpture from Wimbledon College of Arts in 2001. As well as being an illustrator, Fenton has worked in the film industry as a special effects sculptor. Whilst living in New York he produced two award-winning children's picture books, *What's Under the Bed?* (2008) and *Boo!* (2010). Fenton received international acclaim for his large-format drawing titled *Solitude* (2011). At eight-feet wide and over five-feet high, the mixed-media work took more than ten months to produce. Fenton's work explores the recurring themes of fear and death—notions that have preoccupied his vivid imagination since childhood. An array of references, from the grotesque depictions of Hieronymus Bosch to religious symbolism from around the world, intertwine in dark, science-fiction-like

Joe Fenton ist ein britischer Künstler, der für seine großformatigen surrealistischen, monochromen Zeichnungen mit Grafit, Tusche, Acryl und Öl auf Papier, Leinwand und anderen Untergründen bekannt ist. Geboren wurde er 1971 in Hampstead (London) und wuchs in Bath, London und Südspanien auf. Er erhielt 2001 einen Bachelor (mit Auszeichnung) in Bildhauerei vom Wimbledon College of Arts. Fenton ist nicht nur Illustrator, sondern war auch als Bildhauer für Spezialeffekte in der Filmbranche tätig. Während seines Aufenthalts in New York produzierte er zwei preisgekrönte Bilderbücher für Kinder: *What's Under the Bed?* (Was ist unter dem Bett) (2008) und *Boo!* (2010). Fenton erntete internationale Anerkennung für seine großformatige Zeichnung mit dem Titel *Solitude* (2011). Die Produktion der Mixed-Media-Arbeit mit einer Größe von 2,40 x 1,50m nahm mehr als zehn Monate in Anspruch. Fentons Arbeiten untersuchen die immer wiederkehrenden Themen Angst und Tod, die seine lebhafte Fantasie seit

Joe Fenton est un artiste britannique apprécié pour ses dessins monochromes et surréalistes de grandes dimensions, qu'il réalise au crayon graphite, à l'encre, à la peinture acrylique et à l'huile sur papier et sur toile, entre autres supports. Né en 1971 dans le quartier londonien de Hampstead, il a grandi à Bath et dans le sud de l'Espagne. En 2001, il a obtenu avec les honneurs une licence en sculpture au Wimbledon College of Arts. Outre son activité d'illustrateur, Fenton a travaillé dans l'industrie cinématographique en tant que concepteur d'effets spéciaux. Pendant ses années à New York, il a produit deux livres d'images pour enfants qui ont été primés : *What's Under the Bed?* (2008) et *Boo!* (2010). Avec son dessin grand format intitulé Solitude (2011), il s'est fait un nom sur la scène internationale, une œuvre mixte de 2,5 mètres de large et 1,5 mètre de haut qui lui a demandé dix mois de réalisation. Le travail de Fenton tourne autour des thèmes récurrents de la peur et de la mort qui hantent son imagination fertile

scenes populated by eyeball-headed aliens, often framed in ornate, European Baroque-style borders. Fenton has also produced designs for guitars and directed short films tracing his creative process. Favoring the control of pencil—he does not employ any digital media—as well as the depth achieved by layering with acrylics and inks, Fenton's images are both arresting and provocative.

seiner Kindheit beschäftigt haben. Eine Reihe von Referenzen, von Hieronymus Boschs grotesken Darstellungen, bis hin zur religiösen Symbolik aus aller Welt, verflechten sich in dunklen, Science-Fiction-ähnlichen Szenen, die von Augapfelköpfigen Außerirdischen bevölkert werden, oft eingerahmt von kunstvollen Bordüren im europäischen Barockstil. Fenton hat auch Designs für Gitarren entworfen und Regie bei Kurzfilmen geführt, die seinen kreativen Prozess nachzeichnen. Fenton bevorzugt den Stift – er verwendet keine digitalen Medien. Die Tiefe, die durch das Aufeinanderschichten von Acrylfarbe und Tusche erzielt wird, verleiht seinen Bildern einen fesselnden und provozierenden Charakter.

depuis l'enfance. Diverses références, des représentations grotesques de Jérôme Bosch au symbolisme religieux du monde entier, s'entremêlent dans des scènes sombres et aux allures de science-fiction, remplies d'extraterrestres avec un globe oculaire en guise de tête et souvent encadrées de bordures de style baroque. Fenton a également signé des décorations pour guitares et réalisé des courts-métrages expliquant son processus de création. Il préfère manier le crayon et n'emploie aucun outil numérique, cherchant à créer une profondeur par des couches de peinture acrylique et d'encre pour obtenir des images saisissantes et provocantes.

The Arrivals, 2016
Personal work;
hand drawing on paper

opposite
Love Me Not, 2016
Personal work;
hand drawing on paper

p. 224
The Landing Triptych, 2016
Personal work;
hand drawing on paper

Solitude, 2011
Personal work; acrylic, gouache,
ink, and graphite on paper

Selected Exhibitions: 2016, *The Art of Joe Fenton*, solo show, London International Tattoo Convention, London · 2016, *The Guillermo del Toro Art Show*, group show, Gallery 1988, Los Angeles · 2015, *Giants Among Us*, group show, Corey Helford Gallery, Los Angeles · 2013, *Attention Earth*, group show, Strychnin Gallery, Berlin · 2011, *Russell Simmon's Bombay Sapphire Artisan Series*, group show, Art Basel, Miami

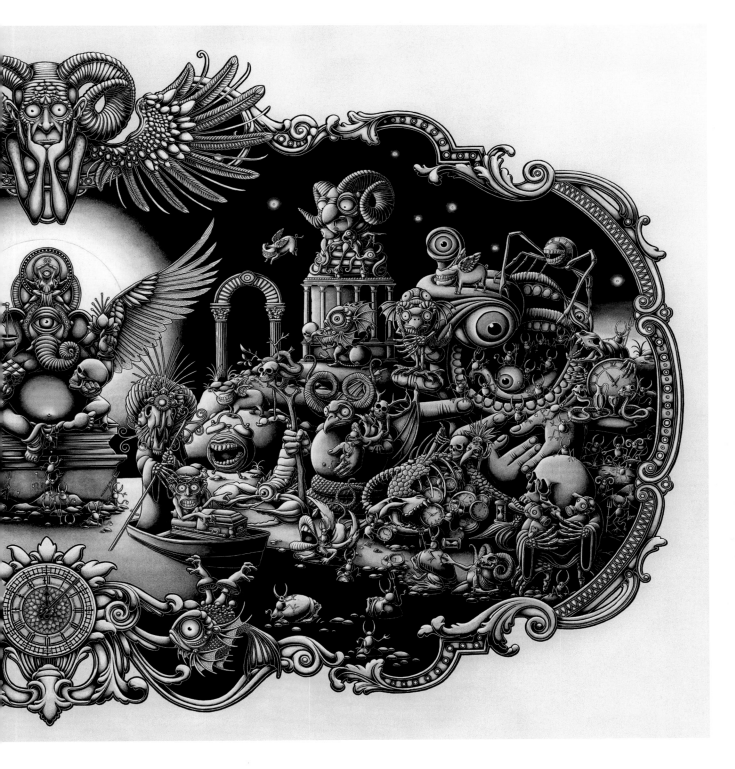

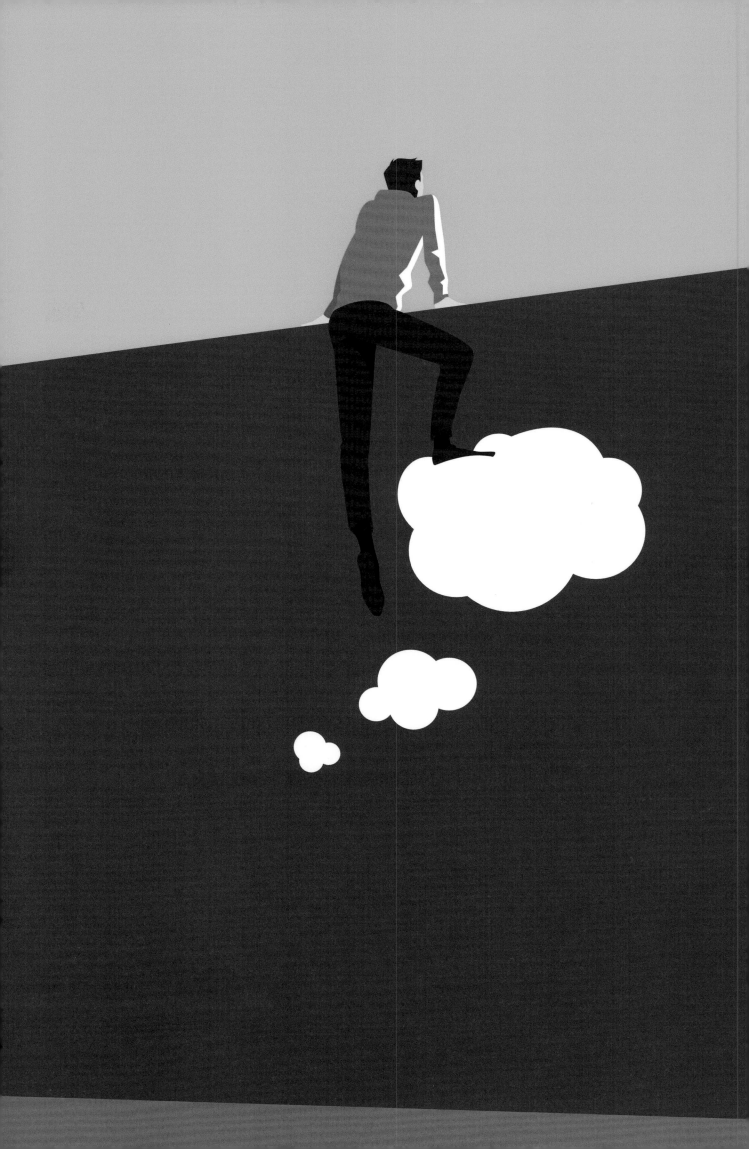

"That was always my goal: to voice an opinion, not with Twitter but with a picture. Now that people take my image and make it theirs, because we share the same ideals and the same opinion, it's the best thing ever." for *Mic*

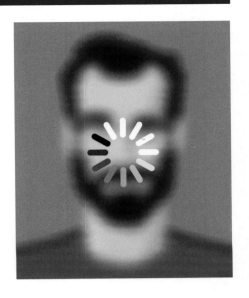

LENNART GÄBEL

WWW.LENNARTGAEBEL.COM · @lennartgaebel

Lennart Gäbel was born in Hanover, Germany, in 1981. After initially studying economics, followed by a period working for marketing and advertising agencies, he became disgruntled, moved to the Netherlands, and commenced studies in illustration at the Minerva Art Academy, Groningen, before attending the Willem de Kooning Academy in Rotterdam and then the School of Visual Arts in New York. Gäbel's studio is now located in a shared hall in the Schanzenviertel quarter of Hamburg, where he combines an "analog" practice of freehand illustration using ink, oil, and watercolor, with a Wacom tablet and MacBook for "digital" work. Often inspired by news and current affairs, his output encompasses a broad mixture of editorial and commercial illustration. His work has appeared on the cover of *Amnesty International* magazine and featured as wallpaper on WeTransfer. Other clients of his include *Der Spiegel*, *Playboy*, *The Huffington Post*, Samsung, and Tommy Hilfiger.

Lennart Gäbel wurde 1981 in Hannover geboren. Nachdem er zunächst Wirtschaftswissenschaften studiert hatte, gefolgt von einer Zeit in Marketing- und Werbeagenturen, wurde er unzufrieden, zog in die Niederlande und studierte Illustration an der Minerva Art Academy in Groningen, bevor er die Willem de Kooning Akademie in Rotterdam und die School of Visual Arts in New York besuchte. Gäbels Atelier befindet sich heute in einer gemeinschaftlich genutzten Halle im Hamburger Schanzenviertel. Dort kombiniert er die „analoge" Arbeit der Freihandillustration in Tusche, Öl und Aquarellfarben mit einem Wacom-Tablet und einem MacBook für die „digitale" Arbeit. Inspiriert von Nachrichten und aktuellen Ereignissen, umfasst sein Output eine breite Mischung aus Editorial und Werbung. Seine Arbeit erschien auf dem Cover des *Amnesty-International*-Magazins und war Hintergrundbild bei WeTransfer. Andere Kunden sind zum Beispiel *Der Spiegel*, *Playboy*, *The Huffington Post*, *Samsung* und Tommy

Lennart Gäbel est né à Hanovre en 1981. Après des études d'économie, puis une période à travailler dans des agences de marketing et de publicité, il a ressenti une insatisfaction : il s'est alors rendu aux Pays-Bas pour étudier l'illustration à l'académie Minerva de Groningue, avant de s'inscrire à la Willem de Kooning Academy à Rotterdam, puis à la School of Visual Arts à New York. Le studio de Gäbel se trouve aujourd'hui dans un espace partagé dans le quartier de Schanzenviertel de Hambourg. Il combine une pratique « analogique » d'illustration à main levée à l'encre, la peinture à l'huile et l'aquarelle, et l'utilisation d'une tablette Wacom et d'un MacBook pour les tâches « numériques ». S'inspirant de l'actualité, il réalise une variété de projets dans les domaines éditorial et commercial. Son travail est paru en couverture du magazine *Amnesty International* et comme fond d'écran sur le site WeTransfer. Parmi ses autres clients, il compte *Der Spiegel*, *Playboy*, *The Huffington Post*, Samsung et Tommy Hilfiger.

Gäbel's political cartoons earned him a German Art Directors Club Award in 2017.

Hilfiger. Für seine politischen Cartoons erhielt Gäbel 2017 den Preis des deutschen Art Directors Club.

Ses caricatures politiques ont remporté en 2017 un prix de l'Art Directors Club Allemagne.

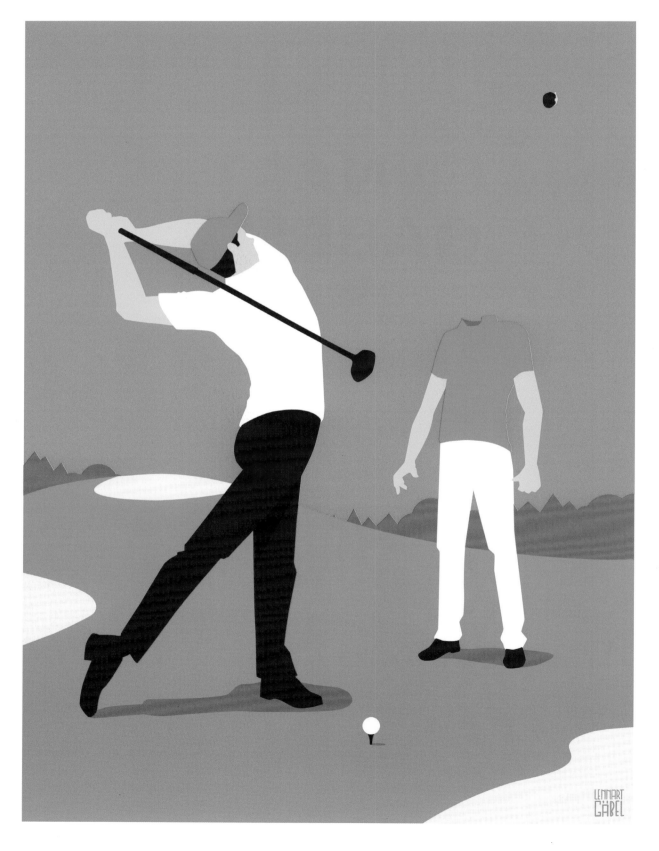

LENNART GÄBEL

(Merkel's) End Times, 2018
Der Spiegel, magazine cover; digital;
art direction: Katja Kollmann

right
Turkey, 2017
Personal work, exhibition; digital

opposite
Law 15: Crush Your Enemy Totally, 2016
Personal work, exhibition; digital

p. 230
Creativity, 2019
Harvard Business Manager,
magazine; digital;
art direction: Judith Mohr

LENNART GÄBEL

Selected Exhibitions: 2018, *NYC*, solo show, Zurück zum Glück, Hannover · 2018, *World Illustration Award*, group show, Somerset House, London · 2017, *ADC Award Germany*, group show, Museum der Arbeit, Hamburg · 2017, *World Illustration Award*, group show, Somerset House, London · 2016, *Stimmt's?*, solo show, Projektor, Hamburg

Selected Publications: 2018, *Signs of Resistance*, Artisan, Bonnie Siegler, USA · 2018, *World Illustration Award Catalogue*, Association of Illustrators, United Kingdom · 2017, *Resist! Vol. II*, Françoise Mouly & Nadja Spiegelman, USA · 2016, *IO Setbook*, Illustratoren Organisation, Germany · 2016, *Read* magazine, Radar Hamburg, Germany

Escapade, 2017
Playboy, magazine; digital;
art direction: Stefan Müller

opposite top
WhatsApp Spam, 2016
Bento, *Spiegel Online*; digital

opposite bottom
New Year's Eve, 2017
Bento, *Spiegel Online*; digital

> "I try to achieve a balanced mixture of delicacy and forcefulness."

CARMEN GARCÍA HUERTA

WWW.CGHUERTA.COM · @carmen_garcia_huerta

Carmen García Huerta is one of Spain's most renowned illustrators. Born in Madrid in 1975, she went on to study advertising and PR at the Complutense University of Madrid, gaining a bachelor's degree in 1999. She spent her early career working in the communications sector before moving into fashion illustration in 2001. Her work has graced the style pages of news publications like *El País* and high-end fashion magazines like *Vanidad*. Her clientele ranges from high-profile agencies such as Publicis Dialog Paris and Custo Barcelona to fashion labels Roberto Verino and Louis Vuitton. Her subjects include glamorous, sophisticated, and sexy women and men, and stylized arrangements of flora and fauna. She cites Louise Bourgeois as an inspiration and philosophizes on fashion in sociological terms—as an industry, a sense of design, material, trend, and attitude. She translates these complexities and intangibilities through a duality of styles, either stylized chic for commissioned works or minimalist reductions.

Carmen García Huerta ist eine der renommiertesten Illustratorinnen Spaniens. Geboren wurde sie 1975 in Madrid. Sie studierte Werbung und PR an der Complutense-Universität in Madrid und erlangte dort 1999 einen Bachelor-Abschluss. Ihre Karriere begann zunächst in der Kommunikationsbranche, bevor sie 2001 zur Modeillustration wechselte. Ihre Arbeiten zierten die Stilseiten von Nachrichtenmagazinen wie *El País* und High-End-Modemagazinen wie *Vanidad*. Zu ihren Kunden zählen namhafte Agenturen wie Publicis Dialog Paris und Custo Barcelona, wie auch die Modelabels Roberto Verino und Louis Vuitton. Ihre Themen sind glamouröse, anspruchsvolle und sexy Frauen und Männer sowie stilisierte Arrangements aus Flora und Fauna. Sie gibt Louise Bourgeois als ihre Inspiration an und philosophiert über Mode in soziologischer Hinsicht – als eine Industrie, ein Gefühl für Design, Material, Trend und Haltung. Sie übersetzt diese Komplexität und Nichtgreifbarkeit in eine Dualität von

Carmen García Huerta est l'une des illustratrices les plus réputées d'Espagne. Née à Madrid en 1975, elle a suivi des études de publicité et de relations publiques à l'université Complutense de Madrid où elle a obtenu une licence en 1999. Sa carrière a débuté dans le secteur de la communication, avant de passer à l'illustration de mode en 2001. Son travail a orné les pages de journaux comme *El País* et de magazines de mode haut de gamme comme *Vanidad*. Sa clientèle inclut des agences en vue comme Publicis Dialog Paris et des labels de mode comme Custo Barcelone, Roberto Verino et Louis Vuitton. Ses sujets sont des femmes et des hommes chics, sophistiqués et sexy dans des compositions stylisées de flore et de faune. Elle cite Louise Bourgeois comme source d'inspiration et philosophe sur la mode en termes sociologiques, comme industrie, concept de design, matière, tendance et attitude. Pour traduire ces complexités et intangibilités, elle obéit à une dualité de styles, entre

Lines and brushstrokes create languid contours that accentuate her subject's expressions; marbled hues fade into each other, and fabrics fold. The Madrileña artist's work has featured in gallery exhibitions as far and wide as Shanghai and Tel Aviv, and has adorned notebooks and album covers.

Stilen, entweder stilisierter Chic für Auftragsarbeiten oder minimalistische Reduktion. Linien und Pinselstriche erzeugen schwache Konturen, die den Ausdruck des Motivs betonen; marmorierte Farbtöne verblassen ineinander, und Stoffe falten sich. Das Werk der Künstlerin aus Madrid war bislang in Galerie-Ausstellungen von Schanghai bis Tel Aviv zu sehen, und sie hat Notizbücher und Albumcover verziert.

sophistiqué pour les commandes qu'elle reçoit et minimaliste pour le reste. Les lignes et les coups de pinceau tracent des contours langoureux pour souligner les expressions du sujet, des teintes marbrées se fondent entre elles et des tissus se plient. Le travail de l'artiste madrilène a été exposé dans des galeries, arrivant jusqu'à Shanghai et Tel Aviv, et a agrémenté des carnets et des pochettes.

CARMEN GARCÍA HUERTA

Makech Collection, 2018
Suarez Jewellery, shop
displays and windows;
color pencil, digital

opposite
Adele, 2016
Revista Sábado, magazine,
El País newspaper;
color pencil, digital

p. 236
The Year of the Dog, 2018
El Corte Inglés, advertising;
color pencil, digital

Selected Exhibitions: 2018, *Dionaea Muscipula,* solo show, La Fábrica, Madrid · 2018, *Gabinete Art Fair,* group show, Centro Cultural de la Villa, Madrid · 2017, *Decodé,* group show, We Crave Design, Madrid · 2016, *Aliadas,* group show, Centro Cibeles, Madrid · 2014, *Tres de 100,* group show, Ministerio de Asuntos Importantes, Madrid

Selected Publications: 2014, *100 Illustrators,* TASCHEN, Germany · 2013, *Fashion Illustration Now!,* TASCHEN, Germany · 2010, *The Beautiful,* Gestalten, Germany · 2007, *Fashion Unfolding,* Victionary, Hong Kong · 2005, *It's a Matter of Illustration,* Victionary, Hong Kong

CARMEN GARCÍA HUERTA

Black Power, 2017
Vein, magazine;
graphite pencil

opposite
Gufa para el fan de
Madonna, 2016
Revista Sábado, magazine,
El País newspaper;
color pencil, digital

> "My work conveys the deep sense of respect and passion I feel for the ocean through a style that is clean and intense."

DANI GARRETON

WWW.DANIGARRETON.COM · @danigarreton

Dani Garreton lives and breathes the life aquatic. Born in Santiago, Chile, in 1983, at an early age she discovered the seduction of the sea and a creative talent for making things. After high school she moved to Europe and worked in design in Hamburg before settling in the Spanish coastal city of San Sebastián in 2010. Here, she would marry her love for all things maritime with illustration. Much of Garreton's imagery focuses on the fisherman icon as a metaphor. Through facial features and expressions she evokes the "intensity and emotion" of humankind's relationship with water. It comes as no surprise that surfing and diving are also passions of the Latin American artist—both themes she has explored in her work. In collaboration with Posca pens, she created a special-edition "Poseidon" design for surf brand Ripcurl live in front of an audience in 2010. Garreton's work has been presented in group and solo shows across Europe, and her art has been sold at Christie's Green Auction in New York. She has also

Dani Garreton lebt und atmet das Leben im und am Wasser. 1983 in Santiago de Chile geboren, entdeckte sie früh die Verführung des Meeres und ein kreatives Talent für die Herstellung von Dingen. Nach dem Abitur zog sie nach Europa und arbeitete als Designerin in Hamburg, bevor sie sich 2010 in der spanischen Küstenstadt San Sebastián niederließ. Hier konnte sie ihre Liebe für alles Maritime mit der Illustration verbinden. Viele Bilder Garretons konzentrieren sich auf die Fischerikone als Metapher. Durch Gesichtszüge und Gesichtsausdrücke beschwört sie die „Intensität und Emotion" der menschlichen Beziehung zum Wasser. Kein Wunder, dass auch Surfen und Tauchen zu den Leidenschaften der lateinamerikanischen Künstlerin gehören. Beide Themen hat sie in ihrer Arbeit untersucht. In Zusammenarbeit mit Posca Pens kreierte sie 2010 eine Sonderedition „Poseidon" für die Surfmarke Ripcurl live vor Publikum. Garretons Arbeiten wurde in Gruppen- und Einzelausstellungen in ganz Europa präsentiert,

Dani Garreton vit et respire la vie aquatique. Née en 1983 à Santiago, au Chili, elle a découvert très jeune l'attrait de la mer et un talent pour créer des choses. À la fin du lycée, elle est partie en Europe et a travaillé à Hambourg dans le design avant de s'installer dans la ville balnéaire espagnole de Saint-Sébastien en 2010, où elle a uni son amour pour toutes les choses maritimes à l'illustration. Grande partie de l'imagerie de Garreton se sert de la figure du pêcheur comme métaphore. À travers les traits et les expressions du visage, elle représente « l'intensité et l'émotion » des relations de l'homme avec l'eau. Rien de surprenant à ce que cette artiste latino-américaine soit aussi passionnée de surf et de plongée, deux disciplines qui se retrouvent dans ses œuvres. En 2010, en collaboration avec les stylos Posca, elle a créé en direct, devant un public, l'édition spéciale « Poseidon » pour la marque de surf Ripcurl. Le travail de Garreton a été présenté dans des expositions collectives et individuelles en Europe, et des

received media attention through various online and TV channels like Food Network (US), and through niche culture magazines like *Huck* (UK), *Wait* (Italy), and *Desillusion* (France).

und ihre Kunst wurde bei der Christie's-Green-Auktion in New York verkauft. Sie erhielt mediale Aufmerksamkeit durch verschiedene Online und TV-Kanäle wie Food Network (US) und durch Nischen-kulturzeitschriften wie *HUCK* (UK), *Wait* (Italien) und *Desillusion* (Frankreich).

créations ont été vendues à la Green Auction de Christie's à New York. Elle a également suscité un intérêt médiatique grâce à plusieurs apparitions en ligne, sur des chaînes de télévision comme Food Network (États-Unis) et dans des magazines de culture de niche comme *HUCK* (Royaume-Unie), *Wait* (Italie) et *Desillusion* (France).

Selected Exhibitions: 2017, *Pleamar*, solo show, Tabakalera, San Sebastián · 2016, *Panthalassa*, group show, Providence Guéthary · 2014, *Sea Legend*, group show, 25 Hours Gallery, Hamburg · 2014, *Working Artisans*, group show, Huck Gallery, London · 2012, *Alamar*, solo show, Nautilus Gallery Aquarivm, San Sebastián

Selected Publications: 2018, *C41 magazine*, Vice Digital, Italy · 2017, *Mare Zeitung*, Mare Verlag, Germany · 2014, *Huck magazine*, TCO London, United Kingdom · 2013, *Bluemag*, Blue Media Network, Germany · 2012, *Lamono magazine*, Spain

Requin Bleu, 2018
Bask in the Sun,
catalogue; pencil

right
Seagull Cinco, 2016
Personal work;
pencil, acrylic

opposite
Luna en Marte, 2017
Personal work;
acrylic on wood

p. 242
Perrolobo, 2018
Salt Point, packaging,
website, merchandising

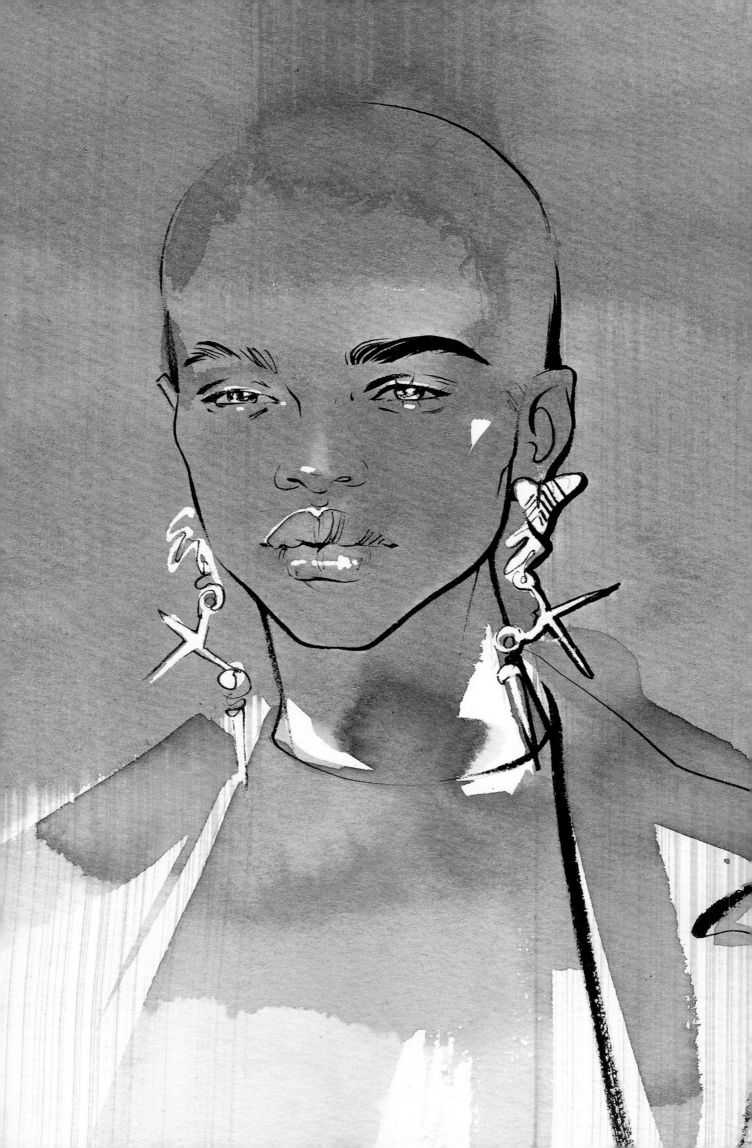

> "I have found a means of narration through blending modern fashion illustration with figurative painting. To bring illustration to life I have dropped digital images in favor of the intuitive expression through hand-painting with coal, watercolor, and acrylic."

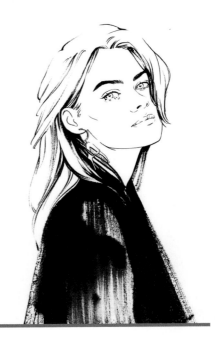

ALINA GRINPAUKA

WWW.ALINAGRINPAUKA.COM · @grinpauka

Born in Ventspils, Latvia, in 1989, Alina Grinpauka's alluring style encapsulates the progression of fashion illustration from the post-WWII era through to the present, yet with a very fresh appeal. She favors traditional techniques over digital. Watercolors and inks disperse over pencil lines and blot on paper, creating a rich contrast of shadow and light. Grinpauka lists her inspirations through such juxtapositions as "iconoclast heritage vs redefining; craftsmanship vs deconstruction; mystery vs modern elegance; conceptualism of modern art vs mundane Wednesday morning coffee." Her philosophy and research-based approach stems from her education. She graduated with a BA in Industrial Design from the Art Academy of Latvia in 2014, and prior to that studied environmental design at the Riga School of Design and Art. After freelancing as an illustrator in New York, Grinpauka returned to live and work in her native Latvia. With a growing portfolio of work to her name, including book covers for social media

Alina Grinpaukas wurde 1989 in Ventspils (Lettland) geboren. Ihr verführerischer Stil verkörpert die Entwicklung der Modezeichnung von der Nachkriegszeit bis in die Gegenwart, aber mit einem sehr frischen Ansatz. Sie bevorzugt traditionelle Techniken gegenüber den digitalen. Aquarelle und Tusche verteilen sich über Bleistiftlinien, als Farbflecken auf Papier und schaffen einen reichen Kontrast aus Licht und Schatten. Grinpauka listet ihre Inspirationen durch Gegenüberstellungen wie „Ikonoklastisches Erbe vs. Neudefinition" auf; „Handwerkskunst vs. Dekonstruktion"; „Mystik vs. moderne Eleganz"; „Konzeptualismus der modernen Kunst vs. profaner Mittwochmorgenkaffee." Ihre Philosophie und ihr forschungsbasierter Ansatz beruhen auf ihrer Ausbildung. 2014 schloss sie ihr Studium in Industriedesign an der Kunstakademie in Lettland ab, davor studierte sie Umweltdesign an der Rigaer Schule für Design und Kunst. Nachdem sie freiberuflich als Illustratorin in New York gearbeitet hat, lebt und arbeitet

Né en 1989 à Ventspils, en Lettonie, Alina Grinpauka possède un style attrayant qui résume l'évolution de l'illustration de mode de l'après-guerre à nos jours avec un charme original. Elle préfère les techniques traditionnelles à celles numériques : les aquarelles et les encres se répandent sur des lignes au crayon et tâchent le papier pour créer un jeu contrasté d'ombre et de lumière. Grinpauka dit s'inspirer de juxtapositions comme « héritage iconoclaste/redéfinition, savoir-faire/déconstruction, mystère/élégance moderne, conceptualisme de l'art moderne/café sans intérêt du mercredi matin ». Sa philosophie et sa démarche de recherche lui viennent de son éducation. En 2014, elle a décroché une licence en design industriel à l'académie des beaux-arts de Lettonie, qui est venue compléter des études de design environnemental à l'école d'art et de design de Riga. Après avoir travaillé à son compte à New York comme illustratrice, Grinpauka est rentrée vivre dans sa Lettonie natale. Son portfolio n'a

entrepreneur Mimi Ikonn and illustrated editorials for the Latvian edition of *Cosmopolitan*, Grinpauka continues to experiment with materials and evolve her style.

Grinpauka nun wieder in ihrer Heimat Lettland. Parallel zu ihrem wachsenden Portfolio an Arbeiten unter ihrem Namen, darunter Buchcover für Social-Media-Unternehmer Mimi Ikonn und illustrierte Leitartikel für die lettische Ausgabe von *Cosmopolitan,* experimentiert Grinpauka immer wieder mit Materialien und entwickelt ihren Stil weiter.

cessé de s'agrandir, avec des couvertures de livres pour Mimi Ikonn, qui gère un canal sur les réseaux sociaux, et des éditoriaux illustrés pour l'édition lettone de *Cosmopolitan.* Grinpauka ne cesse d'expérimenter avec les matériaux pour faire évoluer son style.

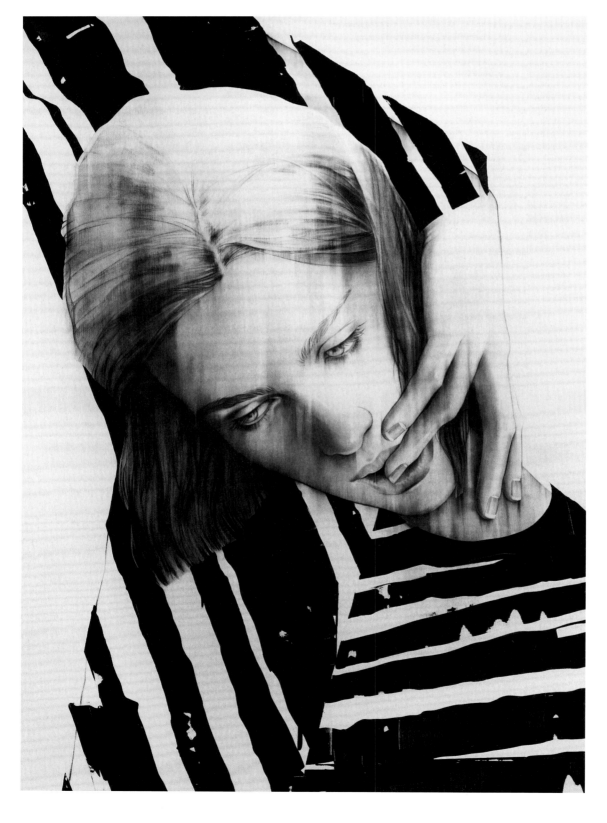

ALINA GRINPAUKA

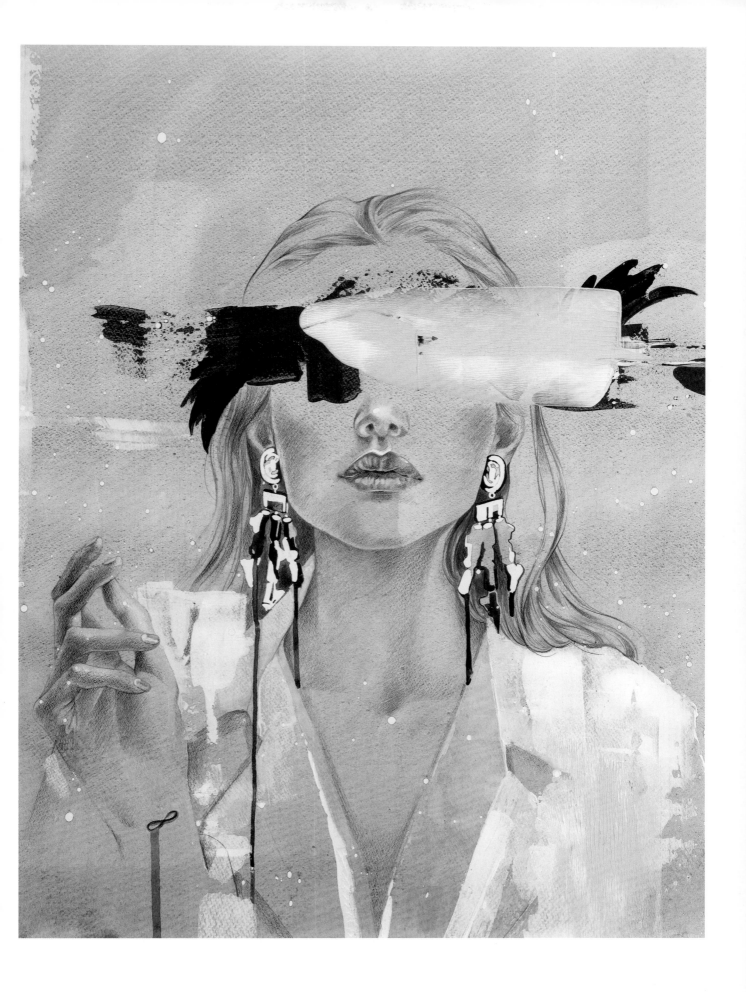

Infinity, 2016
Personal work; watercolor, acrylic

opposite
Untitled, 2017
Personal work; charcoal on canvas

p. 246
Valentino Spring/Summer 2018
Personal work; watercolor, ink

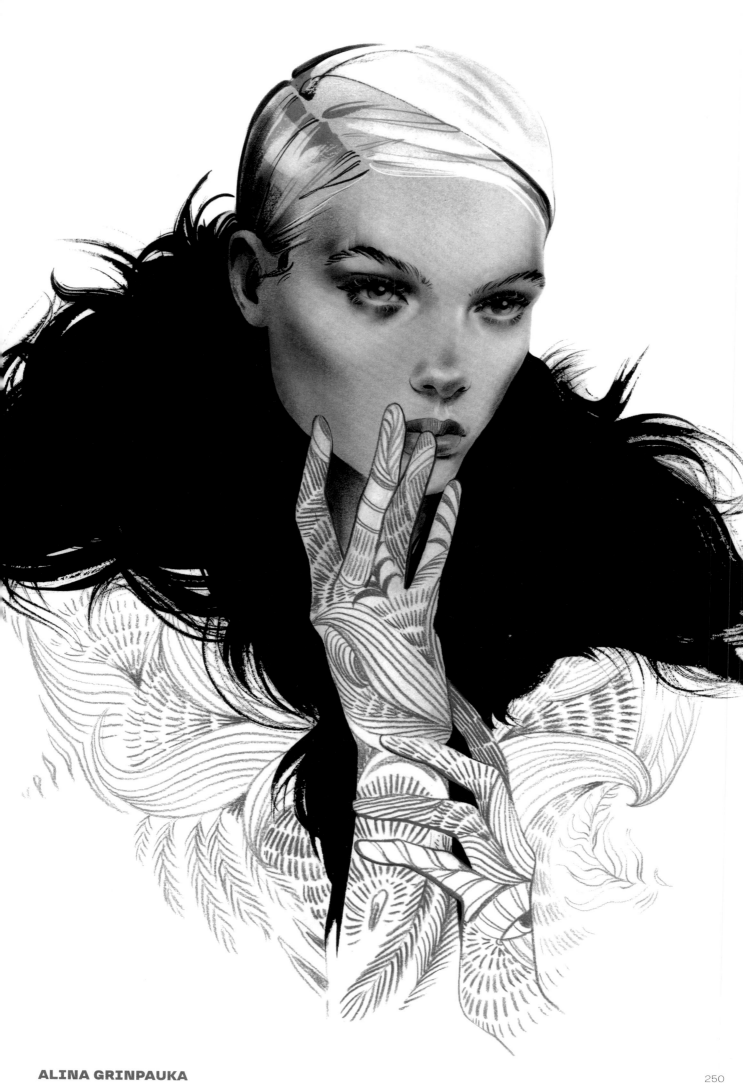

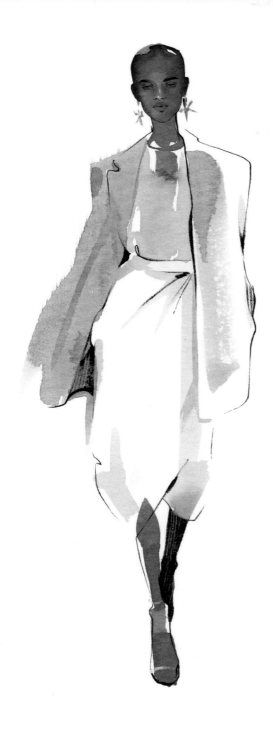

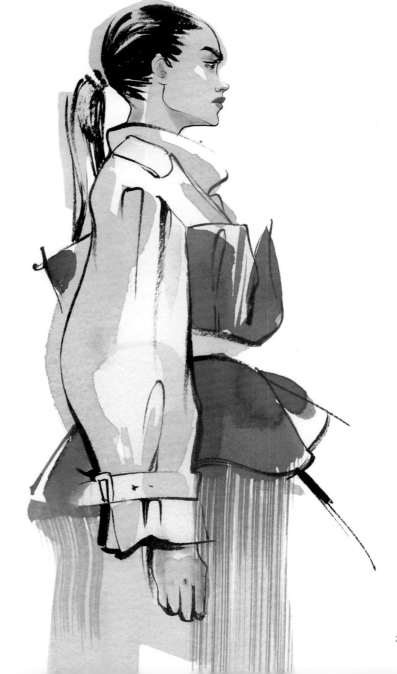

Valentino Spring/Summer 2018
Personal work; watercolor, ink

right
Maison Margiela Spring/Summer 2018
Personal work; watercolor, ink

opposite
Dries Van Noten Fall/Winter 2018/2019
Personal work; ink, pencil, charcoal

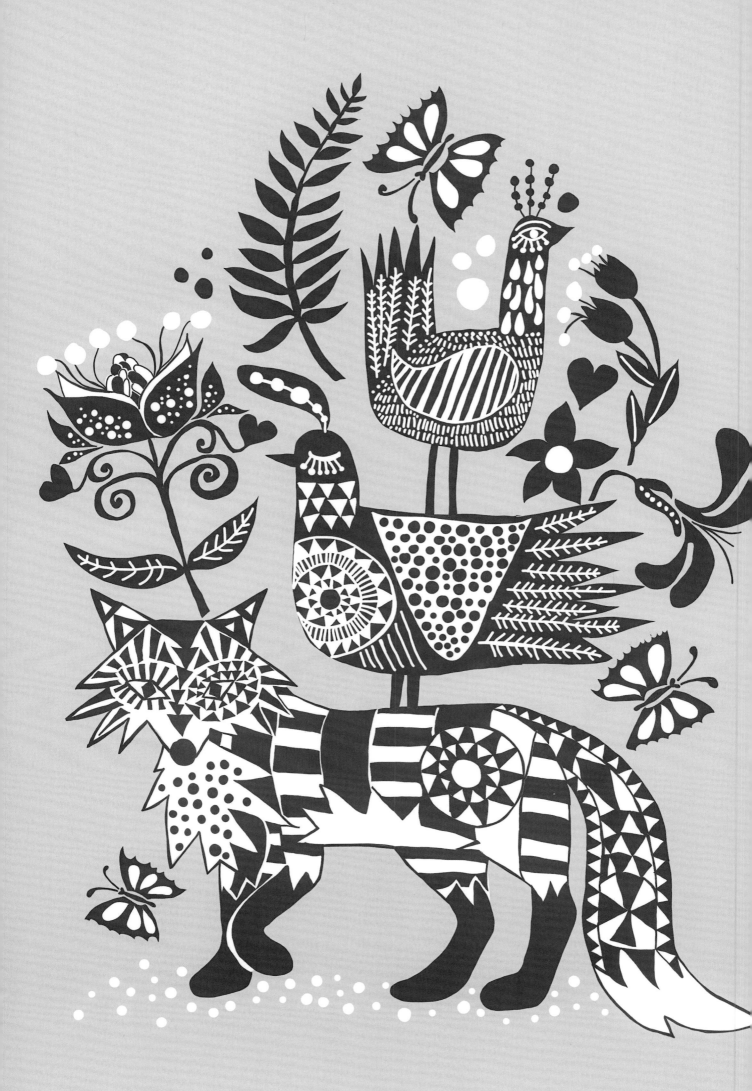

> "I want to invite people into my universe, where rabbits, owls, butterflies, and mysterious cats rule the world, and neon-pink plants, patterns, and mushrooms entice you to remember the magic in everyday life."

LISA GRUE

WWW.LISAGRUE.COM · @lisagrue

Born in 1971, Lisa Grue's modest upbringing in the Danish seaport of Kalundborg did not stop her from using her creative talent to fulfil her ambitions. She and her sister entered drawing competitions whenever the opportunity arose, most of which they won; prizes ranged from ghetto blasters to skiing holidays and, most importantly, drawing equipment. As she grew older, the Royal Danish Academy of Design beckoned. There, in 2001, she received a master's degree in graphic design. From that point her career blossomed into a varied practice—a confluence of illustration, design, and fine art. Grue is constantly experimenting, with a visual language inspired by her love of nature and the urban environment. Whether working in pencil, acrylic, digitally, or crafting in embroidery and porcelain, she is in her element with a variety of media. Feminine and charming, with hints of folklore and fairytale, Grue's imagery has a distinctly Scandinavian essence, though it is unclichéd and has a worldly outlook. She has been awarded grants from the Danish

Lisa Grue wurde 1971 in der dänischen Hafenstadt Kalundborg in sehr bescheidene Verhältnissen hineingeboren. Dies hinderte sie jedoch nicht daran, ihr kreatives Talent einzusetzen, um ihre Ziele zu erreichen. Sie und ihre Schwester nahmen häufig an Malwettbewerben teil, wenn sich die Gelegenheit bot, von denen sie die meisten gewannen; Die Preise reichten von einem Gettoblaster über einen Skiurlaub bis hin zu Zeichenmaterial. Als sie älter wurde, winkte die Königlich Dänische Akademie für Design, an der sie 2001 einen Master in Grafikdesign erhielt. Von diesem Zeitpunkt an entwickelte sich ihre Karriere zu einer abwechslungsreichen Tätigkeit – einem Zusammenfluss von Illustration, Design und bildender Kunst. Grue experimentiert ständig mit einer Bildsprache, die von ihrer Liebe zur Natur und zum städtischen Umfeld inspiriert ist. Ob mit Bleistift, in Acryl, digital oder mit Stickereien und Porzellan – sie ist in verschiedenen Techniken in ihrem Element. Grues Bildsprache ist feminin und charmant, mit

Née en 1971, Lisa Grue a reçu une éducation modeste dans la ville portuaire danoise de Kalundborg, ce qui ne l'a pas empêchée d'employer son talent créatif pour atteindre ses objectifs. Avec sa sœur, elle a a participé à des concours de dessin chaque fois qu'une occasion s'est présentée, remportant à elles deux la plupart avec des prix allant de combinés radio-cassette à des séjours au ski, et surtout du matériel de dessin. Puis un jour, elle a décidé de s'inscrire à la Royal Danish Academy of Design, où elle a obtenu en 2001 une maîtrise en design graphique. À partir de là, sa carrière a prospéré avec des œuvres d'une grande variété marquant la rencontre de l'illustration, du design et des arts plastiques. Grue se livre constamment à des expériences, et son langage visuel trouve inspiration dans son amour pour la nature et l'environnement urbain. Qu'elle travaille au crayon, à la peinture acrylique, sur ordinateur, en brodant ou sur de la porcelaine, elle est toujours dans son élément. Féminine et séduisante, avec des

Arts Foundation and her reputation has steadily grown on an international scale, with an impressive client list spanning Ace Hotel in New York, Fujifilm, *Nylon* magazine, Anna Sui, and Vogue. In addition, she also designed the official t-shirt for *Dukale's Dream* (2014), a documentary following actor Hugh Jackman's exploration of the fair trade coffee industry. Together with her designer husband, Denis Sytmen, Grue founded the design studio "Summer will be back" in 2014, based in the old meatpacking district of Copenhagen.

Andeutungen von Folklore und Märchen, und ihre Bilder haben eine eindeutig skandinavische Essenz, obwohl sie nicht klischeehaft sind und eine weltoffene Sicht spiegeln. Sie erhielt Stipendien von der dänischen Kunststiftung, und ihr Ruf ist auf internationaler Ebene stetig gewachsen, mit einer beeindruckenden Kundenliste, wie dem Ace Hotel in New York, Fujifilm, *Nylon*-Magazin, Anna Sui und *Vogue*. Außerdem entwarf sie das offizielle T-Shirt für *Dukale's Dream* (2014), einem Dokumentarfilm, über die Durchleuchtung der Fair-Trade-Kaffeeindustrie des Schauspielers Hugh Jackman. Grue gründete zusammen mit ihrem Ehemann Denis Sytmen, einem Designer, 2014 das Designstudio „Summer will be back", das im alten Meatpacking District von Kopenhagen sein Quartier hat.

touches de folklore et de conte de fées, l'imagerie de Grue possède une essence clairement scandinave, sans jamais tomber dans les clichés et en posant un regard éclairé. La Danish Arts Foundation lui a décerné des bourses et sa réputation n'a cessé de grandir à l'échelle internationale, avec une liste impressionnante de clients incluant Ace Hotel à New York, Fujifilm, le magazine *Nylon*, Anna Sui et *Vogue*. Elle a par ailleurs conçu le T-shirt officiel pour le documentaire *Dukale's Dream* (2014), sur les investigations de l'acteur Hugh Jackman en matière de commerce équitable du café. Avec son mari concepteur Denis Sytmen, Grue a fondé en 2014 le studio de design Summer will be back dans l'ancien quartier de conditionnement de viande de Copenhague.

Night Walkers, 2011
Ace Hotel New York, mural;
digital, hand painting

opposite top
Asoko Series, 2017
Water bottle label; digital

opposite bottom
Wallpaper/Lisa, 2016
Sandberg Wallpaper; digital

p. 252
Scandinavian Diary, 2015
Kokka Fabric; digital

LISA GRUE

Selected Exhibitions: 2017, *Top Drawer*, group show, London · 2016, *Tent*, group show, London Design Fair · 2015, *New Nordic Fashion Illustration*, vol. 2, group show, Tallinn · 2011, *Owls Have More Fun*, solo show, New York · 2011, *AvantGarden*, group show, London Design Fair

Selected Publications: 2018, *Friendship, a Fill-in Keepsake*, Abrams Books, USA · 2018, *Luk naturen ind (Re-connect with Nature)*, Gyldendal, Denmark · 2016, *Dream Diary*, Lindhardt & Ringhoff, Denmark · 2011, *Illustration Now! Portraits*, TASCHEN, Germany · 2007, *Fashion Unfolding*, Victionary, Hong Kong

BENJAMIN GÜDEL

WWW.GUEDEL.BIZ · @benjamin_guedel

Benjamin Güdel (b. 1968) produces illustrations with a raw and edgy style akin to film noir, pulp detective covers from the 1950s, and rotoscoped animation (where drawings are traced over live-action motion-picture footage). After studying graphic design in his home city of Bern in the early 1990s, he became disenchanted with the discipline and began developing his skills as a cartoonist and publishing his own underground comics. His process utilizes traditional hand-drawn sketches, which he inks with brushes before scanning to digital for coloring and sometimes retouching. Güdel's gritty world of fiction is a far cry from his suburban family life in Zurich, where he confesses to occasionally mowing the lawn at home. Prior to resettling in Switzerland, Güdel spent a period in Berlin and in 2005 produced *Blood Sweat and Tears*, an artist's monograph featuring a collection of personal works as well as commissioned illustrations for the likes of Berlin's avant-garde Schaubühne Theater and innovative Swiss

Benjamin Güdel (geb. 1968) produziert Illustrationen mit einem rohen und ausgefallenen Stil, der dem Film noir sowie Pulp-Detektiv-Covers aus den 1950er-Jahren und rotoskopischen Animationen (wo Zeichnungen von live abgespieltem Filmmaterial erstellt werden) ähnelt. Nachdem er Anfang der 1990er-Jahre in seiner Heimatstadt Bern Grafikdesign studiert hatte, war er von der Disziplin enttäuscht und begann, seine Fähigkeiten als Karikaturist zu entwickeln und seine eigenen Underground-Comics zu veröffentlichen. In seinem Verfahren werden traditionelle, von Hand gezeichnete Skizzen verwendet, die er mit Pinseln einfärbt, bevor sie digitalisiert und einscannt und manchmal retuschiert. Güdels düstere Welt der Fiktion ist weit entfernt von seinem vorstädtischen Familienleben in Zürich. Dort, gesteht er, mäht er gelegentlich den Rasen. Bevor er wieder in die Schweiz zog, verbrachte Güdel einige Zeit in Berlin und produzierte 2005 *Blood Sweat and Tears*, eine Künstlermonografie mit einer Sammlung

Né en 1968, Benjamin Güdel produit des illustrations dans un style cru et audacieux évoquant le film noir, les couvertures de romans policiers à sensation des années 1950 et les animations par rotoscopie (technique consistant à relever image par image les contours d'une figure filmée en prise de vue réelle). Après des études de design graphique dans sa ville natale de Berne au début des années 1990, il a perdu l'intérêt pour cette discipline, s'est formé comme dessinateur humoristique et a publié ses propres bandes dessinées underground. Il réalise des croquis à la main, qu'il encre au pinceau avant de les scanner pour les colorier et éventuellement les retoucher sur ordinateur. Le monde de fiction brut de décoffrage de Güdel est très éloigné de la vie de famille ordinaire qu'il mène à Zurich, où il reconnaît tondre parfois sa pelouse. Avant de s'établir à nouveau en Suisse, Güdel a passé un temps à Berlin et en 2005, il a produit *Blood, Sweat and Tears*, une monographie d'œuvres personnelles et

magazines *Du* and *Soda*. His editorial work has appeared in *Rolling Stone*, *Der Spiegel*, *Fused*, and *Time Out* (London), to name but a few.

persönlicher Arbeiten, sowie Auftragsabbildungen für das Berliner Avantgardetheater „Die Schaubühne" und arbeitete für die innovativen Schweizer Zeitschriften *Du* und *Soda*. Redaktionelle Arbeiten von ihm erschienen u. a. in *Rolling Stone*, *Der Spiegel*, *Fused* und *Time Out* (London).

d'illustrations pour des clients, comme le théâtre berlinois d'avant-garde Schaubühne et les magazines suisses innovants *Du* et *Soda*. Son travail éditorial est paru entre autres dans *Rolling Stone*, *Der Spiegel*, *Fused* et *Time Out* (Londres).

BENJAMIN GÜDEL

War, 2016
Die Weltwoche, magazine;
mixed media

On The Road, 2017
Die Weltwoche, magazine;
mixed media

opposite
Lost Youth, 2016
Personal work, poster;
mixed media

BENJAMIN GÜDEL

Selected Exhibitions: 2017, *Poster Bazar*, group show,
K-3000, Zurich · 2016, *Fumetto*, group show, Fumetto
Festival, Luzern · 2015, *Mord und Totschlag*, group show,
Stauffacher, Bern · 2014, *Poster Bazar*, group show,
K-3000, Zurich · 2013, *LTD Edition*, group show,
Walchenturm, Zurich

Selected Publications: 2013, *Doods,* SSE Project,
South Korea · 2010, *Fresh,* Slanted, Germany · 2009,
3x3 Annual, USA · 2007, *American Illustration Annual,*
Society of Illustrators, USA · 2005, *Blood Sweat and Tears,*
Gestalten, Germany

> "There is something beautiful about the solitude of pen, paper, and a voice. The joy of making images, to me, is telling a small story. Not a lofty goal, nor a unique one, to be sure."

JOHN HENDRIX

WWW.JOHNHENDRIX.COM · @johnhendrix

John Hendrix has had a lifelong passion for drawing. From depicting cartoon characters as a child, he has ascended in a career as an award-winning illustrator throughout the United States. Born in St Louis, Missouri, in 1976, Hendrix studied visual communication at the University of Kansas, graduating with a BA in 1999. After an initial period working in design, he made the pilgrimage to New York, where he attended the School of Visual Arts MFA "Illustration as Visual Essay" program, attaining an honors degree in 2003. Soon after, he received his first assignment for *The Village Voice*, which led to a longstanding relationship with *The New York Times*, for whom he worked as an assistant art director on the op-ed page. His work has appeared in the editorials of numerous major titles from *Entertainment Weekly* to *Esquire*. Hendrix's first children's book, *Abe Lincoln Crosses the Creek*, was chosen as the American Library Association's Notable Book of 2008. An active educationalist, Hendrix has taught at Parsons School of Design

John Hendrix hat eine lebenslange Leidenschaft fürs Zeichnen. Er kritzelte schon als Kind Zeichentrickfiguren und ist inzwischen zum preisgekrönten Illustrator in den USA aufgestiegen. Hendrix wurde 1976 in St. Louis (Missouri) geboren und studierte visuelle Kommunikation an der Universität von Kansas, wo er 1999 seinen Bachelorabschluss machte. Nach einem Karrierestart als Designer reiste er nach New York, wo er das MFA-Programm „Illustration as Visual Essay" der School of Visual Arts besuchte und 2003 mit Auszeichnung absolvierte. Bald darauf erhielt er seinen ersten Auftrag für *The Village Voice*, was zu einer langjährigen Zusammenarbeit mit der *New York Times* führte, für die er als Assistant Art Director an der Op-Ed-Seite arbeitete. Seine Arbeiten sind in den Editorials zahlreicher großer Titel erschienen, von *Entertainment Weekly* bis *Esquire*. Hendrix' erstes Kinderbuch *Abe Lincoln Crosses the Creek* (Abe Lincoln überquert den Bach) wurde 2008 von der American

John Hendrix a depuis toujours eu une passion pour le dessin. Depuis qu'il représentait des personnages de dessins animés quand il était enfant, il s'est forgé une carrière comme illustrateur primé dans tous les États-Unis. Né en 1976 à Saint-Louis, dans le Missouri, Hendrix a suivi des études de communication visuelle à l'université du Kansas, où il a obtenu une licence en 1999. Il a dans un premier temps travaillé dans le milieu du design, puis fait le pèlerinage jusqu'à New York où il s'est inscrit au programme de master en beaux-arts « Illustration as Visual Essay » de la School of Visual Arts, et s'est diplômé en 2003 avec les honneurs. Peu après, il a reçu sa première commande pour *The Village Voice*, le point de départ d'une collaboration durable avec *The New York Times*, pour lequel il a travaillé comme assistant directeur artistique de la tribune libre. Ses créations sont parues dans les éditoriaux de nombreuses grandes publications, telles que *Entertainment Weekly* ou *Esquire*. Le premier livre pour enfants

and served as Chair of Design in the Sam Fox School of Design & Visual Arts at Washington University in St Louis. In 2012, he became President of ICON 7, the Illustration Conference, and also chaired the Society of Illustrators 55th annual exhibition. His favored medium is pen and ink, with coloring in acrylic and occasionally gouache. With meticulous attention to form, color, and typography, Hendrix has an uncanny knack of being able to convey a clear message, sometimes through the most complex and dense compositions.

Library Association als bemerkenswertes Buch ausgewählt. Als aktiver Pädagoge lehrte Hendrix an der Parsons School of Design und hatte den Lehrstuhl für Design an der Sam Fox School für Design und Bildende Kunst an der Washington University in St. Louis inne. 2012 wurde er Präsident von ICON 7, The Illustration-Conference und leitete auch die 55. Jahresausstellung der Society of Illustrators. Seine bevorzugten Techniken sind Feder und Tusche, Acrylfarbe und gelegentlich Gouache. Mit akribischer Aufmerksamkeit für Form, Farbe und Typografie hat Hendrix die verblüffende Fähigkeit, eine klare Botschaft vermitteln zu können, manchmal durch die komplexesten und dichtesten Kompositionen.

qu'il a signé, *Abe Lincoln Crosses the Creek*, a été élu meilleur livre de 2008 par l'American Library Association. Très pédagogue, Hendrix a enseigné à la Parsons School of Design et s'est vu proposer la chaire de design à la Sam Fox School of Design & Visual Arts de l'université de Washington à Saint-Louis. En 2012, il a assuré la présidence de ICON 7 – The Illustration Conference, ainsi que de la 55e exposition annuelle de la Society of Illustrators. Il préfère dessiner à l'encre, et il applique la couleur à la peinture acrylique, éventuellement à la gouache. Prêtant une attention méticuleuse aux formes, aux couleurs et à la typographie, Hendrix a un don pour transmettre un message clair, parfois par le biais de compositions denses et complexes.

The Word, 2017
Christianity Today, magazine;
pen, ink, digital, fluid acrylics;
art direction: Sarah Gordon

right

Will You Miss Me
When I'm Gone?, 2010
Gallery Nucleus, poster;
pen, ink, fluid acrylics

opposite

Solar Sailing, 2018
National Geographic, magazine;
pen, ink, digital, fluid acrylics;
art direction: Marianne Seregi

p. 262

Serpent Surfing, 2016
Plan Sponsor, magazine cover;
pen, ink, digital, fluid acrylics;
art direction: SooJin Buzelli

The Rock Follows, 2017
Personal work, sketchbook;
pen, ink, fluid acrylics

JOHN HENDRIX

GOD'S MANNA

COMMUNION IS THE ORIGINAL HAPPY MEAL

OLLOWED

Trembles, 2017
Personal work, sketchbook;
pen, ink, fluid acrylics

top
Cain & Able, 2017
Personal work, sketchbook;
pen, ink, fluid acrylics

opposite
Wolves vs. Knights, 2013
Plan Sponsor, magazine cover;
pen, ink, fluid acrylics;
art director: SooJin Buzelli

JOHN HENDRIX

Selected Exhibitions: 2019, *Society of Illustrators*, group show, New York · 2018, *Society of Illustrators*, group show, New York · 2018, *Communication Arts Annual*, group show, USA · 2018, *American Illustration*, group show, New York ·

Selected Publications: 2018, *Summer Movies, The New York Times*, USA · 2018, *The Faithful Spy: Dietrich Bonhoeffer*, Abrams Books for Young Readers, USA · 2018, *Solar Sailing, National Geographic*, USA · 2018, *Best Books of 2018*, NPR, USA · 2015, *Drawing is Magic: Discovering a Sketchbook*, Abrams Books for Young Readers, USA

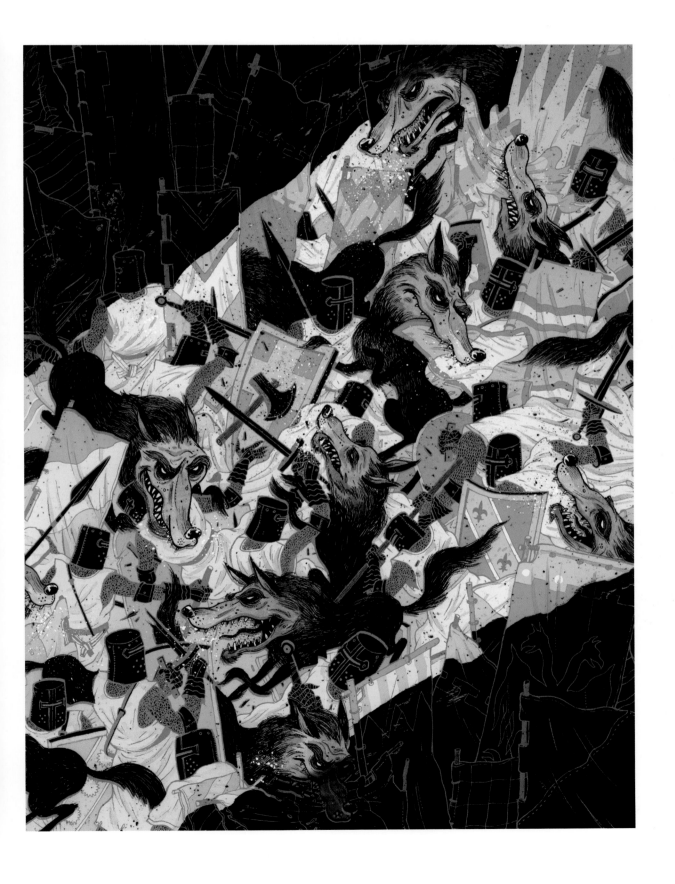

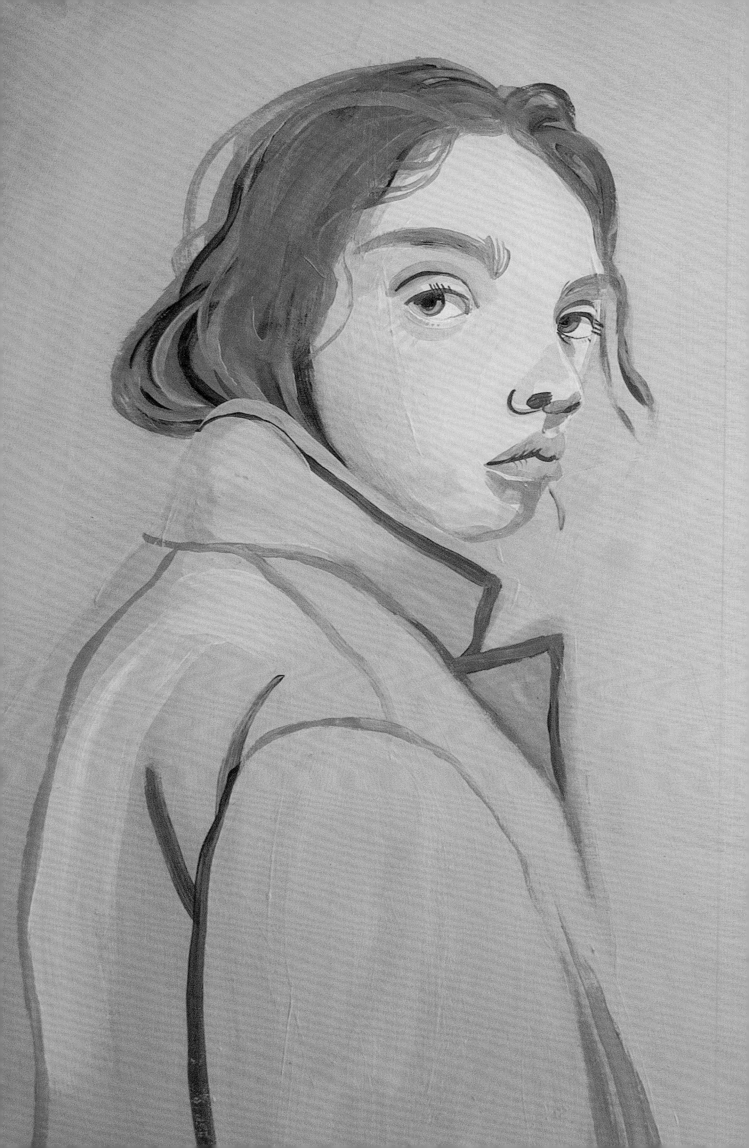

> "I want to surprise, provoke, and even soften with portraits, and my aim is to create a special beauty and sensitivity."

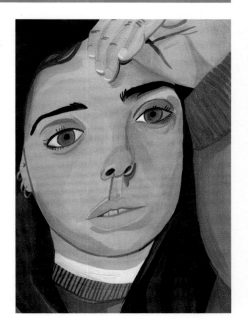

MARIA HERREROS

WWW.MARIAHERREROS.COM · @mariaherreros

Another millennial talent to have emerged on the Spanish scene is María Herreros. Born in Valencia in 1983, she graduated from the San Carlos Royal Academy of Fine Arts in 2007 and gained a postgraduate degree in professional illustration in 2009. Herreros went freelance straight away, and soon began attracting attention for her remarkable style. Her work plays with societal perceptions. Portraits of pop cultural icons are distorted and stretched, offering the viewer nuances and expressions previously unseen. Surface areas are watercolored with a peculiar palette, scored by sharp lines and shading marks. Herreros has published several books. Her first title *Fenómeno* (2012) is populated with a host of tattooed freaks and double-headed twins—or "phenomenal human beings" as the artist calls them—designed to challenge our preconceived notions of the grotesque and the beautiful. With a distinctive voice that defies categorization, Herreros has accumulated an enviable list of clients from Coca-Cola

Ein weiteres Millennium-Talent, das in der spanischen Szene auftauchte, ist Maria Herreros. Sie wurde 1983 in Valencia geboren, machte 2007 an der Königlichen Akademie der Schönen Künste San Carlos ihren Abschluss in Bildender Kunst und absolvierte 2009 ein Aufbaustudium in professioneller Illustration. Herreros wurde sofort freiberuflich tätig und erregte mit ihrem bemerkenswerten Stil bald Aufmerksamkeit. Ihre Arbeit spielt mit gesellschaftlichen Wahrnehmungen. Porträts von Ikonen der Popkultur werden verzerrt und gestreckt und bieten dem Betrachter bisher unerkannte Nuancen und Ausdrücke. Oberflächenbereiche werden mit Aquarellfarben in einer besonderen Farbpalette gefüllt und mit scharfen Linien und Schattierungen versehen. Herreros hat mehrere Bücher veröffentlicht. Ihr erster Titel *Fenómeno* (2012) wird von einer Vielzahl tätowierter Freaks und doppelköpfiger Zwillinge bevölkert – oder von „phänomenalen Menschen", wie die Künstlerin sie nennt – und damit unsere

Autre talent de la génération du millénaire apparu sur la scène espagnole, María Herreros est née à Valence en 1983. Diplômée de l'académie royale des beaux-arts de San Carlos en 2007, elle a conclu deux ans plus tard des études de troisième cycle en illustration professionnelle. Herreros s'est aussitôt installée à son compte pour se faire rapidement remarquer par son style étonnant. Elle joue avec ses perceptions de la société et fait des portraits déformés et étirés d'icônes de la culture pop, avec des nuances et des expressions inédites. Les surfaces dans une originale palette d'aquarelles mélangent lignes nettes et effets d'ombre. Herreros a publié plusieurs livres : le premier intitulé *Fenómeno* (2012) montre dans ses pages des types couverts de tatouages et des siamoises à deux têtes, des « êtres humains phénoménaux » comme l'artiste les qualifie, et ses ouvrages visent en général à remettre en cause nos idées préconçues du grotesque et de la beauté. Sa voix distinctive met au défi toute

and Smart to Reebok and *El País*. A growing social media following coupled with gallery exhibitions in Madrid, Porto, Barcelona, Berlin, New York, and Beijing have put her firmly on the international map.

vorgefassten Meinungen vom Grotesken und Schönen in Frage stellt. Mit einer unverwechselbaren Stimme, die sich der Kategorisierung widersetzt, hat Herreros eine beneidenswerte Kundenliste angesammelt, von Coca Cola und Smart bis Reebok und *El País*. Eine wachsende Menge Social-Media Follower, verbunden mit Galerie-Ausstellungen in Madrid, Porto, Berlin, Barcelona, New York und Peking, haben ihr einen festen Platz auf der internationalen Landkarte verschafft.

catégorisation, et sa liste de clients est enviable, de Coca-Cola et Smart à Reebok et *El País*. Elle est très présente sur la scène internationale grâce au nombre de personnes qui la suivent sur les réseaux sociaux et à des expositions dans des galeries de Madrid, Porto, Barcelone, Berlin, New York et Pékin.

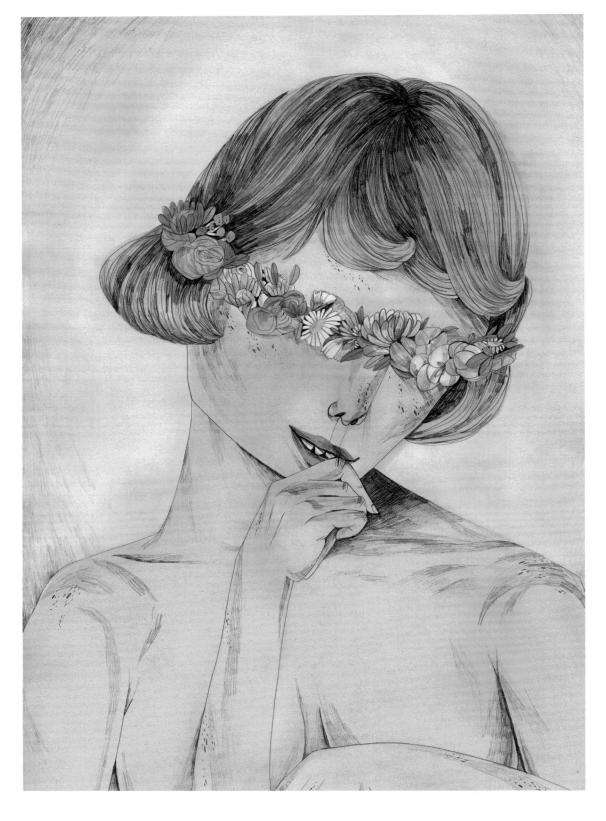

MARIA HERREROS

Vogue, 2017
Personal work, exhibition,
Junior High, Los Angeles;
watercolor, graphite on paper

opposite
The Blind, 2016
Personal work, *Botanical Rage,* solo show;
watercolor, graphite on paper

p. 270
Mermaid Ranch, 2017
Personal work, acrylic on wood

Selected Exhibitions: 2018, *Maria Herreros*, solo show, SIPicture Institute of Arts, Seoul · 2018, *Got it for Cheap*, *international tour*, group show, Emma Pardos, Barcelona · 2017, *Illustrating Life*, group show, Prince Gong's Mansion, Ministry of Culture, Beijing · 2017, *Miss Representation*, group show, Junior High Gallery, Los Angeles · 2017, *Saturns Return*, solo show, Pepita Lumier, Valencia

Selected Publications: 2018, *Paris sera toujours Paris*, Maxim Huerta, Lunwerg Editores/Planeta de Libros, Spain · 2018, *Nosotras*, Rosa Montero, Alfaguara, Random House, Spain · 2018, *Mi vida es un poema*, Javier García, SM, Spain · 2016, *Marilyn ten'a once dedos en los pies*, Lunwerg Editores, Spain · 2015, *Tea*, Diminuta, Spain

Paula Vogel, 2018
Lenny Letter, online newsletter;
acrylic on wood

right
Travolta, 2016
Lunwerg Editores/Planeta
de Libros, book; watercolor,
graphite on paper

opposite
Bob Is Real, 2017
Personal work; watercolor,
graphite on paper

> "I do not plan much before I start. I simply take the ideas that run through my brain and, when I think they are beautiful, I make them." for *Metal* magazine

MARÍA HESSE

WWW.MARIAHESSE.ES · **@mariahesse**

Born in Huelva, Andalusia, in 1982, María Hesse grew up in Seville, in 1982 but grew up in Seville, where she began drawing at the age of six. After initial training to be a teacher she attended the San Telmo School of Art in Málaga before pursuing a professional career in illustration in 2012. After working for Edelvives publishers, she began illustrating for Spanish magazines, including *Jot Down* and *Maasåi Magazine*. Her subjects include characters from cinema and music who have influenced her: David Bowie as Ziggy Stardust and Mia Wallace from *Pulp Fiction*. A running theme in her work is the portrayal of women, which she explores through her favored medium of gouache and watercolor on cotton paper. Often centered in dark or white spaces with open ribcages and rich, red hearts in full view, Hesse's imagery reveals both the inner and external strength and sensitity of her female characters. In 2014, she produced an illustrated biography of Frida Kahlo, which was followed by a delightful

María Hesse wurde 1982 in Huelva (Andalusien) geboren und wuchs in Sevilla auf, wo sie im Alter von sechs Jahren anfing zu malen. Nach ihrer ersten Ausbildung zur Lehrerin besuchte sie die Kunstschule San Telmo in Málaga, bevor sie 2012 eine professionelle Karriere als Illustratorin anstrebte. Nachdem sie für den Edelvives-Verlag gearbeitet hatte, begann sie für spanische Zeitschriften zu illustrieren, zum Beispiel für *Jot Down* und das *Maasåi Magazine*. Zu ihren Themen gehören Figuren aus Kino und Musik, die sie beeinflusst haben: David Bowie als Ziggy Stardust und Mia Wallace aus *Pulp Fiction*. Die Darstellung von Frauen ist ein wiederkehrendes Thema ihrer Arbeit, das sie durch ihre bevorzugte Technik Gouache und Aquarell auf Baumwollpapier erforscht. Die Figuren in Hesses Bildern sind oft zentriert und stehen vor dunklen oder weißen Räumen, mit offenen Brustkörben und vollen roten Herzen, und zeigen sowohl die innere als auch die äußere Stärke und Sensibilität ihrer weiblichen Charaktere.

María Hesse est une Andalouse née à Huelva en 1982 mais qui a grandi à Séville, où elle a commencé à dessiner à l'âge de six ans. Après une formation initiale pour devenir enseignante, elle a étudié à l'école d'art San Telmo de Malaga, puis entamé en 2012 une carrière professionnelle dans l'illustration. Elle a d'abord travaillé pour la maison d'édition Edelvives, avant de se mettre à illustrer pour des magazines espagnols, dont *Jot Down* et *Maasåi Magazine*. Ses sujets représentent des personnages du monde du cinéma et de la musique qui l'ont influencée, comme David Bowie en Ziggy Stardust et Mia Wallace dans *Pulp Fiction*. Elle exploite son thème récurrent des portraits de femmes avec ses peintures préférées que sont la gouache et l'aquarelle sur du papier chiffon. Souvent produite sur des fonds en noir et blanc, avec des cages thoraciques ouvertes et de grands cœurs rouges, l'imagerie de Hesse parle de la force et de la sensibilité tant internes qu'externes de ses sujets féminins.

monochrome interpretation of Jane Austen's *Pride and Prejudice* (2017). In addition to her personal work, Hesse has collaborated with brands such as Compañía Fantástica, Louise Boutin, and Martini.

Im Jahr 2014 produzierte sie eine illustrierte Biografie von Frida Kahlo, der eine reizvolle monochrome Interpretation von Jane Austens *Stolz und Vorurteil* (2017) folgte. Zusätzlich zu ihrer persönlichen Arbeit hat Hesse mit Marken wie Compañía Fantástica, Louise Boutin und Martini zusammengearbeitet.

En 2014, elle a illustré la biographie de Frida Kahlo, puis une superbe interprétation monochrome de l'œuvre *Orgueil et Préjugés* de Jane Austen (2017). Parallèlement à son travail personnel, Hesse a collaboré avec des marques comme Compañía Fantástica, Louise Boutin et Martini.

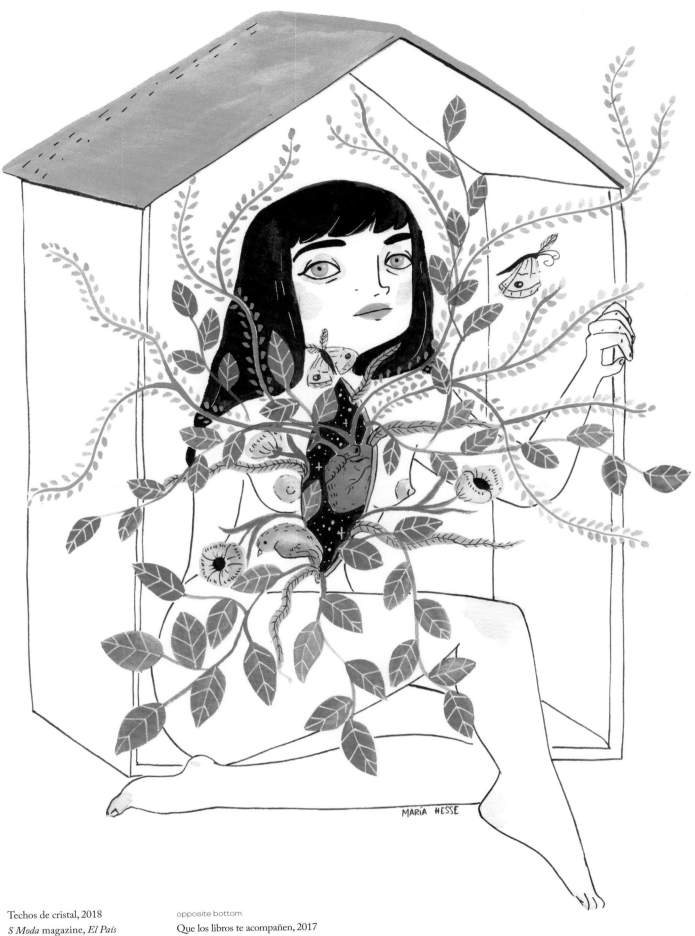

Techos de cristal, 2018
S Moda magazine, *El País*
newspaper; gouache, ink

opposite bottom
Que los libros te acompañen, 2017
Kireii; gouache, ink

opposite top
Have a Good Time, 2017
Personal work; gouache, ink

p. 276
Mirar al dolor, 2018
Personal work; gouache, ink

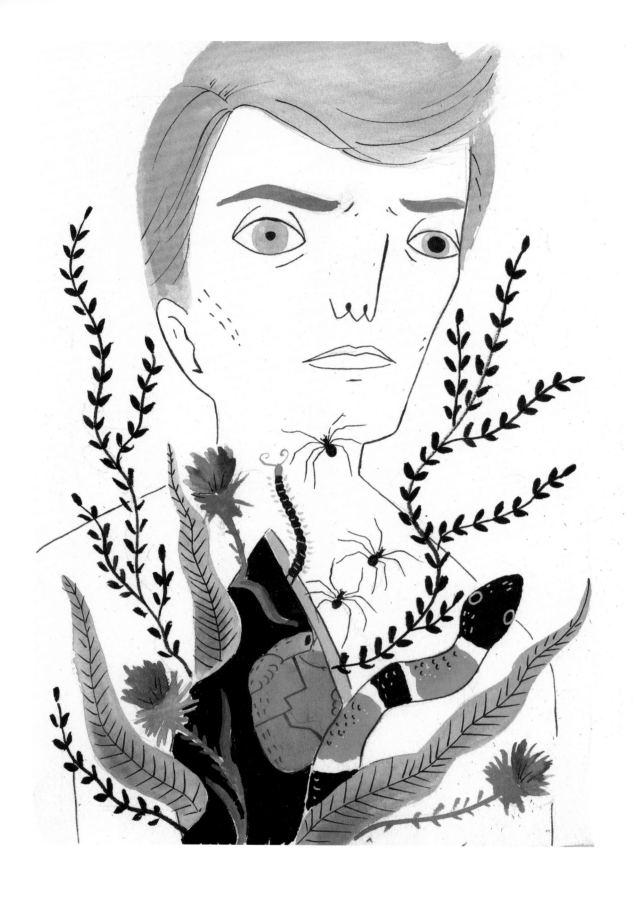

Bowie, 2018
Editorial Lumen; gouache, ink

opposite
Algo anda mal, 2018
Personal work; gouache, ink

MARÍA HESSE

Selected Exhibitions: 2019, *Retrospectiva*, solo show, Galería Roja, Seville · 2018, *Retrospectiva*, solo show, Museo ABC, Madrid · 2018, *Icono*, group show, Mad is Mad Gallery, Madrid · 2018, *Viva la vida*, solo show, Belgrade · 2017, *Viva la vida*, solo show, Sala Fenix, Barcelona

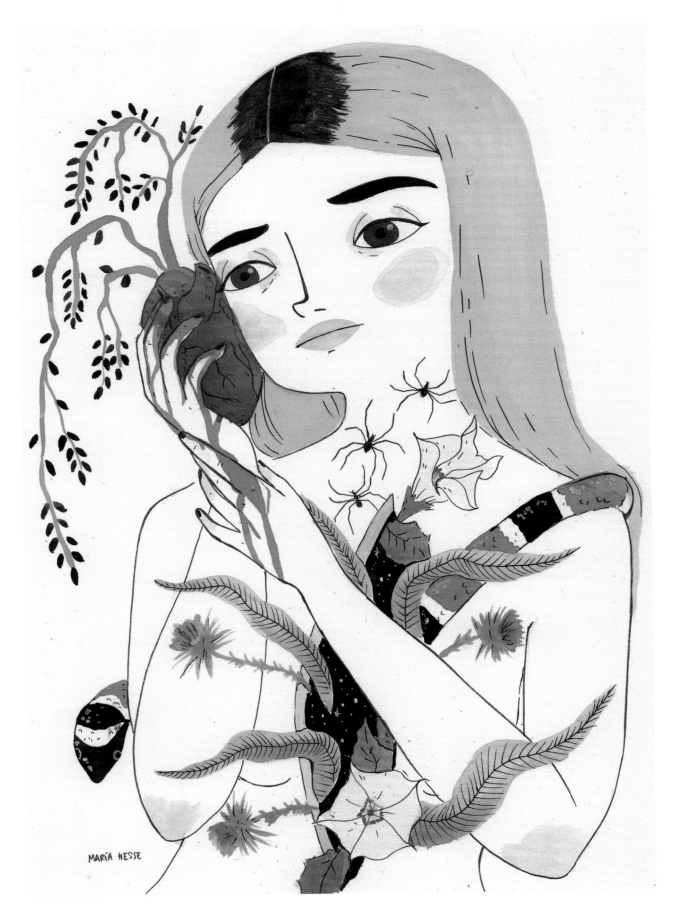

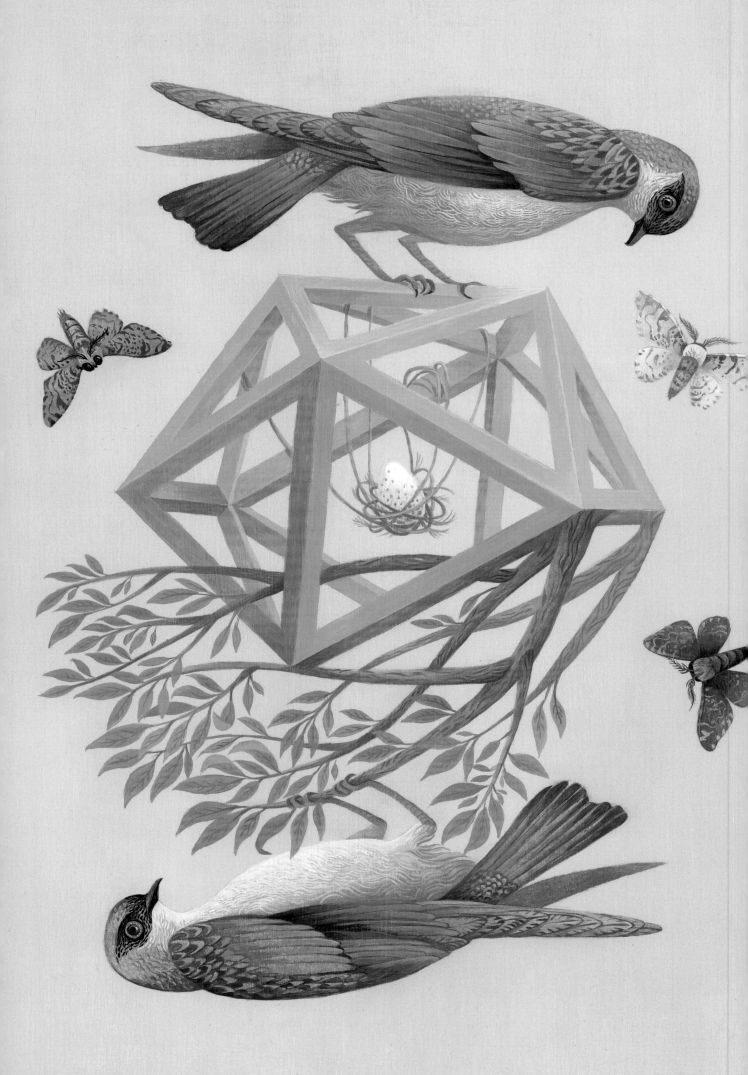

> "I don't confine myself to literal depiction because I like to employ a little magic realism in some of my pieces."

JODY HEWGILL

WWW.JODYHEWGILL.COM · WWW.JODYHEWGILLART.COM · @jhewgill

Born in 1961 in Montréal, Québec, Jody Hewgill recalls that in her early childhood she accompanied her father to his art supply store on weekends and drew pub customers on placemats as they ate their lunch. An entrepreneurial streak developed and by the age of 17 Hewgill had received her first commission: to illustrate Pier 1 products in newspaper ads. Jody Hewgill attended the commercial art program at Dawson College until 1981 before graduating from the Ontario College of Art and Design in Toronto in 1984, where her association continues to this day as a faculty member in the illustration department. Since the late 1980s, Hewgill's paintings and illustrations have graced countless book covers, posters, and interior retail murals. Her projects include pop music icons, such as Elton John for *Rolling Stone* and Morrissey for *Spin*, and commemorative stamps for the United States Postal Service. Among her numerous accolades are awards from *Communication Arts*, the Society of Publication Designers, and the Society of Illustrators

Jody Hewgill wurde 1961 in Montréal (Québec) geboren. Sie erinnert sich, dass sie in der frühen Kindheit ihren Vater an Wochenenden zu seinem Kunstgeschäft begleitete und Pub-Kunden auf Tischsets zeichnete, während sie zu Mittag aßen. Dank ihrer unternehmerischen Ader erhielt Hewgill bereits im Alter von 17 Jahren ihren ersten Auftrag, Produkte von Pier 1 in Zeitungsanzeigen zu illustrieren. Jody Hewgill besuchte bis 1981 den Studiengang für Werbegrafik am Dawson College und erlangte ihren Abschluss 1984 am Ontario College of Art & Design in Toronto, wo sie bis heute als Hochschullehrerin im Illustrationsbereich arbeitet. Seit den späten Achtzigerjahren schmücken Hewgills Gemälde und Illustrationen unzählige Buchumschläge, Poster und Wandbilder für den Einzelhandel. Sie illustrierte Ikonen der Popmusik, wie Elton John für *Rolling Stone* und Morrissey für *Spin*, sowie Gedenkmarken für den Postdienst der Vereinigten Staaten. Zu ihren zahlreichen Ehrungen zählen Auszeichnungen von *Communication Arts*,

Née en 1961 à Montréal, Jody Hewgill se souvient que dans sa petite enfance, elle rejoignait son père le week-end à son magasin de fournitures d'art et dessinait des clients du pub sur des sets de table pendant le déjeuner. Sa veine d'entrepreneur s'est développée et dès l'âge de 17 ans, Hewgill recevait sa première commande pour illustrer les produits de Pier 1 dans des annonces de journaux. Elle a suivi le programme d'art commercial du Dawson College jusqu'en 1981, puis s'est diplômée à l'Ontario College of Art and Design à Toronto en 1984, auquel elle reste liée aujourd'hui encore en tant que membre du corps enseignant du département d'illustration. Depuis la fin des années 1980, les peintures et les illustrations de Hewgill ont agrémenté d'innombrables couvertures de livres, affiches et fresques à l'intérieur de magasins. Entre autres projets, elle a représenté des icônes du pop comme Elton John pour *Rolling Stone* et Morrissey pour *Spin*, mais aussi conçu des timbres commémoratifs pour le service postal

in New York and Los Angeles. Hewgill's posters can also be found in the Permanent Poster Collection of the Library of Congress in Washington, D.C. Her process is largely handcrafted. She works with graphite or color pencil and finishes in acrylics. From first glance to deeper study, a myriad of art references seem to imbue her works, from Early Renaissance to 1920s Art Deco portraiture and beyond. Her figurative studies of celebrities and almost folkloric depictions of animals in nature draw the viewer through a fantasy realm, prompting us to question reality.

Society of Publishing Designers und der Society of Illustrators in New York und Los Angeles. Hewgills Plakate sind auch in der permanenten Sammlung der Kongressbibliothek in Washington, D.C. zu finden. Ihr Arbeitsprozess verläuft weitgehend in Handarbeit. Sie arbeitet mit Grafit oder Buntstift und führt in Acryl aus. Vom ersten Blick bis zum tieferen Studium scheinen unzählige Kunstreferenzen ihre Arbeiten zu durchdringen, von der Frührenaissance bis zu Art-déco-Porträts der Zwanzigerjahre und darüber hinaus. Ihre figurativen Studien zu Berühmtheiten und die fast folkloristischen Darstellungen von Tieren in der Natur ziehen den Betrachter in ein Fantasy-Reich und veranlassen ihn, die Realität zu hinterfragen.

américain. Les distinctions reçues sont nombreuses, dont des prix de *Communication Arts,* de la Society of Publication Designers et de la Society of Illustrators de New York et Los Angeles. Les affiches qu'elle a créées figurent dans la collection permanente de la bibliothèque du Congrès à Washington. Son processus créatif se fait principalement à la main, au graphite ou aux crayons de couleur et avec des finitions à l'acrylique. De prime abord et en y regardant de plus près, on découvre que ses œuvres renferment une myriade de références artistiques, de la Première Renaissance aux portraits Art déco des années 1920 et ultérieures. Ses études figuratives de personnalités et les représentations presque folkloriques d'animaux dans la nature font pénétrer le public dans un monde fantastique et remettre en question la réalité.

Two Marilyns, 2017
National Geographic, magazine;
acrylic on gessoed panel;
art direction: Marianne Seregi

opposite
The Avett Brothers, 2016
Rolling Stone, magazine;
acrylic on wood panel;
art direction: Matthew Cooley

p. 282
Balance, 2018
Personal work, fundraising
auction catalogue; acrylic on
Baltic birch panel

Pink Lady, 2017
Personal work, limited-
edition prints for Cancer
Research fundraiser;
acrylic on masonite panel

opposite
Courage, 2015
Middlebury, magazine;
acrylic on gessoed ragboard

Selected Exhibitions: 2018, *American Gods*, group show, Star Gallery, New York · 2018, *Women Making a Mark*, group show, Christel DeHaan Fine Arts Center Gallery, Indianapolis · 2011, *Instinct(s)*, solo show, Richard C. von Hess Gallery, Philadelphia · 2010, *Kaboom*, group show, La Luz de Jesus, Los Angeles · 2007, *Green*, group show, Robert Berman Gallery, Santa Monica

Selected Publications: 2016, *AI–AP Profiles*, American Illustration, USA · 2011, *The Essence of Contemporary Illustration*, Gestalten, Germany · 2011, *Illustration Now! Portraits*, TASCHEN, Germany · 2008, *Icons & Images: 50 Years of Illustration*, Society of Illustrators, USA · 1997, *Communication Arts*, USA

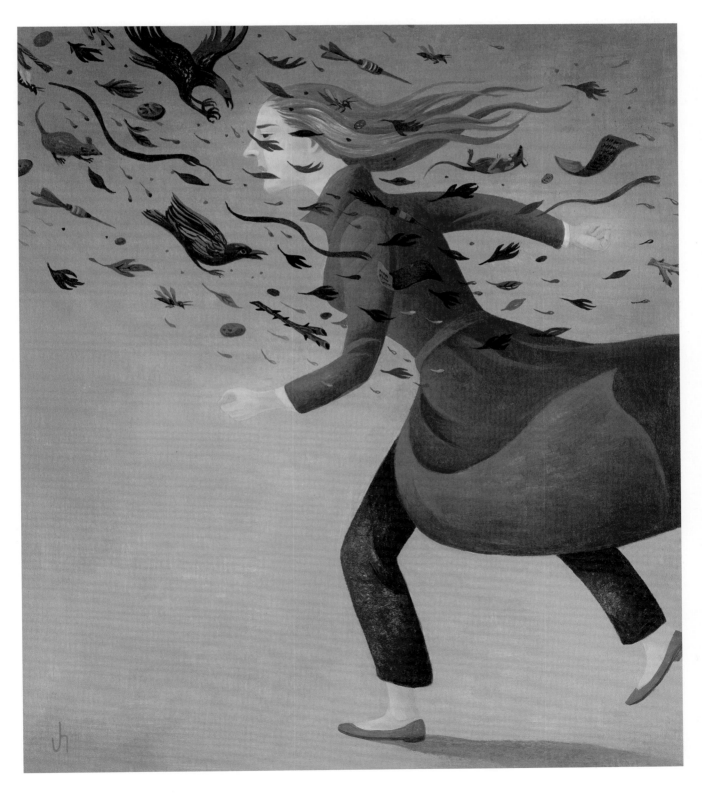

> "Whenever something that used to bring you joy no longer brings you joy, it's time to try something new. It's not that that thing will never give you joy again, it's just that you need some time away." *for Ways We Work*

JESSICA HISCHE

WWW.JESSICAHISCHE.IS/AWESOME · @jessicahische

Jessica Hische is an illustrator whose penchant for lettering developed in grade school when she would customize her classmates' names on their Trapper Keeper folders. Little did she know that her doodling obsession would blossom into a celebrated career as a hand letterer and type illustrator. Born in Charleston, South Carolina, in 1984, Hische graduated from the Tyler School of Art at Temple University, Philadelphia, with a degree in graphic and interactive design in 2006. She soon found herself working as senior designer at Louise Fili Ltd in New York, and with them she created a "Love" stamp for the US Postal Service that sold over 250 million units. For over a decade, Hische's ornate, handcrafted style has adorned a plethora of book jackets, brands, and logos. Her client projects scroll from logo refreshes for MailChimp to movie title sequences for Wes Anderson. With a string of accolades to her name, including two consecutive citations in *Forbes* "30 under 30," and a Young Guns award from the

Jessica Hische ist eine Illustratorin, deren Neigung zu Schriftzügen sich schon in der Grundschule entwickelte, als sie die Namen ihrer Klassenkameraden individuell auf ihre Trapper-Keeper-Mappen zeichnete. Sie ahnte ja nicht, dass ihre Obsession für das Kritzeln zu einer blühenden und gefeierten Karriere der Schriftillustration vom Hand Lettering bis zur Typo-Illustration führen würde. Geboren wurde sie 1984 in Charleston (South Carolina). 2006 schloss Hische ihr Studium an der Tyler School of Art an der Temple University in Philadelphia mit einem Abschluss in Grafik und interaktiver Gestaltung ab. Bald arbeitete sie als leitende Designerin bei Louise Fili Ltd in New York, wo sie eine „Love"-Briefmarke für den Postdienst der Vereinigten Staaten kreierte, die über 250 Millionen mal verkauft wurde. Seit über einem Jahrzehnt schmückt Hisches verzierter, handgefertigter Stil eine Fülle von Buchumschlägen, Marken und Logos. Ihre Kundenprojekte reichen von der Modernisierung von Logos für MailChimp bis

Jessica Hische est une illustratrice dont le penchant pour le lettrage a pris forme dès l'école primaire, quand elle personnalisait les classeurs de ses camarades avec leurs noms. Elle n'avait pas idée que son obsession pour le crayonnage déboucherait sur une brillante carrière dans les domaines du lettrage à la main et de l'illustration de caractères d'écriture. Née en 1984 à Charleston, en Caroline du Sud, Hische a obtenu en 2006 un diplôme en design graphique et interactif à la Tyler School of Art de l'université Temple de Philadelphie. Très vite, elle a trouvé un poste de conceptrice senior chez Louise Fili Ltd à New York, où elle a créé pour le service postal américain le timbre « Love » qui s'est vendu à plus de 250 millions d'unités. Pendant plus d'une décennie, le style artisanal et ornementé de Hische s'est retrouvé dans une pléthore de couvertures de livres, de marques et de logos. Elle a travaillé sur des projets variés, allant de la refonte du logo de MailChimp au texte de génériques de films pour Wes Anderson.

Art Directors Club of New York, Hische has become one of America's in-demand lettering artists. A noted advocate in her field, she is a frequent speaker worldwide and has served on the Type Directors Club board of directors. In her own words an "avid Internetter," Hische runs logotype masterclasses online, and since 2009 has regularly posted an illustrative drop cap in her "Daily Drop Cap" project. In 2015, Hische authored the seminal *In Progress: See Inside a Lettering Artist's Sketchbook and Process, from Pencil to Vector*. She lives and works in San Francisco.

zu Filmtitelsequenzen für Wes Anderson. Mit einer Reihe von Ehrungen, darunter zwei aufeinanderfolgende Nennungen in *Forbes* „30 unter 30" und eine Young-Guns-Auszeichnung vom Art Directors Club von New York, ist Hische zu einer der gefragtesten Schriftkünstlerinnen Amerikas geworden. Sie tritt als bekannte Fürsprecherin ihres Gebiets weltweit häufig als Rednerin auf und war Vorstandsmitglied des Type Directors Club. Als „begeisterte Internetterin", wie sie sich selbst bezeichnet, leitet Hische eine Online- Logo-Masterclass und veröffentlicht seit 2009 in ihrem Projekt „Daily Drop Cap" regelmäßig eine illustrative Initiale. 2015 verfasste Hische das bahnbrechende Werk *In Progress: See Inside a Lettering Artist's Sketchbook and Process, from Pencil to Vector*. Sie lebt und arbeitet in San Francisco.

Avec à son actif une série de distinctions, dont deux mentions consécutives dans la liste « 30 under 30 » de *Forbes* et un prix Young Guns décerné par l'Art Directors Club de New York, Hische est devenue l'une des artistes en lettrage les plus prisées d'Amérique. Illustre militante dans sa discipline, elle fait régulièrement des interventions dans le monde entier et a été membre du conseil d'administration du Type Directors Club. Se définissant comme une « avide Internetteuse », Hische donne des cours en ligne de logotypage et depuis 2009, elle publie régulièrement une capsule illustrée pour son projet « Daily Drop Cap ». En 2015, elle a publié *In Progress: See Inside a Lettering Artist's Sketchbook and Process, from Pencil to Vector*. Elle réside et travaille aujourd'hui à San Francisco.

Heart of Darkness, 2018
Barnes & Noble, Sterling Publishing;
vector, art foil stamped on leatherette;
art direction: Jo Obarowski

opposite
Chill Vibes, screen print, 2016
California Sunday Magazine;
vector with bitmap texture;
art direction: Leo Jung

p. 288
Virtue, 2016
The Baffler, magazine; vector;
art direction: Lindsay Ballant

AMERICA
The Great Cookbook

FROM 100 OF

OUR FINEST CHEFS

AND

FOOD HEROES

EDITED BY

Joe Yonan

America: The Great Cookbook,
2017, by Joe Yonan, book,
Weldon Owen

opposite top
More Salt, 2014
Snacks Quarterly; salt on wood;
art direction: Brad Simon

opposite bottom
Magical Bitch, 2018
Sonya Yu and Zack Lara; cast as
gold necklace; vector drawing

Love Stencil, 2018
Personal work; vector

Forever Love Stamps,
postage stamp, 2015
United States Postal
Service, vector

opposite bottom
Edgar Allan Poe and
The Metamorphosis, 2017
Barnes & Noble, Sterling
Publishing, book covers;
vector, art foil stamped on
leatherette; art direction:
Jo Obarowski

JESSICA HISCHE

Selected Exhibitions: 2018, *Text Me: How We Live in Language*, group show, Museum of Design, Atlanta · 2017, *We the People*, group show, The Cooper Union Gallery, New York · 2015, *Type Directors Club*, group show, traveling exhibition · 2010, *Jessica Hische*, solo show, Lamington Drive Gallery, Melbourne · 2009, *Lubalin Now*, group show, Cooper Union, New York

Selected Publications: 2018, *Jessica Hische: Tomorrow I'll Be Brave*, Penguin Books, USA · 2017, *The Typography Issue*, *Print* magazine, USA · 2015, *In Progress*, Chronicle Books, USA · 2013, *30 Under 30*, *Forbes* magazine, USA

"My pictures are like book jackets for stories I haven't written and couldn't write because they're not stories that can be told in words."

BRAD HOLLAND

WWW.BRADHOLLAND.NET

Bradford Wayne Holland was born in Fremont, Ohio, in 1943. Entirely self-taught as an artist, the ambitious teenager sent drawings to Walt Disney and *The Saturday Evening Post*. Despite receiving a spate of rejection letters, Holland persevered, and at 20 he got his first break illustrating books as a staff artist for Hallmark in Kansas City. By the late 1960s, Holland had moved to New York, where he quickly gained the attention of prominent art directors—the likes of Art Paul at *Playboy* and the maverick Jean-Claude Suares at *The New York Times* op-ed page. Through his mastery of visual metaphor, Holland's work signaled a radical shift in the way illustration married with editorial writing. He gained plaudits for his coverage of the Watergate scandal under the Nixon administration, and in 1973 his work was showcased in *The Art of the Times*, edited by Suares and published by Darien House. In 1976, he was nominated for a Pulitzer Prize. Throughout his career, Holland has traversed from monochrome pen and ink to color

Bradford Wayne Holland wurde 1943 in Fremont, Ohio geboren. Der ehrgeizige Teenager und Autodidakt schickte Zeichnungen an Walt Disney und *The Saturday Evening Post*. Trotz einer Reihe von Ablehnungsschreiben machte er beharrlich weiter und bekam mit 20 seine erste Chance, als mitarbeitender Künstler Bücher für Hallmark in Kansas City zu illustrieren. In den späten 1960er-Jahren zog Holland nach New York, wo er schnell die Aufmerksamkeit prominenter Artdirectors auf sich zog – Leute wie Art Paul vom *Playboy* und der Außenseiter Jean-Claude Suares von der Op-Ed-Seite der *New York Times*. Durch seine Beherrschung der visuellen Metapher markiert Hollands Arbeit eine radikale Verschiebung in der Art und Weise, wie Illustration mit redaktionellem Schreiben verbunden ist. Er wurde für seine Berichterstattung über den Watergate-Skandal unter der Nixon-Regierung ausgezeichnet, 1973 wurde seine Arbeit in *The Art of the Times* präsentiert, bearbeitet von Suares und veröffentlicht von Darien House.

Bradford Wayne Holland est né en 1943 à Fremont, dans l'Ohio. Artiste totalement autodidacte, l'adolescent plein d'ambition qu'il était envoya des dessins à Walt Disney et *The Saturday Evening Post*. Malgré la pile de lettres de rejet reçues, Holland a insisté et à 20 ans, il a fait une première percée en illustrant des livres comme artiste employé chez Hallmark à Kansas City. À la fin des années 1960, Holland est parti vivre à New York, où il a rapidement attiré l'attention de grands directeurs artistiques comme Art Paul chez *Playboy* et le marginal Jean-Claude Suares chargé de la tribune libre de *The New York Times*. Grâce à sa maîtrise de la métaphore visuelle, Holland a supposé un tournant radical pour l'intégration d'illustrations dans des éditoriaux. Il a été acclamé pour sa couverture du scandale du Watergate sous l'administration Nixon et en 1973, son travail est paru dans *The Art of the Times*, édité par Suares et publié par Darien House ; en 1976, il a été nominé pour un prix Pulitzer. Au fil de sa carrière, Holland est passé

paintings with consummate ease, conjuring textural images that appear to defy the very mediums used to create them. His works have graced the pages of such major publications as *Atlantic Monthly* and *Vanity Fair*, whilst his many exhibitions include one-man shows at the Musée des Beaux-Arts in Clermont-Ferrand, France, and the Museum of American Illustration in New York. In 1999, Holland co-founded the Illustrators' Partnership of America to champion the rights of commercial artists amid the growing influence of stock illustration houses. In 2005, he was inducted into the Society of Illustrators Hall of Fame.

1976 wurde er für den Pulitzer Prize nominiert. Im Laufe seiner Karriere ging Holland mit absoluter Leichtigkeit von monochromen eder-und-Tusche-Zeichnungen zu Farbbildern über und hat strukturelle Bilder geschaffen, die genau den Medien zu trotzen scheinen, mit denen sie geschaffen wurden. Seine Werke zierten die Seiten großer Publikationen wie *Atlantic Monthly* und *Vanity Fair*. Zu seinen zahlreichen Ausstellungen zählen Einzelschauen im Musée des Beaux-Arts im französischen Clermont-Ferrand und im Museum of American Illustration in New York. 1999 war Holland Mitbegründer der Illustrators' Partnership of America, um die Rechte kommerzieller Künstler angesichts des wachsenden Einflusses von Stock-Illustration-Agenturen zu vertreten. 2005 wurde er in die Society of Illustrators Hall of Fame aufgenommen.

avec une facilité déconcertante des dessins monochromes à l'encre aux peintures en couleur, créant des images texturées semblant défier les matières employées. Ses œuvres ont rempli les pages d'importantes publications comme *Atlantic Monthly* et *Vanity Fair*, et figuré dans de nombreuses expositions, dont certaines en solo, au musée des Beaux-Arts de Clermont-Ferrand, et au Museum of American Illustration à New York. En 1999, Holland a cofondé l'Illustrators' Partnership of America en vue de défendre les droits des artistes commerciaux face à l'influence croissante des fournisseurs de stock d'illustrations. En 2005, il a été intégré au Hall of Fame de la Society of Illustrators.

BRAD HOLLAND

Runaround, 2015
The Baffler, magazine cover;
pen, ink, colored pencil, digital;
art director: Patrick J.B. Flynn

opposite
Paradiso, 2015
The Odeon Theater, Vienna,
poster, magazine and advertising;
acrylic on masonite panel

p. 296
Avant Garde, 2016
The Odeon Theater, Vienna,
poster, magazine and advertising;
acrylic and pencil

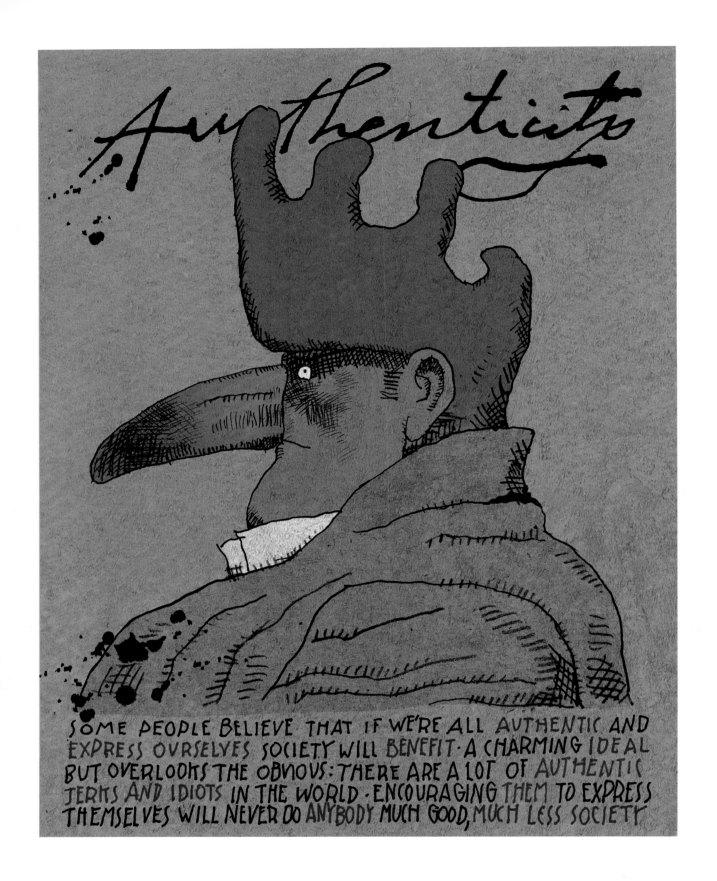

Authenticity, 2017
Poor Bradford's Almanac, poster;
pencil, ink, pastel, digital

opposite
Sleeper, 2016
Personal work; pen, ink, pastel, digital

Selected Exhibitions: 2018, *Art as Witness*, group show, School of Visual Arts, Chelsea Gallery, New York · 2017, *Brad Holland*, solo show, Spazio 32 Gallery, La Spezia, Italy · 2016, *Brad Holland*, solo show, Nuages Gallery, Milan · 2016, *Realism in an Abstract World*, group show, Norman Rockwell Museum, Stockbridge, Massachusetts · 2016, *Creation*, group show, Niigata Prefectural Museum of Modern Art, Nagaoka

Selected Publications: 2018, *Ghaveh Magazine*, Ghaveh Publishing, Iran · 2018, *The Illustration Idea Book*, Laurence King, USA · 2016, *Beauty and Sorrow*, The London Encounter, United Kingdom · 2016, *First Choice: Volume 4*, The Images Publishing Group, Australia · 2015, *Advanced Life*, Advanced Life, Mexico

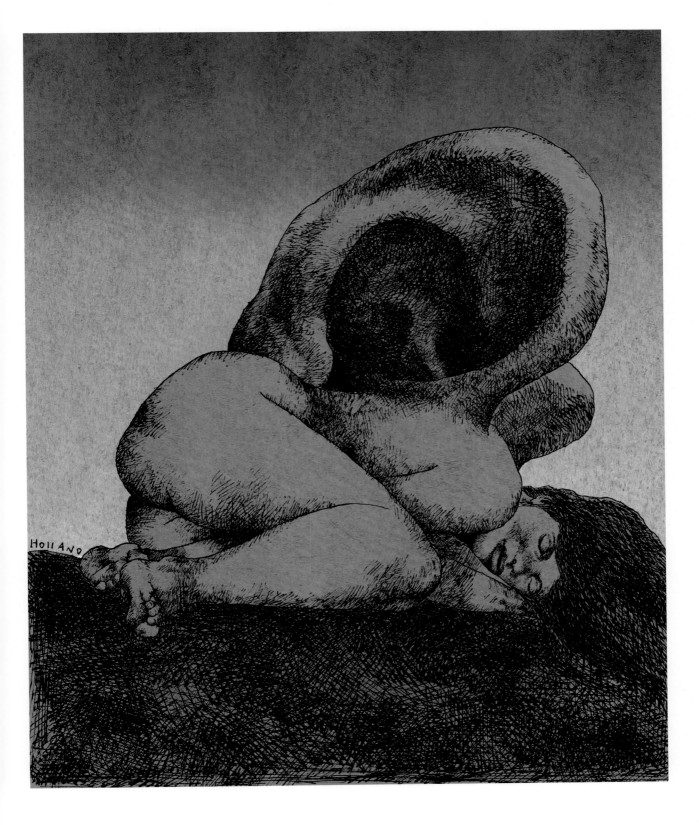

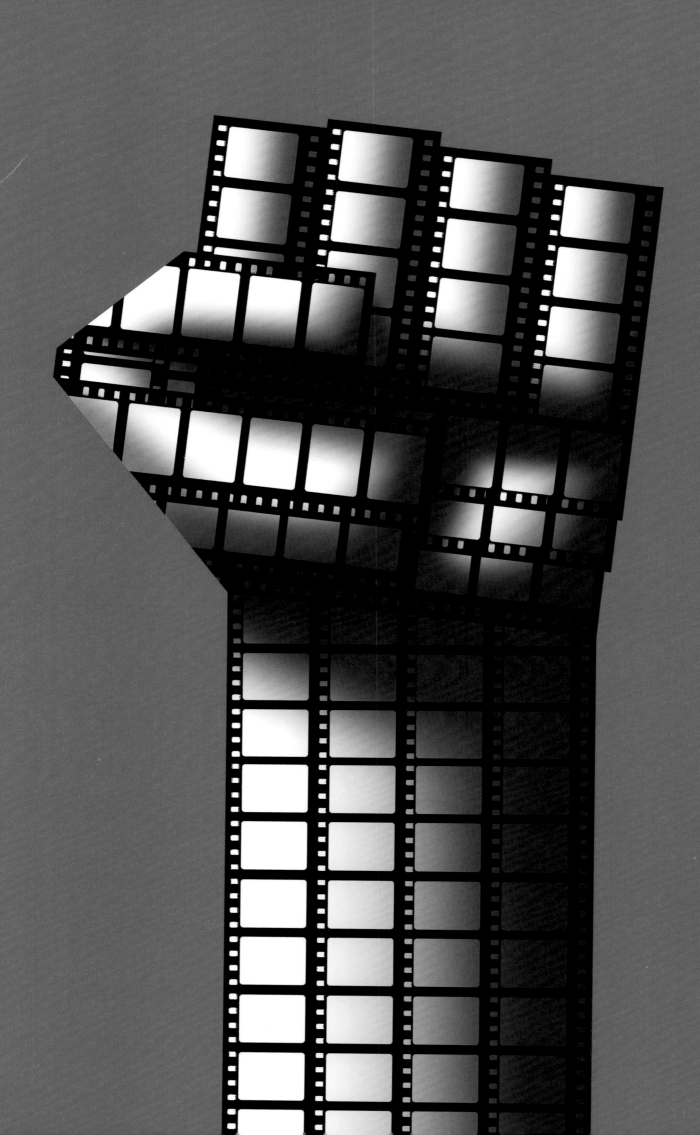

> "Work philosophy: there must be any one of three things (if not all).
> 1. Lots of money;
> 2. Lots of freedom;
> 3. Lots of time."

MIRKO ILIĆ

WWW.MIRKOILIC.COM · @mirkoiliccorp

Quite simply, Mirko Ilić has defined the direction of commercial illustration over the last four decades. Born in Bijeljina, Bosnia and Herzegovina, in 1956, he graduated from the School of Applied Arts in Zagreb, Croatia, and began publishing political comics in the early 1970s. Through posters, books, and record sleeves, Ilić's work became a representative visual force in the new wave music movement of the former Yugoslavia. In 1977, he began illustrating for American sci-fi fantasy magazines *Heavy Metal* and Marvel's *Epic Illustrated*, though by the early 1980s his focus had shifted to graphic design and illustration. A move to New York in 1986 would catapult his career on an upward trajectory. By the dawn of the 1990s, Ilić had become art director of *Time* magazine international edition, and soon after he took the helm of *The New York Times* op-ed pages, where he tore up the rule book and radically transformed their visual language. In 1995, he founded Mirko Ilić Corp to facilitate his diverse projects, from

Mirko Ilić hat ganz einfach in den letzten vier Jahrzehnten die Richtung der kommerziellen Illustration definiert. Geboren 1956 in Bijeljina (Bosnien und Herzegowina), absolvierte er die Kunstgewerbeschule in Zagreb und begann Anfang der 70er-Jahre, politische Comics zu veröffentlichen. Durch Poster, Bücher und Plattenhüllen wurde Ilićs Arbeit zu einer repräsentativen visuellen Kraft in der New-Wave-Music-Bewegung des ehemaligen Jugoslawien. 1977 begann er, für amerikanische Science-Fiction-Fantasy-Magazine wie *Heavy Metal* und Marvels *Epic Illustrated* zu illustrieren. In den frühen Achtzigerjahren konzentrierte er sich jedoch zunehmend auf Grafikdesign und Illustration. Ein Umzug nach New York 1986 sollte seine Karriere nach oben katapultieren. Zu Beginn der 1990er-Jahre wurde Ilić Art Director der internationalen Ausgabe der Zeitschrift *Time*, und bald darauf übernahm er die Leitung der Op-Ed-Seiten der *New York Times*, wo er das Regelbuch zerriss und die Bildsprache radikal veränderte.

Mirko Ilić a tout bonnement déterminé la direction que l'illustration commerciale a prise au cours des quatre dernières décennies. Né en 1956 à Bijeljina, en Bosnie-Herzégovine, il a obtenu un diplôme de l'école d'arts appliqués de Zagreb et a commencé à publier des dessins humoristiques politiques au début des années 1970. Comptant affiches, livres et pochettes de disques, le travail d'Ilić est devenu une référence visuelle au sein du mouvement new wave de l'ancienne Yougoslavie. En 1977, il a illustré les magazines américains de science-fiction *Heavy Metal* et des numéros de *Epic Illustrated* pour Marvel, et au début des années 1980, il a donné la priorité au design graphique et à l'illustration. Son installation à New York en 1986 a catapulté sa carrière. À l'aube des années 1990, Ilić était directeur artistique de l'édition internationale du magazine *Time* : il a ensuite assuré la direction des pages de tribune libre de *The New York Times*, dans lesquelles il a désobéi aux règles et fait une refonte totale du

graphic design to motion-picture titles, such as the animated opening sequence to the hit comedy *You've Got Mail* (1998), which he created with Milton Glaser and Walter Bernard. Since 1999, Ilić has been an instructor at the School of Visual Arts for their MFA in illustration program. His works are in the permanent collection of the Museum of Modern Art (MoMA) and the Smithsonian Institution.

1995 gründete er die Mirko Ilić Corp. um seine vielfältigen Projekte zu fördern, vom Grafikdesign bis hin zu Filmtiteln, wie die animierte Eröffnungssequenz der Erfolgskomödie *E-Mail für Dich* (1998), die er mit Milton Glaser und Walter Bernard kreierte. Seit 1999 ist Ilić an der School of Visual Arts Dozent für den Masterstudiengang Illustration. Seine Arbeiten sind in der permanenten Sammlung des Museum of Modern Art (MoMA) und der Smithsonian Institution zu finden.

langage visuel. En 1995, il a fondé Mirko Ilić Corp pour promouvoir ses projets tant de design graphique que de titres de films, comme l'animation pour la bande titre qu'il a créée avec Milton Glaser et Walter Bernard pour la célèbre comédie *Vous avez un message* (1998). Depuis 1999, Ilić est professeur du programme de master en beaux-arts d'illustration de la School of Visual Arts. Ses œuvres figurent dans la collection permanente du Museum of Modern Art (MoMA) et de la Smithsonian Institution.

In Command, 2014
The Serb National Council
(Srpsko narodno vijeće, SNV);
pencil, digital

right
Demystifying the Blockchain, 2018
The New York Times, newspaper;
pencil, digital

opposite
Freedom to Vote
(and Make it Count), 2016
The Wolfsonian Museum, poster;
pencil, digital

p. 302
Crisis in Black & White, 2016
The New York Times, newspaper;
pencil, digital

VRAT OD STAKLA

BILJANA SRBLJANOVIĆ

režija i scenografija
JAGOŠ MARKOVIĆ
kostimografija
BOJANA NIKITOVIĆ

igraju
JELISAVETA SABLIĆ
VESNA TRIVALIĆ
ANITA MANČIĆ
DRAGAN MIĆANOVIĆ
IRFAN MENSUR
MILICA GOJKOVIĆ
MARKO JANKETIĆ
MILOŠ SAMOLOV
SLOBODAN TEŠIĆ
BOJAN LAZAROV
ANA ČARMAN

70 JUGOSLOVENSKO
DRAMSKO
POZORIŠTE

sezona 2018/2019 jdp.rs
dizajn: MIRKO ILIĆ CORP.

Beograd
beograd.rs

The Glass Neck, 2018
Yugoslav Drama Theatre,
Belgrade, poster; digital

opposite top
The Lion, 2015
Arena Stage Theater,
poster; pencil, digital

opposite bottom
Demystifying the Blockchain, 2017
The New York Times, newspaper;
pencil, digital

MIRKO ILIĆ

306

Selected Exhibitions: 2018, *Posterfest*, group show, Budapest · 2018, *Underground Images*, group show, De Affiche Galerij, The Hague · 2017, *Get With the Action: Political Posters from the 1960s*, group show, San Francisco Museum of Modern Art · 2017, *1917–2017*, group show, Media Centre of Zaryadye Park, Moscow · 2017, *Mirko Ilić, Skyline*, solo show, Madrid Gráfica 17, Madrid

Selected Publications: 2018, *The History of Graphic Design: 1960–Today*, TASCHEN, Germany · 2018, *The Illustration Idea Book*, Laurence King Publishing, United Kingdom · 2018, *Graphic Style: From Victorian to Hipster*, Harry N. Abrams, USA · 2018, *Head to Toe: The Nude in Graphic Design*, Rizzoli, USA · 2017, *Graphic: 500 Designs That Matter*, Phaidon, United Kingdom

"You have to grab the angel by the neck and squeeze an idea out. I like working fast, and thinking fast. I don't like to over-think a project; usually my first instinct for a solution is the best." *for I love Mega*

JEREMYVILLE

WWW.JEREMYVILLE.COM · @jeremyville

Brooklyn-based Jeremyville is an illustrator-entrepreneur at the vanguard of art as a force for social change. Born in 1975 in Sydney, Jeremy Ville grew up in the aptly named Wonderland Avenue near Bondi Beach, where Lego, Smurfs, sea-monkeys, Tintin, and Mr. Men books were all part of his creative universe. At 19, while studying architecture at Sydney University, he edited the student newspaper, filling in the blank spaces with his cartoons, which quickly led to freelance editorial work for *The Sydney Morning Herald*. After graduating in 1996, he decided to forego architecture and open an illustration studio, despite having no formal qualifications. A notable early commission came in the mid-1990s, when he began illustrating wrappers for the confectionery brand Minties. In 2008 he co-founded Studio Jeremyville, with creative director Megan Mair. Under this moniker, the couple have diversified into such areas as product design and animation. Projects have included footwear for Converse, art toys for Kidrobot, and snowboards for

Der in Brooklyn ansässige Jeremyville ist als Illustrator und Unternehmer einer der Vorreiter der Kunst, die sich als Kraft für den gesellschaftlichen Wandel versteht. Jeremy Ville wurde 1975 in Sydney geboren und wuchs passenderweise in der Wonderland Avenue auf, wo Lego, Schlümpfe, Urzeitkrebse und Tim-und-Struppi-Bücher Teil seines kreativen Universums waren. Mit 19 Jahren gehörte er während eines Architekturstudiums an der Universität Sydney zur Redaktion der Studentenzeitung und füllte die leeren Flächen mit seinen Cartoons, was schnell zu freiberuflicher Arbeit für den *Sydney Morning Herald* führte. Nach seinem Abschluss im Jahr 1996 entschied er sich, die Architektur aufzugeben und ein Illustrationsstudio zu eröffnen, obwohl er keine formellen Qualifikationen vorweisen konnte. Ein bemerkenswerter Auftrag kam Mitte der 1990er-Jahre, als er begann, Verpackungen für die Süßwarenmarke Minties zu illustrieren. 2008 gründete er zusammen mit Megan Mair als Creative Director das Studio Jeremyville.

Installé à Brooklyn, Jeremyville est un illustrateur et entrepreneur à l'avant-garde de l'art comme moteur de changement social. Né en 1975 à Sydney, Jeremy Ville a grandi près de Bondi Beach, sur Wonderland Avenue (qui porte bien son nom), où Lego, Schtroumpfs, kits d'œufs d'artémias Sea-Monkeys, Tintin et livres Monsieur Madame ont enrichi son univers créatif. À 19 ans, alors inscrit en architecture à l'université de Sydney, il s'est chargé de l'édition du journal étudiant et remplissait les espaces vides avec ses propres dessins, une expérience qui l'a rapidement conduit à des missions éditoriales en freelance pour *The Sydney Morning Herald*. Une fois son diplôme en poche en 1996, il a renoncé à l'architecture et ouvert un studio d'illustration, même s'il n'avait pas de qualifications officielles dans le domaine. Pour une première commande importante au milieu des années 1990, il a illustré des emballages pour la marque de confiserie Minties. En 2008, il a cofondé Studio Jeremyville avec la directrice de

Rossignol. In the mid-2010s, he started the daily online project "Community Service Announcements"—an ongoing series of positive visual messages on topics such as self-empowerment and the environment. Drawing inspiration from the Fleischer Studios cartoons of the 1930s and references from the history of modern art and pop culture, Jeremyville has evolved a distinctive visual voice. His simple pen and ink style, sometimes with characters set against detailed isometric landscapes, has endeared him to a growing fanbase throughout the world. Jeremyville has exhibited widely, including at the Andy Warhol Museum in Pittsburgh, La Casa Encendida in Madrid, and in the 798 Art District in Beijing. His 2004 book *Vinyl Will Kill!* is regarded as one of the first to focus on the designer toy movement. In 2018, he teamed up with Hugo Boss to produce a seasonal collection and campaign for the Boss label.

Unter diesem Namen hat sich das Paar in Bereichen wie Produktdesign und Animation diversifiziert. Zu den Projekten gehörten Schuhdesign für Converse, Art Toys für Kidrobot und Snowboards für Rossignol. Mitte der 2010er-Jahre startete Jeremyville das tägliche Onlineprojekt „Community Service Announcements"— eine fortlaufende Reihe positiver visueller Botschaften zu Themen wie Selbstermächtigung und Umwelt. Inspiriert von den Cartoons des Fleischer Studios der 1930er-Jahre und von Referenzen aus der Geschichte der modernen Kunst und der Popkultur, hat er eine unverwechselbare visuelle Stimme entwickelt. Sein einfacher Stil mit Feder und Tusche hat ihm eine wachsende Fangemeinde in der ganzen Welt eingebracht. Jeremyville hat viel ausgestellt, unter anderem im Andy Warhol Museum in Pittsburgh, in der Casa Encendida in Madrid und im Kunstbezirk 798 in Peking. Sein 2004 erschienenes Buch *Vinyl Will Kill!* gilt als eines der ersten, das sich mit dem Designer Toys Movement beschäftigte. Im Jahr 2018 arbeitete er mit Hugo Boss zusammen, um eine saisonale Kollektion und Kampagne für das Label Boss zu produzieren.

création Megan Mair. Sous ce nom, le duo a diversifié son activité, de la conception de produits à l'animation, avec des modèles de chaussures pour Converse, des art toys pour Kidrobot et des snowboards pour Rossignol. Au milieu des années 2010, Jeremyville s'est lancé dans le projet en ligne « Community Service Announcements », une série de messages visuels positifs publiés chaque jour sur des thèmes comme l'auto-émancipation et l'environnement. Puisant son inspiration dans les dessins de Fleischer Studios des années 1930 ainsi que dans l'histoire de l'art moderne et de la culture pop, Jeremyville s'est imposé avec son style visuel distinctif. Avec ses dessins simples à l'encre intégrant parfois des personnages sur fond de paysages isométriques, il a su se gagner un nombre croissant d'inconditionnels dans le monde entier. Jeremyville a souvent exposé, y compris à The Andy Warhol Museum de Pittsburgh, à La Casa Encendida à Madrid et dans le quartier artistique 798 à Pékin. Sorti en 2004, son ouvrage intitulé *Vinyl Will Kill!* est l'un des premiers consacré au mouvement de designer toys. Il a collaboré en 2018 avec Hugo Boss afin de créer une collection saisonnière pour le label Boss.

Brooklyn Museum
Streetscape, 2018, signed
and numbered screenprint

p. 308

opposite
A Quest Unlimited, 2018
Personal work; acrylic on canvas

Woodstock and Friends, 2019
APortfolio, Hong Kong, drawing
for a vinyl toy series; digital

FIND YOUR GROOVE
TO PLAY YOUR SONG.

SUDDENLY THINKING OF YOU.

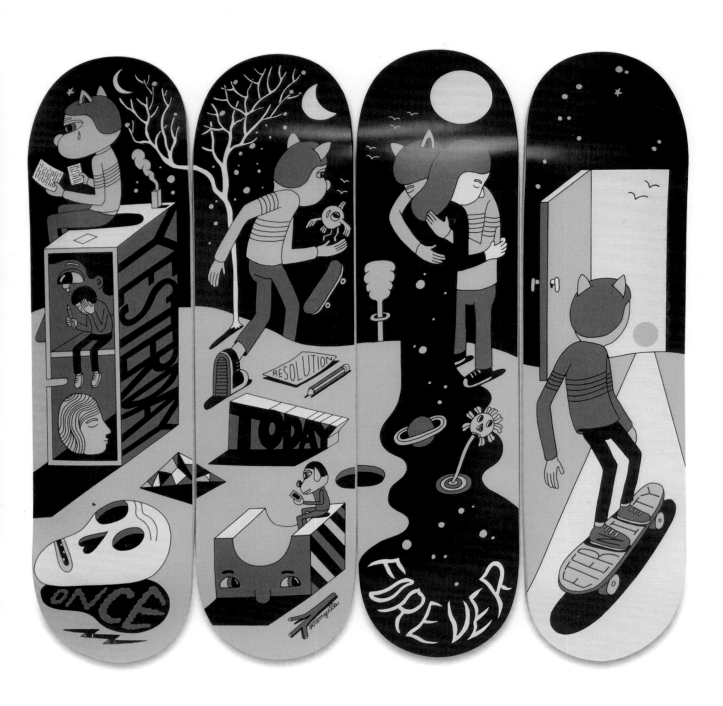

Yesterday/Today/Forever/Eternity, 2018
The Skateroom, skate deck series;
hand drawing

opposite
Find Your Groove to Play Your Song
and Suddenly Thinking of You, 2019
Personal work, posters; hand drawing

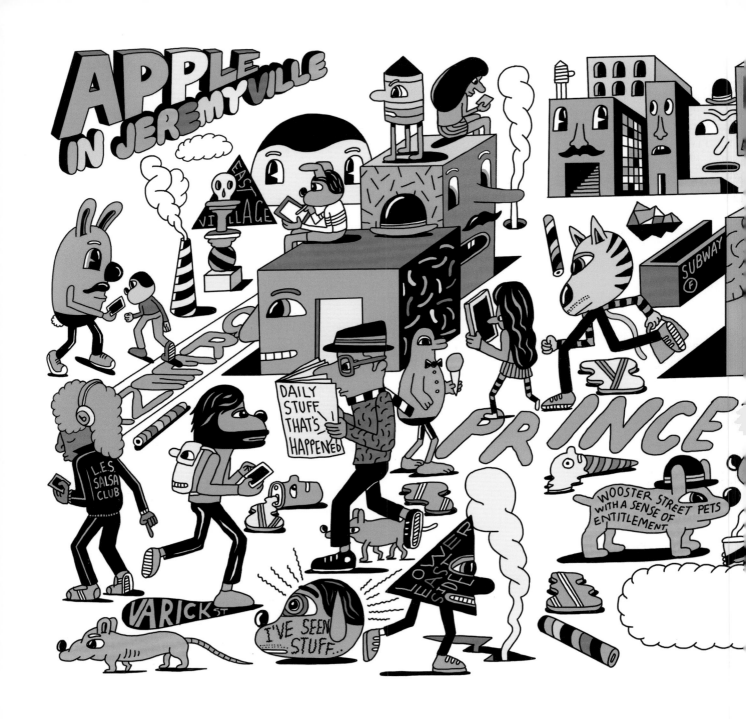

Apple in Jeremyville, 2018
Animated screen at Apple stores
worldwide; digital

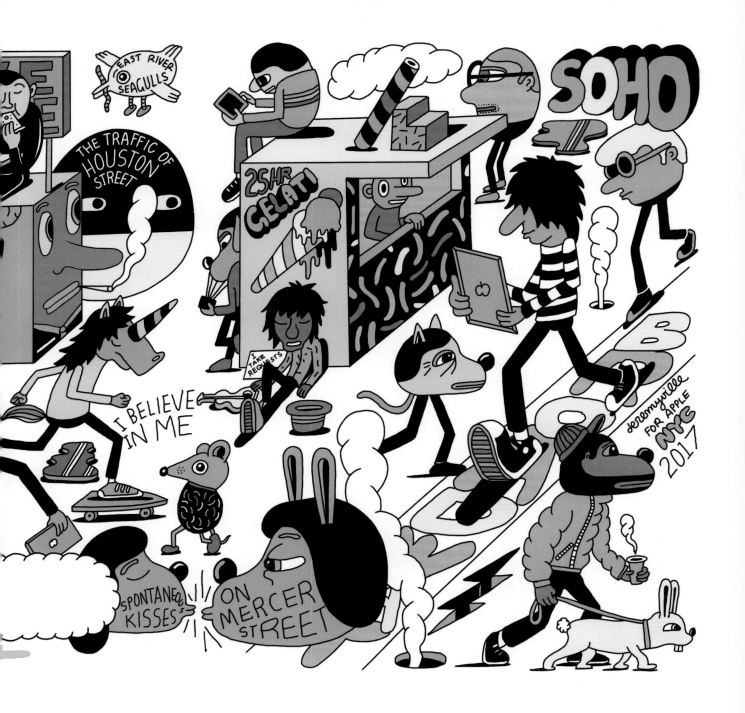

315

"His style is effortless and full of humour, grinning at our modern world through a wry squint—an ability that most of the great illustrators through time have nearly all had in common." *for It's Nice That*

JEAN JULLIEN

WWW.JEANJULLIEN.COM · **@jeanjullien**

Jean Jullien is a French artist based in Paris after a long period in London. He was born in Cholet in the Loire Valley in 1983, and grew up in Nantes. After post-baccalauréat studies in Quimper he moved to London, where he received a BA in graphic design from Central St Martins in 2008, followed by an MA in visual communication from the Royal College of Art in 2010. Jullien has since evolved a prolific output with his strikingly simple, doodling style manifesting in every conceivable form from posters and video to apparel, furniture, and installations. Jullien's hard work and rapid rise has led to the founding of a moving-image studio with his brother Nico, the publication of books—his first monograph came out in 2016—and the launch of a product range named Nounou with Jae Huh & Co. in South Korea. Jullien has collaborated extensively with Le Centre Pompidou, Amnesty International, *Vogue*, Petit Bateau, and hundreds of other clients. His iconic illustration of the Eiffel Tour inside a circle became the symbol of

Jean Jullien ist ein französischer Künstler, der nach langer Zeit in London wieder in Paris lebt. Er wurde 1983 in Cholet im Loiretal geboren und wuchs in Nantes auf. Nach einem Studium in Quimper zog er nach London, wo er 2008 einen Bachelor in Grafikdesign vom Central St. Martins erhielt, gefolgt von einem Master in visueller Kommunikation vom Royal College of Art im Jahr 2010. Seitdem war Jullien mit seinem auffallend einfachen, kritzelnden Stil überaus produktiv, seine Werke finden sich auf Postern, in Videos auf Kleidung, Möbeln und als Installationen. Julliens harte Arbeit und sein rasanter Aufstieg führten zur Gründung eines Filmstudios mit seinem Bruder Nico sowie zu Buchveröffentlichungen – seine erste Monografie erschien im Jahr 2016 – außerdem kreierte er mit Jae Huh & Co. in Südkorea eine eigene Produktreihe. Jullien hat intensiv mit dem Centre Pompidou, Amnesty International, *Vogue*, Petit Bateau und Hunderten anderer Kunden zusammengearbeitet. Seine ikonische Darstellung des

Jean Jullien est un artiste français qui s'est installé à Paris après une longue période passée à Londres. Né en 1983 à Cholet, dans la vallée de la Loire, il a grandi à Nantes. Au terme de ses études universitaires à Quimper, il est allé vivre à Londres, où il a décroché en 2008 une licence en design graphique au Central St Martins College, puis en 2010 une maîtrise en communication visuelle au Royal College of Art. Depuis, la production de Jullien est prolifique, dans un style d'une merveilleuse simplicité qui se manifeste dans tous les formats imaginables, qu'il s'agisse d'affiches, de vidéos, de vêtements, de meubles ou d'installations. Jullien a travaillé dur et sa montée en flèche l'a motivé à fonder un studio d'animation avec son frère Nico, à publier des ouvrages (sa première monographie est sortie en 2016) et à lancer une gamme de produits nommée Nounou avec Jae Huh & Co. en Corée du Sud. Jullien a largement collaboré avec le Centre Pompidou, Amnesty International, *Vogue*, Petit Bateau et des centaines

"Peace for Paris" in 2015. His most recent undertakings include collaborations with Galeries Lafayette and Maison Plisson in Paris, a poster for Netflix's *Stranger Things* season 3, and commissions for magazines including *Télérama* and *M Le magazine du Monde*.

Eiffelturms in einem Kreis wurde zum Symbol von „Peace for Paris" im Jahr 2015. Zu seinen jüngsten Projekten zählen Kooperationen mit Galeries Lafayette und Maison Plisson in Paris, ein Poster für die dritte Staffel von Netflix' *Stranger Things* und Auftragsarbeiten für Zeitschriften wie *Télérama* und *M Le magazine du Monde*.

d'autres clients. En 2015, son illustration iconique de la tour Eiffel au centre d'un cercle est devenue le symbole de « Peace for Paris ». Plus récemment, il a collaboré pour des projets avec les Galeries Lafayette et Maison Plisson à Paris, l'affiche de la saison 3 de *Stranger Things* sur Netflix, ainsi que des commandes de magazines comme *Télérama* et *M Le magazine du Monde*.

MAISON PLISSON

ALIMENTATION GÉNÉRALE

Footballer, 2017
Champion, limited-edition artists
series, curated by Beams & Co.

right
Bottle, 2017
Kiblind, magazine cover

opposite
Maison Plisson, 2018
Illustrations for visual identity

p. 316
Dog's Own Spots, 2017
Personal work

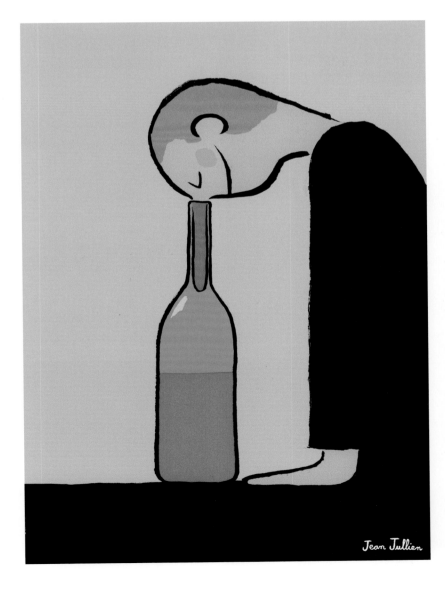

Untitled, 2018
Onaji Umi, solo show
Gallery Target, Tokyo

JEAN JULLIEN

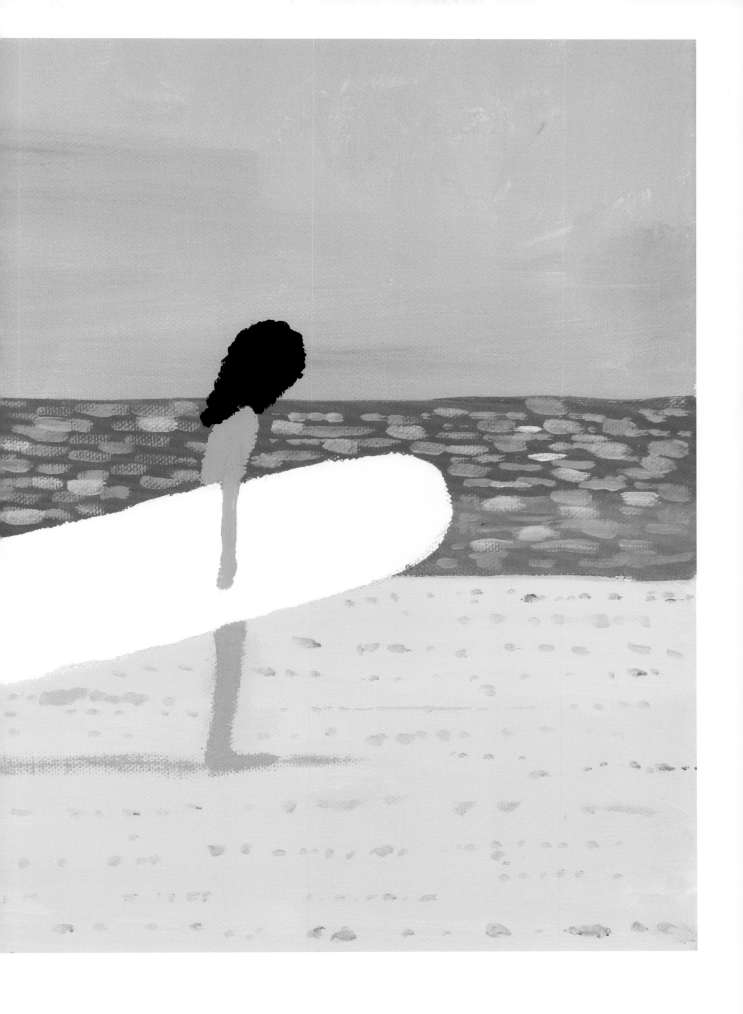

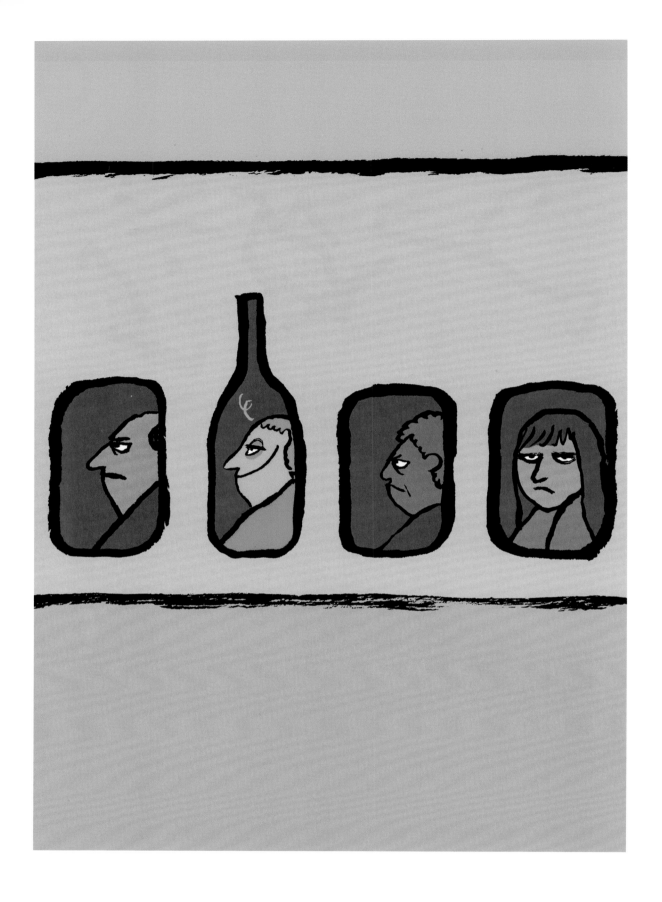

Series for *LineAge*, solo show,
2018, Studio Concrete, Seoul

Selected Exhibitions: 2018, *GIB*, solo show, Arsham Fieg Gallery, New York · 2018, *Le Volet Jaune*, solo show, Encore Alice Gallery, Brussels · 2018, *Le Jardin Bleu*, solo show, Chandran Gallery, San Francisco · 2018, *Ona ji Umi*, solo show, Gallery Target, Tokyo · 2018, *LineAge*, solo show, *Studio Concrete*, Seoul

Selected Publications: 2018, *Why the Face,* Phaidon, USA · 2017, *Under Dogs,* Hato, United Kingdom · 2016, *This Is Not a Book,* Phaidon, United Kingdom · 2016, *Modern Life,* teNeues, Germany · 2016, *Ralf,* Frances Lincoln, United Kingdom

"I think we'll need more red and black."

KAKO

WWW.KAKOFONIA.COM · @kakofonia

Born in São Paulo in 1975, Franco D'Angelo Bergamini has been conjuring up award-winning graphics as "Kako" since the early years of the millennium. Growing up in his native city, Kako and his brother spent afternoons learning to draw at a local comic-book school. His first job was as a camera assistant for an advertising company. A stint at art college followed but he dropped out in favor of freelancing in graphic and web design, eventually realizing his passion for illustration in 2002. Balancing technique and style, Kako creates vector-based imagery reminiscent of Japanese *ukiyo-e* prints. His muted palette elicits a distinctively "dark and dirty" landscape suited to his re-imaginings of Edgar Allan Poe's short stories (2018) or Ridley Scott's cult film *Blade Runner*. Indeed, it is the cinematic, subterranean atmosphere he dreams up that has earned him recognition by the Society of Illustrators, inclusion in *Lürzer's Archive*'s "200 Best Illustrators Worldwide," along with a Cannes Gold Lion to boot. As his career reaches its

Franco D'Angelo Bergamini wurde 1975 in São Paulo geboren und zaubert als „Kako" seit Beginn des Jahrtausends preisgekrönte Grafiken. In seiner Heimatstadt aufgewachsen, verbrachten Kako und sein Bruder die Nachmittage zeichnend in einer örtlichen Comicbuchschule. Sein erster Job war der eines Kameraassistenten bei einer Werbeagentur. Es folgte ein Aufenthalt an der Kunsthochschule, aber er schied zugunsten einer freiberuflicher Tätigkeit im Grafik- und Webdesign wieder aus und verwirklichte schließlich 2002 seine Leidenschaft für Illustration. Kako ist ein Vertreter von ausgewogener Technik und Stil und erzeugt vektorbasierte Bilder, die an japanische *ukiyo-e*-Drucke erinnern. Seine reduzierte Farbpalette lässt eine unverwechselbare „dunkle und schmutzige" Landschaft entstehen, gut geeignet für seine Neufassung von Edgar Allen Poes *Kurzgeschichten* (2018) oder Ridley Scotts Kultfilm *Blade Runner*. Tatsächlich ist es die von ihm geschaffene filmische, unterirdische

Né à São Paulo en 1975, Franco D'Angelo Bergamini est l'auteur depuis le début des années 2000 de graphismes primés créés sous le pseudonyme « Kako ». Pendant son enfance, il passait des après-midis entiers avec son frère à apprendre à dessiner dans une école locale. Après un premier emploi en tant qu'assistant cameraman pour une agence de publicité, il a fait un court passage par une école d'art, qu'il a abandonnée pour travailler à son compte en conception Web et graphique et finalement satisfaire sa passion pour l'illustration en 2002. Il trouve un équilibre entre technique et style et crée une imagerie vectorielle rappelant les estampes japonaises ukiyo-e. Sa palette de couleurs sourdes donne des paysages particulièrement sombres et sales, appropriés pour ses réinterprétations des *Histoires extraordinaires* d'Edgar Allan Poe (2018) ou du film culte *Blade Runner* de Ridley Scott. C'est d'ailleurs cette atmosphère cinématographique underground qu'il s'invente qui lui a valu la reconnaissance

20th year, Kako is working as a production designer at Arvore Immersive Experiences and looking forward to improving his understanding of creativity and communication through his exploration of virtual reality.

Atmosphäre, für die er von der Society of Illustrators ausgezeichnet und deretwegen, er unter die „200 besten Illustratoren weltweit" des *Lürzer's Archive* aufgenommen und in Cannes mit einem goldenen Löwen ausgezeichnet wurde. Da Kako nun schon fast 20 Jahre in der Branche tätig ist, arbeitet er nun als Produktionsdesigner bei Arvore Immersive Experiences und freut sich darauf, sein Verständnis von Kreativität und Kommunikation durch die Erforschung der virtuellen Realität zu verbessern.

de la Society of Illustrators, une mention dans la liste « 200 Best Illustrators Worldwide » de *Lürzer's Archive,* ainsi que l'or aux Cannes Lions. Sur le point de fêter ses 20 ans de carrière, Kako travaille comme concepteur artistique chez Arvore Immersive Experiences et mise sur l'exploration de la réalité virtuelle pour mieux aborder la créativité et la communication.

KAKO

T-70 X-Wing, 2015
Hero Complex Gallery,
limited-edition screen print; digital

right

Righteous Rides, Le Mans, 2013
Hero Complex Gallery,
giclée print; digital

opposite

Ivan Turgenev, Spirits, 2014
Editora Autêntica, book; digital

p. 324

Enter the Dragon, 2015
Limited-edition screen print; digital

Selected Exhibitions: 2015, *Strange Cities*, group show, Onassis Cultural Center, Athens · 2012, group show, Mondo Gallery, Austin · 2011, *Katalogue XXL*, group show, Museu Oscar Niemeyer, Curitiba, Brazil · 2009, *Society of Illustrators*, group show, New York · 2008, *Creative Art Session*, group show, Kawasaki City Museum

Selected Publications: 2013, *100 Illustrators*, TASCHEN, Germany · 2013, *New Illustrators File*, Art Box, Japan · 2013, *Alternative Movie Posters*, Schiffer Publishing, USA · 2011, *Illustration Now!*, TASCHEN, Germany · 2008, *Society of Illustrators Annual*, USA

Die Bith-Machine, 2015
Hero Complex Gallery,
giclée print; digital

right
Death of a Man, 2014
Alex Nicholson, short movie
poster; ink, digital;
handwriting: Futoshi Yoshizawa

opposite
The Warriors – These Are the
Armies of the Night, 2017
Limited-edition screen print; digital

> "I think I'm incredibly lucky because I had the patience and perseverance and single-mindedness to believe that I belonged in that world." *for The Great Discontent*

MAIRA KALMAN

WWW.MAIRAKALMAN.COM · @mairakalman

Maira Kalman is an Israeli-born American illustrator based in Manhattan. Her quirky, idiosyncratic vision of the modern world marries observational wit with an equal measure of irreverence. Born in Tel Aviv in 1949 to Russian-Jewish parents, Kalman moved to the Bronx in New York with her family when she was four. After studying art at the High School of Music & Art, she met her future husband, graphic designer Tibor Kalman, with whom she would collaborate closely under the auspices of their graphic and product design company M&Co. The firm became noted for its eclectic portfolio, including work for magazines such as Interview, bands like Talking Heads, and title sequences for Jonathan Demme's blockbuster movie *The Silence of the Lambs* (1991). Kalman is particularly well regarded for her children's books, the first of which, *Stay Up Late* (1987), illustrated the lyrics of David Byrne. As well as being a regular contributor to *The New Yorker*, designing fabrics for Isaac Mizrahi, and sets for the Mark Morris Dance Group, Kalman's diverse

Maira Kalman ist eine in Manhattan geborene US-amerikanische Illustratorin. Ihre skurrile, eigenwillige Vision der modernen Welt verbindet Beobachtungswitz mit einem ebenso hohen Maß an Respektlosigkeit. Kalman wurde 1949 als Tochter russisch-jüdischer Eltern in Tel Aviv geboren. Mit vier Jahren zog sie mit ihrer Familie in die Bronx in New York. Nach einem Kunststudium an der High School of Music & Art lernte sie ihren zukünftigen Ehemann, den Grafikdesigner Tibor Kalman, kennen, mit dem sie in ihrer gemeinsamen Grafik- und Produktdesignfirma M&Co. eng zusammenarbeiten sollte. Das Unternehmen wurde für sein vielseitiges Portfolio bekannt, sie arbeiteten unter anderem für Zeitschriften wie *Interview*, für Bands wie Talking Heads und erstellten die Titelsequenz für Jonathan Demmes Blockbuster *Das Schweigen der Lämmer* (1991). Besonders berühmt ist Kalman für ihre Kinderbücher. In ihrem ersten, *Stay Up Late* (1987), illustrierte sie die Gedichte von David Byrne. Neben regelmäßigen Beiträgen

Maira Kalman est une illustratrice américaine d'origine israélienne qui vit à Manhattan. Sa vision excentrique et idiosyncratique du monde moderne combine un esprit d'observation et la même dose d'irrévérence. Née à Tel Aviv en 1949 de parents juifs russes, Kalman avait quatre ans quand sa famille s'est installée dans le Bronx. Après des études au High School of Music & Art, elle a rencontré son futur mari, le concepteur graphique Tibor Kalman, avec qui elle a travaillé en étroite collaboration sous les auspices de leur agence de conception de produits et graphique M&Co. La société s'est fait un nom grâce à son portfolio éclectique qui inclut des projets pour des magazines comme *Interview*, des groupes comme Talking Heads et la séquence d'ouverture pour la superproduction *Le Silence des agneaux* (1991) de Jonathan Demme. Kalman est notamment appréciée pour ses livres pour enfants dont le premier, intitulé *Stay Up Late* (1987), illustrait les paroles d'une chanson de David Byrne. Outre ses

illustrational output has been show-cased in numerous exhibitions, including the 2010 retrospective *Maira Kalman: Various Illuminations (of a Crazy World)* at the Institute of Contemporary Art in Philadelphia. Her two monthly online columns for *The New York Times*, "The Principles of Uncertainty" (2006–07), a narrative journal of her life, followed by "And The Pursuit of Happiness" (2009), a year-long historical investigation into American democracy, have been amal-gamated into book form.

für den *New Yorker* design sie Stoffe für Isaac Mizrahi und Sets für die Mark Morris Dance Group. Kalmans vielfältige Illustrationsarbeiten wurden in zahl-reichen Ausstellungen gezeigt, zum Bei-spiel 2010 in der Retrospektive *Maira Kalman: Various Illuminations (of a Crazy World)* im Institute of Contem-porary Art in Philadelphia. Ihre zweimo-natlichen Online-Kolumnen für die *New York Times*, „The Principles of Uncertain-ty" (2006/07), ein erzählerisches Tage-buch ihres Lebens, gefolgt von „And The Pursuit of Happiness" (2009), eine jah-relange historische Untersuchung der amerikanischen Demokratie, wurden in Buchform zusammengefasst.

contributions fréquentes pour *The New Yorker*, la conception de tissus pour Isaac Mizrahi et de décors pour le Mark Morris Dance Group, Kalman a produit une variété d'illustrations largement exposées, dont la rétrospective en 2010 intitulée *Maira Kalman: Various Illumina-tions (of a Crazy World)* à l'Institute of Contemporary Art de Philadelphie. Deux ouvrages compilent ses colonnes men-suelles « The Principles of Uncertainty » (2006–07), un essai sur sa vision per-sonnelle du monde, et « And The Pursuit of Happiness » (2009), une étude menée pendant un an sur la démocratie américaine, qu'elle a tenues pour *The New York Times*.

MAIRA KALMAN

Afternoon in the Park, 2007
The Principles of Uncertainty,
The New York Times, newspaper;
gouache on paper

opposite
Candy Store in Rome, 2014
My Favorite Things, Harper Design;
gouache on paper

p. 330
Vladimir Nabokov as a Young Boy, 2007
The Principles of Uncertainty,
The New York Times, newspaper;
gouache on paper

Gertrude and Alice, 2019
The Autobiography of Alice B. Toklas, Gertrude Stein, book, Penguin Press 2020; gouache on paper

MAIRA KALMAN

Selected Exhibitions: 2019, *Maira Kalman*, solo show, Julie Saul Gallery, New York · 2017, *Sara Berman's Closet*, solo show, Metropolitan Museum of Art, New York · 2014, *Maira Kalman: Selects*, solo show, Cooper Hewitt, New York · 2010, *Maira Kalman: Various Illuminations*, solo show, ICA, Philadelphia

Selected Publications: 2007, *The Principles of Uncertainty*, Penguin Press, USA · 2005, *The Elements of Style*, Penguin Press, USA

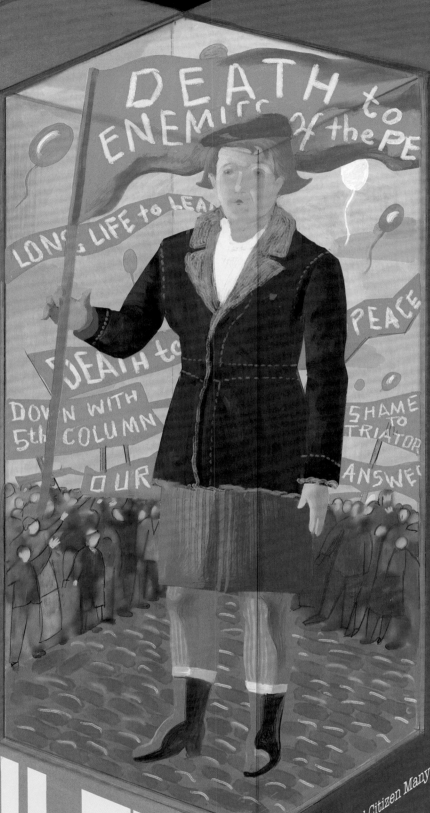

DEATH to ENEMIES of the PE

LONG LIFE to LEA

PEACE

DEATH to

DOWN WITH
5th COLUMN

SHAME
TO
TRIATOR

OUR

ANSWE

GULAG

GULAG

Action Figure Loyal Citizen Manya
For ages 5 and up
Item # 1918 1937 1948 1954 2018
Made in Russian Federation 2018

> "One day, I realized that simple ink lines and brushstrokes are doing exactly what I want them to; they are projections of my emotional state and thought processes. This was the beginning of my own visual story."

IGOR KARASH

WWW.IGORKARASH.COM · @igorkarash

Born in 1960, Igor Karash grew up in Baku, the capital of the former Soviet Republic of Azerbaijan. After studying architecture, he attended the Kharkov State Academy of Design and Arts in Ukraine, gaining an MA in Graphic Arts and Illustration in 1988. He immigrated to the United States in 1993, initially living in Houston, and later settling in St. Louis, where he lives and works today. The breadth of his practice can be gauged by his numerous projects in book and editorial illustration, graphic design, theater and film set design, as well as teaching. Karash works in a variety of traditional media, including pencil or gouache on paper, and ink on cardboard, though he sometimes experiments with digital tools. Imbued with a dark mysticism and deep sense of nostalgia, his personal work explores the political grotesque. Referencing the Bolshevik coup of 1917, his conceptual project *The Red Series* (2018) examines the power of the state over the creative process through a personal exploration of his native country's past as "a purely

Igor Karash wurde 1960 geboren und wuchs in Baku, der Hauptstadt der ehemaligen Sowjetrepublik Aserbaidschan, auf. Nach seinem Studium der Architektur besuchte er die Kharkov Staatliche Akademie für Design und Kunst in der Ukraine und erhielt 1988 einen Master in Grafik und Illustration. Er emigrierte 1993 in die Vereinigten Staaten, lebte zunächst in Houston und ließ sich später in St. Louis nieder, wo er noch heute lebt und arbeitet. Die Bandbreite seiner Arbeiten lässt sich an seinen zahlreichen Projekten in den Bereichen Buch- und redaktionelle Illustration, Grafikdesign, Theater- und Filmset-Design sowie Unterricht abschätzen. Karash arbeitet mit einer Vielzahl traditioneller Techniken, darunter Bleistift oder Gouache auf Papier und Tusche auf Karton, experimentiert aber manchmal auch mit digitalen Werkzeugen. Seine Arbeit ist von dunkler Mystik und einem tiefen Gefühl der Nostalgie durchdrungen und erkundet das politisch Groteske. Unter Verweis auf die

Né en 1960, Igor Karash a grandi à Bakou, la capitale de l'ancienne république socialiste soviétique d'Azerbaïdjan. Après des études d'architecture, il a obtenu en 1988 une licence en arts graphiques et illustration à l'académie d'État Kharkiv de design et d'art d'Ukraine. Il a émigré aux États-Unis en 1993, d'abord à Houston, puis à Saint-Louis, où il réside actuellement. L'étendue de sa pratique peut se mesurer aux nombreux projets d'illustration de livres et d'éditoriaux, de design graphique, de conception de décors de théâtre et de cinéma, ainsi que d'enseignement. Karash travaille avec un matériel varié, du crayon et de la gouache sur papier à l'encre sur carton, employant aussi parfois des outils numériques. Imprégnées d'un mysticisme sombre et d'un profond sentiment de nostalgie, ses œuvres traitent du grotesque en politique. Renvoyant au coup d'État bolchevique de 1917, son projet conceptuel *The Red Series* (2018) analyse le pouvoir qu'exerce l'État sur le processus créatif à travers une exploration personnelle du

337

artistic reflection in the form of intimate graphic narratives that border on the absurd." A constant innovator, his ability to strike a fine balance between the familiar and the novel has earned him the highest critical regard. In 2012, he won the Book Illustration Competition run in partnership by The House of Illustration and The Folio Society for reimagining Angela Carter's *The Bloody Chamber and Other Stories*. This led to one of his most notable projects to date when, in 2014, he was commissioned by The Folio Society to illustrate a limited two-volume edition of Leo Tolstoy's epic novel *War and Peace*. Karash has twice been honored as one of *Lürzer's Archive's* "200 Best Illustrators Worldwide."

russische Oktoberrevolution von 1917 untersucht sein konzeptionelles Projekt *The Red Series* (2018) die Macht des Staates über den kreativen Prozess durch eine persönliche Erkundung der Vergangenheit seines Heimatlandes als „eine rein künstlerische Reflexion in Form von intimen grafischen Erzählungen, die an das Absurde grenzen". Als ständiger Innovator, hat ihm seine Fähigkeit, eine gute Balance zwischen dem Vertrauten und dem Neuen zu finden, höchste Anerkennung gebracht. 2012 gewann er The Book Illustration Competition, die gemeinsam von The House of Illustration und der Folio Society für die Neugestaltung von Angela Carters *The Bloody Chamber and Other Stories* ausgerichtet wurde. Dies führte zu einem seiner bemerkenswertesten Projekte: der 2014 von der Folio Society beauftragten Illustration einer limitierten zweibändigen Edition von Leo Tolstois epischem Roman *Krieg und Frieden*. Karash wurde zweimal als einer der „*200 besten Illustratoren weltweit*" vom *Lürzer's Archive* ausgezeichnet.

passé de son pays, « une réflexion purement artistique via un récit graphique intime à la limite de absurde ». Il ne cesse d'innover et de se gagner un grand respect car il sait trouver le juste équilibre entre les choses familières et celles nouvelles. En 2012, il a remporté la Book Illustration Competition organisée en partenariat avec The House of Illustration et The Folio Society pour sa réinterprétation de l'ouvrage *La Compagnie des loups et autres nouvelles* d'Angela Carter. Cette production a été suivie de l'un de ses projets d'envergure, quand il a été sollicité en 2014 par The Folio Society pour illustrer une édition limitée en deux volumes du roman épique *Guerre et Paix* de Léon Tolstoï. À deux reprises, Karash a été choisi par *Lürzer's Archive* comme l'un des « 200 Best Illustrators Worldwide ».

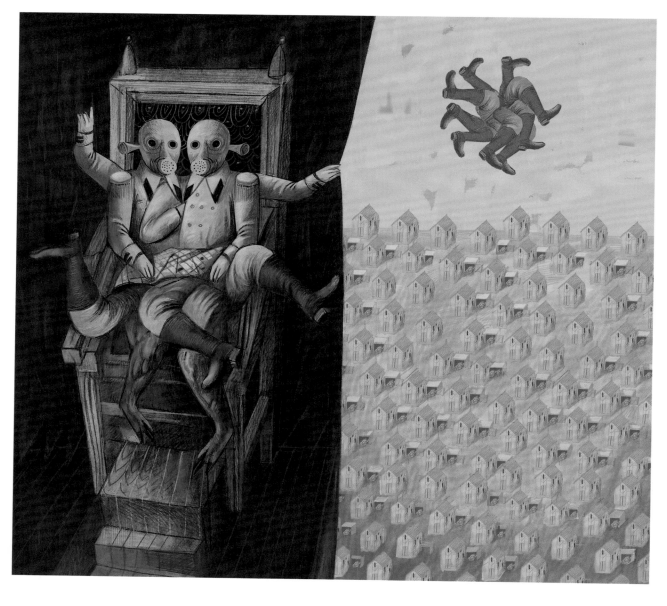

IGOR KARASH

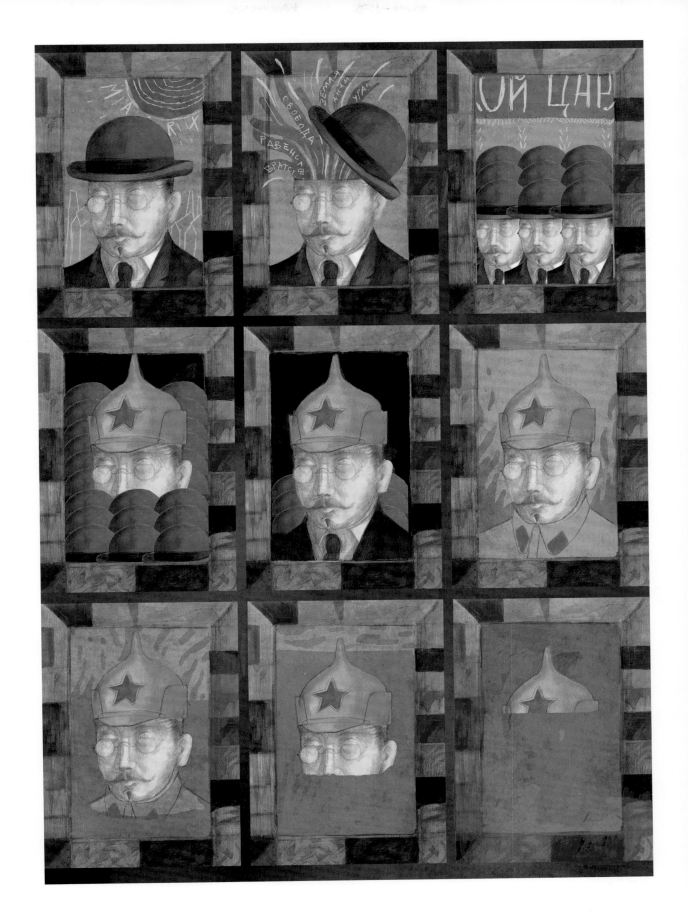

Bolshevik Icon,
One Page Comic, 2018
Personal work, print;
pencil, digital

opposite
A Day of the Dictator, 2018
Personal work; pencil, digital

p. 336
Loyal Citizen Manya,
Gulag Action Figures, 2018
Personal work, competition
entry for the Golden Bee
International Poster Biennial,
Moscow; digital

Selected Exhibitions: 2019, *Society of Illustrators*, group show, Museum of Illustration, New York · 2018, *Gulag Posters*, group show, Gulag Museum, Moscow · 2018, *In Red & Black*, solo show, Russian Cultural Center, Houston · 2016, *Telling Tales*, group show, British Academy, London · 2016, *Illustrating War & Peace*, solo show, Modern Graphic History Library, Saint Louis

Selected Publications: 2019, *Daily Heller: Dramatic Life, Dramatic Art, Print* magazine, USA · 2018, *Golden Bee Biennale Catalogue,* Russia · 2018, *Drawn,* Capsule Books, Australia · 2017, *200 Best Illustrators Worldwide, Lürzer's Archive,* Austria · 2017, *Design Annual,* Graphis, USA

IGOR KARASH

Warlight, Michael Ondaatje, 2017
Oprah magazine, book review;
digital; art direction: Jill Armus

opposite bottom
Swine Lake, Grand Finale, 2018
Personal work; digital

opposite top
Dirty Pond or the Day Before
the Battle, 2014
War & Peace, by Leo Tolstoy,
book, the Folio Society;
gouache on Arches paper;
art direction: Sheri Gee

> "The main focus of my work is the face and the subtleties of capturing a certain feel and expression. Sometimes my subject's gaze is away from the viewer in a contemplative, self-reflecting way, but often I confront the viewer with a direct stare or glance, as if to say, 'I see you. I am here. I exist.'" *for Prohbtd*

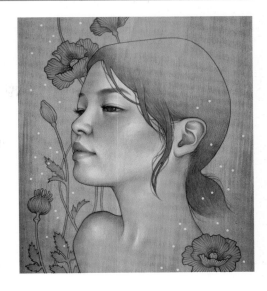

AUDREY KAWASAKI

WWW.AUDREY-KAWASAKI.COM · @audkawa

Audrey Kawasaki, a Japanese-American artist, was born in Los Angeles in 1982. As a child with a bicultural upbringing, she immersed herself in Japanese TV, food, and manga comics. An introduction to fine art classes at the Mission: Renaissance Fine Art Studio led her to enrol in the Pratt Institute in New York. However, Kawasaki left the painting course after two years, citing discouragement of her style by her faculty professors and a personal disconnection with the New York conceptual art scene. Returning to Los Angeles in the mid-2000s, Kawasaki soon emerged on the art scene, creating her own identifiable style of oil on wood panel. Her work explores the enigmatic qualities of female sensuality through innocent yet uninhibited young women—primarily focusing on the face, often looking directly at the viewer—posing in ethereal or sometimes ornate backgrounds. Blending influences from Art Nouveau and manga, her precision lines on natural grain evoke both grace and eroticism in her subjects. Ka-

Die japanisch-amerikanische Künstlerin Audrey Kawasaki wurde 1982 in Los Angeles geboren. Als bikulturell aufwachsendes Kind tauchte sie in japanisches Fernsehen, Essen und Manga-Comics ein. Eine Einführung in den Kunstunterricht an der Mission: Renaissance Fine Art Studio veranlasste sie dazu, sich am Pratt Institute in New York anzumelden. Kawasaki verließ den Malkurs jedoch nach zwei Jahren, weil die Professoren ihren Stil kritisierten und sie sich von der New Yorker Konzeptkunstszene löste. Als Kawasaki Mitte der 2000er-Jahre nach Los Angeles zurückkehrte, tauchte sie bald in der Kunstszene auf und kreierte ihren eigenen Stil mit Öl auf Holzplatten. Ihre Arbeit erforscht die rätselhaften Qualitäten weiblicher Sinnlichkeit durch unschuldige, aber ungehemmte junge Frauen – sie fokussiert sich dabei auf das Gesicht, das oft direkt zum Betrachter gerichtet ist. Die Figuren posieren oft vor ätherischen oder kunstvollen Hintergründen. Ihr von Art Nouveau und Manga beeinflusster

L'artiste américano-japonaise Audrey Kawasaki est née à Los Angeles en 1982. L'éducation biculturelle qu'elle a reçue l'a plongée dans les programmes télé, la nourriture et les mangas du Japon. Après une introduction aux beaux-arts au Mission: Renaissance Fine Art Studio, elle a décidé de s'inscrire à l'institut Pratt à New York. Mais après deux années à étudier la peinture, elle a abandonné, découragée par ses professeurs concernant son style et ressentant une déconnexion personnelle avec la scène artistique new-yorkaise. À son retour à Los Angeles au milieu des années 2000, Kawasaki s'est vite fait un nom dans le monde de la création en se forgeant un style caractéristique de peinture à l'huile sur des panneaux de bois. Dans ses œuvres, elle se penche sur les qualités énigmatiques de la sensualité féminine en représentant des jeunes femmes innocentes mais désinhibées, et en s'intéressant surtout à leur visage : elles regardent souvent directement le public et posent dans des décors éthérés ou

wasaki's artworks have appeared in art magazines such as *Hi-Fructose* and *Juxtapoz*. In 2011, her painting *My Dishonest Heart* was tattooed on singer Christina Perri by Kat Von D on an episode of reality TV show *LA Ink*.

Stil präziser Linien auf der natürlichen Maserung des Holzes, verleiht ihren Motiven sowohl Anmut als auch Erotik. Kawasakis Kunstwerke erschienen in Kunstmagazinen wie *Hi-Fructose* und *Juxtapoz*. 2011 wurde der Sängerin Christina Perri von Kat Von D in einer Episode der Reality-TV-Show *LA Ink*, Kawasakis Gemälde *My Dishonest Heart* (Mein unehrliches Herz) auf die Haut tätowiert.

parfois ornementés. Mêlant des influences de l'Art nouveau et du manga, ses contours précis sur un grain naturel transmettent grâce et érotisme. Les œuvres de Kawasaki sont apparues dans des magazines d'art comme *Hi-Fructose* et *Juxtapoz*. En 2011, la chanteuse Christina Perri s'est fait tatouer sa peinture *My Dishonest Heart* par Kat Von D au cours de l'émission de télé-réalité *LA Ink*.

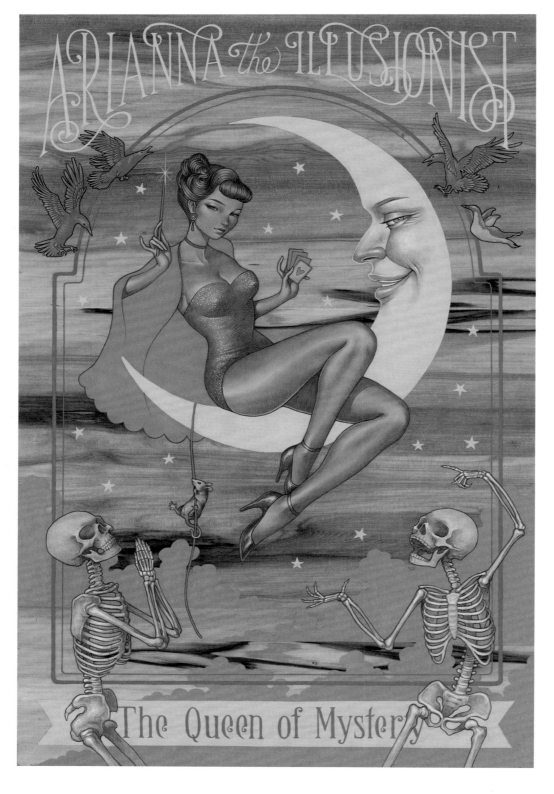

AUDREY KAWASAKI

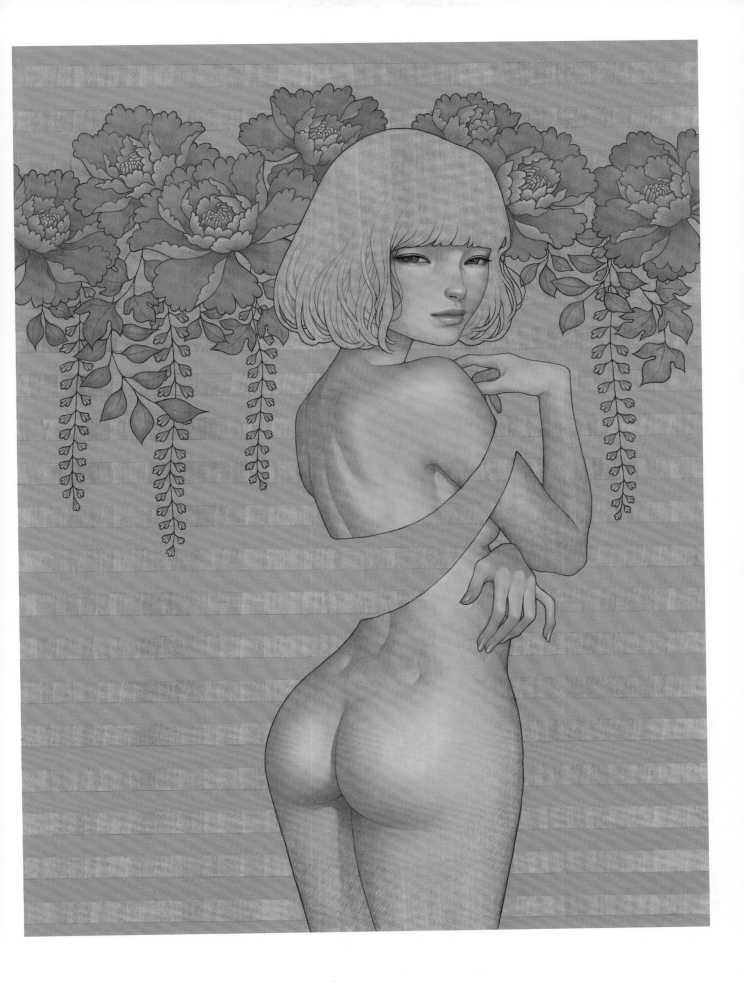

Charmer, 2016
Interlude, solo show, Thinkspace
Gallery, Los Angeles; graphite,
acrylic, and oil on wood panel

opposite
Arianna, 2017
Thinkspace Gallery, Moniker
Art Fair, London; graphite,
and acrylic on wood panel

p. 342
Nocturne, 2016
Interlude, solo show, Thinkspace
Gallery, Los Angeles; graphite,
acrylic, and oil on wood panel

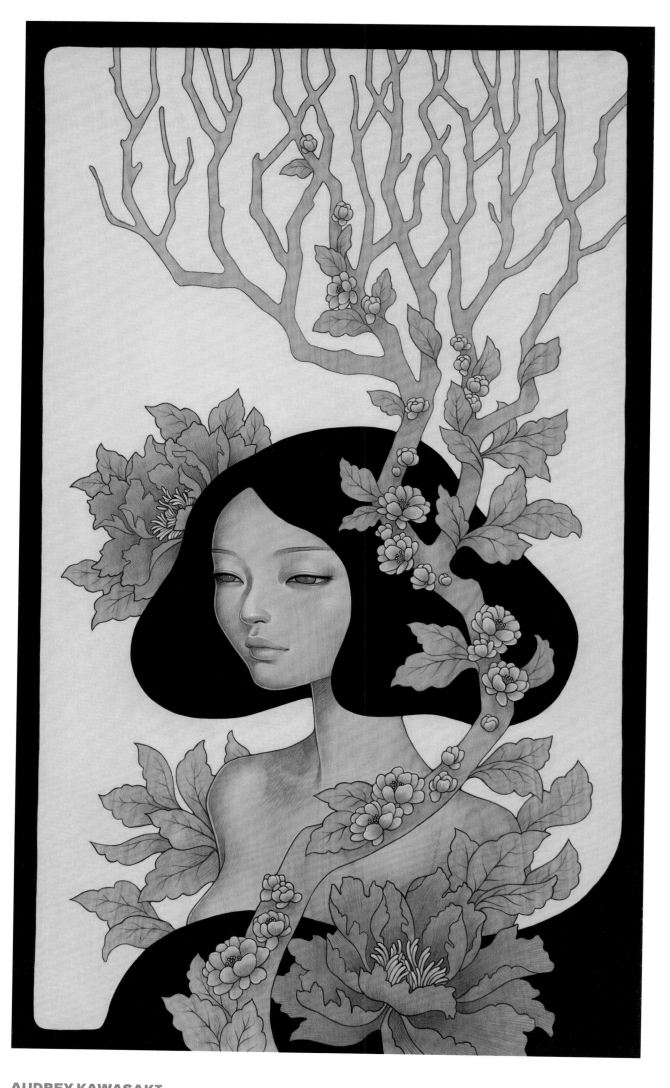

Selected Exhibitions: 2017, *Gilded Horizons*, solo show, Merry Karnowsky Gallery, Los Angeles · 2017, *Moniker Art Fair*, solo show, Thinkspace Gallery, London · 2016, *Interlude*, solo show, Thinkspace Gallery, Los Angeles · 2013, *Scope Miami Art Fair*, solo show, Thinkspace Gallery, Miami · 2012, *Midnight Reverie*, solo show, Jonathan Levine Gallery, New York

Selected Publications: 2017, *Graffitti Art*, magazine, France · 2015, *VNA Magazine*, United Kingdom · 2013, *Beautiful Bizarre Magazine*, Australia · 2012, *Hi-Fructose Magazine*, USA · 2012, *Juxtapoz Magazine*, USA

Charlotta, 2017
Gilded Horizons, solo show,
KP Projects Gallery, Los Angeles;
graphite, acrylic, and oil on wood

right
It Was You, 2014
Hirari Hirari, group show,
KP Projects Gallery,
Los Angeles; graphite, acrylic,
and oil on wood panel

opposite
Ponderer, 2013
Thinkspace Gallery, Scope
Miami Art Fair; graphite,
acrylic, and oil on wood panel

"If something is so strong within you that you're incomplete without it, I would say give yourself permission. Because that's all you need in the end anyway." *for Your Creative Push*

ADONNA KHARE

WWW.ADONNAK.COM · @adonnakhare

Adonna Khare is recognized for her large-scale carbon pencil drawings on paper. Born in Glendale, California, in 1980, she received both her BA in Art (2003) and MFA (2007) from California State University, Long Beach. Her playful, anthropomorphic studies of the natural world are metaphorical reflections on the human condition. Rendered in a photorealist style, Khare's animals inhabit a surreal, almost fairytale-esque environment. References stream from Dürer to Darwin to Disney. She takes the viewer on a journey through the looking glass, where scales are subverted in a twist on the origin of species. In real life the size of her works ranges from eight-feet by ten-feet drawings to wall-size murals. Her work has featured in the *Los Angeles Times*, *American Art Collector*, and *The Huffington Post*, and has captivated audiences online and in galleries across the United States. In 2012, Khare was selected from over 1,500 artists around the world as winner of ArtPrize, the world's largest art competition. Her works can also be found in

Adonna Khare ist bekannt für ihre großformatigen Bleistiftzeichnungen auf Papier. Geboren 1980 in Glendale (Kalifornien), erhielt sie sowohl ihren Bachelor in Kunst (2003) als auch ihren M. F. A. (2007) von der California State University in Long Beach. Ihre spielerischen, anthropomorphen Untersuchungen der natürlichen Welt sind metaphorische Reflexionen über die Conditio humana. Ihre in einem fotorealistischen Stil gehaltenen Tiere bewohnen eine surreale, fast märchenhafte Umgebung. Referenzen sind Dürer, Darwin oder Disney. Sie nimmt den Betrachter mit auf eine Reise hinter die Spiegel, wo die Größenverhältnisse bei der Entstehung der Arten einfach aufgehoben sind. Im wirklichen Leben reicht die Größe ihrer Werke von 2,5 – 3m großen Zeichnungen bis zu wandgroßen Gemälden. Ihre Arbeiten wurden in der *Los Angeles Times*, *American Art Collector* und der *Huffington Post* abgebildet und haben das Publikum online und in Galerien überall in den Vereinigten Staaten fasziniert. 2012

Adonna Khare est célèbre pour ses dessins de grandes dimensions au crayon carbone sur papier. Née dans la ville californienne de Glendale en 1980, elle a reçu sa licence (2003) et son master en beaux-arts (2007) de l'université d'État de Californie à Long Beach. Ses amusantes études anthropomorphiques de la nature apportent des réflexions métaphoriques sur la condition humaine. Illustrés avec un rendu photoréaliste, les animaux de Khare évoluent dans un environnement irréel, presque de conte de fées, et ses références vont de Dürer à Darwin en passant par Disney. Elle fait passer le public de l'autre côté du miroir, où les échelles sont bouleversées et l'origine des espèces revisitée. Dans la vie réelle, ses œuvres imposantes font minimum 2,5 mètres par 3 et occupent parfois tout un mur. Son travail est paru dans le *Los Angeles Times*, *American Art Collector* et *The Huffington Post*, et elle a séduit un public en ligne et dans des galeries à travers les États-Unis.

the permanent collections of the Long Beach Museum of Art, Grand Rapids Art Museum, and Crystal Bridges Art Museum. Khare is a member of The Drawing Center in New York.

wurde Khare aus über 1.500 Künstlern auf der ganzen Welt zur ArtPrize-Gewinnerin gewählt, dem weltweit größten Kunstwettbewerb. Ihre Werke befinden sich auch in den Dauerausstellungen des Long Beach Museum of Art, Grand Rapids Art Museum und Crystal Bridges Art Museum. Khare ist Mitglied des Drawing Centers in New York.

En 2012, Khare a été choisie parmi plus de 1500 artistes du monde entier pour le prix ArtPrize, le plus grand concours d'art mondial. Ses créations figurent également dans les collections permanentes du Long Beach Museum of Art, du Grand Rapids Art Museum et du Crystal Bridges Museum of American Art. Khare est membre du Drawing Center à New York.

ADONNA KHARE

Selected Exhibitions: 2017, *Animal Meet Human*, solo show, Crystal Bridges Museum of American Art, Bentonville, Arkansas · 2017, *State of the Art*, group show, Frist Center for the Arts, Nashville · 2016, *Adonna Khare: Kingdom*, solo show, Boise Art Museum, Boise, Idaho · 2016, *Between the Lines*, solo show, Lora Schlesinger Gallery, Los Angeles · 2016, *Adonna Khare*, solo show, Hollis Taggart Gallery, New York

Selected Publications: 2016, *Juxtapoz Magazine*, USA · 2016, *American Art Collector*, USA · 2015, *Hi-Fructose Magazine*, USA · 2015, *Juxtapoz Wild*, Gingko Press, USA

Screaming Wolves, 2014
Personal work;
carbon pencil on paper

opposite
Elephants, 2012
Personal work;
carbon pencil on paper

p. 348
Elephant House Birds, 2015
Personal work; carbon
pencil on paper

> "I enjoy subtracting the noise from the unnecessary information to be as simple as possible. It's a hard process because you have to take away things that are dear to you. You have to kill your darlings."

for *Design Indaba*

MAX KISMAN

WWW.KISMANSTUDIO.NL · @max_kisman

Max Kisman is a Dutch graphic designer and illustrator based in Amsterdam. Born in Doetinchem in 1953, he studied graphic design, illustration and animation at the Academy of Art and Industry in Enschede before graduating from the Gerrit Rietveld Academy in 1977 and starting his own studio. An early adopter of digital technology, he created computer-aided type designs and illustrations for *Language Technology* and *Vinyl Music*. In 1986, he co-founded the magazine *TYP/Typografisch Papier*, and designed postage stamps for the Dutch Postal Service. With an editor's brain, Kisman's pictographic style is concerned with simplifying concepts to the bare essentials or, as he terms it, "subtracting the noise"— a process that is evident in his striking poster work. In 1989, he received a grant from the Netherlands Foundation for Visual Arts, Design and Architecture to explore aspects of his personal visual graphic symbolism and iconography. A move into television in the early 1990s saw a new direction in his career and

Max Kisman ist ein niederländischer Grafikdesigner und Illustrator mit Sitz in Amsterdam. Geboren 1953 in Doetinchem, studierte er Grafikdesign, Illustration und Animation an der Akademie für Kunst und Industrie in Enschede, bevor er 1977 an der Gerrit Rietveld Akademie seinen Abschluss machte und sein eigenes Studio öffnete. Er war ein früher Anhänger der digitalen Technologie und erstellte computergestützte Schrift-Entwürfe und Illustrationen für *Language Technology* und *Vinyl Music*. 1986 war er Mitbegründer der Zeitschrift *TYP/Typografisch Papier* und entwarf Briefmarken für die niederländische Post. Mit dem Verstand eines Redakteurs geht es in Kismans piktografischem Stil darum, Konzepte auf das Wesentliche zu beschränken oder, wie er es nennt, „das Rauschen zu subtrahieren" – ein Prozess, der sich in seiner markanten Plakatarbeit zeigt. 1989 erhielt er ein Stipendium der niederländischen Stiftung für Bildende Kunst, Design und Architektur. Der Einstieg in das Fernsehgeschäft Anfang der

Max Kisman est un concepteur graphique et illustrateur hollandais installé à Amsterdam. Né en 1953 à Doetinchem, il a suivi des études de design graphique, d'illustration et d'animation à l'académie des arts et de l'industrie d'Enschede avant de se diplômer en 1977 de l'académie Gerrit Rietveld et de monter son propre studio. Pionnier en matière de numérique, il a créé en CAO des designs et des illustrations pour *Language Technology* et *Vinyl Music*. En 1986, il a cofondé le magazine *TYP/Typografisch Papier* et conçu des timbres pour le service postal des Pays-Bas. Avec son approche d'éditeur, son style pictographique vise à simplifier les concepts au strict minimum ou, dans ses termes, « à éliminer le bruit », une volonté manifeste dans ses affiches. En 1989, il a reçu une bourse de la Netherlands Foundation for Visual Arts, Design and Architecture afin de travailler sur des aspects de son symbolisme graphique visuel et de son iconographie. Son passage par le monde de la télévision au début des années 1990 a ouvert une

practice. As chief graphic designer for VPRO in the Netherlands he began to shift his focus to their interactive media arm VPRO-digital. He designed icons for the pioneering web magazine *HotWired* before moving to San Francisco to work for Wired Television. In 2002, he became a member of the Alliance Graphique Internationale. During his illustrious career, Kisman has taught in institutions throughout Holland and in San Francisco, and has designed typefaces for FontShop International, Fuse, and his own Holland Fonts foundry.

1990er-Jahre verlieh seiner Karriere und Praxis eine neue Richtung. Als leitender Grafikdesigner für VPRO in den Niederlanden begann er, seinen Fokus auf den interaktiven Medienarm VPRO-digital zu verlagern. Er entwarf Icons für das bahnbrechende Webmagazin *HotWired*, bevor er nach San Francisco ging, um für Wired Television zu arbeiten. 2002 wurde er Mitglied der Alliance Graphique Internationale. Während seiner illustren Karriere hat Kisman an Institutionen in ganz Holland und in San Francisco unterrichtet und Schriften für FontShop International, Fuse und seine eigene Holland Fonts Foundry entworfen.

nouvelle voie pour sa carrière et sa pratique. Alors concepteur graphique en chef chez VPRO aux Pays-Bas, il s'est mis à travailler davantage pour le département médias interactifs VPRO Digital. Il a créé des icônes pour le magazine Web précurseur *HotWired* avant de partir à San Francisco pour intégrer Wired Television. En 2002, il est devenu membre de l'Alliance Graphique Internationale. Au cours de sa brillante carrière, Kisman a enseigné dans diverses institutions des Pays-Bas et à San Francisco ; il a aussi créé des polices de caractères pour FontShop International, Fuse et sa propre fonderie Holland Fonts.

The Year of Space, 2015
S+RO magazine;
analog sketching, digital

opposite
Du bist mein Geheimnis, 2018
Paradiso, poster; analog
sketching, digital, screen print

p. 352
Indonesian DNA, 2014
CODA Museum, Apeldoorn,
poster; analog sketching, digital

Ancestors, 2014
Tablecloth; analog sketching,
digital, Jacquard weaving

opposite top
No Poverty, 2017
Chora Connection, Alliance Graphique
Internationale, poster; analog sketching, digital

opposite bottom
#Metoo, A Year Later, 2018
NRC, newspaper; analog
sketching, digital

Selected Exhibitions: 2018, *Tolerance Poster Show*, group show, traveling exhibition · 2018, *Sex Only*, solo show, Museum Meermanno, The Hague · 2017, *17for17*, group show, Palais de Tokyo (Paris), Dutch Parliament (The Hague) · 2016, *Voor Altijd Jong. Max Kisman en Fiep Westendorp*, solo show, WG Kunst, Amsterdam · 2013, *Max Kisman Beeld Taal*, solo show, Gr-id Museum, Groningen

Selected Publications: 2018, *Sex Only, Max Kisman Diary Documents 1987–2017*, Sub Q Amsterdam, The Netherlands · 2018, *#Geni #Taal #XXX*, Drukwerk in de Marge, By Kisman, The Netherlands · 2017, *Fukt #16 Dirty Drawings. The Sex Issue, Fukt Magazine*, Germany · 2016, *Vlinder wijst de weg*, By Kisman, The Netherlands · 2014, *I Am a Slave of Your Freedom*, By Kisman, The Netherlands

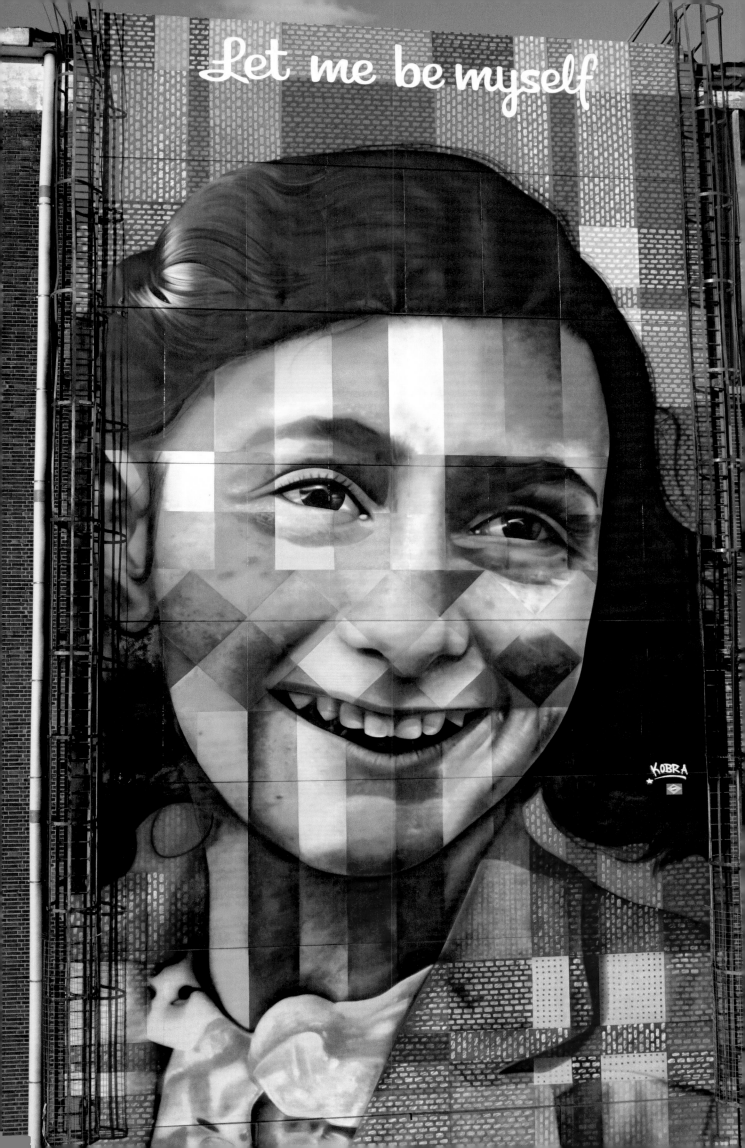

> "I'm a hyperactive person and I am always inside bookstores and museums researching the history of the places I visit, so my murals always have a historic base to them. I usually try to paint themes connected with the city/country where I am." *for Juxtapoz*

EDUARDO KOBRA

WWW.EDUARDOKOBRA.COM · @kobrastreetart

Known for his kaleidoscopic theme of repeating squares and triangles, Brazilian street artist Eduardo Kobra creates murals that are rich in color and spectacular in scale. His renderings of iconic images—from *Let Me Be Myself*, a portrait of Anne Frank on a former shipyard welding hangar in Amsterdam, to Alfred Eisenstaedt's photograph V-J Day in *Times Square* on Manhattan's High Line—both connect with and transcend history and place, creating a visual frisson. Combining aerosol and airbrush with paintbrush techniques, he is able to create a sense of realism through a mosaic of texture and shade. Born in 1976 in the Campo Limpo district of São Paulo, Kobra grew up in the vibrant urban culture of skateboarding, breakdancing, and hip hop. In his teens he discovered two seminal books that would radically expand his perception of the phenomenon that was spreading across New York: *Subway Art* (1984) and *Spraycan Art* (1987). Despite being expelled from school for his graffiti, and

Der brasilianische Straßenkünstler Eduardo Kobra ist bekannt für seine kaleidoskopisches Wiederholung von Quadraten und Dreiecken und schafft farbige Wandbilder in spektakulärem Maßstab. Seine Interpretationen von ikonischen Bildern – von *Let Me Be Myself*, ein Porträt von Anne Frank an einer ehemaligen Werftschweißhalle in Amsterdam bis zu Alfred Eisenstaedts Fotografie *V-J Day in Times Square* auf Manhattans High Line – beide verbinden und transzendieren Geschichte und Ort und erzeugen eine visuelle Spannung. Er kombiniert Aerosol und Airbrush mit Paintbrush-Techniken und schafft es, durch ein Mosaik aus Textur und Schatten ein Gefühl von Realismus zu erzeugen. Geboren wurde Kobra 1976 in São Paulos Stadtteil Campo Limpo und wuchs in der pulsierenden urbanen Kultur des Skateboards, Breakdance und Hip Hop auf. Als Teenager entdeckte er zwei wegweisende Bücher, die seine Wahrnehmung eines Phänomens, das sich in New York ausbreitete, radikal erweitern sollten:

Célèbre pour ses compositions kaléidoscopiques faites de carrés et de triangles, l'artiste de rue brésilien Eduardo Kobra crée des fresques hautes en couleur et aux dimensions spectaculaires. Ses rendus d'images emblématiques, comme le portrait d'Anne Frank intitulé *Let Me Be Myself* sur l'ancien hangar de soudure d'un chantier naval à Amsterdam ou sa version sur la promenade High Line à Manhattan de la célèbre photographie *V-J Day in Times Square* prise par Alfred Eisenstaedt, mettent en scène et transcendent une histoire et un lieu pour provoquer un frisson visuel. Il combine aérosols, aérographes et peinture au pinceau pour obtenir des images réalistes faites d'une mosaïque de textures et de nuances. Né en 1976 dans le quartier de Campo Limpo à São Paulo, Kobra a grandi au sein de la culture urbaine du skateboard, du breakdance et du hip-hop. Quand il était adolescent, deux livres phares, *Subway Art* (1984) et *Spraycan Art* (1987), ont changé radicalement sa perception de ces phénomènes

ignoring frequent heckles from passers-by, Kobra remained unwavering in his passion. Inspired by such artists as Jean-Michel Basquiat and Catie Radney, he learnt his craft on the streets, exchanging murals for skateboards and apparel. Gradually evolving his professional practice through self-discipline, he began to garner attention. Today, Kobra's work can be seen around the world from Los Angeles to Rome. In 2016, to commemorate the Olympic Games in Rio de Janeiro, Studio Kobra set a Guinness World Record for *Etnias*, at 30,000 feet square the largest-ever spray-paint mural. A year later, Kobra and his team broke their own record by painting an entire chocolate factory in São Paulo at twice the size of the previous work.

Subway Art (1984) und *Spraycan Art* (1987). Obwohl Kobra wegen seiner Graffitis der Schule verwiesen wurde und häufig hämische Kommentare von Passanten über sich ergehen lassen musste, blieb er seiner Leidenschaft unerschütterlich treu. Inspiriert von Künstlern wie Jean-Michel Basquiat und Catie Radney, lernte er sein Handwerk auf der Straße und erstellte Wandbilder im Tausch gegen Skateboards und Bekleidung. Nach und nach entwickelte er seine berufliche Praxis durch Selbstdisziplin weiter und erlangte Aufmerksamkeit. Heute ist Kobras Werk auf der ganzen Welt von Los Angeles bis Rom zu sehen. Zur Erinnerung an die Olympischen Spiele in Rio de Janeiro stellte Studio Kobra 2016 einen Guinnessbuch-Weltrekord für *Etnias* auf: Auf einer Fläche von 30.000 Quadratmetern wurde das größte Wandbild aller Zeiten gesprayt. Ein Jahr später brachen Kobra und sein Team ihren eigenen Rekord, indem sie eine komplette Schokoladenfabrik in São Paulo bemalten, die doppelt so groß war wie ihre vorherige Arbeit.

artistiques alors en pleine expansion à New York. Malgré son renvoi de l'école pour ses graffiti, et ignorant les fréquentes interpellations des passants, Kobra est inflexible quand à sa passion. Inspiré par des artistes comme Jean-Michel Basquiat et Catie Radney, il a appris son métier dans la rue, en troquant des peintures murales contre des skateboards et des vêtements. C'est en perfectionnant petit à petit sa pratique professionnelle grâce à son autodiscipline qu'il a commencé à se faire remarquer. Aujourd'hui, ses œuvres sont visibles dans le monde entier, de Los Angeles à Rome. En 2016, pour célébrer les Jeux olympiques de Rio de Janeiro, Studio Kobra a établi un record Guinness mondial avec Etnias, la plus grande peinture murale à la bombe sur 2 800 mètres carrés. Un an plus tard, Kobra et son équipe ont battu leur propre record du monde en peignant toute une chocolaterie de São Paulo, soit une œuvre deux fois plus grande que l'antérieure.

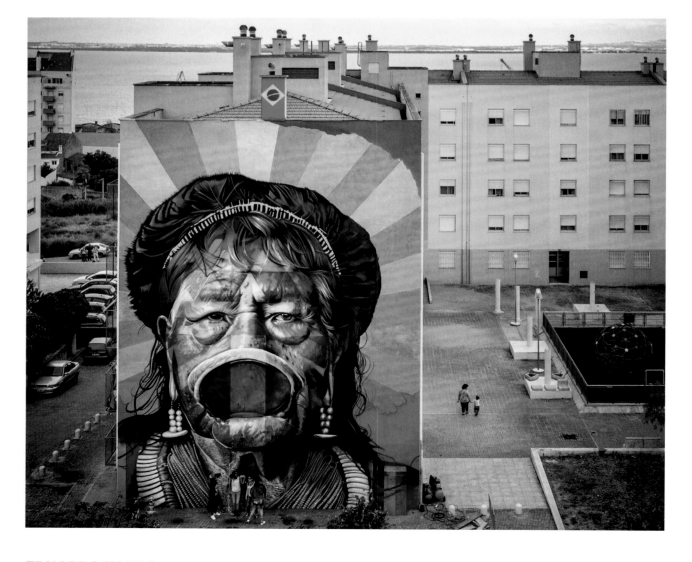

EDUARDO KOBRA

Abraham Lincoln, 2013
Lexington, Kentucky;
photo: Studio Kobra Archives

right
Black or White
(Michael Jackson), 2018
New York; photo: Ben Lau

opposite
Raoni, 2017
Lisbon; photo: José Vicente

p. 358
Let Me Be Myself
(Anne Frank), 2016
Amsterdam; photo: Studio
Kobra Archives

Todos Somos Um (Etnias), 2016
Rio de Janeiro; photo: Studio
Kobra Archives

EDUARDO KOBRA

Selected Publication: 2016, *Kobra,* Arte Ensaio, Brazil

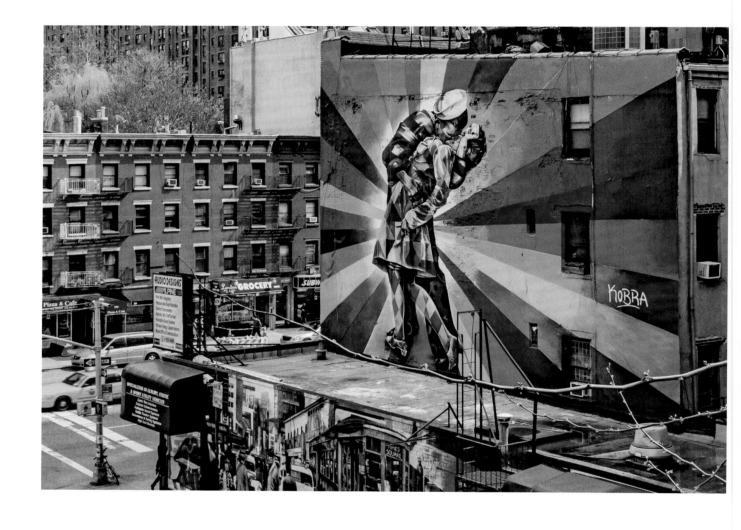

The Kiss, 2012
New York; photo: Studio
Kobra Archives

opposite top
Martin Luther King, 2017
Palm Beach; photo: Studio
Kobra Archives

opposite bottom
Mother Teresa and Gandhi, 2018
New York; photo: Ben Lau

EDUARDO KOBRA

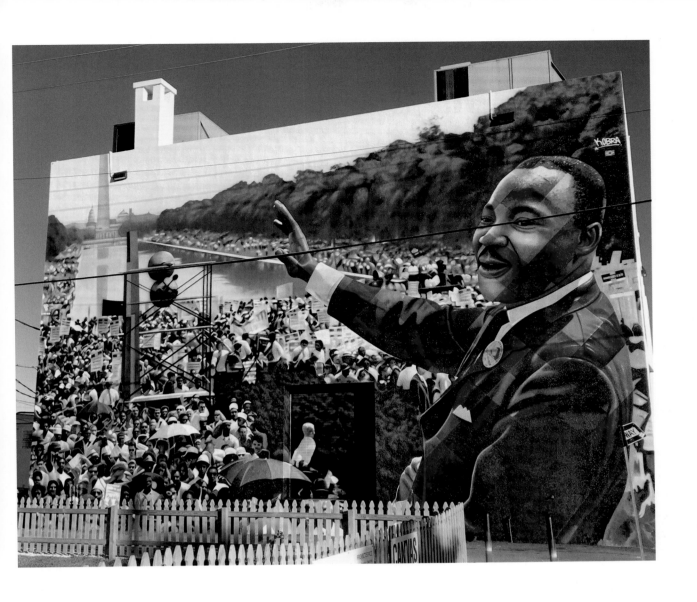

> "Work hard. Draw every day. Draw what is around you. People, places, objects… everything." *for AI-AP*

OLIVIER KUGLER

WWW.**OLIVIERKUGLER**.COM · **@olivierkugler**

German-born Olivier Kugler's reportage illustrations display an extraordinary skill-set for storytelling through graphics and words. From reporting on a veterinarian's work with elephants in the illegal logging industry in Laos, to documenting the remarkable story of a truck driver's journey from Turkey to Iran—which won him a V&A Illustration Award in 2011—Kugler's work has taken him far afield. He documents his subjects first-hand, drawing on location, or from his own photographs, and coloring on his laptop. The resulting panels are loaded with details, prompting the viewer to eye-track a scene. He also produces graphic novels: *Escaping Wars and Waves: Encounters with Syrian Refugees* was first published in 2018. Born in Stuttgart in 1970, Kugler grew up reading Tintin books in Simmozheim, a small village in the Black Forest. After military service in the Navy, he received a diploma in visual communication from the Hochschule Pforzheim before working as an agency designer in Karlsruhe. An opportunity came when he was

Die Reportageillustrationen des in Deutschland geborenen Olivier Kugler offenbaren sein außergewöhnliches Talent für das Geschichtenerzählen mit Grafiken und Worten. Sein Portfolio reicht von der Berichterstattung über die Arbeit eines Tierarztes mit Elefanten in der illegalen Holzindustrie in Laos bis hin zur Dokumentation der außergewöhnlichen Geschichte eines LKW-Fahrers auf seiner Reise von der Türkei in den Iran (Letztere brachte ihm 2011 einen V&A Illustration Award ein). Dank seiner Arbeit ist Kugler viel herumgekommen. Er dokumentiert seine Motive aus erster Hand, zeichnet vor Ort oder von seinen eigenen Fotografien und malt auf seinem Laptop. Die sich daraus ergebenden Panels sind voller Details und fordern den Betrachter auf, eine Szene mit den Augen nachzuzeichnen. Er produziert auch grafische Erzählungen: *Dem Krieg entronnen: Begegnungen mit Syrern auf der Flucht* wurde 2018 veröffentlicht. Der 1970 in Stuttgart geborene Kugler wuchs Tim-und-Struppi

D'origine allemande, Olivier Kugler crée des illustrations de reportages et y démontre un grand talent pour raconter des histoires à travers des graphismes et des mots. Qu'il s'agisse d'un projet sur un vétérinaire qui soigne des éléphants utilisés dans une exploitation forestière illégale au Laos ou d'un documentaire sur le fascinant voyage d'un chauffeur routier entre la Turquie et l'Iran (qui a remporté en 2011 un V&A Illustration Award), le travail de Kugler l'a conduit très loin. Il rend personnellement compte de ses sujets, en dessinant sur le terrain ou à partir de ses propres photos, puis en coloriant sur ordinateur. Les panneaux qu'il obtient sont truffés de détails et poussent le public à en observer tous les recoins. Il réalise également des romans graphiques, comme celui sur les récits de réfugiés syriens intitulé *Escaping Wars and Waves: Encounters with Syrian Refugees* et publié pour la première fois en 2018. Né à Stuttgart en 1970, Kugler a grandi en lisant Tintin dans un petit village de

offered a scholarship to do an MA in Illustration at the School of Visual Arts in New York. Since graduating in 2002, Kugler has specialized in documentary illustration, gaining early support from *The Guardian*, with later commissions from Médecins Sans Frontières, *Harper's Magazine*, and French quarterly *Revue XXI*. He lives and works in London.

lesend in Simmozheim, einem kleinen Dorf im Schwarzwald auf. Nach seinem Wehrdienst bei der Marine erhielt er ein Diplom in visueller Kommunikation von der Hochschule Pforzheim, bevor er als Designer in einer Karlsruher Agentur arbeitete. Er ergriff die Gelegenheit, als ihm ein Stipendium für einen Master in Illustration an der School of Visual Arts in New York angeboten wurde. Kugler hat sich seit seinem Abschluss im Jahr 2002 auf die Dokumentar-Illustration spezialisiert, bekam früh Unterstützung vom *Guardian* und später Aufträge von Médecins Sans Frontières, *Harper's Magazine* und der vierteljährlich erscheinenden französischen Zeitschrift *Revue XXI*. Er lebt und arbeitet heute in London.

la Forêt Noire nommé Simmozheim. Après son service militaire dans la marine, il a obtenu un diplôme en communication visuelle de l'université de sciences appliquées Pforzheim avant de travailler comme concepteur dans une agence à Karlsruhe. Il a ensuite eu la chance de se voir offrir une bourse pour une maîtrise en illustration à la School of Visual Arts de New York, reçue en 2002. Depuis, Kugler s'est spécialisé dans les reportages illustrés et a très vite gagné la confiance de *The Guardian* ; des commandes de Médecins Sans Frontières ont suivi, ainsi que de *Harper's Magazine* et du trimestriel *Revue XXI*. Il réside actuellement à Londres.

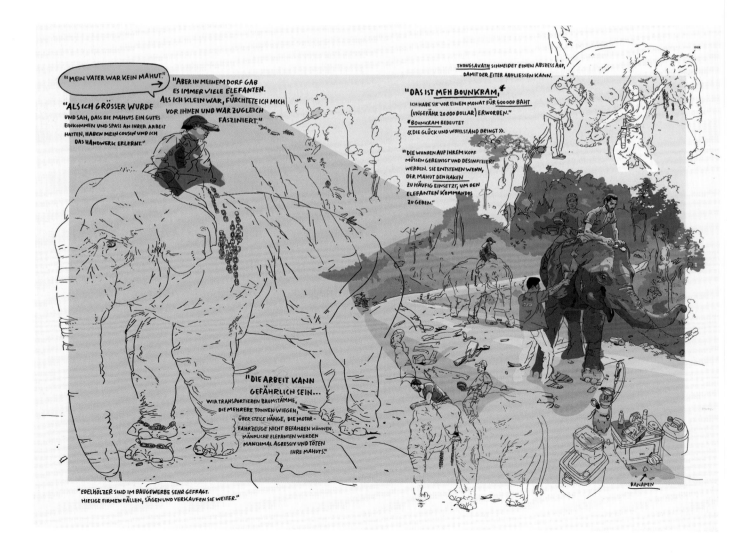

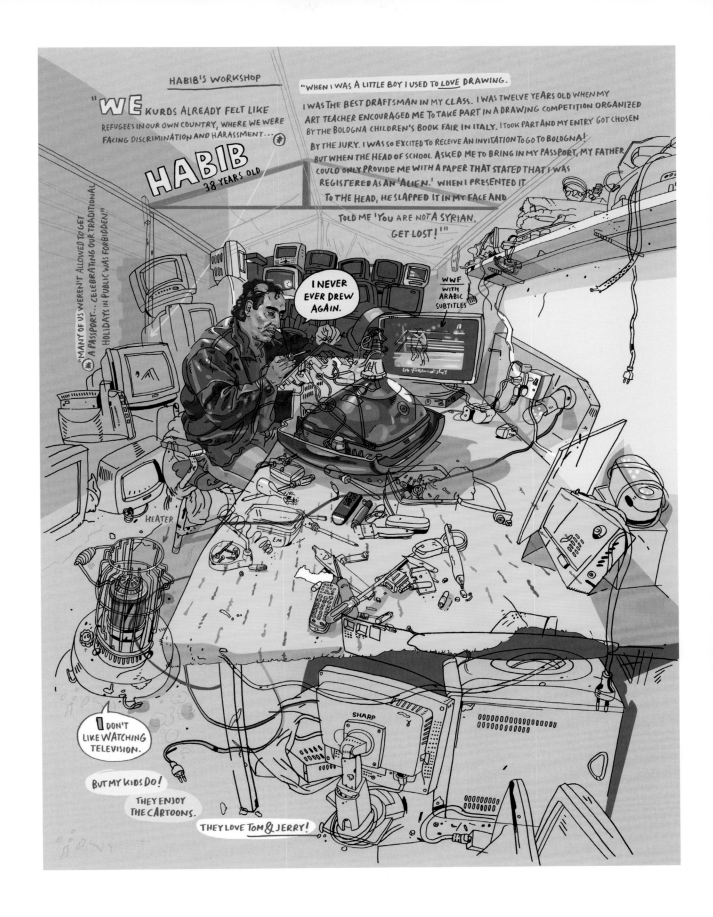

Habib, *Escaping Wars and Waves*,
Myriad Editions (UK), Penn State
University Press (USA), 2018; first
published by *Harper's* magazine, USA,
2014; pencil drawing, colored digitally

opposite and p. 366
Mit dem Elefantendoktor in Laos,
Edition Moderne, 2013; first
published as "Le Docteur Elephants",
Revue XXI magazine, 2012; pencil
drawing, colored digitally

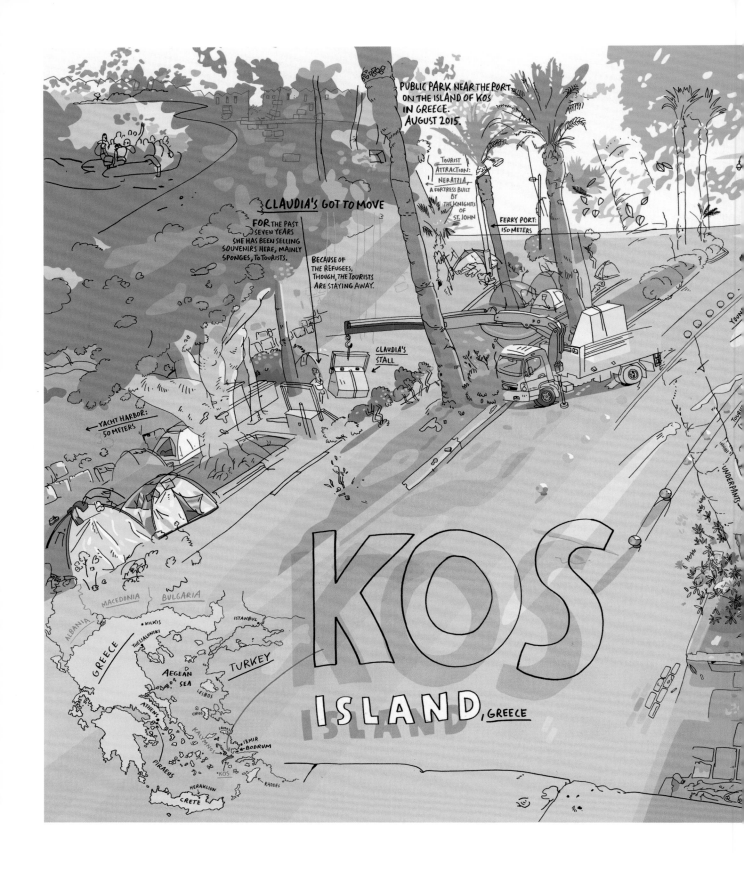

Kos, *Escaping Wars and Waves*,
Myriad Editions (UK), Penn State
University Press (USA), 2018; first
published by *Harper's* magazine, USA,
2014; pencil drawing, colored digitally

OLIVIER KUGLER

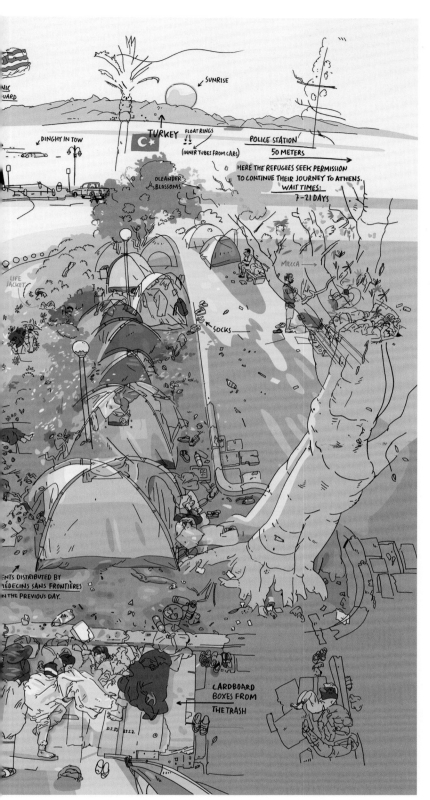

Selected Exhibitions: 2019, *Escaping Wars and Waves*, solo show, School of Visual Arts, Gramercy Gallery, New York · 2018, *Journeys Drawn*, group show, House of Illustration, London · 2018, *Zeich(n)en der Zeit, Comic-Reporter unterwegs*, group show, Comic-Salon, Erlangen · 2014, *Domiz Refugee Camp*, solo show, Fumetto Festival, Lucerne · 2010, *New York, London, Teheran*, solo show, Galerie Oberlichtsaal, Sindelfingen

Selected Publications: 2018, *Escaping Wars and Waves*, Myriad Editions, United Kingdom, and Penn State University Press, USA · 2018, *Reportage Illustration, Visual Journalism*, Bloomsbury, United Kingdom · 2017, *Dem Krieg Entronnen*, Edition Moderne, Switzerland · 2013, *Mit dem Elefantendoktor in Laos*, Edition Moderne, Switzerland · 2012, *Le Docteur Elephants*, Revue XXI, France · 2012, *Grands Reporters: 20 Histoires Vraies*, Les Arènes, France · 2010, *Thé en Iran*, Revue XXI, France

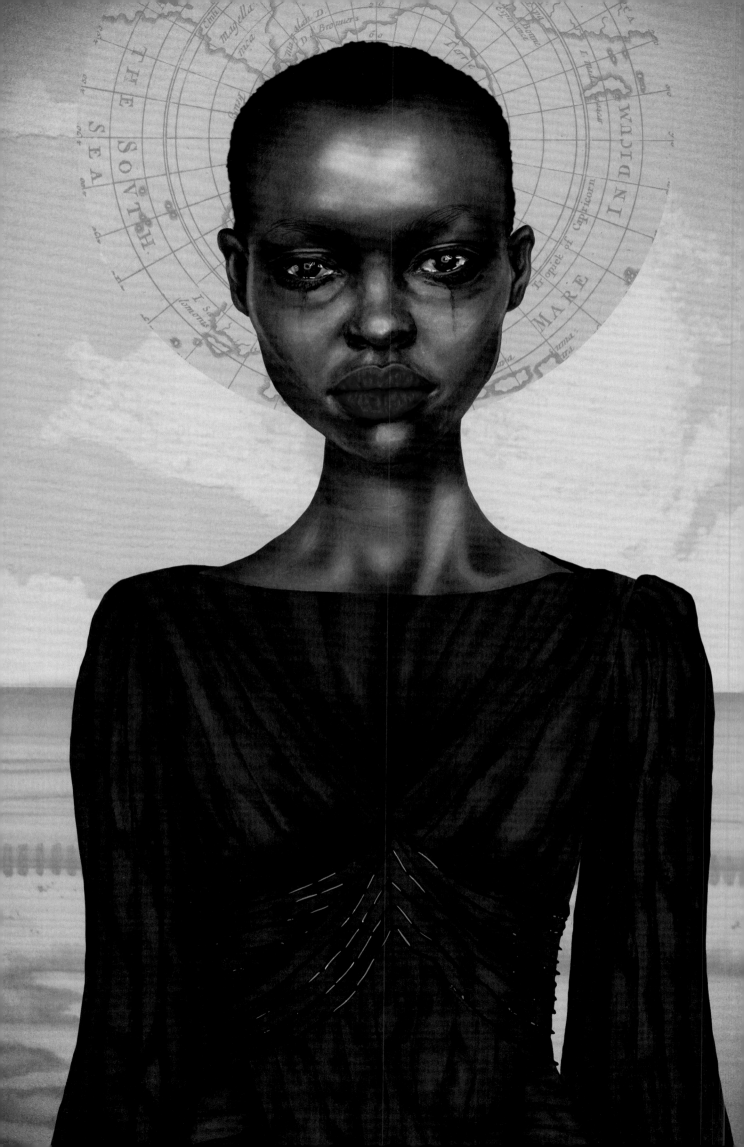

> "I'm very interested in the beauty that lies beneath the surface. That's why there's always something in my drawings that distracts the viewer's eye, like bugs or the skeleton of an ostrich." *for Lagom*

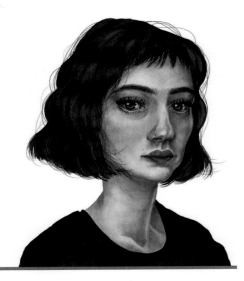

KATARINA KÜHL

WWW.KATARINAKUEHL.COM · @katarinakuehl

Born in 1985, Katarina Kühl is a German freelance illustrator based in her home city of Hamburg, where she graduated in illustration and design at Bildkunst Akademie in 2014. The focal point in much of Kühl's work is the human face in all its myriad expressions, often embellished with her signature circled cheeks. Hints of John Tenniell, Tim Burton, and *commedia dell'arte* bubble up in her slightly caricatured features, inviting the viewer to look beneath the surface. She creates her works directly from the source of inspiration, seldom sketching beforehand. An idea can come from a book or from characters in a film, whether real or fictitious. After responding to a creative brief, her depiction of Cate Blanchett for the 2015 film *Carol* was hand-picked by film director Todd Haynes to appear in the cinema magazine *Little White Lies*. Kühl's personal career highlights include illustrating a book about baking entitled *Die drei Damen auf Café-Fahrt* and entering an online competition by Draw A Dot, in which she illustrated her vision of

Katarina Kühl wurde 1985 geboren und lebt als freiberufliche Illustratorin in ihrer Heimatstadt Hamburg. Dort absolvierte sie 2014 ihr Studium für Illustration und Design an der Bildkunst Akademie. Im Mittelpunkt vieler Arbeiten von Kühl steht das menschliche Gesicht mit all seinen unzähligen Ausdrücken, oft mit den für sie charakteristischen eingefallenen Wangen. Hinweise auf John Tenniell, Tim Burton und die *Commedia dell'arte* zeigen sich in leicht karikierten Gesichtszügen und laden den Betrachter dazu ein, hinter die Fassade zu schauen. Kühl kreiert direkt aus der Inspiration und skizziert selten vor. Eine Idee kann aus einem Buch oder aus Charakteren in einem Film stammen, real oder fiktiv. Ihre für eine kreative Ausschreibung des Kinomagazins *Little White Lies* geschaffene Darstellung von Cate Blanchett im Film Carol von 2015, wurde von Regisseur Todd Haynes persönlich als Gewinnerbeitrag ausgewählt. Zu Kühls persönlichen Karrierehighlights zählen die Illustration des Backbuchs *Die drei Damen*

Né en 1985, Katarina Kühl est une illustratrice freelance allemande qui est installée dans sa ville natale de Hambourg, où elle a obtenu en 2014 un diplôme d'illustration et de design à la Bildkunst Akademie. Dans la plupart de ses œuvres, le centre d'attention est le visage humain dans toutes ses expressions, avec les joues souvent soulignées. On retrouve un peu de John Tenniell, de Tim Burton et de la *commedia dell'arte* dans ses créations quelque peu caricaturales qui invitent le public à ne pas s'en tenir aux apparences. Elle compose directement à partir de ce qui l'inspire, ne réalisant que très rarement des esquisses préalables, et trouve ses idées dans un livre ou dans les personnages d'un film, documentaire ou de fiction. En réponse à un brief créatif, sa représentation de Cate Blanchett dans le film de 2015 intitulé *Carol* a été choisie par le réalisateur Todd Haynes pour la publier dans le magazine de cinéma *Little White Lies*. Les temps forts de sa carrière personnelle incluent l'illustration du livre de recettes

fashion designer Giambattista Valli (who subsequently began to follow her on Instagram).

auf Café-Fahrt und die Teilnahme an einem Online-Wettbewerb von Draw A Dot, bei dem sie ihre Vision des Modedesigners Giambattista Valli (der ihr anschließend auf Instagram folgte) illustrierte.

de gâteaux *Die drei Damen auf Café-Fahrt* et la participation à un concours en ligne organisé par Draw A Dot, pour lequel elle a réalisé le portrait du couturier Giambattista Valli (qui up alors commencé à la suivre sur Instagram).

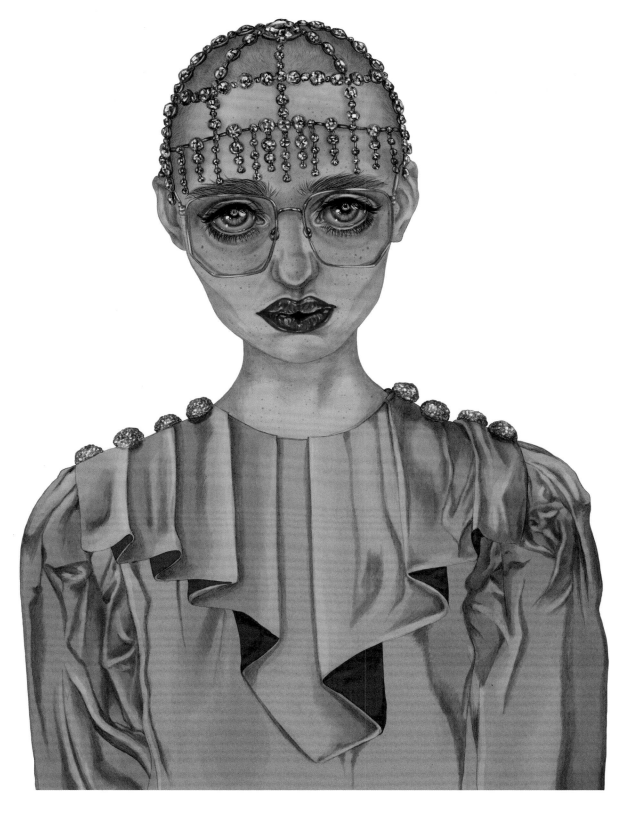

KATARINA KÜHL

Lady Gwendoline, 2017
Personal work, fine art print;
pencil, chalk, digital;
Model: Gwendoline Christie
Dress: Giambattista Valli

opposite

Diamonds, 2018
Personal work, fine art
print; pencil, chalk, digital;
Dress: Gucci

p. 372

Halo, 2018
Personal work, fine art print; pencil,
chalk, digital, collage with photograph,
map, and drawing; Dress: Zac Posen

Stranger Things, 2016
Personal work, fine art print;
pencil, chalk, digital

opposite
Inspired by British *Vogue*, 2018
Personal work, fine art print;
pencil, chalk, digital
Model: Cara Delevingne
Hat: Noel Stewart

KATARINA KÜHL

Selected Exhibition: 2012, *Liebeserklärungen an ein Hotel*, group show, Hotel Wedina, Hamburg

Selected Publications: 2018, *Die drei Herren und das mysteriöse Fischbrötchen*, Wölfchen Verlag, Germany · 2016, *Threaded* magazine, Threaded Media Ltd, New Zealand · 2016, *Rosegarden* magazine, Rosegarden Verlag, Germany · 2015, *Die drei Damen auf Café-Fahrt*, Wölfchen Verlag, Germany · 2013, *GEOmini*, Gruner & Jahr, Germany

"I am a witness to the world around me, and my visual comments are reactions to these events. In every case, there is a fluidity, a desired response, though of course I cannot control that response; in some ways, what I really do is try and encourage thoughtful participation in the cultural moment."

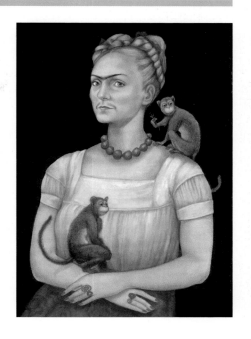

ANITA KUNZ

WWW.ANITAKUNZ.COM · WWW.ANITAKUNZART.COM · @anitakunz

Anita Kunz is one of the most established voices in contemporary illustration. Born in Toronto in 1956, she grew up in a German household in Kitchener, Ontario reading dark children's tales like *Der Struwwelpeter* and *Max und Moritz*. After returning to her native city, she received her degree from Ontario College of Art in 1978. Throughout an illustrious career spanning four decades, Kunz's work has graced the covers of over fifty books and accompanied the editorials of some of the world's leading print magazines, from *Rolling Stone* and *The New Yorker* to *Variety*. A noted speaker, she has lectured on her craft at TED and the Smithsonian, and has also led workshops at the Illustration Academy in Sarasota, Florida and at Syracuse University in New York. Her paintings are in the permanent collections of several important institutions, including the Library of Congress and the Canadian Archives in Ottawa. In 2017, she was inducted to the Museum of American Illustration Hall of Fame in New York. Often irreverent, sometimes haunting,

Anita Kunz ist eine der etabliertesten Stimmen der zeitgenössischen Illustration. Sie wurde 1956 in Toronto geboren, wuchs in einem deutschen Haushalt in Kitchener (Ontario) auf und las die düstere Kindergeschichten wie *Der Struwwelpeter* und *Max und Moritz*. Nachdem sie in ihre Geburtsstadt zurückgekehrt war, erhielt sie 1978 ihren Abschluss am Ontario College of Art. Im Laufe ihrer vierzigjährigen Karriere hat Kunz die Titelseiten von über fünfzig Büchern gestaltet und die Leitartikel einiger der weltweit führenden Printmagazine begleitet, von *Rolling Stone* und *The New Yorker* bis zu *Variety*. Als bekannte Rednerin hat sie über ihr Handwerk bei TED und dem Smithsonian referiert und Workshops an der Illustration Academy in Sarasota (Florida) und an der Syracuse University in New York geleitet. Ihre Bilder befinden sich in den ständigen Sammlungen mehrerer bedeutender Institutionen, darunter auch in der Kongressbibliothek und im Kanadischen Archiv in Ottawa. 2017 wurde sie in die

Anita Kunz est l'une des voix les plus établies de l'illustration contemporaine. Née à Toronto en 1956, elle a grandi au sein d'un foyer allemand à Kitchener, dans l'Ontario, où elle lisait des comptines comme *Crasse-Tignasse* et *Max et Moritz*. Revenue dans sa ville natale, elle a obtenu en 1978 un diplôme de l'Ontario College of Art and Design. Au fil d'une brillante carrière de quatre décennies, Kunz a embelli de ses créations les couvertures de plus de cinquante livres et agrémenté les éditoriaux d'éminents magazines comme *Rolling Stone, The New Yorker* et *Variety*. Illustre oratrice, elle a donné des conférences sur son métier pour TED et la Smithsonian, ainsi que dirigé des ateliers à l'Illustration Academy à Sarasota (Floride) et à l'université de Syracuse à New York. Ses peintures figurent dans les collections permanentes de plusieurs grandes institutions, dont la bibliothèque du Congrès et Bibliothèque et Archives Canada à Ottawa. En 2017, elle a été intégrée au Hall of Fame du National Museum of

Kunz's handcrafted style is steeped in references to art history, from the Flemish Masters to Surrealism. Her process involves collecting reference material and doodling on paper. She usually paints on board, gradually layering with watercolors and gouache.

Hall of Fame des Museum of American Illustration in New York aufgenommen. Oft respektlos, manchmal eindringlich – Kunz' handwerklicher Stil ist voll von Bezügen zur Kunstgeschichte, von den flämischen Meistern bis zum Surrealismus. Ihr Schaffensprozess umfasst das Sammeln von Referenzmaterial und das Kritzeln auf Papier. Sie malt normalerweise auf Pappe und trägt nach und nach Schichten von Aquarellfarben und Gouachen auf.

American Illustration à New York. Souvent irrévérencieux, parfois troublant, son style artisanal est baigné de références à l'histoire de l'art allant des maîtres flamands au surréalisme. Pour créer, elle récupère du matériel et fait des ébauches sur papier, puis peint généralement sur des panneaux à base de couches d'aquarelle et de gouache.

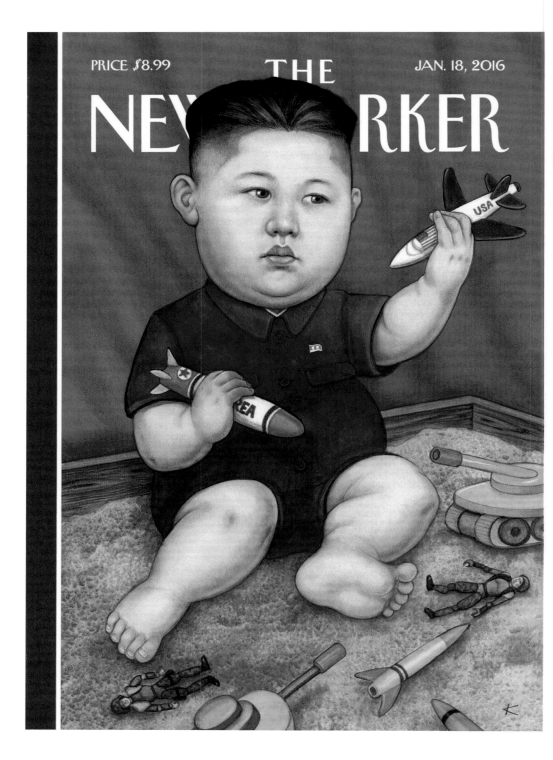

Dangerous Toys, 2015
The New Yorker, magazine
cover; acrylic; art direction:
Françoise Mouly

opposite
Media Monster, 2015
Variety, magazine cover;
acrylic; art direction:
Chuck Kerr

p. 378
Raphael redux, 2018
Personal work;
acrylic on board

REMEMBERING PRINCE p.9

APRIL N° 4

VARIETY

HOLLYWOOD & POLITICS

Media Monster

The presidential candidates star in TV's weirdest reality show By TED JOHNSON p.28

26 PAGES OF CAMPAIGN CRAZINESS INSIDE

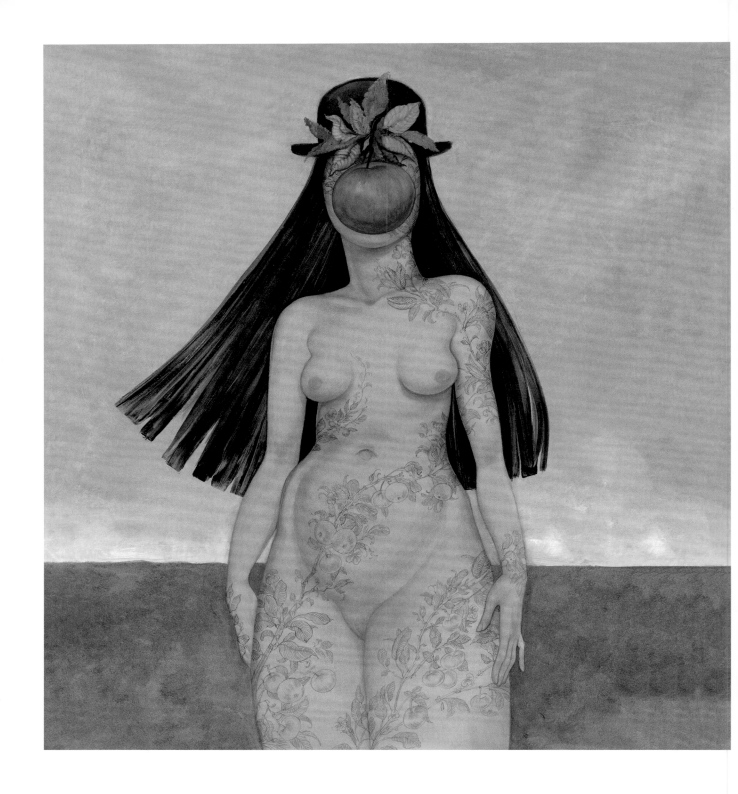

Magritte Redux, 2018
Personal work; acrylic on board

opposite top
Belushi, 2015
Rolling Stone, magazine, acrylic;
art direction: Joe Hutchinson

opposite bottom
Matisse Redux, 2018
Personal work; acrylic on board

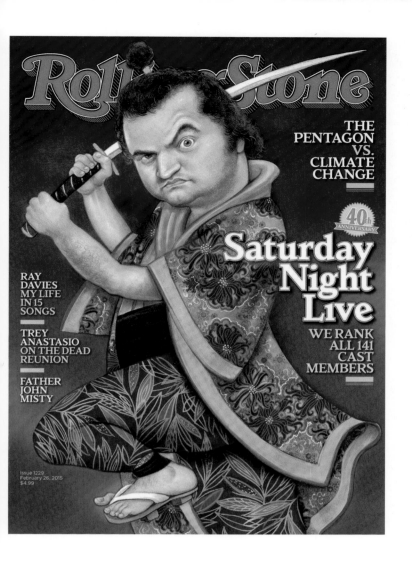

Selected Exhibitions: 2017, *Anita Kunz*, solo show, Ro2 Gallery, Dallas · 2015, *Serious Wit*, solo show, Massachusetts College of Art, Boston · 2008, *Satirical Conclusions*, solo show, Laguna Beach College, California · 2003, *Point Counterpoint*, solo show, Swann Gallery, Library of Congress, Washington, D.C. · 2000, *Retrospective*, solo show, Museum of American Illustration, New York

Selected Publications: 2014, *The 100 Best Illustrators Worldwide, Lürzer's Archive*, Austria · 2012, *Blown Covers, The New Yorker*, USA · 2008, *Illustration Now!*, TASCHEN, Germany · 2002, *Art and Evolution, Nuvo* magazine, Canada · 2000, *Rolling Stone: The Illustrated Portraits*, Chronicle Books, USA

> "It always happens that the illustration moves in a direction of its own during the process. The less control I have over it, the better it becomes. The more I start to analyze and think, the worse it gets." *for Beretkah*

LAURA LAINE

WWW.LAURALAINE.NET · @laine_laura

Born in Helsinki in 1983, Laura Laine belongs to a new wave of gifted Scandinavian artist-illustrators. After specializing in fashion illustration at the University of Art and Design in Helsinki, where she now teaches, Laine embarked on a solo career as a freelancer. Her favored muses, beautifully rendered in pencil and pen, are mainly elongated catwalk models or "twisted-bodied girls with a melancholy attitude," which have made her a sought-after creative talent in the high-end fashion world. Her stylized vision and collaborative approach—working with designers, art directors, stylists, and photographers—has resulted in ad commissions for such clients as Gap, Tommy Hilfiger, Iben Høj, and *Vogue Japan*. In 2011, Laine received the Design Forum Finland's Young Designer of the Year award with fashion designer Heikki Salonen. Outside of her native Helsinki, she has exhibited her work in the Netherlands, New York, London, and Los Angeles. In 2013, Laine forayed into glass art, participating in a group show at the National

Laura Laine, 1983 in Helsinki geboren, gehört zu einer neuen Welle begabter skandinavischer Künstlerillustratoren. Nachdem sie sich an der Universität für Kunst und Design in Helsinki, wo sie heute unterrichtet, auf Modeillustrationen spezialisiert hatte, begann Laine eine Solokarriere als freischaffende Illustratorin. Ihre bevorzugten Musen, wunderschön in Bleistift und Farbstiften wiedergegeben, sind langgestreckte Laufstegmodelle oder „körperlich verdrehte Mädchen mit einer melancholischen Haltung", was sie zu einem begehrten kreativen Talent in der High-End-Modewelt gemacht hat. Ihre stilisierte Vision und ihr kooperativer Ansatz – die Zusammenarbeit mit Designern, Kreativ-Direktoren, Stylisten und Fotografen – hat zu Anzeigenaufträgen für Kunden wie Gap, Tommy Hilfiger, Iben Høj und *Vogue Japan* geführt. Laine erhielt zusammen mit dem Modedesigner Heikki Salonen vom Design Forum Finnland 2011 den Young Designer of the Year Award. Außerhalb ihrer Heimatstadt hat sie ihre

Née à Helsinki en 1983, Laura Laine appartient à la nouvelle génération d'artistes et illustrateurs scandinaves de talent. Après s'être spécialisée en illustration de mode à l'université d'art et de design d'Helsinki où elle enseigne aujourd'hui, Laine s'est lancée dans une carrière solo à son compte. Ses muses préférées, qu'elle représente divinement au crayon et au stylo, sont surtout de grands mannequins ou des « filles au corps déformé, avec une attitude mélancolique » et ont fait d'elle une artiste très prisée dans l'univers de la mode haut de gamme. Sa vision stylisée et son approche collaborative, sachant qu'elle fait équipe avec des créateurs, des directeurs artistiques, des stylistes et des photographes, lui ont apporté des commandes publicitaires pour des clients comme Gap, Tommy Hilfiger, Iben Høj et *Vogue Japon*. En 2011, Laine a remporté le prix Young Designer of the Year du Design Forum Finland avec le couturier Heikki Salonen. En dehors de sa ville natale, ses œuvres ont été exposées

Glass Museum of Holland in Leerdam. Her interest developed into a solo exhibition at the Design Museum, Helsinki in 2015.

Arbeiten in den Niederlanden, New York, London und Los Angeles ausgestellt. 2013 machte Laine einen Exkurs in die Glaskunst und nahm an einer Gruppenausstellung im Nationalen Glasmuseum der Niederlande in Leerdam teil. Ihr Interesse entwickelte sich 2015 zu einer Einzelausstellung im Design Museum in Helsinki.

aux Pays-Bas, à New York, à Londres et à Los Angeles. En 2013, Laine s'est essayée à l'art du verre et a participé à une exposition collective au Nationaal Glasmuseum à Leerdam. Son travail a donné lieu en 2015 à une exposition individuelle au musée du design de Helsinki.

LAURA LAINE

Girl #1, 2018
Personal work, video art;
pencil on paper

right
Girl #2, 2018
Personal work, video art;
mixed media on paper

opposite
Viktor & Rolf, 2017
Personal work; pencil and
markers on paper

p. 384
Lotta Volkova, 2016
Marie Claire, magazine;
pencil and markers on paper

Untitled, 2013
Givenchy, campaign;
pencil on paper

opposite
Unchain My Heart I, 2018
Personal work; pencil on paper

LAURA LAINE

Selected Exhibitions: 2018, *In Bloom*, solo show, Total Arts Gallery, Dubai · 2017, *Moving Kate*, group show, The Mass Gallery, Tokyo · 2015, *The Wet Collection*, solo show, Helsinki Design Museum, Helsinki · 2013, *Maison Martin Margiela*, group show, SHOWstudio SHOWcabinet, London · 2011, *Visual Poetry*, group show, Gallery Hanahou, New York

Selected Publications: 2013, *The Purple Book,* Laurence King, United Kingdom · 2010, *L'oeil De La Mode,* L'Etoile Rouge, France · 2009, *Hair'em Scare'em,* Gestalten, Germany · 2009, *Illusive 3,* Gestalten, Germany · 2009, *The New Age of Feminine Drawing,* AllRightsReserved, Hong Kong

CONNIE LIM

WWW.CONNIELIM.COM · @_connielim_

Connie Lim is an American illustrator with Korean heritage. Born in Los Angeles in 1986, she was bitten by the drawing bug at an early age. Whilst attending ArtCenter College of Design in Pasadena, her penchant for fashion design and illustration developed. This guided her to Central St Martins in London, where she graduated with a BA in Fashion Design and Marketing in 2013. During this period she began honing her craft in the industry—taking on freelance commissions, doing an internship with British designer Giles Deacon, and featuring her work in *Dazed and Confused* and fashion art books such as *The Beautiful: Illustrations for Fashion and Style* (2010). With a style occupying a realm somewhere along the border of 1960s spy comic books (Modesty Blaise) with traces of Art Nouveau (Alphonse Mucha), Lim's fantasy graphic world is inhabited by a host of mysterious, gothic-tinged women, often inked or rendered in Polychromos color pencil on moleskin paper. In 2014, following

Connie Lim ist eine US-amerikanische Illustratorin koreanischer Herkunft. Sie wurde 1986 in Los Angeles geboren und bereits in jungen Jahren mit dem Zeichenfieber infiziert. Während ihres Studiums am ArtCenter College of Design in Pasadena entwickelte sich ihre Vorliebe für Modedesign und Illustration. Dies führte sie ans Central St Martins in London, wo sie 2013 ihren Bachelor in Modedesign und Marketing machte. Während dieser Zeit verfeinerte sie ihr Handwerk durch freiberufliche Aufträge, absolvierte ein Praktikum bei der britischen Designerin Giles Deacon und präsentierte ihre Arbeiten in *Dazed and Confused* sowie in Modebüchern wie *The Beautiful: Illustrations for Fashion and Style* (2010). Mit einem Stil, der irgendwo im Bereich der 1960er-Spionagecomics (Modesty Blaise) mit einem Hauch von Jugendstil (Alphonse Mucha) angesiedelt ist, wird die grafische Fantasiewelt Lims von einer Vielzahl mysteriöser, gotisch angehauchter Frauen bevölkert, die oft mit Tusche oder bunten

Connie Lim est une illustratrice américaine avec des origines coréennes. Née en 1986 à Los Angeles, elle a attrapé le virus du dessin dès son plus jeune âge. Son penchant pour le design et l'illustration de mode s'est affirmé lors de ses études aux Art Center College of Design à Pasadena, puis l'a conduite à étudier au Central St Martins à Londres, où elle a reçu sa licence en design et marketing de mode en 2013. Elle a perfectionné son art à cette époque en acceptant des commandes à son compte, en faisant un stage auprès du concepteur britannique Giles Deacon et en voyant son travail publié dans *Dazed and Confused* et des livres de mode comme *The Beautiful: Illustrations for Fashion and Style* (2010). Son style rappelle les comic strips d'espionnage des années 1960 (comme *Modesty Blaise*) avec des touches d'Art nouveau (rappelant Alphonse Mucha). L'univers graphique fantastique de Lim est ainsi habité d'une série de femmes mystérieuses et quelque peu gothiques, souvent

a successful crowdfunding campaign, she realized a long-term personal project of creating a signature set of 54 hand-drawn and beautifully packaged playing cards. Dividing her time between London, New York, and Los Angeles, Lim has taught at the University for Creative Arts in Rochester (UK), and guest-lectured at London College of Fashion. Her list of clients includes Bulgari, Guerlain, and Maybelline.

Farbstiften auf Moleskin-Papier gezeichnet werden. Nach einer erfolgreichen Crowdfunding-Kampagne realisierte sie im Jahr 2014 ein langfristiges und persönliches Projekt, nämlich den Entwurf eines charakteristischen Sets von 54 handgezeichneten und wunderschön verpackten Spielkarten. Lim teilt ihre Zeit zwischen London, New York und L. A. auf, lehrte an der University for Creative Arts in Rochester (UK) und hält Gastvorlesungen am London College of Fashion. Auf ihrer Kundenliste stehen unter anderem Bulgari, Guerlain und Maybelline.

dessinées à l'encre ou aux crayons de couleur Polychromos sur du papier ivoire. En 2014, suite au succès d'une campagne de financement participatif, elle a réalisé un projet personnel de longue durée consistant à décorer à la main 54 cartes à jouer superbement emballées. Partageant son temps entre Londres, New York et LA, Lim a enseigné à la University for Creative Arts de Rochester (Royaume-Uni) et est intervenue comme conférencière invitée au London College of Fashion. Sa liste de clients inclut Bulgari, Guerlain et Maybelline.

Charme Lipstick #3, 2017
Louboutin, website;
gouache on sketchbook paper

right
Maison Margiela,
Fall/Winter 2016
Show Studio; goauche
on sketchbook paper

opposite
Roses, 2017
Personal work; gouache
and watercolor on
Bockingford paper

p. 390
Smoke, 2016
Personal work; gouache
on sketchbook paper

opposite

Givenchy Fall/Winter 2015
Personal work; pencil, goauche

Elizabeth in Pink #2, 2018
Personal work; pencil, ink

Selected Exhibitions: 2017, *Fashion Illustration Gallery*, group show, Bluebird Chelsea, London · 2017, *SHOWStudio*, group show, Floral Street Gallery, London · 2016, *Fashion Illustration Gallery*, group show, Bluebird Chelsea, London · 2016, *SHOWStudio, Lifedrawing*, group show, Sunbeam Studios, London · 2016, *Connected Lines*, group show, Oxo Gallery, London

Selected Publications: 2010, *The Beautiful: Illustrations for Fashion*, Gestalten, Germany · 2010, *Curvy*, 6th edition, Brio Group, USA · 2007, *Great Big Book of Fashion Illustration*, Batsford, USA

> "I am just this big salad full of different ingredients. And I generally don't think it's very nice when an artist tries to go, 'Hey, I just appeared out of nowhere! I am such an original.' I mean, say thanks, man!"
>
> *for Alt.Latino*

LINIERS

@porliniers

Ricardo Siri likes inappropriate names, and this is reflected in his choice of pseudonym—his namesake ancestor, Liniers, was a French viceroy in Buenos Aires who met his fate via a firing squad. Born in the Argentine capital in 1973, Liniers drew *Star Wars* scenes as a child, so that he could take them home from the cinema. A passion for comics grew. After studying advertising, Liniers began illustrating for fanzines, and soon progressed to magazines and newspapers. A wealth of inspirations abound in Liniers' panels, from Hergé (*Tintin*) to Charles Schulz (*Peanuts*) and Bill Watterson (*Calvin & Hobbes*). His highly popular comic strip Macanudo has been published in Argentine daily *La Nación* since 2002, and has now been translated into English and widely syndicated. Liniers has published over 30 books, including *Rabbit on the Road* (2008), a series of illustrated travelogs with his alter ego as a bespectacled bunny. As well as his meta-humor cartoon strips, Liniers has endeared himself to younger readers

Ricardo Siri mag unangemessene Namen. Das spiegelt sich auch in seiner Wahl des Pseudonyms wider – sein gleichnamiger Vorfahre Liniers war ein französischer Vizekönig in Buenos Aires, dessen Schicksal von einem Erschießungskommando besiegelt wurde. Liniers wurde 1973 in der argentinischen Hauptstadt geboren und zeichnete als Kind *Star-Wars*-Szenen, damit er sie vom Kino mit nach Hause nehmen konnte. Seine Leidenschaft für Comics wuchs. Nach dem Studium der Werbung begann Liniers für Fanzines zu illustrieren und später für Zeitschriften und Zeitungen. In seinen Arbeiten gibt es eine Fülle von Inspirationen: von Hergé (*Tim und Struppi*) bis zu Charles Schulz (*Peanuts*) und Bill Watterson (*Calvin & Hobbes*). Sein populärer Comicstrip *Macanudo* wird seit 2001 täglich in der argentinischen Tageszeitung *La Nación* gedruckt und wurde nun ins Englische übersetzt und an verschiedene Zeitungen verkauft. Liniers hat über 30 Bücher veröffentlicht, zum Beispiel *Rabbit on the Road* (2008),

Ricardo Siri aime les noms inconvenants, d'où le choix de son pseudonyme : son ancêtre homonyme Liniers était un militaire français nommé vice-roi à Buenos Aires et qui termina devant un peloton d'exécution. Né dans la capitale argentine en 1973, Liniers dessinait enfant des scènes de *La Guerre des étoiles* pour les rapporter du cinéma. Sa passion pour la bande dessinée a grandi et après des études de publicité, il a commencé à illustrer d'abord des fanzines, puis très vite des magazines et des journaux. Ses planches sont truffées d'inspirations, de Hergé (*Tintin*) à Charles Schulz (*Snoopy*) en passant par Bill Watterson (*Calvin & Hobbes*). Sa très célèbre bande dessinée *Macanudo* paraît chaque jour depuis 2002 dans le quotidien argentin *La Nación* et a connu une large diffusion à partir de sa traduction en anglais. Liniers a publié plus de 30 livres, dont *Conejo de viaje* (2008), une série de carnets de voyage illustrés avec pour alter ego un lapin à lunettes. Outre ses bandes dessinées de métahumour, Liniers a conquis

with his easy-to-read children's stories, such as *The Big Wet Balloon* (2013), and the wonderful *Written and Drawn by Henrietta* (2015), which charts the process of a young girl as she creates her own color-pencilled world with the help of her cat. In 2018, his book *Good Night, Planet* won the Eisner Award for Best Publication for Early Readers. Liniers' work has graced several covers for *The New Yorker*. He currently lives in Vermont, where he was a fellow at the Center for Cartoon Studies (2016–17).

eine Reisebericht-Reihe mit seinem Alter Ego als bebrillter Hase. Ebenso beliebt gemacht wie mit seinen Comicstrips mit Metahumor, hat Liniers sich beim jüngeren Publikum auch mit seinen leicht lesbaren Kindergeschichten, wie der für einen Eisner Award nominierten Erzählung, *The Big Wet Balloon* (2013) und dem wunderschönen Buch *Written and Drawn by Henrietta* (2015), das den Prozess eines jungen Mädchens beschreibt, die mit Hilfe seiner Katze eine eigene Welt mit Farbstiften kreiert. Liniers Arbeiten haben mehrere Cover für den *New Yorker* geziert. Zurzeit lebt er in Vermont, wo er Stipendiat am Center for Cartoon Studies war (2016/17).

les jeunes lecteurs avec des histoires comme *Un ballon sous la pluie* et la remarquable *Écrit et dessiné par Enriqueta* (2015), qui explique comment une petite fille dessine son propre monde aux crayons de couleur à l'aide de son chat. En 2018, son livre *Buenas noches, Planeta* a remporté le prix Eisner de la meilleure publication pour petits lecteurs. Les œuvres de Liniers sont parues en couverture de *The New Yorker*. Il vit actuellement dans le Vermont, où il a été membre du Center for Cartoon Studies (2016–17).

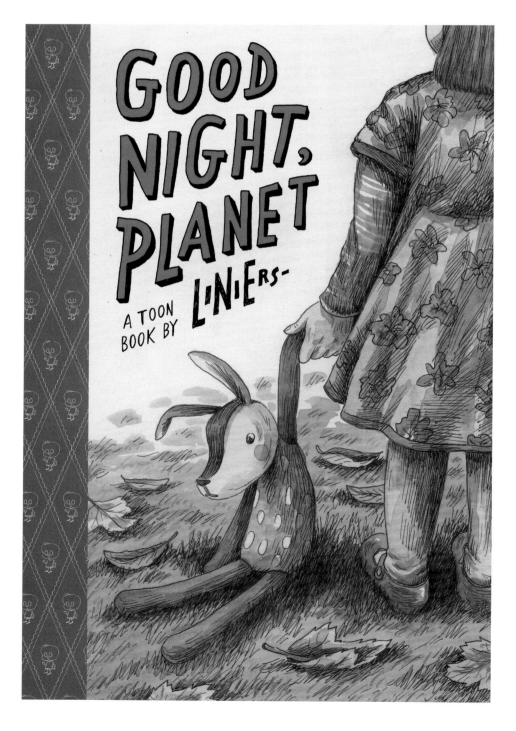

Art by Liniers, 2018
Society of Illustrators, poster

opposite
Good Night, Planet, 2017
Toon Books, book

p. 396
Old school future,
Personal work

El Macanudo Universal 2, 2015
Editorial Común, book cover

EL MACANUDO UNIVERSAL
UNIVERSAL -2-

POR Liniers

Nueve cabezas, 2009
Personal work, acrylic on canvas

opposite
Relatos Salvajes, 2014
Warner Bros. Pictures, movie poster

WARNER BROS. PICTURES PRESENTA

UNA PRODUCCIÓN DE KRAMER & SIGMAN FILMS Y EL DESEO CON EL APOYO DEL INCAA ICAA EN CO-PRODUCCIÓN CON TELEFE PRODUCTORA ASOCIADA CORNER PRODUCCIONES

"RELATOS SALVAJES" CON RICARDO DARÍN OSCAR MARTINEZ LEONARDO SBARAGLIA ÉRICA RIVAS RITA CORTESE JULIETA ZYLBERBERG Y DARÍO GRANDINETTI

MÚSICA ORIGINAL GUSTAVO SANTAOLALLA DIRECCIÓN DE FOTOGRAFÍA JAVIER JULIÁ DIRECCIÓN DE SONIDO JOSÉ LUIS DÍAZ DIRECCIÓN DE ARTE CLARA NOTARI VESTUARIO RUTH FISCHERMAN CASTING JAVIER BRAIER VILLEGAS BROS.

MONTAJE DAMIÁN SZIFRON PABLO BARBIERI COORDINACIÓN DE POST PRODUCCIÓN EZEQUIEL ROSSI PRODUCTORES ASOCIADOS CLAUDIO F. BELOCOPITT GERARDO ROZÍN CO-PRODUCTOR AXEL KUSCHEVATZKY

PRODUCCIÓN EJECUTIVA POLA ZITO LETICIA CRISTI PRODUCIDA POR HUGO SIGMAN AGUSTÍN ALMODÓVAR PEDRO ALMODÓVAR MATÍAS MOSTEIRIN ESTHER GARCÍA ESCRITA Y DIRIGIDA POR DAMIÁN SZIFRON

> "Basically I create eye-roll-inducing art that makes me laugh. Often there are subtle hints of more serious themes, like when I'm walking the streets and find discarded items in trash." *for Widewalls*

ADAM LUCAS

WWW.ADAMLUCASNYC.COM · @adamlucasnyc

Through his delightfully irreverent take on celebritydom, advertising, and consumerism, the artist known as Hanksy (b. Adam Lucas, 1986) has contributed his own humorous voice to street art culture. In 2011, the struggling young creative—recently transplanted to New York from Chicago, and just laid off from work—decided to make a joke piece. Hybridizing Banksy's famous rat with the cartoon head of actor Tom Hanks, he wheatpasted it onto a wall in NoLita, and a new art meme was born. Someone posted it online and it went viral. Propelled by the online sensation (Tom Hanks even tweeted about it), Hanksy embarked on a full-time practice of light-hearted visual spoofing with satirical epigrams. Sold-out exhibitions and interactive installations followed (*Surplus Candy*, 2014, and *Best of the Worst*, 2015). More icons were mashed up, from the waggish Homer Simpson as an "avoca'doh" to the acerbic "Dump Trump"—the latter depicting the presidential candidate as a poop emoji.

Der als Hanksy (geb. Adam Lucas, 1986) bekannte Künstler bringt durch seine herrlich respektlose Haltung in Bezug auf Berühmtheit, Werbung und Konsumverhalten seine eigene humorvolle Stimme in die Street-Art-Kultur ein. 2011 entschied sich der junge Kreative, der sich bis dato mit seiner Arbeit mühsam über Wasser gehalten hatte, erst kürzlich von Chicago nach New York gezogen war und gerade seinen Job verloren hatte, für einen Scherz: Er kreuzte die berühmte Ratte von Banksy mit dem Comickopf des Schauspielers Tom Hanks, kleisterte es in NoLita an die Wand, und ein neues Meme war geboren. Jemand stellte es online, und es ging viral. Angetrieben von diesem Internethype (sogar Tom Hanks twitterte darüber), begann Hanksy sich vollständig der unbeschwerten visuellen Parodie satirischer Epigramme zuzuwenden. Ausverkaufte Ausstellungen und interaktive Installationen folgten (*Surplus Candy,* 2014 und *Best of the Worst,* 2015). Weitere Mash-ups bekannter Ikonen folgten: vom schelmischen

Le regard délicieusement irrévérencieux que l'artiste connu sous le nom de Hansky (né Adam Lucas en 1986) pose sur le star-système, la publicité et la société de consommation se retrouve dans la voix humoristique qu'il a apportée à la culture du street art. En 2011, récemment installé à New York en provenance de Chicago, le jeune créatif qui tentait de percer et venait de perdre son travail a décidé de faire une œuvre pour plaisanter. Hybridant le célèbre rat de Banksy et le portrait caricaturé de l'acteur Tom Hanks, il a collé la composition sur un mur dans le quartier de NoLita : un même artistique était né. Publiée en ligne et devenue virale, l'œuvre a fait sensation sur Internet (même Tom Hanks a fait un tweet à son sujet) ; Hanksy s'est alors consacré à plein temps à la création de parodies légères assorties d'épigrammes satiriques. Des expositions affichant complet et des installations interactives ont suivi (comme *Surplus Candy* en 2014 et *Best of the Worst* en 2015). Il a continué à composer des figures emblématiques,

Unlike his namesake inspiration, in 2016 the artist behind Hanksy decided to reveal his true identity and rebrand himself as Adam Lucas. Signaling a more informed departure from his street-art parody, his inaugural exhibition *Some Grow Up, Others Grow Down* was the result of a long period of isolationist gestation. Comprising a series of multicolored mural panels in a style the artist has dubbed "Synthetic Cubism," Lucas's work addresses cultural coding by mixing text within an abstract pop context. He works from his studio in Chinatown.

Homer Simpson als „Avoca'doh" bis zur bitteren Witzfigur „Dump Trump" – Letzteres zeigt den Präsidenten als Hundehaufen-Emoji. Im Gegensatz zu seinem Namensvetter, der ihn inspirierte, entschloss sich der Künstler hinter Hanksy im Jahr 2016 seine wahre Identität preiszugeben und sich in Adam Lucas zurückzubenennen. Seine Eröffnungsausstellung *Some Grow Up, Others Grow Down*, die einen fundierteren Ansatz als seine Street-Art-Parodie ankündigte, war das Ergebnis eines langen isolierten Reifeprozesses. In einer Reihe von mehrfarbigen Wandbildern in einem Stil, den der Künstler als „synthetischen Kubismus" bezeichnet, beschäftigt sich Lucas' Arbeit mit kultureller Kodierung, indem er einen abstrakten Popkontext mit Text mischt. Er arbeitet in seinem Atelier in Chinatown.

telles que le facétieux Homer Simpson en « avoca'doh » (un jeu de mot avec « avocat » et l'onomatopée qu'il emploie souvent) ou le caustique « Dump Trump » (littéralement, « Chier Trump ») représentant le candidat à la présidentielle par un émoji de crotte. Contrairement à son inspiration homonyme, l'artiste derrière Hanksy a décidé en 2016 de révéler sa véritable identité et de revenir à son nom, Adam Lucas. Marquant un éloignement du street art parodique, son exposition inaugurale *Some Grow Up, Others Grow Down* a été le fruit d'une longue période de gestation isolationniste. Une série de panneaux muraux bigarrés dans un style que le propre artiste a surnommé « cubisme synthétique » s'intéresse aux codes culturels en intégrant du texte à une composition pop abstraite. Lucas travaille actuellement dans son studio à Chinatown.

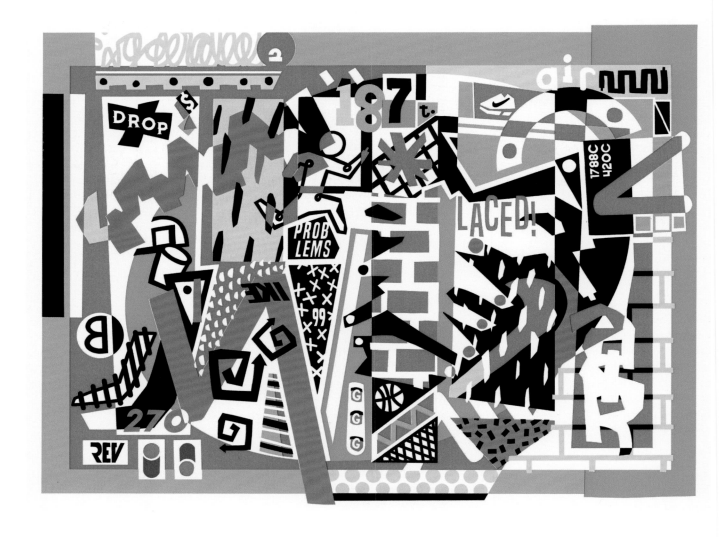

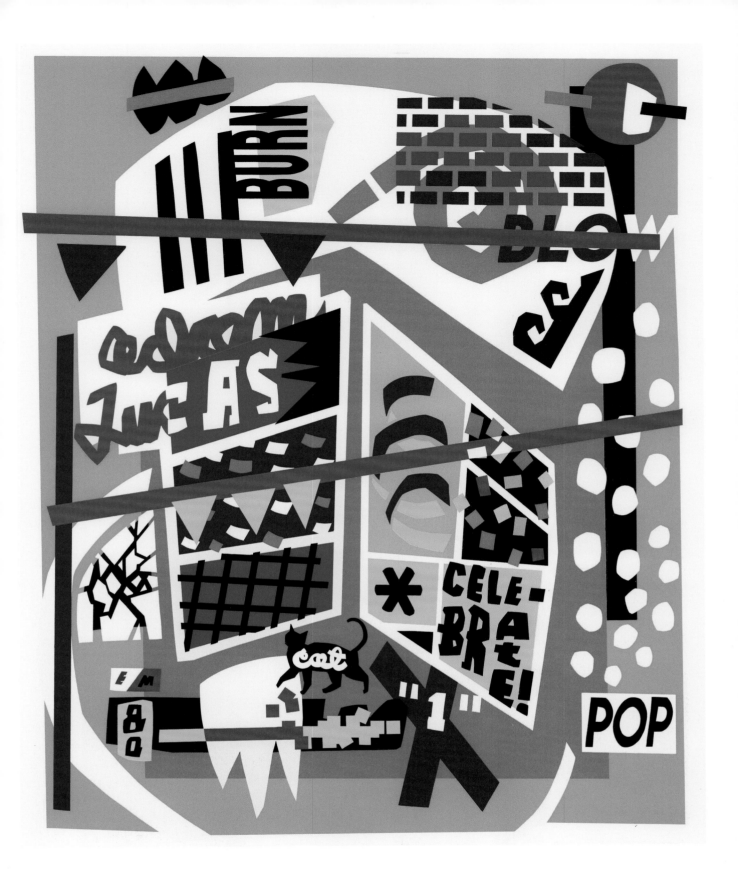

Celebrate, 2018
Comme des Garçons, product;
hand drawing, vector

opposite
Air Max Day, 2018
Nike, in-store activation;
hand drawing, vector

p. 404
If All Else Fails, 2018
Personal work; hand drawing,
acrylic, and vinyl on canvas

Selected Exhibitions: 2018, *Public Display No. 2*, group
show, Galerie du jour Agnés B., New York · 2017,
Some Grow Up, Others Grow Down, solo show, New York

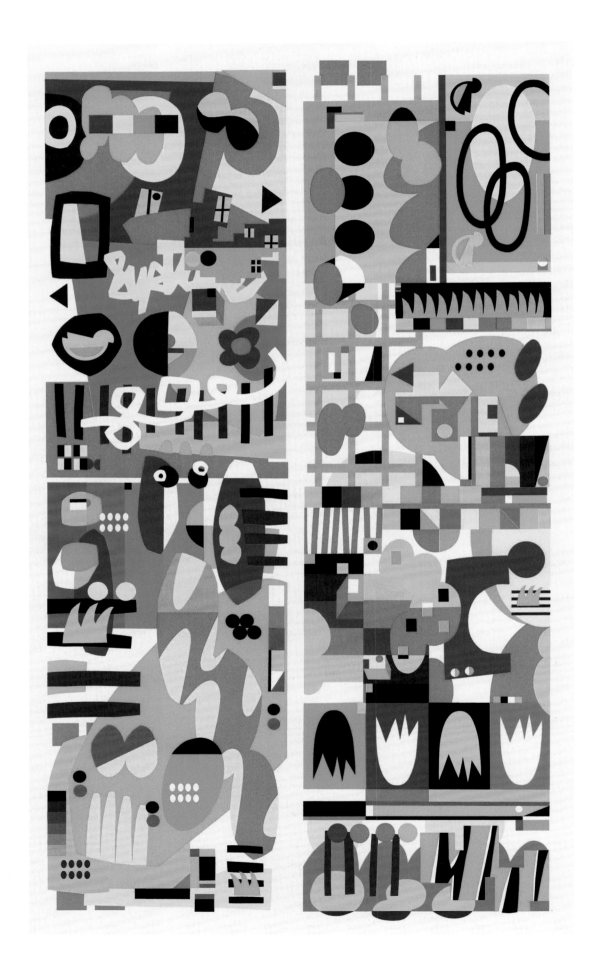

ADAM LUCAS

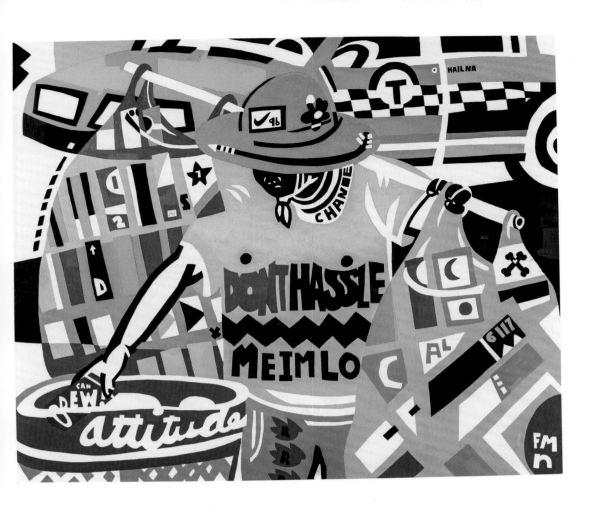

Dont Hassle Me, 2017
Personal work; hand drawing,
acrylic on canvas

right
You Probably Chose It, 2017
Personal work; hand drawing,
acrylic on panel

opposite
Floor & Wall Pattern #2, 2018
1800 Tequila, in-store activation;
hand drawing, vector

> "I always knew that I wanted to do digital art, but it was ridiculous. It was like saying I wanted to be a professional pogoist. When I started, there was nothing: almost no blogs, no tutorials, barely any magazines. Saying you wanted to do that professionally was ludicrous."
>
> for *The Great Discontent*

JUSTIN MALLER

WWW.JUSTINMALLER.COM · @justinmaller

Justin Maller is a freelance digital artist and art director based in Los Angeles. Born in Melbourne in 1983, he studied creative arts at the University of Melbourne, which he found "thoroughly unuseful." In 1998, a friend gave Maller a copy of Photoshop 4, and from that moment he was hooked. Within a few years he was creating digital art and immersing himself in the DeviantArt community. In 2002, he co-founded the Depthcore Collective, an international modern digital art collective of which he is also Creative Director. After some years working for various companies, followed by a move to New York, he went solo in 2007, steadily building an enviable client base, which includes such major brands as Verizon, Google, Nike, Jordan, ESPN, and Ministry of Sound. Maller's style has shifted from displaced hyperrealities to portraits and animals rendered as 3D geometric abstractions. He rarely uses stock imagery, preferring his own photography or collaborative contributions for original source material. In 2013, he set himself

Justin Maller ist ein freiberuflicher Digital Artist und Art Director mit Sitz in Los Angeles. Der 1983 in Melbourne geborene Künstler studierte an der Universität von Melbourne kreative Künste, die er als „völlig unbrauchbar" empfand. 1998 gab ihm ein Freund eine Kopie von Photoshop 4, und ab diesem Moment war er begeistert. Innerhalb weniger Jahre kreierte er digitale Kunst und tauchte in die DeviantArt-Community ein. Im Jahr 2002 war er Mitbegründer des Depthcore Collective, ein internationales Kollektiv für moderne digitale Kunst, dessen Kreativdirektor er ist. Nachdem er einige Jahren für verschiedene Unternehmen tätig gewesen war, gefolgt von einem Umzug nach New York, machte er sich 2007 selbstständig und baute kontinuierlich einen beneidenswerten Kundenstamm auf, zu dem auch große Marken wie Verizon, Google, Nike, Jordan, ESPN und Ministry of Sound gehören. Mallers Stil hat sich von verschobenen Hyperrealitäten zu Porträts und Tieren entwickelt, die als

Justin Maller est un artiste numérique et directeur artistique travaillant à son compte à Los Angeles. Né en 1983 en Australie, il a étudié les arts créatifs à l'université de Melbourne, sa ville natale ; des études qu'il a trouvées « profondément inutiles ». En 1998, un ami lui a donné une copie de Photoshop 4 et il a immédiatement été conquis. En l'espace de quelques années, il a commencé à produire de l'art numérique et a pris part à la communauté DeviantArt. En 2002, il a cofondé Depthcore Collective, un collectif d'art numérique international dont il est également le directeur créatif. Après plusieurs années à travailler pour diverses entreprises, puis un déménagement à New York, il s'est installé à son compte en 2007 et n'a cessé d'agrandir sa base de clients, qui comprend de grandes marques comme Verizon, Google, Nike, Jordan, ESPN et Ministry of Sound. Le style de Maller a évolué pour passer d'hyper-réalités décalées à des portraits et des animaux réalisés via des abstractions géométriques en 3D.

the challenge of producing a new work of art each day for 365 days. The resulting project, titled *Facets*, gained him much kudos on social media.

geometrische 3-D-Abstraktionen dargestellt werden. Er verwendet selten Stock Images, sondern bevorzugt seine eigene Fotografie oder Ergebnisse aus gemeinschaftlichen Arbeiten als Quellenmaterial. 2013 stellte er sich der Herausforderung, 365 Tage lang jeden Tag ein neues Kunstwerk zu produzieren. Das daraus entstandene Projekt mit dem Titel *Facets* brachte ihm beträchtlichen Ruhm in den sozialen Medien.

Il a rarement recours aux stocks d'images car il préfère employer comme matériel source ses propres photos ou des contributions collaboratives. En 2013, il s'est lancé comme défi de créer une œuvre d'art chaque jour pendant un an. Le résultat s'intitule *Facets* et lui a valu de nombreuses félicitations sur les réseaux sociaux.

Dwyane Wade, 2015
Gatorade, print; digital

opposite top
Apple Dreams, 2017
Unico; digital

opposite bottom
Candy Dreams, 2017
Unico; digital

p. 410
Google, 2016
Print, web, merchandising; digital

Selected Exhibitions: 2011, *Depthcore*, group show, Cut & Run, New York · 2009, *Black Salt*, solo show, McCullough Gallery, Melbourne · 2008, *Jacky Winter*, group show, Lamington Drive Gallery, Melbourne · 2007, *Debut*, solo show, Design A Space, Melbourne

> "The light is like 'knowledge,' the perfect moment in an encounter with nature. Great balance could be represented with a near-death experience." *for Odalisque Magazine*

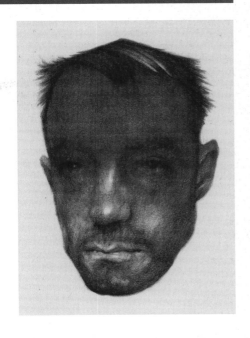

MARCO MAZZONI

@marcomazzoniart

Born in 1982 in Tortona, in the Piedmont region of Italy, Marco Mazzoni discovered drawing at 14 when he created an album cover for some friends' punk band. Local gig posters soon followed and the artist's passion was sparked. Later, Mazzoni studied painting at the Brera Academy in Milan, receiving his bachelor's degree in 2007. Working almost exclusively with colored pencil—a fine line between portraiture and still life—his work is a contemplation on nature and mysticism. Recurring subjects are young women: herbalists from 16th- to 18th-century Sardinian folklore, *Cogas* (faeries) and *Janas* (vampiric witches) that cure and curse. Their eyes are often obscured by shadow or light, or covered with ornate flora and fauna or animal life, as if personifying the mystical properties of their medicines. Fish shoal in clusters, birds and mammals entangle in nests, oozing mucousy sap. His moleskin sketchbooks almost become diptychs, taking on the appearance of the ancient books of remedies themselves. There is an uncanny

Marco Mazzoni wurde 1982 in Tortona in der Region Piemont in Italien geboren. Mit 14 Jahren entdeckte er das Zeichnen für sich, als er ein Albumcover für die Punkband einiger Freunde gestaltete. Bald folgten lokale Gig-Poster, und die Leidenschaft des Künstlers war geweckt. Mazzoni studierte Malerei an der Brera Akademie in Mailand und erhielt dort 2007 seinen Bachelorabschluss. Seine Arbeit, die er fast ausschließlich mit Buntstift auf dem schmalen Grat zwischen Porträt und Stillleben ausführt, widmet sich der Kontemplation über Natur und Mystik. Immer wiederkehrende Themen sind junge Frauen: Naturheilerinnen aus der sardischen Folklore des 16. bis 18. Jahrhunderts, *Cogas* (Feen) und *Janas* (vampirische Hexen), die heilen und verwünschen. Ihre Augen sind oft durch Schatten oder Licht oder mit reich verzierter Flora und Fauna bedeckt, als ob sie die mystischen Eigenschaften ihrer Medizin verkörperten. Fische drängen sich in Schwärmen, Vögel und Säugetiere verfangen sich in Nestern

Né en 1982 à Tortone, dans la région italienne du Piémont, Marco Mazzoni s'est initié au dessin à l'âge de 14 ans en créant une pochette de disque pour un groupe punk de copains. Des affiches pour des petits concerts ont suivi et sa passion s'est éveillée. Plus tard, Mazzoni a étudié la peinture à l'académie Brera de Milan, où il a reçu une licence en 2007. Travaillant presque exclusivement aux crayons de couleur, avec des créations à la frontière entre l'art du portrait et la nature morte, son travail traduit une contemplation de la nature et un certain mysticisme. Les jeunes femmes sont des sujets récurrents : des herboristes du XVIe au XVIIIe siècle évoquant le folklore sarde, des *Cogas* (royaumes des fées) et des *Janas* (sorcières vampiriques) qui guérissent et jettent des sorts. Leurs yeux sont souvent masqués par une ombre ou de la lumière, ou encore recouverts d'éléments de flore, de faune ou de vie animale, comme pour personnifier les propriétés mystiques de leurs remèdes. Des bancs de poissons,

embodiment of the physical in Mazzoni's practice. He remains somewhat aloof online, letting his work speak for itself to hundreds of thousands of followers. Mazzoni has exhibited in Europe and the United States. In 2016, his series titled *The Illustrated Encyclopedia of Mental Diseases* featured in the group exhibition Cluster at the Jonathan LeVine Gallery in New York. The following year saw the launch of a successful Kickstarter campaign to produce his first high-quality, limited-edition hardback book titled *Drawings + Sketches 2012/2017* in collaboration with Satellite Press, a small publishing house dedicated to the Italian underground scene. He lives and works in Milan.

und sondern Schleim aus. Seine Moleskin-Skizzenbücher werden fast zu Diptychen mit dem Aussehen alter Arzneibücher. Die Verkörperung des Physischen in Mazzonis Arbeiten ist unheimlich. Online bleibt er etwas distanziert und lässt seine Werke zu Hunderttausenden Followern für sich selbst sprechen. Mazzoni hat in Europa und den Vereinigten Staaten ausgestellt. 2016 erschien seine Serie mit dem Titel *The Illustrated Encyclopedia of Mental Diseases* (Die illustrierte Enzyklopädie der psychischen Erkrankungen) in der Gruppenausstellung *Cluster* in der Jonathan LeVine Gallery in New York. Im folgenden Jahr wurde eine erfolgreiche Kickstarter-Kampagne gelauncht, um sein erstes hochwertiges Hardcover-Buch in limitierter Auflage mit dem Titel *Drawings + Sketches 2012/2017* in Zusammenarbeit mit Satellite Press zu produzieren, einem kleinen Verlag, der sich der italienischen Underground-Szene widmet. Er lebt und arbeitet in Mailand.

des oiseaux et des mammifères sont enchevêtrés dans des nids dont suinte une sève visqueuse. Ses carnets de dessin Moleskine deviennent presque des diptyques et s'apparentent aux anciens livres de remèdes. Les œuvres de Mazzoni font preuve d'une étrange incarnation du monde physique. Plutôt discret sur Internet, il laisse son travail parler de lui-même à ses centaines de milliers de fàns. Mazzoni a exposé en Europe et aux États-Unis et en 2016, sa série intitulée *The Illustrated Encyclopedia of Mental Diseases* a été intégrée à l'exposition collective Cluster à la Jonathan LeVine Gallery à New York. L'année d'après, il a lancé avec succès une campagne de financement pour produire en édition limitée son livre relié de haute qualité intitulé *Drawings + Sketches 2012/2017* en collaboration avec Satellite Press, une petite maison d'édition spécialisée dans la scène artistique italienne underground. Il vit et exerce actuellement à Milan.

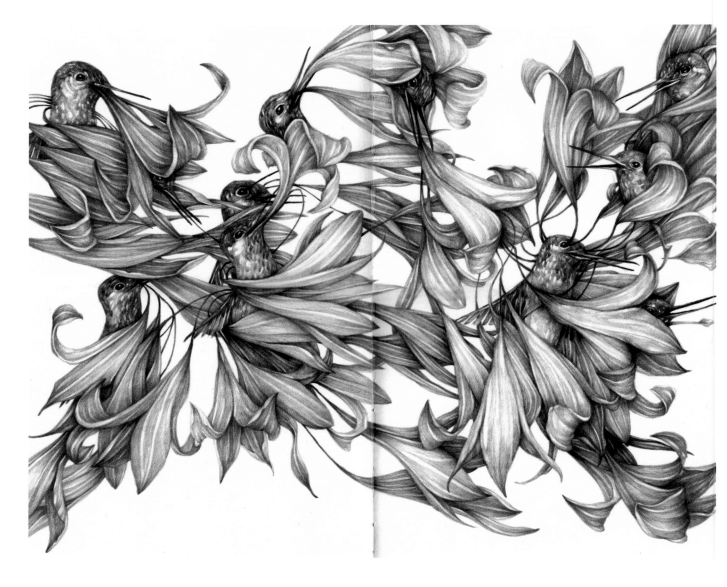

MARCO MAZZONI

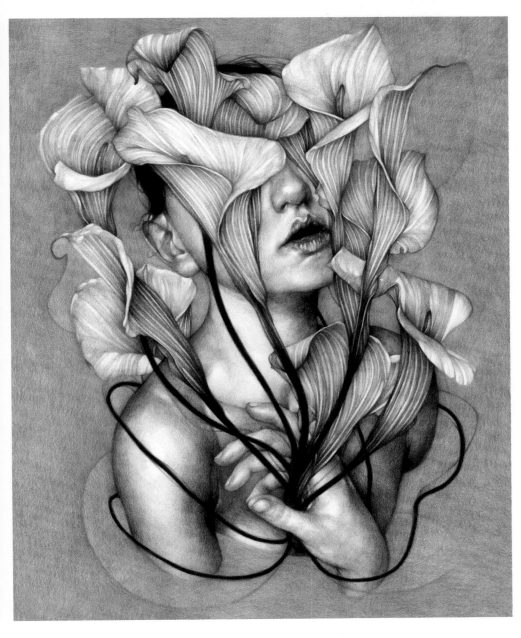

Insecurity, 2017
Personal work; hand drawing;
Thinkspace Gallery

right
Aphonia, 2015
Personal work; hand drawing;
Galleri Benoni

opposite
Prom, 2017
Ltdedn (This is a Limited
Edition); hand drawing

p. 414
Dance, Weep, Dance, 2017
Personal work; hand drawing;
Galleria Giovanni Bonelli

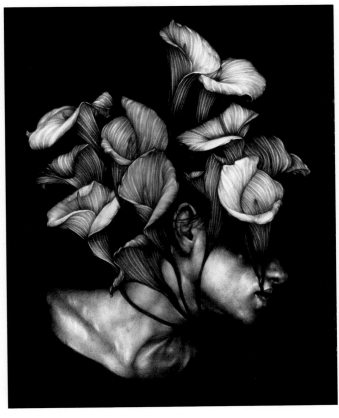

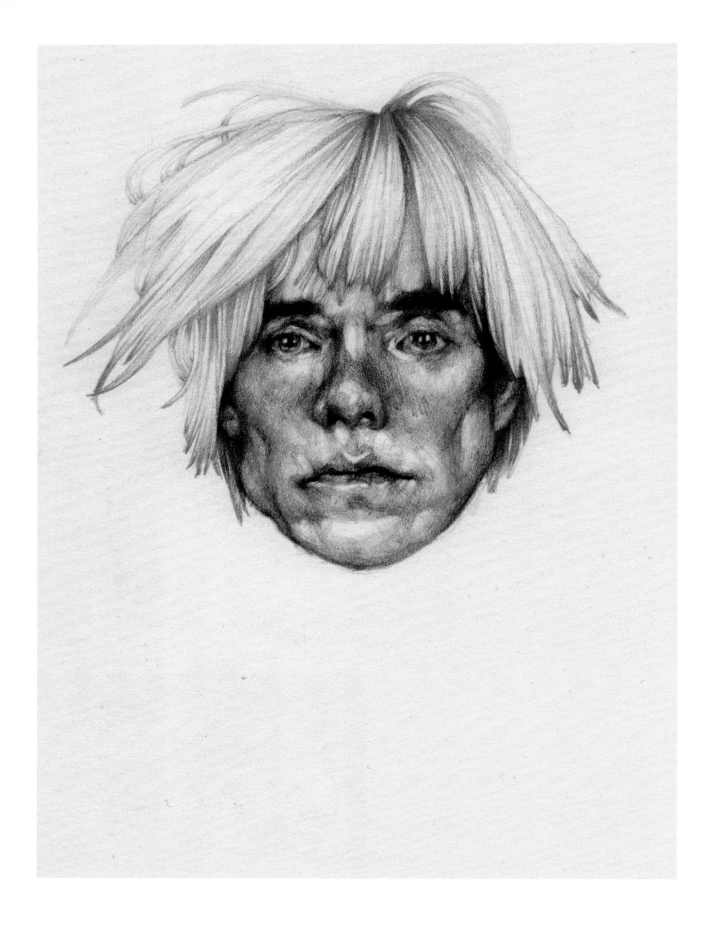

Andy, 2017
Dondup, magazine;
hand drawing

opposite
Sketch #01, 2017
Satellite Press, book;
hand drawing

MARCO MAZZONI

Selected Exhibitions: 2018, *The Moleskine Project VII*, group show, Spoke Art Gallery, New York · 2018, *Imago, a History of Portraits*, group show, Muca Museum, Munich · 2017, *Dear Collapse*, solo show, Thinkspace Gallery, Los Angeles · 2016, *Turn the Page, the First Ten Years of Hi-Fructose*, group show, Virginia Museum of Contemporary Art · 2016, *Monism*, solo show, Galleri Benoni, Copenhagen

Selected Publications: 2018, *Imago, a History of Portraits*, Muca Books, Germany · 2018, *Poucette*, Albin Michel Jeunesse, France · 2017, *The Moleskine Project Volume One of Hi-Fructose*, Paragon Press, USA · 2017, *Vision of the Dark Side: the Best of Dark Illustration*, DPI, Taiwan · 2017, *Turn The Page: the First Ten Years of Hi-Fructose*, Baby Tattoo Books, USA

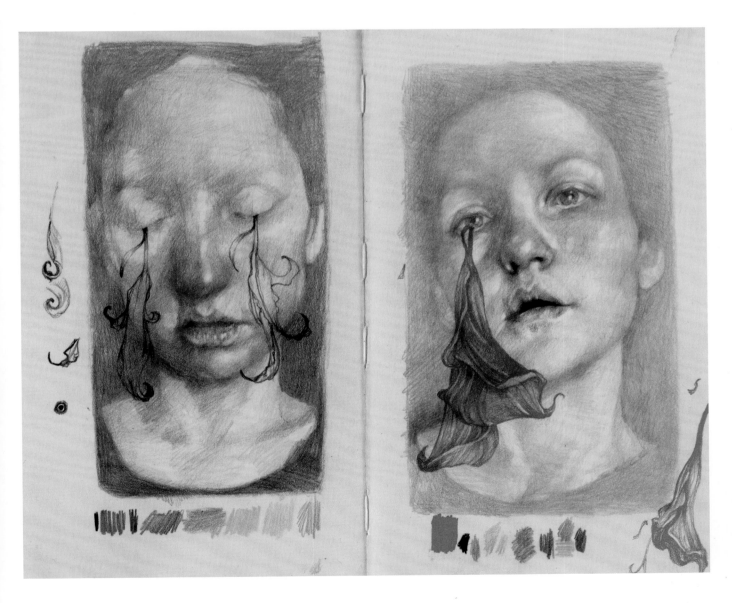

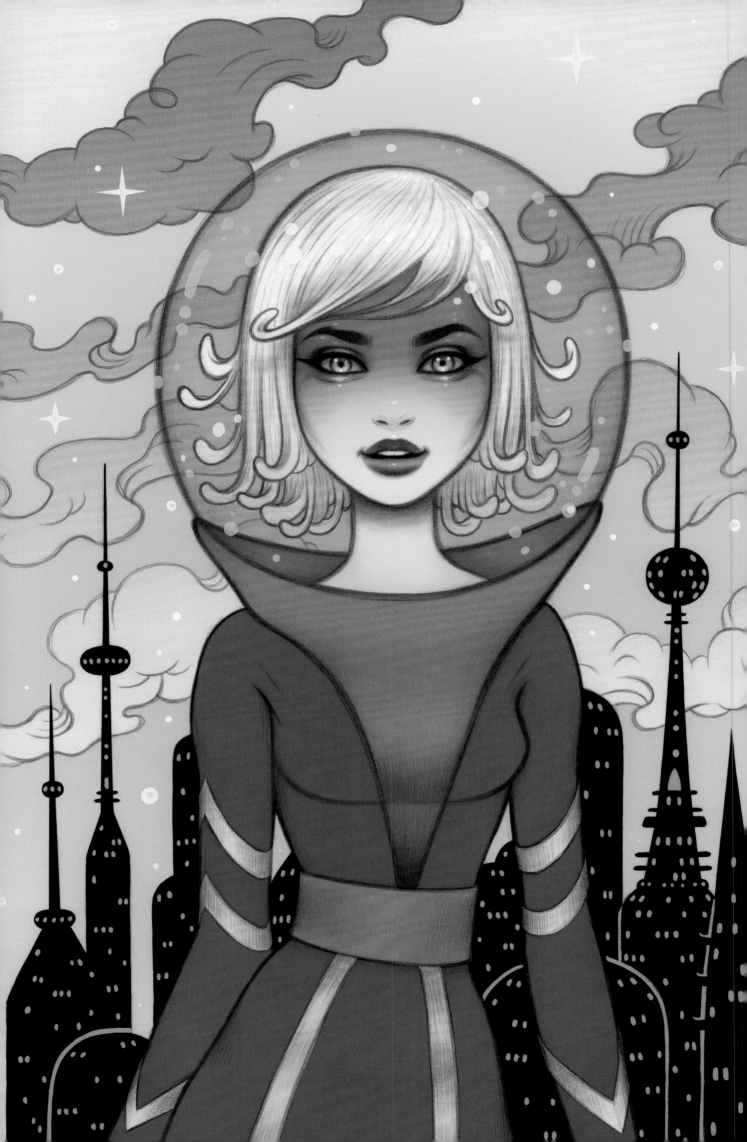

> "I create images that are thought-provoking and seductive. People and their relationships are a central theme throughout my work. Creating art about people and their odd ways, my characters seem to exude an idealized innocence with a glimpse of hard-earned wisdom in their eyes."

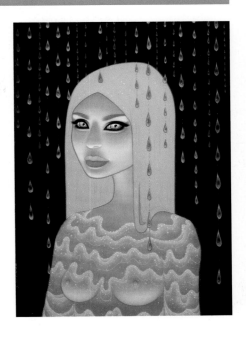

TARA McPHERSON

WWW.TARAMCPHERSON.COM · @taramcpherson

Born in San Francisco in 1976, Tara McPherson grew up in Los Angeles. In 2001, she graduated with a BFA (Hons) in Illustration from ArtCenter College of Design in Pasadena. Whilst still a student she interned at Rough Draft Studios working on Matt Groening's animated series *Futurama*. A move to New York proved pivotal in kickstarting her freelance career. She soon found herself creating gig posters for the Knitting Factory and bands on the alternative scene, including Death Cab for Cutie and Queens of the Stone Age. McPherson's otherworldly imagination harbors a myriad of influences from comic books to science to European folklore. She has described her style as somewhere between "rendered and flat, sweet and creepy, illustrative and figurative." Candy-colored science-fiction girls in space helmets with carved-out hearts float in an abyss with luminous sea creatures or are lifted by strange cartoon-eyed balloons. Loaded with symbols, these surreal depictions give the viewer a kaleidoscopic glimpse into the human

Tara McPherson wurde 1976 in San Francisco geboren und wuchs in Los Angeles auf. 2001 erhielt sie ihren Bachelor (mit Auszeichnung) in Illustration am Art-Center College of Design in Pasadena. Schon während ihres Studiums arbeitete sie als Praktikantin in den Rough Draft Studios an Matt Groenings Animations-serie *Futurama* mit. Der Umzug nach New York war entscheidend für den Start ihrer freiberuflichen Karriere. Bald kreierte sie Gig-Poster für die Knitting Factory und Bands der alternativen Szene, darunter Death Cab for Cutie und Queens of the Stone Age. McPhersons außerweltliche Vorstellungskraft birgt eine Vielzahl von Einflüssen von Comic-büchern über Wissenschaft bis hin zu europäischer Folklore. Sie hat ihren Stil irgendwo zwischen „flach gerendert, süß und gruselig, illustrativ und figurativ" beschrieben. Bonbonfarbene Science-Fiction-Mädchen in Weltraumhelmen mit wie ausgeschnitzten Herzen schwe-ben mit leuchtenden Meeresbewohnern in einem Abgrund oder werden von

Née à San Francisco en 1976, Tara McPherson a grandi à Los Angeles. En 2001, elle a obtenu avec les honneurs une licence d'illustration du Art Center College of Design à Pasadena. Encore étudiante, elle a fait un stage chez Rough Draft Studios et travaillé sur la série d'animation de Matt Groening intitulée *Futurama*. Son installation à New York s'est avérée décisive pour le lancement de sa carrière à son compte. Très vite, elle a créé des affiches de concerts pour la Knitting Factory et des groupes alternatifs, dont Death Cab for Cutie et Queens of the Stone Age. L'imagination hors du commun de McPherson est le fruit d'une myriade d'influences, tant des bandes dessinées que de la science et du folklore européen. Elle qualifie son style de compromis entre « rendu et plat, adorable et glauque, illustratif et figuratif ». Des filles irréelles aux couleurs acidulées portent des casques spatiaux et ont un cœur taillé dans leur buste, elles flottent dans un abysse avec des créatures marines lumineuses ou

psyche. Her art migrates from paintings to murals, posters, comics, books, and toy figures. McPherson lectures around the world and is a former faculty member of Parsons School of Design. Her work is in the permanent collection of the Rock and Roll Hall of Fame. In 2012, her "Lilitu" figure produced by Kidrobot won "Toy of the Year" at the Designer Toy Awards.

seltsamen Luftballons mit Cartoon-Augen hochgehoben. Voller Symbolhaftigkeit geben diese surrealen Darstellungen dem Betrachter einen kaleidoskopischen Einblick in die menschliche Psyche. Ihre Kunst umfasst Gemälde, Wandmalerei, Poster, Comics, Bücher und Spielzeugfiguren. McPherson lehrt weltweit und ist ehemaliges Fakultätsmitglied der Parsons School of Design. Ihre Arbeit befindet sich in der permanenten Sammlung der Rock and Roll Hall of Fame. 2012 gewann ihre von Kidrobot produzierte Figur „Lilitu" den Designer Toy Award für das „Spielzeug des Jahres".

s'élèvent en tenant des ballons dotés d'yeux. Pleines de symboles, ces compositions surréalistes offrent au public un aperçu kaléidoscopique du psyché humain. Son art s'exprime aussi bien dans des tableaux que des fresques, des affiches, des bandes dessinées, des livres et des figurines. McPherson donne des conférences à travers le monde et a dans le passé enseigné à la Parsons School of Design. Ses créations ont leur place dans la collection permanente du Rock and Roll Hall of Fame. En 2012, son personnage « Lilitu » fabriqué par Kidrobot a remporté le prix Toy of the Year aux Designer Toy Awards.

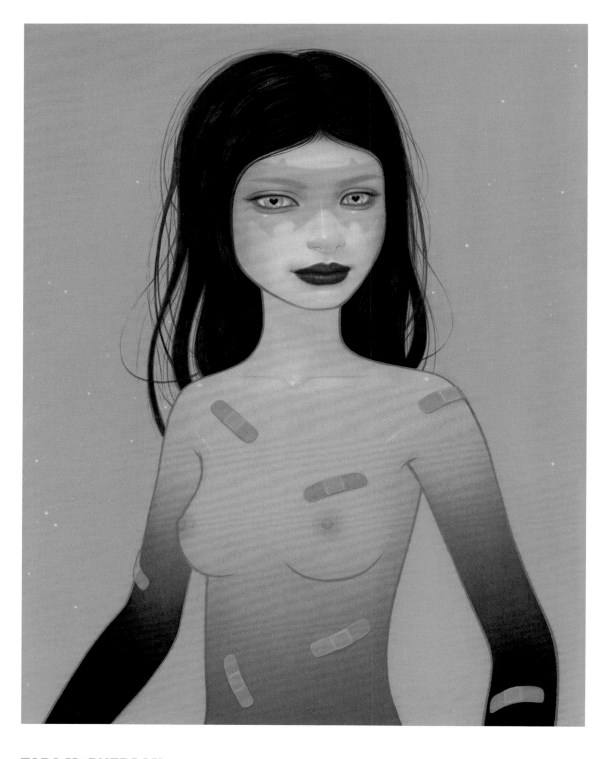

TARA McPHERSON

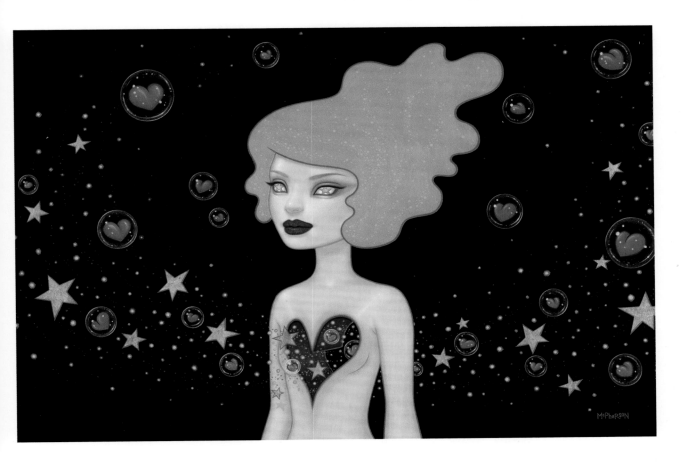

Supernova, 2014
Personal work, exhibition; oil

right
SXSW Film Festival, 2018
Promotional poster;
graphite, digital

opposite
Eyes On You, 2017
Personal work, website; oil

p. 420
Stellar Revolution, 2017
Designer Con, booklet cover;
graphite, ink, digital

SXSW FILM FESTIVAL

25TH EDITION · AUSTIN TX · 2018

Selected Exhibitions: 2015, *I Know it by Heart*, solo show, Dorothy Circus Gallery, Rome · 2014, *Supernova*, group show, Merry Karnowsky Gallery, Los Angeles · 2013, *Wandering Luminations*, solo show, Jonathan LeVine Gallery, New York · 2010, *Bunny in the Moon*, solo show, Jonathan LeVine Gallery, New York · 2009, *Fractal Lake*, group show, Choque Cultural, São Paulo

Selected Publications: 2017, *Hi-Fructose Volume 42,* Ouch Factory Yum Club, USA · 2013, *Bunny in the Moon: The Art of Tara McPherson Volume 3,* Dark Horse Books, USA · 2009, *Lost Constellations: The Art of Tara McPherson Volume 2,* Dark Horse Books, USA · 2006, *Lonely Heart: The Art of Tara McPherson Volume 1,* Dark Horse Books, USA · 2006, *Illustration Now!,* TASCHEN, Germany

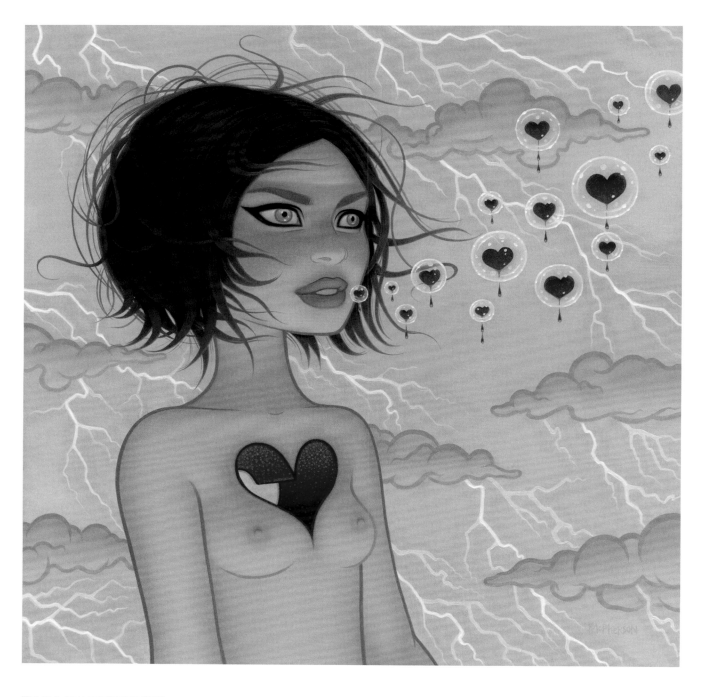

TARA McPHERSON

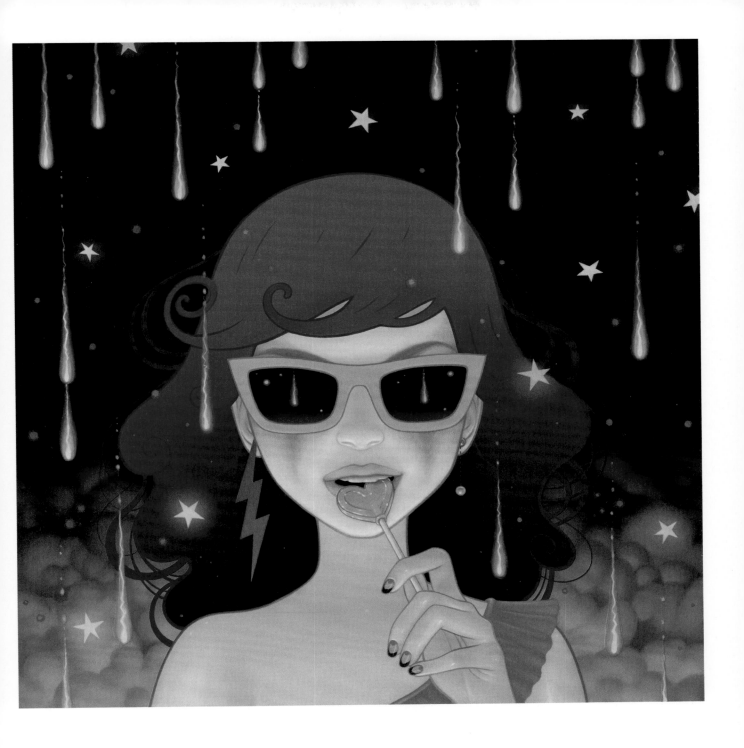

Electric Lola, 2015
Natalia Garcez, album cover; oil

opposite
Storm Queen, 2016
Kevin Cardani, commission; oil

> "I like research. It occupies 40% of my process. I try to see the project from all angles and have visual references. I care a lot because it's signed with my name."

for Winterland

GILDO MEDINA

WWW.STUDIOGILDOMEDINA.COM · @gildomedina

Gildo Medina's nomadic career has imbued him with a world vision and level of cultural and academic sophistication that has translated into his own distinctive visual mark. Medina's multidisciplinary practice spans painting, film, photography, graphic and interior design. He was born in Mexico City in 1980, where he would later study visual arts at the San Carlos Academy and graduate with a degree in graphic design from the Ibero-American University in 1997. He also studied internationally at the Academy of Fine Arts in Florence and Central St Martins in London. Whether creating in pencil or paint, Medina's work marries the figurative with the surreal and the erotic to create art-design pieces that evoke a sense of aged beauty with a contemporary feel. This approach has attracted a sophisticated clientele, from wealthy collectors in Monaco to restaurateurs in Australia. He has collaborated on Parfums de Voyage, a range of home fragrance products with New York-based luxury lifestyle brand L'Objet,

Die nomadische Karriere von Gildo Medina hat ihn mit einer Weltanschauung voller kultureller und akademischer Raffinesse beschenkt, die sich in seiner eigenen unverwechselbaren visuellen Note niederschlug. Die multidisziplinäre Praxis von Medina umfasst Malerei, Film, Fotografie, Grafik und Innenarchitektur. Er wurde 1980 in Mexico City geboren, wo er auch an der San-Carlos-Akademie bildende Kunst studierte und 1997 sein Studium der Grafikwissenschaften an der Iberoamerikanischen Universität abschloss. Er studierte auch an der Akademie der Bildenden Künste in Florenz und am Central St Martins in London. Ob in Bleistift oder Farbe – das Werk von Medina verbindet das Figurative mit dem Surrealen und der Erotik, um Kunstdesignstücke zu kreieren, die ein Gefühl von gealterter Schönheit im Geist der Moderne vermitteln. Dieser Ansatz hat eine anspruchsvolle Kundschaft von reichen Sammlern in Monaco bis zu Gastronomen in Australien angezogen. Er hat an Parfums de Voyage, einer

La carrière nomade de Gildo Medina l'a doté d'une vision du monde et d'un niveau de sophistication culturelle et académique qui se traduisent dans son visuel. Son activité multidisciplinaire englobe peinture, cinéma, photographie, conception graphique et design d'intérieur. Il est né en 1980 à Mexico, où il a étudié les arts visuels à l'académie San Carlos et obtenu un diplôme en design graphique de l'université ibéro-américaine en 1997. Il a également suivi des études internationales à l'académie des beaux-arts de Florence et à la Central St Martins à Londres. Qu'il compose au crayon ou en peignant, son travail combine des éléments figuratifs, surréalistes et érotiques: ses œuvres évoquent un sentiment de beauté mûre assortie d'une note contemporaine. Cette approche a séduit une clientèle sophistiquée, de riches collectionneurs monégasques comme de restaurateurs australiens. Medina a collaboré pour la gamme de produits d'ambiance Parfums de Voyage avec la marque new-yorkaise de luxe L'Objet,

and has illustrated art furniture for Hong Kong luxury fashion retailer Lane Crawford. In 2016, he presented a to-date retrospective at the Cultural Institute of the Mexican Embassy in Paris titled *Couronnes* (Crowns).

Reihe von Heimduftprodukten der in New York ansässigen Luxus-Lifestyle-Marke L'Objet mitgearbeitet und Kunstmöbel für den Hongkonger Luxusmodehändler Lane Crawford illustriert. 2016 präsentierte er im Kulturinstitut der mexikanischen Botschaft in Paris eine aktuelle Retrospektive mit dem Titel *Couronnes* (Kronen).

ainsi que décoré des meubles pour l'enseigne haut de gamme de Hong Kong Lane Crawford. En 2016, il a présenté une rétrospective de toutes ses œuvres intitulée *Couronnes* à l'Institut culturel du Mexique à Paris.

Couronnes, 2017
Personal work; acrylic on leather

opposite
D'ici à l'infini!, 2016
Personal work; ballpoint pen on leather

p. 426
Gesti italiani. Non me ne frega niente, 2017
Personal work; colored pencil on cotton paper

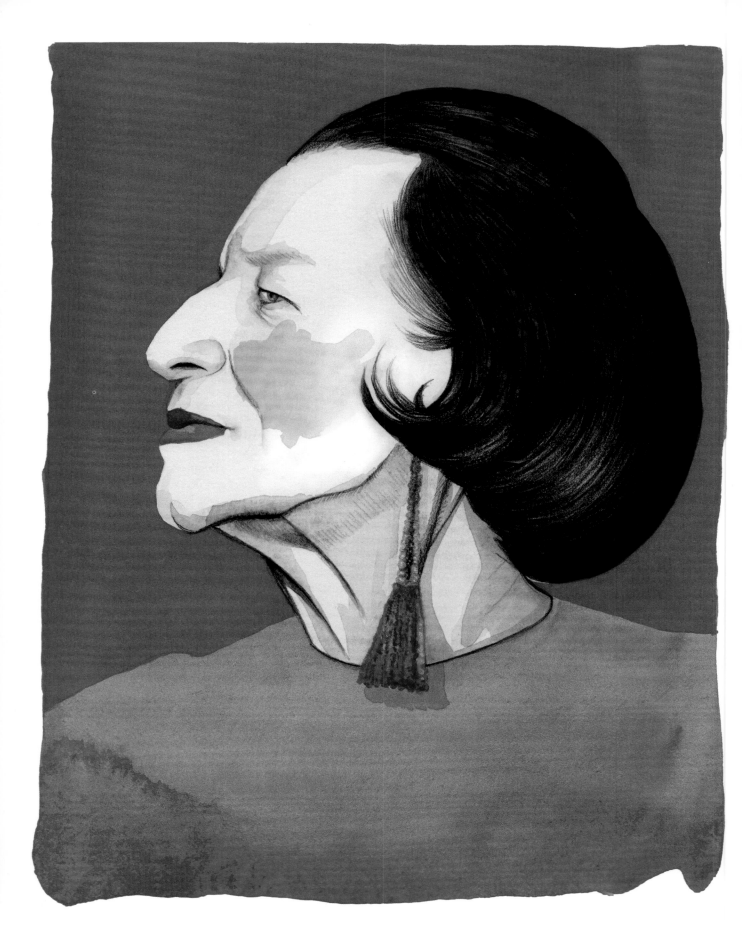

Ms. Vreeland, 2015
Harper's Bazaar, magazine;
charcoal and watercolor on
cotton paper

opposite top
Voyage Voyage, 2018
Louis Vuitton; hand painting

opposite bottom
Korinther 13, 2015
Personal work; pencil
on cotton paper

GILDO MEDINA

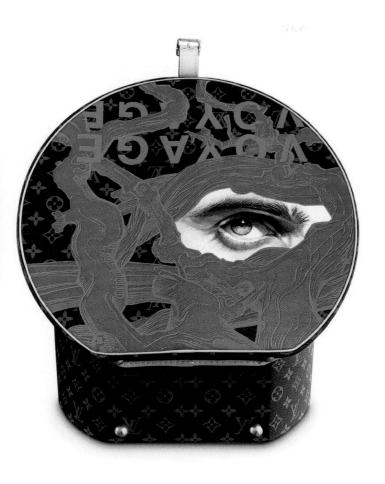

Selected Exhibitions: 2016, *Couronnes*, solo show, Mexican Cultural Institute, Paris · 2016, *Fluctuat nec mergitur*, solo show, Galerie Detais, Paris · 2016, *TechDreamers*, solo show, LuisaViaRoma, Florence · 2016, *Nomadism in Art*, solo show, Appart Paris, Galerie fait maison, Dubai · 2015, *L'objet, Perfum de Voyage*, solo show, Lane Crawford, Hong Kong

Selected Publications: 2016, *Hair*, Assouline, USA · 2013, *100 Illustrators*, TASCHEN, Germany · 2011, *Illustration Now! Portraits*, TASCHEN, Germany · 2010, *The Beautiful. Illustrations for Fashion & Style*, Gestalten, Germany · 2009, *Illustration Now! Vol.3*, TASCHEN, Germany

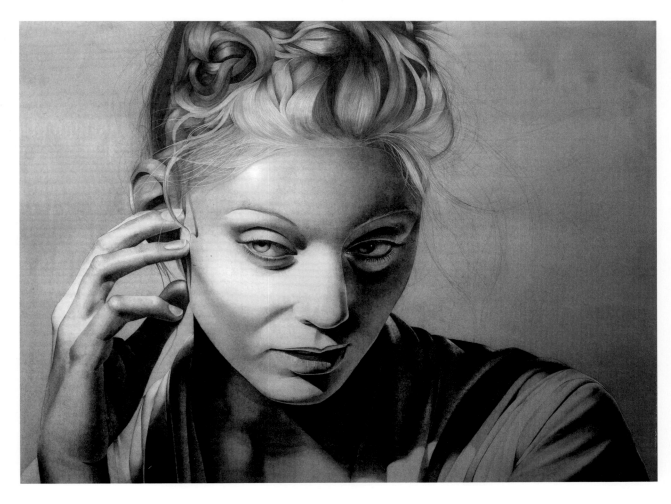

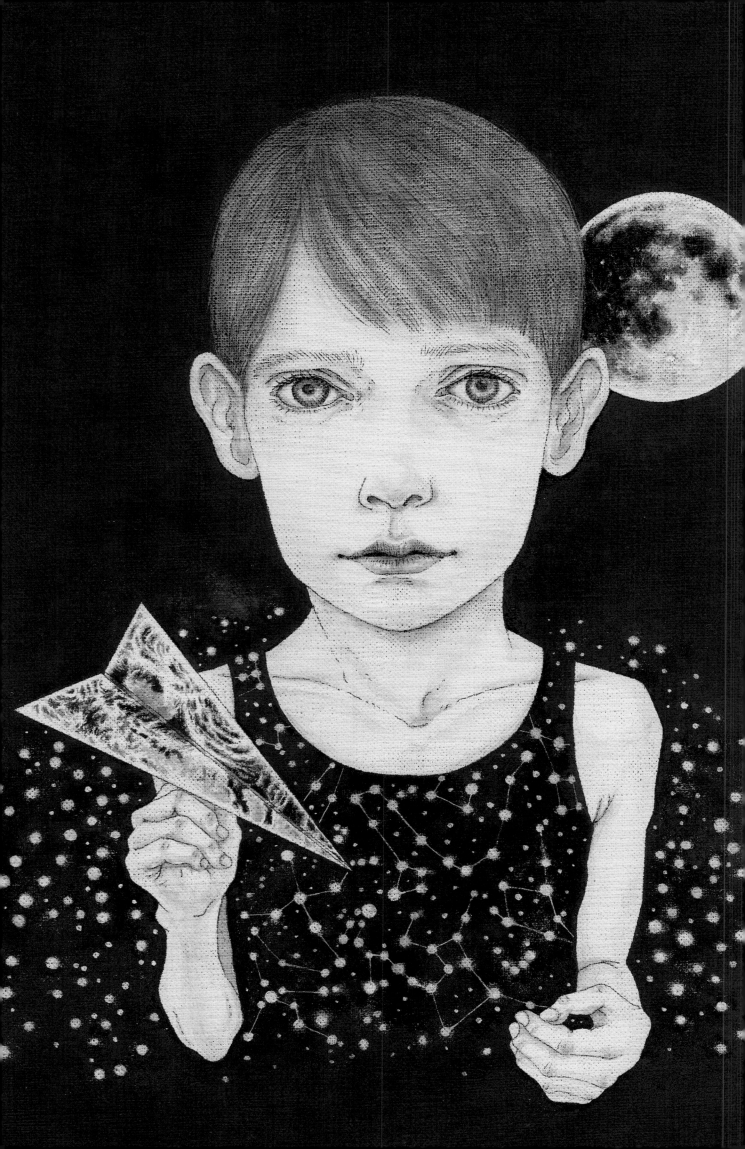

> "I always try to make humor, irony, and hope coincide with a little melancholy in my work. And I try to find the elements of universality that exist in individuals to free us from possessiveness."

MARI MITSUMI

WWW.MARIMITSUMI.COM · @marimitsumi

Mari Mitsumi was born in Yokohama, Japan, in 1967. After attending the Toyo Eiwa Jogakuin Junior College in Tokyo, she worked in publishing as an editor in the early 1990s before shifting her focus to illustration at the prestigious Setsu Mode Seminar. Since graduating in 1996, Mitsumi has undertaken a plethora of freelance commissions for advertising, books, and editorial—All Nippon Airways, Columbia Music Entertainment, *GQ Japan*, Nikkei Business, and Volvo are among her clients. Concept and texture play equal roles in her visual exploration. Working in a variety of media, from acrylic and digital painting to aquatint and etching with letterpress printing, Mitsumi renders her subjects, mostly expressionless portraits of ordinary people with oversized heads, in a style that sits somewhere between graphic novel realism and caricature. Her work has featured in numerous Japanese publications, including *Croissant* and *Illustration File 2018*. She has been recognized by *American Illustration, Communication Arts,*

Mari Mitsumi wurde 1967 in Yokohama geboren. Nach dem Besuch des Toyo Eiwa Jogakuin Junior College in Tokio arbeitete sie Anfang der 1990er-Jahre als Verlagslektorin, bevor sie sich auf die Illustration Setsu Mode Seminar im angesehenen konzentrierte. Seit ihrem Abschluss 1996 hat Mitsumi eine Vielzahl freiberuflicher Aufträge für Werbung, Bücher und redaktionelle Inhalte übernommen – All Nippon Airways, Columbia Music Entertainment, *GQ Japan, Nikkei Business* und Volvo zählen zu ihren Kunden. Konzept und Struktur spielen bei ihrer visuellen Erkundung eine gleichwertige Rolle. Mitsumi arbeitet mit einer Vielzahl von Techniken – von Acryl über digitale Malerei bis hin zu Aquatinta und Radierung mit Hochdruck – und stellt ihre Motive in einem Stil dar (meist ausdruckslose Porträts gewöhnlicher Menschen mit übergroßen Köpfen), der irgendwo zwischen Graphic-Novel-Realismus und Karikatur liegt. Ihre Arbeiten wurden in zahlreichen japanischen Publikationen veröffentlicht, darunter

Mari Mitsumi est née en 1967 à Yokohama, au Japon. Après avoir étudié à l'académie privée Toyo Eiwa Jogakuin à Tokyo, elle a travaillé comme éditrice au début des années 1990, avant de changer de voie et d'étudier l'illustration au prestigieux Setsu Mode Seminar. Diplômée en 1996, Mitsumi a réalisé à son compte une foule de commandes de publicité, de livres et d'éditoriaux pour All Nippon Airways, Columbia Music Entertainment, *GQ Japan, Nikkei Business* et Volvo, entre autres clients. Dans ses études visuelles, concept et texture revêtent autant d'importance, et elle utilise des techniques variées, de l'acrylique et la peinture numérique à l'aquatinte, aux gravures à l'eau-forte et à la typographie. Représentant surtout des portraits inexpressifs de personnes ordinaires, ses sujets possèdent des têtes démesurées dans un style à mi-chemin entre bande dessinée réaliste et caricature. Son travail est paru dans de nombreuses publications japonaises, dont *Croissant et Illustration File 2018*. Elle a été saluée

and *3x3 Magazine*, and has participated in several group and solo exhibitions in her native country.

Croissant und *Illustration File 2018*, und von *American Illustration, Communication Arts* und dem *3x3 Magazine* gewürdigt. In ihrem Heimatland hat sie an mehreren Gruppen- und Einzelausstellungen teilgenommen.

par *American Illustration, Communication Arts* et *3x3 Magazine*, et a pris part à plusieurs expositions collectives et individuelles dans son pays natal.

MARI MITSUMI

Abe's Peanut, 2013
Postcards; hand drawing, digital
author: Daniel Handler

right
Blind Moon, 2012
Personal work, *We'll Be Your Mirrors,*
solo show; acrylic on canvas

opposite
This is the Life, 2014,
Book by Alex Shearer, book cover,
Kyuryudo; acrylic on canvas

p. 432
Love & Systems, 2012,
Book by Taiko Nakajima, book cover,
Gentosha; acrylic on canvas

Selected Exhibitions: 2015, *Une marge laissee de l'estampe*, group show, Museum of Onomichi City University, Hiroshima · 2014, *Eden*, solo show, Galerie Malle, Tokyo · 2012, *We'll Be Your Mirrors*, solo show, Galerie Malle, Tokyo · 2008, *Tangible*, solo show, Galerie Malle, Tokyo · 2002, *Bird on the Wire*, solo show, HB Gallery, Tokyo

Selected Publications: 2013, *Abe's Peanut*, USA · 2011, *3x3 Magazine*, USA · 2011, *Illustration Now! Portraits*, TASCHEN, Germany · 2011, *1000 Ideas by 100 Manga Artists*, Rockport Publishers, USA · 2005, *Illustration Now! Vol.1*, TASCHEN, Germany

Romance, 2013
by Koji Yanagi, book cover,
Bungeishunju; hand drawing, digital

right
All I Know, 2014
Personal work, *Eden*, solo show;
acrylic on canvas

opposite
The Tin Horse, 2015
by Janice Steinberg, book cover,
Hayakawa Publishing; etching,
Ganpishi Japanese paper, digital

MARI MITSUMI

"I like strange cocktails. To combine things that wouldn't normally fit."

SERGIO MORA

WWW.SERGIOMORA.COM · @sergio.mora.art

Sergio Mora (aka Magicomora) is a Spanish artist-illustrator whose identifiable style of imagery has adorned murals in swimming pools as well as packaging and licensed products, such as tableware, apparel, and wallpaper. He was born in Barcelona in 1975. After studying illustration at the Llotja Barcelona Arts and Crafts School in the late 1990s, Mora struggled to find work. His style was deemed too arty for the illustration business and too illustrational for the art gallery world—a dichotomy he would soon dispel by fusing a magical narrative with an otherworldly abstraction to create delightful, funny, eerie, and nostalgic images. Mora's pop surrealist universe with its 1950s sci-fi references, TV characters, iconic logos, and folkloric symbolism has mesmerized viewers around the globe through exhibitions, posters, set designs, and hospitality branding. In 2016, he was awarded a Latin Grammy in the Best Recording Package category for *El Poeta Halley* by Love of Lesbian. The following year,

Sergio Mora (aka Magicomora) ist ein spanischer Künstler-Illustrator, dessen identifizierbare Bildsprache Wandbilder in Schwimmbädern sowie Verpackungen und lizenzierte Produkte wie Geschirr, Kleidung und Tapeten ziert. Er wurde 1975 in Barcelona geboren und studierte in den späten 1990er-Jahren an der Kunstgewerbeschule Llotja Barcelona Illustration. Mora hatte zunächst Schwierigkeiten, Arbeit zu finden, da sein Stil für das Illustrationsgeschäft zu künstlerisch und für die Welt der Kunstgalerien zu illustrativ war— ein Zwiespalt, den er bald aufheben sollte, indem er magische Erzählung mit jenseitiger Abstraktion verschmolz, um reizende, witzige, unheimliche und nostalgische Bilder zu schaffen. Moras pop-surrealistisches Universum mit seinen Science-Fiction-Referenzen an die 1950er-Jahre, TV-Charakteren, ikonischen Logos und seinem folkloristischen Symbolismus hat Betrachter rund um den Globus – in Ausstellungen, auf Postern, Bühnenbildern und Hotelbranding – verzaubert. 2016 bekam er einen

Sergio Mora (alias Magicomora) est un artiste et illustrateur espagnol dont l'imagerie d'un style reconnaissable entre tous a paré des murs de piscines, des emballages et des produits, comme de la vaisselle, des vêtements et des papiers-peints. Né en 1975 à Barcelone, il y a suivi à la fin des années 1990 des études d'illustration à l'école supérieure de design et d'art La Llotja. Il a cependant eu du mal à trouver du travail, son style jugé trop prétentieux pour le domaine de l'illustration et trop illustratif pour le monde des galeries d'art, une dichotomie qu'il a rapidement réglée en créant des images amusantes, étranges et nostalgiques mêlant magie et abstraction. L'univers surréaliste pop de Mora inclut des références à la science-fiction, aux personnages de la télé, à des logos emblématiques et au symbolisme folklorique des années 1950. Ses compositions ont fait des adeptes dans le monde entier à travers des expositions, des affiches, des conceptions de décors et du branding dans le secteur hôtelier.

he joined forces with Philippe Starck to illustrate chef José Andrés' Bazaar Mar restaurant in Miami. Mora's murals were hand-painted on 6,000 tiles to visualize Starck's surrealist, nautical theme.

Latin Grammy in der Kategorie Best Recording Package für *El Poeta Halley* von Love of Lesbian. Im darauffolgenden Jahr tat er sich mit Philippe Starck zusammen, um das Restaurant Bazaar Mar des Küchenchefs José Andrés in Miami mit Illustrationen auszustatten. Um Starcks surrealistisches nautisches Thema zu visualisieren, wurden für Moras Wandbild 6.000 Fliesen handbemalt.

En 2016, il a remporté un Latin Grammy Award dans la catégorie du meilleur design de pochette pour *El Poeta Halley* de Love of Lesbian. L'année suivante, il s'est associé à Philippe Starck pour décorer le restaurant Bazaar Mar du chef José Andrés à Miami. Les fresques de Mora ont été peintes à la main sur 6 000 carrelages pour représenter les scènes nautiques surréalistes de Starck.

SERGIO MORA

Cuentos para niños Rockeros, 2019
Book by Mario Vaquerizo,
Planeta de libros; digital

right
Monster Rock'n'Roll, 2018
Motorzombis, album cover,
Rock Estatal Records; digital

opposite
Cuentos para niños Rockeros, 2019
Book by Mario Vaquerizo,
Planeta de libros; digital

p. 438
El mundo perdido, 2018
Book by Arthur Conan Doyle,
Random House; oil on canvas

El hambre invisible, 2018
Book by Santi Balmes,
Planeta de libros; digital

opposite
Space Hula Yogashan, 2018
Personal work, poster;
oil on paper, digital

next spread top
El mundo perdido, 2018
Book by Arthur Conan Doyle,
Random House; oil on canvas

next spread bottom
Mercado Little Spain, New York, 2019
Think Food Group, chef José Andrés,
mural; oil on canvas, digital

Selected Exhibitions: 2018, *El poeta Halley*, solo show, Galería Senda, Barcelona · 2011, *25 Years*, group show, La Luz de Jesus Gallery, Los Angeles · 2011, *Piñatarama*, group show, Museo de Arte Moderno de México · 2011, *Grafika*, group show, traveling exhibition, Instituto Cervantes · 2004, *Comida para tu alma*, solo show, Iguapop Gallery, Barcelona

Selected Publications: 2019, *Las legendarias aventuras de Chiquito*, Temas de Hoy, Spain · 2018, *Moraland*, Norma Editorial, Spain · 2013, *Typical Spanglish*, La Cúpula, Spain · 2014, *El niño Rock*, Lunwerg Editores, Spain · 2009, *Papá tatuado*, A Buen Paso, Spain

"Many of us are getting on in years and feel it's time to make some things known before they are gone for good." *for CNN*

KADIR NELSON

WWW.KADIRNELSON.COM · @kadirnelson

Kadir Nelson is one of the most respected contemporary illustrators documenting and celebrating the black American story. Richly expressive, his figurative paintings make up an extensive body of work, from commercial and private commissions to personal works of fine art. Born in Washington, D.C., in 1974, Nelson was drawing by the age of three and painting at ten. After winning a scholarship to the Pratt Institute in Brooklyn, he received his BFA in 1996. His first job was with DreamWorks SKG, where he was lead development artist on Steven Spielberg's Oscar-nominated feature film *Amistad* (1997). He attracted attention for his illustrated book *We Are the Ship: The Story of Negro League Baseball* (2008); images from the series were also used as commemorative stamps for the US Postal Service. In addition to clients like Coca-Cola and *Sports Illustrated*, Nelson's work has adorned record sleeves for Michael Jackson's posthumously released album *Michael* (2010), and singer-rapper Drake's LP *Nothing Was The Same* (2013).

Kadir Nelson ist einer der angesehensten zeitgenössischen Illustratoren mit Themenschwerpunkt schwarze amerikanische Geschichte, die in seinen Arbeiten dokumentiert und zelebriert wird. Seine ausdrucksstarken, figurativen Gemälde bilden ein umfangreiches Œuvre, bestehend aus kommerziellen und privaten Aufträgen, aber auch persönlichen Kunstwerken. Geboren wurde er 1974 in Washington, D.C. Er zeichnete schon im Alter von drei und malte im Alter von zehn Jahren. Nach einem Stipendium am Pratt Institute in Brooklyn erhielt er 1996 seinen Bachelor. Seinen ersten Job bekam er bei DreamWorks SKG, wo er als leitender Development Artist an Steven Spielbergs Oscar-nominiertem Spielfilm *Amistad* (1997) arbeitete. Breite Aufmerksamkeit erregte er mit seinem illustrierten Buch *We Are the Ship: The Story of Negro League Baseball* (2008); Bilder aus der Serie wurden auch als Gedenkmarken für den Postdienst der Vereinigten Staaten verwendet. Zusätzlich zu Kundenaufträgen von

Kadir Nelson est l'un des illustrateurs contemporains les plus respectés qui étudie et rend hommage à l'histoire noire américaine. Fort expressives, ses peintures figuratives démontrent une production prolifique pour des commandes commerciales, privées et des œuvres personnelles. Né à Washington en 1974, Nelson dessinait déjà à trois ans et peignait à dix. Il a obtenu une bourse pour étudier à l'institut Pratt à Brooklyn et reçu sa licence en 1996. Son premier poste chez DreamWorks SKG en tant que responsable du développement artistique lui a permis de travailler sur le film de Steven Spielberg *Amistad* (1997), nominé aux Oscars. Son livre illustré *We Are the Ship: The Story of Negro League Baseball* (2008) a été très remarqué, et des images de la série ont été utilisées comme timbres commémoratifs par le service postal américain. Outre des clients comme Coca-Cola et *Sports Illustrated*, Nelson a décoré la pochette de l'album posthume de Michael Jackson intitulé *Michael* (2010) et du LP *Nothing*

447

Whether depicting baseball legend Andrew "Rube" Foster or Nelson Mandela, Nelson approaches his subjects with an affinity and integrity that captures an essence of their narrative. Other works have addressed race through the reinterpretation of cultural icons, such as his version of Grant Wood's 1930 painting *American Gothic* for a 2017 cover of *Ebony* magazine, or transforming *The New Yorker's* mascot Eustace Tilley into a black dandy. Nelson has also authored and illustrated children's books, and is the recipient of Caldecott and Coretta Scott King awards. His paintings are in the permanent collections of the International Olympic Committee and the US House of Representatives. He is based in Los Angeles.

Coca-Cola und *Sports Illustrated*, gestaltete Nelson die Plattenhülle für Michael Jacksons posthum veröffentlichtes Album *Michael* (2010) und die LP *Nothing Was The Same* (2013) des Singer-Rappers Drake. Egal, ob es sich um die Baseballlegende Andrew „Rube" Foster oder um Nelson Mandela handelt, Nelson nähert sich seinen Objekten mit einer Affinität und Integrität, die die Essenz ihrer Geschichte einfängt. Andere Arbeiten beschäftigten sich durch die Neuinterpretation kultureller Ikonen mit dem Thema Rasse, wie seine Version von Grant Woods Gemälde von 1930 *American Gothic*, die er für ein Cover des *Ebony*-Magazins 2017 schuf oder seine Transformation des *New-Yorker*-Maskottchens Eustace Tilley in einen schwarzen Dandy. Nelson hat auch Kinderbücher verfasst und illustriert und erhielt Auszeichnungen von Caldecott und Coretta Scott King. Seine Gemälde befinden sich in den ständigen Sammlungen des Internationalen Olympischen Komitees und des US-Repräsentantenhauses. Er lebt in Los Angeles.

Was The Same (2013) du rapper Drake. Qu'il fasse le portrait de la légende du baseball Andrew « Rube » Foster ou de Nelson Mandela, Nelson aborde ses sujets avec une complicité et une intégrité captant toute l'essence de la personne. Dans d'autres œuvres, il a traité le thème racial en réinterprétant des icônes culturelles, comme sa version de la peinture de Grant Wood datant de 1930 et intitulée *American Gothic* pour une couverture en 2017 du magazine *Ebony,* ou en transformant le mascotte Eustace de *The New Yorker* en dandy noir. Nelson est également l'auteur de livres illustrés pour enfants et a remporté des médailles Caldecott et un prix Coretta Scott King. Ses peintures figurent dans les collections permanentes du Comité international olympique et de la Chambre des représentants des États-Unis. Il vit actuellement à Los Angeles.

Forbidden Fruit, 2014
Personal work; oil on canvas

opposite

Dr. MLK, Jr., A Dream Deferred, 2017
The New Yorker, magazine cover;
oil on canvas; art director: Françoise Mouly

p. 446

Eustace Negro, 2015
The New Yorker, magazine cover;
oil on panel; art director: Françoise Mouly

Michael Jackson,
The King of Pop, 2010
Sony Music, album cover;
oil on canvas

Bright Star, 2017
The New Yorker, magazine
cover; oil on canvas;
art director: Françoise Mouly

opposite
A Hole in the Roof, 2014
Personal work; oil on canvas

KADIR NELSON

Selected Exhibitions: 2017, *The HeLa Project*, group show, traveling exhibition, USA · 2011, *We are the Ship*, solo show, traveling exhibition, USA · 2005, *All the Stories Are True*, group show, Smithsonian Anacostia Museum, Anacostia · 2005, *Ellington Was Not a Street*, solo show, Muskegon Museum of Art, Michigan · 2001, *Black Romantic*, group show, Studio Museum in Harlem, New York

Selected Publications: 2018, *Famed for "Immortal Cells…"*, Smithsonian, USA · 2014, *Sweet Land of Liberty*, *The New York Times*, USA · 2008, *Stepping Up to the Plate*, *Los Angeles Times*, USA · 2008, *Pride of the Game*, *Sports Illustrated*, USA · 2003, *Nurturing Romance of Sport*, *International Review of African American Art*, USA

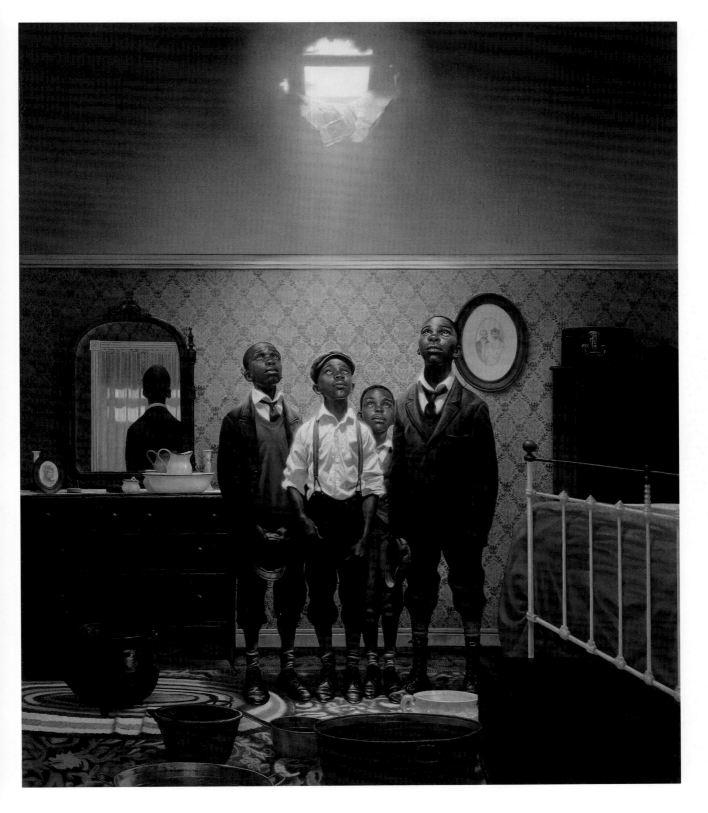

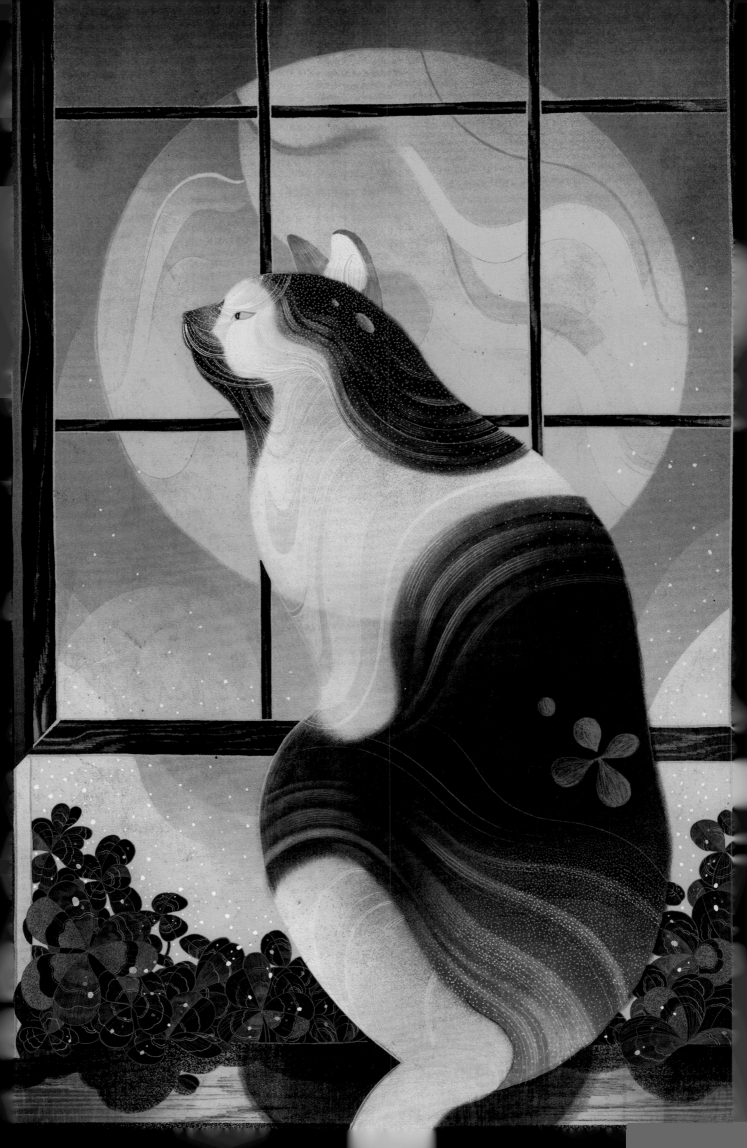

> "I like to understand something and then forget about it for a while. Usually when I least expect it, something will pop into mind."

VICTO NGAI

WWW.VICTO-NGAI.COM · @victongai

A sense of wonder and displacement informs Victo (a nickname derived from Victoria) Ngai's visual perspective, reflecting her own personal migration and her exposure to different cultures and illustration styles. Born in Guangdong Province, China, in 1988, Ngai grew up in Hong Kong, where her early influences included Chinese art and craft styles, such as *nianhua*, *gongbi hua*, and *lianhuanhua*. In 2006, she gained a place at Rhode Island School of Design, where she developed an interest in Japanese *ukiyo-e*, Russian and Chinese poster art, and the Golden Age illustrators. After graduation in 2010, she moved to New York and began freelancing for *The New York Times* and *The New Yorker*. Ngai has since amassed a stellar list of clients, including Audible, HarperCollins, IMAX, Lufthansa, and *The Washington Post*, to name but a few. With meticulous attention to detail, her process involves line work with ink pens, with background and fill textures created on paper in various media, before she colors digitally in

Ein Gefühl des Staunens und der Vertreibung prägt Victo (ein Spitzname für Victoria) Ngais visuelle Perspektive und reflektiert ihre eigene Migration und ihre Auseinandersetzung mit verschiedenen Kulturen und Illustrationsstilen. Geboren wurde sie 1988 in der Provinz Guangdong in China, wuchs aber in Hongkong auf, wo sie früh von chinesischen Kunst- und Kunsthandwerksstilen wie *nianhua*, *gongbi hua* und *lianhuanhua* beeinflusst wurde. 2006 erhielt sie einen Platz an der Rhode Island School of Design, wo sie sich für das japanische *ukiyo-e* sowie für russische und chinesische Plakatkunst und die Illustratoren des Goldenen Zeitalters zu interessieren begann. Nach ihrem Abschluss im Jahr 2010 zog sie nach New York und begann, freiberuflich für die *New York Times* und den *New Yorker* zu arbeiten. Ngai hat seitdem eine herausragende Liste von Kunden zusammengetragen, darunter Audible, HarperCollins, IMAX, Lufthansa und die *Washington Post*, nur um einige zu nennen. Mit viel Liebe zum Detail führt sie die

La perspective visuelle de Victo (diminutif de Victoria) Ngai dégage un sentiment d'émerveillement et de décalage ; elle explique ainsi la migration personnelle de l'artiste et son exposition à plusieurs cultures et styles d'illustration. Née dans la province chinoise de Guangdong en 1988, Ngai a grandi à Hong Kong, où ses influences précoces ont été l'art et l'artisanat chinois, comme les *nianhua* (images décoratives pour le Nouvel an), les *gongbi hua* (peintures artisanales d'exécution minutieuse) et les *lianhuanhua* (bandes dessinées petit format). En 2006, elle a obtenu une place à l'école de design de Rhode Island, où elle s'est intéressée au mouvement artistique japonais ukiyo-e, à l'art de l'affiche russe et chinois, ainsi qu'à l'âge d'or de l'illustration. Avec son diplôme en poche, elle s'est installée en 2010 à New York et a commencé à travailler à son compte pour *The New York Times* et *The New Yorker*. Avec le temps, sa liste de clients est devenue imposante, incluant Audible, HarperCollins, IMAX, Lufthansa

Photoshop. From beautifully dense vistas in limited hues to figures in ornate textures—each work signed with a Chinese symbol that when turned counter-clockwise reads "Victo"—the breathtaking results evoke a visual confluence of her many inspirations. Ngai has received a slew of accolades, including being name-checked on *Forbes* magazine's "30 under 30" list in the category of Art and Style (2014), and receiving a 2018 *Spectrum Fantastic Arts* Gold Medal in Books. She also lectures widely, and has been a juror on such panels as the *Communication Arts Illustration Annual 59* (2018), and Society of Illustrators New York 57th Annual Exhibition (2015). Ngai currently lives in Los Angeles.

Linien und Konturen mit Finelinern aus, Hintergrund- und Fülltexturen kreiert sie auf Papier mit verschiedenen Medien, bevor sie in Photoshop digital koloriert. Von wunderschönen, dichten Perspektivansichten in reduzierten Farbtönen bis hin zu Figuren in reich verzierten Texturen, jeweils signiert mit einem chinesischen Symbol, das, gegen den Uhrzeigersinn gelesen, „Victo" ergibt – ihre atemberaubenden Ergebnisse sind visuelle Ansammlungen ihrer verschiedenen Inspirationsquellen. Ngai hat zahlreiche Auszeichnungen erhalten, zum Beispiel wurde sie 2014 in der „30 unter 30"-Liste der Zeitschrift *Forbes* in der Kategorie Art and Style aufgeführt und erhielt 2018 die Goldmedaille von *Spectrum Fantastic* in der Kategorie Bücher. Sie hält auch viele Vorträge und war Jurorin in Gremien wie dem *Communication Arts Illustration Annual 59* (2018) und der Society of Illustrators New York (in der 57. Jahresausstellung 2015). Ngai lebt zurzeit in Los Angeles.

et *The Washington Post*, pour n'en citer que quelques-uns. Prêtant une attention méticuleuse aux détails, elle procède à l'encre de façon méthodique, créant des fonds et des remplissages sur papier via diverses techniques, avant une phase de coloriage dans Photoshop. Qu'il s'agisse de scènes chargées dans une palette restreinte ou de personnages aux textures élaborées, chaque œuvre est signée d'un symbole chinois se lisant « Victo » s'il est tourné dans le sens antihoraire. Pour ses incroyables compositions, expressions visuelles de ses nombreuses inspirations, Ngai a reçu une foule de distinctions, dont une mention dans la liste « 30 under 30 » établie par le magazine *Forbes* pour la catégorie Art et Style (2014) et la médaille d'or dans la catégorie Livres par *Spectrum Fantastic Arts* en 2018. Elle donne par ailleurs souvent des conférences et a été membre de jurys comme *Communication Arts Illustration Annual 59* (2018) et la 57e exposition annuelle de la Society of Illustrators New York (2015). Ngai vit actuellement à Los Angeles.

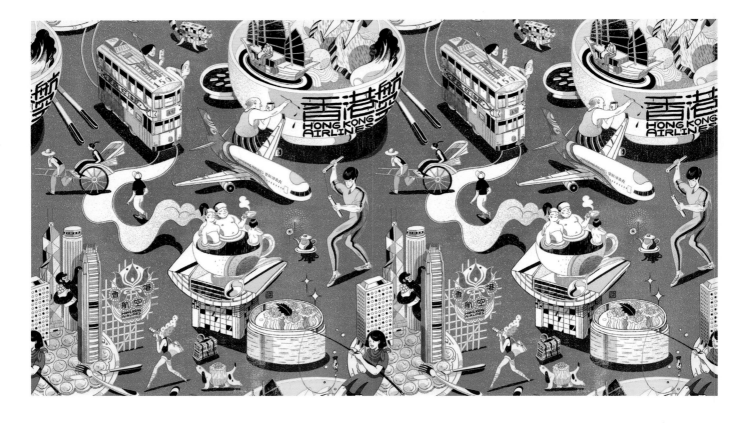

Cocoon, 2016
Personal work, a tribute
to Alexander McQueen;
hand drawing, digital

opposite
Hong Kong Airlines, pattern, 2017
Branding, packaging design; hand
drawing, digital;
art direction: Mokit Fong

p. 454
Clover, 2016
Tor.com, website; hand drawing,
digital; story: Charlie Jane Anders;
art direction: Irene Gallo

Acquisition of a Wife, 2018
Folio Society, book, limited edition
of *The Kama Sutra of Vatsyayana*;
hand drawing, digital;
art direction: Sheri Gee

opposite
Beyond and Above, 2015
Plansponsor, magazine;
hand drawing, digital;
art direction: SooJin Buzelli

VICTO NGAI

Colorless Tsukuru Tazaki's
Years of Pilgrimage, 2015
The Boston Globe, magazine;
hand drawing, digital;
art direction: Kim Vu

opposite
Mixc Christmas Workshop, 2017
CRland, advertisement billboard;
hand drawing, digital;
project head: Bing Hou
art direction: Yong Liu

Selected Exhibitions: 2018, *Go West!*, group show, Museums Quartier, Vienna · 2018, *Krem*, group show, Scarab Club, Detroit · 2016, *Art of Victo Ngai*, solo show, Richard C. von Hess Gallery, UArts, Philadelphia · 2013, *Pixelated*, group show, New Britain Museum of American Art, Connecticut · 2011, *Pick Me Up*, group show, Somerset House, London

Selected Publications: 2018, *The Kama Sutra of Vatsyayana*, Folio Society, United Kingdom · 2017, *Dazzle Ship, World War I and the Art of Confusion*, Lerner Books, USA · 2017, *Elle*, magazine, Hong Kong · 2017, *Cosmopolitan China*, Hearst Media Xhina, China · 2014, *Communication Arts*, Coyne & Blanchard, USA

"I try to base my illustrations on the idea, and then find an appropriate style to best support the concept."

CHRISTOPH NIEMANN

WWW.<u>CHRISTOPHNIEMANN</u>.COM · @<u>abstractsunday</u>

Christoph Niemann illustrates, designs, writes, and animates. He is a conceptualist with a peerless alacrity who turns convention on its head, creating imagery that can dumbfound the viewer with complexity or delight with staggering simplicity. He plays with abstraction and illusion. Physical objects placed on paper become part of the illustration: an ink bottle becomes a camera; an avocado becomes a catcher's glove. Niemann has sketched while running the New York Marathon and drawn live at the Venice Biennale. In 2013, two of his images were used as Google Doodles to celebrate the summer and winter solstices. An interest in technology platforms has led him into the world of interactive illustration. In 2016, he created "On the Go," the first 3D augmented-reality app for the covers of *The New Yorker*. Born in Waiblingen, Germany, in 1970, he attended the State Academy of Fine Arts in Stuttgart, under the tutelage of Heinz Edelmann. After receiving his master's degree in 1997, a move to New York proved timely

Christoph Niemann illustriert, entwirft, schreibt und animiert. Er ist ein Konzeptualist, der, ohne zu zögern, Konventionen auf den Kopf stellt und dabei Bilder schafft, die den Betrachter durch ihre Komplexität verblüffen oder durch ihre erstaunliche Einfachheit begeistern. Er spielt mit Abstraktion und Illusion. Auf Papier platzierte physische Objekte werden Teil der Illustration: Ein Tintenfässchen wird zur Kamera, eine Avocado zum Baseballhandschuh. Niemann hat während der Teilnahme am New-York-City-Marathon und live auf der Biennale in Venedig gezeichnet. Im Jahr 2013 wurden zwei seiner Bilder als Google Doodles anlässlich der Sommer- und Wintersonnenwende verwendet. Sein Interesse an Technologieplattformen hat ihn in die Welt der interaktiven Illustration geführt. 2016 entwickelte er „On the Go", die erste 3-D-Augmented-Reality-App für die Cover des *New Yorker*. 1970 in Waiblingen geboren, besuchte er die Staatliche Akademie der Bildenden Künste in Stuttgart und studierte bei

Christoph Niemann illustre, conçoit, écrit et anime de sa plume de conceptualiste, avec le don de bouleverser les conventions établies et de créer une imagerie qui surprend par sa complexité et émerveille par son impressionnante simplicité. Il joue avec l'abstraction et l'illusion, et fait que des éléments physiques placés sur le papier s'intègrent à l'illustration : une bouteille d'encre devient alors un appareil photo, un avocat un gant d'attrapeur de baseball. Niemann a fait des croquis pendant sa participation au marathon de New York et dessiné en direct lors de la biennale de Venise. En 2013, deux de ses images ont été employées comme doodles Google pour fêter les solstices d'été et d'hiver. Son intérêt pour la technologie l'a conduit au monde de l'illustration interactive. En 2016, il a créé « On the Go », la première application de réalité augmentée en 3D pour les couvertures de *The New Yorker*. Né en 1970 à Waiblingen, en Allemagne, il a étudié à l'académie d'État des beaux-arts à Stuttgart, sous la tutelle de Heinz

in developing his career. Niemann made his name through editorials, with his work gracing covers from *Atlantic Monthly* to *The New York Times Magazine* and *Wired*. His innovative pictorial style has garnered him numerous accolades from the American Institute of Graphic Arts and American Illustration. In 2010, he was inducted into the Art Directors Club Hall of Fame.

Heinz Edelmann. Nach seinem Master-abschluss im Jahr 1997 erwies sich der Umzug nach New York als richtiger Schritt für die Entwicklung seiner Karriere. Niemann machte sich durch Editorials einen Namen, seine Arbeiten zieren die Cover von *Atlantic Monthly*, dem *New York Times Magazine* und *Wired*. Sein innovativer Bildstil hat ihm zahlreiche Auszeichnungen eingebracht, u.a. vom American Institute of Graphic Arts und von American Illustration. 2010 wurde er in die Hall of Fame des Art Directors Clubs aufgenommen.

Edelmann. En 1997, après avoir obtenu sa maîtrise, il s'est installé à New York, un déménagement qui s'est avéré opportun pour le développement de sa carrière. Niemann s'est fait un nom grâce à ses éditoriaux, et ses créations sont apparues en couverture de *Atlantic Monthly*, *The New York Times Magazine* et *Wired*. Son style graphique innovant lui a valu de nombreuses distinctions de l'American Institute of Graphic Arts et d'American Illustration. En 2010, il est entré au Hall of Fame de l'Art Directors.

CHRISTOPH NIEMANN

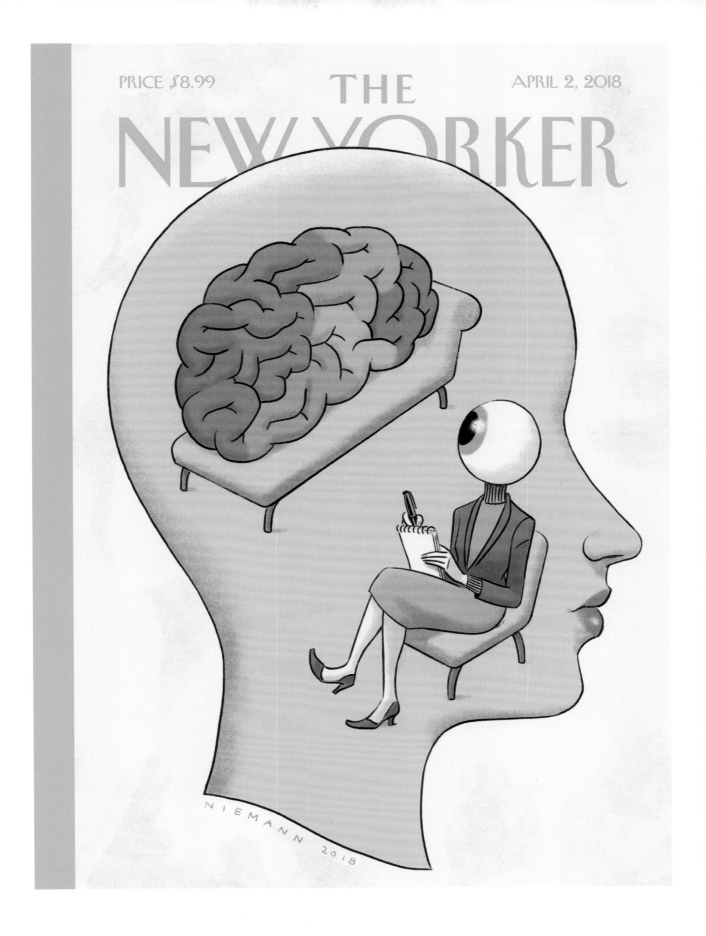

PRICE $8.99

THE
NEW YORKER

APRIL 2, 2018

NIEMANN 2018

Trompe-l'Oeil, 2018
The New Yorker, magazine
cover; digital

Mr. Know-It-All (Erase), 2016
Wired, magazine; digital

opposite top
Offline, 2004
Personal work; digital

opposite bottom
Design and Violence Coffee
(light gray), 2017
Personal work; silkscreen

CHRISTOPH NIEMANN

Cravings, 2018
Die Zeit, magazine cover;
mixed media

Vote!, 2018
Personal work; mixed media

Hello Robot, 2017
Vitra Design Museum;
silkscreen

CHRISTOPH NIEMANN

Selected Exhibitions: 2018, *Im Auge des Betrachters*, solo show, Literaturhaus, Munich · 2017, *That's How!*, solo show, Cartoon Museum, Basel · 2017, *The Masters Series: Christoph Niemann*, solo show, School of Visual Arts Gallery, New York · 2017, *Talking Pictures*, group show, The Metropolitan Museum of Art, New York · 2016, *Unterm Strich*, solo show, Museum of Arts and Crafts (MKG), Hamburg

Selected Publications: 2018, *Hopes and Dreams*, Abstractometer, Germany · 2017, *Souvenir*, Diogenes, Switzerland · 2016, *Words*, Greenwillow Books, USA · 2016, *Sunday Sketching*, Abrams Books, USA · 2012, *Abstract City*, Abrams Books (USA), Knesebeck (Germany)

"To me, style is an ever-evolving process. I think finding your own voice is important, but I've tried not to treat it as something that can never change. I think the evolution happens by itself, out of a natural yearning for change and looking for new challenges."

for *Sense of Creativity*

LOTTA NIEMINEN

WWW.LOTTANIEMINEN.COM · @lottanieminen

Bold and ambitious from an early age, Lotta Neiminen grew up wanting to be a famous movie director but her natural flair was for graphics. As a child she entered a drawing competition and won a computer. Born in Helsinki in 1986, Nieminen studied graphic design at Aalto University School of Arts, Design and Architecture before an exchange to the Rhode Island School of Design helped her fulfill her dream of seeing New York. After returning to her native Finland, she graduated in 2009 and began designing and art directing for Finnish fashion magazine *Trendi*. In 2010, she received the coveted Art Directors Club Young Guns award, and was featured in *Print* magazine's annual New Visual Artists review. Entrepreneurial and creative, Lotta Nieminen epitomizes the millennial approach, having amalgamated her skillset into a multifaceted creative practice that gives a voice to her distinctive style and motivates her to push her own parameters when providing "holistic visual solutions for clients

Lotta Neiminen, von klein auf mutig und ehrgeizig, wuchs mit dem Herzenswunsch auf, eine berühmte Filmregisseurin zu werden, doch als Naturtalent erwies sie sich in der Grafik. Als Kind nahm sie an einem Malwettbewerb teil und gewann einen Computer. Nieminen wurde 1986 in Helsinki geboren und studierte Grafikdesign an der Aalto University of Arts, Design and Architecture bevor ein Austausch mit der Rhode Island School of Design ihren Traum, New York kennenzulernen, erfüllte. Nach ihrer Rückkehr ins heimatliche Finnland schloss sie 2009 ihr Studium ab und begann, für das finnische Modemagazin *Trendi* zu entwerfen und zu gestalten. 2010 erhielt sie den begehrten Art Directors Club Young Guns Award und wurde im jährlichen New Visual Artists Review des *Print*-Magazins vorgestellt. Unternehmerisch und kreativ, wie sie ist, stellt Lotta Nieminen den Inbegriff des jahrtausendealten Ansatzes dar, die eigenen vielfältigen Fähigkeiten zu einer facettenreichen kreativen Praxis zu verschmelzen,

Effrontée et ambitieuse depuis son plus jeune âge, Lotta Neiminen a grandi avec le souhait de réussir comme réalisatrice de films, mais son sens artistique s'est révélé en graphisme. Enfant, elle a participé à un concours de dessin et gagné un ordinateur. Née en 1986 à Helsinki, Nieminen a étudié le design graphique à l'école supérieure Aalto d'art, de design et d'architecture, avant un échange avec l'école de design de Rhode Island qui lui a permis d'accomplir son rêve de connaître New York. Une fois de retour dans sa Finlande natale, elle a obtenu une licence en 2009 et a effectué des tâches de design et de direction artistique pour le magazine de mode finlandais *Trendi*. En 2010, elle s'est vu décerner le prix convoité Art Directors Club Young Guns et a fait l'objet d'un article dans la revue annuelle New Visual Artists du magazine *Print*. D'esprit entrepreneur et créatif, Lotta Nieminen incarne parfaitement l'approche de la génération du millénaire, fusionnant ses compétences dans une activité

across disciplines." Based in Brooklyn, New York, since 2012 Lotta Nieminen Studio has provided art direction, design, and illustration services for a stellar roster, including Bulgari, Hermès, Google, Volkswagen, *Le Monde*, *Monocle*, and *Bloomberg Businessweek*. With attention to form, Nieminen's clear, colorful style, characterized by flat, slightly textured graphics and a penchant for patterning, lends itself it to any print, surface, or digital domain. She has been nominated for *Forbes* magazine's annual "30 under 30" list, and has given talks at conferences and educational institutions across the US and Europe.

die ihrem unverwechselbaren Stil Ausdruck verleiht und sie dazu motiviert, Grenzen zu überwinden, wenn sie „ihren Kunden ganzheitliche visuelle Lösungen über verschiedene Disziplinen hinweg" anbietet. Das in Brooklyn ansässige Lotta Nieminen Studio hat seit 2012 Art Direction, Design und Illustration für eine lange Liste namhafter Kunden übernommen, zum Beispiel für Bulgari, Hermès, Google, Volkswagen, Le *Monde*, *Monocle* und *Bloomberg Businessweek*. Nieminens klarer, farbenfroher Stil, der sich durch flache, leicht strukturierte Grafiken und eine Vorliebe für Muster auszeichnet, eignet sich für jegliche Printoberflächen oder digitale Bereiche. Sie wurde für die jährliche „30 unter 30"-Liste der Zeitschrift *Forbes* nominiert und hält auf Konferenzen und an Bildungseinrichtungen in den USA und Europa Vorträge.

créatrice aux multiples facettes. Elle a ainsi trouvé une voix pour exprimer son style et établi ses propres paramètres en vue d'offrir « des solutions visuelles holistiques aux clients interdisciplinaires ». Installée à Brooklyn depuis 2012, Lotta Nieminen Studio propose des services de direction artistique, de design et d'illustration à une longue liste de clients, dont Bulgari, Hermès, Google, Volkswagen, *Le Monde*, *Monocle* et *Bloomberg Businessweek*. Soignant les formes, son style clair et coloré se caractérise par des graphismes plats et légèrement texturés et par un penchant pour la création de motifs ; il se prête ainsi à n'importe quelle impression, surface ou production numérique. Elle a été retenue pour la liste annuelle « 30 under 30 » du magazine *Forbes* et est intervenue dans des conférences et des institutions éducatives aux États-Unis et en Europe.

above and opposite top

Cityscapes poster series:
Lisbon, *New York*, and *Global*, 2012
Personal work, solo show, Printa
Gallery, Budapest; silkscreen posters

opposite bottom

Union Pearson Express series, 2013
Branding illustration; mixed media;
animation: Guru Studios;
agency: Winkreative

p. 470

Bvlgari Summer
window displays, 2017
Phaidon, campaign;
mixed media

Walk this World, 2015
Book by Jenny Broom, book spreads,
Big Picture Press; mixed media

Selected Exhibitions: 2017, *Behance Pop-Up Gallery*, group show, Red Bull Arts New York, New York · 2013, *What's up North*, group show, Form/Design Center, Malmö · 2012, *Cityscapes*, solo show, Printa Gallery, Budapest · 2012, *Finished Final Def*, group show, GDFB 2012 Festival, Breda · 2012, *Agent Pekka*, group show, Guns & Butter Gallery, Amsterdam

Selected Publications: 2018, *Upstart!*, Gestalten, Germany · 2014, *Pastel*, Victionary, Hong Kong · 2013, *A Map of the World*, Gestalten, Germany · 2012, *Breakthrough!*, Princeton Architectural Press, USA · 2011, *Visual Storytelling*, Gestalten, Germany

> "I love interesting perspectives, a precise setting of light and shadow, and an interaction between illustration and typography."

ROBERT NIPPOLDT

WWW.NIPPOLDT.DE · @robertnippoldt

Robert Nippoldt was born in Kranenburg, Germany, in 1977. He grew up drawing constantly, from caricatures of teachers at school to later stints as a court sketch artist (his father was a judge). Geared towards a career in law, he soon ditched the idea, enrolling instead on the graphic arts and illustration course at the University of Applied Sciences in Münster. Fortuitously, his final degree book project titled *Gangster: The Bosses of Chicago* went into print in 2005, winning a Red Dot Design Award and a German Designer Club Award. Two years later saw the release of *Jazz: The Roaring Twenties in New York*, which was selected as the most beautiful German book of 2007 by Stiftung Buchkunst. *Hollywood in the 1930s* (2010) completed his trilogy on America in the 1920s and 30s. Nippoldt's books have also been released with board games and limited-edition silkscreen prints; he even created and toured a stage show in which he drew live with a music band. Working from Studio Nippoldt in a converted freight yard in

Robert Nippoldt wurde 1977 in Kranenburg geboren und verbrachte seine Kindheit zeichnend —von Karikaturen seiner Lehrer in der Schule bis später zu Skizzen als Gerichtszeichner (sein Vater war Richter). Zunächst strebte er eine juristische Karriere an, gab diese Idee aber bald auf und schrieb sich stattdessen für die Grafik- und Illustrationsklasse an der Fachhochschule Münster ein. Dank eines glücklichen Zufalls ging 2005 das Buch seines Abschlussprojekts mit dem Titel *Gangster: Die Bosse von Chicago* in Druck und gewann einen Red Dot Design Award und einen German Design Award. Zwei Jahre später wurde *Jazz im New York der wilden Zwanziger* publiziert, das von der Stiftung Buchkunst zum schönsten deutschen Buch 2007 gewählt wurde. *Hollywood in den 30er Jahren* (2010) vervollständigte diese Trilogie über das Amerika der 1920er- und 30er-Jahre. Nippoldts Bücher wurden auch mit Brettspielen und Siebdrucken in limitierter Auflage veröffentlicht. Er tourte sogar mit einer Bühnenshow, in

Robert Nippoldt est né en 1977 à Cranenbourg, en Allemagne. Pendant toute son enfance, il n'a cessé de dessiner, que ce soit des caricatures de ses professeurs ou, plus tard, des croquis d'audiences (son père était juge). Il se destinait à des études de droit, mais il a vite abandonné cette idée pour s'inscrire à un cours d'art graphique et d'illustration à l'université de sciences appliquées de Münster. Le livre qu'il a élaboré comme projet final d'études, intitulé *Gangster: The Bosses of Chicago,* a été imprimé en 2005 et remporté un Red Dot Design Award, ainsi qu'un prix du Deutscher Designer Club. Deux ans plus tard est sorti *Jazz: The Roaring Twenties in New York,* élu en 2007 comme le plus beau livre en allemand par Stiftung Buchkunst ; *Hollywood in the 1930s* est venu complété en 2010 sa trilogie sur l'Amérique des années 1920 et 30. La sortie de ses ouvrages a également été accompagnée de jeux de société et de sérigraphies en édition limitée. Il a même conçu un spectacle scénique où il

Münster, his sharp, high-contrast graphic style with its retro edge is a perfect match for his subjects and vintage milieu. Nippoldt's clients include *Le Monde*, *Die Zeit*, Mercedes-Benz, and *Time* magazine. 2017 saw the publication of his fourth book, *Night Falls on the Berlin of the Roaring Twenties*.

der er, begleitet von einer Musikband, live zeichnete. Heute arbeitet er in seinem Studio Nippoldt in einem umgebauten Güterbahnhof in Münster. Der elegante, kontrastreicher Grafikstil Nippoldts mit Retro-Touch passt perfekt zu seinen Motiven und seinem Vintage-Milieu. Nippoldts Kunden sind zum Beispiel *Le Monde*, *Die Zeit*, Mercedes-Benz und das *Time Magazine*. 2017 erschien sein viertes Buch *Es wird Nacht im Berlin der wilden Zwanziger*.

dessine en direct accompagné d'un groupe de musique et avec lequel il a fait une tournée. Dans les locaux de Studio Nippoldt, installé dans une gare de marchandises aménagée, il applique un style graphique vif et contrasté assorti de touches rétro, parfaitement adapté à ses sujets et aux atmosphères vintage. Parmi ses clients, Nippoldt compte *Le Monde*, *Die Zeit*, Mercedes-Benz et le magazine *Time*. En 2017, il a publié son quatrième livre intitulé *Night Falls on the Berlin of the Roaring Twenties*.

The Americans, 2014
The New Yorker, magazine;
ink, digital

p. 476
Untergrund, 2017
*Night Falls on the Berlin
of the Roaring Twenties*, book,
TASCHEN; ink, digital

opposite
EU, 2015
Arte, magazine; ink, digital

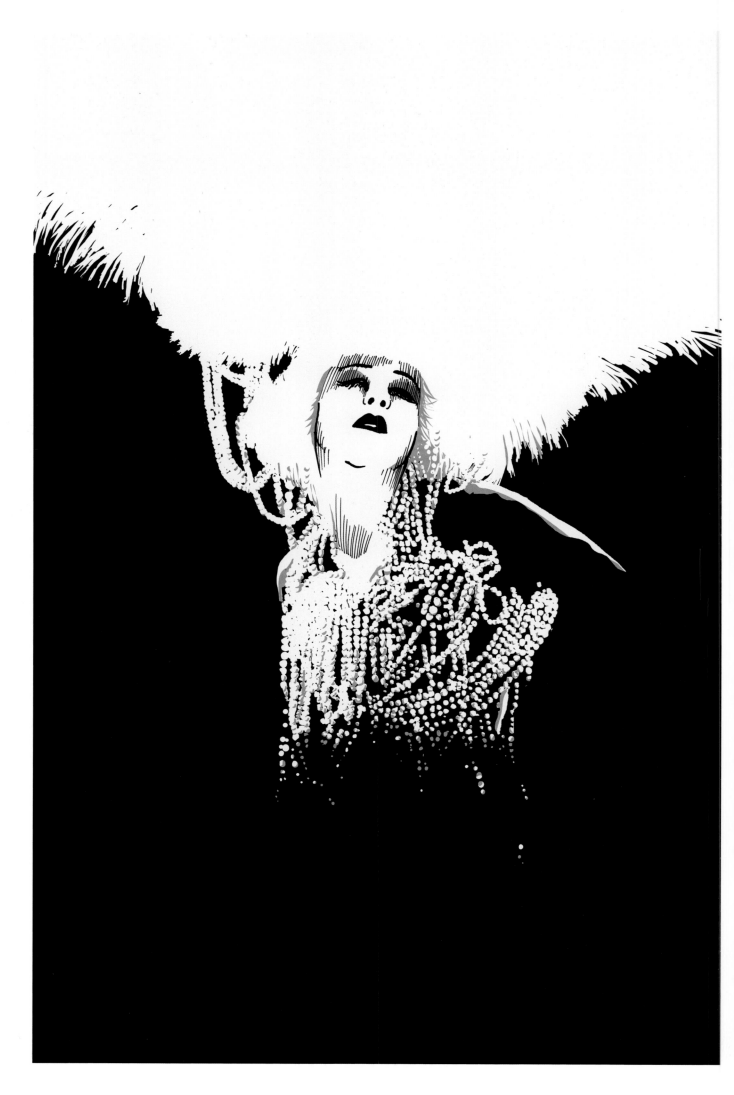

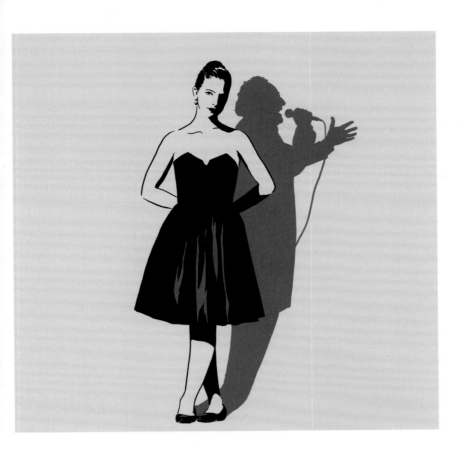

Marie & Jean Claude
Séférian, 2018
album cover; ink, digital

right
Love Song, 2015
Reader's Digest,
magazine cover; ink, digital

opposite
Pearls, 2017
*Night Falls on the Berlin
of the Roaring Twenties*, book,
TASCHEN; ink, digital

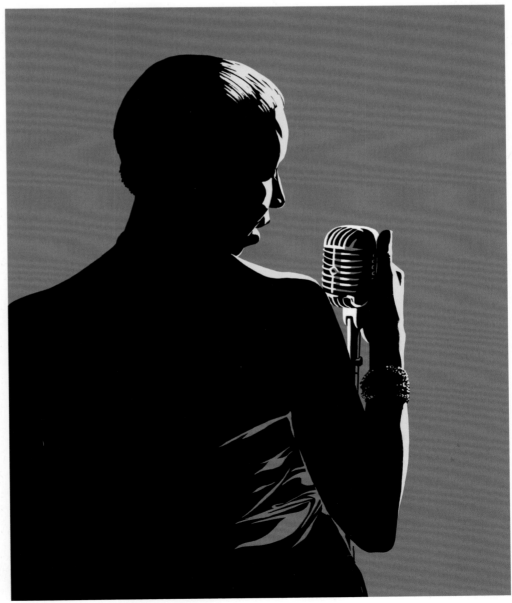

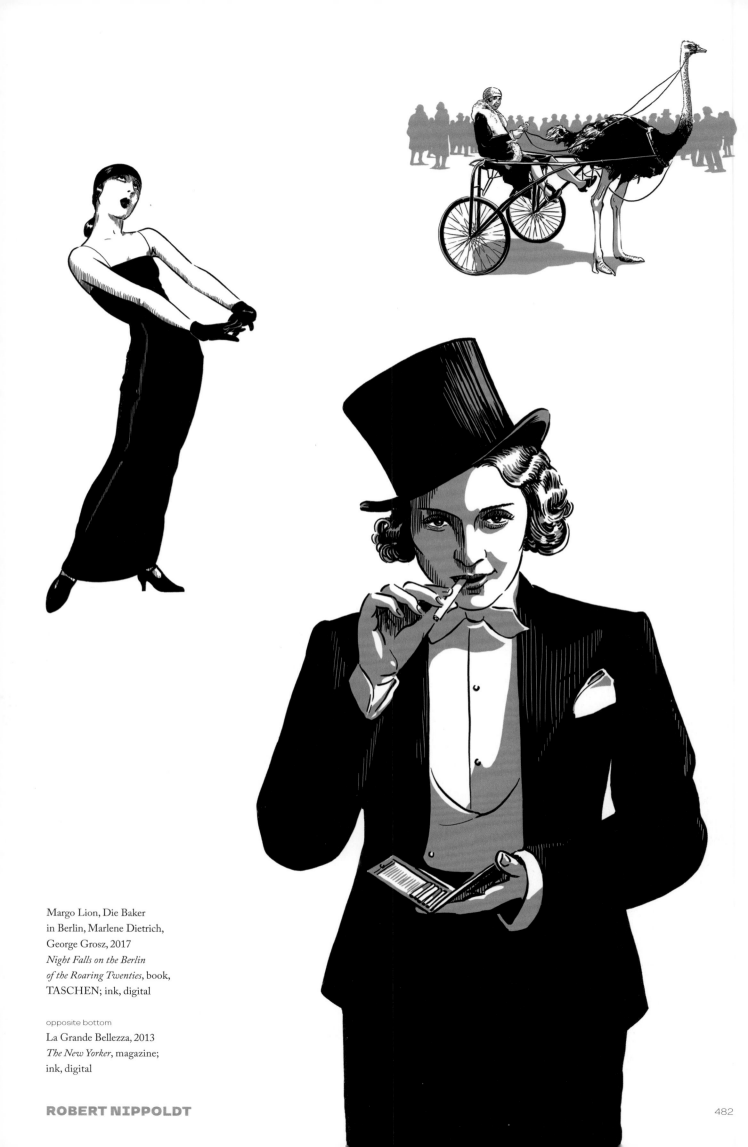

Margo Lion, Die Baker
in Berlin, Marlene Dietrich,
George Grosz, 2017
*Night Falls on the Berlin
of the Roaring Twenties*, book,
TASCHEN; ink, digital

opposite bottom
La Grande Bellezza, 2013
The New Yorker, magazine;
ink, digital

ROBERT NIPPOLDT

Selected Exhibitions: 2018, *Night Falls on the Berlin of the Roaring Twenties*, solo show, TASCHEN Store, Cologne · 2018, *Ein Rätselhafter Schimmer*, solo show, TASCHEN Store, Hamburg · 2018, *Berlin 1912–1933*, group show, Royal Museums of Fine Arts of Belgium, Brussels · 2017, *Ein Rätselhafter Schimmer*, solo show, Galerie am Markt, Weimar · 2017, *Night Falls on the Berlin of the Roaring Twenties*, solo show, TASCHEN Store, Berlin

Selected Publication: 2017, *Night Falls on the Berlin of the Roaring Twenties*, TASCHEN, Germany

> "So many ideas, I'm not quite certain where to start. I'd love to finish a few stories I'm writing. They are a little different from my illustration style so I'm not sure who will want to experience them, but they are the type of story I love, so I hope to do them justice."

for *Freelance Wisdom*

MONICA OBAGA

WWW.MONICAOBAGA.COM · @monicaobaga

From Kisii soapstone sculpture and Maasai beadwork to Kikuyu weaving and Swahili *leso* garments, Washington, D.C.-based graphic designer and illustrator Monica Obaga draws inspiration from her Kenyan roots and wider folk references from across Africa. Bold cut-out-style curves and geometric shapes create a liberating visual flow across a colorful palette. Born in Nairobi in 1983, Obaga grew up doodling her way through schoolbooks and dreaming of becoming a fashion designer until her high-school grades threatened to curb her ambitions. Instead, she discovered Instagram as an ideal platform to develop her creative pathways. A move to the United States in 2007 prompted a shift in focus to freelance illustration. Online collaborations soon led to commissions, and by the early 2010s she was instrumental in evolving the digital marketing of Buni.TV, turning it into one of Africa's leading video-on-demand channels. This foundation allowed Obaga to pool a broad set of creative, digital, and marketing skills. In 2016, to

Von Kisii-Specksteinskulpturen und Massai-Perlenstickereien bis hin zu Kikuyu-Webereien und Swahili-*leso*-Kleidungsstücken – die in Washington, D.C. lebende Grafikdesignerin und Illustratorin Monica Obaga lässt sich von ihren kenianischen Wurzeln und Volkskunst aus ganz Afrika inspirieren. Kräftige Kurven im Scherenschnitt-Stil und geometrische Formen erzeugen einen freizügigen visuellen Flow in einer bunten Farbpalette. Die 1983 in Nairobi geborene Obaga kritzelte ihre Schulbücher voll und träumte davon, Modedesignerin zu werden, bis ihre schlechten Schulnoten ihre Ziele zu verhindern drohten. Stattdessen entdeckte sie Instagram als ideale Plattform, um ihren schöpferischen Pfad zu entwickeln. Infolge ihres Umzugs in die Vereinigten Staaten im Jahr 2007 fokussierte sie sich auf die freiberufliche Illustration. Onlinekooperationen führten bald zu Aufträgen, und Anfang der 2010er-Jahre war sie maßgeblich an der Entwicklung des digitalen Marketings von Buni.TV beteiligt, das

Des sculptures de stéatites du peuple Kisii et des parures en perles des Massaï aux tissages des Kikuyus et aux imprimés *leso* des Swahilis, la conceptrice graphique et illustratrice Monica Obaga (Washington) puise son inspiration dans ses origines kényanes et les cultures folkloriques du reste de l'Afrique. Des courbes franches et des formes géométriques rappelant des découpages forment un visuel libérateur dans une palette haute en couleur. Née à Nairobi en 1983, Obaga griffonnait ses livres d'école et rêvait de devenir une créatrice de mode, mais ses notes au lycée ont menacé de freiner ses ambitions. Elle a trouvé dans Instagram la plateforme idéale pour tracer sa voie créative. Son installation aux États-Unis en 2007 l'a poussée à changer d'orientation, optant pour travailler à son compte comme illustratrice. Des collaborations en ligne ont vite débouché sur plusieurs commandes et au début des années 2010, elle a joué un rôle clé dans le développement du marketing numérique de Buni TV,

promote the launch of their new app, Airbnb selected 12 illustrators to create a travel poster for a world city. Obaga's vibrant vision of Nairobi was one of them. Her clients include Boost Mobile, Kenyan fashion guru Diana Opoti, sustainable fashion company Fauborg, and non-profit organization Girl Effect.

zu einem der führenden Video-on-Demand-Kanäle Afrikas wurde. Auf dieser Grundlage gelang es Obaga, ihr breites Spektrum an Fähigkeiten, sei es kreativ, digital oder im Marketingbereich zu bündeln. Um die Einführung seiner neuen App zu fördern, betraute Airbnb 2016 zwölf Illustratoren damit, ein Reiseposter für eine Weltstadt zu erstellen, Obagas pulsierende Vision Nairobis war eine davon. Ihre Kunden sind zum Beispiel Boost Mobile, die kenianische Fashion-Autorität Diana Opoti, das nachhaltig arbeitende Modeunternehmen Fauborg und die gemeinnützige Organisation Girl Effect.

la convertissant en l'une des principales chaînes de vidéos à la demande d'Afrique. Cette expérience a permis à Obaga d'acquérir tout un éventail de compétences en matière de création, de numérique et de marketing. En 2016, pour promouvoir le lancement de sa nouvelle application, Airbnb a demandé à 12 illustrateurs d'imaginer une affiche de voyage pour une capitale mondiale ; la vision dynamique de Nairobi offerte par Obaga a été l'une de celles retenues. Parmi ses clients, elle compte Boost Mobile, la gourou kényane de la mode Diana Opoti, la marque de mode durable Fauborg et l'ONG Girl Effect.

MONICA OBAGA

Noirwave, 2018
Products of Our Environment,
print; hand drawing, vector

opposite
Eartha Kitt, 2018
Boost Mobile, One Trick Pony,
video; hand drawing, vector

p. 484
Noirwave pattern, 2018
Products of Our Environment,
print; hand drawing, vector

> "I like to study the forms of shapes, and to work closely with light and shadow—keeping the illustrations minimal."

EIKO OJALA

WWW.PLOOM.TV · @o_eiko

All is not what it seems in the illustrated world of Eiko Ojala. At first glance one would be forgiven for mistaking his work for the hand-crafted mastery of a paper-cut artist. In fact he is, though not in the traditional sense. While Ojala draws his illusory landscapes and figures by hand to look like paper cuts, the technical wizardry occurs in Photoshop, where he sometimes incorporates photographed and scanned elements of real paper. His style is minimal and sharp and can be provocative and humorous. The overall raised effect lies in his meticulous attention to detail and skill in rendering shadow and light—he shuns the use of 3D software. Born in Tallinn, Estonia, in 1982, Ojala briefly studied interior design at the EuroAcademy before turning to illustration. A break came in 2013 when his artwork *Vertical Landscapes* went viral on social media. Commissions soon began to flood in: HBO, *National Geographic Traveler*, the Victoria and Albert Museum, and Wellington City Council are among the many clients on his roster.

Es ist nicht alles so, wie es scheint, in der illustrierten Welt von Eiko Ojala. Auf den ersten Blick könnte man sicherlich seine Arbeit mit der handwerklichen Meisterschaft eines Scherenschnittkünstlers verwechseln. Tatsächlich ist er das auch, wenn auch nicht im traditionellen Sinne. Während Ojala seine illusorischen Landschaften und Figuren von Hand zeichnet, damit sie wie Scherenschnitte aussehen, erfolgt die technische Zauberei in Photoshop, wo er manchmal fotografierte und eingescannte Elemente aus echtem Papier einbaut. Sein Stil ist minimal und scharf und kann provokativ und humorvoll sein. Der insgesamt erhöhte Effekt liegt in seiner akribischen Liebe zum Detail und seinem Geschick bei der Darstellung von Licht und Schatten (er meidet die Verwendung von 3-D-Software). Ojala, 1982 in Tallinn (Estland) geboren, studierte an der EuroAcademy kurz Innenarchitektur, bevor er sich der Illustration zuwandte. Der Bruch kam im Jahr 2013, als sein Kunstwerk *Vertical Landscapes* in den sozialen Medien viral ging.

Les apparences sont trompeuses dans le monde illustré d'Eiko Ojala. Au premier abord, on peut confondre son travail avec celui d'un artiste excellant dans le découpage de papier à la main. Tel est en fait son cas, mais pas dans le sens traditionnel du terme. Même si Ojala dessine à la main des paysages et des personnages irréels pour qu'ils paraissent être en papier découpé, son génie entre en jeu dans Photoshop, où il intègre parfois des éléments photographiés et scannés sur du vrai papier. Son style minimaliste et concis peut s'avérer provocateur et humoristique, et l'effet obtenu tient à son extrême souci du détail et à son talent pour rendre ombres et lumière, refusant de recourir à un logiciel 3D. Né en 1982 à Tallinn, en Estonie, Ojala a suivi de courtes études de design d'intérieur à l'université EuroAcademy avant de se tourner vers l'illustration. C'est en 2013 qu'il a vraiment percé, quand son œuvre *Vertical Landscapes* s'est faite virale sur les réseaux sociaux. Les commandes ont alors commencé à affluer de nombreux clients

Participation in shows such as *Art Kaohsiung in Taiwan* (2016) and *Silence & Distance* at London's Pocko Gallery (2018) have pinned Ojala's world exhibition map, while accolades like an Art Directors Club Estonia Gold for "Tallinn Bicycle Week" 2015, and a New Zealand Best Design Awards 2016 Bronze for "Wellington Summer City" have added to his tally. Ojala travels and works between Estonia and New Zealand.

Aufträge gingen bald in Fülle ein: HBO, *National Geographic Traveler*, das Victoria and Albert Museum und der Wellington City Council sind unter den zahlreichen Kunden auf seiner Liste. Die Teilnahme an Shows wie *Art Kaohsiung* in Taiwan (2016) und *Silence & Distance* in der Londoner Pocko Gallery (2018) sind Fähnchen auf Ojalas weltweiter Ausstellungskarte. Er gewann die Gold-Auszeichnungen vom Art Directors Club Estland für die „Tallinn Fahrradwoche" 2015 und einen New Zealand Best Design Award 2016 in Bronze für „Wellington Summer City". Ojala reist und arbeitet zwischen Estland und Neuseeland.

comme HBO, *National Geographic Traveler*, le Victoria and Albert Museum et le conseil municipal de Wellington. Il a participé à des expositions comme *Art Kaohsiung* à Taiwan (2016) et *Silence & Distance* à la galerie londonienne Pocko (2018) qui ont donné une visibilité mondiale à son travail. Diverses distinctions sont venues l'auréoler encore davantage, comme l'or par l'Art Directors Club d'Estonie pour la « Semaine du vélo à Tallinn » en 2015 et le bronze aux New Zealand Best Design Awards 2016 pour « Wellington ville estivale ». Ojala voyage et travaille entre l'Estonie et la Nouvelle-Zélande.

EIKO OJALA

Summer Festivals, 2017
Washington Post, newspaper;
paper cut, digital

opposite
Leaf, 2018
Personal work, print;
paper cut, digital

p. 488
Digital Estonia, 2018
The New Yorker, magazine;
paper cut, digital

Endless Summer, 2017
Personal work, print;
paper cut, digital

right
Landscape, 2016
Personal work, print;
paper cut, digital

opposite
Myth #3, 2016
Personal work, print;
paper cut, digital

EIKO OJALA

Dreamer, 2017
Personal work, print;
paper cut, digital

opposite
Earth, 2017
The New York Times,
newspaper; paper cut, digital

EIKO OJALA

Selected Exhibitions: 2018, *Silence & Distance*, group show, Pocko Gallery, London · 2017, *Endless Summer*, group show, Atelier Meraki, Paris · 2017, *Six Impossible Wishes*, group show, Wisedog, Larisa · 2016, *Op-Ed Art*, group show, Pelham Art Center, New York · 2016, *Art Kaoshung*, group show, Kaoshung, Taiwan

Selected Publications: 2018, *Dadventures,* HarperCollins Publishers, United Kingdom · 2016, *All Year Round,* Scholastic, USA · 2016, *Directory of Illustration,* USA · 2016, *Contemporary Art of Excellence vol.2,* Global Art Agency, United Kingdom · 2016, *Creative Pool Annual,* United Kingdom

> "I know it's a super-clichéd thing to say but I truly believe in balance. You have to keep your body and mind happy." *for Missbish*

NAOMI OTSU

WWW.NAOMIOTSU.COM · @naomiotsu

Naomi Otsu conjures up words, phrases, and images in a compositional style that mixes doodling and lettering. Her work appears on advertising, pin badges, T-shirts, posters, and food infographics. Her unique take on visual communication stems from her diverse background. Half Korean and half Japanese, she was born in Mount Vernon, New York, in 1987, and raised in Tokyo before moving back to the US, where she received her BFA in Illustration and Communication Design from Parsons School of Design in 2010. She started out working for apparel brand and retailer Opening Ceremony, progressing to senior graphic designer. Following a brief stint at creative agency Laird+Partners, Otsu decided to go solo in 2014. Stimulated by her Brooklyn milieu, and equipped with a foundation in producing visual designs across the board, Otsu embarked on her freelance journey with an eclectic lexicon of referents to pool. She has created posters for Red Bull Sound Select and Ms. Lauryn Hill's "Diaspora Calling!" 2016 tour, spot

Naomi Otsu beschwört Wörter, Phrasen und Bilder in einem kompositorischen Stil herauf, der Kritzeleien und Buchstaben mischt. Ihre Arbeiten erscheinen in Werbeanzeigen, auf Anstecknadeln, T-Shirts, Postern und in Lebensmittel-Infografiken. Ihre einzigartige Sicht auf visuelle Kommunikation beruht auf ihrem diversen Hintergrund: Sie ist halb Koreanerin, halb Japanerin, wurde 1987 in Mount Vernon (New York) geboren, wuchs aber in Tokio auf, bevor sie wieder in die USA zog, wo sie 2010 ihren Bachelor in Illustration und Kommunikationsdesign an der Parsons School of Design machte. Sie begann ihre Karriere bei der Bekleidungsmarke Opening Ceremony und avancierte zur Senior Grafikdesignerin. Nach einem kurzen Aufenthalt bei der Kreativagentur Laird + Partners entschied sich Otsu 2014 für eine Solokarriere. Angeregt durch ihr Brooklyn-Milieu und ausgestattet mit einer Grundlage für die Erstellung visueller Designs auf breiter Front, begann Otsu ihre freiberufliche Reise mit einem umfassenden Lexikon

Naomi Otsu s'invente des mots, des phrases et des images dans un style de composition qui fait appel au dessin et au lettrage. Ses créations se retrouvent dans des publicités, des badges, des T-shirts, des affiches et des infographies dans le domaine alimentaire. Son approche unique de la communication visuelle lui vient de ses origines variées. Mi-coréenne, mi-japonaise, elle est née en 1987 à Mount Vernon, dans l'état de New York mais a grandi à Tokyo, avant de revenir s'installer aux États-Unis où elle a obtenu en 2010 sa licence en illustration et conception de communication à la Parsons School of Design. Elle a commencé à travailler pour la marque de vêtements Opening Ceremony, où elle a fini par occuper le poste de conceptrice graphique senior. Après un court passage par l'agence de création Laird+Partners, Otsu a décidé en 2014 de se lancer à son compte, stimulée par sa vie à Brooklyn et forte d'une base solide en conception d'illustrations universelles à partir de référents éclectiques.

Illustrations for *i-D* magazine online, and a host of menu cards for local eateries. Her love of food and drawing is showcased on We8that, a visual blog she created with her sister. Otsu lives and works in Brooklyn.

an Referenzen im Gepäck. Sie hat Plakate für Red Bull Sound Select und 2016 für Lauryn Hills Tour „Diaspora Calling!" erstellt sowie Illustrationen für das Online *i-D*-Magazin und eine Vielzahl von Menükarten für lokale Restaurants. Ihre Liebe zum Essen und Zeichnen wird auf We8that präsentiert, einem visuellen Blog, den sie mit ihrer Schwester betreibt. Otsu lebt und arbeitet in Brooklyn.

Elle a signé des affiches pour Red Bull Sound Select et pour la tournée « Diaspora Calling! » de Ms. Lauryn Hill en 2016, d'illustrations pour le magazine en ligne *i-D* et de menus pour des restaurants locaux. Elle parle de sa passion pour la cuisine et le dessin dans le blog visuel We8that qu'elle a créé avec sa sœur. Otsu vit et exerce aujourd'hui à Brooklyn.

NAOMI OTSU

Chain Reaction, 2017
Versace, sneaker; digital

opposite
Mirror in the Sky, 2015
Personal work; digital

p. 496
Spill the Beans, 2016
Personal work; digital

Kindness, 2017
Kindness Cleaning; digital

opposite
Recommended Diet for
July 4th, 2015
Personal work; digital

NAOMI OTSU

"Practice your passion, with dedication, love, and commitment." for *Multiverso da Arte*

SARA PAGLIA

WWW.SARAPAGLIA.IT · @sarapaglia

Italian illustrator Sara Paglia marries crisp ink lines, hatches, and random Ecoline watercolor marks with digital techniques that result in evocative images that hold the eye. Her portraits of famous faces, from Jimi Hendrix and Amy Winehouse to Nelson Mandela and Italian musicians like Rino Gaetano and Davide "Boosta" Dileo, burst with character and expression. Her work has featured in *Rolling Stone Italia* and the ClioMakeUp blog. Born in Rome in 1984, Paglia studied illustration at the European Institute of Design, receiving her bachelor's degree in 2006. After nearly a decade as a graphic designer for an international sports company, she took a leap of faith into the world of freelance illustration. As well as portraits, she creates murals for restaurants and salons, tattoo art, and sells her own line of merchandise. Like so many of her contemporaries, Paglia has harnessed the power of social media, through which she regularly engages with her thousands of followers. In 2018,

Die italienische Illustratorin Sara Paglia verbindet scharfe Tuschelinien, Schraffuren und zufällig gesetzte Ecoline-Aquarell-Farbspuren mit digitalen Techniken und schafft so eindrucksvolle Bilder, die das Auge fesseln. Ihre Porträts berühmter Gesichter von Jimi Hendrix und Amy Winehouse bis zu Nelson Mandela und italienischen Musikern wie Rino Gaetano und Davide „Boosta" Dileo platzen schier vor Charakter und Ausdruck. Ihre Arbeiten waren im *Rolling Stone Italia* und im ClioMakeUp Blog zu sehen. Paglia wurde 1984 in Rom geboren und studierte Illustration am Europäischen Institut für Design, wo sie 2006 ihren Bachelor-Abschluss erhielt. Nach fast einem Jahrzehnt als Grafikdesignerin für ein internationales Sportunternehmen wagte sie den Sprung in die freiberufliche Illustration. Neben Porträts entwirft sie Wandbilder für Restaurants und Salons, ist in der Tätowierkunst tätig und verkauft ihre eigene Merchandise-Linie. Wie viele ihrer Zeitgenossen hat Paglia die Macht der

L'illustratrice italienne Sara Paglia associe lignes franches à l'encre, hachures et traces d'aquarelle liquide Ecoline à des techniques numériques pour obtenir des images suggestives et attrayantes. Ses portraits de visages célèbres sont pleins de personnalité et très expressifs, comme ceux de Jimi Hendrix, Amy Winehouse, Nelson Mandela ou encore de musiciens italiens comme Rino Gaetano et Davide « Boosta » Dileo. Ses œuvres sont parues dans *Rolling Stone Italia* et le blog ClioMakeUp. Née à Rome en 1984, Paglia a suivi des études d'illustration à l'Istituto Europeo di Design, où elle a obtenu sa licence en 2006. Après près d'une décennie à travailler comme conceptrice graphique pour une marque de sport internationale, elle a fait un acte de foi et s'est lancée à son compte dans l'illustration. Outre des portraits, elle crée des fresques pour des restaurants et des salons, exerce comme tatoueuse et vend sa propre gamme de produits. Comme bien d'autres de ses contemporains, Paglia se sert des

she participated in the *Binario18: Itineraries in Visual Communication* platform at Rome's Officine Farneto.

sozialen Medien genutzt, durch die sie regelmäßig mit ihren Tausenden von Followern Kontakt aufnimmt. 2018 nahm sie an der *Binario18: Itineraries in Visual Communication*, im römischen Officine Farneto teil.

réseaux sociaux pour communiquer régulièrement avec ses milliers de fans. En 2018, elle a participé à l'événement *Binario18: Itineraries in Visual Communication* qui s'est tenu à Officine Farneto, à Rome.

How Long is Forever?, 2018
Personal work; ink, digital

opposite
Lentamente muore, 2018
Galo Restaurant, mural;
ink, digital

p. 502
Robert De Niro, 2018
Galo Restaurant; ink, ecoline

John Belushi, 2018
Personal work; ink, ecoline

opposite
Frida Kahlo, 2018
Frida Beauty Lab, beauty shop;
ink, ecoline

> "Keeping the passion alive is easy when you love what you do, and this helps inspiration. Inspiration is a mystery; the best inspiration comes as you breathe."

for *Dressed and Naked*

PIERRE-PAUL PARISEAU

WWW.PIERREPAULPARISEAU.COM · @pppariseau

Montreal-based Pierre-Paul Pariseau (b. 1958) is an internationally acclaimed mixed-media illustrator. Entirely self-taught, he started out creating manual-cut and paste works before discovering the wonders of Photoshop. For source material he trawls through boxes of print media cut-outs amassed over the years in his studio, which he appropriates into his collage-based universe. There are obvious nods to Pop Art and the anti-Nazi photomontages of John Heartfield, along with the absurd visual antics of Monty Python's Terry Gilliam in his work, yet Pariseau has a distinctively personal voice that elicits an emotional and intellectual response. Embedded within his saturated montages are signifiers that prompt the viewer to construct their own narrative. Pariseau's surreal visualizations have featured in magazines, on book covers, posters, and album sleeves. His clients include Random House, the *British Medical Journal*, and *The Wall Street Journal*, to name but a few. Pariseau has exhibited internationally

Der in Montreal ansässige Pierre-Paul Pariseau (geb. 1958) ist ein international gefeierter Illustrator, der in Mixed-Media arbeitet. Er ist Autodidakt und begann manuell mit Cut-and-Paste, bevor er die Wunder von Photoshop entdeckte. Für das Quellenmaterial durchforstet er Kisten mit Zeitungsausschnitten, die er im Laufe der Jahre in seinem Atelier angehäuft hat und die er an sein collagenbasiertes Universum anpasst. Es gibt zwar ebenso offensichtliche Anspielungen an die Pop-Art, die Anti-Nazi-Fotomontagen von John Heartfield und die absurden visuellen Mätzchen von Monty Pythons Terry Gilliam in Pariseaus Arbeit, doch er verfügt auch über eine unverwechselbar persönliche Stimme, die emotionale und intellektuelle Reaktionen hervorruft. Seine Montagen in gesättigten Farben sind voller Referenzen, die den Betrachter dazu auffordern, eigene Geschichten zu konstruieren. Die surrealen Visualisierungen von Pariseau findet man in Zeitschriften, auf Buchumschlägen, Postern und Albumcovern.

Installé à Montréal, Pierre-Paul Pariseau (1958) est un illustrateur polyvalent qui a été unanimement salué. Totalement autodidacte, il a commencé par des collages manuels avant de découvrir toute la magie de Photoshop. Dans son studio, il trouve dans des boîtes où il a accumulé au fil des années des découpages de quoi alimenter son univers de collages. Dans ses œuvres, les clins d'œil au pop art et aux photomontages anti-nazi de John Heartfield sont évidents, tout comme les singeries de Terry Gilliam comme membre des Monty Python. Pariseau possède néanmoins une voix bien à lui qui déclenche une réponse tant émotionnelle qu'intellectuelle. Ses montages saturés renferment des messages invitant le public à construire son propre récit. Ses représentations surréalistes sont parues dans des magazines, en couverture de livres, sur des affiches et sur des pochettes de disques. Ses clients comptent entre autres Random House, le *British Medical Journal* et *The Wall Street*

and received recognition as one of "200 Best Illustrators Worldwide" published by *Lürzer's Archive*. In 2017, he was selected a winner of the Hiii Illustration International Competition sponsored by Hiiibrand, Nanjing, China. He has been a jury member of the 11th Annual Stereohype Button Badge Design Competition (UK, 2015), and the Alberta Magazine Awards (Canada, 2017–19).

Seine Kunden sind zum Beispiel Random House, das *British Medical Journal* und das *Wall Street Journal*, um nur einige zu nennen. Pariseau hat international ausgestellt und wurde vom *Lürzer's Archive* als einer der „200 besten Illustratoren weltweit" ausgezeichnet. 2017 wurde er zum Gewinner der von Hiiibrand, Nanjing (China), gesponserten Hiii Illustration International Competition gekürt. Er war Jurymitglied bei der elften Annual Stereohype Button Badge Design Competition (England, 2015) und den Alberta Magazine Awards (Kanada, 2017/19).

Journal. Pariseau a exposé dans le monde entier et a été inclus dans la liste des « 200 meilleurs illustrateurs au monde » publiée par *Lürzer's Archive*. En 2017, il fut l'un des gagnants du concours international d'illustration Hiii organisé par Hiiibrand à Nankin, en Chine. Il a été membre du jury du 11e Annual Button Badge Design Competition de Stereohype (Royaume-Uni, 2015) et des Alberta Magazine Awards (Canada, 2017–19).

PIERRE-PAUL PARISEAU

The Euro and the Battle
of Ideas, 2017
The Milken Institute Review,
magazine; collage and digital;
art direction: Joannah Ralston

opposite
Ready to Ware, 2017
Commercial Observer, magazine;
collage and digital;
art direction: Jeff Cuyubamba

p. 508
Refuge, 2018
Personal work, *Ciudad Persona*,
group show, La Nave, Madrid;
collage and digital

The Great Bee Die-off, 2016
Foreign Policy, magazine;
collage and digital;
art director: Margaret Swart

PIERRE-PAUL PARISEAU

Selected Exhibitions: 2018, *Art and (H)Aktivism*, group show, Ugly Duck Creative, London · 2018, *Artbox Project New York 1.0*, group show, Stricoff Gallery, New York · 2016, *Superfine Art Fair*, group show, Miami · 2015, *Fuorisalone*, group show, Milan Design Week · 2014, *The Metamorphosis of Appearances*, solo show, Cultural House, Montreal

Selected Publications: 2019, *200 Best Illustrators Worldwide*, Lürzer's Archive, Austria · 2018, *Pictoria*, vol.2, Capsules Books, Australia · 2014, *Freistil: The Best Illustrators*, Germany · 2014, *Directory of Illustration*, 3X3 Magazine, USA · 2012, *Illustration 2*, Zeixs, Germany

> "The beauty, though, is that we live in a time when the tools to create images and tell stories are readily available." *for Thandie Kay*

ANDREA PIPPINS

WWW.ANDREAPIPPINS.COM · @andreapippins

Born in Washington, D.C., in 1979, Andrea Pippins spent her early childhood in a garment studio with her Brazilian mother. She drew while her mother sewed. This instilled in her a love of textiles, patterns, and color. Another epiphany occurred while watching Halle Berry play an art director in the film *Boomerang* (1992), when she was inspired to see a woman of color in a creative profession. In the period between receiving her BFA and MFA in Graphic and Interactive Design at Tyler School of Art at Temple University, Philadelphia, she worked for Hallmark Cards and TV Land/Nick at Nite. Following a period of teaching she took the plunge and became a full-time freelancer, gradually shifting her focus from graphic design to illustration. With a style that moves from delicate pen and ink doodles to bright, flat, and colorful compositions, Pippins draws upon media and memory to create imagery that is both affirmational and relatable. An advocate of creativity as a means of self-empowerment, Pippins uses her books and design blog "Fly" as

Andrea Pippins, 1979 in Washington, D.C. geboren, verbrachte ihre frühe Kindheit im Bekleidungsatelier ihrer brasilianischen Mutter. Sie zeichnete, während ihre Mutter nähte. Dies weckte in ihr die Liebe zu Textilien, Mustern und Farben. Eine weitere Offenbarung hatte sie, als sie Halle Berry im Film *Boomerang* (1992) sah, in dem sie eine Art Directorin spielte, eine farbige Frau in einem kreativen Beruf. In der Zeit zwischen ihrem Bachelor- und Masterabschluss in Grafik- und interaktivem Design an der Tyler School of Art der Temple University (Philadelphia), arbeitete sie für Hallmark Cards und TV Land/Nick at Nite. Nachdem sie eine Weile als Lehrerin gearbeitet hatte, wagte sie den Sprung und wurde eine Vollzeit-Freiberuflerin, die ihren Schwerpunkt allmählich vom Grafikdesign zur Illustration verlagerte. Mit einem Stil, der sich von zarten Federzeichnungen zu hellen, zweidimensionalen und farbenfrohen Kompositionen bewegt, erschafft sie eine positive und leicht zugängliche Bildsprache, zu der

Née à Washington en 1979, Andrea Pippins a passé sa petite enfance dans un atelier de couture aux côtés de sa mère brésilienne : elle dessinait pendant que sa mère cousait, d'où son amour pour les tissus, les motifs et les couleurs. Elle a vécu une autre épiphanie en voyant Halle Berry interpréter une directrice artistique dans le film *Boomerang* (1992), et trouvé inspirant qu'une femme de couleur occupe une profession créative. Entre l'obtention d'une licence et d'un master en beaux-arts de design graphique et interactif à la Tyler School of Art de l'université Temple à Philadelphie, elle a travaillé pour Hallmark Cards et TV Land/Nick at Nite. Après quelques années passées à enseigner, elle s'est lancée pour exercer à son compte à plein temps, délaissant petit à petit le design graphique au profit de l'illustration. Pippins dessine dans un style alliant traits délicats à l'encre et compositions aux couleurs vives et travaille à partir d'idées qu'elle trouve dans les médias ou ses souvenirs pour créer une imagerie

platforms to inspire young women of color to celebrate their creativity and self-expression. Since publishing *I Love My Hair* (2015), an adult coloring book celebrating the diversity of hair through styles and accessories, Pippins has produced several other titles, including *Becoming Me* (2016), an illustrated activity journal, and *Young Gifted and Black: Meet 52 Black Heroes from Past and Present* (2018), a collaboration with author Jamia Wilson. Pippins' clients include the BlackStar Film Festival, Bloomberg, *Essence Magazine*, *The New York Times*, *O: The Oprah Magazine*, and the National Museum of African American History and Culture. She lives in Stockholm.

sie ihre Erinnerungen und die Medien inspirieren. Als Verfechterin der Kreativität als Mittel zur Selbstermächtigung nutzt Pippins ihre Bücher und den Designblog „Fly" als Plattform, um junge schwarze Frauen dazu anzuregen, ihre Kreativität und ihren Selbstausdruck zu feiern. Seit der Veröffentlichung von *I Love My Hair* (2015), einem Malbuch für Erwachsene, das die Vielfalt von Haar durch verschiedene Stylings und Accessoires zeigt, hat Pippins mehrere andere Titel produziert, zum Beispiel *Becoming Me* (2016), ein illustriertes, interaktives Tagebuch, und *Young Gifted and Black: Meet 52 Black Heroes from Past and Present* (2018), eine Zusammenarbeit mit der Autorin Jamia Wilson. Pippins Kunden sind das BlackStar Film Festival, Bloomberg, das *Essence* Magazin, die *New York Times*, *O: The Oprah Magazine* und das National Museum of African American History and Culture. Sie lebt in Stockholm.

parlante. Préconisant la créativité comme un mode d'auto-émancipation, ses ouvrages et son blog « Fly » lui servent de plateformes pour encourager les jeunes femmes de couleur à créer et à s'exprimer. Depuis la sortie de *I Love My Hair* (2015), un livre de coloriage pour adultes en hommage à la diversité de cheveux à travers des styles et des accessoires, Pippins a publié plusieurs autres titres, dont *Becoming Me* (2016), un journal d'activité illustré, et *Young Gifted and Black: Meet 52 Black Heroes from Past and Present* (2018), en collaboration avec l'auteur Jamia Wilson. Ses clients incluent le BlackStar Film Festival, Bloomberg, *Essence Magazine*, *The New York Times*, *O: The Oprah Magazine* et le Musée national de l'histoire et de la culture afro-américaines. Elle habite actuellement à Stockholm.

Black Star Film Festival, poster,
2013; hand drawing, digital

opposite
Break the Silence, 2015
The Association for Women's
Rights in Development, website;
hand drawing, digital

p. 514
Afro Blue, 2013
Personal work, limited-edition
screen print

CaribBeing Doodles, 2015
Lincoln Center Out of Doors
Summer Festival promotional
material; hand drawing, digital

opposite top
Untitled, 2017
Scoop, magazine cover;
hand drawing, digital

opposite bottom
Young Gifted and Black: Muhammad Ali, 2017
Quarto Knows/Wide Eyed, book;
hand drawing, digital

Selected Exhibitions: 2014, *The Art of Blackness*, group show, NYCH/Robotic Minds Gallery, Chicago · 2013, *Product Lines*, group show, Case[werks], Baltimore

Selected Publications: 2019, *Step Into Your Power,* Quarto Knows/Wide Eye, United Kingdom · 2018, *Young Gifted and Black,* Quarto Knows/Wide Eye, United Kingdom · 2018, *We Inspire Me,* Chronicle Books, USA · 2016, *Becoming Me,* Schwartz & Wade, USA · 2015, *I Love My Hair,* Schwartz & Wade, USA

> "I like to think of my illustrations as puzzles that need to be solved within a certain amount of time."

HANOCH PIVEN

WWW.PIVENWORLD.COM · @hanochpiven

Hanoch Piven is an artist and editorial caricaturist who creates collage illustrations with found objects and materials. His witty portraits and caricatures of celebrities and icons have appeared in countless editorials, from *Rolling Stone* and *The Times* to *Die Welt Woche* and *Der Spiegel*. Born in Montevideo in 1963, Piven moved to Israel at the age of 11, where he grew up in Ramat Gan. After graduating from the School of Visual Arts in New York in 1992, he returned home where he began his long association with Israeli newspaper *Haaretz*. Piven's playful and abstract approach elicits an immediacy of response, prompting the viewer to examine the objects he arranges so carefully to make up a subject's features. Piven is the author of children's books including *My Best Friend is as Sharp as a Pencil* (2010), and he has also developed a series of face-making apps for the iPad. A passionate educator, he has inspired both children and adults alike through his regular creative workshops and animations for TV. Piven has

Hanoch Piven ist ein Künstler und Karikaturist, der aus gefundenen Gegenständen und Materialien collagenartige Illustrationen erstellt. Seine witzigen Porträts und Karikaturen von Prominenten und Ikonen sind in unzähligen Zeitungen und Zeitschriften erschienen, vom *Rolling Stone* über die *Times* bis zur Schweizer *Weltwoche* und zum *Spiegel*. Piven wurde 1963 in Montevideo geboren und zog im Alter von elf Jahren nach Israel, wo er in Ramat Gan aufwuchs. Nach seinem Abschluss an der School of Visual Arts in New York im Jahr 1992 kehrte er nach Hause zurück, wo er seine langjährige Zusammenarbeit mit der israelischen Zeitung *Haaretz* begann. Pivens spielerische und abstrakte Herangehensweise löst eine unmittelbare Reaktion aus und veranlasst den Betrachter, die angeordneten Objekte, mit denen die Mimik der Figuren gestaltet wurde, sorgfältig zu untersuchen. Piven ist Autor von Kinderbüchern, zum Beispiel *My Best Friend is as Sharp a Pencil* (2010), und er hat auch eine Reihe von Face-Making-Apps

Hanoch Piven est un artiste et caricaturiste éditorial qui crée des illustrations à base de collages à partir d'objets et de matériaux trouvés. Ses portraits et ses caricatures pleins d'esprit de personnalités et de figures emblématiques sont parus dans d'innombrables éditoriaux, comme *Rolling Stone*, *The Times*, *Die WeltWoche* et *Der Spiegel*. Né en 1963 à Montevideo, Piven est parti vivre en Israël à l'âge de 11 ans, où il a grandi à Ramat Gan. Une fois diplômé de la School of Visual Arts de New York en 1992, il est rentré au pays et a entamé une longue collaboration avec le journal israélien *Haaretz*. Son approche espiègle et abstraite provoque une réaction immédiate, invitant le public à observer les objets qu'il agence avec soin dans ses compositions. Piven est l'auteur de livres pour enfants comme *My Best Friend is as Sharp as a Pencil* (2010) et a développé une série d'applications pour iPad qui permettent de créer des visages. Éducateur passionné, il a inspiré petits et grands avec ses ateliers de création et ses

also lectured at several institutions, from the China Academy of Fine Arts in Beijing and Sheridan College in Toronto to the Instituto Europeo di Design in Rome and Bezalel Academy of Arts and Design in Israel. Among his awards, Piven is the recipient of a Gold Medal from the Society of Illustrators of New York (1994). His book *What Presidents Are Made Of* was chosen as one of the "10 Best Children's Books of 2004" by *Time* magazine. He lives between Tel Aviv and Barcelona.

für das iPad entwickelt. Als leidenschaftlicher Erzieher hat er durch seine regelmäßigen Kreativworkshops und Animationen für das Fernsehen sowohl Kinder als auch Erwachsene inspiriert. Piven hat an mehreren Institutionen Vorträge gehalten, darunter sind die chinesische Akademie der Künste in Peking, das Sheridan College in Toronto, das Instituto Europeo di Design in Rom und die Bezalel Akademie für Kunst und Design in Israel. Zu Pivens Auszeichnungen zählt eine Goldmedaille der Society of Illustrators of New York (1994) und sein Buch *What Presidents Are Made Of* schaffte es in die Liste der „zehn besten Kinderbücher des Jahres 2004" des *Time Magazine*. Er lebt in Tel Aviv und Barcelona.

animations pour la télé. Il a également donné des conférences dans plusieurs institutions, comme l'académie centrale des beaux-arts de Chine à Pékin, le Sheridan College à Toronto, l'Istituto Europeo di Design à Rome et l'école des beaux-arts de Bezalel en Israël. Entre autres distinctions, Piven s'est vu décerner la médaille d'or par la Society of Illustrators de New York (1994). Son ouvrage *What Presidents Are Made Of* a été élu comme l'un des «10 meilleurs livres pour enfants de 2004» par le magazine *Time*. Il partage son temps entre Tel Aviv et Barcelone.

Donald Trump, 2016
Personal work; digital collage

opposite

Vladimir Putin, 2018
Am Oved Books, book cover;
photographed 3D collage

p. 520

Nelson Mandela, 2016
King David School, Johannesburg;
photographed 3D collage

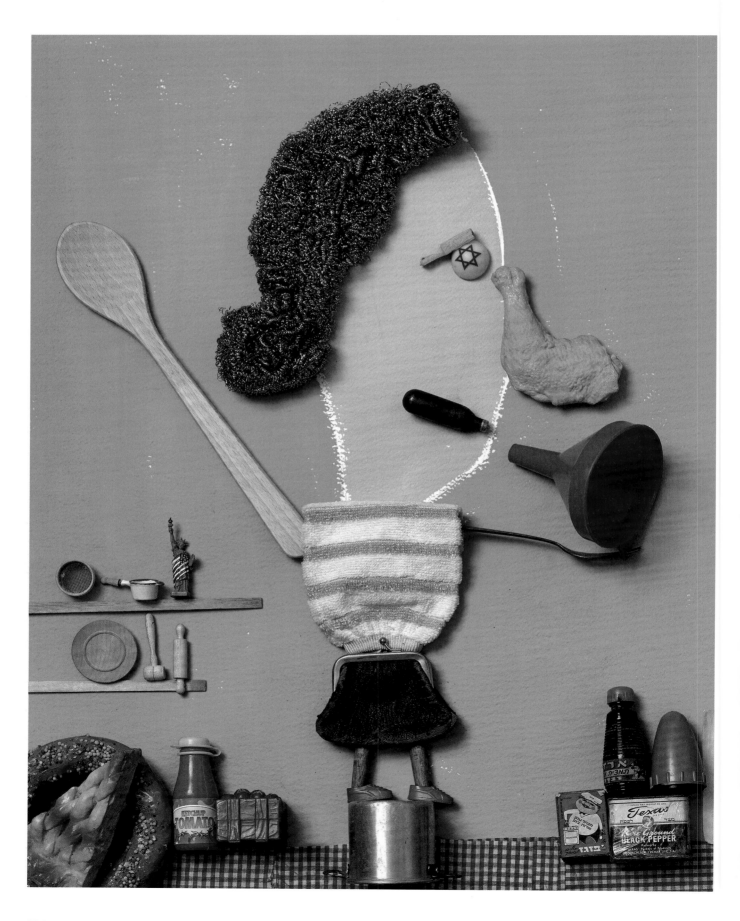

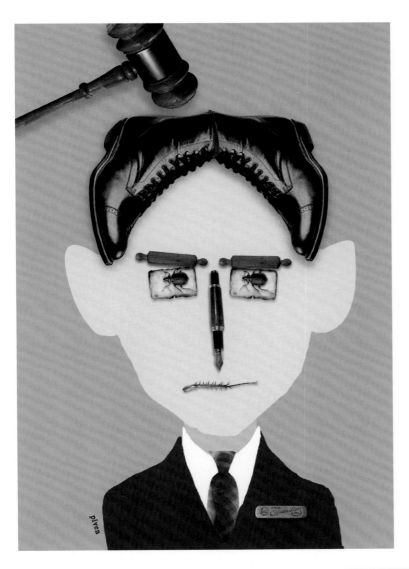

Selected Exhibitions: 2018, *Pivenworld*, solo show, Sefika Kutluer Festival, Ankara · 2014, *Pivenworld*, solo show, Bangkok National Art Gallery, Bangkok · 2011, *Making Faces*, solo show, Czech Cultural Center, Prague · 2010, *Pivenworld*, solo show, Skirball Cultural Center, Los Angeles

Selected Publications: 2017, *The Art of Living*, Romania · 2017, *The Straight Times*, Singapore · 2016, *IRB Barcelona*, Spain · 2012, *La Vanguardia*, Spain · 2017, *The Romania Journal*, Romania

Franz Kafka, 2017
Jewish Soul, by Hanoch Daum
and Ariel Hirschfeld, book,
Yediot Books; digital collage

right
Willem Dafoe, 2018
Hemispheres, magazine, United
Airlines; photographed 3D collage;
art director: Rickard Westin

opposite
Golda Meir, 2018
What Are Prime Ministers Made Of,
Kinneret Publishers, book cover;
photographed 3D collage

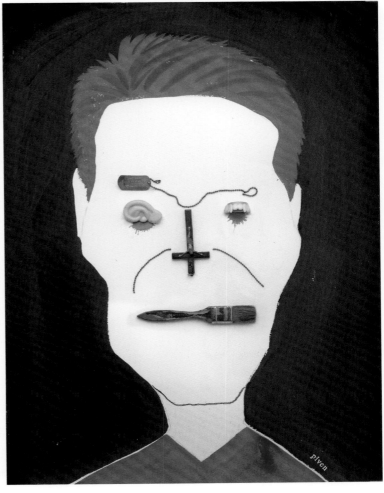

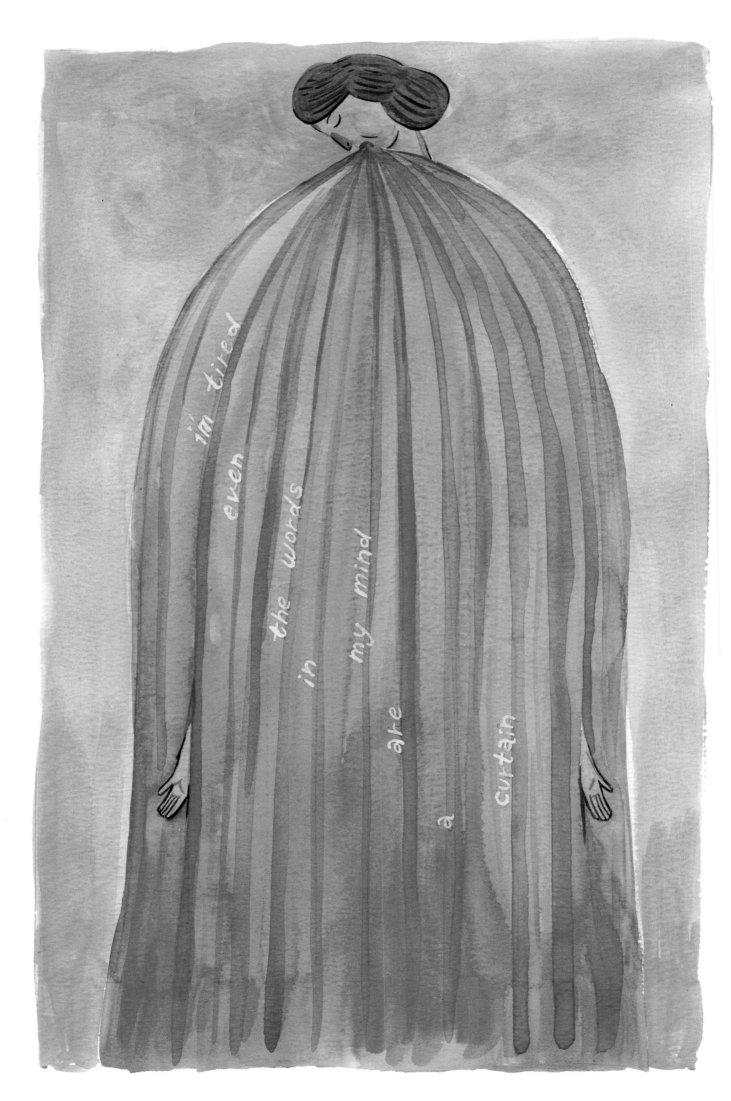

> "I try always to plan and think about the next thing I want to make by surrounding myself with creative people. That's what always gets me motivated and reminds me how much I love to make art."

GEFFEN REFAELI

WWW.GEFFENREFAELIART.COM · @dailydoodlegram

Born in Tel Aviv in 1984, Geffen Refaeli began drawing around the age of five, producing weird, dark, and humorous illustrations. Upon reflection, Refaeli confesses that she grew up refusing to let go of her childhood universe, choosing to inhabit a solitary world of memories through her practice. Her love of animals, combined with a desire to escape her life of seclusion, nearly led her to become a veterinarian, but in the end she could not forego her passion for drawing. Since graduating from the Bezalel Academy of Arts and Design in Jerusalem with a bachelor of design in 2010, she has undertaken various freelance illustration commissions and projects. In May 2012, Refaeli launched her "DailyDoodleGram" project on Instagram. Initially she created illustrations of her friends, but the project evolved into an obsessive everyday practice with tens of thousands of followers eagerly awaiting her next creation. Scrolling through her Instagram photostream, she selects elements from random photos that catch her eye,

Geffen Refaeli wurde 1984 in Tel Aviv geboren und begann im Alter von fünf Jahren mit dem Zeichnen von seltsamen, dunklen und humorvollen Illustrationen. Reflektiert betrachtet, gesteht Refaeli, dass sie sich bis heute weigert, ihr Universum aus Kindertagen loszulassen. Stattdessen hat sie sich dafür entschieden, durch ihre Arbeit eine einsame Welt der Erinnerungen zu bewohnen. Ihre Liebe zu Tieren, verbunden mit dem Wunsch, ihrem Leben in Abgeschiedenheit zu entkommen, hätte sie fast zur Tierärztin gemacht, aber am Ende konnte sie nicht auf ihre Leidenschaft für das Zeichnen verzichten. Seit ihrem Abschluss an der Bezalel Akademie für Kunst und Design in Jerusalem mit einem Bachelor of Design im Jahr 2010 hat sie verschiedene freiberufliche Illustrationsaufträge und Projekte übernommen. Im Mai 2012 startete Refaeli ihr „DailyDoodleGram"-Projekt auf Instagram. Anfangs schuf sie nur Illustrationen von ihren Freunden, aber das Projekt entwickelte sich zu einer obsessiven täglichen Arbeit

Née en 1984 à Tel Aviv, Geffen Refaeli s'est mise à dessiner vers l'âge de cinq ans des illustrations étranges, sombres et comiques. Elle admet avoir grandi sans laisser aller l'univers de son enfance et en évoluant, à travers son activité, dans la solitude d'un monde de souvenirs. Son amour pour les animaux et sa volonté d'échapper à sa vie d'isolement l'ont presque conduite à devenir vétérinaire, mais elle n'a finalement pas pu renoncer à sa passion pour le dessin. Depuis l'obtention de sa licence de design en 2010 à l'académie des beaux-arts de Bezalel à Jerusalem, elle a réalisé à son compte plusieurs commandes et projets d'illustration. En mai 2012, Refaeli a lancé son projet « DailyDoodleGram » sur Instagram : d'abord pensé pour y publier des illustrations de ses amis, il s'est converti en une pratique quotidienne obsessive, des dizaines de milliers de fans attendant avec impatience sa prochaine création. Elle fait défiler son flux d'actualité dans Instagram et choisit au hasard des éléments attirant son attention, pour

combining them to create playful, surreal doodles. Pencil sketches manifest into sharp, black India-ink illustrations, sometimes embellished with digital color overlays. Users whose photos she has referenced are then tagged, allowing them and others to click and view both artwork and original image.

an neuen Bildern, auf die Zehntausende Anhänger mit Spannung warten. Beim Scrollen durch ihren Instagram-Fotostream wählt sie Elemente aus Zufallsfotos aus, die ihr ins Auge fallen, und kombiniert sie zu verspielten surrealen Kritzeleien. Bleistiftskizzen manifestieren sich in scharfen, schwarzen Tuschezeichnungen, die manchmal mit digitalen Farbüberlagerungen verziert sind. Die User, deren Fotos sie nutzt, werden in Refaelis Arbeiten markiert. Auf diese Weise können sie und andere sowohl das Kunstwerk an sich, aber gleichzeitig auch das Originalbild anklicken und ansehen.

composer des œuvres surréalistes et amusantes. Des croquis au crayon deviennent des illustrations à l'encre de Chine parfois coloriées en numérique. Les utilisateurs dont elle a référencé les photos sont alors étiquetés, ce qui leur permet, ainsi qu'à d'autres utilisateurs, de cliquer pour afficher son œuvre et l'image originale.

it's so fragile but in that moment everything exists inside me

my whole past,

every single moment

all that can still be.

and i feel so full,

like the sun,

like an ocean,

like my heart

could burst.

and i want to keep it.

above and p. 526

Why Do You Speak So Vaguely?, 2018
Hideout, Humdrum Collective;
ink and watercolors on paper

opposite

Pupikus Volcanus, 2017
Children's Health Guide,
self-published 2017;
ink and watercolors on paper

Plantation and Birds, 2017
Shufff silk scarves,
print design; ink on paper

opposite
Untitled, 2015–2018
Personal work,
Dailydoodlegram;
ink on paper

GEFFEN REFAELI

Selected Exhibitions: 2017, *Dailydoodlegram*, solo show,
Fumetto Comics and Illustration Festival, Lucerne · 2017,
With Just One Pearl, solo show, Kandinof Gallery, Jaffa ·
2016, *From Instagram to the Museum and Back*, solo show,
Israel Museum, Illustration Library, Jerusalem 2016,
Dailydoodlegram, group show, Lustre Festival, Prague ·
2013, *DailyDoodlegram*, solo show, Urban Spree, Berlin

Selected Publications: 2018, *The Elementary Particle*,
Israel · 2018, *Why Do You Speak So Vaguely?*, Humdrum
collective, Israel · 2017, *Children's Health Guide*, Israel ·
2017, *Yolanda De Meow*, Kibuz-Poalim, Israel · 2016, *Ink*,
Victionary, China

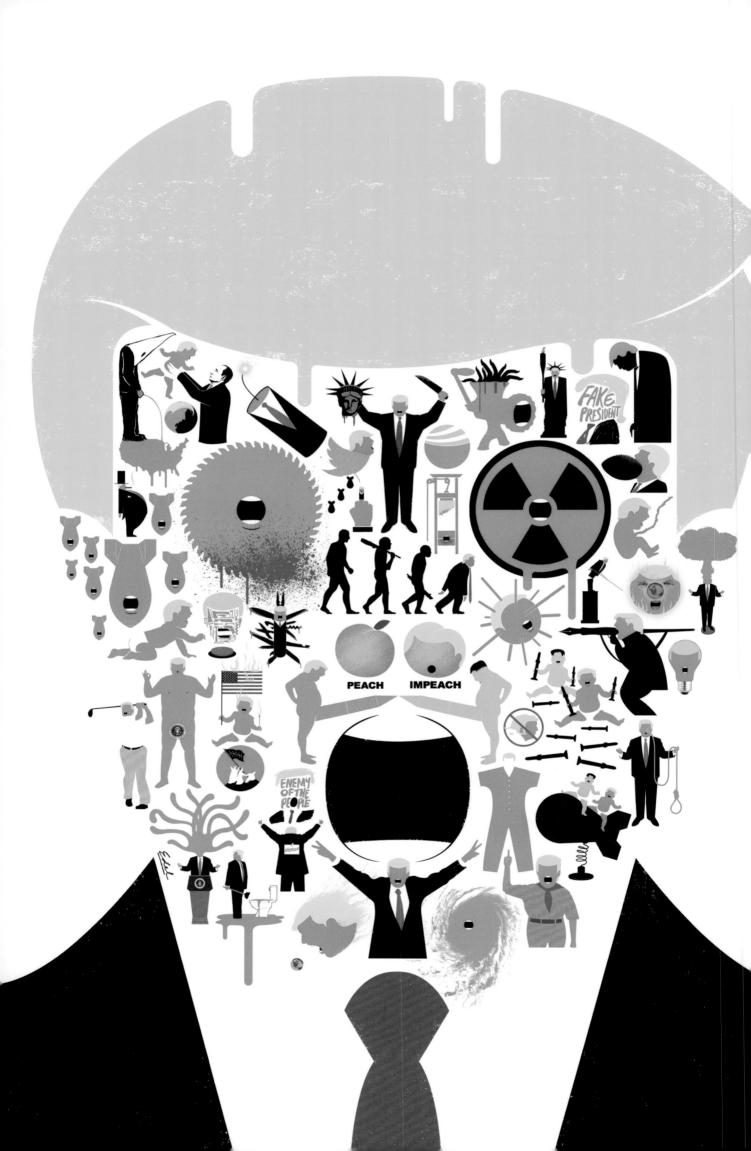

> "I try to get at the essence of the subject in a clear and concise manner and often include biographical details that help inform the viewer."

EDEL RODRIGUEZ

WWW.EDELRODRIGUEZ.COM · @edelstudio

Born in Havana in 1971, Edel Rodriguez grew up in rural Cuba amid fields of tobacco and sugar cane. In 1980, he and his family emigrated to Miami as political refugees. In 1994, Rodriguez received an honors degree in painting from the Pratt Institute in Brooklyn. After graduating, he followed up on a lead to join *Time* magazine as a temp, and soon became the youngest art director of the publication's Canadian and Latin American editions at 26. He enrolled on a master's course at Hunter College in Manhattan, graduating in 1998. The same year, his work appeared in *Print* magazine's *New Visual Artists Annual*. Rodriguez has since accumulated numerous awards from the likes of *Communication Arts* and the Society of Publication Designers. His distinctive visual language stems from his direct personal experiences dealing with political repression, cultural identity, and displacement. Employing a limited palette of acrylics, his saturated images are laden with references from politics and religion to island life

Edel Rodriguez wurde 1971 in Havanna geboren und wuchs im ländlichen Kuba inmitten von Tabak- und Zuckerfeldern auf. 1980 emigrierten seine Familie und er als politische Flüchtlinge nach Miami. Im Jahr 1994 erhielt Rodriguez einen Abschluss mit Auszeichnung in Malerei vom Pratt Institute in Brooklyn. Nach seinem Abschluss bewarb er sich auf einen Tipp hin als Aushilfe beim *Time Magazine* und wurde bald, mit 26 Jahren, der jüngste Art Director der kanadischen und lateinamerikanischen Ausgabe. Er schrieb sich für einen Masterkurs am Hunter College in Manhattan ein und schloss sein Studium 1998 ab. Im gleichen Jahr erschienen seine Arbeiten im *New Visual Artists Annual* der Zeitschrift *Print*. Rodriguez hat seitdem zahlreiche Auszeichnungen etwa von *Communication Arts* und der Society of Publication Designers erhalten. Seine unverwechselbare Bildsprache beruht auf seinen direkten persönlichen Erfahrungen mit politischer Unterdrückung, kultureller Identität und Vertreibung.

Né en 1971 à La Havane, Edel Rodriguez a grandi dans le Cuba rural, au milieu des champs de tabac et de canne à sucre. En 1980, il a émigré avec sa famille à Miami comme réfugiés politiques. En 1994, Rodriguez a reçu avec les honneurs une licence en peinture de l'institut Pratt à Brooklyn. Après avoir répondu à une annonce pour un poste temporaire au magazine *Time*, il est rapidement devenu, à 26 ans, le plus jeune directeur artistique des éditions canadienne et d'Amérique latine de la publication. Il s'est ensuite inscrit à un master au Hunter College à Manhattan, qu'il a obtenu en 1998. La même année, son travail est paru dans le numéro *New Visual Artists Annual* du magazine *Print*. Rodriguez n'a depuis cessé de remporter des distinctions, comme celles de *Communication Arts* et de la Society of Publication Designers. Son langage visuel particulier est le fruit de ses expériences personnelles en matière de répression politique, d'identité culturelle et de déplacement des populations. Employant une palette

and urban pop. A pivotal moment came in 2016–17, when Rodriguez's controversial visual reductions of Donald Trump for *Time* and *Der Spiegel* went viral around the globe. His personal art contains bold, conceptual portraits and landscapes. Notable examples include his series painted directly on cigar boxes, diptychs that load his visualizations into an almost tangible cultural artefact. His art has been exhibited in Los Angeles, Toronto, New York, Dallas, Philadelphia, and Spain.

Seine gesättigten Bilder, für die er nur eine begrenzte Palette von Acrylfarben verwendet, sind voller Referenzen aus Politik und Religion über Inselleben bis hin zu urbanem Pop. Ein entscheidender Moment war 2016/17, als Rodriguez' kontroverse visuelle Herabsetzungen von Donald Trump für die *Time* und den *Spiegel* weltweit viral gingen. Seine persönliche Kunst besteht aus mutigen, konzeptuellen Porträts und Landschaften. Bemerkenswerte Beispiele sind seine direkt auf Zigarrenschachteln gemalten Serien, Diptychen, die seine Visualisierungen in ein fast greifbares kulturelles Artefakt verwandeln. Seine Kunst wurde in Los Angeles, Toronto, New York, Dallas, Philadelphia und Spanien ausgestellt.

restreinte d'acryliques, ses images saturées sont chargées de références au monde politique, à la religion, à la vie insulaire et au pop urbain. Sa carrière a connu un moment charnière en 2016–17, quand ses réductions visuelles de Donald Trump pour *Time* et *Der Spiegel* se sont faites virales. Son art personnel est fait de portraits et de paysages conceptuels audacieux. Parmi ses œuvres phares, sa série de peintures sur des boîtes à cigares forment des diptyques qui font de ses créations des biens culturels presque tangibles. Son travail a été exposé à Los Angeles, Toronto, New York, Dallas, Philadelphie et en Espagne.

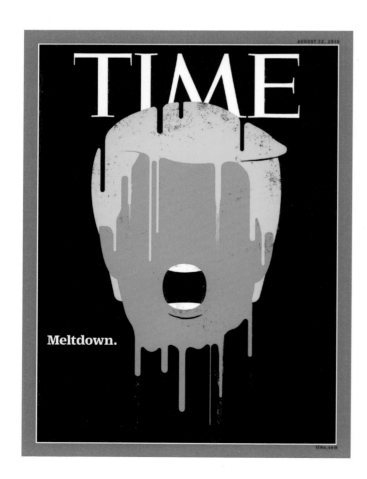

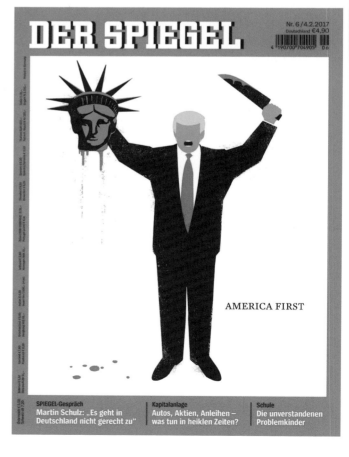

Lights, 2016
Personal work; acrylic on paper

p. 532
Agent Orange, 2017
Personal work, poster; mixed
media, acrylic on paper, digital

opposite left
Meltdown, 2016
Time, magazine cover; mixed
media, acrylic on paper, digital

opposite right
America First, 2017
Der Spiegel, magazine cover; mixed
media, acrylic on paper, digital

Totem, 2017
Personal work; ink on paper

opposite
Stage, 2013
Personal work; acrylic on canvas

EDEL RODRIGUEZ

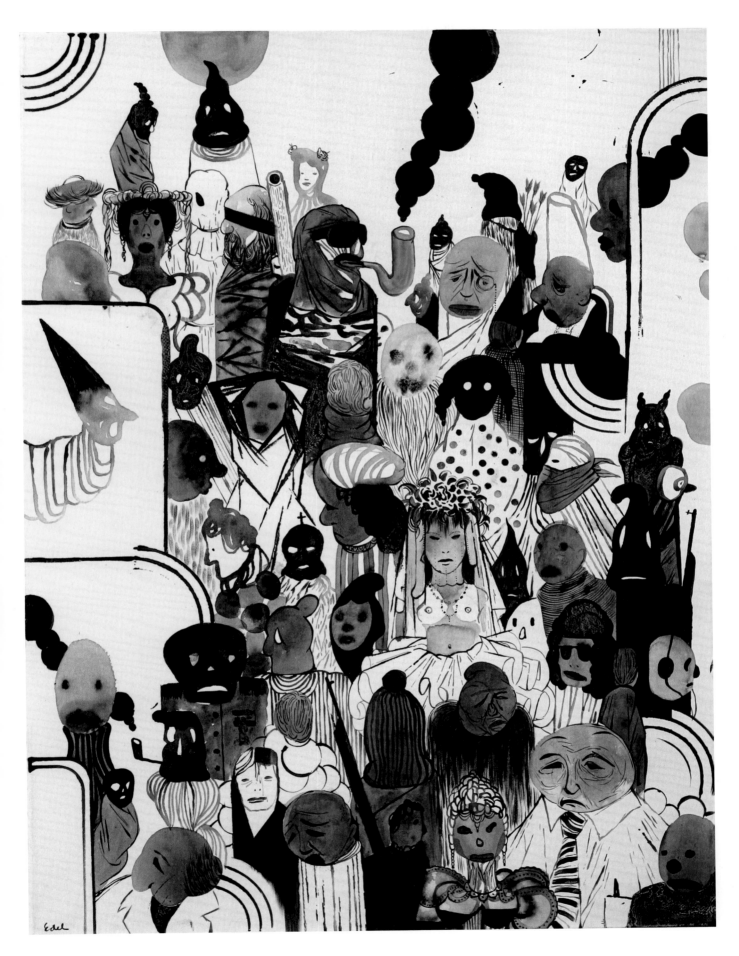

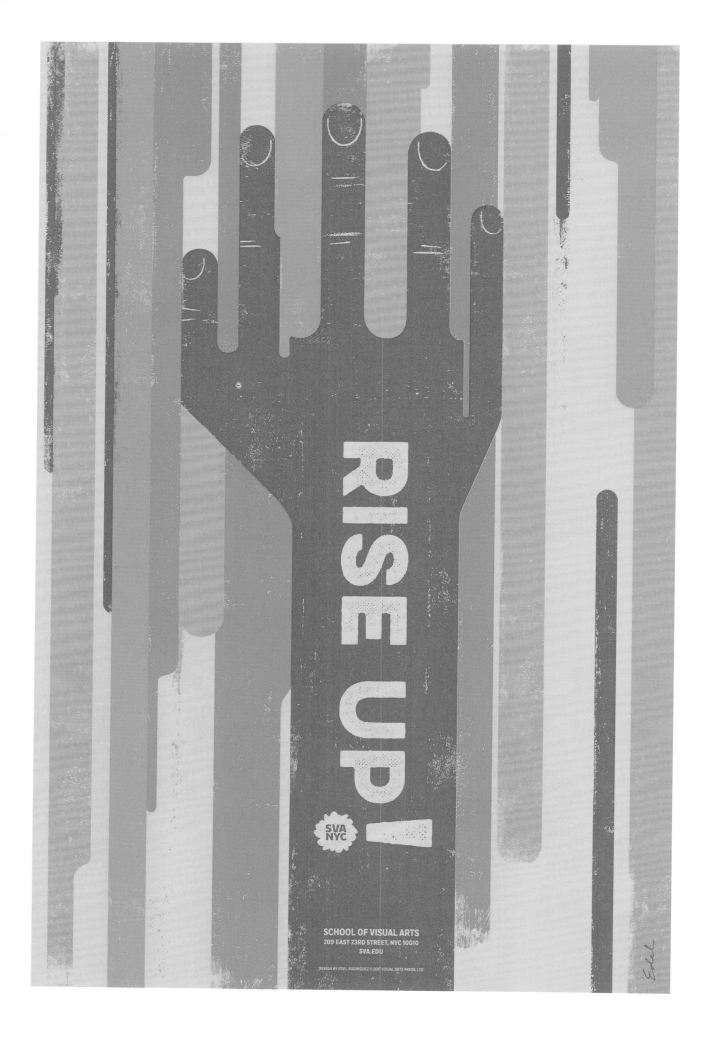

EDEL RODRIGUEZ

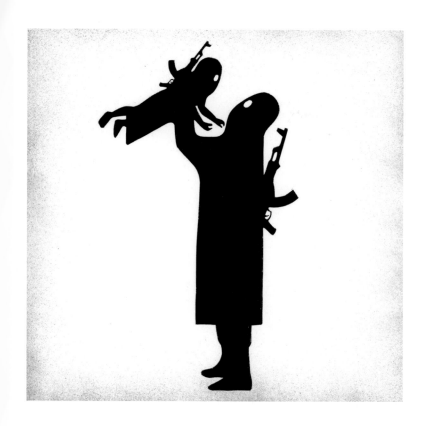

Selected Exhibitions: 2018, *Fault Lines*, group show,
Paul Roosen Contemporary, Hamburg · 2018, *Freedumb*,
solo show, Ministerium für Illustration, Berlin · 2018,
Agent Orange, solo show, Wieden+Kennedy, Portland ·
2013, *Dystopia*, solo show, Curly Tale Fine Art, Chicago ·
2010, *Here There*, solo show, Nucleus Gallery, Los Angeles

Selected Publications: 2018, *The History of Graphic Design:
1960–Today*, TASCHEN, Germany · 2018, *Printed Pages*,
It's Nice That, United Kingdom · 2018, *De Volkskrant*,
De Persgroep, The Netherlands · 2017, *Americas Quarterly*,
Council of the Americas, USA · 2017, *The Design of Dissent*,
Rockport, USA

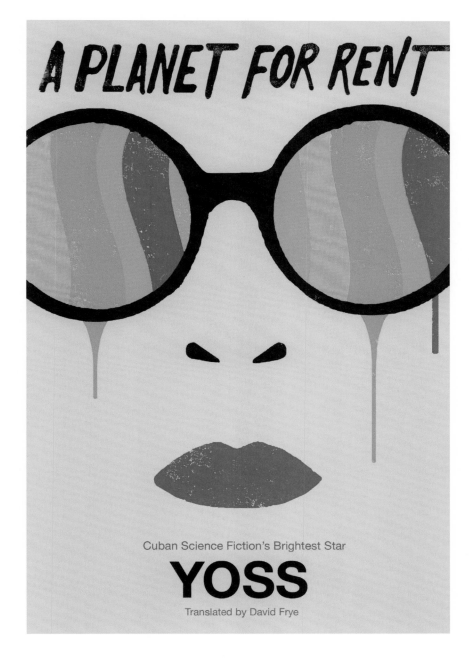

Father and Son, 2014
Personal work; ink and spray
paint on paper

right
A Planet for Rent, 2015
Restless Books, book cover;
mixed media, acrylic and ink
on paper and digital

opposite
Rise Up!, 2017
School of Visual Arts, poster;
mixed media, acrylic on paper
and digital

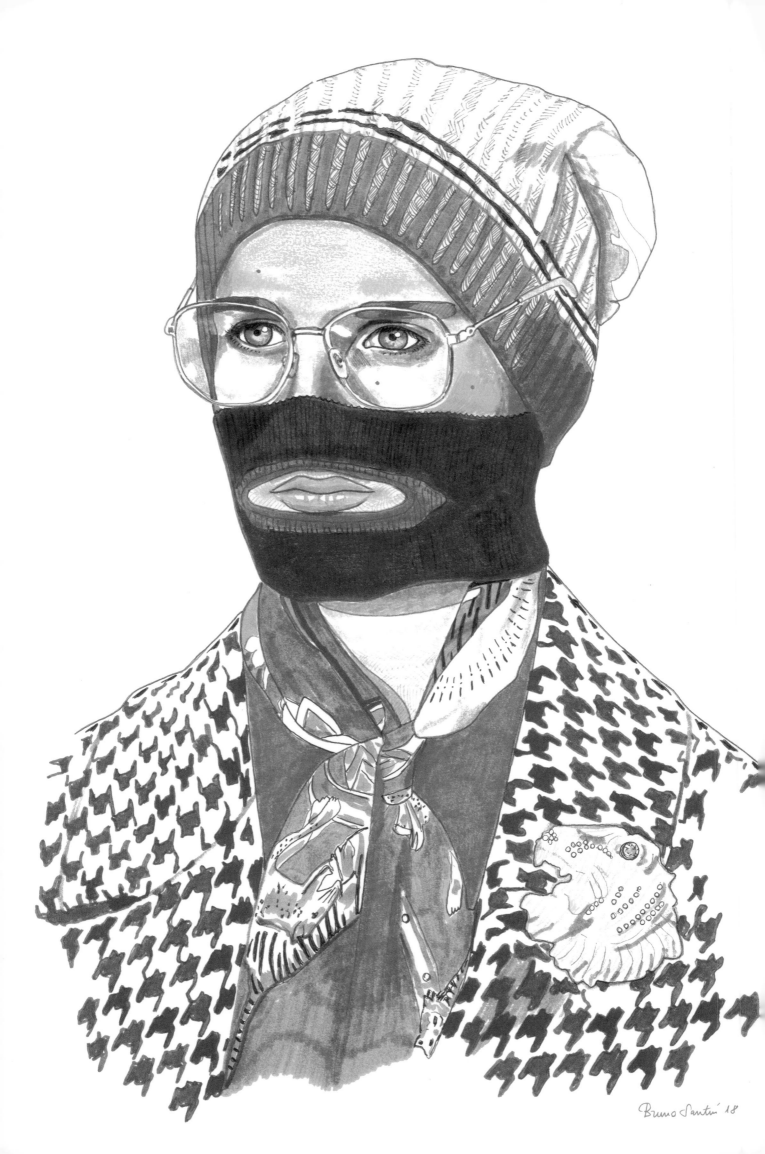

Bruno Santini '18

> "I really like to walk around and look (if I can force myself to detach from my iPhone), and I take pictures of things I find interesting on the way—people, places, or situations that I can afterwards draw." *for Culture Trip*

BRUNO SANTÍN

@aquilesbrunosantin

Bruno Santín is a freelance illustrator who lives and works in Ponferrada, Spain, where he was born in 1972. He studied textile design at the School of Applied Arts in León, where he worked in glass, sculpture, and fabric design. Upon graduating with distinction in 1999 he began defining his peculiar illustrational voice, which is characterized by a penchant for bearded men and accentuated by a distinct palette of reds and pinks. His fashion portraits often merge into wonderful abstract compositions: floral garlands, butterflies, jellyfish, or a fusion of technology. Santín creates imagery that absorbs both the folkloric and psychedelic. His practice involves creating multiple drawings simultaneously with pencil and paper. His work has appeared in numerous fashion and lifestyle publications, including *The Evening Standard Magazine* (London), *IF Magazine* (Chile), and *Prizm*, Ohio's LGBTQ community magazine. With group and solo exhibitions to his name in his native Spain, Santín's

Bruno Santín ist ein freiberuflicher Illustrator, der in Ponferrada (Spanien) lebt und arbeitet, wo er 1972 geboren wurde. Er studierte Textildesign an der Kunstgewerbeschule in León, und arbeitete dort im Bereich Glas-, Skulpturen- und Stoffdesign. Nach seinem Abschluss mit Auszeichnung im Jahr 1999 begann er, seine eigentümliche Illustrationsstimme zu definieren, die sich durch eine Vorliebe für bärtige Männer auszeichnet und durch eine ausgeprägte Palette von Rot- und Rosatönen akzentuiert wird. Seine Modeporträts verschmelzen oft zu wunderbaren abstrakten Kompositionen: Blumengirlanden, Schmetterlinge, Quallen oder eine Fusion aus Technologien. Santín schafft Bilder, die sowohl das Folkloristische als auch das Psychedelische vereinen. Bei seiner Arbeitsweise entstehen mehrere Zeichnungen gleichzeitig mit Bleistift und Papier. Seine Arbeiten wurden in zahlreichen Mode- und Lifestyle-Publikationen veröffentlicht, zum Beispiel in *The Evening Standard Magazine* (London), *IF Magazine* (Chile)

Bruno Santín est un illustrateur freelance espagnol qui réside à Ponferrada, où il est né en 1972. Il a suivi des études de design textile à l'école d'arts appliqués de León, au cours desquelles il a eu l'occasion d'apprendre le travail du verre, la sculpture et la conception de tissus. Diplômé en 1999 avec les honneurs, il a commencé à façonner sa technique d'illustration et s'est forgé une voix caractérisée par son penchant pour les hommes barbus et une palette de rouges et de roses. Ses portraits de mode se convertissent souvent en de superbes compositions abstraites : guirlandes de fleurs, papillons, méduses ou fusion d'éléments en numérique. Santín produit une imagerie aux accents folkloriques et psychédéliques, travaillant à la fois sur plusieurs dessins au crayon. Ses œuvres sont parues dans de nombreuses publications de mode et de style de vie, dont *The Evening Standard Magazine* (Londres), *IF Magazine* (Chili) et *Prizm*, le magazine de la communauté LGBTQ de l'Ohio. Il a pris part à des expositions

growing portfolio and following can also be found on Istahu, Pinterest, and Instagram.

und *Prizm*, Ohios LGBTQ-Community-Magazin. Mit Gruppen- und Einzelausstellungen in seinem Heimatland Spanien ist Santíns wachsendes Portfolio und die steigende Anzahl seiner Follower auch auf Istahu, Pinterest und Instagram zu beobachten.

collectives et en solo sous son nom dans son Espagne natale, et son portfolio est aussi disponible en ligne sur Istahu, Pinterest et Instagram.

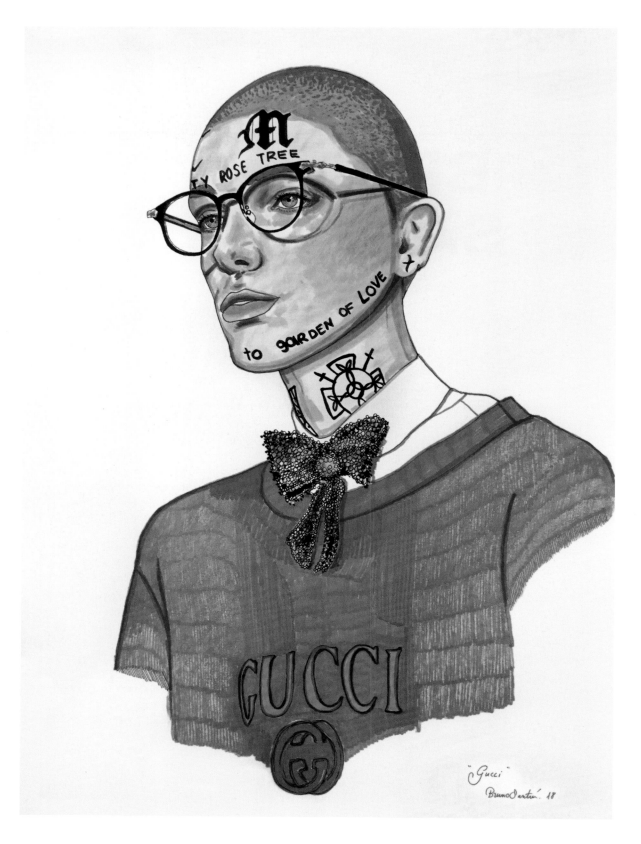

BRUNO SANTÍN

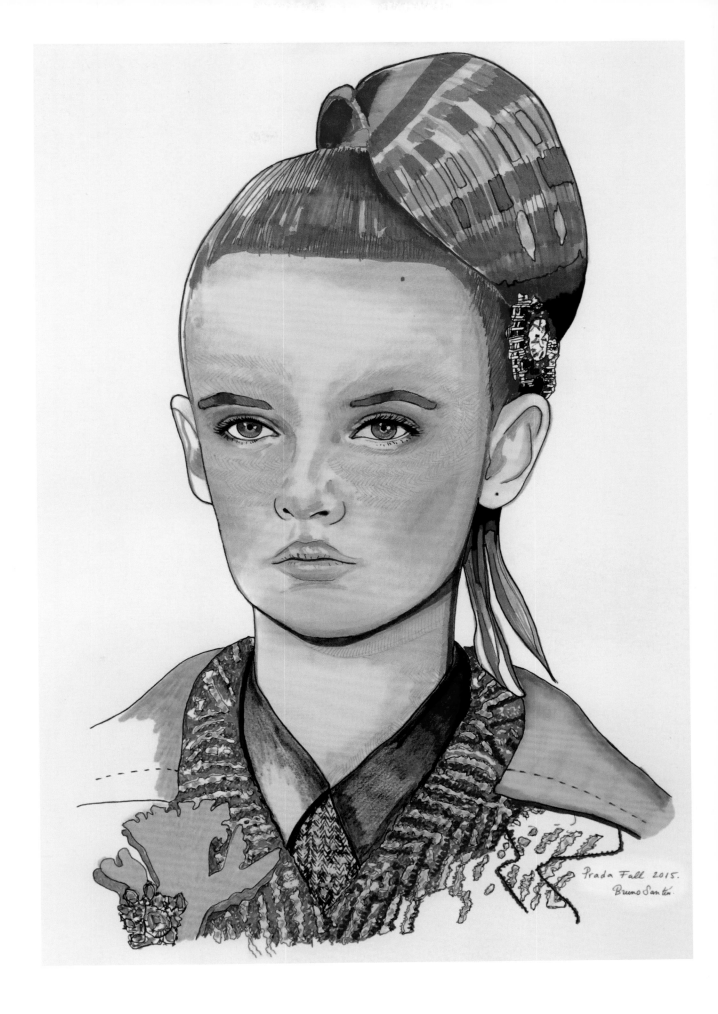

Prada Fall 2015.
Bruno Santos.

Prada, Fall 2015
Personal work; hand drawing,
ink, pen, pencil

opposite and p. 540
Gucci, 2018
Personal work; hand drawing,
ink, pen, pencil

Gucci, 2017
If, online magazine;
hand drawing, ink pen, pencil

Gucci, Fall 2016
Personal work; hand drawing,
ink, pen, pencil

Gucci, 2018
Personal work; hand drawing,
ink, pen, pencil

BRUNO SANTÍN

Selected Exhibitions: 2018, *Cuatro Años/Four Years*, solo show, Fabero Exhibition Center, León · 2017, *Pulse: Acts of Love and Kindness*, group show, Fort Mason Center, San Francisco · 2016, *Barbitour*, solo show, Museo Arqueológico de Cacabelos, León · 2016, *Bearded Men, Mermaids & Sailors*, solo show, La Doce Gallery, A Coruña · 2013, *Stone, Paper, Scissors, and Polaroids*, solo show, La Casona Fundación, León

Selected Publications: 2018, *Shangay* magazine, Editorial Imani, Spain · 2018, *Dear* magazine, Influencer Press & EdM Revistas, Spain · 2018, *If* magazine, Aly Bonilla, Chile · 2018, *Prizm* magazine, Carol Zimmer Clark, USA · 2017, *Mitologia. Rafa Spunky*, DK Records, Spain

> "In my work I try to put the same emphasis on the visual landscape as I do on the conceptual elements, which together comprise the whole."

KOREN SHADMI

WWW.KORENSHADMI.COM · @korenshadmi

Born in Kfar Saba, Israel, in 1981, Koren Shadmi is an Israeli-American illustrator and cartoonist. He enrolled in a comics course at the age of nine, then his first graphic novel *Profile 107* was released in Israel at the age of 17, produced in collaboration with his mentor, the famed cartoonist, Uri Fink. In 2002, after completing his military service, Shadmi moved to New York and attained a bachelor's degree in illustration at the School of Visual Arts in 2006, where he now teaches the subject. His style traverses from simple to detailed, while sustaining a minimal quality. A unique palette of color gradients and background textures gives his pictures an uncanny, tonal light. This otherworldly quality has appeared on numerous captivating covers and editorials for such publications as *The New York Times*, *The Wall Street Journal*, *Spin*, and *Popular Mechanics*. In addition, Shadmi's graphic books and short stories—exploring themes of love, relationships, and death—have featured in various anthologies; one example is the short story "Antoinette"

Koren Shadmi, geboren 1981 in Kfar Saba (Israel), ist ein israelisch-amerikanischer Zeichner und Karikaturist. Mit neun Jahren schrieb er sich für einen Comickurs ein und veröffentlichte im Alter von 17 Jahren seine erste Graphic Novel, *Profile 107*, in Israel, produziert in Zusammenarbeit mit seinem Mentor, dem berühmten Cartoonisten Uri Fink. Nach seinem Militärdienst zog Shadmi 2002 nach New York und machte 2006 seinen Bachelorabschluss in Illustration an der School of Visual Arts, wo er inzwischen selbst dieses Fach unterrichtet. Sein Stil reicht von einfach bis detailliert, bleibt dabei aber immer minimalistisch. Eine einzigartige Palette von Farbverläufen und Hintergrundtexturen verleiht seinen Bildern ein unheimliches tonales Licht. Diese außerweltliche Qualität ist auf zahlreichen fesselnden Titelseiten und Editorials von Veröffentlichungen, wie der *New York Times*, dem *Wall Street Journal*, *Spin* und *Popular Mechanics* erschienen. Außerdem sind Shadmis grafische Bücher und Kurzgeschichten – in denen

Né en 1981 à Kfar Saba, en Israël, Koren Shadmi est un illustrateur et dessinateur humoristique israélo-américain. À l'âge de neuf ans, il s'est lancé dans la bande dessinée et a publié en Israël sa première BD intitulée *Profile 107* quand il avait 17 ans, produite en collaboration avec son mentor, le célèbre dessinateur Uri Fink. En 2002, au terme de son service militaire, Shadmi s'est installé à New York : il y a obtenu en 2006 une licence en illustration à la School of Visual Arts, où il enseigne aujourd'hui sa matière. Son style peut être simple ou détaillé, mais toujours d'une qualité minimale. Ses images dégagent une lumière tonale troublante grâce à la palette de dégradés et les textures qu'il emploie pour le fond. Cette nature d'un autre monde est apparue dans grand nombre de couvertures et d'éditoriaux, pour des publications comme *The New York Times*, *The Wall Street Journal*, *Spin* et *Popular Mechanics*. Shadmi a par ailleurs signé des BD et des nouvelles traitant de l'amour, des relations et de

in *Best American Comics 2009*, taken from his first graphic novel *In the Flesh*. Amongst other accolades, his distinctive style has earned him a Society of Illustrators Albert Dorne Medal and a Rudolph Dirks Award at the German Comic Con.

er Themen wie Liebe, Beziehungen und Tod erforscht – in verschiedenen Anthologien erschienen, zum Beispiel wurde die Kurzgeschichte „Antoinette", aus seiner ersten Graphic Novel *In the Flesh*, in *Best American Comics 2009* veröffentlicht. Sein unverwechselbarer Stil brachte ihm unter anderem die Albert-Dorne-Medaille der Society of Illustrators ein und einen Rudolph-Dirks-Preis der German Comic Con.

la mort qui ont été incluses dans diverses anthologies : tel est le cas de son histoire intitulée « Antoinette », extraite de sa première BD *In the Flesh* et parue dans *Best American Comics 2009*. Entre autres distinctions, son style caractéristique lui a valu une médaille Albert Dorne de la Society of Illustrators et un Rudolph Dirks Award au German Comic Con.

KOREN SHADMI

Chop & Change, 2017
Newsweek, magazine cover; digital

opposite
Streetwear Woman, 2018
Women's World Daily, magazine; digital

p. 546
Bionic, 2018
Personal work, book cover; digital

The Last Words, 2016
Hadassah Magazine; digital

opposite
Sanctuary, 2017
Personal work, poster; digital

Selected Exhibitions: 2010, *Society of Illustrators*, group show, New York · 2009, *Comics & Paintings*, solo show, BilBalBul Festival, Bologna · 2009, *Artists Against the War*, group show, Society of Illustrators, New York

Selected Publications: 2013, *Tribute to Robert Crumb*, Edition 52, Germany · 2010, *Society of Illustrators*, USA · 2009, *Best American Comics*, Houghton Mifflin, USA · 2008, *Communication Arts*, USA

> "I think in illustration, you have to start with a certain style, even if it's not as concrete as it will be ten years later on. My ultimate goal is to be respected by my peers and people I respect." *for Adobe*

YUKO SHIMIZU

WWW.YUKOART.COM · @yukoart

Yuko Shimizu was born in Tokyo in 1963. She spent her early teens living in New York before returning to Japan. After receiving a degree in marketing and advertising at Waseda University she worked in corporate PR for over a decade before abandoning her career to follow her true path. In 1999, she arrived back in New York, where she enrolled in the School of Visual Art's "Illustration as Visual Essay" program. Soon after completing an MFA in 2003, she gained her first commission for *The Village Voice*, and has since developed a highly successful career as a visual artist. Referencing both traditional and contemporary Japanese culture—from traditional woodblock printing to manga graphic novels—Shimizu's style reflects her background viewed with a Western eye. Her process is labored and meticulous. Working with ink on paper and only coloring in Photoshop, Shimizu creates imagery that is dreamlike, sometimes erotic, and always beautiful. The breadth of her output is evidenced by her client list, which includes Apple, Adobe,

Yuko Shimizu wurde 1963 in Tokio geboren, verbrachte ihre frühen Teenagerjahre aber in New York, bevor sie nach Japan zurückkehrte. Nachdem sie an der Waseda University einen Abschluss in Marketing und Werbung gemacht hatte, arbeitete sie über zehn Jahre lang in der Unternehmens-PR, bevor sie ihre Karriere aufgab, um ihrer wahren Berufung zu folgen. 1999 kam sie wieder nach New York zurück, wo sie sich für das Programm „Illustration als visuelle Erzählung" an der School of Visual Art einschrieb. Kurz nachdem sie 2003 ihren Master abgeschlossen hatte, erhielt sie ihren ersten Auftrag für *The Village Voice* und kann seitdem auf eine sehr erfolgreiche Karriere als bildende Künstlerin zurückblicken. In Anlehnung an die traditionelle wie auch die zeitgenössische japanische Kultur – vom traditionellen Farbholzschnitt bis zu Manga-Grafikromanen – spiegelt Shimizus Stil ihren Hintergrund wider, den sie mit westlichen Augen betrachtet. Ihr Arbeitsprozess ist mühsam und akribisch. Shimizu arbeitet

Yuko Shimizu est née à Tokyo en 1963 et a passé son adolescence à New York, pour ensuite repartir vivre au Japon. Une fois diplômée en marketing et publicité à l'université Waseda, elle a travaillé dans les relations publiques pendant plus de dix ans avant d'abandonner cette carrière et suivre sa véritable voie. En 1999, vivant de nouveau à New York, elle s'est inscrite au programme « L'illustration comme essai visuel » proposé par la School of Visual Arts. Peu de temps après l'obtention en 2003 d'un master en beaux-arts, elle a reçu une première commande de *The Village Voice* et a depuis mené une brillante carrière comme artiste visuelle. Avec des références à la culture japonaise traditionnelle comme contemporaine allant des estampes aux mangas, le style de Shimizu reflète ses origines, sur lesquelles elle pose un regard occidental. Son processus créatif est laborieux et méticuleux. Elle travaille à l'encre sur papier et ajoute les couleurs dans Photoshop, produisant une imagerie onirique, parfois érotique et toujours

the Library of Congress, MTV, and Nike. Shimizu produced 70 covers for the DC Comics series *Unwritten*. In 2009, she collaborated on an 11-panel mural project in Brooklyn with graphic designer Stefan Sagmeister as part of the Robin Hood Foundation Library Initiative, and produced limited-edition T-shirts for Gap's AIDS charity line Product RED. The same year, Shimizu was listed in *Newsweek Japan* as one of "100 Japanese People The World Respects." In 2018, she won the prestigious Society of Illustrators Hamilton King Award. Shimizu lives and works in midtown Manhattan and also teaches at her alma mater.

mit Tusche auf Papier, koloriert nur in Photoshop und schafft so Bilder, die traumähnlich, manchmal erotisch und immer schön sind. Der Umfang ihres Schaffens wird durch ihre Kundenliste belegt, auf der sich zum Beispiel Apple, Adobe, die Kongressbibliothek, MTV und Nike finden. Shimizu hat 70 Cover für die DC-Comics-Serie *Unwritten* produziert. 2009 arbeitete sie zusammen mit dem Grafikdesigner Stefan Sagmeister in Brooklyn an einem elf-tafeligen Wandbild als Teil der Bibliotheksinitiative der Robin-Hood-Stiftung und produzierte T-Shirts in limitierter Auflage für Gaps AIDS-Wohltätigkeitslinie Product RED. Im selben Jahr wurde Shimizu in *Newsweek Japan* als eine der „100 japanischen Personen, die die Welt respektiert", aufgeführt. Im Jahr 2018 gewann sie den prestigeträchtigen Hamilton King Award der Society of Illustrators. Shimizu lebt und arbeitet in Midtown Manhattan und unterrichtet an ihrer Alma Mater.

remarquable. L'étendue de ses œuvres est proportionnelle à sa liste de clients, qui incluent Apple, Adobe, la bibliothèque du Congrès, MTV et Nike. Shimizu a créé 70 couvertures pour la série *Unwritten* de DC Comics. En 2009, elle a participé à Brooklyn à un projet de peinture murale sur 11 panneaux aux côtés du concepteur graphique Stefan Sagmeister dans le cadre de la Robin Hood Foundation Library Initiative ; elle a par ailleurs réalisé en édition limitée des T-shirts pour la marque caritative Product RED de Gap. La même année, Shimizu a été retenue par *Newsweek Japan* parmi les « 100 Japonais respectés dans le monde ». En 2018, elle a remporté le prestigieux Hamilton King Award de la Society of Illustrators. Elle réside actuellement dans le quartier Midtown de Manhattan et enseigne à son alma mater.

YUKO SHIMIZU

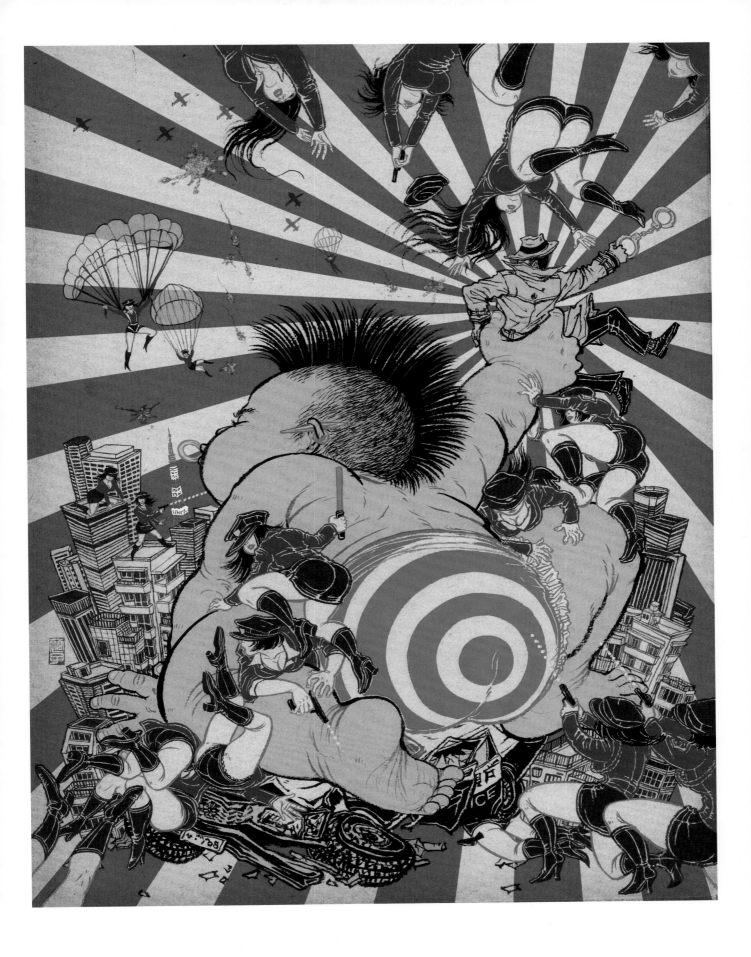

Deka vs. Deka, 2015
Maximum the Hormone, DVD sleeve;
ink drawing, digital; art direction:
Maximum the Ryo-kun,
Keiichi Iwata (7 Stars Design)

opposite
Through the Water Curtain, 2018
Japanese Tales, The Folio Society,
book; ink drawing, digital;
art direction: Raquel Leis Allion

p. 552
Untitled, 2017
Fully Booked, cover;
ink drawing, digital;
art direction: Jaime Daez

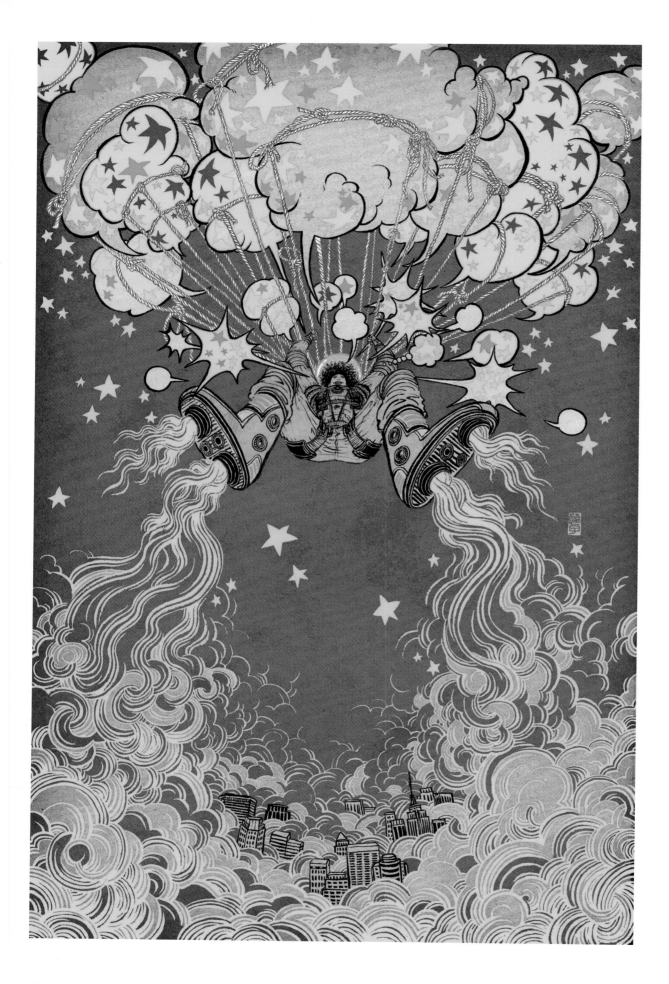

Fly Higher, 2016
School of Visual Arts, poster;
ink drawing, digital;
supervision: Anthony Rhodes,
art direction: Gail Anderson,
design: Ryan Durinick

opposite
Camp Festival, 2015
Poster and key graphic;
ink drawing, digital;
art direction: Bram Timmer

YUKO SHIMIZU

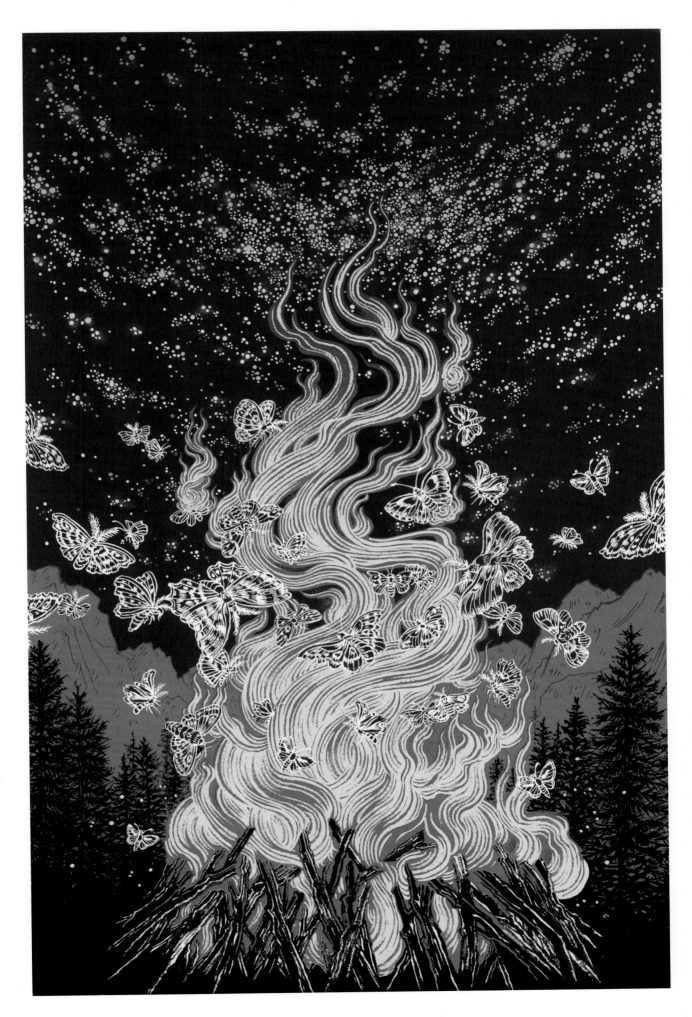

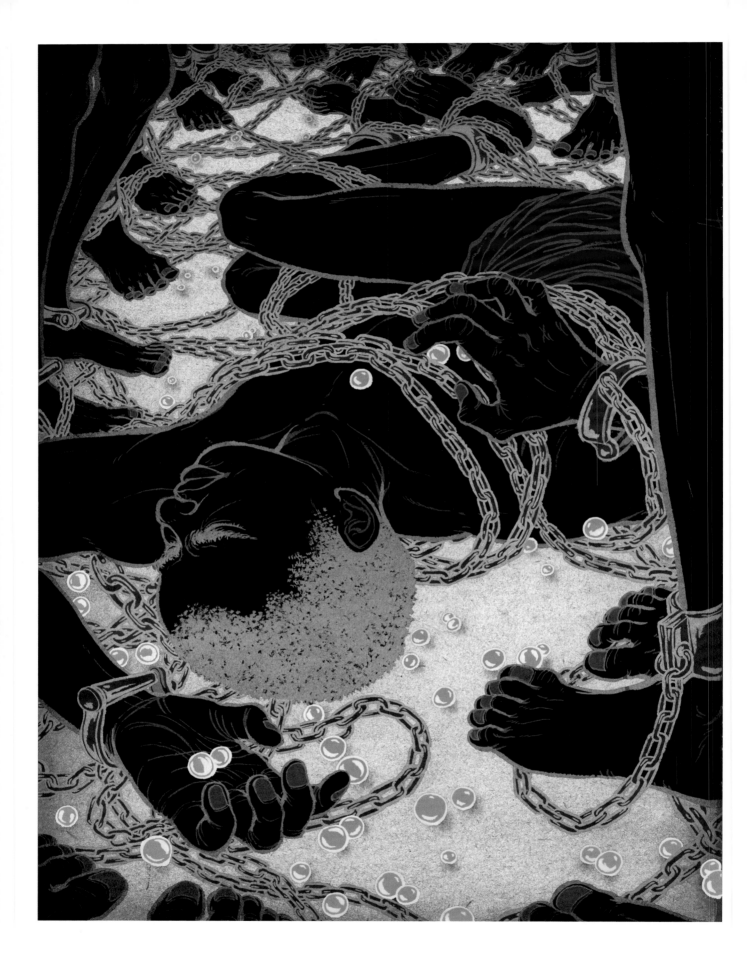

above and opposite

The Young King, 2018
Oscar Wilde Fairytales,
book, Beehive Books;
ink drawing, digital;
art direction: Josh O'Neill

YUKO SHIMIZU

Selected Exhibitions: 2018, *Art as Witness Political Graphics 2016–2018*, group show, SVA Chelsea Gallery, New York · 2015, *Wrath of the Gods*, group show, Philadelphia Museum of Art · 2015, *Samurai by Giant Robot*, group show, Worcester Art Museum, Massachusetts · 2013, *Sketchtravel*, group show, Kyoto International Manga Museum · 2011, *Rolling Stone and the Art of the Record Review*, group show, Society of Illustrators, New York

Selected Publications: 2016, *Living with Yuko Shimizu,* Roads, Ireland · 2014, *Fifty Years of Illustration,* Laurence King Publishing, United Kingdom · 2011, *Yuko Shimizu,* Gestalten, Germany · 2008, *Things I have Learned in Life So Far,* Abrams, USA · 2008, *Illustration: A Visual History,* Abrams, USA

> "My graphic approach to illustration has been inspired by some of the great poster artists of the first half of the 20th century. Those who have influenced me the most have done so because of their simplicity and directness."

LAURA SMITH

WWW.LAURASMITHART.COM

Through her eclectic, revivalist style, Laura Smith harks back to a bygone era of advertising illustration—an era of Art Deco travel ads and post-war baby boomers. Minimal graphic forms are married with American folk or 1950s–60s typography, which add to the endearing sense of retro-pastiche. Born in Texas, Smith grew up in a mid-century modern house on Manhattan Beach in Southern California. A sense of color, light, and nostalgia would leave an indelible imprint on her creative mind. An early inspiration was the work of Donald "Putt" Putnam, her best friend's father—an artist and instructor at Pasadena's ArtCenter College of Design, which Smith would later attend. After graduating she moved to New York, where she spent more than a decade evolving her distinct visual voice before returning to the West Coast, and eventually settling in Hollywood with her husband, the renowned font designer Michael Doret—with whom she has collaborated. From advertising billboards to magazine covers, Smith's

Mit ihrem eklektischen, wiederbelebenden Stil blickt Laura Smith auf eine längst vergangene Ära der Werbeillustration zurück – eine Ära der Art-déco-Reisewerbung und der Babyboomer der Nachkriegszeit. Minimale grafische Formen werden mit amerikanischem Volkstum oder der Typografie der 1950er- bis 60er-Jahre verbunden, was das bezaubernde Gefühl von Retro-Pastiche erzeugt. Die in Texas geborene Smith wuchs in einem modernen Mid-Century-Haus am Manhattan Beach in Südkalifornien auf. Ein Gefühl von Farbe, Licht und Nostalgie sollten einen bleibenden Eindruck in ihrem kreativen Denken hinterlassen. Eine frühe Inspiration war die Arbeit von Donald „Putt" Putnam, dem Vater ihres besten Freundes – einem Künstler und Ausbilder am ArtCenter College of Design in Pasadena, das Smith später besuchen sollte. Nach ihrem Abschluss zog sie nach New York, wo sie mehr als ein Jahrzehnt auf die Entfaltung ihrer visuellen Stimme verwandte, bevor sie an die Westküste zurückkehrte und sich mit

À travers son style éclectique s'inspirant de modes passées, Laura Smith rappelle une époque révolue de l'illustration publicitaire, marquée par les annonces Art déco de voyage et les baby-boomers de l'après-guerre. Elle combine des formes graphiques minimales à des éléments du folklore américain et à la typographie des années 1950-60, l'ensemble contribuant à donner des pastiches rétro. Née au Texas, Smith a grandi dans une maison du milieu de siècle à Manhattan Beach, en Californie du Sud ; de cette époque, les couleurs, la lumière et une touche de nostalgie ont marqué son esprit créatif d'une empreinte indélébile. Petite, elle a été inspirée par les œuvres du père de sa meilleure amie, qui n'était autre que Donald « Putt » Putnam, artiste et professeur à l'Art Center College of Design à Pasadena où elle a plus tard étudié. Son diplôme en poche, elle est partie vivre à New York, où elle a pendant plus d'une décennie perfectionné son originale voix visuelle. Repartie sur la côte Ouest, elle s'est installée à Hollywood avec son

illustrations have been commissioned for a stream of major clients, including *Businessweek*, Ferrari, HBO, Macy's Thanksgiving Parade, the New York Knicks, the World Series, and The Walt Disney Company. To boot, her work has been recognized in such leading publications as *Illustration* and *Communication Arts*, with posters in the permanent collections of the Museum of Modern Art (MoMA), the Smithsonian Institution, and the Victoria and Albert Museum.

ihrem Ehemann, dem bekannten Fontdesigner Michael Doret, mit dem sie zusammenarbeitete, in Hollywood niederließ. Von Werbetafeln bis hin zu Zeitschriftencovern wurden Smiths Illustrationen von einer Reihe wichtiger Kunden in Auftrag gegeben, zum Beispiel *Businessweek*, Ferrari, HBO, Macy's Thanksgiving Parade, den New York Knicks, der World Series und der Walt Disney Company. Außerdem wurde ihre Arbeit in führenden Publikationen wie *Illustration* und *Communication Arts* gewürdigt. Ihre Poster befinden sich in den permanenten Sammlungen des Museum of Modern Art (MoMA) und der Sammlung der Smithsonian Institution sowie im Victoria and Albert Museum.

mari, le célèbre concepteur de polices de caractères Michael Doret, avec qui elle a collaboré. De panneaux publicitaires aux couvertures de magazines, les illustrations de Smith ont été sollicitées par de nombreux clients importants, dont *Businessweek*, Ferrari, HBO, la Macy's Thanksgiving Parade, les Knicks de New York, les Worlds Series et The Walt Disney Company. Ses créations sont parues dans de grandes publications comme *Illustration* et *Communication Arts*, et ses affiches figurent dans les collections permanentes du Museum of Modern Art (MoMA), de la Smithsonian Institution et du Victoria and Albert Museum.

LAURA SMITH

Highland Village-Housewares, 2007
Lamp post poster; acrylic;
art direction: Chris Hill

opposite
Falcon Diner, 2005
Ameristar Casino, poster; acrylic

p. 560
Solpuri Furniture, 2017,
brochure; digital; art direction:
Roland Althammer

The Future is Now, 2017
American Public Works Association,
poster; digital; art direction: Jon Dilly

opposite top
Graphic Artists Guild Handbook,
2014, book cover; acrylic;
art direction: Sarah Love

opposite bottom
Strongman, 2017
Personal work; digital

LAURA SMITH

Selected Exhibitions: *Art of the Kentucky Derby*, solo show, Kentucky Derby Museum, Louisville, USA · *Society of Illustrators*, group show, New York · *AIGA*, group show, New York · *New York Art Directors Club*, group show · *American Pop Culture Images Today*, group show, La Foret, Tokyo

Selected Publications: *A Century of Olympic Posters*, Victoria and Albert Museum, United Kingdom · *Society of Illustrators*, USA · *Illustration Magazine*, Seibundo Shinkosha Publishing, Japan · *Gráfica*, Oswaldo Miranda, Brazil · *Communication Arts*, Patrick Covne, USA

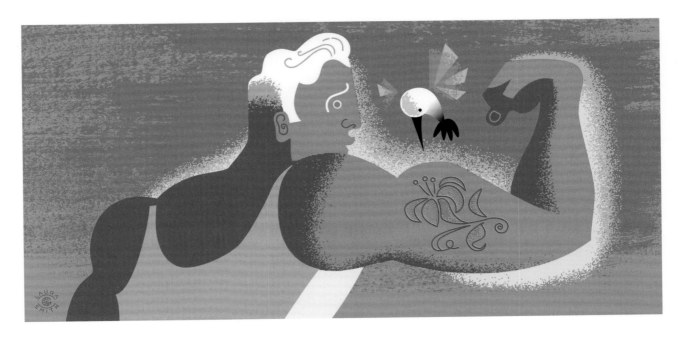

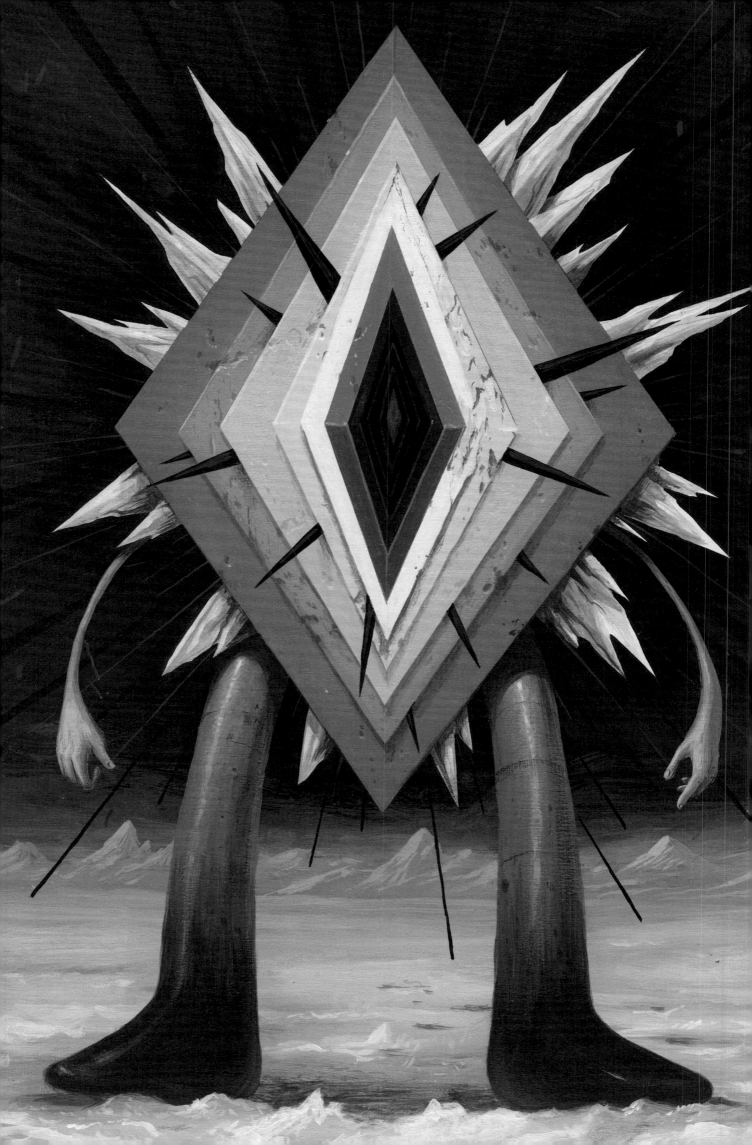

> "I'm not trying to fit into any scene, I'm just trying to create work that I'm proud of. My work gets grouped in with the underground artists—graffiti, illustration, hot rod, skate, comics, etc.—and I know many of these people so maybe I am part of the movement. I'll let someone else decide." *for Webesteem*

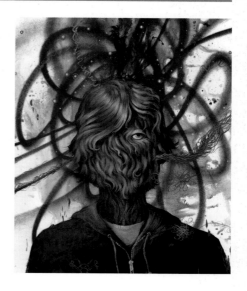

JEFF SOTO

WWW.JEFFSOTO.COM · @jeffsotoart

Born in Fullerton, Orange Co., California, in 1975, Jeff Soto grew up in a family of outdoor enthusiasts. Getting his first skateboard at the age of nine introduced him to the world of graffiti and illegal street art, whilst a staple diet of film and television—the likes of *Star Wars* and *Robotech*—further fed into his visual language. In high school he formed a graffiti crew with a friend and began stencilling his signature "Sotofish." Under the aliases of "Kilo" and "Trek" he began to "bomb," "tag," and create "pieces," eventually teaming up with artist Maxx242, with whom he would form Bashers Crew on the Los Angeles scene. A decade-long hiatus followed in 1999 after Soto received an associate degree in arts from Riverside City College. He then majored in illustration at ArtCenter College of Design in Pasadena, earning a BFA with distinction in 2002. When he channeled his concepts into commercial illustration, Soto's highly detailed, colorful style, which connects pop surrealism with street art, soon began to reel in prized commissions for the

Jeff Soto wurde 1975 in Fullerton, Orange County (Kalifornien) geboren und wuchs in einer Familie von Outdoor-Enthusiasten auf. Als Neunjähriger lernte er mit seinem ersten Skateboard die Welt des Graffitis und der illegalen Straßenkunst kennen, während eine Grundnahrung aus Film und Fernsehen – wie *Star Wars* und *Robotech* – ebenfalls seine Bildsprache nährte. In der Highschool bildete er mit einem Freund eine Graffiti-Crew und begann, mit seiner Stencil-Signatur „Sotofish" zu unterschreiben. Unter den Aliasen „KILO" und „TREK" begann er, „Bombs", „Tags" und „Pieces" zu erstellen, wobei er sich manchmal mit dem Künstler Maxx242 zusammentat, mit dem er in der Szene von Los Angeles die Bashers Crew bildete. 1999 folgte eine zehnjährige Pause, nachdem Soto am Riverside City College ein Associate Degree in Kunst erworben hatte. Anschließend studierte er am ArtCenter College of Design in Pasadena und erhielt 2002 einen Bachelor mit Auszeichnung. Als er seine Konzepte in kommerzielle Illustrationen

Né en 1975 à Fullerton, dans le comté d'Orange en Californie, Jeff Soto a grandi dans une famille adepte des activités en plein air. Il a eu son premier skateboard à l'âge de neuf ans et découvert ainsi l'univers des graffiti et du street art illégal ; en parallèle, sa consommation de films et de télévision (comme La *Guerre des étoiles* et *Robotech*) a alimenté son langage visuel. Au lycée, il faisait des graffiti avec un ami et a commencé à peindre au pochoir sa signature « Sotofish ». Sous les pseudonymes « KILO » et « TREK », il s'est mis à « bomber », à « tagger » et à créer des « œuvres », s'associant à l'artiste Maxx242 pour former la Bashers Crew et se faire connaître à Los Angeles. Il a arrêté en 1999, une interruption de dix ans après l'obtention d'un BTS artistique du Riverside City College. Il s'est ensuite spécialisé en illustration à l'Art Center College of Design à Pasadena, décrochant une licence avec les honneurs en 2002. Quand il a mis ses idées au service de l'illustration commerciale, dans un style coloré et très détaillé

likes of United Airlines, Disney, and rock bands like Pearl Jam and Soundgarden. In 2010, Sota returned to graffiti (though he considers himself a "muralist") and has since created pieces around the world. Soto exhibits regularly in galleries and museums as well as urban, public spaces. His work has been showcased in two monographs, *Potato Stamp Dreams* (2005) and *Storm Clouds* (2009). He lives and works in Riverside, where he continues to instruct at his alma mater.

umsetzte, zog Sotos detailreicher, farbenfroher Stil, der Pop-Surrealismus mit Street Art verbindet, begehrte Aufträge von Unternehmen wie United Airlines, Disney und Rockbands wie Pearl Jam und Soundgarden an. 2010 kehrte er zum Graffiti zurück (obwohl er sich selbst als „Wandmaler" bezeichnet) und hat seitdem Werke auf der ganzen Welt geschaffen. Soto stellt regelmäßig in Galerien und Museen sowie im städtischen und öffentlichen Raum aus. Seine Arbeiten wurden in zwei Monografien gezeigt: *Potato Stamp Dreams* (2005) und *Storm Clouds* (2009). Er lebt und arbeitet in Riverside, wo er weiterhin an seiner Alma Mater unterrichtet.

mariant surréalisme pop et street art, il a très vite reçu d'importantes commandes de clients comme United Airlines, Disney et les groupes de rock Pearl Jam et Soundgarden. En 2010, Sota est revenu aux graffiti (même s'il se définit comme un « muraliste »), réalisant des œuvres dans le monde entier. Il expose régulièrement dans des galeries et des musées, ainsi que dans des espaces publics urbains. Son travail a été présenté dans les monographies *Potato Stamp Dreams* (2005) et *Storm Clouds* (2009). Il réside actuellement à Riverside, où il continue d'enseigner à son alma mater.

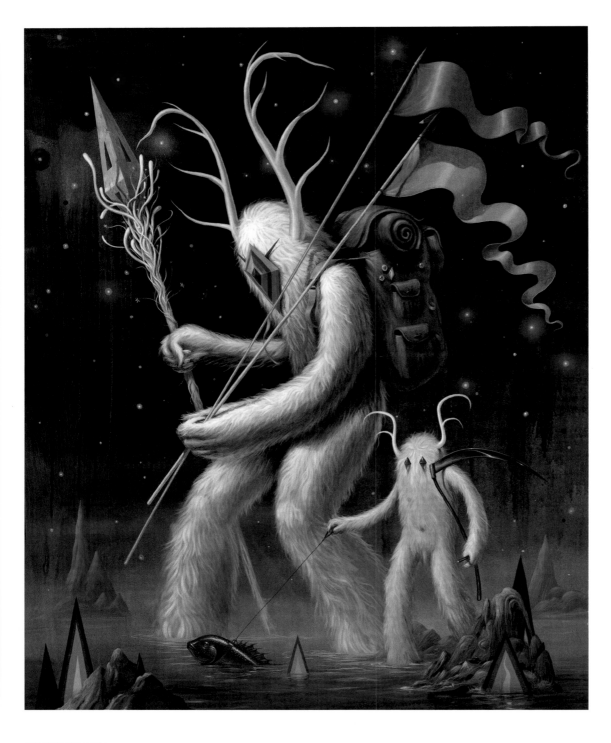

The Cat, 2015
Personal work;
acrylic on wood

right
Night Flight, 2015
Personal work;
acrylic on wood

opposite
Night Walkers, 2015
Personal work;
acrylic on wood

p. 566
Winter Nights, 2016
Personal work;
acrylic on wood

opposite

Tree of Love, 2015
Personal work;
acrylic on wood

Red Terrarium Keeper, 2016
Personal work;
acrylic on wood

JEFF SOTO

Selected Exhibitions: 2017, *The Sotofish Society*, solo show, Jonathan LeVine Projects, New York · 2015, *Nightgardens*, solo show, Merry Karnowsky Gallery, Los Angeles · 2013, *Fire Within*, solo show, Bunsen Goetz Gallerie, Nuremberg · 2009, *Inland Empire*, solo show, Stolen Space Gallery, London · 2001, *Potato Stamp*, solo show, New Image Art, Los Angeles

Selected Publications: 2019, *Staf Magazine*, Staf Malaga, Spain · 2015, *Very Nearly Almost*, magazine, VNA London, United Kingdom · 2009, *Stormclouds: Jeff Soto*, Murphy Books, USA · 2009, *Juxtapoz*, High Speed Publications, USA · 2005, *Potato Stamp Dreams: Jeff Soto*, Murphy Books, USA

BONOBO

RALPH STEADMAN

WWW.RALPHSTEADMAN.COM · @steadmanart

Renowned for his trademark slash and splatter technique, British artist Ralph Steadman is one of the most imitated illustrators and political caricaturists today. With a style that blends the Abstract Expressionism of Jackson Pollock with the grotesque figures of Francis Bacon, Steadman exaggerates his subjects using a sardonic detonation of humor that reveals the absurdity and psychosis of the human condition. Born in Wallasey, in 1936, and raised in North Wales, Steadman attended East Ham Technical College and the London College of Printing in the 1960s. During this period he began garnering attention for his contributions to the satirical magazines *Punch* and *Private Eye*, and to newspapers like *The Daily Telegraph* and *The New York Times*. Steadman is most recognized for his long association with American journalist and writer Hunter S. Thompson, for whom he illustrated several articles and books, most notably the 1971 roman à clef *Fear and Loathing in Las Vegas: A Savage Journey to the Heart of the*

Der britische Künstler Ralph Steadman, der für sein Markenzeichen, die „Slash and Splatter"-Technik, bekannt wurde, ist heute einer der am meisten nachgeahmten Illustratoren und politischen Karikaturisten. Mit einem Stil, der den abstrakten Expressionismus von Jackson Pollock mit den grotesken Figuren von Francis Bacon verbindet, überhöht Steadman seine Objekte mit einer sardonischen Detonation des Humors, die die Absurdität und Psychose der Conditio humana offenbart. Steadman wurde 1936 in Wallasey geboren und wuchs in Nordwales auf. In den 1960er-Jahren besuchte er das East Ham Technical College und das London College of Printing. In dieser Zeit erregten seine Beiträge in Satirezeitschriften wie *Punch* und *Private Eye* und Zeitungen wie dem *Daily Telegraph* und der *New York Times* viel Aufmerksamkeit. Steadman ist vor allem für seine langjährige Zusammenarbeit mit dem amerikanischen Journalisten und Schriftsteller Hunter S. Thompson bekannt, für den er mehrere Artikel und

Célèbre pour sa technique caractéristique à base de giclées et d'éclaboussures, l'artiste britannique Ralph Steadman est l'un des illustrateurs et caricaturistes politiques les plus imités du moment. Son style mêle l'expressionnisme abstrait de Jackson Pollock et les personnages grotesques de Francis Bacon : Steadman exagère ses sujets avec une explosion sournoise d'humour qui révèle toute l'absurdité et la psychose de la condition humaine. Né en 1936 à Wallasey, il a grandi dans le pays de Galles du Nord et étudié au East Ham Technical College et au London College of Communication dans les années 1960. C'est à cette époque qu'il a commencé à attirer l'attention avec ses contributions dans les magazines satiriques *Punch* et *Private Eye* et dans des journaux comme *The Daily Telegraph* et *The New York Times*. Steadman s'est surtout fait un nom pour sa collaboration de longue date avec le journaliste et écrivain américain Hunter S. Thompson, pour lequel il a illustré plusieurs articles

American Dream. His erratic visual style complemented the savage wit and high-octane gonzo journalism of Thompson. Throughout his career, Steadman has visually reinterpreted several literary classics, from Lewis Carroll's *Alice in Wonderland* to Ray Bradbury's *Fahrenheit 451*. A wine lover, he traveled extensively during the 1990s creating illustrations for Oddbins alcohol retail chain, and he subsequently produced three travel books: *The Grapes of Ralph* (1992), *Still Life with Bottle* (1994), and *Untrodden Grapes* (2005). His numerous accolades include the 1979 American Institute of Graphic Arts Illustrator of the Year award, a BBC Design Award, and a number of D&AD mentions. In 2012, Steadman was the subject of a documentary *For No Good Reason*, directed by Charlie Paul, which premiered that year at the London Film Festival. He lives and works in the village of Loose in Kent.

Bücher illustrierte, insbesondere 1971 den Schlüsselroman *Fear and Loathing in Las Vegas: A Savage Journey to the Heart of the American Dream* (Angst und Abscheu in Las Vegas. Eine wilde Reise ins Herz des amerikanischen Traums). Sein erratischer visueller Stil ergänzte Thompsons grausamen Witz und hyperdynamischen, exzentrischen Journalismus. Im Laufe seiner Karriere hat Steadman mehrere literarische Klassiker visuell neu interpretiert, so Lewis Carrolls *Alice im Wunderland* und Ray Bradburys *Fahrenheit 451*. Als Weinliebhaber reiste er in den 1990er-Jahren ausgiebig, um Illustrationen für die Alkoholhandelskette Oddbins herzustellen, und produzierte anschließend drei Reisebücher: *The Grapes of Ralph* (1992), *Still Life with Bottle* (1994) und *Untrodden Grapes* (2005). Zu seinen zahlreichen Auszeichnungen zählen 1979 der American Institute of Graphic Arts Illustrator of the Year Award, ein BBC Design Award und eine Reihe von D&AD-Nennungen. Im Jahr 2012 war Steadman Gegenstand der Dokumentation *For No Good Reason* unter der Regie von Charlie Paul, die im gleichen Jahr auf dem London Film Festival Premiere feierte. Er lebt und arbeitet im Dorf Loose in Kent.

et ouvrages, notamment son roman à clef sorti en 1971 et intitulé *Las Vegas Parano*. Le style visuel imprévisible de Steadman d'un côté, et l'esprit mordant et le journalisme gonzo explosif de Thompson de l'autre, s'avèrent totalement complémentaires. Au fil de sa carrière, Steadman a réinterprété en images plusieurs classiques de la littérature, de *Les Aventures d'Alice au pays des merveilles* de Lewis Carroll à *Fahrenheit 451* de Ray Bradbury. Amateur de vin, il a beaucoup voyagé dans les années 1990 pour produire des illustrations pour la chaîne de détaillants de boissons alcoolisées Oddbins. Il a aussi réalisé trois livres de voyage autour du sujet: *The Grapes of Ralph* (1992), *Still Life with Bottle* (1994) et *Untrodden Grapes* (2005). Il a reçu de nombreuses distinctions, dont en 1979 le prix d'illustrateur de l'année de l'American Institute of Graphic Arts, un BBC Design Award et plusieurs nominations aux D&AD. En 2012, il a fait l'objet du documentaire *For No Good Reason*, réalisé par Charlie Paul et récompensé cette année-là au festival du film de Londres. Steadman réside aujourd'hui dans le village anglais de Loose, dans le Kent.

American Swamp Pet, 2018
Rolling Stone, magazine;
Indian ink, acrylic, dirty water

opposite
The Invention of the Wheel, 1987
The Big I Am, book; Indian ink,
pen, atomizer

p. 572
Bonobo and Little Guy, 2018
Critical Critters, book by Ceri Levy;
Indian ink, dirty water

TIPPING AT WILLMILLS

Walter White, 2014
Sony Television,
DVD collectors' sleeve;
Indian ink, dirty water

opposite
Frenchman on Bike, 1987
Oddbins Wine Merchants,
The Grapes of Ralph, catalogue
cover; Indian ink, dirty water

pp. 576–577
Tipping at Willmills, 2004
The Independent, magazine,
psychogeography series;
Indian ink, collage

Selected Exhibitions: 2016, *Retrospective*, solo show,
traveling exhibition, USA · 1992, *The Cutting Edge*, Barbican
Art Gallery, London · 1987, *Visagen und Visionem*, solo show,
Wilhelm Busch Museum, Hanover · 1986, *Alice and the
Paranoids*, solo show, Royal Festival Hall, London · 1984,
Between the Eyes, solo show, Royal Festival Hall, London

"Predominantly, I'm an illustrator—but then I work in so many different fields as well, [including] photography and fashion, and I also consider myself an artist." *for Digital Arts*

HATTIE STEWART

WWW.HATTIESTEWART.COM · @hattiestewart

In an era of Internet memes, London-based artist and illustrator Hattie Stewart has received attention for her "doodle-bombing," a technique she coined for customizing photographs and images with an array of bright, primary-colored characters and icons. Stewart's collection of cartoonish marks, characterized by wide eyes, love hearts, and bubble-gum-pink lips, play on a lexicon of graphic references from the early animations of Disney and Max Fleischer to 1970s decals, 80s typefaces, slot-machine cherries, and Mexican Day of the Dead designs. Her implements of choice are Posca pens. Stewart's anthropomorphisms have appeared in art and fashion mags from *Interview* to *Vogue*, for brands like Urban Outfitters and Marc by Marc Jacobs, and animated title cards for movies such as Charlie Lyne's film essay *Beyond Clueless* (2014). Her tongue-in-cheek characters have also featured in a pull-out book, *Living With: Hattie Stewart* (2016). The same year, she was invited to illustrate over a series of photographs

In einer Zeit der Internet-Memes hat die in London lebende Künstlerin und Illustratorin Hattie Stewart viel Aufmerksamkeit für ihr „Doodle-Bombing" erlangt, eine von ihr geprägte Technik, mit der sie Fotos und Bilder mit einer Reihe von hellen, primärfarbenen Zeichen und Symbolen individualisiert. Stewarts Sammlung cartoonesker Zeichen, gekennzeichnet durch große Augen, Liebesherzen und Kaugummirosafarbene Lippen, spielt auf eine ganze Enzyklopädie von Referenzen an, die von den frühen Animationen von Disney und Max Fleischer über Abziehbilder aus den 1970er-Jahren, Schriftarten aus den 80ern bis zu Spielautomaten-Kirschen und Designs zum mexikanischen Tag der Toten reichen. Ihre bevorzugten Werkzeuge sind Stifte der Marke Posca. Stewarts Anthropomorphismen sind in Kunst- und Modemagazinen, von *Interview* bis *Vogue* erschienen, sie arbeitete für Marken wie Urban Outfitters und Marc by Marc Jacobs und animierte die Zwischentitel für Filme wie Charlie Lynes filmischen

À l'ère des mèmes sur Internet, l'artiste et illustratrice londonienne Hattie Stewart s'est fait remarquée par son « doodle-bombing », une technique qu'elle a inventée pour retoucher des photographies et des images de personnes et d'icônes dans des couleurs primaires vives. Ses créations caricaturales, aux yeux écarquillés, assorties de symboles de cœur et aux lèvres rose bonbon, utilisent un éventail de références graphiques, des premières animations de Disney et Max Fleischer aux décalcomanies des années 1970, aux typographies des années 80, aux cerises des machines à sou et aux designs mexicains du Jour des morts. Créés de préférence à l'aide de marqueurs Posca, les anthropomorphismes de Stewart sont parus dans des revues d'art et de mode comme *Interview* et *Vogue*. Ils ont aussi servi pour l'image de marques comme Urban Outfitters et Marc by Marc Jacobs et dans des séquences d'ouverture, comme dans le documentaire de Charlie Lyne intitulé *Beyond Clueless* (2014).

of various performing artists, including Pharrell Williams, Katy Perry, and Queens of the Stone Age, to celebrate the tenth annual Apple Music Festival. Born into a creative family in Colchester, England, in 1988, she studied illustration at Kingston University and graduated in 2010. Stewart has exhibited her work in Los Angeles, Miami, New York, and Berlin.

Essay *Beyond Clueless* (2014). Ihre ironischen Charaktere bevölkerten auch ihr Buch *Living With: Hattie Stewart* (2016) mit herausnehmbaren Bildern. Im selben Jahr wurde sie eingeladen, eine Reihe von Fotografien verschiedener darstellender Künstler zu illustrieren, zum Beispiel Pharrell Williams, Katy Perry und Queens of the Stone Age, um das zehnte Apple Music Festival zu feiern. Sie wurde 1988 in eine kreative Familie im englischen Colchester hinein geboren. Sie studierte Illustration an der Kingston University und schloss 2010 ihr Studium ab. Stewart hat ihre Arbeiten in Los Angeles, Miami, New York und Berlin ausgestellt.

Ses personnages ironiques se retrouvent aussi dans le livre aux pages détachables *Living With: Hattie Stewart* (2016). La même année, elle a été invitée à illustrer une série de photographies de plusieurs artistes de scène, dont Pharrell Williams, Katy Perry et Queens of the Stone Age, à l'occasion du dixième Apple Music Festival. Née en 1988 à Colchester, en Angleterre, au sein d'une famille créative, elle a fait des études d'illustration à l'université Kingston et s'est diplômée en 2010. Stewart a exposé à Los Angeles, Miami, New York et Berlin.

Checkerboard, 2018
Personal work, postcard; digital

right
MAC Cosmetics, 2016
Advertisement; digital
illustration over photography

opposite
Tender Loving Care, 2018
Personal work; digital

p. 580
Ouch, 2017
Personal work; hand drawing

I Don't Have Time For This, 2018
Now Gallery; digital file which was
recreated into a painted installation

opposite
Squish, 2018
Personal work; hand drawing

HATTIE STEWART

Selected Exhibitions: 2018, *I Don't Have Time for This*, solo show, Now Gallery, London · 2016, *Untitled, Artist Rooms*, solo show, Firstsite Contemporary Gallery, Colchester · 2015, *Adversary*, solo show, House of Illustration, London · 2015, *Pattern/Shape/Fluidity/Versions*, solo show, No Walls Gallery, Brighton · 2015, *Dollhouse*, solo show, KK Outlet, London

Selected Publications: 2017, *Hattie Stewart's Doodlebomb Sticker Book,* Laurence King, United Kingdom · 2016, *Living With: Hattie Stewart,* Roads Publishing, United Kingdom

> "I work in a reductive way; it's kind of a safety net, like, 'Oh it's already kind of done, I'll just add a few things here and there.' It's intimidating otherwise." *for Cool Hunting*

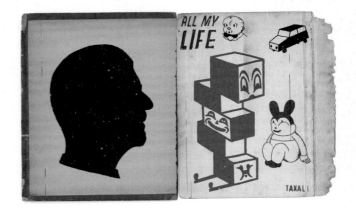

GARY TAXALI

WWW.GARYTAXALI.COM · @taxali

Through a hybrid style that mixes Depression-era comics and advertising graphics with Pop Art, celebrated Canadian artist and illustrator Gary Taxali has put his own unique stamp on contemporary visual culture. Taxali was born in 1968 in Chandigarh, India, and his family emigrated to Toronto when he was still a baby. Encouraged to draw from an early age, he enrolled in summer art classes before eventually studying illustration at the Ontario College of Art and Design (OCAD). Soon after graduating in 1991, he moved to New York and began working professionally and participating in group shows in the East Village. Upon his return to Canada a year later, his reputation was already spreading to the West Coast and in 2000, he had his first solo exhibition at the Anno Domini Gallery in San Jose. Throughout an illustrious career, Taxali has managed to bridge the gap between high art and pop culture. By reinterpreting graphic elements of the past, his work offers a fresh, satirical take on today's social issues. He works

Mit seinem hybriden Stil, der Comics und Werbegrafiken aus der Zeit der Großen Depression mit Pop-Art vermischt, hat der berühmte kanadische Künstler und Illustrator Gary Taxali der zeitgenössischen visuellen Kultur seinen eigenen Stempel aufgedrückt. Taxali wurde 1968 in Chandigarh (Indien) geboren, doch seine Familie emigrierte nach Toronto, als er noch ein Baby war. Er wurde früh zum Zeichnen ermutigt und schrieb sich für Sommerkunstkurse ein, bevor er am Ontario College of Art and Design (OCAD) Illustration studierte. Bald nach seinem Abschluss im Jahr 1991 zog er nach New York, wo er professionell zu arbeiten begann und an Gruppenausstellungen im East Village teilnahm. Als er ein Jahr später nach Kanada zurückkehrte, hatte sich sein Ruf bereits bis an die Westküste verbreitet, und im Jahr 2000 hatte er seine erste Einzelausstellung in der Anno Domini Gallery in San Jose. Während seiner illustren Karriere ist es Taxali gelungen, die Kluft zwischen hoher Kunst

Grâce à un style hybride qui mêle bandes dessinées et publicités de l'époque de la Grande Dépression au pop art, le célèbre artiste et illustrateur canadien Gary Taxali a marqué de son empreinte la culture visuelle contemporaine. Taxali est né en 1968 à Chandigarh, en Inde, et sa famille a émigré à Toronto quand il était encore un nourrisson. Encouragé à dessiner dès son plus jeune âge, il a pris des cours d'été d'art et fini par étudier l'illustration à l'Ontario College of Art and Design (OCAD). Peu après l'obtention de son diplôme en 1991, il a déménagé à New York où il a commencé à travailler et à participer à des expositions collectives dans l'East Village. À son retour au Canada un an plus tard, sa renommée était déjà parvenue jusqu'à la côte Ouest : en 2000 a eu lieu sa première exposition individuelle à la Anno Domini Gallery de San José, en Californie. Au fil d'une brillante carrière, Taxali a réussi à combler le fossé entre le grand art et la culture pop. En réinterprétant des éléments graphiques du passé, ses œuvres

with pencil, ink, and silkscreen, sometimes employing found objects. Applying art to surfaces stems from his childhood habit of drawing on walls, headboards, desks, and chairs. It comes as no surprise that his work has migrated onto designer products. He has created silk pocket squares for Canadian menswear brand Harry Rosen and released a range of toys and stationery. Among his numerous exhibitions, Taxali has showcased his work at the Whitney Museum of American Art, MondoPOP Gallery, and the Andy Warhol Museum. His clients range from Gap to Nintendo, and the Royal Canadian Mint to Sony. Taxali is a professor in the design faculty at OCAD.

und Popkultur zu überbrücken. Durch die Neuinterpretation grafischer Elemente aus der Vergangenheit, bietet seine Arbeit eine neue, satirische Sicht auf die heutigen gesellschaftlichen Themen. Er arbeitet mit Bleistift, Tusche sowie Siebdruck und verwendet manchmal Fundstücke. Die Angewohnheit, Kunst auf Oberflächen zu applizieren, stammt noch aus seiner Kindheit, in der er auf Wänden, Kopfenden von Betten, Schreibtischen und Stühlen zeichnte. Es ist also kein Wunder, dass seine Arbeit auf Designerprodukte übergegangen ist. Er hat Einstecktücher aus Seide für die kanadische Herrenmarke Harry Rosen entworfen und brachte Spielzeug und Schreibwaren heraus. Taxali wurden viele Ausstellungen gewidmet. Er präsentierte seine Arbeiten im Whitney Museum of American Art, in der MondoPOP Gallery und im Andy Warhol Museum. Seine Kunden reichen von Nintendo und der Royal Canadian Mint bis hin zu Sony. Taxali ist Professor an der Designfakultät der OCAD University.

apportent un regard original et satirique sur les problèmes sociaux actuels. Il travaille au crayon, à l'encre et par sérigraphie, se servant parfois d'objets trouvés. Le fait d'utiliser des surfaces comme base artistique lui vient de son enfance, habitué à dessiner sur les murs, les têtes de lit, les tables et les chaises. Rien de surprenant par conséquent à ce que son activité se soit orientée vers la conception de produits. Il a ainsi créé des pochettes en soie pour la marque canadienne de vêtements pour hommes Harry Rosen, ainsi que toute une gamme de jouets et d'articles de papeterie. Parmi les nombreuses expositions sont à retenir celles au Whitney Museum of American Art, à la MondoPOP Gallery et au Andy Warhol Museum. Ses clients incluent Gap, Nintendo, la Monnaie royale canadienne et Sony. Taxali enseigne actuellement à la faculté de design de l'OCAD.

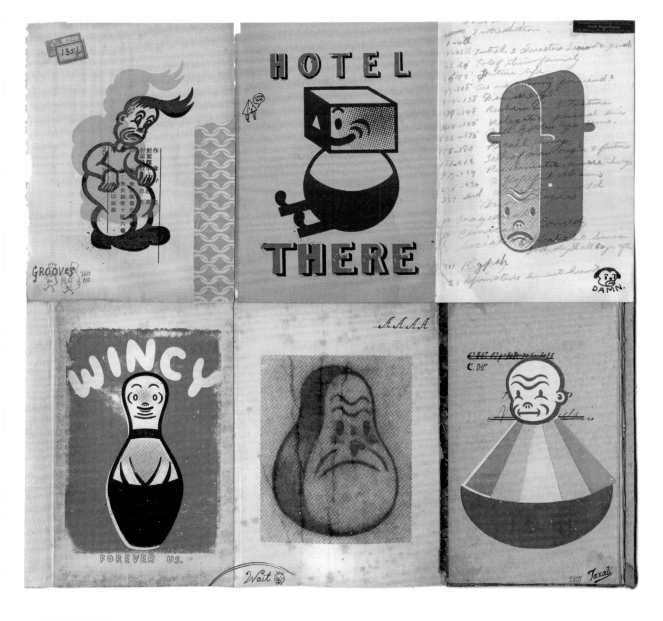

GARY TAXALI

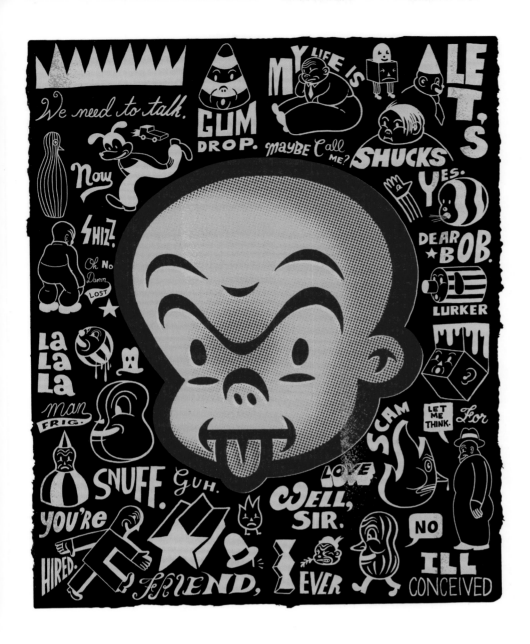

We Need to Talk, 2015
Personal work, *Jonathan
LeVine Gallery 10th Anniversary*,
group show; limited-edition
silkscreen print

right
Can We Stop, 2015
Personal work, *Hotel There*,
solo show; acrylic on Baltic birch

opposite
Wincy, 2015
Personal work, *Hotel There*,
solo show; mixed media

p. 586
GOP Paranoia, 2018
The Baffler, magazine;
mixed media; art director:
Lindsay Ballant

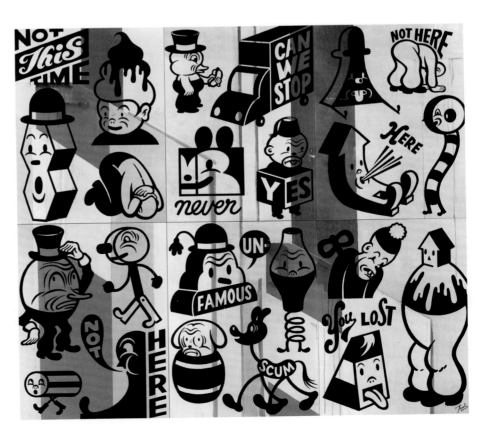

Selected Exhibitions: 2019, *Society of Illustrators*, group show, New York · 2017, *Winter Show*, group show, Gallery Arts Factory, Paris · 2016, *Unfamous*, solo show, First Canadian Place Gallery, Toronto · 2015, *Hotel There*, solo show, The Jonathan LeVine Gallery, New York · 2014, *Unforget Me*, solo show, The Jonathan LeVine Gallery, New York

Selected Publications: 2018, *Off the Wall. Art of the Absurd*, Victionary, China · 2017, *Happiness with a Caveat*, Chump, Canada · 2011, *This is Illustration! American Illustrators*, Monsa, Spain · 2011, *Mono Taxali*, 27_9, Italy · 2011, *I Love You, Ok?*, teNeus, Germany

Benny's Celebrates 30 Years, 2018
Benny's Burritos, menu cover;
mixed media; art director:
Ken Sofer

right
One Love, 2016
The New Yorker, magazine;
mixed media; art director:
Deanna Donegan

opposite
NO, 2018
Personal work; mixed media

GARY TAXALI

> "I spend a lot of time crafting each painting. I won't step away from it till I feel it's right. You are only as good as your last piece, that's just real."

MIKE THOMPSON

WWW.MIKETARTWORKS.COM · @miketartworks

Mike Thompson is an Illustrator and digital sculptor based in Washington, D.C. As a child, he drew comic-book characters immortalized by heavyweight artists like Neal Adam and John Byrne—an early passion that would kindle his creative path. The discovery of Norman Rockwell would prove another major influence on his future style of realism. Born in Aschaffenburg, Germany, in 1968, Thompson started out as a designer and art director in the fashion sector, working for the likes of Marc Ecko, Nike, and Timberland, before going freelance. For over two decades, he has embraced new technology in his practice, expanding from traditional 2D painting to 3D illustration. His digital expertise coupled with an affinity with contemporary American culture—notably the celebration of black identity—has made him a go-to artist in the realms of editorial, package, promo, and 3D displays. Thompson has created video game covers for EA, High 5, Volition, and 2K Sports, and has illustrated a host of characters for Marvel, such as Guardians of

Mike Thompson ist ein Illustrator und digitaler Bildhauer mit Sitz in Washington, D.C. Als Kind zeichnete er Comicfiguren, die von so hochkarätigen Künstlern wie Neal Adam und John Byrne inspiriert waren – eine frühe Leidenschaft, die seinen kreativen Weg prägen sollte. Auch die Entdeckung von Norman Rockwell sollte großen Einfluss auf die Entwicklung seines zukünftigen realistischen Stils haben. Der 1968 in Aschaffenburg geborene Thompson begann seine Karriere als Designer und Art Director im Modesektor und arbeitete zunächst für Marc Ecko, Nike und Timberland, bevor er freiberuflich tätig wurde. Seit über zwei Jahrzehnten hat er bereitwillig die neuen Technologien in seine Arbeit integriert und diese von der traditionellen 2-D-Malerei zur 3-D-Illustration erweitert. Sein digitales Fachwissen, gepaart mit einer Affinität für zeitgenössische amerikanischen Kultur – vor allem die der schwarzen Identität –, hat ihn zu einem Rundumkünstler im Bereich Editorial, Verpackungen, Promo- und 3-D-Displays

Mike Thompson est un illustrateur et sculpteur numérique installé à Washington. Enfant, il dessinait les personnages de BD immortalisés par de grandes pointures comme Neal Adam et John Byrne. Cette passion précoce a tracé son parcours créatif, puis la découverte de Norman Rockwell a grandement influencé son style réaliste. Né en 1968 à Aschaffenbourg, en Allemagne, Thompson a débuté comme concepteur et directeur artistique dans le milieu de la mode, travaillant pour des marques comme Marc Ecko, Nike et Timberland, avant de se mettre à son compte. Pendant plus de deux décennies, il a intégré à sa pratique les nouvelles technologies et est passé de la peinture en 2D à l'illustration en 3D. Sa maîtrise des outils numériques et son intérêt pour la culture américaine contemporaine, notamment l'hommage à l'identité noire, l'ont converti en un artiste prisé dans les domaines des éditoriaux, des emballages, des promotions et des présentations en 3D. Thompson a illustré des boîtes de jeux

the Galaxy and the Black Panther. He has also produced package art for G.I. Joe (Hasbro), and DC's Infinite Earths collection of toys by Mattel. His work has adorned editorials for a variety of music, entertainment, and sports magazines, including *XXL*, *Vibe*, and *Slam Presents Kicks*. In 2010, he created illustrations for a large-scale interactive fan wall for Verizon Wireless at the New Meadowlands Stadium in New Jersey. Thompson has also hosted webinars for Corel's "Painter Masters" series.

gemacht. Thompson hat Video-Game-Covers für EA, High 5, Volition und 2K Sports erstellt sowie eine Vielzahl von Charakteren für Marvel illustriert, etwa Guardians of the Galaxy und Black Panther. Er hat auch Verpackungskunst für G.I. Joe (Hasbro) geschaffen und DCs Infinite Earths Spielzeugsammlung von Mattel gestaltet. Seine Arbeit hat Editorials einer Vielzahl von Musik-, Unterhaltungs- und Sportmagazinen geschmückt, zum Beispiel *XXL, Vibe* und *Slam Presents Kicks*. 2010 erstellte er Illustrationen für eine große interaktive Fan-Wand für Verizon Wireless im New Meadowlands Stadium in New Jersey. Thompson veranstaltete auch Webinare für Corels „Painter Masters"-Reihe.

vidéo pour EA, High 5, Volition et 2K Sports, et il a créé une foule de personnages pour Marvel, comme les Gardiens de la galaxie et Black Panther. Il a également signé des emballages pour G.I. Joe (Hasbro) et la collection de jouets Infinite Earths de DC par Mattel. Son travail a paré les éditoriaux d'une variété de magazines de musique, de loisirs et de sports comme *XXL, Vibe* et *Slam Presents Kicks*. En 2010, il a réalisé des illustrations pour un mur interactif de grandes dimensions pour Verizon Wireless au MetLife Stadium dans le New Jersey. Thompson a par ailleurs organisé des webinaires pour la série « Painter Masters » de Corel.

MIKE THOMPSON

Hidden Figures, 2017
20th Century Fox,
Gravillis Inc; digital

opposite

Tracy Morgan, 2018
TBS, Gravillis Inc; digital

p. 592

Juggernaut, 2018
Upper Deck; digital

Cappie & Sheila, 2018 Miles Brown and DJ D Sharp, 2018
Nike; digital Nike; digital

MIKE THOMPSON

Selected Exhibitions: 2017, *Black History Exhibit*, group show, Smithsonian Museum, Washington, D.C. · 2011, *Hip Hop: A Cultural Odyssey*, group show, Grammy Museum, Los Angeles

Selected Publications: 2016, *Los Angeles Times Magazine*, Ross Levinsohn, USA · 2010, *Secrets of Corel Painter Experts*, Cengage Learning PTR, USA · 2008, *GQ* magazine, Condé Nast, USA · 2007, *Two Faced*, System Design Ltd, Hong Kong · 2005, *Illustration Now!*, TASCHEN, Germany


"I like to play with the surreal, since all the messages found in society are designed to communicate simply through logic and reason. I let the ideas emerge from deep down in my mind without trying to adapt them to reason or a specific concept."


for *Keep Rotating*

TRECO (DECO FARKAS)

WWW.DECOFARKAS.COM · @decotreco

André "Deco" Farkas (aka Treco) was born in São Paulo in 1985. Brought up around his renowned cinematographer father, Pedro Farkas, and Hungarian-born grandfather, photography pioneer Thomaz Farkas, visual creativity was in his blood from an early age. Whilst studying art at the Armando Alvares Penteado Foundation he quickly became disillusioned with the commercial art world and began his journey into street art, where he found his true artistic calling. Vibrant colors and wonderful hybrid figures with machine-like extensions define his cerebral style, while echoes of Hockney, Picasso, and de Chirico abound in his striking murals. The world of Farkas is a serendipitous journey into a surreal landscape. He has a natural disregard for intellectual analysis; his spontaneous approach flings open the doors of perception with no preconceived intent. He divides his time between painting at home on canvas and creating street murals—both distinctly separate approaches. Farkas' multidisciplinary

André „Deco" Farkas (aka Treco) wurde 1985 in São Paulo geboren. Aufgewachsen bei seinem Vater, dem bekannten Kameramann Pedro Farkas, und dem in Ungarn geborenen Großvater, dem Fotopionier Thomaz Farkas, lag ihm die visuelle Kreativität schon im Blut. Während seines Kunststudiums an der Armando Alvares Penteado Foundation war er bald enttäuscht von der kommerziellen Kunstwelt und begann seine Reise in die Street Art, in der er seine wahre künstlerische Berufung fand. Lebendige Farben und wunderbare Hybridfiguren mit maschinenartigen Erweiterungen prägen seinen vergeistigten Stil, während Hockney, Picasso und de Chirico in seinen markanten Wandgemälden anklingen. Die Welt von Farkas ist eine zufällige Reise in eine surreale Landschaft. Er hat eine natürliche Abneigung gegenüber der intellektuellen Analyse; seine spontane Vorgehensweise öffnet die Türen der Wahrnehmung ohne vorgefasste Absicht. Er teilt seine Zeit zwischen dem Malen zu Hause auf Leinwand und dem

André « Deco » Farkas (alias Treco) est né en 1985 à São Paulo. Il a grandi aux côtés d'un père cinématographe connu, Pedro Farkas, et est le petit-fils de Thomaz Farkas, un pionnier de la photographie d'origine hongroise ; autant dire qu'il portait donc en lui la créativité visuelle depuis son plus jeune âge. Lors de ses études d'art à la Fondation Armando Alvares Penteado, il a rapidement été désabusé par le monde de l'art commercial ; il a donc entrepris son voyage vers le street art, dans lequel il a trouvé sa véritable vocation artistique. Son style se caractérise par des couleurs vives et des figures hybrides aux extensions robotiques, avec une profusion de clins d'œil à Hockney, Picasso et de Chirico dans ses impressionnantes fresques. Le monde de Farkas est comme un périple inattendu dans un paysage surréaliste. Sa nature le fait fuir de toute analyse intellectuelle, son approche spontanée laissant la porte ouverte aux perceptions sans idées préconçues. Il partage son temps entre la peinture sur toile à

practice includes animation projects and, in 2016, in collaboration with film directors Daniela Thomas and Fernando Meirelles, and French company Plasticiens Volants, he created four large-scale inflatable hands for the opening of the Rio Olympics, exploring universal hand gestures as cultural references.

Erstellen von Straßenbildern auf Wänden auf – beide sind deutlich voneinander getrennte Ansätze. Farkas multidisziplinäre Arbeitsweise umfasst auch Animationsprojekte. Im Jahr 2016 schuf er in Zusammenarbeit mit den Filmregisseuren Daniela Thomas und Fernando Meirelles und der französischen Firma Plasticiens Volants für die Eröffnung der Olympischen Spiele in Rio vier großformatige aufblasbare Hände, die für die Erforschung universeller Handgesten als kulturelle Bezüge stehen.

son domicile et la réalisation de peintures murales dans la rue, deux approches clairement distinctes. La pratique multidisciplinaire de Farkas inclut des projets d'animation et, en 2016, en collaboration avec les réalisateurs Daniela Thomas et Fernando Meirelles et la compagnie de théâtre Les Plasticiens Volants, il a réalisé quatre mains gonflables de grande taille pour la cérémonie d'ouverture des Jeux olympiques de Rio, prenant comme références culturelles des gestes universels de la main.

TRECO (DECO FARKAS)

Untitled, 2018
Personal work; acrylic on canvas

right
Philip K. Dick, 2016
Companhia das Letras, book
cover; acrylic on canvas, digital

opposite
Brasília, 2018
Personal work; acrylic on canvas

p. 598
Hungry Pig, 2018
Zona Central, newspaper; acrylic

TRECO (DECO FARKAS)

Selected Exhibitions: 2017, *Tropicality*, group show, The Printspace Gallery, London · 2014, *Esse Treco*, solo show, Galeria Virgílio, São Paulo · 2013, *Recorte Transversal*, group show, Galeria Transversal, São Paulo

Selected Publications: 2018, *Zupi 57*, Brazil · 2013, *Graffiti São Paulo*, Ricardo Czapsky, Brazil · 2011, *Nuevo Mundo. Latin American Street Art*, Gestalten, Germany

Flaghead, 2018
Personal work, embroidery;
cotton shreds on cotton fabric

opposite top
Imperatriz Assassina, 2018
Jai Mahal e os Pacíficos da Ilha,
album cover; acrylic on canvas, digital

opposite bottom
Pontes para Si, 2015
Pitanga em Pé de Amora,
album cover; pen on paper

> "I start any new project by first gathering lots of beautiful imagery to help inspire me. I then grab a pencil and scribble down lots of ideas in my sketchbook, and once I have settled on an idea I develop it as much as possible."
>
> for *The Smuggler*

CHARLOTTE TROUNCE

WWW.CHARLOTTETROUNCE.CO.UK · @charlottetrounce

The immediate appeal of Charlotte Trounce's work lies in her peculiar ability to translate visually her observations of people, objects, greenery, and architectural spaces. With economy of form, and a carefully selected palette (often dominated by pastel hues), Trounce creates painterly compositions—hand-rendered using either traditional or digital media—that perfectly suit her eclectic client briefs. Born in Tunbridge Wells, England, in 1988, she studied illustration at University College Falmouth on the Cornish coast, receiving her BA (Hons) in 2011. Trounce has since gone on to establish herself as a noted artist-illustrator and educator. She has illustrated various publications, from an activity book to accompany the Barbican exhibition *The World of Charles and Ray Eames* (2016), to *Panorama Pops: The British Museum* (2017), a three-dimensional expanding pocket guide celebrating the institution's famous collection of artefacts. The same year, the release of her delightful children's alphabet book *A to Zakka*

Der unmittelbare Reiz von Charlotte Trounces Arbeit liegt in ihrer besonderen Fähigkeit, Beobachtungen von Menschen, Objekten, Grünflächen und architektonischen Räumen visuell zu übersetzen. Trounce schafft mit sparsamer Form und einer sorgfältig ausgewählten Farbpalette (oft dominiert von Pastelltönen) malerische Kompositionen – mit traditionellen oder digitalen Medien von Hand ausgeführt –, die perfekt zu ihrem vielseitigen Kundenstamm passen. Geboren 1988 im englischen Tunbridge Wells, studierte sie Illustration am University College Falmouth an der Küste von Cornwall und erhielt 2011 ihren Bachelor (mit Auszeichnung). Trounce konnte sich seitdem als bekannte Illustratorin und Pädagogin etablieren. Sie hat verschiedene Publikationen illustriert: von einem Activity Book zur Ausstellung *The World of Charles and Ray Eames* (Die Welt von Charles und Ray Eames) 2016 in der Barbican Gallery bis *Panorama Pops: The British Museum* (2017), einem dreidimensionalen expandierenden

L'intérêt immédiat que suscite le travail de Charlotte Trounce tient à son étrange capacité de rendre de façon visuelle ses observations des gens, des objets, de la végétation et des espaces architecturaux. Avec une simplicité formelle et une palette choisie avec soin (où dominent souvent les teintes pastels), Trounce crée des compositions picturales à la main, avec des techniques traditionnelles ou des outils numériques, qui répondent parfaitement aux demandes de ses clients éclectiques. Née en 1988 à Tunbridge Wells, en Angleterre, elle a étudié l'illustration à l'université de Falmouth sur la côte de Cornouaille et obtenu sa licence avec les honneurs en 2011. Depuis lors, Trounce s'est affirmée comme une artiste, une illustratrice et une éducatrice de talent. Elle a illustré diverses publications, comme un livre d'activités à l'occasion de l'exposition *The World of Charles and Ray Eames* (2016) au Barbican Centre, ou *Panorama Pops: The British Museum* (2017), un guide de poche dépliant en trois dimensions

coincided with an exhibition of objects and prints at Ground Floor Space, a dn&co gallery in London. In 2018, Trounce published *My Modern House*, a sourcebook for aspiring young architects. Her growing client list includes Art Fund, It's Nice That, *Financial Times*, Shiseido, and the Women's Prize for Fiction. Trounce has been an artist-in-residence at Seiunkan Farmer's Guest House in Komoro, Japan, and has led creative children's workshops at the Barbican in London. She lives and works in North London.

Taschenführer, der die berühmte Sammlung an Artefakten dieser Institution zeigt. Im gleichen Jahr brachte sie ihr entzückendes Alphabetbuch für Kinder: *A to Zakka* gleichzeitig mit einer Ausstellung von Objekten und Drucken im Ground Floor Space, einer dn&co-Galerie in London, heraus. Im Jahr 2018 veröffentlichte Trounce *My Modern House* (Mein modernes Haus), eine Quellensammlung für angehende junge Architekten. Ihre stetig wachsende Kundenliste umfasst Art Fund, It's Nice That, die *Financial Times*, Shiseido und den Women's Prize for Fiction. Trounce war Artist-in-Residence im Seiunkan Farmer's Guest House in Komoro (Japan) und hat kreative Kinderworkshops in der Barbican Gallery in London geleitet. Sie lebt und arbeitet in Nordlondon.

pour présenter la célèbre collection de l'institution. La même année, la sortie de son ravissant livre d'alphabet pour enfants *A to Zakka* a coïncidé avec une exposition d'objets et de tirages à la galerie londonienne Ground Floor Space de dn&co. En 2018, Trounce a publié *My Modern House*, un recueil de ressources pour les jeunes architectes en herbe. Sa liste croissante de clients inclut Art Fund, It's Nice That, *Financial Times*, Shiseido et le prix Women's Prize for Fiction. Trounce a été artiste en résidence à la Seiunkan Farmer's Guest House à Komoro, au Japon, et elle a organisé des ateliers créatifs pour enfants au Barbican Centre à Londres. Elle réside actuellement dans le quartier de North London.

CHARLOTTE TROUNCE

Japan, 2018
Personal work; digital

right
I Love Dick, 2018
Personal work, book cover;
acrylic and crayon on paper, digital

opposite
Paediatrics, 2018
One Medical, branding;
acrylic on paper, digital;
art direction: Moniker

p. 604
The Trees of San Francisco, 2018
Personal work, digital

Carrot, 2018
Shiseido, advertising;
acrylic on paper, digital;
art direction: Hiromi Shibuya

opposite top
Ian Callum, 2015
Nest Supper Club, *Wallpaper** event, live portrait
drawing; acrylics on paper; art direction: Anyways

opposite bottom
Do We Need Another Chair?, 2015
Fiera, magazine; acrylic and
crayon on paper, digital

CHARLOTTE TROUNCE

Selected Exhibitions: 2017, *A to Zakka*, solo show, Ground Floor Space, London

Selected Publications: 2019, *Barbican Monthly Guide,* Barbican, United Kingdom · 2018, *ES Magazine, The Evening Standard,* United Kingdom · 2016, *Artless: Art & Illustration by Simple Means,* Laurence King, United Kingdom · 2014, *The Parisianer,* Little Brown, United Kingdom · 2012, *Wrap Magazine,* United Kingdom

OLIVIA TWIST

WWW.YESOLIVIATWIST.COM · @yesoliviatwist

Hailing from East London (b. 1992), Olivia Mathurin-Essandoh (aka Olivia Twist) is an exemplar of the new generation of illustrators whose practice is informed by research-based approaches, community participation, and relational aesthetics. In her website statement, Twist cites her aims as being able to "provide her audience with 'the shock of the familiar' and encourage intergenerational discussion." Working with various media, including pen and ink, collage, print, and pencil, Twist contrasts the peripheral elements of everyday urban life—streets, walls, and entrances to apartment blocks—with subjects, notably black people, rendered in her distinctive style. After completing a BA in design for graphic communication at the University of the Arts London in 2015, Twist was accepted on the MA visual communication course at the Royal College of Art, which she completed in 2017. As a student and subsequent freelancer, her prolific output has been shown in over 70 exhibitions and events, including the Black British Girlhood

Die 1992 in East London geborene Olivia Mathurin-Essandoh (aka Olivia Twist) ist ein Beispiel der neuen Generation von Illustratoren, deren Praxis durch forschungsbasierte Ansätze, Gemeinschaftsbeteiligung und die Relationale Ästhetik geprägt ist. Twist nennt in ihrem Website-Statement als ihre Ziele, „ihr Publikum mit dem ‚Schock des Vertrauten' zu versehen und die Diskussion zwischen den Generationen anzuregen". Sie arbeitet in verschiedenen Techniken wie Stift und Tusche, Collage, Druck und Bleistift und kontrastiert in ihrem unverwechselbaren Stil die peripheren Elemente des urbanen Alltags – Straßen, Mauern und Eingänge zu Wohnblöcken – mit Motiven, vor allem schwarzen Menschen. Nach einem Bachelor in Design für grafische Kommunikation an der Universität der Künste in London im Jahr 2015 wurde Twist in den Masterkurs für visuelle Kommunikation am Royal College of Art aufgenommen, den sie im Jahr 2017 abschloss. Als Studentin und später als Freiberuflerin konnte sie ihre

Née à East London (1992, Olivia Mathurin-Essandoh (alias Olivia Twist) incarne parfaitement la nouvelle génération d'illustrateurs, avec une pratique éclairée par une démarche fondée sur la recherche, la participation collective et l'esthétique relationnelle. Dans son site Web, Twist explique son objectif de « confronter son public au ‹ choc du familier › et motiver une discussion intergénérationnelle ». Se livrant à plusieurs techniques, comme l'encre, le collage, la gravure et le crayon, Twist oppose les aspects périphériques du quotidien urbain (les rues, les murs et les entrées de blocs d'immeubles) aux personnes, principalement la population noire, pour rendre le tout dans un style distinctif. Après avoir reçu en 2015 une licence en design de communication graphique à l'University of the Arts London, Twist a été admise en maîtrise de communication visuelle au Royal College of Art, qu'elle a terminée en 2017. Pendant ses années universitaires, puis une fois installée à son compte, elle a vu sa

Festival at the Centre for Mental Health (London) and Diaspora Britain (Birmingham), both in 2015. Twist was a British Council-funded artist in residence for ColabNowNow X at the Fak'ugesi African Digital Innovation Festival in Johannesburg in 2017. A proactive arts facilitator, Twist regularly gives talks and conducts art and creative writing workshops. In 2017, Twist won the Quentin Blake Narrative Drawing Prize.

produktive Leistung in über 70 Ausstellungen und Veranstaltungen zeigen, zum Beispiel während des Black British Girlhood Festivals im Centre for Mental Health (London) und der Diaspora Britain (Birmingham), beide im Jahr 2015. Twist war 2017 ein vom British Council finanzierter Artist in Residence für ColabNowNow X beim Fak'ugesi African Digital Innovation Festival in Johannesburg. Als proaktive Kunstvermittlerin hält Twist regelmäßig Vorträge und führt Workshops für Kunst und kreatives Schreiben durch. Im Jahr 2017 gewann Twist den Quentin Blake Narrative Drawing Prize.

production prolifique présentée dans plus de 70 expositions et événements, dont le festival Black British Girlhood au Centre for Mental Health (Londres) et Diaspora Britain (Birmingham), tous deux en 2015. Twist a reçu des fonds du British Council en tant qu'artiste en résidence pour ColabNowNow X au Fak'ugesi African Digital Innovation Festival 2017 à Johannesbourg. Intervenante proactive en matière d'art, Twist a fréquemment donné des conférences et dirigé des ateliers d'art et d'écriture créative. En 2017, elle a remporté le Quentin Blake Narrative Drawing Prize.

Balcony Babes, 2018
ASOS, magazine; hand drawing

opposite top
Redbean Stew, 2016
Varoom, magazine; digital
print on cotton drill

opposite bottom
Move for *mi* to stretch *mi* foot, 2017
Personal work; hand drawing

p. 610
3:45 – Spice Hut #2, 2017
Personal work; hand drawing

Second Floor, 2016
Personal work; hand drawing

right
Boss, 2016
Personal work; hand drawing;
permanent marker on lino tile

opposite
5 Times a Day, 2018
Personal work, *Afropunk*,
solo show; hand drawing

Selected Exhibitions: 2018, *Reconstructing Practice*, group show, ArtCenter College of Design, Pasadena · 2018, *Don't Ask How We're Cousins*, solo show, Parkgate Road, London · 2017, *British Council*, group show, Faku'gesi African Digital Innovation Festival, Johannesburg · 2017, *3:45*, solo show, Wolverhampton Art Gallery, United Kingdom · 2015, *Acts of Looking, Africa Utopia*, group show, Southbank Centre, London

Selected Publications: 2018, *Varoom*, Association of Illustrators, United Kingdom · 2018, *OOMK*, United Kingdom · 2018, *ASOS*, United Kingdom · 2018, *Yellow*, United Kingdom · 2017, *Galdem*, United Kingdom

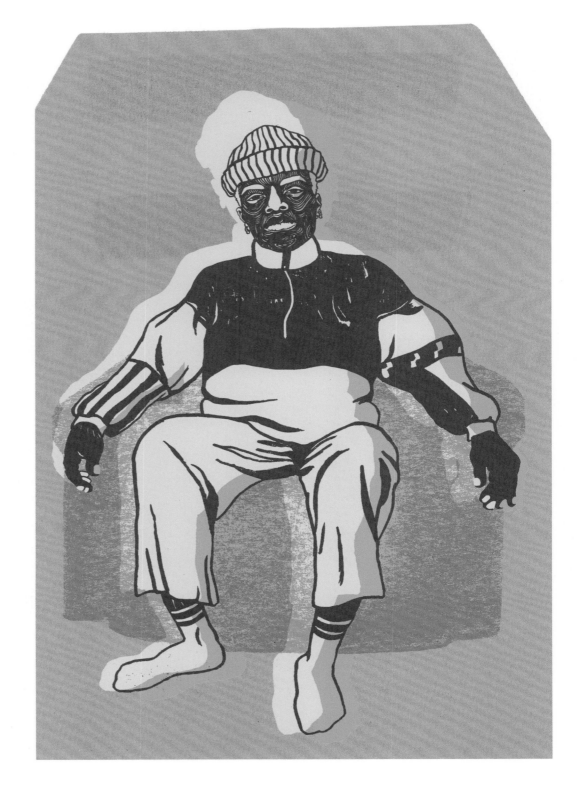

All Good, 2018
Print Social, illustration fair,
T-shirt design; screen print

opposite top
Brothers, 2018
Royal College of Art, mural;
hand drawing

opposite bottom
Telisha and Shahab, 2018
Royal College of Art, mural;
hand drawing

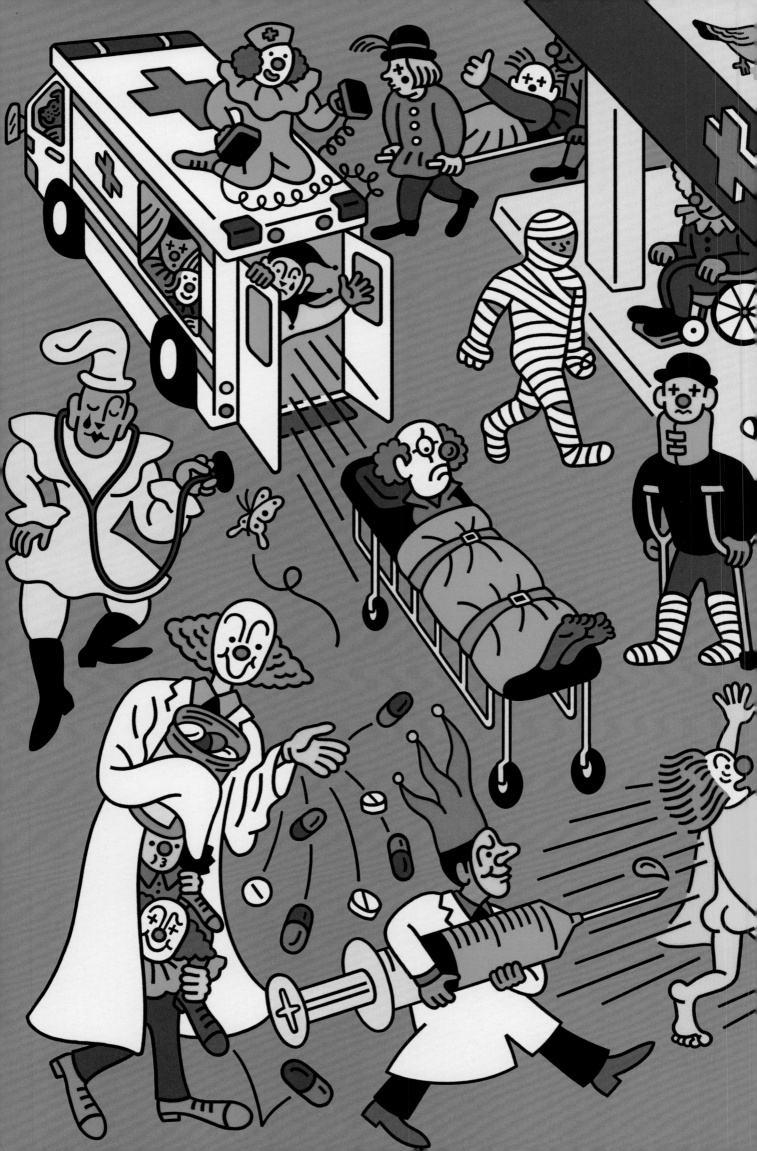

> "I love watching people on the street and observing the different ways they move about, look, and sound. Hours can go by as I imagine where they are going, what's in their luggage, and what their homes look like." *for AI-AP*

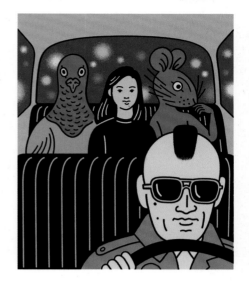

TOMI UM

WWW.TOMI.WORK · @tomium

Tomi Um's clean, wavy lines exude references to traditional Chinese art—and a self-confessed love of "curly noodles." Through meticulous execution, she is able to communicate a dense flow of graphic information in a clear and genial way—a talent that has seen her lauded with equal acclaim for both editorial and advertising work as well as her wonderfully conceived publications. Originally from Seoul, Haenim Um (b.1981) attended Parsons School of Design in New York, where she received her BFA in 2004. She returned home and briefly taught art but succumbed to the industry pull of New York. Um began developing her freelance illustration portfolio whilst working as a textile designer at Tom Cody Design—a practice that enhanced her skills in composition and coloring. Her landscapes and urban scenes are teeming with the hustle and bustle of everyday life. Um's style is also a result of her use of silkscreen, linocut, and scratchboard. Her personal projects are visual narratives that are filled with a wonderful

Tomi Ums klare Wellenlinien verweisen auf die traditionelle chinesische Kunst – und auf eine bekennende Liebe zu „gewellten Nudeln". Ihre akribische Ausführung erlaubt es ihr, einen dichten Fluss grafischer Informationen auf klare und angenehme Weise zu kommunizieren – eine Begabung, die ihr sowohl für ihre redaktionellen Arbeiten und Werbetätigkeiten als auch für ihre wunderbar konzipierten Publikationen viel Lob eingebracht hat. Haenim Um (geb. 1981) stammt ursprünglich aus Seoul und besuchte die Parsons School of Design in New York, wo sie 2004 ihren Bachelor erhielt. Sie kehrte nach Hause zurück und lehrte dort für kurze Zeit Kunst, erlag aber bald der Anziehungskraft der New Yorker Szene. Während ihrer Arbeit als Textildesignerin bei Tom Cody Design – einer Arbeit, die ihre Kompositions- und Farbkompetenz steigerte – begann Um, ihr Portfolio an freiberuflichen Illustrationen zu entwickeln. Ihre Landschaften und urbanen Szenen zeigen die Hektik des Alltags. Ums Stil

Les lignes nettes et ondulées de Tomi Um renvoient à l'art traditionnel chinois et à son amour déclaré pour les « nouilles bouclées ». Suivant une exécution méticuleuse, elle parvient à transmettre un flux dense d'informations graphiques avec une grande clarté. Ce talent lui a valu des éloges unanimes pour ses œuvres éditoriales et publicitaires, ainsi que pour ses publications d'une conception remarquable. Originaire de Séoul, Haenim Um (1981) a reçu de la Parsons School of Design à New York une licence en beaux-arts en 2004. Rentrée au pays, elle a brièvement enseigné l'art, avant de succomber à l'appel de la scène new-yorkaise. Travaillant à son compte, Um a alors commencé à développer son portfolio de projets d'illustration tout en exerçant comme créatrice textile chez Tom Cody Design, une expérience qui lui a permis de perfectionner ses compétences en composition et coloriage. Ses paysages et ses scènes urbaines transmettent parfaitement le tohu-bohu du quotidien. Elle a également recours à la

array of Buddhist imagery and anthropomorphic characters. Notable works include her screenprinted comic series, *The Noodle Monk* (2008), her curated and illustrated issue of Italian art magazine *Un Sedicesimo* (2010)—printed as a single folded typographic sheet—and *Little Opera* (2011), a limited-edition silkscreened accordion book. She has illustrated *Billboard* magazine and Fab.com, and has been a regular contributor to the "The Ethicist" column of *The New York Times*. Um has been recognized in *Print* magazine's *New Visual Artists Annual* (2010), and as one of the recipients of the Art Directors Club Young Guns title (New York, 2011). She currently lives in Brooklyn.

resultiert auch aus ihrer Verwendung von Siebdruck, Linolschnitt und Scratchboard. Ihre persönlichen Projekte sind visuelle Erzählungen, die mit einem wundervollen Spektrum buddhistischer Bildsprache und anthropomorpher Charaktere gefüllt sind. Zu ihren bemerkenswerten Werken zählen die Siebdruck-Comicserie *The Noodle Monk* (2008), ihre kuratierte und illustrierte Ausgabe des italienischen Kunstmagazins *Un Sedicesimo* (2010) – als einmal gefaltetes typografisches Blatt gedruckt – und *Little Opera* (2011), ein Siebdruck-Leporello in limitierter Auflage. Sie hat das *Billboard*-Magazin und Fab.com illustriert und liefert regelmäßig Beiträge in der Kolumne „The Ethicist" in der *New York Times*. Um wurde vom *Print*-Magazin im *New Visual Artists Annual* (2010) ausgezeichnet und ist eine der Empfängerinnen des Art Directors Club Young Guns Award (New York, 2011). Sie lebt zurzeit in Brooklyn.

sérigraphie, à la linogravure et aux cartes à gratter. Pour ses projets personnels, elle réalise des histoires visuelles remplies d'une foule d'images bouddhistes et de personnages anthropomorphiques. Parmi ses grandes œuvres sont à retenir ses BD sérigraphiées *The Noodle Monk* (2008), le numéro qu'elle a conçu et illustré pour le magazine d'art italien *Un Sedicesimo* (2010) et qui a été imprimé sur une simple feuille pliée, et *Little Opera* (2011), un livre sérigraphié, plié en accordéon et imprimé en édition limitée. Elle a créé des illustrations pour le magazine *Billboard* et pour Fab.com, et ses contributions pour la colonne « The Ethicist » de *The New York Times* sont régulières. Um a été citée dans le numéro annuel *New Visual Artists* du magazine *Print* (2010) et elle a reçu un titre Art Directors Club Young Guns (New York, 2011). Elle réside actuellement à Brooklyn.

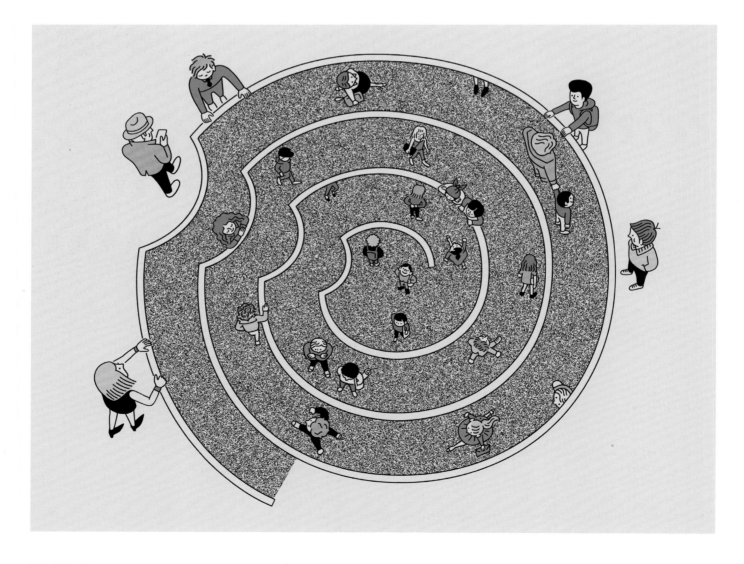

TOMI UM

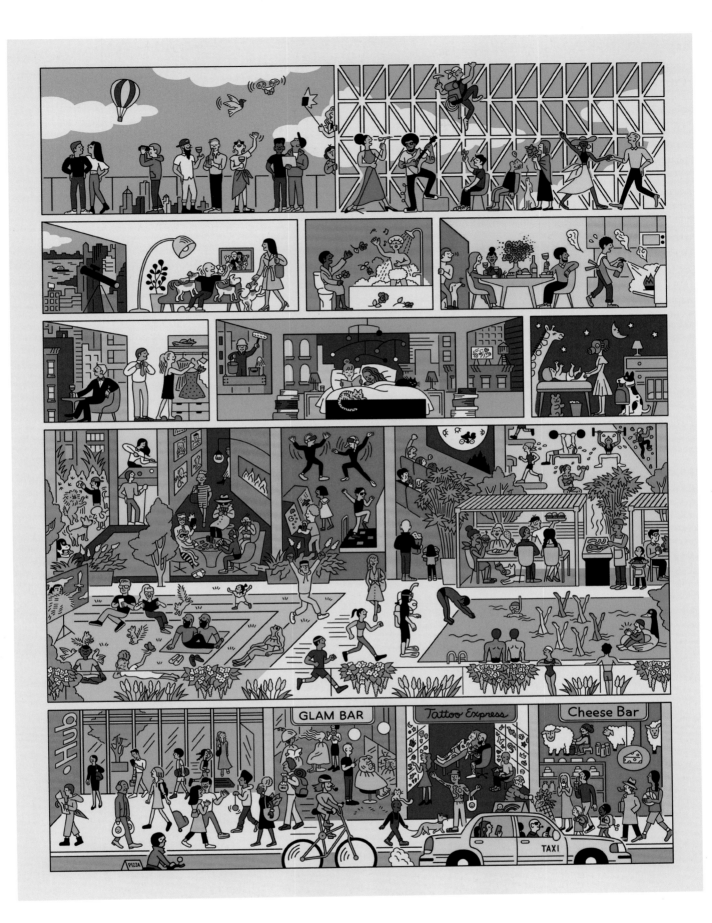

Apartment, 2016
The Hub, And Partners,
poster and website; digital

opposite
The Guggenheim is…, 2016
Guggenheim Museum, website; digital

p. 618
Hospital, 2018
Stern, magazine; digital

pp. 622–623
Bedford Station, 2018
Personal work, print; digital

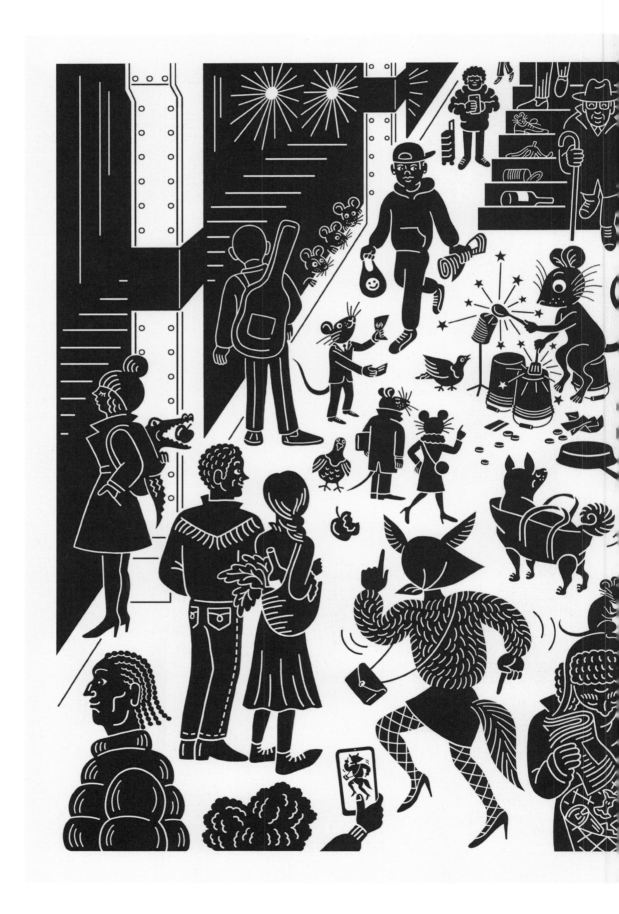

Selected Exhibitions: 2013, *Che farò senza*, solo show, Spazio Elastico, Bologna · 2011, *New Prints*, group show, International Print Center New York · 2009, *New Prints*, group show, International Print Center New York

Selected Publications: 2019, *Buon Giorno*, Strane Dizioni, Italy · 2013, *Che farò senza*, Strane Dizioni, Italy · 2011, *Little Opera*, Strane Dizioni, Italy · 2010, *Un Sedicesimo*, Corraini Edizioni, Italy · 2009, *The Feast vol. 1–4*, Tomi Um, USA

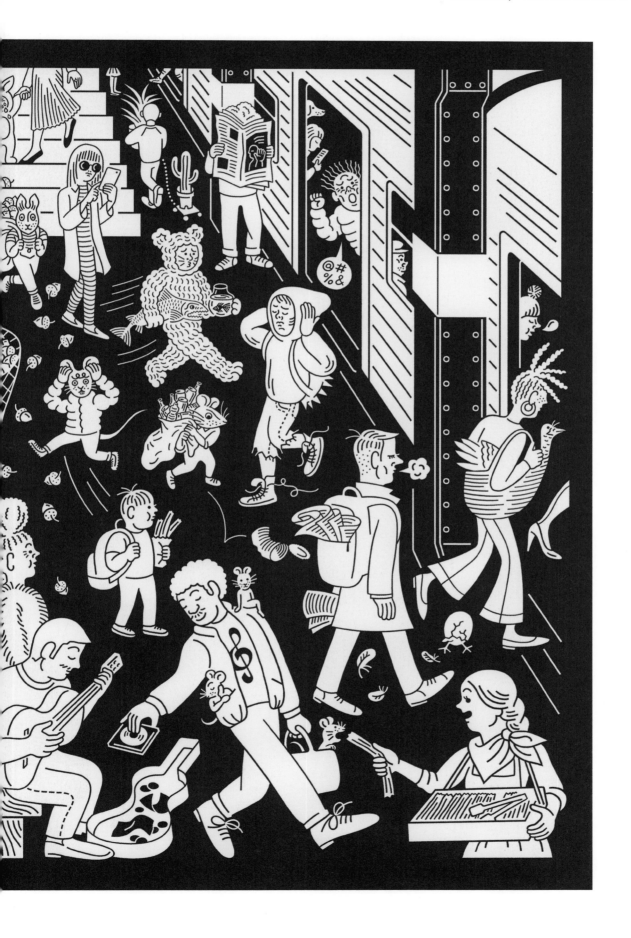

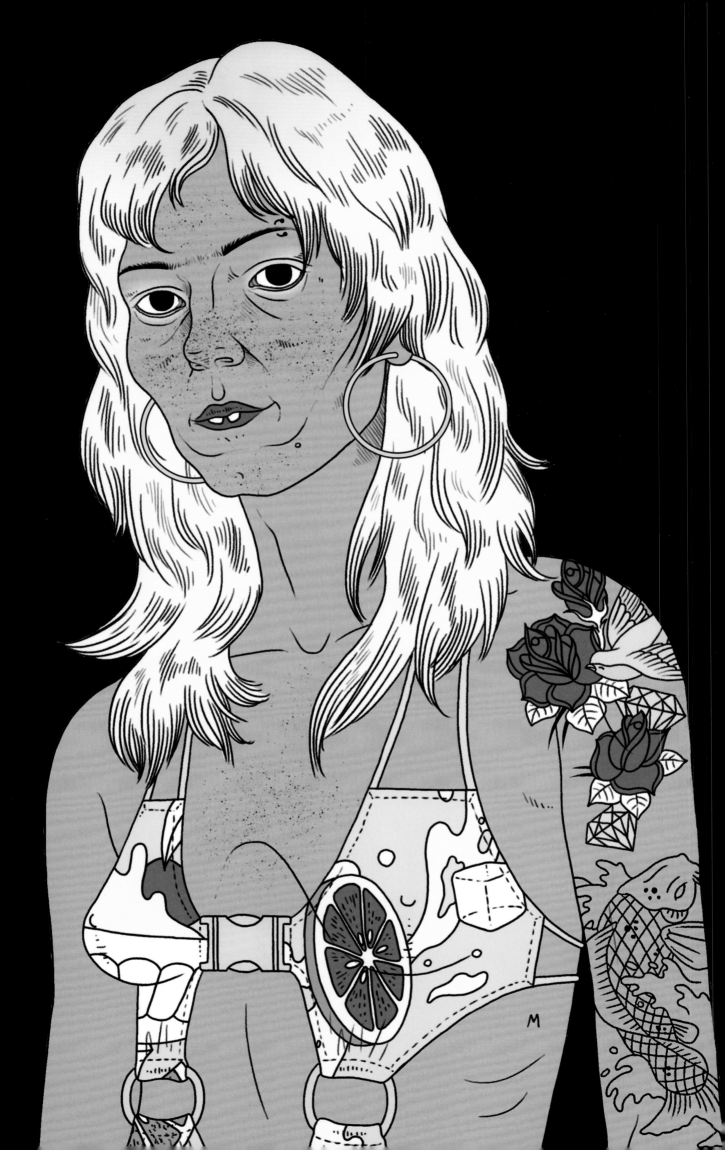

> "Berta Vallo combines astute observations with a signature humorous tone in her illustration work." Central St Martins

BERTA VALLO

WWW.BERTAVALLO.COM · @bertavallo

For London-based illustrator Berta Vallo, observation is key to her creative approach. With a strong interest in human behavior and emotions, she addresses what she describes as "the notion of identity formation and female sexuality in relation to consumerist culture." She was born in Budapest, in 1995, where she grew up drawing and later studied world literature and media studies. She found herself learning traditional animation in the studio of Oscar-winning animator Ferenc Rófusz at the Art School of Buda. After two years she took up life drawing and began studying graphic design and painting. In 2014, she moved to London after being accepted on the BA graphic communication design course at Central St Martins, where she specialized in illustration in her second year. During this period she began working as a junior designer at the London studio of Icelandic artist Kristjana S. Williams, where she contributed visuals for art installations at the Rio Olympics. In 2016, Vallo presented her first solo exhibition at the

Für die in London ansässige Illustratorin Berta Valló ist Beobachtung der Schlüssel zu ihrem kreativen Ansatz. Mit einem starken Interesse an menschlichem Verhalten und menschlichen Emotionen spricht sie das an, was sie als „den Begriff der Identitätsbildung und der weiblichen Sexualität in Bezug auf die Konsumkultur" beschreibt. Sie wurde 1995 in Budapest geboren, wo sie mit dem Zeichnen aufwuchs und später Weltliteratur und Medienwissenschaften studierte. Sie lernte traditionelle Animationen im Atelier des Oscar prämierten Animators Ferenc Rófusz an der Art School of Buda. Nach zwei Jahren begann sie mit dem Zeichnen und studierte Grafikdesign und Malerei. 2014 zog sie, nach ihrer Aufnahme in den Bachelorstudiengang Grafikdesign im Central St Martins nach London, wo sie sich im zweiten Jahr auf Illustration spezialisierte. Während dieser Zeit arbeitete sie als Junior Designerin im Londoner Studio der isländischen Künstlerin Kristjana S. Williams, wo sie Visuals für Kunstinstallationen bei den Olympischen

Pour l'illustratrice londonienne Berta Valló, l'observation est la clé de son approche créative. Démontrant un intérêt poussé pour le comportement humain et les émotions, elle se penche sur ce qu'elle décrit comme « le concept de formation d'identité et de sexualité féminine par rapport à la culture consumériste ». Née en 1995 à Budapest, elle dessinait quand elle était enfant ; elle a ensuite étudié la littérature mondiale et les médias, puis suivi une formation en animation traditionnelle au studio de l'animateur oscarisé Ferenc Rófusz, à l'école d'art de Buda. Deux ans plus tard, elle s'est mise au dessin d'après modèles et a pris des cours de design graphique et de peinture. En 2014, elle est partie vivre à Londres après avoir été admise en licence de communication graphique au Central St Martins, où elle s'est spécialisée en illustration la seconde année. À cette époque, elle a travaillé comme conceptrice junior au studio londonien de l'artiste islandaise Kristjana S. Williams, ce qui lui a permis de participer à la

Weöres Sándor Theater in Budapest. *Pixels* is a series of observational studies that showcase her practice of combining traditional analog media techniques with digital collaging. Precision lines and exaggerated features reveal behavioral glimpses through grotesque caricature and everyday scenes. Since graduating with honors in 2017, Vallo has produced an informational mural on London's food markets for Stansted Airport and has collaborated with British rapper Professor Green for the UK online support network The Book of Man.

Spielen in Rio beitrug. Im Jahr 2016 präsentierte Valló ihre erste Einzelausstellung im Weöres-Sándor-Theater in Budapest. *Pixels* ist eine Serie von Beobachtungsstudien, die ihre Arbeitsweise, die Kombination traditioneller analoger Medientechniken mit digitaler Collage zeigt. Präzise Linien und übertriebene Gesichtsausdrücke offenbaren durch groteske Karikaturen und Alltagsszenen Einblicke in menschliche Verhaltensweisen. Nach ihrem Abschluss mit Auszeichnung im Jahr 2017 hat Valló für den Flughafen Stansted ein Info-Wandbild zu den Londoner Lebensmittelmärkten geschaffen und mit dem britischen Rapper Professor Green für das britische Online-Support-Netzwerk The Book of Man zusammengearbeitet.

création de visuels pour des installations artistiques destinées au Jeux olympiques de Rio. En 2016, Valló a inauguré sa première exposition en solo au théâtre Weöres Sándor de Budapest. *Pixels* est une série d'observations qu'elle a réalisées en combinant des techniques analogiques traditionnelles et des collages en numérique. Par des lignes précises et des traits exagérés, elle révèle des aspects du comportement dans des caricatures grotesques et des scènes du quotidien. Depuis l'obtention de son diplôme en 2017 avec les honneurs, Valló a créé une fresque informative sur les marchés londonien dans l'aéroport de Stansted et collaboré avec le rapper britannique Professor Green pour la plateforme d'entraide en ligne The Book of Man.

Jordan Dingle, 2018,
private commision, print; digital

opposite

7 Wentwood House, 2018
Personal work, print; digital

p. 624

Georgia Seeds, 2018
Personal work, print; digital; inspired
by Vanessa Winship's photo series
"Georgia Seeds Carried by the Wind"

Selected Exhibitions: 2017, *London Design Festival*, group show, Lethaby Gallery, London · 2017, *Sweet 16*, group show, Jaguar Shoes Collective, London · 2017, *Obscure Relatives*, group show, Central St Martins, London · 2017, *CSM Illustration Show*, group show, Menier Gallery, London · 2016, *Pixels*, solo show, WSSZ Gallery, Szombathely, Hungary

Selected Publications: 2017, *New Stars of Design, Computer Arts* magazine, United Kingdom · 2017, *New Talent*, Creative Bloq, United Kingdom · 2017, *Take Five*, Central St Martins, United Kingdom · 2017, *On How Instagram Illustration Became the Heartbeat, Grazia Daily*, United Kingdom

BERTA VALLO

Summers in Buda, 2018
Personal work, print; digital

right
Sweet Nothings, 2018
Personal work, print; digital;
inspired by Vanessa Winship's
Sweet Nothings

opposite
Fake Bag, 2018
BBC website, *Vice* magazine; digital

> "Humor is important to me and drives a lot of my decision-making. If a drawing makes me smile or laugh out loud, it usually means I'm heading in the right direction."
>
> for *Communication Arts*

ARMANDO VEVE

WWW.ARMANDOVEVE.COM · @armandoveve

Armando Veve's mind-boggling graphite and pen creations, depicting surreal constructions and weird inventions, are rendered with meticulous attention to detail and texture. References abound, from pointillism to vintage reference books, with hat doffs to the likes of Fritz Kahn and M.C. Escher. Such skill and imagination have brought the Philadelphia-based illustrator deserved attention through his work for major publications and a slew of awards to boot. Born in Lawrence, Massachusetts, in 1989, Veve attended the Rhode Island School of Design, where he began to find his voice studying editorial illustration under Chris Buzelli. After he graduated with honors in 2011, commissions soon began to flow. To date, he has contributed to *Condé Nast Traveler*, *MIT Technology Review*, *New Scientist*, and *Wired*, to name but a few. In 2017, he was awarded two Gold Medals from the Society of Illustrators and named an ADC Young Guns winner by the One Club for Creativity in New York. *Forbes* included him in the 2018

Armando Veves verblüffende Grafit- und Kugelschreiberkreationen, die surreale Konstruktionen und verrückte Erfindungen darstellen, werden mit viel Liebe zu Details und Texturen geschaffen. Referenzen gibt es zuhauf: vom Pointillismus zu alten Vintage-Nachschlagewerken, mit einem respektvollen „Chapeau" für Leute wie Fritz Kahn und M. C. Escher. Diese Fähigkeit und Fantasie haben dem in Philadelphia ansässigen Illustrator durch seine Arbeit für große Publikationen und eine Reihe von Auszeichnungen viel Aufmerksamkeit zuteilwerden lassen. Der 1989 in Lawrence (Massachusetts) geborene Veve besuchte die Rhode Island School of Design, wo er, während er bei Chris Buzelli Editorial Illustration studierte, zunehmend seine eigene Stimme entwickelte. Nachdem er im Jahr 2011 mit Auszeichnung seinen Abschluss gemacht hatte, wurde er bald mit Aufträgen überschüttet. Bis heute arbeitet er für *Condé Nast Traveler*, *MIT Technology Review*, *New Scientist* und *Wired*, nur um einige zu nennen.

Armando Veve crée des œuvres époustouflantes au graphite et au stylo, dans lesquelles il représente des constructions surréalistes et d'étranges inventions. Il travaille en portant un soin absolu aux détails et aux textures, s'inspire de nombreuses références allant du pointillisme aux livres vintage, et est un grand admirateur de Fritz Kahn et M.C. Escher. Son talent et son imagination ont valu à cet illustrateur installé à Philadelphie la reconnaissance de son travail dans des publications phares et tout un lot de récompenses. Né en 1989 à Lawrence, dans le Massachusetts, Veve a étudié à la Rhode Island School of Design, où il s'est forgé son style en étudiant l'illustration éditoriale auprès de Chris Buzelli. Diplômé avec les honneurs en 2011, il a très vite reçu ses premières commandes et à ce jour, il a contribué pour *Condé Nast Traveler*, *MIT Technology Review*, *New Scientist* et *Wired*, parmi bien d'autres. En 2017, il s'est vu décerner deux médailles d'or par la Society of Illustrators, ainsi que le prix ADC Young

631

edition of its "30 under 30" list. Veve has also exhibited in art shows such as *1+() Global Network* at the Seoul Illustration Fair, *Go West!* at Vienna Design Week, and *The Shape of Things to Come* at Jonathan LeVine Projects in New York.

2017 wurde er von der Society of Illustrators mit zwei Goldmedaillen ausgezeichnet und vom One Club for Creativity in New York zum ADC Young Guns Winner ernannt. *Forbes* nahm ihn in die 2018er-Ausgabe seiner „30 unter 30"-Liste auf. Veve hat auch an Kunstausstellungen, wie *1+() Global Network* auf der Seoul Illustration Fair, *Go West!* bei der Vienna Design Week und *The Shape of Things to Come* bei den Jonathan LeVine Projects in New York. teilgenommen.

Guns par The One Club for Creativity à New York ; *Forbes* l'a par ailleurs inclus dans son édition 2018 de sa liste « 30 under 30 ». Veve a en outre pris part à des expositions comme *1+() Global Network* à la Seoul Illustration Fair, *Go West!* à la Vienna Design Week et *The Shape of Things to Come* à la galerie new-yorkaise Jonathan LeVine Projects.

10 Theses on Russia, 2017
Global Brief, magazine;
graphite, watercolor, digital

opposite
Escape Room, 2018
*The New York Times
Magazine*; graphite

p. 630
Streamlining Data, 2018
Planadviser, magazine;
graphite, watercolor, digital

Hacienda Hedge, 2017
Bloomberg Markets,
magazine; graphite

p. 636
Your Conscious
Unconscious, 2016
New Scientist, magazine; graphite

p. 637
War Music, 2016
The New York Times Book Review,
newspaper supplement; graphite, digital

ARMANDO VEVE

Selected Exhibitions: 2018, *The Art of Armando Veve*, solo show, Richard C. von Hess Gallery, UArts, Philadelphia · 2018, *Art as Witness*, group show, School of Visual Arts, Chelsea Gallery, New York · 2018, *Go West!*, group show, Designforum Wien, designaustria, Vienna · 2018, *Krem*, group show, The Scarab Club, Detroit · 2017, *Storybook Style*, group show, Morris Museum, New Jersey

"I like skating, the 1970s, and astronauts."

STEFAN VOGTLÄNDER

WWW.LUTZOWCASTLES.COM · @lutzowcastles

Stefan Vogtländer is a freelance illustrator and art director based in Berlin. Working with silkscreen printing and digital tools, he reduces landscapes and compositions to minimal line, color, and shadow. A notable example is *Travelgram* (2017), a personal series of illustrations inspired by the travel photographs commonly posted on Instagram. Using images taken during a road trip in the summer of 2017, he charted a journey across Switzerland and down through Italy. The body of work also formed his first exhibition at ILLU18 in Cologne. Born in Marl in 1987, whilst studying at the Academy for Communication Design (Cologne), Vogtländer worked at a printing shop, where he was able to experiment with different techniques, papers, and binding—explorations he translates in his digital work. He also began freelancing in editorial design, which gained him a Junior Art Directors Club award in the print media category for his thesis. Since graduating in 2014, Vogtländer has worked as an art director and graphic designer for various agencies,

Stefan Vogtländer ist ein freiberuflicher Illustrator und Art Director mit Sitz in Berlin. Er arbeitet mit Siebdruck und digitalen Werkzeugen und reduziert Landschaften und Kompositionen auf minimale Linien, Farben und Schatten. Ein bemerkenswertes Beispiel ist *Travelgram* (2017), eine persönliche Serie von Illustrationen, die von, auf Instagram veröffentlichten, Reisefotos inspiriert wurden. Mit Bildern, die während eines Roadtrips im Sommer 2017 aufgenommen wurden, zeichnete er eine Reise durch die Schweiz und Italien nach. Das Werk bildete auch seine erste Ausstellung auf der ILLU18 in Köln. Vogtländer wurde 1987 in Marl geboren und war während seines Studiums an der Akademie für Kommunikationsdesign (Köln) in einer Druckerei tätig, wo er mit verschiedenen Techniken, Papieren und Bindungen experimentieren konnte – Untersuchungen, die er in seine digitale Arbeit überträgt. Er begann auch freiberuflich im Editorial Design zu arbeiten, was ihm eine Auszeichnung des Junior

Stefan Vogtländer est un illustrateur et directeur artistique indépendant résidant à Berlin. Se livrant à la sérigraphie et aux outils numériques, il réduit des paysages et des compositions à l'expression minimale en termes de lignes, de couleurs et d'ombres. Œuvre remarquable, sa série d'illustrations *Travelgram* (2017) est le fruit de photographies de voyage que des personnes ont publiées sur Instagram. À partir d'images prises au cours d'un voyage par la route l'été 2017, il a aussi représenté graphiquement un itinéraire à travers la Suisse et l'Italie. L'ensemble de ses œuvres a été présenté dans sa première exposition au festival ILLU18 à Cologne. Né en 1987 à Marl, Vogtländer a étudié à l'académie de design de communication à Cologne, tout en travaillant en parallèle dans un atelier d'imprimerie : il s'est ainsi initié à une variété de techniques, de papiers et de reliures, autant de connaissances qu'il a ensuite transposées dans ses créations numériques. Il a également accepté en freelance des

including BBDO and Hirschen. He lists his inspirations as ranging from Edward Hopper and early graphic designers like Edward McKnight Kauffer and A.M. Cassandre to mid-century modern design, vintage video games, and skateboarding. Among his commissions to date, he has illustrated campaigns for Düsseldorf's Schauspielhaus theater, the German Skateboard Championships, and Wrigley's gum.

Art Directors Club in der Kategorie Printmedien für seine Abschlussarbeit einbrachte. Seit seinem Abschluss im Jahr 2014 hat Vogtländer als Art Director und Grafikdesigner für verschiedene Agenturen gearbeitet, zum Beispiel für BBDO und Hirschen. Seine Inspirationen reichen von Edward Hopper und frühen Grafikdesignern wie Edward McKnight Kauffer und A. M. Cassandre bis hin zu Midcentury Design, klassischen Videospielen und Skateboarding. Zu seinen bisherigen Aufträgen zählen Kampagnen für das Düsseldorfer Schauspielhaus, die Deutsche Skateboard Meisterschaft und Wrigley's Gum.

commandes de conception éditoriale qui lui ont valu un prix Junior Art Directors Club dans la catégorie presse écrite pour sa thèse. Depuis l'obtention de son diplôme en 2014, Vogtländer a exercé comme directeur artistique et concepteur graphique pour diverses agences, dont BBDO et Hirschen. Il puise son inspiration chez Edward Hopper et les premiers concepteurs graphiques comme Edward McKnight Kauffer et A.M. Cassandre, mais aussi dans le design de milieu de siècle, les jeux vidéo vintage et le skateboard. Il a illustré des campagnes pour le théâtre Schauspielhaus de Düsseldorf, le Championnat de skateboard d'Allemagne et les chewing-gum Wrigley.

STEFAN VOGTLÄNDER

Selected Exhibitions: 2018, *ILLU18*, group show, Michael
Horbach Stiftung, Cologne · 2018, *Parks*, solo show, Gloria
Café, Cologne · 2017, *ADC Festival*, group show, Kampnagel,
Hamburg · 2016, *Skatespots*, solo show, Pivot, Cologne ·
2014, *ADC Festival*, group show, Oberhafenquartier, Hamburg

Selected Publications: 2017, *Art Directors Club Annual*,
Edel, Germany · 2014, *Art Directors Club Annual*,
Avedition, Germany

Alex's Yard, 2017
Personal work,
poster; digital

opposite
Alexander Platz, 2018
Personal work,
poster; digital

p. 638
Lago Maggiore, 2018
Personal work,
poster; digital

> "I find people-watching endlessly fascinating and I get a lot of inspiration from just observing people on the streets, especially in cities and in public transportation where all sorts of people gather." *for Inky Goodness*

JOOHEE YOON

WWW.JOOHEEYOON.COM · @joooheeeyooon

JooHee Yoon uses traditional printmaking techniques to produce beautiful illustrations. Born in Seoul, in 1989, she grew up traveling and spending time on the West Coast of the United States. In 2011, whilst studying at Rhode Island School of Design, she won a student scholarship competition run by the Society of Illustrators—by whom she would later be awarded a Gold Medal. Her inspirations range from observations of everyday life to the natural world, medieval art, and European posters of the early 1900s. When tackling client briefs her approach is to problem-solve and create "parallel metaphors" that make the visual component to the narrative accessible, whilst adding a conceptual dimension. Yoon is fascinated by printing processes, in particular early-20th-century reproduction methods that employed limited colors which, when overlapped, produce secondary shades. This is a technique she uses to great effect in works such as her first book aimed at younger readers. *Beastly Verse* (2015) is a selection of

JooHee Yoon verwendet traditionelle Drucktechniken, um wunderschöne Illustrationen zu erzeugen. 1989 in Seoul geboren, verbrachte sie viel Zeit ihrer Kindheit auf Reisen und an der Westküste der Vereinigten Staaten. Während ihres Studiums an der Rhode Island School of Design gewann sie 2011 einen Stipendienwettbewerb der Society of Illustrators, von der sie später eine Goldmedaille erhalten sollte. Ihre Inspirationen reichen von Beobachtungen des Alltags und der Natur bis zur mittelalterlichen Kunst und zu europäischen Plakaten des frühen 20. Jahrhunderts. Bei der Bearbeitung von Kundenaufträgen geht es ihr darum, Probleme zu lösen und „parallele Metaphern" zu erstellen, die die visuelle Komponente der Erzählung zugänglich machen, und gleichzeitig eine konzeptuelle Dimension hinzuzufügen. Yoon ist fasziniert von Druckprozessen, insbesondere von den Reproduktionsmethoden des frühen 20. Jahrhunderts, bei denen begrenzte Farben verwendet wurden, die bei

JooHee Yoon emploie des techniques traditionnelles de gravure pour réaliser ses magnifiques illustrations. Née à Séoul en 1989, son enfance a été rythmée par les voyages et quelques années passées sur la côté Ouest des États-Unis. En 2011, lors de ses études à la Rhode Island School of Design, elle a remporté un concours de bourses organisé par la Society of Illustrators, qui lui a d'ailleurs décerné plus tard une médaille d'or. Elle puise son inspiration dans ses observations du quotidien, la nature, l'art médiéval et les affiches européennes du début du XXe siècle. Pour aborder les briefs de ses clients, elle suit une approche de résolution de problème et tente de créer des « métaphores parallèles » rendant le composant visuel accessible, tout en lui ajoutant une dimension conceptuelle. Yoon a une grande passion pour les procédés d'impression, notamment les méthodes de reproduction du début du siècle dernier qui employaient des couleurs en nombre limité mais qui, superposées, donnaient des teintes secondaires.

16 poems about animals—both real and imaginary—by such classic writers as William Blake, D.H. Lawrence, and Ogden Nash. By using elements of the physical structure of the book, such as fold-out pages, she brings the creature-filled verses to life with a rhythmic sense of motion and play. Her subsequent interpretation of James Thurber's 1956 fable, *The Tiger Who Would Be King*, was named a *New York Times* Book Review "Best Illustrated Children's Book of 2015." Yoon has produced work for such prominent clients as *Die Zeit*, MailChimp, Fortnum & Mason, and *The New Yorker*. She regularly gives talks and workshops, and has taught screenprinting and illustration at her alma mater. Having lived in various cities throughout the United States and Germany, Yoon travels frequently, and works in what she describes as a "transitory state."

Überlappung sekundäre Farbtöne erzeugten. Diese Technik setzte sie in Werken wie in ihrem ersten Buch für jüngere Leser sehr wirkungsvoll ein. *Beastly Verse* (2015) besteht aus einer Auswahl von 16 Gedichten über – sowohl echte als auch imaginäre – Tiere von klassischen Autoren wie William Blake, D. H. Lawrence und Ogden Nash. Durch die Verwendung von Elementen der physischen Struktur des Buches, z. B. ausklappbare Seiten, erweckt sie die mit Geschöpfen gefüllten Verse mit einem rhythmischen Gefühl von Bewegung und Spiel zum Leben. Ihre darauffolgende Interpretation von James Thurbers Fabel *The Tiger Who Would Be King* von 1956 wurde 2015 von der *New York Times Book Review* als „Bestes illustriertes Kinderbuch" ausgezeichnet. Yoon hat für so prominente Kunden gearbeitet wie *Die Zeit*, MailChimp, Fortnum & Mason und den *New Yorker*. Sie hält regelmäßig Vorträge und Workshops und unterrichtet Siebdruck und Illustration an ihrer Alma Mater. Yoon hat in verschiedenen Städten in den Vereinigten Staaten und in Deutschland gelebt und ist häufig auf Reisen. Sie arbeitet in einem Zustand, den sie als „Übergangsstatus" bezeichnet.

Elle utilise cette technique avec brio dans ses créations, comme son premier ouvrage adressé aux jeunes lecteurs et intitulé *Beastly Verse* (2015), un recueil de 16 poèmes sur des animaux (réels comme imaginaires) de grands écrivains classiques comme William Blake, D.H. Lawrence et Ogden Nash. À partir d'éléments de la structure physique du livre, comme des pages rabattables, elle anime les vers dédiés aux créatures avec un sens du rythme et une touche ludique. Son interprétation de la fable de 1956 de James Thurber, *Le Tigre qui voulait être roi*, a été élue par *New York Times Book Review* « meilleur livre illustré pour enfants de 2015 ». Yoon a travaillé pour des clients importants comme *Die Zeit*, MailChimp, Fortnum & Mason et *The New Yorker*. Elle donne régulièrement des conférences et anime des ateliers ; elle a aussi enseigné la technique de sérigraphie et l'illustration à son alma mater. Ayant vécu dans plusieurs villes aux États-Unis et en Allemagne, Yoon voyage souvent et travaille dans ce qu'elle nomme un « état transitoire ».

JOOHEE YOON

Best of the Best, 2018
Planadviser, magazine;
hand drawing, digital;
art direction: SooJin Buzelli

opposite
The Friend, 2018
New York Times Book Review, newspaper
supplement; hand drawing, digital;
art direction: Matt Dorfman

p. 642
Fishmonger, 2017
Personal work,
limited-edition print;
screen printing

Ikumen, 2018
Topic, online publication;
colored pencil

right
Baby school, 2018
Topic, online publication;
colored pencil

opposite
Decomposers, 2018
The New York Times, newspaper;
hand drawing, computer;
art direction: Nathan Huang

JOOHEE YOON

Selected Exhibitions: 2018, *The Art of JooHee Yoon*, solo
show, Richard C. von Hess Gallery, UArts, Philadelphia ·
2018, *Ilustrarte*, group show, Centre for Contemporary
Culture, Castelo Branco, Portugal · 2017, *New Prints 2017
Summer*, group show, International Print Center New York ·
2016, *Visual Taipei*, group show, Songshan Cultural &
Creative Park, Taipei · 2016, *Bologna Illustrators Exhibition*,
group show, Bologna Book Fair

Selected Publications: 2018, *30 under 30, Forbes* magazine,
USA · 2016, *Communication Arts*, USA · 2016, *American
Illustration*, USA · 2015, *Best Illustrated Picture Books, The New
York Times*, USA · 2015, *Society of Illustrators*, USA

> "My inspiration comes from the great artists of the past mixed with psychedelic night visions and some pop songs. I like to play with shapes and lines and make them do a little dance before creating the final piece."

OLIMPIA ZAGNOLI

WWW.OLIMPIAZAGNOLI.COM · @olimpiazagnoli

Born in Reggio Emilia, Italy, in 1984, to photographer and artist parents, Olimpia Zagnoli absorbed visual references from an early age. She has referred to her kindergarten as her most profound creative influence. At the age of six she moved to Milan, where she would later study at the European Institute of Design. In 2008, New York beckoned and Zagnoli's bright, colorful vision soon splashed onto the editorials of *The New York Times* and *The New Yorker*, migrating to the city's subway system and the Guggenheim Museum. Drawing inspiration from childhood memories of Italy in the 1980s—from psychedelic animated TV commercials to soda can logos, coupled with a diverse set of influences ranging from Bruno Munari to Kermit the Frog—Zagnoli has created a fizzy-pop universe of brightly colored flat shapes. Based in Milan, she sketches quickly, and doodles on her iPhone before bringing her concepts to life on tablet and computer. Her portfolio has expanded to books, stamps, and art installations. Together with her father she has designed

Olimpia Zagnoli, 1984 in Reggio Emilia (Italien) als Kind von Fotografen und Künstlern geboren, sog schon im frühen Alter visuelle Referenzen auf. Als stärksten kreativen Einfluss bezeichnet sie aber ihren Kindergarten. Im Alter von sechs Jahren zog sie mit ihrer Familie nach Mailand, wo sie später am Europäischen Institut für Design studierte. Im Jahr 2008 winkte New York, und Zagnolis helle, farbenfrohe Visionen erschienen bald in den Editorials der *New York Times* und des *New Yorker*, von wo aus ihre Arbeiten in die U-Bahn-Stationen und das Guggenheim Museum gelangten. Inspiriert von Kindheitserinnerungen an das Italien der 1980er-Jahre – von psychedelisch animierten TV-Werbespots bis hin zu Limonadenlogos, gepaart mit vielfältigen Einflüssen, die von Bruno Munari bis zu Kermit dem Frosch reichen –, hat Zagnoli ein Brause-Pop-Universum aus bunten, flachen Formen geschaffen. Sie lebt in Mailand und skizziert schnell und kritzelt auf ihrem iPhone, bevor sie ihre Konzepte auf dem Tablet und dem

Née en 1984 à Reggio d'Émilie, en Italie, de parents photographes et artistes, Olimpia Zagnoli s'est dès son plus jeune âge alimentée de références visuelles, décrivant l'école maternelle comme sa plus profonde influence créative. Quand elle avait six ans, sa famille a déménagé à Milan, où elle a plus tard étudié à l'Istituto Europeo di Design. Partie vivre à New York en 2008, sa vision dynamique et colorée n'a pas tardé à parer les éditoriaux de *The New York Times* et *The New Yorker*, ainsi que les murs du métro de la ville et le musée Guggenheim. Puisant son inspiration dans les souvenirs de son enfance dans l'Italie des années 1980, époque des spots TV psychédéliques et des logos sur les canettes de soda, ainsi que chez Bruno Munari et Kermit la grenouille, Zagnoli s'est inventé un univers pop pétillant composé de formes plates aux couleurs vives. Installée à Milan, elle fait des esquisses rapides et gribouille sur son iPhone avant de matérialiser ses idées sur sa tablette et son ordinateur. Son portfolio s'est étendu et inclut à

and launched Clodomiro, an offbeat range of apparel and cookery wares. Constantly experimenting, Zagnoli has ventured into art installation, mobiles, stickers, video, and light art. Her nostalgic worlds have featured in solo exhibitions, such as *Parco Zagnoli* (2014) at Ninasagt Galerie in Düsseldorf, and *Cuore di Panna* (2018) at HVW8 in Los Angeles.

Computer zum Leben erweckt. Ihr Portfolio hat sich um Bücher, Briefmarken und Kunstinstallationen erweitert. Zusammen mit ihrem Vater hat sie Clodomiro entworfen und lanciert, eine außergewöhnliche Auswahl an Kleidung und Kochgeschirr. Da sie ständig experimentiert, hat Zagnoli sich an Kunstinstallationen, Handys, Aufkleber, Video- und Lichtkunst herangewagt. Ihre nostalgischen Welten wurden in Einzelausstellungen gezeigt – bei *Parco Zagnoli* (2014) in der Ninasagt Galerie in Düsseldorf und *Cuore di Panna* (2018) bei der HVW8 in Los Angeles.

présent des livres, des timbres et des installations artistiques. Avec son frère, elle a conçu et lancé Clodomiro, une ligne de vêtements et d'articles de cuisine décalés. Ne cessant d'expérimenter, Zagnoli s'est essayée aux installations artistiques, mobiles, autocollants, vidéos et éclairages. Ses mondes nostalgiques ont été présentés dans des expositions en solo, comme *Parco Zagnoli* (2014) à la galerie Ninasagt de Düsseldorf, et *Cuore di Panna* (2018) à la galerie HVW8 à Los Angeles.

OLIMPIA ZAGNOLI

How to Eat Spaghetti
Like a Lady, 2017
Antonio Colombo Gallery,
print; digital

opposite
Untitled, 2018
Dueostudio, rug; digital,
hand-knitted wool and silk

p. 648
Prada, Spring/Summer 2018
Textile and fashion
accessories; digital

Oz Fever, 2018
Marella, textile and fashion
accessories; digital

right
Summer in the City, 2018
BASE Milano, poster; digital

opposite
Rock Stars, 2015
Bang & Olufsen, magazine; digital

OLIMPIA ZAGNOLI

Prada, Spring/Summer 2018
Textile and fashion
accessories; digital

opposite
Black and White, 2016
Guggenheim Museum,
website; digital

OLIMPIA ZAGNOLI

Selected Exhibitions: 2018, *Cuore di Panna*, solo show, HVW8 Gallery, Los Angeles · 2017, *How to Eat Spaghetti Like a Lady*, solo show, Antonio Colombo Gallery, Milan · 2015, *Cinetica Zagnoli Elettrica*, solo show, Galleria 121+, Milan · 2014, *Parco Zagnoli*, solo show, Ninasagt, Düsseldorf · 2014, *Welcome to OZ!*, solo show, Yoyogi Art Gallery, Tokyo

Selected Publications: 2018, *The Illustration Idea Book*, Laurence King Publishing, USA · 2016, *W. Women in Design*, Triennale Design Museum, Italy · 2016, *In The Company of Women*, Artisan, USA · 2016, *Una Storia Americana*, Corraini Edizione, Italy · 2013, *It's Nice That Annual*, United Kingdom

> "To draw is not impossible, and to draw well is to feel satisfied with what you are leaving as a message, and not with what people say about your work." *for Delirium Nerd*

ISADORA ZEFERINO

WWW.IMZEFERINO.COM · @imzeferino

Isadora Zeferino is a freelance illustrator and visual development artist from Rio de Janeiro. Born in 1993, she initially studied biology, but later realized it was probably because she enjoyed drawing cell structures so much. Eventually, she attended classes on the product design and visual communication course at the Industrial Design School of the Rio de Janeiro State University. Zeferino weaves through her work a colorful style that harks back to European folklore and children's book illustration. She shares her thoughts and images on a daily basis, delighting her tens of thousands of social media followers. Disney fan art illustrations are posted alongside mermaids and the very occasional attack of sinister irony. Just for fun, Zeferino takes up 24-hour illustration challenges, such as "Inktober," or reinterprets classic book covers like Douglas Adams' *Hitchhiker's Guide to the Galaxy*, Aldous Huxley's *Brave New World*, and J.K. Rowling's *Harry Potter and the Philosopher's Stone*. Her clients include the Association of

Isadora Zeferino ist eine freiberufliche Illustratorin und Visual Development Artist aus Rio de Janeiro. Sie wurde 1993 geboren und studierte zunächst Biologie. Später wurde ihr jedoch bewusst, dass der Grund für dieses Studium war, dass sie so gern Zellstrukturen zeichnete. Schließlich besuchte sie Kurse im Bereich Produktdesign und Visuelle Kommunikation an der Industriedesignschule der Staatlichen Universität von Rio de Janeiro. Zeferino zeichnet sich durch einen farbenfrohen Stil aus, der auf europäische Folklore und Kinderbuchillustrationen zurückgeht. Sie teilt täglich ihre Gedanken und Bilder in den sozialen Medien mit ihren Zehntausenden von begeisterten Followern. Disney-Fan-Art-Illustrationen finden sich hier neben Meerjungfrauen und gelegentlichen Anfällen düsterer Ironie. Nur zum Spaß nimmt Zeferino Herausforderungen wie die 24-Stunden-Illustration „Inktober" an oder interpretiert Buchumschläge von Klassikern wie Douglas Adams' *Per Anhalter durch die Galaxis*, Aldous Huxleys

Originaire de Rio de Janeiro, Isadora Zeferino est une illustratrice et artiste en développement visuel qui travail à son compte. Née en 1993, elle a d'abord fait des études de biologie, pour comprendre ensuite pourquoi elle aimait autant dessiner des structures cellulaires. Elle a donc pris des cours de conception de produits et de communication visuelle à l'école de design industriel de l'université d'État de Rio de Janeiro. Zeferino applique à ses œuvres un style haut en couleur qui rappelle les livres illustrés pour enfants et le folklore européen. Chaque jour, elle partage ses pensées et ses images pour le bonheur de ses dizaines de milliers de fans qui la suivent sur les réseaux sociaux. Elle publie ainsi du fan art de personnages Disney, mais aussi des sirènes et occasionnellement, des messages ironiques. Pour s'amuser, Zeferino accepte des défis d'illustration de 24 heures comme « Inktober », ou réinterprète les couvertures de classiques de la littérature comme *Le Guide*

Public Defenders of Rio de Janeiro and Brazilian concert crowdfunding company Queremos. Zeferino is currently developing concepts for books.

Schöne neue Welt und J. K. Rowlings *Harry Potter und der Stein der Weisen* neu. Zu ihren Kunden zählen der Verband der Pflichtverteidiger von Rio de Janeiro und das brasilianische Crowdfundingunternehmen Queremos. Zeferino entwickelt derzeit Konzepte für Bücher.

du voyageur galactique de Douglas Adams, *Le Meilleur des mondes* d'Aldous Huxley et *Harry Potter à l'école des sorciers* de J.K. Rowling. Elle compte parmi ses clients l'Association des avocats commis d'office de Rio de Janeiro et la plateforme numérique de financement participatif Queremos destinée aux musiciens brésiliens. Zeferino travaille actuellement sur le développement de concepts de livres.

ISADORA ZEFERINO

Mercado de Artesanias de la
Ciudadela, Mexico City, 2018; digital

right
Knowledge Blooms, 2018
Personal work; digital

opposite
A Stroll around the Block, 2018
Personal work; digital

p. 656
A Gossip All Your Friends
Should Hear, 2018
Personal work; digital

INDEX

ACKNOWLEDGMENTS

I have now worked in partnership with Steve Heller on over ten books, one way or another: sometimes as a consultant and others as a proactive co-editor. This man's knowledge is insurmountable, and so is his generosity in sharing it. I would like also to thank my other partner for over 14 years, the always impeccable Daniel Siciliano Bretas, who has managed many of the publications I edit. I have also to thank Chris Mizsak for researching and writing about each of the illustrators in this book. It is not a showcase in classic terms, and therefore the profiles demanded both persistence and wit, and he has done an accurate and tireless job. When it comes to editors, we also had the supreme work of Gill Paul, who revised and edited the texts. To make everything look good throughout, we counted on Jens Müller designing the book and Daniela Asmuth taking care of the pre-press. We also had the honor of having the cover and front matter illustrated by Christoph Niemann, who proposed many new solutions for the challenges we faced during the course of producing the book. Many thanks to all of you.

The soul of this book is the work done by each artist featured here. And by being here, they also represent many more artists who could have been. Their collaboration and proactive involvement is fundamental to make a book like this relevant. I would like to thank all the illustrators, and extend that to the studio staff who helped us put this book together. They are the true heroes, and have certainly swum against many currents, and against many odds thrived in a world that doesn't fail to stun us daily with overwhelming visual experiences. They have raised the bars, and the book is here to crown it.

Last but not least I would like to thank all TASCHEN staff, and everyone in my department who has been involved in the book, from production to marketing. Developing a new book with a new concept demands the involvement of many people, and our guys have never failed to give this book their full support.

Julius Wiedeman

Savoring Summer, by Kadir Nelson, 2018
The New Yorker, magazine cover; oil on linen;
art director: Françoise Mouly